Buddhist Treasures from Nara

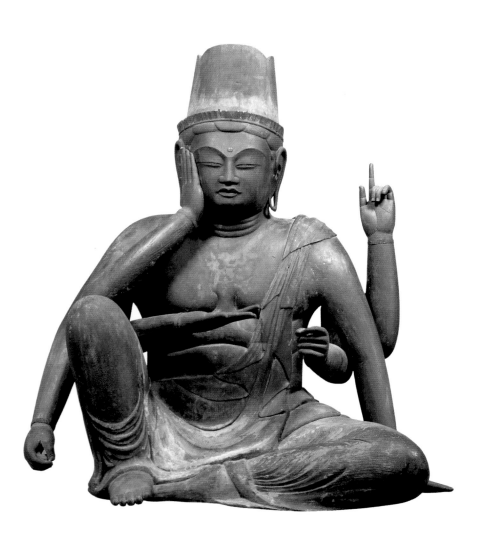

Michael R. Cunningham

Buddhist Treasures from Nara

THE CLEVELAND MUSEUM OF ART

WITH ESSAYS BY
JOHN M. ROSENFIELD AND
MIMI HALL YIENGPRUKSAWAN

Distributed by Hudson Hills Press, New York

Major support for the exhibition and catalogue is provided by the E. Rhodes and Leona B. Carpenter Foundation. Additional funding is provided by Audio Technica, Bridgestone/Firestone Trust Fund, Honda of America Mfg., Inc., NACCO Industries, Inc., Nordson Corporation, and The Standard Products Company/ Nishikawa Rubber Company.

The exhibition is supported by an indemnity from the Federal Council on the Arts and the Humanities.

Editing: Barbara J. Bradley and Kathleen Mills
Design: Thomas H. Barnard III
Maps and diagrams: Thomas H. Barnard III
Production: Charles Szabla
Composed in Adobe Optima and Univers Thin Ultra Condensed adapted for use in this publication
Printing: Amilcari Pizzi, Milan

Distributed by Hudson Hills Press, Inc.
Fifth Floor, 122 East 25th Street
New York, NY 10010–2936
Editor and Publisher: Paul Anbinder

Distributed in the United States, its territories and possessions, and Canada through National Book Network. Distributed in the United Kingdom, Eire, and Europe through Art Books International Ltd.

Front cover: Yakushi Nyorai [24]
Back cover: Kakebotoke with Images of Ten Shinto Deities [65]
Title page: Nyoirin Kannon [26]

EXPLANATORY NOTES
Unless noted otherwise, all works are on loan from the Nara National Museum.

To identify works of art considered important to Japan's cultural heritage, the Agency for Cultural Affairs (Bunka-chō) supervises a registration system for protecting designated works. The classifications are: National Treasure, Important Cultural Property, and Important Art Object.

Romanized Japanese names, places, and terms appear without the usual diacritical marks. Japanese personal names appear in the traditional style: family name first, followed by given name.

Numbers in brackets in the text refer to catalogue numbers of works in the exhibition.

Dimensions are given in centimeters (cm), height preceding width (or length).

All the following endings mean "temple":
"-era," "-in," "-ji."
The ending "-kyō" means "sutra."

LIBRARY OF CONGRESS CATALOGING-IN-PUBLICATION DATA
Cunningham, Michael R.
 Buddhist treasures from Nara / Michael R. Cunningham ; with essays by John M. Rosenfield and Mimi Hall Yiengpruksawan.
 p. cm.
 Catalog of an exhibition held at the Cleveland Museum of Art, Aug. 9–Sept. 27, 1998.
 Includes bibliographical references.
 ISBN 0–940717–48–4 (cloth : alk. paper).
—ISBN 0–940717–49–2 (pbk. : alk. paper)
 1. Art, Buddhist—Japan—Nara-shi—Exhibitions.
2. Art, Japanese—To 1600—Exhibitions. 3. Art, Japanese
—Japan—Nara-shi—Exhibitions. 4. Nara Kokuritsu
Hakubutsukan—Exhibitions. I. Rosenfield, John M.
II. Yiengpruksawan, Mimi Hall, 1948– . III. Cleveland
Museum of Art. IV. Title.
N7357.N3C86 1998
704.9'48943'095207477132—dc21 98–27230
 CIP

Contents

Preface

It is a privilege for the Cleveland Museum of Art to have been chosen by the Nara National Museum as its partner in an exhibition exchange program of the Bunka-chō and the Japanese National Museums sponsored by the Japanese government. We feel particularly honored as one of only three art museums in the Western world selected to participate in this enterprise.

The relationship between the Cleveland Museum of Art and Japan is a venerable and profound one, dating back even earlier than the service in Japan of former director Sherman Lee and former curator Howard Hollis following World War II. The museum's relationship with Nara is particularly close. Langdon Warner, special consultant in oriental art at the museum from about 1915 to about 1930, is buried at the Hōryū-ji, the only foreigner so honored. The Cleveland museum helped publish his book on early Buddhist sculpture in Japan, primarily derived from Nara temple collections. One painting in last year's one-hundredth anniversary exhibition at the Nara National Museum, a mandala featuring the Kasuga Jinja, the pre-eminent Shinto shrine in Nara, was purchased for the Cleveland museum by Warner in 1916, the year it opened to the public. Sherman Lee's close professional relationship with former Nara National Museum director Kurata Bunsaku was also an important part of the friendship between the two museums over the years.

In recent years the Nara National Museum, under directors Kurata Bunsaku and Nishikawa Kyōtarō, supported a government fellowship that allowed Cleveland curator Michael R. Cunningham to live for an extended period in Nara during preparation of the important exhibition *The Triumph of Japanese Style,* which was a centerpiece of the Cleveland Museum of Art's seventy-fifth anniversary year in 1991–92. That exhibition was organized with the collaboration of the Bunka-chō, whose painting specialist at the time was Miyajima Shinichi, now chief curator at the Nara National Museum. Subsequently, our museum sponsored the extended research visit of a Nara National Museum curator to Cleveland and other American museum collections.

We now pursue the current exchange as a happy collaboration between our two museums. In early 1998 the exhibition *Highlights of Asian Painting from the Cleveland Museum of Art* opened at the Nara National Museum and was subsequently shown at Tokyo's Suntory Museum. Now some of Nara's greatest treasures are on view in Cleveland, in the unique exhibition *Buddhist Treasures from Nara.* We are honored to have been entrusted with some of Japan's most important early Buddhist objects. It has been my particular pleasure to work with Uchida Hiroyasu, director of the Nara National Museum, in the most cordial and fruitful of partnerships.

We look forward to future collaborations with the Nara National Museum, Bunka-chō, and other friends in Japan. Already we have begun two conservation initiatives under the auspices of the Tokyo National Research Institute of Cultural Properties. These and other projects in the coming millennium will strengthen an already enduring relationship fostering mutual interests in the art and cultural traditions of East Asia. In the future, may our historical commitment to having "East meet West" in important artistic and cultural spheres continue to inspire projects that will afford the people of Japan and the United States new opportunities to share each other's cultural accomplishments.

Foremost, I wish to acknowledge Michael Cunningham, whose curatorial achievements, time, and dedication sustained our museum's participation in this marvelous venture. I thank catalogue authors John Rosenfield and Mimi Hall Yiengpruksawan for their splendid, informative essays. We are also grateful to His Excellency Kunihiko Saito, the Japanese ambassador to the United States, for serving as honorary chair of the Honor Committee for the exhibition. I would like to express our special gratitude to the E. Rhodes and Leona B. Carpenter Foundation for its major support to the project. Cleveland and Japan are most fortunate that the exhibitions are supported by an indemnity from the Federal Council on the Arts and the Humanities, an agency of the United States government. Seven distinguished members of Ohio's corporate community recognized the significance of the project through additional funding: Audio Technica, Bridgestone/Firestone Trust Fund, Honda of America Mfg., Inc., NACCO Industries, Inc., Nordson Corporation, and The Standard Products Company/Nishikawa Rubber Company. Japan Air Lines (JAL) generously provided transportation support for the exhibitions. To these agencies and companies, and to all others who collaborated in this extraordinary enterprise, I offer the museum's gratitude.

Robert P. Bergman, Director
The Cleveland Museum of Art

Greetings

It is a great honor and privilege to have the opportunity to exhibit at the Cleveland Museum of Art refined pieces of Japanese Buddhist art selected mostly from the collections of the Nara National Museum.

In recent years a mounting interest in Japanese culture has been observed, a trend particularly noticeable in the United States and the countries of Europe. Amid such an environment, Japan's Agency for Cultural Affairs, in conjunction with all three national museums—in Tokyo, Kyoto and Nara—has begun to implement an exchange exhibition program with the help of museums in the United States and Europe that collect objects of Japanese art. This program has contributed greatly to deepening the understanding among participating institutions, resulting in outstanding achievements in academic fields as well.

One hundred Asian paintings from the collection of the Cleveland Museum of Art were shown at the Nara National Museum this past February. These works have been globally acknowledged to be of the highest artistic value, for which the Cleveland museum can be proud. We had the supreme privilege of appreciating such masterpieces at our museum in Japan, and I would like to express my gratitude to the director of the Cleveland Museum of Art, Dr. Robert P. Bergman, for having realized such a superb project.

In return for the courtesy extended to us, an exhibition of eighty-seven selected pieces representing Japanese Buddhist art is now on view in Cleveland. Because great importance was placed on the genre of Buddhist art when our collections in Nara were assembled, we are sure that these objects can be acknowledged as representative works of Japanese art. Some were even entrusted to our museum by local temples. The works on view on this occasion cover such genres as archaeological finds, sculptures, paintings, calligraphy, and crafts. All were created between the seventh and the fourteenth centuries. Among them are twelve objects designated as National Treasures and forty-five designated as Important Cultural Properties. Many are being shown to the American public for the first time after a long journey over the ocean. We hope the people of the United States will appreciate the highlights of Japanese Buddhist art during this exhibition.

I would hereby like to express my deepest gratitude to Dr. Bergman as well as his staff for their generous understanding and collaboration in organizing this exhibition. It is my sincere wish that these cultural projects will lead to closer ties between our two institutions and eventually contribute toward enhancement of the friendship between the peoples of the United States and Japan.

Uchida Hiroyasu, Director
Nara National Museum
August 1998

Foreword and Acknowledgments

Although the Japanese court left Nara for Kyoto at the end of the eighth century, that ancient city continues to represent the core values that through the centuries have come to symbolize Japanese identity regardless of contemporary events in history. Like the five-story pagoda identifying a Buddhist sanctuary from afar, Nara endures as a beacon of the conjoining of imperial lineage, nation, and Japanese Buddhism. There the coveted relics of the past persist among the sundry Buddhist and Shinto establishments dotting the landscape of the city, the outlying Yamato plain, and the nearby hills and valleys of the Asuka region to the south. The public and the faithful still throng to these religious sites, where they witness awesome architectural structures and sculptural ensembles and, if they are fortunate or well informed, rites of veneration.

A city of more than 100,000 whose inhabitants reflected the diverse origins of the Japanese people as well as a vibrant international community of tradesmen, artisans, government officials, and clerics, Nara constituted the eastern terminus of the Silk Road at the height of its activity. Undeterred by the rigors of long-distance travel over land and by sea, visitors enriched the life of the Nara community as they partook of its rich spiritual, and worldly, offerings. The earnestness with which the Buddhist faith was being embraced by the Japanese populace and particularly by those governing the nation imbued the city with an air of intellectual curiosity, practical worldliness, and religious community. The several large Buddhist temples located within the city proper and the surrounding countryside served as spiritual and secular guideposts for the leaders of the newly formed nation as it navigated its course toward political and geographical unification. Church and state formed a bond (vividly described by Mimi Yiengpruksawan in the introductory essay) that characterized much of Nara culture in the eighth century and endures today, as evidenced by continuity in rituals.

As much as we wish to consider the extraordinary objects in this exhibition as "works of art," in fact, they were neither created nor conscientiously safeguarded as such. They represent instead visual symbols of spiritual ideas. That modern society or cultural historians might classify them according to historical period or some arcane iconographical subject means little to the cleric and his parishioners. These objects are, rather, vehicles toward gaining spiritual insight and awakening. Matters of aesthetics, authorship, and patronage pale next to the Buddhist creed and ritual of religious exegesis. But as John Rosenfield has so ably pointed out in his essay, early twentieth century Western concepts of "art" applied to the paraphernalia of Japanese Buddhism have indeed created a new order of identification for these Japanese Buddhist objects and—importantly—aided in their preservation by a modern generation of admirers for posterity.

No other institution can be identified with Nara's cultural heritage as is the Nara National Museum. Founded a little more than one hundred years ago as the last of the three national museums, it has served as the primary resource in Japan, and indeed in all of East Asia, for explicating the abundant visual materials associated with Buddhism. A permanent exhibition gallery for showing its collection of religious art as well as objects lent by Nara temples and a program of annual special exhibitions have been augmented over the decades by an impressive body of scholarship produced by its small curatorial staff. The two-week exhibition of eighth-century objects

from the Shōsō-in treasury held each autumn attracts more than 100,000 visitors. And over the years staff members have traveled extensively in their pursuit of scholarly learning, having initiated formal relationships with the Korean national museum system and an exchange of personnel and objects for special exhibitions. As the smallest of the three national museums in Japan, it has consistently taken the lead in international exhibition projects, reflecting its role as explicator of Nara's international cultural tradition. Each year staff members greet countless visitors to the museum and also serve as the most informed guides to the area's religious monuments and historical sites.

Buddhist Treasures from Nara, which provides Westerners with an opportunity to experience the museum's holdings for the first time, includes twelve National Treasures and forty-five Important Cultural Properties. In addition the museum has generously secured the loan of several pieces from Nara temples to augment the exhibition, much the same way it does in its own galleries. Earlier this year, one hundred Asian paintings from the collection of the Cleveland Museum of Art traveled to the Nara National Museum and the Suntory Museum of Art. In exchange, eighty-seven works of art have come to Cleveland. This project issued from a personal professional bond and continued contacts that have evolved over a fifteen-year period, beginning with my first extended visit to Nara in 1981. Then the incomparable scholar and director of the museum, the late Kurata Bunsaku, took me under his wing as we ventured from one temple to another collecting Buddhist sculpture for the annual spring special exhibition. Other trips followed to important Shinto and Buddhist sites still

very much off the beaten track but revelatory of Japanese Buddhism's extraordinary reach into the lives of the people living in Japan's distant (from Nara) provinces.

Later in my career Nishikawa Kyōtarō, scholar and Nara museum director, and Mitsumori Masashi, the museum's chief curator, provided much-needed assistance and institutional support in organizing one of the three special exhibitions celebrating the Cleveland Museum of Art's seventy-fifth anniversary, *The Triumph of Japanese Style.* Subsequent interactions between the two museums have developed and strengthened over the years, making the current exhibition exchange project the "jewel in the crown" of our relationship to date. To all the curatorial and administrative staff of the Nara National Museum, in the recent past and the present, I offer my heartfelt thanks for their support, fellowship, and interest in explaining the incredibly rich fabric of Buddhist art in East Asia. Kajitani Ryōji deserves everyone's praise for initiating this exchange project and then acting as its facilitator while juggling numerous other museum projects at the Nara National Museum. His experience, good humor, and energetic leadership have been extraordinary assets in realizing two major international exhibitions within less than a year.

Nearer home, this project could have been neither undertaken nor accomplished without the encouragement and support of Bob Bergman, director, and many Cleveland Museum of Art staff members from the development and external affairs division, led by Kate Sellers, and with special mention of the publications department, the design and facilities division, the Ingalls Library staff, the conservation division, and in the curatorial

division the registrar's office and the Asian art department. I am grateful to them all for their efforts in realizing this project. In particular I would like to thank Barbara Bradley, the editor of this catalogue, and Tom Barnard, its designer. Katie Solender, exhibition coordinator, and Jeffrey Baxter, whose installation design has also aided considerably in making these art objects more understandable to the museum public, also deserve mention. Special thanks are extended to Elizabeth ten Grotenhuis of Boston University for her comments on the catalogue manuscript. My colleagues in the Asian art department, Nancy Grossman and Beth Sanders-blevans, made extraordinary efforts to facilitate the success of this publication, this exhibition, and the attendant loan of CMA paintings to the Nara National Museum and the Suntory Museum of Art. I am most grateful to them and hope that with the realization of this project they may finally share in the enjoyment of its riches.

I should like, finally, to dedicate my efforts in this project to two incomparable teachers of Far Eastern art, the late Kurata Bunsaku and Father Harrie Vanderstappen, professor emeritus at the University of Chicago. While they must not be held accountable for my errors of fact and judgment, without their guidance and efforts over the years on my behalf—as well as for numerous other students of Japanese and Buddhist art—this exhibition could not have been realized.

Michael R. Cunningham
Curator of Japanese and Korean Art

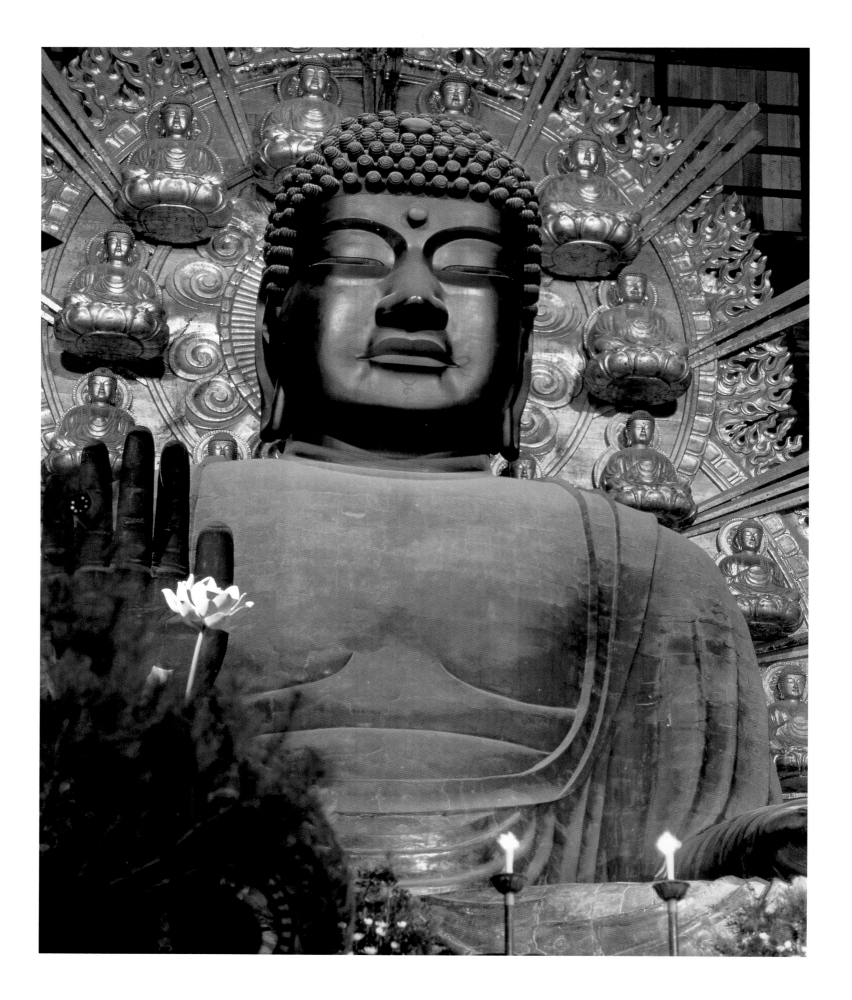

The Legacy of Buddhist Art at Nara

MIMI HALL YIENGPRUKSAWAN

More than twelve centuries ago, when the ancient world was ruled by Byzantium and the Ummayads to the west and Tang China to the east, a Japanese emperor called Shōmu attended the consecration of a colossal gilt-bronze statue of the Cosmic Buddha that he had sponsored (fig. 1). It was a moment of anticipation and fulfillment, for the project had been under way for many years. This statue meant much to the emperor, as a statement of his personal faith and as a symbol of cultural and political legitimacy for his government. When he saw it towering above him, its golden body gleaming in the light, he must have thought: This is the true form of Buddha and of the empire that I rule in his name. Now all rulers from Tang to Byzantium will know that my kingdom is a righteous domain.

The emperor's statue occupied a great worship hall at the center of the most important religious institution of his reign, the monastery Tōdai-ji. It stood among rolling hills on a low mountain called Mt. Mikasa (Mikasa-yama) where deer roamed freely. Those who ventured up the slopes of Mt. Mikasa looked back to see monastery grounds descending toward a bustling city that stretched to the horizon. Perhaps the emperor had found time to make the climb. In the distance, across a sea of buildings arranged in blocks along an orderly grid of avenues, he would have seen his palace and government offices. Here and there the pagodas of the city's ubiquitous monasteries rose into the sky. The green tile roofs of hundreds of buildings, some painted in bright vermilion, glittered under the sun. Faraway mountains framed the broad basin on which the city spread like a chessboard.

This was Nara, imperial capital of the Japanese archipelago since 710, and one of the great cities of the ancient world. Poets called it the city of greens and vermilions. It was the geographical and cultural hub of the Japanese islands, where all roads converged and people made their way to seek fortune and civilization. City streets were crowded with merchants, artisans, pilgrims, laborers, and monks. There were also visitors from across the sea, sometimes merchants from China and Central Asia, even a few monks from India. For Nara, capital of Japan, was also the eastern terminus of the Silk Road, an ancient trade route that traversed the Eurasian continent. A traveler to Nara in 710 might have come from as far away as Rome.

Shōmu ruled over this great city from 724 until his death in 756, first as its reigning monarch, then in retirement as its devoutly Buddhist senior emperor. In 749 Shōmu had abdicated the throne in favor of his daughter, Kōken, to pursue the project to which he had then dedicated his life: the construction of a colossal buddha as an act of devotion in keeping with Buddhist ideals of faith and imperial benevolence. For counsel he had turned to his wife, the redoubtable empress Kōmyōshi, who had similar political and religious goals, and to their affiliates in the monastic and palace communities. Kōmyōshi had been instrumental to the construction of Tōdai-ji, and had in fact built it around her own tutelary chapel on Mt. Mikasa. The completion of the Cosmic Buddha, and its enshrinement at Tōdai-ji, provided Shōmu with the symbol he needed to articulate a vision of holy Buddhist empire that he shared with his powerful wife and their priestly confidants.

Fig. 1. Daibutsu (Great Buddha), originally made in AD 752 of gilt bronze, in the Daibutsuden (Great Buddha Hall) of Tōdai-ji, Nara

1

When Shōmu attended the consecration ceremony, in 752, he was met by ten thousand monks gathered at Tōdai-ji to mark the occasion. He had asked a monk from India, Bodhisena, to preside. A Chinese monk, Daoxuan, led Shōmu, Kōmyōshi, Kōken, and hundreds of dignitaries in prayers and chanting. Thousands of monks recited from scripture under the direction of Bodhisena and Daoxuan. The international flavor of the ceremony was enhanced by the statue itself. The Great Buddha (Daibutsu), as it came to be known, was modeled on other Great Buddhas in China and along the Silk Road. It was also based on scriptures and an iconography only recently introduced from the continent, whose focus was the Cosmic Buddha called Birushana.

Newly consecrated in its beautiful setting at Tōdai-ji on the slopes of Mt. Mikasa, the Great Buddha would serve Shōmu well as an emblem of Buddhist empire. But the huge statue was also a technological feat. Its political and religious significance was deepened by the sheer complexity of its construction, which testified to the ability of a Japanese emperor to muster the economic and technical resources to erect such a monument in the name of Buddha and state. The statue had been years in the making as thousands of workers labored under the direction of government artists and designers. What they produced was as much a manifesto, of the power of art to fulfill a Buddhist dream, as it was a symbol of empire.

The Daibutsu embodied a vibrant artistic culture that had flourished in Nara since the city's foundation in 710. It was a culture deeply rooted in Buddhist ideals, of benevolent government and monastic rule to be sure, but also of art as a means to understanding and enlightenment. Through art the world of Buddhist doctrine came alive, its various Buddhas and Buddha-beings given form as sculpture or in painting, its realm of practice made manifest in chapels and halls filled with objects of prayer and ritual. This affiliation followed directly from the teachings expressed in sutras, the scriptures of Buddhism, and encouraged a strong orientation toward the plastic arts. Tremendous spiritual merit is gained, the sutras say, by the construction of monasteries and pagodas, the making of Buddhist images, the copying of scriptures. In

Buddhism the study of text and doctrine has always been tempered by vision and insight, and by the creation of images to facilitate understanding.[1]

From the beginning Nara was a city of art and artists engaged in visionary exploration of Buddhist teachings. The Great Buddha symbolized this above all, its ideological agenda notwithstanding, for it was a monument to the visual arts as the expression of Buddhist doctrine and practice. Nara was literally filled with art and architecture sponsored as a result of Buddhist devotion. There were monasteries or temples virtually everywhere, their precincts home to all manner of sculptures, paintings, and decorative objects. Tōdai-ji alone contained hundreds of works of art. This profusion of objects was not simply a function of didactic goals, such as the explication of scripture, nor did it signify the accumulation of merit alone. It was at the same time an exuberant celebration of visuality as a path to illumination and insight through the experience of "awesome beauty" (shōgon).

The Nara that Shōmu knew, then, was as much an art capital as it was the administrative and political hub of empire. Sponsorship and production of Buddhist art and architecture was a constant in the lives of court aristocrats but also for the state and at monasteries. Hundreds of artists and artisans were employed in the execution of various commissions. Most artists were based at prominent monasteries in Nara, but the government maintained its own workshops, as did the imperial palace. Kuninaka no Kimimaro, the principal designer of the Daibutsu, had come to Shōmu as head of the top government studio and was in effect a civil servant. He traced his family lineage back to the Korean kingdom of Paekche. The man in charge of casting the statue, Takechi no Ōkuni, was from an immigrant Chinese family.[2]

So diverse a community of artists, with immigrants arriving from China and Korea on a regular basis, contributed to a high level of experimentation in medium and style. The Great Buddha was one such example. For these reasons the art of Nara was characterized by formal and technical sophistication but also by steady transformation through the various media of metal, lacquer, clay, and wood. It was an art where the concerns and strategies of artists were ever evident. The visual culture

that developed out of this matrix, in effect the classical foundation of Japanese Buddhist art, was one of such creative energy that its legacy lasted for centuries.

After Shōmu died in 756, Kōmyōshi presented the Great Buddha with his personal collection of art objects. It was an act that perhaps better than any other summed up the full potential of the colossal statue at the heart of Nara. For if the Daibutsu was a symbol of state and mandate, as it surely was, it also bore witness to the abiding importance of art as a treasury of Buddhist understanding. As such the Great Buddha, receptacle of Shōmu's treasures, became in the end a symbol of the most important role that Nara as a cultural capital would play in history: the preservation of Buddhist art and tradition.

In 784 the Japanese government moved out of Nara to new quarters at Nagaoka and finally to Kyoto in 794. The metropolitan monasteries were left behind in the old capital, and the Great Buddha stayed as well at Tōdai-ji on Mt. Mikasa. Through the coming years of political and cultural transition, Nara retained its original character as a Buddhist capital and the base of venerable artistic traditions. The Daibutsu was destroyed and rebuilt a number of times through the eighteenth century, and the Nara monasteries also experienced vicissitudes over the centuries.

Nonetheless, so much was preserved and maintained at Nara, whether as material culture or the philosophical ruminations of monks, that the old capital remained what it had always been, one of the great Buddhist cities of East Asia.

Today Nara is a busy metropolis with all the conveniences and nuisances of modern life. The monasteries still survive and have even flourished as tourists and pilgrims fill the city year round to admire and to worship before painted and sculpted images as old as Nara itself. Inside worship halls at Tōdai-ji are the same objects that Shōmu and Kōmyōshi knew. It is easy to imagine for a moment that nothing has changed in twelve centuries, not the art and its power to hold our gaze, not the worshipers whispering nearby, not even the deer on Mt. Mikasa. The monks in their habits, their cellular phones notwithstanding, pray as monks have done since Nara was founded.

The importance of Nara is exactly the opportunity it affords, in the modern age, to know the past through Buddhist vision and the physical artifacts of Buddhist practice. An extraordinary opportunity to explore that vision in depth is provided by the objects in this exhibition. In their diversity and beauty they embody the vivid Buddhist culture of Nara and its lasting traditions. It is to better

know these objects, and the world of Buddhism that gave rise to them, that a closer look at Nara and its culture is warranted.[3]

The Nara Capital

The capital city of Nara was built at the southern end of the Nara Plain in central Japan. Since the early days of the Japanese state this region had been called Yamato and was regarded as the cradle of Japanese civilization. The area was dotted with the tombs of emperors going back to the fourth century and had seen the construction and abandonment of several capitals before Nara, among them Asuka and Fujiwara. Indeed, Nara was the first Japanese capital to survive beyond a generation. Its formal name was Heijō-kyō, borrowed from the old Chinese capital at Pingcheng, although most people probably called it Nara even in the eighth century. In its prime, when Shōmu was on the throne, Nara boasted a population of more than 100,000 inhabitants.[4]

The decision to construct a new capital at Nara was taken by Empress Genmei in 708 from her palace at Fujiwara some twenty kilometers south of the planned site. Her government had grown rapidly with the institution of a centralized bureaucracy based on Chinese and Korean prototypes, and there was need for expanded quarters for a burgeoning metropolitan population. Moreover, the increasing demands of diplomatic and commercial exchange with the continent necessitated a more strategically accessible site. There was also the matter of imperial succession. Genmei had recently lost her son, Emperor Monmu, to smallpox and probably wanted to remove her grandson Obito, the future Shōmu, to a palace and capital untouched by such pollution. In this sense Nara began as peripatetic Japanese capitals always had: in flight from disease and death.

That Nara was intended to last is clear from the scale of the enterprise and its ideological framework. Certainly Genmei and her closest advisor, the powerful nobleman Fujiwara no Fuhito, had empire in mind as they planned the city where Shōmu would reign. As their model they used Changan, the celebrated capital of Tang China. Famed throughout the ancient world for its riches and cosmopolitan culture, Changan was a formidable palace-city that housed the Chinese imperial

Fig. 2. Reconstruction drawing of Nara capital

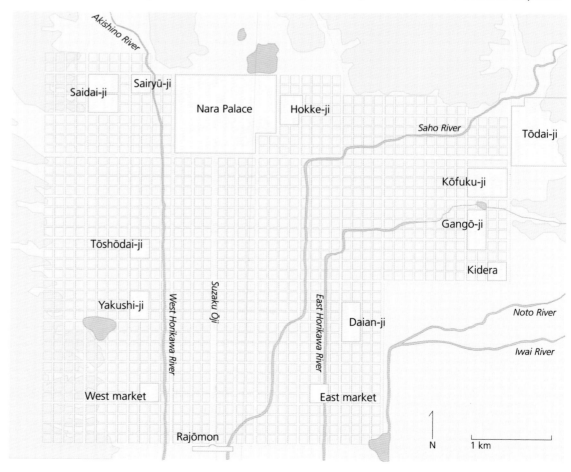

family. Nara would be a new Changan, where the Silk Road brought diplomats and traders as well as the Buddhist monks who would in time shape the destiny of the city and its rulers.

Nara was laid out on flat land as a rectangle that measured nearly three miles north to south and two-and-one-half miles east to west (fig. 2). About a third the size of Changan, its streets formed a regular grid pattern similar to a chessboard: eight boulevards running north to south; twelve avenues east to west. The main boulevard, Suzaku Ōji, divided the city into eastern and western sectors. Visitors to Nara entered via the main gate on the south, Rajōmon, and made their way up Suzaku Ōji into the city proper. Two rivers were diverted to flow through the eastern and western sectors. Eventually a subsidiary sector was attached on the northeast as an outer capital. The city was surrounded by elevated terrain on three sides: the Nara hills to the north; the mountains Mikasa, Kasuga, and Wakakusa on the east; and Mt. Ikoma on the west. To the south stretched the Nara Plain and the rice paddies on which the economic structure of the city rested.

Genmei moved her court to Nara in 710, and the city became the political and religious capital of Japan and its first permanent capital. During earlier regimes, indeed since the dawn of the early Japanese state some time in the fifth century, there had been no permanent capital. When a ruler died, the palace and often its surrounding city were deserted and a new site chosen for a new palace and capital. For example, the Fujiwara capital, where Genmei's son Monmu had been enthroned as emperor, had replaced an older palace and government complex at nearby Asuka on the death of its monarch, Tenmu. Subsequently Genmei ordered a move out of Fujiwara in 708, after the death of her son Monmu in 707.

As it grew over the next few decades Nara became home to three interdependent populations whose presence gave the city its distinctive flavor. The aristocracy was clustered in mansions in the north of the city around the palace compound where the imperial family and government were based. The commoners, their homes packed closely around the busy markets and street communities of trade and craft, occupied the eastern and western sectors of the capital. The religious community—so large that ten thousand monks could be summoned to the consecration of the Great Buddha in 752—transected the city high and low, for its members bridged the worlds of aristocrat and commoner as they served the Nara populace at large in the inculcation of Buddhist ideals. At the top of the monastic community was an aristocracy of high prelates and administrators, often drawn from the ranks of the nobility, which would play an enormous role in the emergent Buddhist political and visual culture of Nara in the time of Shōmu and Kōmyōshi.

The Nara capital was dominated by its palace sector, a walled city within a city that stood at the northern end of Suzaku Ōji and measured approximately one-half mile square. The compound was called the Great Palace (Daidairi) and contained various residences and government buildings. The imperial family lived there, as did members of their extended families and a security force. Most government business was conducted at the compound, where the reigning sovereign held court in a hall of state. The main gate to the compound, on Suzaku Ōji, was opened each morning shortly after sunrise and closed at sunset.[5] The business of state took place at the Ministries Compound (Chōdōin), a complex of twelve government offices, or in the Great Hall of State (Daigokuden), where the emperor or empress held formal audience on a daily basis. Here, as well, were staged the various Buddhist services directed to the peace and prosperity of the Nara state. To the rear of the Daigokuden was a domestic sector, the Inner Palace (Dairi), where the imperial family resided. There were private chapels in this sector, where icons were enshrined and cherished, and rooms for the daily round of private Buddhist prayer and recitation that was as important to rulership as politics and state ceremony.

Architecturally the structures of the Daidairi conformed to two standards, one continental, the other indigenous to Japan. Government buildings looked much like similar structures at Changan: stone foundation and podium; wood construction with a complex roof support system of brackets and bearing blocks; heavy ceramic tiles as roofing; and exterior decoration in green and vermilion. The residential halls followed the native tradition of

plain wood construction with rounded pillars set directly into the ground, a raised floor, and cypress-bark shingles over a simple roof framework of transverse beams. If Shōmu held audience in a hall appropriate to a Chinese emperor, its roof glittering with green tiles, he spent the private hours of his day in a traditional wooden home probably not that different from those of his subjects.

Outside the Daidairi it was the monasteries of Nara that dictated the life of the city from its incipience, especially those that literally had been carried to Nara with Genmei and her court as the primary religious centers of the Nara state. Daikan Dai-ji, the foremost state temple of the Asuka capital, was dismantled, reconstructed in Nara in 716 as the principal religious establishment of the city's eastern sector, and renamed Daian-ji. The imperial temple of Genmei's lineage, Yakushi-ji, was brought from Fujiwara to Nara in 718 as the principal religious establishment of the western sector. An additional sector, called the Outer Capital (Gekyō), was constructed some three blocks east of the Daidairi to accommodate two more monastic complexes from the Asuka region. One was Yamashina-dera, the tutelary temple of the Fujiwara family, rebuilt as the state temple Kōfuku-ji in 710; the other was the state monastery Asuka-dera, rebuilt as Gangō-ji in 718. Shōmu knew this group of early Nara temples as the Four Great Monasteries (Shi Dai-ji). After he took the throne in 724, still more state temples would be built through the second reign of his daughter, Kōken, under her new name, Shōtoku: Kōmyōshi's Hokke-ji of 745, a convent abutting the Daidairi on the east; her Shinyakushi-ji of 747, in the hills east of Kōfuku-ji; Tōdai-ji on its mountain in 752; and Shōtoku's Saidai-ji, constructed a few blocks west of the Daidairi in 764. Added to these were the numerous private temples and chapels scattered throughout the Nara capital, many of their names now lost to history. By the close of the eighth century, Nara contained upward of twenty-five major monastic complexes and had become a veritable monk's metropolis.

Most of these monasteries were based on Chinese and Korean prototypes—the model for temple architecture since the early seventh century. They conformed to the grand continental style seen at the Daidairi, with its vermilion and green structures opening on broad courtyards. Monastery sites tended to be square or rectangular in plan, situated on level terrain (even Tōdai-ji stood on land excavated so as to be flat despite its mountain setting), and surrounded by thick earthen walls. Typically a monastery precinct contained seven main structures in keeping with the Chinese and Korean tradition that a proper temple had seven halls: pagoda (tō); main hall or "golden hall" (kondō); lecture hall (kōdō); library of scriptures (kyōzō); belfry (shurō); refectory (jikidō); and dormitories or cells for monks (sōbō).

The halls were usually arranged along a north-south axis in the enclosed courtyard formed by the precinct walls. Formal access was from the south through an external gate (nandaimon) and internal middle gate (chūmon). Most buildings in the monastery precinct stood atop a podium on a stone foundation, were square or rectangular in plan, supported a complex roof system of brackets and bearing blocks, and had plaster walls with beams, pillars, and other wood elements painted a bright vermilion. Elaborate roof tiles of the type in the exhibition were typical of such structures [1a–h].

The most striking structure at a monastery tended to be the towerlike pagoda, which rose in multiple stories sometimes to a height of one hundred feet. Some of that flavor is preserved in the ceramic model of a pagoda [3]. The pagoda as an architectural construction is a distant relative of the Indian stupa, or burial mound, and has a complex iconography that makes it both a symbol and a manifestation of Buddha. It represents the place where a relic of Buddha is kept and worshiped, and, as such, can be understood as the holiest site within a monastery complex. It is also equated with the Buddha body itself and worshiped as the absolute form of Buddha at the moment of enlightenment. The ceramic model, from the Sanage kilns near modern-day Nagoya, shows yet another facet of this symbolic framework: it was probably intended for use as a reliquary of some sort, possibly containing bits of bone or ash from cremated human remains.

To step into the interiors of a Nara monastery, into the rooms and sanctuaries of its many buildings, was to enter a world of visual splendor. The doors of a main hall, for

instance, typically opened on an inner space filled with statuary, paintings, altar furnishings, ornaments, and offerings. It was a colorful space, bright with the iridescent hues of traditional Buddhist decoration, and one that provided sensual as well as spiritual enjoyment even as the protocols of worship were observed. Lamplight and candles enhanced the radiance of gold and silver; fragrant incense rose in clouds; monks chanted and sometimes sang their lines of scripture. Within the precincts of Kōfuku-ji or Yakushi-ji, or any number of the thriving Nara temples, monks and laity mingled in the celebration of Buddha through visually stimulating environments crowded with images and decorations.

The words "monastery" and "temple" are used interchangeably for these complexes, "monastery" because monks lived and meditated there, "temple" because, as in the *templum* of Greece and Rome, the religious exercises performed in that space involved a corpus of mediating priests and yielded a variety of benefits from spiritual merit to hope for the future. When Buddhism first emerged as a systematic philosophy and practice in ancient India, the monastery and the temple were separate institutions: a monastery was where communities of monks lived and studied; a temple, built around a relic of Buddha, was where laymen and laywomen came for worship and instruction. At Nara, as elsewhere in China and Korea of the eighth century, monastery and temple had been merged into one religious complex that addressed the needs of monks and laity alike.

It was in large part at these religious complexes in Nara, where the public and private universes of monks and patrons met, that the classical Buddhist culture of Nara came into being and was perpetuated for centuries. What has come to be called Nara Buddhism took form among the monks who studied and philosophized at these establishments and who shared their ideas, and agendas, with Shōmu and other monarchs. At monastery halls and chapels were held the sundry rituals of meditation, prayer, and instruction that sustained the Buddhist community that was Nara, from the Daidairi to the commoners who thronged its congested streets. Here was a world for which art mattered, for every moment of practice from meditation to prayer involved Buddhist images and visual stimulation.

Nara Buddhism

Buddhist philosophy and practices were long established in Japan by the time that Nara was built.[6] Around the middle of the sixth century a Korean king had sent Buddhist scriptures and statuary to his Japanese counterpart, and the new philosophy soon gained a following in palace society. For some time there was conflict between proponents of Buddhism and those who wished to preserve the native system of belief in gods called *kami*. However, by the close of the seventh century an equilibrium had been reached, and both Buddhist and kami worship flourished under state patronage.

Shōmu and Kōmyōshi were devout Buddhists, to be sure, but it must be emphasized that the celebration of kami was also an integral part of their lives. The imperial house claimed the foremost kami of all, the sun goddess Amaterasu, as their progenitrix, and messengers were regularly dispatched with offerings to her shrine at Ise on the coast of what is now Mie Prefecture. Eventually Amaterasu would be equated with the Great Buddha and worshiped as a manifestation of the Cosmic Buddha. There were also shrines for kami worship at many Nara temples. For example, Tōdai-ji included within its precincts a shrine to Usa Hachiman; Kōfuku-ji was bordered on the east by the Kasuga Shrine, where a family of kami were worshiped as the tutelary gods of the Fujiwara house [see 54]. Nonetheless, it was the Buddhism of Nara that most overtly informed the political and cultural life of the city and profoundly affected its rulers, as seen in the legacy of art and culture that they left behind.

In a pattern known throughout the Buddhist world, from India to China, the rulers of Japan had found much in the person and teachings of Buddha that they could relate to their own needs and circumstances. It is not surprising that emperors saw the figure of the Historic Buddha—the Buddha who is part of human history—as especially compelling. The Historic Buddha, one of myriad Buddhas in the infinite Buddhist cosmos, appeared in our world system in the late sixth century BC out of compassion toward sentient beings trapped in the cycle of transmigration. He was born an Indian prince, the famous Siddhartha, and grew up as the scion of the powerful Śākya clan of northern

Indian kings. But Siddhartha in due time renounced his heritage, choosing instead to seek and finally attain enlightenment as a Buddha or "knower of the truth of all things." He lived out the remainder of his days as an itinerant monk in simple robes, who, given the name Śākyamuni or "Sage of the Śākyas" by his followers, preached a message of liberation for all sentient beings.

Basically the message consisted of four propositions: all is suffering; suffering arises from illusion and desire; there is a realm free from suffering called nirvana; there is a path of practice that leads to nirvana. These "four noble truths," preached by Śākyamuni and disseminated by his disciples, formed the backbone of a body of teachings that came to be called Buddhism. In the millennia since Siddhartha completed his quest for enlightenment and provided humans with a means to transcendence, there have been many schools of Buddhism and diverse systems of Buddhist practice, but all share a common ground in this core teaching of the four truths as first realized by Siddhartha at the moment he became Buddha.

Kōmyōshi and her circle would have known the story of Siddhartha well, for narratives about the past lives of Buddha were as important to the inculcation of Buddhist values as the subtleties of doctrine. Indeed, illustrated biographies of the Historic Buddha, called Shaka in Japan, were among the articles presented to Tōdai-ji by Kōmyōshi in 756 in memory of Shōmu. On exhibit is a biography in the same vein, *Kako Genzai E-inga-kyō* (Scenes from the life of Shaka) [14], that was probably commissioned by Kōmyōshi or someone at her court around the same period. Naive and engaging, the brightly painted figures of Siddhartha and his retinue provide a lively pictorialization of the static text that stretches below them. This work addresses a theme surely of interest to a Nara ruler such as Shōmu: the origins of Buddhism in the benevolent actions of a prince who, not content with kingship over men, sought a greater and more universal role as the paramount king of all, Buddha.

For there is no question that, whatever Siddhartha's status as a simple monk who begged for a living, as Buddha he was a king of kings. The conflation dates to earliest times and has been connected to the ancient Indian ideal of the benevolent monarch called a Wheel-roller (Cakravartin) because, granted a cosmic wheel by which to rule on behalf of the gods, he brings order to the world by turning the wheel of mandate like the sun crossing the sky and illuminating the earth. The Ichiji Kinrin mandala on exhibit [42] presents this symbology of kingship clearly. Buddha is shown in the garb and aspect of a king: he wears a crown and jewelry, sits atop a lion throne, is silhouetted against a solar disk, and has a golden wheel strung around his torso on a thread.

Shōmu and Kōmyōshi certainly would have understood Buddha in these regal terms if only by virtue of their own visual culture. To enter the sanctuary of any one of their worship chapels, at Tōdai-ji or elsewhere, meant an encounter with an image of Buddha seated on a throne or dais, attendants and retinue at the ready, and tribute presented in the form of offerings. Even the word of Buddha, those sermons recorded as scripture, was understood as the law or dharma (Japanese: *hō*) that gave order to all things. Such an encounter, monarch to monarch, might have encouraged a certain humility in a devout emperor such as Shōmu, for one bracing moment not the most powerful figure in the room. But it also no doubt raised the fundamental fact that, all things considered, Buddha and emperor came from the same privileged class.

Another reason that Buddhism appealed to rulers such as Shōmu derived from scriptural assurances that a benevolent monarch would gain the support and protection of Buddha through study and devotion. This notion was especially strong in the diverse system of teachings called Mahāyāna Buddhism, which was developed in India around the beginning of the common era and then spread into Central Asia as monks and lay believers introduced its various forms to communities along the Silk Road.[7] By the fifth century, Mahāyāna Buddhism had emerged as the principal variety of Buddhism practiced along the Silk Road and from there made its way into China, Tibet, Korea, and Japan.

As doctrine, Mahāyāna Buddhism is a dauntingly complex collection of philosophical treatises on the notion of nonsubstantiality or emptiness, the nature of Buddha and mind, and other intellectual concerns well

outside the purview of ordinary people. At the same time, Mahāyāna Buddhism is a resilient system of devotional practices centered around numerous Buddhas and other Buddha-beings as objects of cultic worship. As such it marks a significant departure from an earlier order of conservative Buddhist philosophy and practice that was primarily monastic in emphasis, with a strong bias toward self-sufficiency in the pursuit of wisdom and enlightenment.

Mahāyāna Buddhism, by contrast, offered the easier path of reliance on Buddha through faith and devotion as well as discipline. This transformation, toward what might be called a user-friendly form of Buddhism in view of human foibles, has been linked to the rise of lay devotion in the centuries following the death of Shaka, known as the "final nirvana" or "final cessation," around 480 BC. Initially such lay devotion had tended to focus on the stupa, that distant relative of the pagoda, where a relic of the Buddha had been entombed. At first there were but eight stupas, for the eight relics taken from the body of Shaka after his cremation, but later centuries saw the proliferation of such sites for the worship of Buddha in the form of his burial mound. All Buddhist reliquaries, even those on exhibit [78, 79], are distant relatives of these first burial mounds.

Another formative element in the development of the Mahāyāna movement was the biographical narrative. Like veneration of stupas, it was a function of the human need to somehow recover the beloved Buddha after the final nirvana, or *parinirvāna* (Japanese: *hatsunehan*), when he completely disappeared from the world. Representations of the final nirvana, such as the canonical Nehan (Death of Buddha Shaka) [37], were typical of the trend toward biography and, in showing the distress of Buddha's followers, underlined the deep sadness posed by his passing. The narrative impulse led to devotional practices involving images of Buddha and to related meditational strategies for the recollection of his form. It was also a major factor in another prominent aspect of Mahāyāna Buddhism: its reliance on the visual arts as a means to seeing and venerating Buddha.

As the Mahāyāna movement gained acceptance, new scriptures were compiled from the second through fifth centuries, among them a collection of sutras on wisdom (or gnosis) popularly known as the Prajñāpāramitā (Japanese: Hannyaharamitsu) literature: the *Kegon Sutra* (Sanskrit: *Avatamsaka sūtra*; Japanese: *Kegon-kyō*) on Buddha's enlightenment and the nature of the bodhisattva, or compassionate being destined for Buddhahood; the *Lotus Sutra* (*Saddharmapundarīka sūtra*; *Hokke-kyō*) on the purity of mind and Buddha nature, the perfect enlightenment of Buddha, and the expediency—the "one-vehicle" efficacy—of Mahāyāna tenets; the *Golden Light Sutra* (*Suvarnaprabhāsa sūtra*; *Konkōmyō-kyō*) on benevolent kingship; the *Land of Bliss Sutra* (*Sukhāvatīvyūha sūtra*; *Muryōju-kyō*) on rebirth in paradise and the liberating power of faith; and many others. On the one hand complicated philosophical tracts addressing various matters of doctrine, these Mahāyāna sutras also describe a universe of practice that encompasses, not simply Buddha, but manifold Buddhas and literally hundreds of Buddha-beings as objects of worship.

Such Mahāyāna devotion pivots on the idea that there are many Buddhas, not just one (although all share in the same nature), and that these Buddhas are attended by bodhisattvas and other beings often in great numbers.[8] Buddha is understood as having three bodies: absolute, magical, and manifest. The absolute body is the prime—Buddha as the state of enlightenment itself—and strictly speaking cannot be conceived; as such the absolute body is the cosmic essence, or support, of the other two bodies. It is this Buddha body, the absolute body of the dharma, that the stupa and pagoda symbolize. The manifest body appears, or manifests itself, in a world system such as ours; the Historic Buddha is an example, but there are many more since there are infinite world systems in the Buddhist cosmos. The magical body is the form taken by Buddha in one of an infinite number of paradisal Buddha-fields, or pure lands, that exist as a kind of visionary virtual reality granted to those who have achieved advanced understanding. On exhibit is a representation of one such paradise, that of Amida in Gokuraku, his "Land of Bliss" in the western quadrant of the cosmos [52]. Known as the Taima mandala, the painting shows Amida enthroned at the heart of his pure land and was probably used as a teaching aid in the explication of the rigorous sixteen-

step visualization practice characteristic of Amidist worship.

As important to Mahāyāna devotion as the idea of multiple Buddhas, and also the foundation of its doctrinal framework, is the ideal of the bodhisattva. A bodhisattva is a being who has evolved through practice and wisdom to a state of such perfection that enlightenment is imminent. The term means as much: *bodhi* is the Sanskrit term for the Buddha nature that brings about enlightenment; *sattva* means a living sentient being. Out of compassion, however, the bodhisattva stops short of ultimate release and remains in the world of the sentient to guide others along the path to enlightenment. For early Buddhists this notion marked a radical departure from the former ideal of the *arhat* (Japanese: *rakan*) or reclusive holy man, who focused on his own enlightenment rather than that of others. The arhat remained an object of reverence in Mahāyāna Buddhism, but the bodhisattva came to embody the Mahāyāna philosophy of compassion.

As the paintings and statues in the exhibition amply demonstrate, there are many kinds of bodhisattva. One of the most prominent is the versatile Avalokiteśvara, or Kannon as the bodhisattva is popularly known in Japan. Androgynous and changeable, Kannon is regarded as a compassionate savior who takes a variety of different forms in order to expedite the process of bringing sentient beings to enlightenment. On view are six varieties of Kannon, from the simple to the complex [22–23, 26, 29, 31, 45–49, 67]. Shōmu and Kōmyōshi would have been familiar with most of these forms in connection with the Mahāyāna Buddhism that flourished at their court and the emphasis on Kannon as one of its exemplars.

They also would have known that the Buddhas and bodhisattvas of Mahāyāna belief, along with the various subsidiary guardian beings that surrounded them, could act on the world to protect those who worshiped them and cherished their scriptures. Such worship took several forms besides prayer, faith, and the study and self-discipline required of serious students of Buddhism. One of the greatest of meritorious acts was the making of Buddhist imagery. This included sponsoring and financing a wide variety of objects: paintings, sculptures, sutra transcriptions, ritual implements, altar decorations and furnishings. It extended as well to the construction and maintenance of monasteries and temples. In the world of Shōmu and Kōmyōshi, such activity was an essential part of the practice and indeed the experience of Buddhism. Art garnered protection and merit, to be sure, but it was also a magnificent display of faith in Buddha according to the Mahāyāna tradition.

For help in this task, and instruction, Shōmu and Kōmyōshi turned to the erudite community of monks who inhabited the Nara monasteries. Monks had their own history within Buddhism as its preservers and sustainers. Sworn to lives of strict discipline in the pursuit of their own enlightenment, monks also studied and commented on Buddhist scripture, debated doctrine, gave instruction on Buddhist tenets, oversaw the daily round of worship, and for the most part served as the representatives of Buddhism to the lay community at large. They were expected to pattern their lives after Shaka, who spent the forty-odd years of his ministry as a peripatetic wanderer who begged for his food, ate one meal a day, dressed in a simple robe, and slept under trees or atop stones.

The monks of Nara were kept to this ideal by the state, which legislated through its administrative codes a specific set of requirements for those who would enter the monastery and thus escape taxation and military service. Regulations promulgated in the decade following the move to Nara made it compulsory that a monk live at a monastery and not wander through the countryside, study doctrine and give sermons, meditate, and recite scriptures. The state also controlled the monastic community through a centralized system of ecclesiastical ranks and as overseer of the ordination of monks. The monks named to the top positions in this religious hierarchy, akin to its pope and cardinals, held power over the Nara monastic population as its ranking prelates. Such men could come from any one of the Nara monasteries but traditionally had been drawn from Yakushi-ji, the principal imperial temple of the old Fujiwara capital and a key institution for the imperial lineage to which Shōmu belonged. Not surprisingly, prelates were usually affiliated with the imperial house or noble families. It is doubtful that any but a

handful of these aristocrats, strongly bound to the state as they were, lived strictly in accordance with their precepts.

But there were some monks in Nara who believed in the Shaka ideal and went out to preach among the common and the outcast. One such populist was Gyōki, who kept to a life of poverty and itinerancy modeled on that of Shaka. Another was Rōben, who kept to an austere lifestyle in a small chapel on Mt. Mikasa detached from the world of monastic politics. Both Gyōki and Rōben, although influential in the lay community, were marginalized by the Nara establishment for much of their lives. Gyōki in particular was censured repeatedly for his refusal to abide by the regulation that monks not venture outside their monastic compound. That Gyōki and Rōben would eventually have prominent roles in the planning and construction of Tōdai-ji may have come as a shock to more conservative members of their community. For Shōmu and Kōmyōshi, however, theirs was a praxis that surely would have seemed a model of simple Buddhist piety in the complicated world of doctrine embraced by the Nara monastic establishment.

The salient characteristic of this establishment, aside from its close association with the Nara state, was a scholastic orientation in the practice and exposition of Buddhism. Several philosophical traditions coexisted at the Nara monasteries and were studied assiduously by monks in a seminar or study group format. In the early years the Sanron and Hossō traditions were especially prominent, their proponents meeting at Hōryū-ji, Daian-ji, Yakushi-ji, Kōfuku-ji, and other monasteries for discussion and debate. These were rarefied matters: Sanron adepts focused on three early Mahāyāna tracts on the notion of the middle path and a doctrine of eight negative truths in its realization; Hossō thinkers pursued the "consciousness-only" doctrine of Yogacara philosophy, a fifth-century branch of the Mahāyāna movement. Similarly abstract in emphasis were the Jōjitsu and Kusha traditions. With the introduction of the Kegon and Ritsu schools under Shōmu at mid-century, Nara became home to six Mahāyāna intellectual traditions of distinctly philosophical cast. Later these were called the "six schools" of Nara Buddhism.

Scholasticism meant a sometimes pedantic or dogmatic approach to Buddhism and a corollary emphasis on exegesis over faith, but it also encouraged intellectual diversity in the Nara community. Many monks traveled to China to study or seek Buddhist masters to invite back to Nara as new participants in a thriving society of thinkers. Bodhisena and Daoxuan had come to Nara in this way in 736. The scriptures and treatises introduced through such exchange prompted yet more interpretation, more argument, more philosophizing. It is probably accurate to say that Nara Buddhism by the time of Shōmu was first and foremost a Buddhism for scholars.

Shōmu and his peers turned to these scholars, especially the most erudite and respected among them, for advice and guidance in matters of religion public and private. Such experts oversaw the Buddhist rites that preserved the safety of the nation under the rubric *chingo kokka* (tutelary protection of the national polity). These rites, held at the Daigokuden, were a staple of the Nara government and served to promote a sense of stability even in times of high anxiety resulting from political assassination, epidemic disease, earthquake, and, toward the end of the century, war with recalcitrant tribesmen in the north. But the most influential role for a Nara monk was that of private advisor to a member of the imperial house or a high aristocrat. It was to such men, from the Nara hierarchy but also from its margins, that Shōmu and Kōmyōshi turned for instruction in the scriptures, teachings, and rites that would become the basis not only for the Great Buddha and Tōdai-ji, but also for the outpouring of art that came to describe their regime.

Iconography and Vision
The monks who served Shōmu and Kōmyōshi and gave them advice, whether for worship activities or for sponsoring images, needed to negotiate a body of iconography and ritual practice handed down over centuries as part of the Mahāyāna canon. In this sense the Buddhist art of Nara, in all its complexity and aesthetic sophistication, stood atop an edifice of Mahāyāna visual culture that stretched back into the deep past of Buddhism itself. It was an edifice built on the power of sight, and insight, in the quest for Buddhist transcendence.

Strong emphasis on visual materials in meditation and ritual is characteristic of Mahāyāna Buddhism, whose primary scriptures encourage visionary engagement with various Buddhas and Buddha-beings. The importance of seeing these figures, of making contact with them through vision and contemplation, is consequently a critical aspect of Mahāyāna practice. The very process of awakening itself, through which enlightenment becomes possible, is understood as one of seeing or gaining insight.

What worshipers saw at the beginning of Buddhist art, in the first centuries after the final nirvana, was Buddha as symbol: Buddha represented by a wheel or a stupa, by footprints, by an empty throne. This system of representation, called aniconic, has been likened to epithets or nicknames for the Buddha presence, which cannot be localized in one place. It is possible that reluctance to depict Buddha in human form—human existence being a product of the world of illusion—also contributed to the early proliferation of aniconic representation. In time fully anthropomorphized figures of Buddha became the norm, but aniconic imagery continued to form the deep grammar of Buddhist visual culture. The pagoda is but one example of the lasting power of this formative symbolic order.[9]

Representation of Buddha in human form has been linked to the Mahāyāna movement. The ideal of the Buddha body is fully articulated in the *Sutra of the Great Nirvana* (*Mahāparinirvāna sūtra; Daihatsu nehan-kyō*), a central Mahāyāna text that is believed to be a record of the final sermon of Buddha. The sutra describes how Shaka, preparing to enter the final nirvana, displayed his naked body to his disciples and showed them the major and minor characteristics that identified it as a Buddha body. There were thirty-two major characteristics and eighty minor marks. Among the major characteristics were long fingers, broad heels, soft and delicate hands and feet, a sheathed penis, a rounded body, golden skin, blue eyes, white teeth. After the viewing, Shaka died and was cremated. The resulting ash and bone were distributed for deposit in stupas.[10]

This account, written hundreds of years after Shaka disappeared from the earth, nonetheless articulates the basic features of Buddha's figuration in art. First of all, Buddha causes his own representation to be seen as an act of compassion. The representation is that of a beautiful human male. This is not to say that Buddha, as the state of enlightenment, is gendered; Buddha should properly take the pronoun "it." The male body is simply a strategy for representing Buddha to humans. Like other expedient means in the quest for insight, it makes it possible to visualize Buddha as if he were still in the world in the form of Shaka, once an Indian prince, now an enlightened being for whom gender is ultimately meaningless.

By the sixth century, as the Mahāyāna movement spread through the various communities of the Silk Road, the expediency of images in devotion and meditation had resulted in a proliferation of Buddhas and Buddha-beings. Early Mahāyāna scripture and practice generated thousands of iconic possibilities for Buddha alone, an example being the *Kegon Sutra* with its myriad Buddhas and Buddha-realms emanating from the sunlike Cosmic Buddha that is the central image of the text. Shōmu knew this iconography well. There were pictures of those myriad realms engraved on the gilt-bronze lotus petals attached to the pedestal on which the Daibutsu sat enthroned.

A means to managing this burgeoning population of Buddha-beings, which grew exponentially as Buddhism crossed Central Asia, was developed in the Vajrayāna or "Diamond Vehicle" movement. Emerging from within the Mahāyāna fold during the sixth century, later to be brought to Japan as the Shingon school in 806, Vajrayāna Buddhism promoted high levels of ritual interaction with Buddha-beings and developed a systematic understanding of the Buddhist universe as a hierarchical space. Adepts were initiated into secret teachings transmitted directly from Buddha and accessible only to those taught esoteric ritual behaviors including hand gestures, mantras and other chants, and visualization techniques. Mastery of the behaviors was expected to produce union with Buddha or a Buddha-being, magical power resulting from such contact, and various earthly benefits and merits. The emphasis on secrecy, initiation, and transmission explains why the Vajrayāna movement is also called Esoteric Buddhism (Japanese: Mikkyō). Other designations for the movement are

Mantrayāna, after the extensive use of mantras by practitioners, and, more generally, Tantrism after the importance of tantras or secret scriptures.

The central Buddha of the Vajrayāna system is Dainichi, the Great Sun Buddha, who is an amplified form of Birushana, the Cosmic Buddha of the *Kegon Sutra*. Dainichi is understood as having revealed the ultimate secret teachings of Buddha in the form of two scriptures: the *Dainichi Sutra* (*Mahāvairocana sūtra; Dainichi-kyō*), which explains the Womb World (Garbhadhātu; Taizōkai) and the presence of Dainichi as a manifest energy at the heart of all things; and the *Diamond Crown Sutra* (*Vajraśekhara sūtra; Kongōchō-kyō*) on the Diamond World (Vajradhātu; Kongōkai) and the all-pervasive wisdom of Dainichi as imminent in the world. These texts emphasize that the universe, as substance and as form, is generated from the body of Dainichi and can be conceptualized as the Womb and Diamond worlds. To make the matter clear, the *Dainichi* and *Diamond Crown* sutras refer to visual aids called mandalas that picture the universe as emanating from Dainichi in the form of Buddhas, bodhisattvas, and other Buddha-beings.

The Ryōkai mandala on exhibit [41], completed in the twelfth century but entirely consistent with the canonical mandala format of Vajrayāna Buddhism, is a finely wrought representation, in gold and silver on indigo-dyed silk, of this universe of emanations. As a mandala, or transformation of doctrine into pictures, the painting shows the paired Womb and Diamond realms in a schematic geometrical arrangement that presents the universe as a crowd of Buddhas, bodhisattvas, and other beings emanating from Dainichi. There are 414 images of Buddha-beings in the Womb mandala, taken from the second and ninth chapters of the *Dainichi* sutra; and 1,461 for the Diamond mandala as explained in the second part of the *Diamond Crown Sutra*. It is a dizzying explication in pictures of the generative force that is Dainichi in the world.

As such the Ryōkai mandala exemplifies the enormous importance of the visual arts in the explication and dissemination of Buddhist doctrine. The prelate Kūkai said as much when he introduced Vajrayāna teachings to the Japanese court in the early ninth century:

In truth, esoteric doctrines are so profound as to defy their enunciation in writing. With the help of painting, however, their obscurities may be understood. . . . Thus the secrets of the sūtras and commentaries are depicted in art, and the essential truths of the esoteric teaching are all set forth therein. . . . Art is what reveals to us the state of perfection.[11]

While these words are directed specifically to Vajrayāna practice, they are grounded in centuries of Buddhist emphasis on the importance of visuality in the quest for insight.

The mandala is an important manifestation of this need to make doctrine perceivable through vision and has taken many forms since its beginnings in ancient India as an altarlike structure, or dais, containing two-dimensional and three-dimensional representations of sacred teachings or gods.[12] In its broadest sense a mandala is a transformation of words into pictures, or concepts into their graphic forms, and thus takes many shapes: the orderly Ryōkai mandala; the Taima mandala with its perspectival depth and juxtaposition of geometric with natural imagery [52]; the "shrine" mandala with its rolling landscape and schematic architectural elements [54, 56].

The crucial place of visual materials as an armature for doctrine is made clear in the *Dainichi* and *Diamond Crown* sutras when they explain their respective mandalas. There is little doubt that the compilers of the texts were working from visual records at hand. For example, the *Dainichi Sutra* describes Shaka as having a purple-gold body that displays the thirty-two marks, and Dainichi as wearing a crown of gold with colored lights streaming out from his body.[13] The language is so pictorially specific that the sutras recall the Greek rhetorical art of ekphrasis or vivid description of a painting, sculpture, or building.

Such specificity indicates the existence of a coherent Buddhist iconography by the time that the *Dainichi* and *Diamond Crown* sutras were compiled. As the Buddhas and Buddha-beings of Mahāyāna Buddhism proliferated, a general taxonomic structure was developed for their description and classification. The Vajrayāna movement prompted yet more classification through a fully articulated Buddhist iconographical movement directed to

the needs of ritual and meditation. Consequently, a systematic Buddhist iconography was in place by the close of the sixth century. It was further codified and streamlined through various iconographic manuals that combined textual references with specific images, such as the *Iconographical Sketches of the Deities of the Taizōkai Mandala* [40]. The Mahāyāna emphasis on visuality had produced both a vast system of imagery and its codification through visual aids—mandalas and manuals—of critical importance to the preparation of artistic and ritual environments.

Shōmu and Kōmyōshi would not have known the complex Vajrayāna iconographical system as represented in the Ryōkai mandala, for it would be another fifty years before its teachings reached the Japanese court. However, they would have been acquainted with the fundamentals of Buddhist taxonomy—the root structures on which later Vajrayāna iconography was based—and with the idea that the universe emanated from a Cosmic Buddha. The Daibutsu at Tōdai-ji, after all, was precisely such a Cosmic Buddha whence emanated infinite worlds as engraved on the lotus petals of the dais. The fundamentals of Buddhist iconography were also in evidence throughout the temples of Nara, whose various structures contained a strikingly diverse community of Buddhas and Buddha-beings rendered as paintings and statuary.

Buddhist iconography begins with two paramount concerns on initial encounter with a Buddhist image: who is it, and what can it do?[14] The first concern, of typing and identification, is addressed by a hierarchical ordering of Buddha-beings into four general classifications—Buddha, bodhisattva, wisdom king, and god—and by assignment of distinctive personalities and behaviors to the members of each classification. The second concern, about intentions and interactions, is resolved through a reading of hand gestures and implements displayed by individual members of the various classifications.

Hand gestures, called mudras after the Sanskrit term *mudrā* (*insō*), are like a sign language that structures the relationship between icon and beholder. A mudra might signal meditation or trance [10, 63]; indicate an active state of preaching and comforting [19,

24]; suggest a state of creative energy [20, 30, 42]; demonstrate prayer [35–36]. Implements held in the hands, called attributes, also relay information about the image. One of the most common attributes is the lotus, which symbolizes purity and transformation because it blossoms above muddy water. The numerous attributes held in the hands of the thousand-armed version of Kannon—lotus, magic jewel, rosary, water jar, wheel—signal in no uncertain terms the vast capabilites of this powerful bodhisattva [46, 48].[15]

For the most part Buddhas, bodhisattvas, wisdom kings, and gods, each with its respective mudras and attributes, take the human form as their point of departure. There is considerable androgyny for Buddhas and bodhisattvas, especially in the East Asian interpretations of Mahāyāna iconography, paralleled by strongly gendered representations for wisdom kings and gods. The variations on human anatomy can be striking: multiple eyes, heads, arms, even legs; multicolored bodies; a wide range of affect from the furious to the delighted. There are even a few zoo-anthropomorphic figures, such as the form of Kannon that has the head of a horse [29]. Such variety supports the basic premise of the Mahāyāna pantheon: Buddha displays—and takes—many forms in order to expedite the salvation of sentient beings through the expedient means of visuality and devotion. The role of Buddhist iconography, with its four orders of Buddha-being and their respective conventions, is to make those many forms comprehensible.

The "Buddha" order is structured around the notion of the three Buddha bodies of absolute enlightenment, magic, and manifestation. Developed early in the Mahāyāna movement, this idea allows for the singularity of Buddha to generate multiple Buddhas of the past, present, and future. Thus there are many Buddhas possible as bodies of enlightenment, magic, and manifestation. There has been only one manifestation body in human history, of course, that of Shaka, but there will be many more in future world systems. One such Future Buddha, now a bodhisattva in a state of suspension awaiting the next world, is Miroku, who will begin a new world system once the current one has ended.

The cosmic Birushana and Dainichi are bodies of pure enlightenment, or dharma, and

represent Buddha in the most abstract sense. So cerebral is the emphasis that there is even a form of dharma body called Wisdom Peak Buddha, or Butchōson, after the cranial protuberance atop Buddha's head. The Ichiji Kinrin mandala [42] and Daibutchō mandala [43] contain representations of the most powerful of the Wisdom Peak Buddhas, Ichiji Kinrin. The Buddhas Amida and Yakushi, by contrast, represent blissful enjoyment bodies eternally present in their respective pure lands to the west and east. These Buddhas make themselves manifest to men and women in visions or waking dreams, often as a reward for meritorious behavior, and are capable of acting on the world. Amida comes to take the dying back to paradise, as shown in the "welcoming descents" or Raigō [53, 72]. Yakushi, the Healer Buddha, grants aid to those suffering from illness; thus Yakushi Nyorai [24] raises his right hand in a soothing gesture while holding a medicine jar in his left hand.

There are two conventions for the representation of the Buddha body, although each includes some of the characteristic marks described in the *Sutra of the Great Nirvana* such as a cranial protuberance, long earlobes, snailshell curls, and tuft of hair between the brows. The most common convention is Buddha as monk. In this guise Buddha wears a simple robe thrown over the left shoulder to leave the chest bare and a skirtlike loincloth known as a dhoti [37]. There is neither ornament nor jewelry, and the head is bald or covered in short curls. The second convention is Buddha as an Indian king, which is limited to depictions of the dharma body such as Dainichi and Ichiji Kinrin. Buddha wears his hair long and bound in a high topknot; is dressed as a prince in dhoti and sash, his chest bare; and displays ornaments such as a crown, thick jewelry, and a golden wheel [see 42]. Such raiment symbolizes the role of Buddha as the ultimate Cakravartin even though he appeared in human history in the guise of an ordinary monk.

Most figures of Buddha are shown in a state of meditation or in quiet poses of instruction and reassurance. For example, Dainichi sits still with legs folded even as his hands form one of the most aggressive mudras, that of the "wisdom fist," which signals the procreative force of the Cosmic Buddha and sets

the world in motion [see 42]. The emphasis on stasis follows logically from the notion that Buddha is in essence the state of enlightenment, the doors of which are opened by meditation. In the stillness and symmetry of the Buddha image is reflected an ideal moment of complete containment and centeredness.

The "bodhisattva" order has many members in keeping with the importance of the bodhisattva to Mahāyāna doctrine and devotion. Bodhisattvas take numerous forms, for they embody the infinite ways in which Buddha makes it possible to find the path to enlightenment. Dressed like dharma bodies in dhoti and sash, covered in jewelry from head to foot, their scarves fluttering: bodhisattvas are the high royalty of Buddhist iconography [22, 48]. There are a few exceptions, such as Jizō Bosatsu [27], who is dressed as a monk for journeys along the six paths of existence to help those trapped in the cycle of reincarnation and suffering. But most bodhisattvas, even the zooanthropomorphic Batō Kannon, are depicted as Indian princes.

Bodhisattvas are understood to be extroverted, ready to grant aid to those in need, and so their representations often suggest that the figure is moving through space. A bodhisattva may stand in a langorous pose with hips swaying; may sit in relaxation with one leg bent at the knee; may seem to walk toward the viewer; may even fan multiple arms in a cobralike display of attributes [48]. Some bodhisattvas ride animals with which they are totemically linked. For example, Monju [34] is often depicted atop a roaring lion that, lunging forward, symbolizes the voiced teachings of Buddha and the wisdom of Monju as caretaker of those teachings. Fugen [35–36] rides a steadily advancing white elephant which possibly symbolizes the longevity and knowledge that the bodhisattva bestows.

The "wisdom king" order originates in the Vajrayāna notion that certain syllables and words are supercharged with the vast energies and wisdom of the Cosmic Buddha. A wisdom king is a syllable or chant embodied and, as such, is a manifestation of the secret teachings of Vajrayāna Buddhism—its generative wisdom—and the enormous forces that the teachings unleash. Through the wis-

dom king these forces are channeled toward the obstruction of evil, the destruction of illusion, and the awakening of sentient beings to the Buddha nature within. Of all the Buddha-beings of the Mahāyāna pantheon, it is the wisdom king who is the most overt articulation of the terrible power that is latent within Buddha.

Wisdom kings are usually depicted as angry or belligerent, their bodies flushed red or blue or yellow with emotion, and they rarely stand still [51]. They grimace like monsters, throw their muscular male bodies into a variety of dramatic poses, and generally make a spectacle of themselves [77]. Even the costume of a wisdom king is intimidating. Over clothing akin to that of a bodhisattva, a wisdom king might wear an animal skin, a necklace of human skulls, even a writhing snake. Beneath his feet he might even trample a demon writhing in agony. The Aizen Myōō on exhibit [30] well illustrates the typical demeanor and accouterments of a wisdom king, here in a body stained red with human lust transformed into its opposite: the conquest of desire.

The "god" classification in Buddhist iconography encompasses the many benevolent supernatural beings who, with humans and animals, ply the world of illusion. As distinguished from Buddhas, bodhisattvas, and wisdom kings, whose fundamental task is to guide sentient beings toward enlightenment, gods have a more mundane duty as tutelary protectors of Buddhism and its community of believers. They are fully gendered, not surprisingly, and for the most part are either aristocratic or military in bearing. The aristocratic types are usually shown in some form of fancy dress with a local provenance instead of the classical Indian costume worn by Buddhas, bodhisattvas, and wisdom kings. For example, the ten female gods in the Fugen and Ten Rasetsunyo [36] wear Japanese court robes.

In striking contrast to these elegant women are the rough types, the bodyguards and bouncers, who make up the military gods. These macho figures embody the protective powers of Buddha that can be mustered in the name of Buddhism to safeguard the faithful. Most wear suits of colorful Central Asian armor and brandish weaponry while grimacing furiously; others appear with chests bared

in a display of musculature. The figure of Bishamonten in the Hekija (Extermination of Evil by Buddhist Deities) [39] exemplifies the typical military god, here protecting a virtuous monk by chasing away demons. Another protector, the Rikishi with chest and arms flexed in a show of muscles [20], represents the type of military god called a "strongman" (rikishi), who stood guard at the entrances to temples and cities. Genmei had colossal statues of such sentries placed inside Rajōmon, gateway to the Nara capital.

The taxonomy of Buddhas, bodhisattvas, wisdom kings, and gods is just that: a classification system that provides a convenient way of sorting the various Buddha-beings of the Mahāyāna pantheon. But it must be emphasized that this classification system charts a world of interrelations, unities, potentialities, and constant shifts of identity. Whether in scripture or ritual, Buddhas and Buddha-beings are always in some sort of relationship. They are usually presented in the company of other Buddhas and Buddha-beings; with crowds of humans and sometimes animals nearby; entertained by various magical creatures, among them the humanized songbird karyōbinga depicted in one of the keman (hanging votive ornament) on exhibit [68].

Most figures of Buddha are provided with attendant bodhisattvas. The standard configuration is that of the Buddha triad, in which Buddha is flanked to each side by a bodhisattva especially important to that particular cult. For example, Shaka is usually shown with the bodhisattvas Monju and Fugen, as seen in the Shaka Nyorai triad [33]. Kannon and Seishi accompany Amida and are seen directly to his right and left in the Taima mandala [52]. Usually such a triad is surrounded by images of military gods known as the shitennō, or four heavenly kings, who guard it from danger at the four cardinal points.

Sometimes Buddhas and bodhisattvas require especially large retinues of attendants and guardians. A figure of Shaka, for example, might be accompanied by images of Monju and Fugen, the original ten disciples of Buddha, the four heavenly kings, and the five hundred arhats who symbolize the earliest community of Buddhists. Yakushi has a retinue that includes ten bodhisattvas, twelve guardian generals, and seven emanations

from his own body. Amida is often depicted with twenty-five attendant bodhisattvas or in nine emanations that symbolize the nine sectors of his paradise.

The phenomenon of emanation is a basic tenet of Mahāyāna philosophy. Fundamentally speaking, the whole of the Mahāyāna universe emanates from Buddha, and Buddha as the cosmic dharma body—Birushana or Dainichi—generates all Buddhas, bodhisattvas, wisdom kings, and gods. In this sense there are no stable iconic identities but rather various states of multiplicity and intersubjectivity. Thus Amida takes nine identical forms for the nine levels of rebirth in his pure land; and the bodhisattva Jizō has six identical forms for the six paths of existence.

In a complex articulation of the same principle, Buddha gives rise to five hypostatized forms, or condensations of Buddha, collectively known in Vajrayāna doctrine as the five Great Wisdom Buddhas. They are seen in the most important sectors of the Diamond and Womb mandalas. For example, the sector at the middle of the Kongōkai mandala shows the group clearly [41]: Dainichi in a circle at the apex or center; Amida to Dainichi's west in the circle above; Fukūjōju to the north in the circle to the right of Dainichi; Ashuku to the east in the circle below; and Hōshō to the south in the circle to the left of Dainichi. These Buddhas trigger their own sets of emanations in the form of bodhisattvas and wisdom kings, here shown surrounding each Buddha at the center of its circle. Thus Dainichi is also the bodhisattva Fugen and the wisdom king Fudō.

A remarkable set of emanations occurs in the case of Kannon, who seems to be the most versatile bodhisattva of all in the art of shape changing. There are at least thirty-three forms of Kannon, "the all-seeing and all-hearing," whose chameleonlike aspects are emphasized in scripture. Shōkannon is the prime or "original" Kannon and usually appears in simple human form with extra eyes hidden in the palms of its hands [67]. Other forms of Kannon are memorable for the imaginative and even freakish shapes that they take. Jūichimen Kannon has eleven heads and multiple arms [23], Senju eleven heads and a thousand arms [46, 48], Batō the head of a horse and an angry face [29]. Fukūkenjaku, a third eye transecting its forehead vertically, grasps in two of its six arms the rope and hook by which it reels in humans like fish from the sea.

Buddhist iconography as a taxonomy organizes this universe of emanations in efficient ways directed toward devotional practice. For it is ultimately devotion itself that drives the need to sort, arrange, and connect the various Buddha-beings of the Mahāyāna pantheon. When Shōmu and his advisors followed iconographic protocols in the making of Buddhist imagery, there was more at stake than simple accuracy of depiction from a textual or doctrinal standpoint. Even more extensive connections had to be made: between icon and worshiper, and heart to heart. The rules of iconography offered a means to vouchsafe the proper ritual environments for these engagements.

Domains of Worship
The temples of Nara, from magnificent Tōdai-ji to the humble establishments frequented by the inhabitants of its market districts, held in common a heritage that stretched back to ancient India and the first temple, Jetavana, where Buddha had lived and taught after attaining enlightenment. Fundamentally, Nara temples were places where a worshiper might still hope to encounter Buddha and hear his voice. They were also places for gifts, decoration, and the experience of shōgon in the celebration of Buddha and his teachings. It was a world suited to art and aesthetic experience.

Shaka had been an itinerant preacher for much of his life and did not collect material goods. But he was frequently invited into the homes of his followers, proffered food and clothing, and entertained as a prelude to the sermon it was hoped he would give. A special setting was prepared for the occasion. Furniture was brought in, cloth hangings put up, lamps and incense lit, food and water set out in containers, flowers arranged in attractive ways. From these early gestures of hospitality arose the protocols of Buddhist ritual practice: preparation and decoration of a ritual environment; presentation of offerings; and spiritual and intellectual engagement.

By the time that Shōmu was building Tōdai-ji, the basic Mahāyāna worship space had already been standardized. At the center of the space, in its sanctuary, was a raised

dais of square or octagonal format that served as the altar. Objects of worship were placed on the altar in a variety of ways. Statues typically occupied a lotus pedestal or some form of throne; paintings were hung inside a shrine or occasionally suspended from ceiling beams; sutras might have their own elaborate container such as the shrine for *Daihannya Sutras* [75]. There were also altar furnishings, such as the three-legged table [85] and stand for a *kei* (ritual chime) [83].

Above the altar was a ceremonial canopy decorated with strings of beads and other ornaments. The pillars and beams of the sanctuary space around the altar were hung with textiles, such as the *ban* (ritual banner) [71], and openwork ornaments called *keman* [68–70]. On the altar were placed containers for the precious offerings of Buddhist worship: incense, flowers, and light. The set of ritual implements [84], although considerably more complex an assortment than anything Shōmu or Kōmyōshi would have known in their day, provides a full complement of such containers.

The creation of a beautiful ritual space—fragrant, radiant, replete with offerings—ensured a proper environment for prayer and transcendence. It was an environment meant to bring to mind the universe of a Buddha or Buddha-being. Completely distinct from the world beyond its walls, such a space allowed worshipers who entered it to cross over into a domain of spiritual engagement in which art—statuary, paintings, ornamentation—set the parameters of religious experience. Here was the territory of worship and ritual so important to Shōmu and his peers, where Buddhist images in their decorated sanctuaries became the object of intense devotion and desire.

Such devotion was predicated on the awakening of a Buddhist image to its ritual environment and the beauties offered therein. After all, even the Great Buddha in the last analysis was nothing but a pile of bronze over which artisans had climbed with their chisels and hammers. Like all Buddha images—statues, paintings, mandalas—the Great Buddha had needed to be "awakened" in a consecration ritual known as the Kaigen Kuyō, or Eye-opener. The ritual was held whenever a newly completed (or repaired) image was readied for worship in its sacred environment. It consisted of a simple but

powerful act: the painting of pupils into the eyes of the icon so that it could see.

The Eye-opener for the Great Buddha had been a spectacular event. Bodhisena had presided in the early summer of 752 and painted in the pupils from a scaffolding far above the crowd of monks and courtiers gathered in the courtyard below. From the large brush that he held in his hands stretched an indigo-blue cord at least six hundred feet in length. It reached down to Shōmu, Kōmyōshi, Kōken, and many others behind them who took it in their hands and thus participated directly in the ritual. When the ceremony ended and the Daibutsu awoke, dancers and musicians filled the courtyard with the joyous sounds of celebration.

By the mid-eighth century the world of Buddhist ritual practice, dominated by the interventions of Nara monks before such awakened images, consisted largely of four areas besides the spontaneous moments of individual prayer characteristic of Buddhism in general: the reading and chanting of scriptures; communal worship involving the presentation of offerings followed by formal prayers or sermons and, depending on the circumstances, penitential rites; formal debates on points of scripture; and funerary or memorial rituals. Most services of this type were held at temples, either on a platform in front of the main hall where the primary object of worship was housed, or in the subsidiary halls and chapels prepared for individual worship. Some were staged at the imperial compound or in aristocratic residences. One of the most important state rituals of the eighth century was the Gosaie, a series of worship services held annually at the Daigokuden in conjunction with readings of the *Golden Light Sutra*.

What did Shōmu and others hope to gain when they held such services in the opulent sacred spaces of Buddhist ritual practice? One objective was the generation of spiritual merit, which, like money saved in a bank, could be exchanged for safe passage in the afterlife, perhaps toward a better reincarnation. Another was the garnering of earthly benefits such as tutelary protection, good health, affluence, the comfort of high status. The Gosaie was expected to generate such benefits on a national scale for the Nara state: peace, prosperity, a good harvest.

The construction of the Great Buddha, seen against this context of devotional practice and ritual space, was the making of a sacred domain at the heart of the Nara imperium. In a sense it made the whole of the Japanese archipelago into a temple that enshrined the colossal unifying force symbolized by the huge gilt-bronze Buddha. Having negotiated the terrain of iconography and practice, Shōmu and his advisors arrived at a magnificent formula for Buddhist empire as expressed through art and worship. That Nara would remain the cradle of Japanese Buddhism for centuries to come, even as the Nara state itself was lost, is eloquent testimony to the wisdom of that formula.

The Beauties of Scripture

In ancient Sanskrit the word *sūtra* means "thread," but it is also used for aphorisms, teachings, or philosophical arguments that have been committed to writing as if strung on a thread of logic. The first Buddhist sutras were recorded in the early centuries following the final nirvana, to swell to an enormous literature with the advent of Mahāyāna philosophy. More than one thousand sutras made up the Buddhist canon as Shōmu and Kōmyōshi knew it, written out in ink on paper in upward of five thousand fascicles, or rolls, in the standard handscroll format common throughout East Asia.

In 736 Genbō, a Kōfuku-ji monk resident in China for nearly two decades, had brought a recent edition of the canon back with him to Nara.[16] It was written in Chinese translated from original Sanskrit texts. No doubt Shōmu and Kōmyōshi were educated enough to read the Chinese texts and copy them as well because both had been raised among scholars and were accomplished calligraphers in the Chinese tradition. But it is clear that Shōmu and Kōmyōshi, like most of their peers, would have relied on their Nara Buddhist masters for full exegesis and instruction.

Aside from study and analysis, sutras lent themselves to votive transcription and worship as beautiful objects. The copying of sutras was regarded as a highly meritorious activity and indeed was promoted in the texts of many sutras. Kōmyōshi was an especially active patron of votive sutra transcription. By 727 she had her own scriptorium at the Nara palace, where calligraphers produced thousands of fascicles of copied sutra texts. For example, in 736 as a memorial to her parents Kōmyōshi had sponsored a full transcription of the canon brought back by Genbō. Votive transcription of sutras was also carried out in behalf of the state as an offering to Buddha and to garner protection and prosperity for the nation.[17]

Sometimes sutras were placed in metal or ceramic containers and buried on mountains or at temples. The practice was an ancient one having to do with faith in the Future Buddha, Miroku, and in the tremendous merit to be gained by preserving the Buddhist teachings until he arrived on Earth. It was believed that, shortly before the coming of Miroku, there would be an apocalyptic "devolution" of the dharma that would trigger social chaos and the destruction of Buddhism itself. In time a sutra burial cult emerged in Japan in connection with worship of Miroku. The various sutra containers on exhibit were used for such burials, which often involved the construction of sutra tombs (*kyōzuka*) to accommodate the large numbers of sutras deposited.

Most sutras were copied in the standard format of ink on paper and averaged seventeen characters per line. The *Ajaseō-kyō (Sutra of King Ajaseō)* in the exhibition [11] exemplifies this type of transcription. The postscript indicates that it was copied in 742 as part of the Buddhist canon ordered by Kōmyōshi, which took nearly a decade to complete. Sutras were also transcribed in gold or silver pigment on decorated or dyed papers. Such luxurious transcriptions, with their lavish appearance and costly materials, were largely the province of imperial patronage. Adornment of sutra texts in this manner was regarded as an offering to Buddha that enhanced the copying itself. On exhibit are two examples of the embellished format: the *Golden Light Sutra* in gold pigment on purple-dyed paper, completed in 746 at Shōmu's request [12]; and the *Kegon Sutra* in silver pigment on indigo-dyed paper [13]. Typically such luxurious sutras would be kept in a sutra repository [6–9], in sutra boxes [74], or placed in sutra shrines [75].

The rich decoration of the *Golden Light* and *Kegon* sutras is also related to the great importance these texts held for Shōmu and Kōmyōshi. With the *Lotus Sutra* they formed

the philosophical and ideological foundation of the Nara regime. They were also part of a new wave of Buddhist teachings that had entered the Nara monastic community in the early years of Shōmu's reign to produce notable doctrinal ferment. The *Lotus Sutra* had been well established in Japan since the seventh century and would remain a prominent force in state Buddhism for centuries. On the one hand a dense exposition of Mahāyāna philosophy, the *Lotus Sutra* at the same time encouraged lay practices such as penitence, good works, and making art as a means to garner, for state or for person, the tutelary protection of Buddha and the Buddhist gods.

The teachings of the *Golden Light* and *Kegon* sutras, over a foundation of belief and practice centering on the *Lotus Sutra,* gained importance in Nara during the second and third decades of the eighth century. Both were useful to the type of centralized government that Shōmu and his advisors envisioned. Like the *Lotus Sutra* each addressed complex matters of doctrine but simultaneously offered practical instructions on earning merit and protection. Each also offered a model for Buddhist empire. The *Golden Light Sutra,* which had been newly translated into Chinese from Sanskrit in 703, was brought to Nara in 718 by the Japanese monk Dōji from the Chinese capital at Changan. Its focus on righteous kingship in the name of Buddha, and on the benefits granted a virtuous ruler, made it especially attractive as a philosophical basis for empire.[18]

The *Kegon Sutra* marked a doctrinal watershed by addressing enlightenment, or the state of awakening, through the image of a cosmic and absolute Buddha—Birushana (Resplendence)—at the center of a vast universe of Buddha worlds. Hallucinatory and dreamlike, the text of the *Kegon Sutra* is a record of what Buddha preached in the moment of his enlightenment through the medium of light (he did not speak) as interpreted by the bodhisattvas Fugen and Monju. It also sets out the various stages on the path to becoming a bodhisattva. It is a difficult text, Esoteric in orientation and very hard going for the uninitiated or casual reader. But the sutra's notion of a Cosmic Buddha as the organizing principle of the universe is readily grasped. Its appeal as a symbol of empire must have been significant.

By the middle of the seventh century the teachings of the *Kegon Sutra* had become the basis of a school of Buddhism in China. In 733 two experts on Kegon teachings, the monks Bodhisena and Daoxuan, met with a Japanese delegation in Changan and were invited to Nara. They arrived in 736 to begin a program of instruction in Kegon doctrine and ritual, bringing with them a new translation of the sutra in sixty fascicles. Another translation, in eighty fascicles, was introduced by the monk Genbō that same year as part of the Buddhist canon that he carried home with him from China. Within a few years Rōben, from his base on Mt. Mikasa, had developed a special interest in the *Kegon Sutra* and in 740 asked a Korean expert on the sutra to deliver a series of lectures about it. Shōmu and Kōmyōshi are believed to have attended these lectures and to have relied on Bodhisena, Daoxuan, Rōben, and Genbō, then the highest ranking prelate in Nara, for subsequent advice and instruction.

It is evident that Shōmu and Kōmyōshi were influenced in their political and cultural decisions by the influx of scripture and doctrine arriving from China in the 730s. Indeed, the introduction of teachings based on the *Golden Light* and *Kegon* sutras was critical to the philosophy of benevolent empire that Shōmu had begun to develop in those years. The most important advisory role in this project fell to Rōben, who was both a proponent of Kegon teachings and a close affiliate of Kōmyōshi and her Fujiwara relatives. His independence from the Nara monastic community may also have allowed him freedom in developing new lines of practice that led away from scholasticism toward more devotional goals. They led also to the notion of Buddhist empire sustained by the sponsorship and execution of temples and art in the name of Buddha.

In 741 Shōmu instituted a system of state monasteries and convents whose role was to support, through prayers and offerings, the central government at Nara and thus the Nara imperium. Each monastery in the network bore the same name, Konkōmyō Shi Tennō Gokoku no Tera (Monastery for the Protection of the Nation by the Four Heavenly Kings of Golden Light), and enshrined a copy of the *Golden Light Sutra* in its pagoda. The nunneries were named Hokke Metsuzai no

Tera (Convent for the Eradication of Sin through the Lotus) and enshrined a copy of the *Lotus Sutra* in their main halls. Over the next decade, as the culmination of an ideological and political program of unification, Shōmu and Kōmyōshi saw to completion the Cosmic Buddha and, around it, the great temple Tōdai-ji as the philosophical seat of their empire.

The Great Buddha at Tōdai-ji
The decision to construct a colossal image of the Cosmic Buddha of the *Kegon Sutra* was made by Shōmu in the winter of 743.[19] In sponsoring the statue, he said, "Our fervent desire is that, under the aegis of the Three Treasures, the benefits of peace may be brought to all in heaven and on earth."[20] Inspiration for such a project came from the *Kegon Sutra* and related scriptures whose focus was a central figure of the radiant Birushana. Here, the advice of Rōben, Genbō, and other monks was critical. Inspiration also came from the continent, where the Tang Emperor Gaozong had commissioned an enormous figure of the Cosmic Buddha— more than fifty feet in height—at the Lungmen cave temples in 672, and his wife, Empress Wu, ordered a similarly large statue in the city of Luoyang in 700. Possibly Bodhisena or Daoxuan told Shōmu about these colossal sculptures. Moreover, the Nara region already boasted a large statue of the Cosmic Buddha, at a temple called Chishiki-ji, which Shōmu had visited several times in 740.

Originally the Daibutsu was planned for a subsidiary capital outside Nara proper. Work began late in 744 with the construction of a scaffolding for the huge statue. By the summer of 745 the site had been moved to Mt. Mikasa on the eastern border of the Nara capital. This was the home of Rōben, who had lived since 728 in a small monastery on Mt. Mikasa built for him by Shōmu and Kōmyōshi in memory of their son. In 742 this small monastery was designated a state temple and given the standard title Konkōmyō Shi Tennō Gokoku no Tera. At first called Konkōmyō-ji, after the first word in its title, the monastery by mid-century was known as Great Eastern Temple (Tōdai-ji) in reference to the enormous complex it had become on the eastern edge of the outer capital.

For several years work on the Great Buddha at Konkōmyō-ji proceeded slowly as a new frame was assembled and, over it, a clay core built up. In the winter of 746, Shōmu and Kōmyōshi held a lamplit ceremony to dedicate the clay core. Casting in bronze began in 747 and continued through 749, with the statue prepared in eight segments moving upward toward the head. It took another three years to cast details, such as the canonical snailshell curls atop the Buddha's head, and to complete the two bodhisattva attendants. Gilding began early in 752 and would continue through 757 because of fluctuations in the availability of gold and mercury.

Once cast, the Daibutsu marked a spectacular achievement. It stood more than fifty feet in height and weighed at least five hundred tons. Temple documents indicate that a labor force of some 218,000 workers had been mustered in its construction.[21] The job was a dangerous one: molten metal took its toll, as did mercury during the gilding process. One of the most important figures in the organization and management of these workers was the monk Gyōki, who in 743 joined the Great Buddha project at the behest of Shōmu. Gyōki also raised funds and promoted the Daibutsu among commoners. In 745, in an irony surely not lost on his critics, Gyōki was named to high ecclesiastical rank.

Expansion of Konkōmyō-ji into the great monastery that would be called Tōdai-ji proceeded in tandem with erection of the Great Buddha. In 748 the government established the Office of Tōdai-ji Construction (Zō Tōdai-ji Shi) and assigned a large area of land on Mt. Mikasa to the new complex. The monastery was laid out on flattened land along a north-south axis. It had two southern main gates, twin pagodas on the east and west respectively, a main hall, a lecture hall, and numerous other halls and chapels. Construction continued well into the 760s as more structures were added to accommodate the increasing religious and administrative importance of Tōdai-ji. The earlier monastery where Rōben had lived and preached was retained as a subsidiary precinct. It stood on a steep slope of Mt. Mikasa just east of the new compound and was at first named Kenjakuin (Kenjaku Precinct) after the important lacquer statue of the bodhisattva Fukūkenjaku Kannon that it enshrined.

The main hall at Tōdai-ji was built for the Great Buddha. Construction began in 750 after the statue had been cast in bronze, and by its completion in 751 the building rose nearly ninety feet into the sky. Appropriately enough, it was named the Great Buddha Hall (Daibutsuden). One of the largest monastic structures of its time, and certainly the most spectacular with its golden Buddha and green and red trim, the Daibutsuden was an appropriate emblem of empire. For it seemed to echo in religious terms the centralized political structure at Nara, where Shōmu and his heirs held audience from a splendid hall in the heart of the palace compound.

Consecration of the Daibutsu took place in 752 with performance of the eye-opening service by Bodhisena and Shōmu. Numerous offerings and gifts were presented to the newly awakened image in beautifully crafted receptacles such as the Jar with Hunting Scene [4]. There was music and dance, prayer, the fragrance of incense and flowers. The throngs of courtiers and monks who crowded the Daibutsuden and its courtyard for the ceremony would have understood that, with this dedication, Shōmu had achieved a dream many years in the making. Rōben was named abbot of Tōdai-ji and thus became the most powerful monk in Nara as the monastery became the administrative headquarters of the network of provincial temples. It also replaced Yakushi-ji as the monastery whence high prelates were drawn. In 754 Shōmu, Kōmyōshi, Kōken, and others took vows of bodhisattva practice before the Great Buddha and pledged benevolent rule as their aspiration. When Shōmu died in 756, he must have taken comfort in the statue that symbolized his regime, his good works, and his visionary ideals.

Tenpyō Culture

In 729, on hearing reports of an auspicious omen in the form of a tortoise, Shōmu changed the era name of his reign to Tenpyō

Fig. 3. Shaka triad, 623, originally gilt bronze, in the Kondō (Golden Hall), Hōryū-ji, Nara

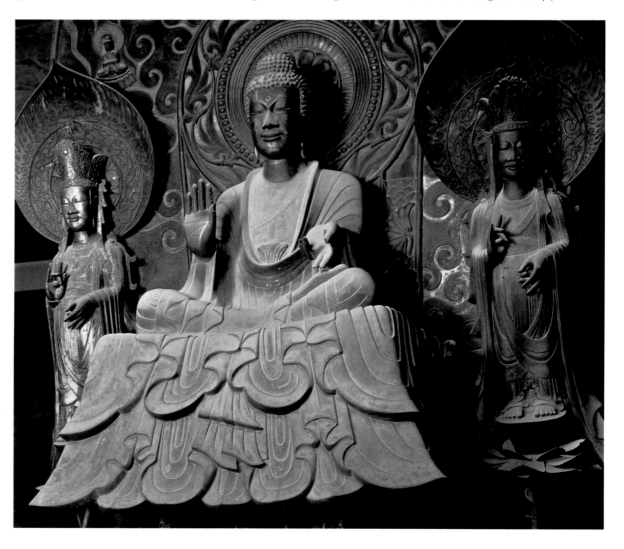

(Celestial Equanimity). Kōmyōshi was awarded the status of empress shortly thereafter. Thus began an epoch in Japanese cultural history, the Tenpyō era, whose significance lasted well beyond its conclusion in 749 when Shōmu ceded the throne to his daughter, Kōken. For during the Tenpyō era, in the thriving international climate of eighth-century Nara that by extension has come to be called the Tenpyō culture, the classical foundations of Japanese civilization were laid. Shōmu and Kōmyōshi were but the most prominent of a community of patrons for whom art was a critical part of public and private life. Through art the Buddhist teachings became tangible, whether as beautiful objects that were also didactic, or in the symbolisms by which Nara rulers negotiated power in the name of Buddha. The Great Buddha embodied this marriage of art and doctrine from the personal and political perspectives. It was in this sense the Tenpyō monument par excellence and drew upon a world of culture that encouraged exuberant art production as a manifestation of faith and benevolence.

What made the Tenpyō culture especially rich in art and technology was a constant engagement, on the part of patrons and artists alike, with continental civilization. The court of Shōmu itself was attentive to developments in China and Korea. Wary of the Silla empire on the Korean peninsula, the Nara government dispatched regular diplomatic missions to the Tang Chinese capital at Changan and to the northern Korean kingdom of Parhae. In fact, it was during such a mission to China in 733 that Bodhisena and Daoxuan were invited to Japan by a contingent of Nara monks. Such contact furthermore ensured that Nara rulers were also aware of cultural developments along the Silk Road. Shōmu had collected musical instruments, glass vessels, metalwork, textiles, and other objects whose provenance led to Central Asian states such as Khotan. It was this collection that Kōmyōshi presented to the Great Buddha when Shōmu died in 756. The objects were deposited in a storehouse called the Shōsō-in, which itself became synonymous with Tenpyō culture and the reign of Shōmu as a receptacle of motifs and techniques known throughout the ancient Eurasian world. The statue as well may have had roots in Central Asia and even India. Shōmu and Kōmyōshi

were familiar with the travel diary of the Chinese monk Xuanzuang, who in 630 had made his way to Bāmiyan in what is now Afghanistan, where a colossal statue of the Historic Buddha had been built to a height of some 150 feet.[22]

Crucial to the effloresence of Tenpyō art was the community of Chinese and Korean artists resident in Nara as part of its burgeoning population of builders, sculptors, painters, and other art workers. Some belonged to families of artisans that had settled in central and southwestern Japan early in the seventh century; others were newly arrived from the continent through the avenue of diplomatic missions or monastic exchanges. That the most prominent artist lineages tended to be continental in origin, such as the Paekche Korean family of Kimimaro, reflects again the international cast of art production under the Shōmu regime. It also suggests that in the eighth century Nara, on the eastern end of the Silk Road, was part of a broad community of cultures across Eurasia for whom a key point of exchange was art and specifically Buddhist art. If Nara patrons of Buddhist art tended to look to the continent for new techniques and new styles, supporting those artists most familiar with such trends, it was in large part due to the fundamentally cosmopolitan character of the global culture to which they belonged.

From the outset art making was a prominent facet of life in Nara, whether by the state or through private donations. Most residents of Nara would have seen at least once the construction of a major temple complex; many probably even participated as laborers. The many monasteries built throughout the city, culminating in a project like Tōdai-ji, required the production of immense numbers of sculptures and paintings as well as the preparation of sutras for chanting and the decoration of buildings. So important was art making that the government itself was involved in the organization and management of artists. Many artists were in effect civil servants. For example, painters were assigned posts in the Painting Office (Gakōshi) of the Ministry of Central Affairs (Nakatsukashō); bronze workers and lacquerers belonged to the Metalwork Office (Imono no tsukasa) and Lacquer Office (Nuribe no tsukasa) of the Ministry of the Treasury (Ōkurashō); and

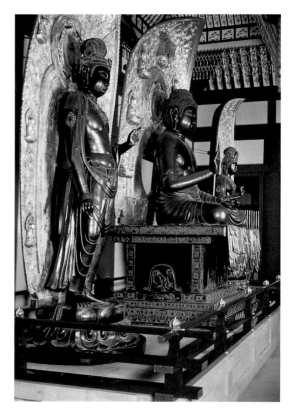

Fig. 4. Yakushi triad, early 8th century, originally gilt bronze, in the Kondō, Yakushi-ji, Nara

woodworkers and architects served the Bureau of Carpentry (Mokuryō) in the Ministry of the Sovereign's Household (Kunaishō). The calligraphers who worked for Kōmyōshi, preparing votive sutra transcriptions and the like, were probably recruited from the Bureau of Books and Drawings (Zushoryō) in the Ministry of Central Affairs.[23]

They might also have come from workshops at influential monasteries such as Yakushi-ji, Kōfuku-ji, and, by mid-century, Tōdai-ji. Although it is evident that most artists and artisans belonged to the lay community and were not monks, there were indeed active studios at various monasteries. At such workshops monks and government artists cooperated to produce a broad spectrum of sculptures and paintings in a variety of media and styles. The excitement and energy of these works, a good number of which have survived into the modern era, make the Tenpyō period one of the most exciting in the history of Japanese art. By the very circumstances of their times Tenpyō artists were granted license to experiment, to test the limits of technology and representation, as they fulfilled the goals of patrons who themselves promoted innovation. It is clear that, for the better part of the eighth century, an aesthetically sophisticated cohort of patrons and artists was active in Nara and made possible the emergence of an artistic culture of extraordinary breadth.

The most striking medium in which this Tenpyō sensibility was brought to bear is sculpture. Hundreds of statues were produced over the course of the eighth century in a variety of iconographic types. Those that survive provide clear evidence of a technically and stylistically diverse workshop milieu in Nara. Basically there were four materials favored for statuary through the end of the eighth century: bronze, lacquer, clay, and wood. Documentary evidence also exists for small sculptures of gold or silver and in fragrant woods such as sandalwood. Of these materials, bronze would have been for Shōmu and his circle the medium with the most prestigious associations. Costly and difficult to work, bronze had been used since the seventh century for the great sculpture projects sponsored by the imperial house or high aristocracy. Immigrant artists at Hōryū-ji and Yakushi-ji had prepared the ground for the

Great Buddha with such works as the Shaka triad of 623 at Hōryū-ji (fig. 3) by a sculptor called Tori Busshi, and the Yakushi triad at Yakushi-ji (fig. 4), a magnificent example of bronze casting at its finest completed sometime early in the eighth century.

The gilt-bronze Shaka in the exhibition [17] well illustrates the stylistic characteristics of what came to be called the Tori style of the seventh century. It is hieratic and symmetrical in appearance, posed stiffly as if frozen, and generally reticent in expression. The Yakushi-ji style, often understood as signifying a formal shift toward what would become Tenpyō taste, is seen in the gilt-bronze Yakushi [19]. Lively and lifelike, it shows attention to volume and fluid drapery emphasizing the physical presence of body beneath cloth. Bronze images such as these were cast according to the lost-wax technique. In this technique a wax model was first prepared over a clay core. The model was then encased in a clay mold and molten metal poured into the mold to displace the wax. This complicated procedure reached an apogee with the Great Buddha of 752, to be sure, but it also came to an end. Subsequently dwindling resources and stylistic change brought a gradual decline in bronze statuary in favor of works in wood by the close of the eighth century.

Lacquer statuary was produced over a relatively short period in the first half of the eighth century under strong imperial and Fujiwara patronage. As was the case for bronze imagery, sculpting in lacquer was a complicated procedure that required a workshop setting with numerous laborers. It is believed that the impetus for this technique, not common in Japan in earlier times, came from China and Central Asia. Possibly news of the technique, perhaps even a few examples, reached Kōmyōshi with the returning diplomatic mission of 736. Her subsequent interest in lacquer imagery suggests she was ready to promote what was seen as an innovative continental technology in sculpture.

Making a lacquer statue involved considerable investment of time and energy. It was also a dangerous endeavor: lacquer fumes are toxic, and the sap causes a skin rash and other irritations. To make a sculpture using lacquer, a clay core was first modeled in the desired form. At least five layers of hemp cloth or linen dipped in lacquer were then

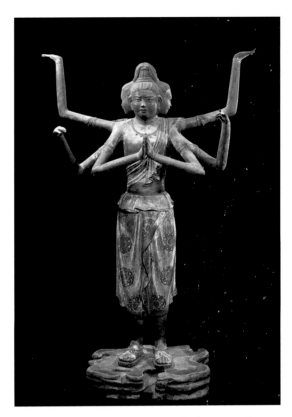

Fig. 5. Ashura, 734, lacquer with polychromy, in the Saikondō (West Golden Hall), Kōfuku-ji, Nara

Fig. 6. Fukūkenjaku Kannon (center), lacquer with gold leaf, and Nikkō (right) and Gakkō (left), clay, mid-eighth-century, in the interior of Sangatsudō, Nara

applied and shaped over the clay core, with ample time between layers to allow for complete drying. Next a thick paste of lacquer and sawdust was spread over the image for further modeling. Once dry, the statue was cut open at the bottom or back and the clay core removed. Typically a wood frame was inserted to prevent shrinkage. Finally the image was painted and gilt. The Rikishi on view [20] was executed in this difficult technique.

The two principal workshops for lacquer statuary were located at Kōfuku-ji and Tōdai-ji. The Kōfuku-ji workshop was in operation by 720 and, closely connected to the Fujiwara family as the atelier of their clan temple, would become one of the great studios of Buddhist sculpture and painting. In 734 the head sculptor of the studio, Shōgun Manpuku, completed a large group of lacquer images for the Saikondō (West Golden Hall) at Kōfuku-ji. The request had come from Kōmyōshi, who built the hall in memory of her mother. The vividly lifelike appearance

of the works, some of which survive, may reflect her personal tastes (fig. 5). It has been noted that Kōmyōshi may have opted for lacquer instead of bronze, the more standard choice for such a commission, because she had become interested in what was seen as a new Chinese fashion in sculpture.

Lacquer statuary was also made at the Tōdai-ji workshop, which was headed by Kimimaro after 746. An important group of sculptures in lacquer survives today in the principal hall, variously called the Sangatsudō and Hokkedō, at the old Kenjaku Precinct where Rōben lived at Tōdai-ji. It includes a colossal image of Fukūkenjaku, said to have been the primary object of worship at the precinct, and a group of attendant and guardian figures (fig. 6). The works are dated to mid-century and thus were contemporaneous with the Daibutsu. Since Kōmyōshi had promoted Rōben from early in her reign and was responsible for the small monastery out of which the Kenjaku Precinct had grown as a core com-

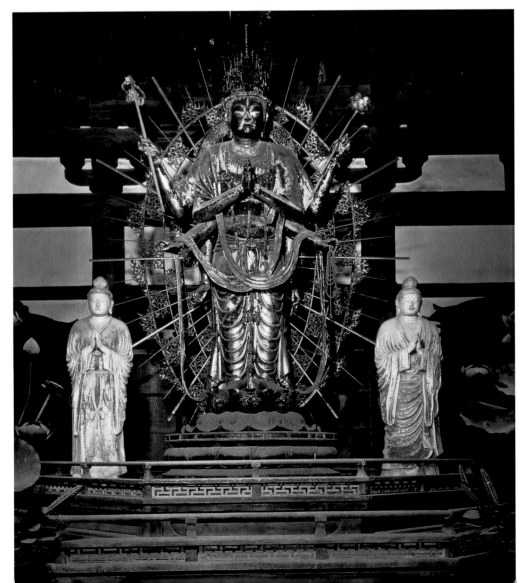

Fig. 7. Kōmokuten (Shitennō), mid-eighth century, clay, Kaidan-in, Nara

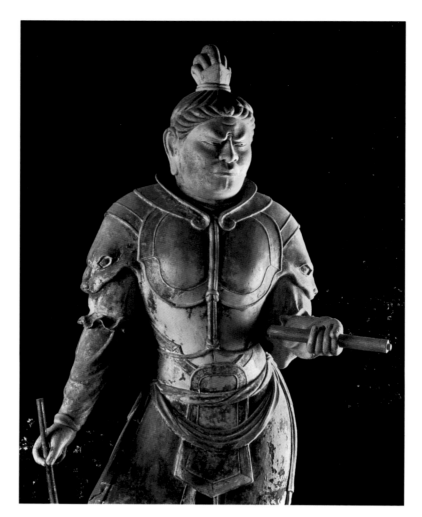

plex within Tōdai-ji, it is conceivable that she ordered Kimimaro to sculpt the lacquer images for Rōben.

The versatile Tōdai-ji workshop also produced sculptures in unbaked clay around the same period, such as the group of guardian figures in the monastery's ordination hall (fig. 7). Clay had been used extensively for statuary since at least the seventh century but was highly perishable. Relatively few sculptures in clay survive despite evidence that, on the continent as well as in Japan, it was often the medium of choice for statuary. One type of clay sculpture did tend to survive, however, since it was usually baked: roof tiles and eaves-end tiles. The Tōdai-ji eaves-end tiles in the exhibition [1] were probably made by the Tōdai-ji workshop around the time the Great Buddha was built.

Workshops such as those at Kōfuku-ji and Tōdai-ji usually counted painters among their ranks for decoration of finished statuary and other tasks. Because of the demand for murals and other wall art to embellish the ob-

jects of worship on the altar or to complete iconographic programs, many monasteries also had painting ateliers. Although most of these works have been lost, those still extant, such as a cycle of wall paintings originally at Hōryū-ji dating to the early eighth century, show striking technical and stylistic affinity to continental prototypes in China and Central Asia. Their naturalness and ease of pose recall Tenpyō statuary as well. Here, too, the cosmopolitan sophistication of eighth-century Nara artistic culture is evident.

Painters also served the court of Shōmu and Kōmyōshi either at palace ateliers or through the Painting Office. Among them would have been those who copied, in an archaic style reminiscent of seventh-century Chinese paintings, the *Kako Genzai E-inga-kyō* [14]. One of several such copies from the eighth century, the work dates to the period 749–56 and was probably commissioned by Kōmyōshi or someone in her circle. It is the earliest known example of an illustrated handscroll in Japan. The naive style is understood as deriving from

Fig. 8. Screen with ladies under trees, mid-eighth century, ink and color on paper, Shōsō-in, Nara

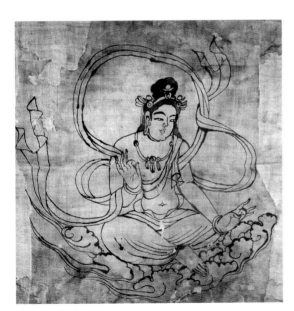

Fig. 9. Sketch of a bodhisattva, 8th century, ink on hemp cloth, Shōsō-in, Nara

the sixth- or seventh-century original, which the painter and calligrapher sought to replicate. But it also assumes a certain level of sophistication, even connoisseurship, in the knowledge of archaic modes of painting. Such an awareness is not surprising in such a milieu as that of Shōmu and Kōmyōshi, with their interest in art and collecting as expressed in the Shōsō-in depository.

In the Shōsō-in collection, which represented the tastes and interests of both Shōmu and Kōmyōshi, were drawings and paintings that epitomized the Tenpyō artistic culture of the eighth century. Works surviving from the original collection include depictions of secular themes, such as a set of screen panels each depicting a lovely woman beneath a tree, as well as Buddhist images with a ceremonial intent. The ladies under trees, their robes originally covered in bird feathers, show Chinese and Central Asian fashion in the representation of corpulent women (fig. 8). Among the Buddhist paintings are colorful banners with images of bodhisattvas drawn in the latest Central Asian mode, and an expertly rendered sketch of a bodhisattva on hemp cloth (fig. 9). These Shōsō-in works offer ample testimony that, in painting as well as in statuary, the Tenpyō sensibility was fundamentally cosmopolitan and gave rise to aesthetic and artistic flair.

The Tenpyō era, seen from the wider frame of Japanese art history, was a time when the basics were laid down under the auspices of a regime of patrons, headed by Shōmu and Kōmyōshi, who prized the visual splendors of Buddhist culture. In sculpture various materials and techniques were brought to maturity at the Nara monasteries, which became the foundation for some five centuries of enthusiastic sculpture production through the medieval period. The pigments, techniques, and formats of what was to become traditional Japanese painting were also developed in the Tenpyō era. Any one of the numerous later works on exhibit, from handscroll to hanging scroll, belongs to a heritage of painting that reaches back into the eighth century. Even in form and style the Tenpyō culture left a legacy of the lifelike image at ease in space and full of energy. It would be an enduring paradigm in subsequent stylistic shifts and transformations.

New Directions

In 754 a Chinese monk called Jianzhen arrived in Nara and was greeted with fanfare by Shōmu and Kōmyōshi. Known as Ganjin to his Japanese contemporaries, he had been invited to Nara in 733, along with Bodhisena and Daoxuan, but encountered great difficulties in making the sea crossing. By the time Ganjin reached Nara, on his sixth attempt, he was blind and in poor health. Nonetheless he set about introducing the Buddhist teachings in which he was expert, the rules and regulations of monastic life called ritsu (Sanskrit: vinaya), and founded the Ritsu school of Buddhism in Japan. In this capacity he was asked to ordain Shōmu and Kōmyōshi in the bodhisattva precepts. Within two months of his arrival, Ganjin initiated Shōmu, Kōmyōshi, and Kōken into the bodhisattva path on an ordination platform built expressly for that purpose in front of the Daibutsuden. With the Great Buddha their witness, Shōmu and his wife and daughter vowed on that day to dedicate their lives to good works and exemplary behavior as bodhisattva novices.

Such sentiments were surely understandable in a period of increasing tensions at court. Even as the Great Buddha had been constructed as a symbol of peaceful empire, factional strife disrupted the inner circles of government at Nara. The rapid rise to power of Fujiwara no Nakamaro after 743 was the major contributing factor. Ambitious and ruthless, Nakamaro was the nephew of Kōmyōshi and an older cousin of Kōken, whom he bullied. His enemies were many. In 745 he had engineered the exile of Genbō despite the prelate's high standing in the Nara monastic community. A few years later, in 749, Shōmu named Nakamaro to the highest post in the government and in effect gave him control of the empire. The death of Shōmu in 756 granted Nakamaro still greater leverage through his close association with Kōmyōshi and Kōken. Rivals attempted to unseat him in 757 but were mercilessly put down. In 758 Kōken ceded the throne to Junnin, a protégé of Nakamaro, and went into semi-retirement with her mother.

Ganjin thus came to Nara in a time of much tension. At first he was based at Tōdai-ji, having been welcomed there by Rōben and Bodhisena, but in 757 he moved to a plot of land given him by the Nakamaro court

so that he could establish a private monastery. That Ganjin chose to leave Tōdai-ji for this rather distant site, in the south of the capital near Yakushi-ji, suggests that he was not at ease in the Nakamaro circle. In 759 work began on Ganjin's new monastery, Tōshōdai-ji. Many of the workers are believed to have been Koreans and Chinese who accompanied Ganjin on his journey from China. The monastery became one of the great Nara establishments but retained its private status as Ganjin's headquarters.

Although Ganjin is best remembered as a specialist in the Buddhist precepts and in matters of ordination, he was also a proponent of Kegon teachings. Indeed, Ganjin had brought with him from China a new version of the

Kegon Sutra in forty fascicles. Thus it is not surprising that the principal object of worship at Tōshōdai-ji was Birushana, the same Cosmic Buddha as enshrined in the Daibutsuden at Tōdai-ji. The statue can be seen today in the main hall of the Tōshōdai-ji complex (fig. 10). It is a large lacquer sculpture that measures more than ten feet in height and was originally covered in gold leaf. The name of the project supervisor, Mononobe no Hirotari, is known from an inscription inside the pedestal. Contemporary records indicate that Hirotari worked for the government as a manager of artisans, suggesting that Tōshōdai-ji initially was viewed as an official endeavor by the state.[24] It is conceivable that the choice of lacquer for the Birushana image had to do

Fig. 10. Birushana, mid-eighth century, lacquer with gold leaf, in the Kondō, Tōshōdai-ji, Nara

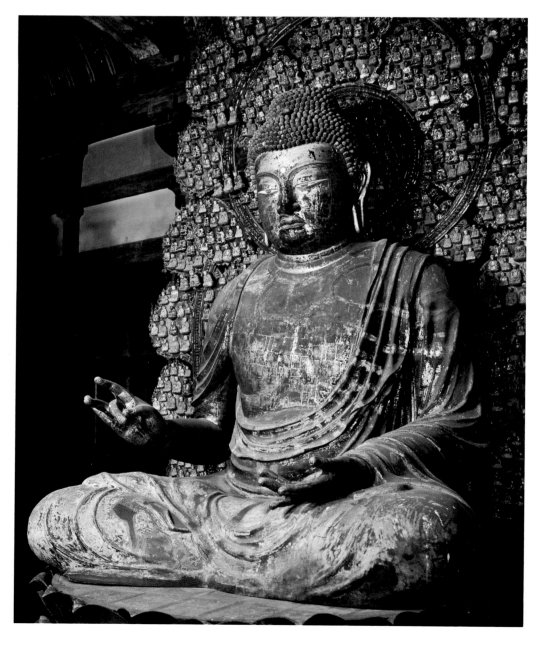

with such semi-official status. Perhaps artists from the Tōdai-ji workshop were assigned to the job for similar reasons.

Other sculptures at Tōshōdai-ji depart significantly from Tenpyō technical standards for statuary. These are the works thought to have been sculpted in the 760s by the community of continental artists in residence at Tōshōdai-ji as part of Ganjin's original entourage. Wood was their material of choice even for images clearly based on the lacquer technique. For example, the colossal statue of Senju Kannon that stands next to the Birushana imgae at Tōshōdai-ji strictly speaking is a lacquer sculpture (fig. 11). However, the lacquer has been layered over a wood core that, unlike the removable clay core of earlier lacquer statuary, is an integral part of the sculpture. The large corpus of wood sculptures at Tōshōdai-ji, of a type not found at Nara monasteries of the Tenpyō era, further indicates a strong emphasis on wood at the complex. Like the Yoryū Kannon on exhibit [22], these works are carved for the most part from a single block of wood. It is clear that such wood carving was what the Tōshōdai-ji workshop knew best, and that this predilection marked a paradigm shift related to changing continental standards at mid-century. Statues once modeled and shaped were now hewn from blocks of wood and carved.

With technological innovation came a formal vocabulary and style that profoundly

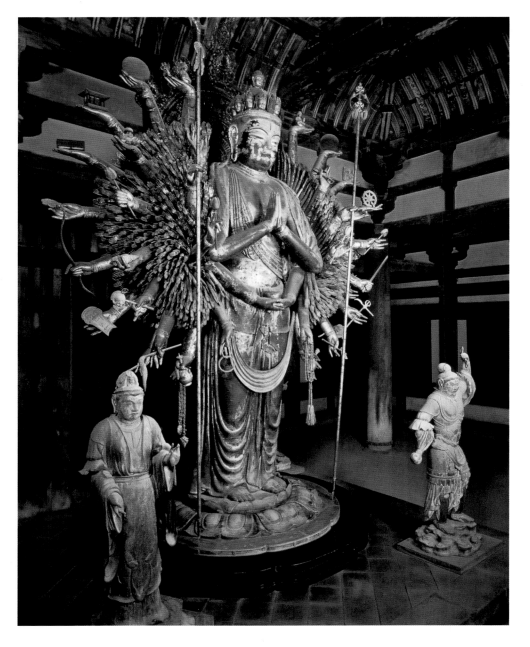

Fig. 11. Senju Kannon, late 8th century, lacquer over wood core, Tōshōdai-ji, Nara

differed from the Tenpyō mode. Virtually every sculpture produced by the Tōshōdai-ji workshop has a solemn and monolithic appearance. Gone is the naturalism and liveliness of form so characteristic of Tenpyō taste, as also the pleasures of elaborately modeled and adorned surfaces. In part this development has to do with the limits of technology: carving a statue is fundamentally different from modeling one from clay and then casting or lacquering it. But the works at Tōshōdai-ji also address another aesthetic entirely, in which Buddha and Buddha-beings are understood as awesome forces capable of generating great magic when ritually invoked. Dour and forbidding, they signal a changing Buddhist world view and visual ideology.

This new order of Buddhist knowledge and visuality, the Vajrayāna movement, began to take hold in Nara as Kōken and others developed an interest in Esotericism and in the monks who were its skilled proponents. The growing attention to the powerful unseen forces of Buddha, which added an element of fear to the activities of worship and ritual, found its most direct expression in solemn and increasingly abstract representations of Buddhas and Buddha-beings. The wood statuary produced at Tōshōdai-ji exemplified this trend, which jettisoned the naturalistic for the metaphysical. Esotericism in effect triggered a paradigm shift in the visual arts.

The Nara monastic community included in its ranks many monks who used Esoteric rituals to heal or comfort members of the lay community. Rōben initially came to the attention of Shōmu because of the magical powers of an image he worshiped as his own tutelary protector on Mt. Mikasa. Genbō had been the personal healer of Tachibana no Michiyo, the mother of Kōmyōshi. Monks in Ganjin's entourage no doubt were familiar with Esotericism as well, since so much of the imagery at Tōshōdai-ji shows iconographical and stylistic evidence of the new trend. The old ties that bound the Nara monastic community to the imperial house, a function of the ideological program of Buddhist empire, ensured as well that in times of stress or illness it would be Nara monks from the great metropolitan monasteries who were called to the palace. Of the many factors that led to the demise of the world that Shōmu had built at Nara, none was more devastating in the long term than this close association between monk and ruler.

In 763 Kōken arranged that her personal healer, a priest called Dōkyō, be allowed free access to the palace. Nakamaro objected furiously but was overruled by the empress. She had grown close to Dōkyō in the years following her mother's death, in 760, in part because he had healed her depression; he seems also to have shared her bed. When Nakamaro attempted a coup d'état in 764, Kōken had him beheaded. Within a month of Nakamaro's death, she had named Dōkyō to a new post she invented for him, Daijin Zenji (Buddhist Minister); exiled the reigning emperor, Junnin; and taken the throne herself under a new name, Shōtoku. In 765 she appointed Dōkyō to still higher status, Dajō Daijin Zenji (Buddhist Prime Minister), in effect granting him control of her government. By 769 Kōken had decided to make Dōkyō emperor. However, she died before the appointment was formalized, in 770, and Dōkyō was exiled soon thereafter by the outraged statesmen who had watched helplessly as he rose to power.

The Dōkyō scandal set in motion a process that led to a new regime within two decades. The imperial lineage whence Shōmu had emerged, to build the Nara capital, gave way to the rival lineage that had preceded it in the seventh century. For four centuries the Shōmu lineage would remain in its shadow. A new capital was subsequently built to the north at Kyoto, and by 784, led by the new emperor, Kanmu, the court and the government had vacated Nara. One of the great cities of the ancient world, filled with art and monastic traditions, was summarily abandoned to time and history. The Daibutsu, once a symbol of empire, would now come to signify the classical Buddhist civilization of old Japan.

The Southern Capital
The move from Nara to Kyoto did not include the monastic community. Kanmu had decreed that Tōdai-ji, Kōfuku-ji, Yakushi-ji, and the other Nara monasteries remain behind at the old capital. New directions in Buddhism were afoot as Esoteric teachings gained ascendance at court in the form of the Tendai and Shingon schools. Kanmu and his circle, all too familiar with the likes of Dōkyō, were

also wary of heavy monastic involvement in government and palace life. It was better that the powerful monks of Nara remain behind in their monasteries and keep to the traditions of scholasticism. At first only two temples were constructed at the new capital, neither of them directly affiliated with Nara. They stood to each side of the main gate into the city, Rajōmon, and were charged with tutelary protection of Kyoto and its imperial compound.

Tendai and Shingon teachings, newly introduced to a community ready for change in Buddhist doctrine and practice, also encouraged the construction of temples and monasteries outside metropolitan areas. The Tendai school, a philosophy and program of meditations centered on the *Lotus Sutra* that was introduced from China by the monk Saichō in 805, flourished at a mountain complex on Mt. Hiei northeast of the Kyoto capital. Vajrayāna Buddhism, introduced in 806 as the Shingon or "True Word" sect by Kūkai in reference to the magical chants used in its teachings, had its first monastic headquarters on Mt. Kōya several days' journey to the south in what is now Wakayama Prefecture. There were also facilities at the imperial compound for Tendai and Shingon worship. In due time temples of both denominations were constructed inside city walls as their followers increased in number and their monks grew powerful at court.

The scholastic Buddhism of Nara was displaced over the ensuing centuries by forms of Buddhism that emphasized devotional practices, magical rituals, and faith as expedient means toward enlightenment and salvation. While equally formidable as intellectual traditions, and by no means inferior to the six schools of Nara in terms of doctrinal complexity, the Tendai and Shingon schools allowed greater lay involvement and opened a path to the truly popular forms of Buddhism that emerged in the early medieval era. Out of the Tendai fold came Pure Land Buddhism as taught by Shinran, whose forceful personality is well represented in his portrait in the exhibition [58], and others at the close of the twelfth century. Believers were instructed to have faith in Amida, chant his name, and through these simple measures expect a deathbed encounter with Amida and his entourage come to take them away to the land of bliss as in the "welcoming descents" [53, 72].

Shingon philosophy for its part encouraged a syncretic view of divinity and Buddhahood that promoted the integration of kami worship into the Buddhist fold. The Sannō mandala [57] exemplifies this syncretism in its canonical representation of the Buddhas and kami of the Mt. Hiei complex as sharing in the same essential nature. As such the mandala demonstrates the theory of *honji suijaku*, in which kami are understood as manifestations (*suijaku*) of an original Buddha identity (*honji*). Another result of the turn toward syncretism was the development of composite deities such as Zaō Gongen, who was the central object of worship in the Shugendō movement of mountain ascetics that emerged in the early medieval era [28, 64]. For these rugged monks, Zaō Gongen represented Shaka manifest as the resident kami of Mt. Kimpusen near Nara. Syncretism also brought about the invention of a new medium, that of the mirrorlike relief sculpture called a *kakebotoke* (hanging votive plaque), for iconic representations of Buddhas and kami alike [65–67].

As new directions took hold in the century following the move from Nara northward to Kyoto, Nara itself took on a new character and came to be called Nanto (Southern Capital). This was not Nara as a political or administrative center, although Tōdai-ji and the other monasteries remained influential, but rather Nara as a religious and artistic center. Indeed, no sooner had Kanmu set up government in Kyoto, along with a new cultural regime, than Nara began to be called Shaji no Miyako (Shrine and Temple Capital). The name stuck and even today is seen on travel posters and other advertisements for Nara.

As a religious capital Nara was similar to Rome or Jerusalem in the historical and spiritual significance of its institutions and places of worship in a world rapidly changing. Preserved at Nara were the first great monasteries of Japan, whose presence had vouchsafed the emergence of empire and a flourishing classical culture of Buddhist art and learning. By the twelfth century they were called Nanto Shichidai-ji (Seven Great Temples of the Southern Capital): Tōdai-ji, Kōfuku-ji, Gangō-ji, Daian-ji, Yakushi-ji, Saidai-ji, Hōryū-ji. There was also the magnificent Kasuga Shrine,

home to the tutelary kami of the Fujiwara house, and in a sense the native guardian of the old Yamato culture on which Buddhism and state had been erected at the dawn of Japanese civilization.

Consequently, the Nara legacy remained powerful and its monastic community influential even as the actual scene of political and cultural leadership shifted to Kyoto, Kamakura, and finally Tokyo in the early modern era. In a pattern that would become typical, Kūkai studied at Tōdai-ji before embarking on the trip to China that would lead him to the Vajrayāna movement. Even after his return, as the founder of the Shingon school in Japan, he maintained close ties with Tōdai-ji and other Nara monasteries. For the many Buddhist teachers and diverse Buddhist movements to come, be they Tendai, Shingon, or the Zen tradition in all of its idiosyncrasy, Nara would keep its role as the spiritual and philosophical home of Buddhism in Japan.

The Nara establishment for its part was equally attentive to developments at the Kyoto capital. By the tenth century, Nara prelates from Tōdai-ji, Kōfuku-ji, and Yakushi-ji were involved in numerous Buddhist activities at court, from chanting and studying sutras to various annual prayers. Indeed, Nara monks expected to be called to participate in such events and were prepared to lodge suits if they were denied equal standing with their Tendai and Shingon peers at court. So powerful was the Nara monastic community by the twelfth century that, led by Tōdai-ji and Kōfuku-ji, it even waged war on competitors such as the Tendai complex on Mt. Hiei. Tōdai-ji and Kōfuku-ji were famous—and feared—for their large standing armies, which they mustered in behalf of allies while bullying opponents at court. Such militancy, by no means unusual for the unstable social conditions of early medieval Japan, would eventually lead to grief for Tōdai-ji and Kōfuku-ji as newly emergent military rulers, unrestrained by earlier taboos, saw fit to destroy them.

The move from Nara to Kyoto had important repercussions for the world of Buddhist art as well. In 789 the official Tōdai-ji workshop was closed and its artists moved on to the Kyoto capital for other assignments; other Nara ateliers, such as that at Tōshōdai-ji, followed suit. Many of these artists were

employed in 796 in the construction of Tō-ji and Sai-ji, the paired temples built to the east and west of Kyoto's Rajōmon respectively, and were able to adapt styles and techniques developed in Nara, such as the woodcore lacquer medium for statuary, to the emerging Shingon aesthetic promoted by Kanmu and his successors. Kūkai was named abbot of Tō-ji in 823, and his longstanding association with Tōdai-ji probably kept its artistic traditions alive as well.

One Nara atelier was not shut down and indeed flourished as others closed in the wake of the new ninth-century aesthetic of plain wood and stylistic abstraction seen in the Miroku Nyorai [25] and Yakushi Nyorai [24]. This was the Kōfuku-ji workshop, whose painters and sculptors—well supported by the Fujiwara family—began a long history of conservation, preservation, and connoisseurship that would last into the thirteenth century and beyond. Much of their business was repair: old statues in and around Nara, works brought from Kyoto for appraisal and reconstruction, an occasional new commission in a style reminiscent of the Tenpyō tradition. It was to be a lasting responsibility. Even today, as traffic hums along busy streets nearby, Kōfuku-ji remains the pre-eminent center for the technical study and restoration of Buddhist statuary in Japan.

But the Kōfuku-ji workshop would play another role as one of three ateliers dominating the world of sculpture patronage and production in the twelfth century. The other ateliers were based in Kyoto, not at temples but in studio-residences within the city itself. Theirs was a technology and style that had little direct association with Nara, having emerged in the context of Tendai belief from a lineage of sculptors based on Mt. Hiei, and belonged more to the world of Kyoto palace society than to the classical Buddhist environment of the southern capital. There was fierce competition among these ateliers, but Kōfuku-ji held its own as the guardian and preserver of Nara traditions. So prestigious did the workshop become that leading Kyoto sculptors sought appointment as master artist of the Kōfuku-ji atelier.

Politics and a propensity for warfare made Tōdai-ji and Kōfuku-ji targets in the civil war that erupted at the end of the twelfth century. They were burned to the ground in 1180 by

members of the Taira family, a military lineage seeking to gain control over the imperial house and the Kyoto government. The flames that engulfed the Great Buddha, horrifying the Nara monks who gathered in a futile attempt to save the colossal statue, signaled the end of the great civilian empire that Shōmu and Kōmyōshi had once envisioned. In a few years the warlord Minamoto no Yoritomo would come to power as the de facto ruler of Japan, his military government firmly in place in distant Kamakura, and a new social and cultural order—that of the samurai—rapidly taking shape on the old landscape of Buddhism and state.

One of the first tasks that Yoritomo undertook was the reconstruction of Tōdai-ji and Kōfuku-ji. Both monasteries had been fully rebuilt by the early thirteenth century and enjoyed a resurgence as centers for the reformist movement within Buddhism that gained prominence after the civil war. Reform meant a revival of Kegon and Hossō teachings, as well as increased interest in Tenpyō sensibilities in art. The Kōfuku-ji workshop flourished in this climate, backed by the Minamoto regime, and became home to the vaunted Kei school of sculptors led by Kōkei and his disciples Unkei and Kaikei. These artists crafted a new vocabulary of style that, based on Tenpyō forms, adapted contemporary tastes—aristocratic and military—to a Nara aesthetic and reconfigured the parameters of Japanese Buddhist sculpture for a new age.

Nara in the time of Yoritomo briefly revived its old role as a cosmopolitan capital. Chinese artists participated in the reconstruction of Tōdai-ji, working closely with the Kōfuku-ji workshop, and there was considerable intel-

lectual ferment as the radical teachings of Zen Buddhism were introduced and began to flourish under military patronage. But the major significance Nara would hold in the coming centuries, in the diverse religious and cultural climates that developed as shōguns ruled from Kamakura, Kyoto, and Tokyo, would be as the receptacle of a classical Buddhist past. Nara would be the backbone of tradition that gave structure, cognitively and physically, to the future.

Although Nara and its monasteries experienced vicissitudes during the wars of the sixteenth century, warlords and monks alike worked to rebuild and preserve its monuments. The city's unique role in Japanese culture, as the home of an ancient Buddhism and its treasures, made such endeavors not only possible but inevitable. In 1945, as the threat of bombing loomed large, scholars and curators scrambled to carry the statues at Kōfuku-ji and other Nara monasteries to safety. If the art of Nara was lost, they believed, so was their heritage.[25]

The Nara National Museum has sustained the Nara legacy through its treasury of Buddhist art. Founded in 1875, the museum held its first exhibitions in the Great Buddha Hall at Tōdai-ji. Thus the Cleveland Museum of Art, in bringing the art of the Nara National Museum before an American audience, shares in a heritage that began with the Great Buddha and the cosmopolitan world of Shōmu and Kōmyōshi. The appreciation of these celebrated objects, in all of their richness and diversity, is in itself an act of lasting merit that helps to preserve one of the great traditions of Asian art.

Notes

1. For example, see Leon Hurvitz, trans., *Scripture of the Lotus Blossom of the Fine Dharma* (New York: Columbia University Press, 1982), 38–40, 178–79.

2. Sugiyama Jirō, *Classic Buddhist Sculpture: The Tempyō Period,* trans. Samuel Crowell Morse (Tokyo and New York: Kōdansha International, 1982), 95, 98, 122–23.

3. The following discussion of Nara and Nara politics is based on Kojiro Naoki, "The Nara State," in *Ancient Japan,* ed. Delmer M. Brown, vol. 1 of *The Cambridge History of Japan* (Cambridge: Cambridge University Press, 1993), 221–60.

4. The estimate is often as high as 200,000 persons. See Tsuboi Kiyotari and Tanaka Migaku, *The Historic City of Nara: An Archaeological Approach* (Tokyo and Paris: Centre for East Asian Cultural Studies, 1991), 126, 129.

5. Ibid., 123.

6. For Nara Buddhism and the Nara monastic community, see Daigan and Alicia Matsunaga, *Foundation of Japanese Buddhism* (Los Angeles and Tokyo: Buddhist Books International, 1974), 1:26–135.

7. Discussion of early Mahāyāna Buddhism is based on Akira Hirakawa, *A History of Indian Buddhism from Śākyamuni to Early Mahāyāna,* trans. Paul Groner (Honolulu: University of Hawaii Press, 1990).

8. Discussion of Buddha, Buddha-beings, and the Buddha body is based on Malcolm David Eckel, *To See the Buddha: A Philosopher's Quest for the Meaning of Emptiness* (Princeton, N.J.: Princeton University Press, 1994); Paul J. Griffiths et al., *The Realm of Awakening: Chapter Ten of Asanga's Mahāyānasangraha* (New York and Oxford: Oxford University Press, 1989); and Paul J. Griffiths, *On Being Buddha: The Classical Doctrine of Buddhahood* (Albany: State University of New York Press, 1994).

9. For an investigation into early Buddhist imagery, and a critique of the idea of aniconism, see Susan L. Huntington, "Early Buddhist Art and the Theory of Aniconism," *Art Journal* 49 (Winter 1990).

10. *Daihatsu nehangyō* (Sutra of the great nirvana), sutra 220, vol. 6 of *Taishō shinshū Daizōkyō* (Newly revised tripitaka of the Taishō era), ed. Takakusu Junjiro, Watanabe Kaikyoku, and Ono Gemmyō (Tokyo: Daizō Shuppan, 1924–32), 968–69; Griffiths, *On Being Buddha,* 68, 99–100.

11. Ryusaku Tsunoda et al., eds., *Sources of Japanese Tradition* (New York: Columbia University Press, 1964), 1:138.

12. Discussion of mandalas is based on Elizabeth ten Grotenhuis, *The Sacred Geography of the Japanese Mandala* (Honolulu: University of Hawaii Press, forthcoming 1998).

13. *Dainichi-kyō* (Dainichi sutra), sutra 848, vol. 18 of *Taishō shinshū Daizōkyō,* 5, 7.

14. Discussion of Buddhist iconography is based on Sawa Ryūken, *Butsuzō annai* (Guide to Buddhist images) (Tokyo: Yoshikawa Kōbunkan, 1967) and *Butsuzō zuten* (Iconographical dictionary of Buddhist images) (Tokyo: Yoshikawa Kōbunkan, 1962); and Louis Frédéric, *Buddhism* (Paris and New York: Flammarion, 1995).

15. For a compendium of the various mudras and attributes see E. Dale Saunders, *Mudrā: A Study of Symbolic Gestures in Japanese Buddhist Sculpture* (Princeton, N.J.: Princeton University Press, 1985).

16. Mizuno Kogen, *Buddhist Sutras: Origin, Development, Transmission* (Tokyo: Kōsei Publishing Co., 1982), 164–67.

17. Ibid., 167–68. For sutra copying, see Willa J. Tanabe, *Paintings of the Lotus Sutra* (New York and Tokyo: Weatherhill, 1988), 28–36.

18. For English-language translations of the sutras, see R. E. Emmerick, trans., *The Sūtra of Golden Light: Being a Translation of the Suvarnabhasottamarajasūtra* (Oxford: Pali Text Society, 1990), and Thomas Cleary, trans., *The Flower Ornament Scripture: A Translation of the Avatamsaka Sutra* (Boston and London: Shambhala, 1993).

19. Discussion of the Great Buddha project is based on Takeuchi Rizō, "Daibutsu kaigen" (Great Buddha Eye-opener), in Takeuchi Rizō, ed., *Kodai kokka no han'ei* (Flowering of the ancient Japanese state) (Tokyo: Shueisha, 1974), and Ishino Tōru, "Daibutsu konryū" (Construction of the Great Buddha), in Mayuzumi Hiromichi, ed., *Zusetsu Nihon no rekishi: Nara* (Illustrated history of Japan: Nara) (Tokyo: Shōgakkan, 1979).

20. Tsunoda Ryusaku et al., *Sources of Japanese Tradition,* 1:104. The Three Treasures are Buddha, sutras, and monks.

21. Takeuchi, "Daibutsu kaigen," 197.

22. Inoue Kaoru, "Daibutsu kaigen" (Great Buddha Eye-opener), in Tsuchida Naoshige and Ishii Masatoshi, eds., *Kentōshi to Shōsō-in* (Shōsō-in and the diplomatic envoys to Tang China) (Tokyo: Gyōsei, 1986), 111. For the account, see *Si-Yu-Ki: Buddhist Records of the Western World,* trans. Samuel Beal (New York: Paragon Book Reprints, 1968), 51.

23. See Earl Miner et al., *The Princeton Companion to Classical Japanese Literature* (Princeton, N.J.: Princeton University Press, 1985), 452.

24. Sugiyama, *Classic Buddhist Sculpture,* 134.

25. Interview with Professor Kameda Tsutomu (Sendai, 1977).

Catalogue

1. Temple Roof Tiles; molded earthenware

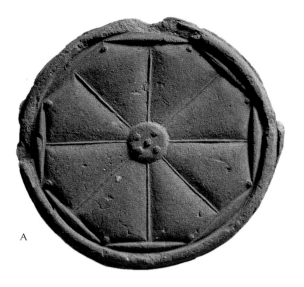

A

Starting in the Asuka valley in the third and fourth centuries, the head of the Yamato state (a term used to refer to the ancient Japanese country at that time) and his clan leaders ruled a large agricultural plain and had established contacts on the Korean peninsula. Before Heijo-kyō (Nara) became the capital in 710, the seat of imperial authority had moved several times. Large burial mounds indicate where clan groups lived, and similar funeral monuments in the Kawachi and Izumi areas (close to modern Osaka) indicate a ruling center there in the fifth century. As the network of clans and clan affiliations expanded, the authority of the Yamato king increased as well as the awareness of maintaining respect for the local Shinto deities (*kami*).

A succession of Yamato kings ruled from their own palace residences in the fifth century, a period of intense foreign contact and impressive domestic development, especially in technology and agricultural production. A developing interest in Chinese cultural achievements and governmental and legal systems characterizes the last decades of the century and the ensuing Asuka period. Diplomatic missions with Korea—particularly the

kingdom of Paekche—were curtailed in favor of strengthening ties with Tang China. Yet Korean Buddhist monks arriving in the early sixth century, followed later in the century by Chinese priests, were included as part of the official missions between these countries and Yamato, and it is they who initially conveyed the precepts of Buddhism.

Besides bringing texts, these monks—many of whom became immigrants—also brought icons, ritual implements, textiles, and the artisans capable of constructing the proper buildings for honoring these images. In the sixth century, following a struggle between supporters of Buddhism and the more conservative forces favoring the maintenance of the local kami belief system, temple structures began to be built in the Asuka valley, then the seat of government.

One of Japan's early histories, the *Nihongi,* provides valuable accounts of the events leading up to this momentous period in the history of Japanese Buddhism; it also relates activities surrounding the establishment of Buddhist temples by the imperial family and clan leaders who supported the new religion and its powerful backers.[1] More than forty

compounds are recorded as having been founded. Although none has survived intact, many have been reconstructed.

Unlike the residential palaces of the time in the Asuka valley or in Naniwa (Osaka), which used unfooted pillars and thatched roofs, these new Buddhist structures used stone for foundation work on column footings and ceramic tiles to protect roofs and adorn interior spaces. The status accorded clan leaders and aristocrats who sponsored temple construction resulted in their appearance from Asuka to the Ikaruga area southwest of Nara where the Hōryū-ji (Temple of the Exalted Law) is located, to the Naniwa region near the port of Osaka. While all the original buildings have been lost, modern archaeological excavation has yielded a great deal of information about them and this extraordinary period in the formation of the Japanese state.[2] Roof tiles—both the circular and the arched eaves-end—constitute the bulk of material that has been recovered and offer glimpses of the magnificence of these substantial architectural structures. Because of the nation's official support of Buddhism through the *kokubun-ji* (state temple) system

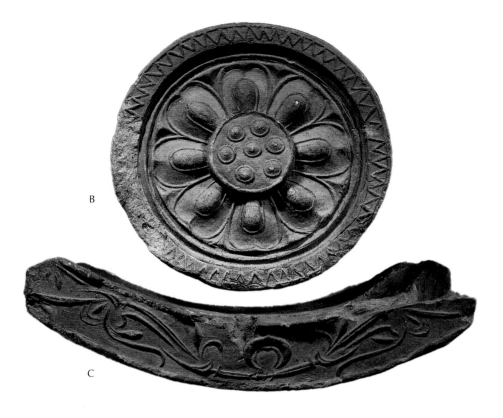

Fig. 1a. Architectural detail showing the 8th-century roof tiles on the main hall at the Hōryū-ji, Nara

[12] and later as part of the natural fabric of the culture, these molded ceramic artifacts were excavated, collected, revered, and published extensively for centuries.

But the pre-Heian temples that have survived are not in their original forms, meaning tiles such as those illustrated here best reflect that past and provide valuable insights into the forms and styles of related Buddhist art of their respective periods.

A. EAVES-END TILE FROM A TEMPLE SITE AT YOKOI, NARA, 7TH CENTURY; DIAM. 15.5 CM

The earliest tile is noteworthy in that its design demonstrates close affinities with Korean tiles recovered from temple sites in the area of the ancient kingdom of Paekche. In the late sixth and seventh centuries Paekche was a close ally of the fledgling Yamato state and provided the first craftsmen experienced with the materials (clay, metal, wood) needed to construct large-scale architecture. The geometric eight-petal design is strikingly modern. The same design reversed to form concave patterns is also known in early seventh-century examples.

B. EAVES-END TILE FROM A TEMPLE SITE AT YAMAMURA, NARA, 7TH CENTURY; DIAM. 19 CM

C. EAVES-END TILE FROM A TEMPLE SITE AT YAMAMURA, NARA, 7TH CENTURY; L. 31 CM

This set comes from a temple in the eastern area of Nara. The lotus petal design of the circular tile is sculptural, a visual effect made more pronounced by the coursing, raised zig-zag pattern on the surface of the outermost band. The lower tile contains one of the earliest and most beautiful renderings of the raised palmette design that subsequently dominates the decorative repertoire of such tiles, but seldom with the clarity and elegance visible here.

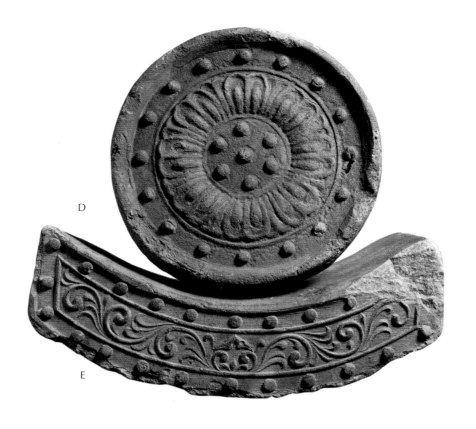

D

E

F

G

H

D. EAVES-END TILE FROM TŌDAI-JI, NARA, DATABLE TO CA. 752; DIAM. 19.3 CM

E. EAVES-END TILE FROM TŌDAI-JI, NARA, DATABLE TO CA. 752; L. 28.5 CM

This set illustrates how tile decor and form changed in the eighth century, moving away from the sharply outlined, fulsome modeling inspired by Korean prototypes toward a more compacted, linear, and stylized format. Comparison of the floral composition and delineation in this set with the previous example is telling. The clay bodies are similar although this set is more highly fired. Because the Eye-opener ceremony (Kaigen Kuyō) for the Great Buddha was held in 752, these tiles are accorded that date.

F. EAVES-END TILE FROM A TEMPLE SITE AT IZUMO KOKUBUN-JI, SHIMANE PREFECTURE, 8TH CENTURY; DIAM. 14.4 CM

G. EAVES-END TILE FROM A TEMPLE SITE AT IZUMO KOKUBUN-JI, SHIMANE PREFECTURE, 8TH CENTURY; L. 24.4 CM

This set comes from the kokubun-ji established in the western coastal province of Izumo (modern Shimane Prefecture) near modern Matsue city. Excavation beginning in the mid-1950s revealed the location of the site and its various buildings, as well as roof tiles. The temple was built on an impressive scale that also included a nunnery. Both sites have revealed a number of types of roof-end and eaves-end tile designs of which this set represents a sharply molded example.

The form, decor, and detailing are different from the metropolitan Tōdai-ji (Great Eastern Temple) vocabulary, indicating the independence of local ceramic artisans there. Indeed, the influence of Korean Silla period tile decor is apparent in the tight, sharp scroll patterns and quatrefoil floral shapes in the long tile.[3] Silla style tiles also appear in the Fukuoka region in Kyūshū where there was a large Korean immigrant population.

H. EAVES-END TILE FROM BYŌDŌ-IN, UJI, KYOTO PREFECTURE, 11TH CENTURY; DIAM. 14 CM

The Byōdō-in was built in 1053 as a private devotional hall for Fujiwara no Yorimichi (990–1074), an influential statesman and dedicated Buddhist follower. The sharp outlines of the overlapping raised lotus petal shapes and the indented band encircling the center roundel are this tile's distinctive features. These elements seem not to have been used elsewhere in Kyoto, probably because the special, personal nature of the entire project and its patronage has no equal in extant Heian, and Buddhist, culture.[4]

1. See *Nihongi: Chronicles of Japan from the Earliest Times to A.D. 697,* trans. W. G. Aston (London: Allen and Unwin, 1956).

2. Suzuki Kakichi, *Asuka-Nara kenchiku* (Architecture of the Asuka and Nara periods), vol. 196 of *Nihon no bijutsu* (Arts of Japan) (Tokyo: Shibundō, 1982).

3. *Nihon Bukkyō bijutsu no genryū* (Sources of Japanese Buddhist art), exh. cat., Nara National Museum (1978), 110–37, nos. 35–36.

4. See Inegaki Yukinari, *Kodai no kawara* (Ancient roof tiles), vol. 66 of *Nihon no bijutsu* (Tokyo: Shibundō, 1971).

2. Tile with Phoenix Design

7TH CENTURY; MOLDED EARTHENWARE; 39 X 39 CM; MINAMI HOKKE-JI, NARA PREFECTURE. IMPORTANT CULTURAL PROPERTY

The arts of the Asuka period focused primarily on the production of icons, the copying of sutras (sacred Buddhist scriptures containing the sermons attributed to the Historic Buddha, Shaka), and the building and adornment of the devotional halls or spaces where the icons were to be venerated. In addition to the wood used for architectural framing and decoration, clay was an essential, often-used material. Both economical and durable, it had many uses in residential and religious settings. Mixed with mud and straw fibers it formed the walls that surrounded religious compounds. In the hands of potters it became kitchenware of various shapes, sizes, durability, and function. To metalworkers it provided the heat-tolerant material for casting bronze images, large and small. For tilemakers it was

the raw material for manufacturing the large numbers of tiles needed for the roofs of temples and aristocratic residences in the Nara area and Asuka valley [1].

Other popular low-cost ceramic products of the late seventh and early eighth centuries in Japan were press-molded Buddhist icons and tiles such as this impressive example. The icons were usually small, easily portable (hand-held) clay slabs, excavated examples of which are in the Tokyo National Museum, Nara National Museum, and several Nara area temple collections. They were no doubt based on a continental tradition of ceramic image making. Or they were multi-figural plaques of a relatively high-fired fabric whose surfaces were then sometimes decorated with gold leaf. Although widely in use in Nara and the Asuka and Osaka regions, these *senbutsu* (press-molded images) have not survived in anywhere near the numbers of the related bronze *oshidashibutsu* (repoussé-molded plaques) that have been passed on to subsequent generations.[1]

This phoenix tile represents an unusual type of Buddhist artifact, a rare ceramic subject in an unprecedented scale. It is fully ten centimeters thick and weighs several kilos. It was excavated in southern Nara at the Oka-dera site, an imperially sponsored temple founded in 663, where it is believed to have been part of the wainscoting for the devotional hall.[2] Many rows of tiles with this design—just how many is unknown as it is the only intact example—were presumably affixed to the walls around or near the principal devotional icon. How many courses high the tiles were arranged is also unknown, but certainly the factors of weight and durability would have helped determine that aspect of the design. In Korea thinner, higher-fired, press-molded tiles reached well over human height and were used in the vaulted tombs of the fifth and sixth centuries in Paekche, Japan's nearest continental ally.[3]

The Japanese tiles may also have served as decorative side panels set into the bases of a temple's central devotional image. Unlike oshidashibutsu, a number of senbutsu fragments featuring seated Nyorai (Buddha or enlightened being) or Tenbu (standing guardian figures) show the wooden platform supporting the enthroned deities. These portray *apasaras* (celestial attendants), *bosatsu* (those destined for enlightenment or bodhisattvas), *karashishi* (mythical lion beasts), and heavenly musicians, among other subjects. They also provide evidence that molded relief panels were set into the facades of Asuka-period bases in between the vertical struts that support the base plates. The most important and elaborate painted version of such an arrangement is the Tamamushi Shrine at the Hōryū-ji temple in Nara.[4]

But the scale and aesthetic maturity of this phoenix tile, and a closely related example still in the collection of the Oka-dera with a single kneeling apasaras figure, point to a level of production, usage, and visual sophistication unprecedented among the roof tile remains that have come down to us through modern archeological excavation. The phoenix image occupies nearly the entire surface, save the scudding clouds that help define the mythical bird's airy world. The bird is deeply molded to suggest nearly a three-quarter view; its spread wings and rear tail plumage are a swooping series of plain rounded forms that encapsulate and frame the cocked head. Although considerable detail has been lost since the seventh century, the visual impact is still substantial. Look, for example, at the remarkable modeling of the clawed feet. The closest visual parallel to this phoenix left in Japan is a pair of mid eleventh-century gilt-bronze roof finials atop the Phoenix Hall at the Byōdō-in outside Kyoto.

Closer mates in time if not in place are the tiles from the Unified Silla period (and earlier) whose scale, technical sophistication, and splendid decoration provide phoenix as well as floral motifs. An early seventh-century floor tile with central phoenix design from a temple site in the Paekche capital of Puyŏ provides an instructive comparison between peninsular stylization and the Japanese presentation of the identical images (fig. 2a).[5] Essentially this same approach to phoenix portrayal can be seen in stencil-dyed textiles and some lacquerware in the Shōsō-in treasury of the mid-eighth century in Nara and then continues in Japan unabated into the Kamakura period in various media. Its popularity in later eras, however, reaches its zenith in the later Heian in lacquerware designs, metalwork affixed to Buddhist altars, dais for priests (as at the Chūson-ji in northern Japan), and ritual implements such as *kei* (ritual chimes) [82]. Worth noting is the evolution of the form from a two-winged portrayal to basically a profile image showing overlapping wings by the eleventh century.[6]

Thus this auspicious Buddhist emblem of secular and religious harmony and even spiritual rebirth, employed as a repetitive motif adorning the interior walls and image platforms of Japan's earliest Buddhist devotional halls, reappeared dramatically and in a number of guises precisely when the end of Buddhist Law (*mappō*) was forecast. This ceramic tile is today the single most important vestige of the legendary bird's genesis in Japanese art in three-dimensional form.

Fig. 2a. Tile with phoenix design, 6th–7th century; Korea, Paekche Kingdom; molded stoneware; 29 cm square. Tokyo National Museum

1. See Kuno Takeshi, *Oshidashibutsu to senbutsu* (Repoussé and press-molded Buddhist images in relief), vol. 118 of *Nihon no bijutsu* (Arts of Japan) (Tokyo: Shibundō, 1976).

2. *Bukkyō bijutsu meihin ten zuroku* (Masterpieces of Buddhist art), exh. cat., Nara National Museum (1971), 13.

3. See *5000 Years of Korean Art,* exh. cat., Asian Art Museum of San Francisco (1979), nos. 61–62, 65–67.

4. Kuno Takeshi, *Oshidashibutsu to senbutsu*, pl. 82.

5. *Kachō no bi* (The art of flowers and birds), exh. cat., Kyoto National Museum (1982), no. 37.

6. Ibid., nos. 32–34, 57, 60, 69, 73–74, 91.

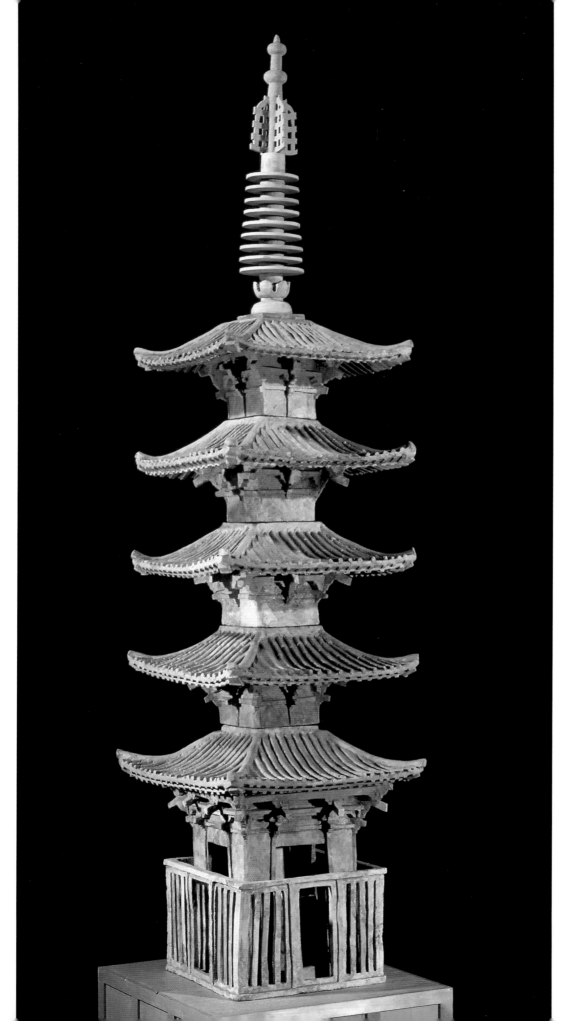

3. Five-story Pagoda

8TH CENTURY; MOLDED, CUT, AND INCISED
EARTHENWARE; H. 202.7 CM

Numerous small-scale pagodas and stupas of
various styles and materials [79] were made
in the late Heian and Kamakura eras to serve
as kinds of reliquaries. Small gilt-bronze or
carved-wood images placed inside them
became the principal objects of devotion of
the hall in which the models were set, often
on special centrally located platforms. While
more informal placement occurred also,
occasionally an entirely new building was
added to a temple compound to house a
model that had become so popular that more
space was needed for receiving the ensem-
ble's devotees. In Nara the Kairyūō-ji and
Tōdai-ji own, respectively, important medi-
eval examples of pagoda and reliquaries
housed in specially created settings.

Most such architectural models were cast
in bronze or iron, like other contemporary
reliquaries, or assembled from wood. This
imposing five-story pagoda is an important
predecessor to these medieval types, both in
material and in time. It is fabricated from a
type of clay that can be linked to deposits in
the Nagoya area, west along the coast from
where this piece was excavated. The kilns
established by about the seventh century
in the vicinity of Mt. Sanage, southeast of
present- day Nagoya, constitute the most
important ceramic production center in early
Japan operating between the eighth and
twelfth centuries. The wares produced here
are known as Sanage.[1]

At Sanage improvements in the clay fabric,
kiln design, and firing techniques during the
eighth century resulted in a product more
desirable to Nara's aristocratic families than
the established Sue ware items. One early
type of Sanage ceramic called *shirashi*
("white" ceramics) resulted when the refined
clay body fired to a pale tone, and this pa-
goda was made from that clay. Either natural
or applied ash glaze complemented this tone
handsomely and became popular at court.

The structure is composed of five nesting
sections, capped by a finial that is a modern
replacement. The tall fence around the base
unit is an independent element, but like the

pagoda sections demonstrates a number of clay techniques—molding, incising, finger rolling, hand building—used in composing this large complex sculpture. Each unit issues from a molded four-sided walled stand that bears the heavy weight of the flaring roofs and accompanying architectural details. These segments are elaborately detailed, providing valuable information about eighth-century architectural norms.

Each unit nests in sequence to the roof section below, which, in turn, has a round hole in the middle to symbolize the presence of the important central column in such Buddhist structures and to provide—as is done today as well—an internal device for aligning and stabilizing the stacked segments. Careful attention was paid to scale and proportion in fashioning the sections so that as the structure rises, the supporting walls of each segment become taller while the outer dimensions and roofs diminish, thereby producing the classic upward lift to the overall pagoda form.

Each of the roofs is a single thick slab of clay, press molded and then manipulated to produce the sweeping arcs. These roofs were joined to the upright walls after they were leather hard and the rolled tile lines, tile ends, and rafter systems had been securely applied and given their incised detailing. A sharp bamboo knife no doubt created the edges for the double-rafter detailing and was used to cut the strips of clay assembled into the walls, which represent the classical bracketing system supporting the heavy tiled roofs in Buddhist architecture. Comparison with the Hōryū-ji and Yakushi-ji (Temple of the Healing Buddha) buildings is instructive. Although extensive modern restoration was necessary on this excavated object, scrutiny of the original clay surfaces and applied detailing reveals the care with which the various clay elements were fabricated throughout the process of building this structure. Distortion and cracking from shrinkage, for example, is slight.

The large bottom section is particularly noteworthy for its proportions and the fence that surrounds it. This floor has four tall, narrow doors cut into each face, with door jambs linking the whole and providing stability. These cut details as well as the applied ones are finely executed, and the luting of the appliques precisely finished.

The lattice fence tightly encompassing the first floor is an unusual feature, not seen for example at the Hōryū-ji (or nearby Hokki-ji), where the pagoda is inside a large walled compound with a colonnade. Other temple plans from the seventh and eighth centuries, however, indicate examples in which a pagoda (or pagodas) was located outside the walls of the inner compound and could therefore possess its own protective colonnade.[2] The remarkable condition of this particular feature thus lends important information to architectural historians of early Japan.

Also noteworthy are the remnants of a plain baked-clay cubicle (not included in the exhibition) that was placed inside the first floor. These fragments, all that remains of the original box, make clear that a pair of molded clay bodhisattva images were inside the pagoda on the ground floor inside this cubicle.[3]

The most important extant example of early Buddhist clay imagery in Japan can be found in the pagoda at the Hōryū-ji in an extraordinary ceramic tableau depicting four scenes from the life of Buddha. The numerous figures demonstrate the acceptance of baked clay as an important medium in the seventh and early eighth centuries in the Nara basin. Temple records note the existence of clay statuary now lost; other, mostly fragmentary images survive such as a small glazed pagoda in the Shōsō-in and the famous cast-bronze *Lotus Sutra* plaque from the Hase-dera outside Nara dating to the late eighth century that was fabricated using a clay mold.[4] Besides demonstrating a number of important Buddhist iconographical features, this depiction of a three-story pagoda shows a tall four-sided fence enclosing the first floor. The Shōsō-in piece illustrates another type of three-color glazed ceramic pagoda form, assembled in sections. While the detailing of architectural form is minimal, the glazed surfaces are appealing. The scale is also modest in comparison.

Although a number of architectural models made from wood or cast in iron or bronze were produced in medieval Japan as reliquaries or miniature shrines, ceramic examples are rare and precede or are contemporary with all other types. Precisely how this large piece was used remains uncertain. Excavated from a site in the rural countryside east of Nagoya in Shizuoka Prefecture, its size sug-

gests that it served an important, even focal role in a local temple's compound. It could have been placed within a devotional hall, although the context of its excavation site does not support this theory. Medieval practices support such a view, however, and also highlight the rarity of this early ceramic prototype. Future excavations in the Sanage area or at the kilns themselves hopefully will reveal more information.

1. For a general discussion of Sanage wares, see Narazaki Shōichi, *Shirashi* (White wares), vol. 6 of *Nihon tōji zenshū* (A survey of Japanese ceramics) (Tokyo: Chūōkōronsha, 1976).

2. Kasuga paintings and other depictions of Shinto shrines in a landscape are also good sources for seeing the architectural tradition of fenced pagodas and outbuildings. See J. Edward Kidder, *Early Buddhist Japan* (London: Thames and Hudson, 1972), chaps. 7–8.

3. *Asuka no senbutsu to sōzō* (Asuka period stamped clay images and dry clay sculpture), exh. cat., Nara National Museum (1976). For the pagoda fragments, see Nara National Museum, *Nara Kokuritsu Hakubutsukan zōhin zuhan mokuroku kōgōhin: Bukkyō kōgō* (Illustrated catalogue of the collection of the Nara National Museum: Buddhist archaeological objects) (Nara: Tenri Jihōsha, 1993), pls. 6, 17. See also Nishikawa Kyōtarō, *Sōzō* (Dry clay images), vol. 253 of *Nihon no bijutsu* (Arts of Japan) (Tokyo: Shibundō, 1987).

4. For one of the Shōsō-in glazed pagodas, see Ishida Mosaku, *Shōsō-in* (Tokyo: Mainichi Shinbunsha, 1954), pl. 115. For the Hase-dera relief, see Washizuka Hiromitsu, *Enlightenment Embodied: The Art of the Japanese Buddhist Sculptor,* exh. cat., Japan Society Gallery (New York, 1977), no. 3.

4. Jar with Hunting Scene

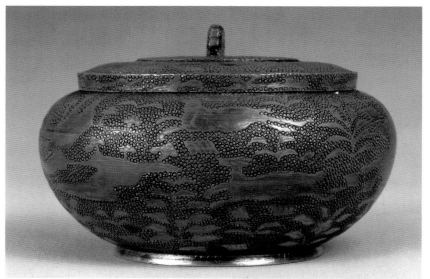
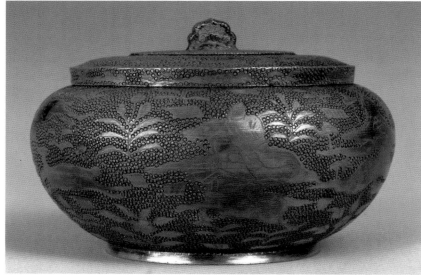

8TH CENTURY; CAST SILVER WITH GILDING AND INCISED AND TOOL PUNCHED DESIGNS; H. 4.4 CM; TŌDAI-JI, NARA. NATIONAL TREASURE

This small jar together with the cicada-shaped lock [5] was originally part of a large group of objects buried in the rammed-earth platform supporting the altar at the *Kondō* ("golden" or main hall) at Tōdai-ji. Placed there for the official ceremonies held in 752 to consecrate the Daibutsuden (Great Buddha Hall), this set of objects was retrieved during a restoration project undertaken at the temple in the early twentieth century.

Such sets, known typologically as *chindangū* (buried ritual objects), were traditionally made for auspicious ceremonies as a tangible way to appease the natural spirits of a site disturbed by human intervention. The relics were distributed in the four cardinal directions and made of materials traditionally associated with Buddhist emblems, here fashioned into objects of exquisite beauty, craftsmanship, and symbolic import. This custom enjoyed a long history in China and Korea before it arrived in Japan, where other sets of chindangū have been uncovered in the Nara plain and at the sites of government-sponsored temples outside the eighth-century

capital.[1] This practice is closely related, of course, to that of placing reliquaries in free-standing stupas (a tradition well documented in ancient Korea for example) or under the central pillars of their larger relatives: the pagodas of East Asia.[2]

This Tōdai-ji group of fifteen objects is the most renowned in Japanese cultural history, and the various pieces have long been registered as National Treasures. This jar and the cicada lock are the two best preserved and the most aesthetically compelling objects in the group, which also includes a lidded crystal case containing pearls, crystal beads, stone and glass rosary beads, and a cast-bronze mirror. The presence of related materials in the Shōsō-in treasury and at the Hōryū-ji temple in Nara of comparable age provides background for this small jar whose shape and decor hark back to Tang China, and even farther west. Indeed, the hunting scene encircling the jar can be traced to even earlier Near Eastern and Scythian portrayals of royal hunts across lush schematized landscapes.

But in eighth-century Nara these attractive, dynamic scenes, which arrived after having traveled across the Silk Route, China, and then the China Sea, were altered to Japanese taste and usage. Thus, for example, the stag

hunt subject was adapted to become a vivid and compositionally intricate lion hunt on the plectrum of a sandalwood *biwa* (similar to a European lute) in the Shōsō-in collection. The Scythian influence likewise appears at the Shōsō-in in a set of marble relief panels of the twelve animals of the zodiac, of which one—the fleeing stag—is related to the animal depicted on this small jar.[3]

Particularly fascinating too (and not well known) are the colored sheets of paper from the central section of the Shōsō-in that bear stenciled designs of birds, insects, plants, and small mountain silhouettes judiciously placed across the paper with ample amounts of space between the individual elements. These were laid out on the paper, and then colored ink was blown through a bamboo tube, creating a finely sprayed surface that served as the ground for the imagery (fig. 4a).[4]

In much the same manner, the metalworker responsible for the decor of this cast-silver jar surveyed the compact surface and lid and then proceeded to lay out the principal hunt scene motifs of the composition, perhaps using paper cutouts. Next came the landscape elements of plants, grass tufts like those in the *Kako Genzai E-inga-kyō (Sutra of Cause and Effect)* [14], and miniature mountainscapes with birds on the lid. Once the composition

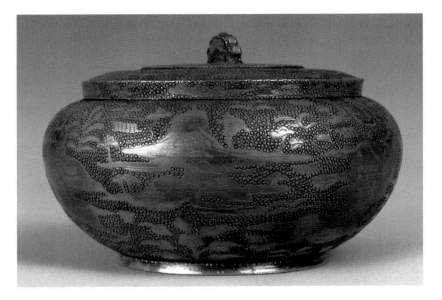

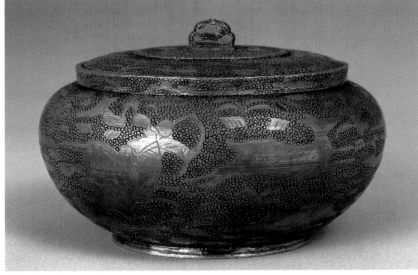

Fig. 4a. Colored paper with stenciled designs of birds, insects, and flora; 8th century; Shōsō-in, Nara

Fig. 4b. Detail of hunting scene on cast-silver jar; dated 767; Shōsō-in, Nara

was revised and approved within the metal-working studio system, the outlines of the stencils were recorded with a fine, sharp stylus on the clear metal surface. Then the engraving and chasing process began in earnest. This was followed by the equivalent of the sprayed ink ground seen in the decorated papers: a field of punched, circular rings fill the spaces between the engraved—and then parcel gilt—designs. Known in Japan as *nanako* (fish roe) decor, this punched decoration is also a Japanese adaptation of a Chinese technique, and one seen in early Korean metalwork, too.

The Nara metalworker responsible for this phase of the project used a punch of greater diameter and ring size than is customary for Tang silver and gold decor. Also, the Japanese nanako pattern usually follows a repetitive linear approach not as precisely executed as its continental prototypes. An alms bowl in the chindangū set from the Kōfuku-ji in Nara exhibits a similar approach to nanako decor.[5] A much larger ungilded silver jar (perhaps of Chinese origin) in the Shōsō-in also depicting a hunt illustrates the differences in technique and surface composition (fig. 4b). Yet precisely this matter of scale adds to the appeal of this jar and helps make it the most important example of its type in the history of early

Japanese metalwork. Small in size and precious in materials, its narrative illuminates a drama of epic dimensions in eighth-century East Asian art and, indeed, for all time.

1. For the Kōfuku-ji chindangū, see *Nihon Bukkyō bijutsu meihōten* (Masterpieces of Japanese Buddhist art), exh. cat., Nara National Museum (1995), pl. 72.

2. *Pul Sari changŏm* (Art of Sarira reliquary), exh. cat., Seoul National Museum (1991).

3. *Shōsō-inten* (Exhibition of objects from the Shōsō-in), exh. cat., Nara National Museum (1996), pls. 69 and 6; *Shōsō-inten* (1993), pl. 10; and *Shōsō-inten* (1987), pls. 6–7.

4. *Nakakura 2* (Middle storage room 2), vol. 5 of *Shōsō-in hōmotsu* (Treasures of the Shōsō-in) (Tokyo: Mainichi Shinbunsha, 1995), 19, 122–25.

5. *Nihon Bukkyō bijutsu meihōten,* pl. 72.

5. Cicada-shaped Lock

8TH CENTURY; CAST SILVER WITH GILDING; L. 3.5 CM; TŌDAI-JI, NARA. NATIONAL TREASURE

The most fetching of all the chindangū retrieved from beneath the earthen floor of the eighth-century Tōdai-ji altar is this lock in the form of a cicada surrounded with an openwork design of *hōsōge* (floral arabesque designs common to Buddhist art in East Asia). The floral designs are similar to those in a leather *keman* (hanging openwork element) encircled by young unfurling leaves [68]. The lock comprises three separately cast elements, all in silver: a cicada (with partial gilding) and an upper and lower floral base. A narrow rectangular slot between the two bulging eyes of the cicada form indicates where a key was inserted to lock (or unlock) the two base elements, both of which were originally attached to the flat wooden or lacquered surface of a container. Remnants of a hide box [74] with a decorated lacquer surface were uncovered near this lock in excavations conducted from September 1907 to January 1908, when fifteen objects (or remnants of objects) were retrieved. Other chindangū sets have been recovered from the Kōfuku-ji in Nara and kokubun-ji outside the capital,[1] temples and nunneries established in the provinces in 741 by edict of Emperor Shōmu (701–756).

Whether or not that hide box was where the lock was placed originally cannot be determined conclusively, but it is possible to offer some ideas pertinent to the subject. First, given its structure, the lock was placed vertically on a flat surface whose two adjoining sections met flush with one another. The gap between the floral elements on the lock's upper and lower bases indicates where the join occurred. Consequently, this style of lock could not have been used for a container with a capping lid descending over and down its side walls such as can be seen in the twelfth-century sutra box [74]. A number of wood and lacquer chests in the eighth-century imperial treasury, the Shōsō-in, are of that type. They depend on two pins of different lengths with loops at the end pins that are attached to and rise from the chest panel to align evenly with the lock that connects them together.[2] These Shōsō-in locks are often hexagonal cylinders, with two or three raised clusters of surface bands their only decoration.

The smaller, more intricately designed and technically demanding boxes in the Shōsō-in feature surfaces of various rare inlaid woods, ivory, painted panels in mineral pigments or colored lacquer, and even cut gold and silver designs. They normally have a flush body and lid surfaces incorporated into their design. A few of these still possess their copper or bronze locks, and while these tend to have been conceived with stronger decorative elements in mind, none of the surviving examples begins to approach the ingenuity and functional elan of this delightful cicada lock (fig. 5a). Envisioning the base elements attached by pins (one beneath each base) to a decorated surface, one can only imagine now how this novel design would have melded into the container's overall surface decor with just the slit between the cicada's eyes revealing the object's true function.

The lock is superbly cast in silver with incised and chased linear detailing added. Partial gilding applied to the cicada adds another distinctive visual touch to the ensemble, despite its current weakened patination. But what did the cicada mean in this context, given that it appears to be unique among the imagery found in decorative arts of Nara and Heian Japan? Even considering the varied insect life that appears in eighth-century metalwork decor and textile patterns in the Shōsō-in repository, other depictions of this insect are unknown. The life cycle of a cicada,

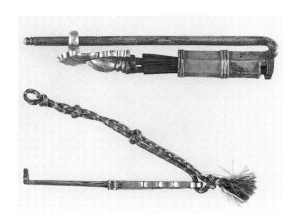

Fig. 5a. Lock (top) and key (bottom) for a small chest, 8th century; gilt bronze; l. 17.2 cm; Shōsō-in, Nara

whose haunting sonorous presence is well known during late summer in Japan and well recorded in the early poetry of the country, includes a number of years beneath ground growing toward maturity. Thus the internment of this cicada-shaped lock in the earth beneath the Tōdai-ji altar may have been viewed as a visual metaphor for securing the future of the (now lost) box and its contents— a more appropriate symbol than the ubiquitous butterfly so frequently portrayed in Buddhist decorative arts.

Whether it was intended to allude to Buddhist themes of rebirth or as a symbol for the inevitability of the human life cycle can only be suggested. Certainly the emotional ennui associated with the sound of the cicada in Nara and Heian period poetry, as much as it derives from Chinese sources, points to an indigenous presence as well as the common imagery of eighth-century Japan. In the visual arts of the time this unpretentious functional object represents the level of craftsmanship and design imparted to aristocratic furnishings, often laden with subtle religious meaning.

1. *Kokubun-ji* (The state temples in the provinces), exh. cat., Nara National Museum (1980). The Kōfuku-ji excavation of the Kondō in 1884 yielded more than one thousand chindangū, which today are shared by the temple and Tokyo National Museum. See also *Tōdai-jiten* (Exhibition of Tōdai-ji treasures), exh. cat., Nara National Museum (1980), no. 105.

2. Kimura Norimitsu, *Shōsō-in hōmotsu ni miru kagu: Chōdo* (Treasures of the Shōsō-in: Furniture and interior furnishings) (Kyoto: Shikosha, 1992), nos. 46, 48–49, 71.

6. Sutra Case with Two Figures

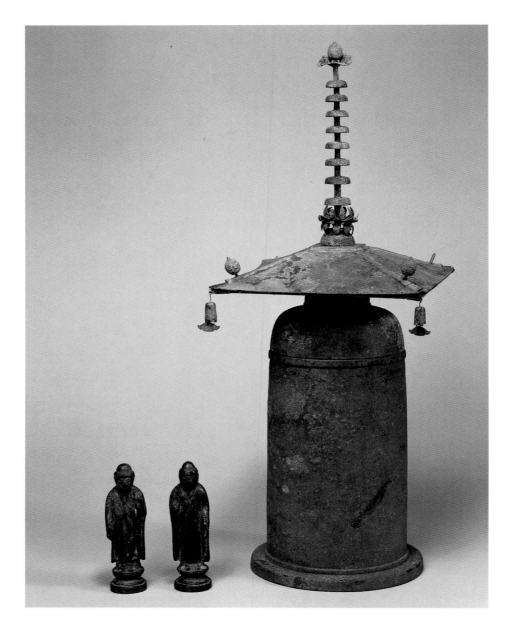

DATED 1116; CAST BRONZE WITH GILDING;
CASE: 45.6 X 15.1 CM; FIGURES: H. 11.2 CM
EACH. IMPORTANT CULTURAL PROPERTY

The number and the scale of *kyōzuka* (sutra mounds) already excavated, as well as those still intact, in northern Kyūshū indicate the importance of this area in Japanese history. By the latter part of the seventh century an impressive network of military defensive positions had been constructed in this strategic region in anticipation of a Chinese invasion (which never materialized). The development and maintenance of this governmental military headquarters, the Daizaifu, further consolidated the area's strategic and cultural importance as the country's principal gateway for continental—especially Korean—contact, nurturing a distinctive regional culture in western Japan that continues to the present.

During the late Nara and Heian periods Buddhist temples, pilgrimage routes, and singular venerated images were established in northern Kyūshū, oftentimes in conjunction with important Shinto establishments. There the number and concentration of kyōzuka exceeds that found elsewhere in Japan. In addition to the Daizaifu locale, just outside the port of Hakata (near modern Fukuoda city), sutra mounds are clustered in known Shinto and Shugendō [64] sites and along the coast.

This sutra case was reportedly excavated in Kyūshū, although that provenance cannot be confirmed because, like so many other kyōzuka, it was unearthed decades ago in the course of urban and agricultural development without today's rigorous governmental supervision. Nevertheless, by virtue of its form and style and the appearance of the two small Buddhist images contained within the case, it can be favorably compared to other dated examples from northern Kyūshū.

The two figures were summarily cast, with only general outlines of robing and facial features depicted. Each stands on a plain lotus form base displaying complementary hand gestures. A similarly conceived carved stone image of a Nyorai unearthed from the Daizai-fu helps secure a provenance. It is dated 1119, three years following this Nara National Museum pair, which are thought to represent the Nyorai Shaka and Tahō [79].[1] These deities appear in the "Kenhōtō" (Apparition of the Jeweled Stupa) chapter of the

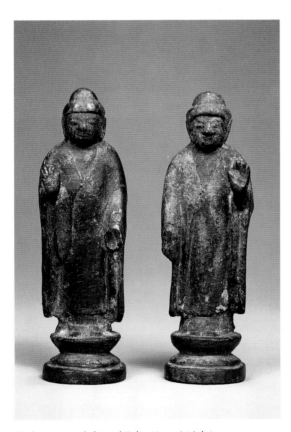

Shaka Nyorai (left) and Tahō Nyorai (right)

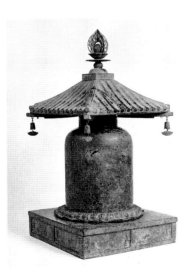

Fig. 6a. Tahōtō-type reliquary, 12th century; cast bronze with metalwork attachments; Kurama-dera, Kyoto. National Treasure

Lotus Sutra, one of the earliest, most popular, and influential of all Buddhist scriptures introduced into Japan.[2] The context and structure of the text, which uses parables rather than arcane philosophical reasoning to convey its message, was a great help in promoting the sutra's insights. Knowledge of it was widespread in the Nara area by the seventh century, and public lectures by eminent monks interpreting it are recorded in the eighth century. In the Kenhōtō chapter Shaka joins Tahō in Shaka's stupa in the sky, signifying the universality of his teaching. In the text and in the famous seventh-century plaque in the Hase-dera collection previously cited, the two deities sit beside one another, signifying the universality—past, present, and future—of Buddhist law.[3] Here, to fit in the stupa-shaped reliquary case, Shaka and Tahō stand upright.

The sutra case has three basic elements: the body, flaring roof with attachments, and multi-leveled spire. The spire is notable for its nine stages in sōrin configuration, lotus leaf base, and the squared flange just beneath the round finial. From the four corners of that finial chains with bells once swayed down to each of the four roof corners, where they were attached to the raised lotus buds on the roof ridges (two are lost). Today these features are best seen in the impressive sutra container from Narahara-yama in Ehime Prefecture on Shikoku, also of late Heian date.[4]

The modest size of this Nara National Museum piece helps highlight the craftsmanship of the late Heian period metalwork studio, which composed a sturdy graceful vessel while integrating small, thin bronze sheets into supporting decorative elements. The roof for example is a cast piece to which bronze strips have been added and crimped to portray stacked ceramic ridge lines and accept holes for the insertion of the lotus blossom posts. The bronze plate under the roof flares up and under the roof lines, hiding its supportive function and allowing an unimpeded viewing of the classic stupa form.

The body of the case was cast and then turned on a lathe to create the gently splaying lower contours. The raised band below the shoulder identifies the place where body and lid separate for the insertion of the bronze images and *Lotus Sutra* scroll. Close scrutiny of the body surface shows lines engraved to depict doors, a motif seen in paintings of this

Lotus Sutra subject and the Hase-dera plaque. Under the base a separate sheet of bronze was cut to fit the opening. Its surface has an inscription providing the date and information about the contents of the sutra container (although the existence of a smaller bronze bell found in the excavation is not mentioned). Other Heian period examples of small cast-bronze images included with relics and sutras in reliquary mounds exist, although they are rare. Notable single figures have been retrieved from Nachi in Wakayama Prefecture and are kept at the Tokyo National Museum. Zaō Gongen [28] images have been excavated from Mt. Kimpu (Kimpusen) south of Nara, and two remarkable sets, twelfth century in date, have been retrieved from northern Kyoto at Kurama-dera and Fukuda-dera. The pagoda-shaped sutra cases in bronze and steel from Kurama-dera provide instructive references for differentiating these late Heian metalwork forms in the northern Kyūshū and Kansai areas.[5]

1. *Kyōzuka ihōten* (Exhibition of relics excavated from sutra mounds), exh. cat., Nara National Museum (1973), no. 31.

2. Leon Hurvitz, trans., *Scripture of the Lotus Blossom of the Fine Dharma* (New York: Columbia University Press, 1976).

3. See Washizuka Hiromitsu, *Enlightenment Embodied: The Art of the Japanese Buddhist Sculptor,* exh. cat., Japan Society Gallery (New York, 1977), no. 3.

4. *Kyōzuka ihōten,* no. 25 (and cover).

5. Ibid., nos. 83–84, 125–32, 136.

7. Sutra Case and Container

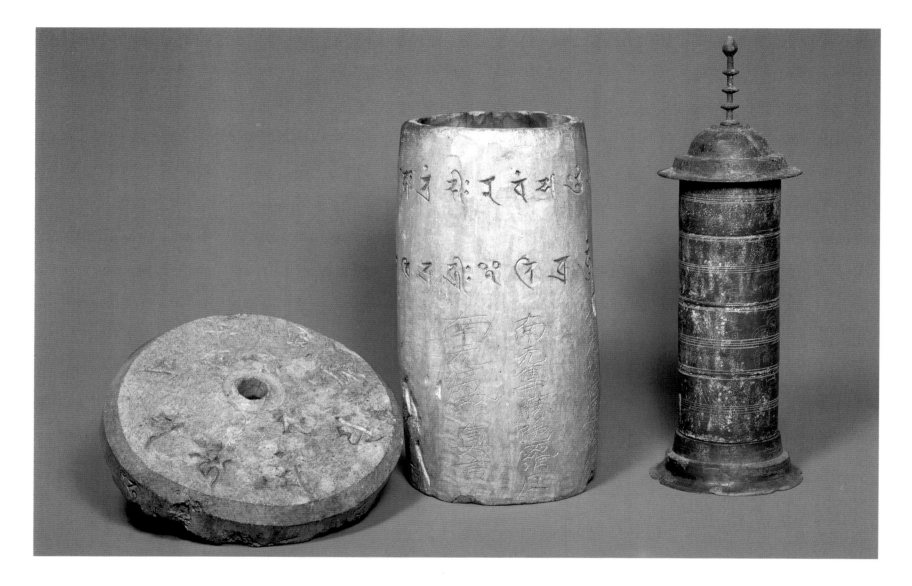

DATED 1141; CONTAINER: CARVED STEATITE WITH INCISED INSCRIPTIONS, H. 40.2 CM; CASE: CAST BRONZE WITH INCISED DESIGN, H. 41.3 CM. IMPORTANT CULTURAL PROPERTY

Sutra cases may be categorized according to their general shape, including any ornamentation or surface embellishments. The exhibition provides examples of the stupa [6] and banner [8] types, the latter referring to the container's faceted sides, which resemble the flat surfaces of ritual decorative textiles called *ban* [71]. This slender cylindrical form with

the ball finial on the lid takes its name, *sōrin fukubatchi,* from the tall three-level spire surmounting its lid that ends in a knob shaped like a flaming jewel. A few other examples are known, one in particular from the Daizaifu area in Fukuoka, northwest Kyūshū, which has a three-stage spire and "umbrella" lid similar to this example. It is dated 1126 and was originally gilded. A number of other excavated pieces, some buried in sets, display similar shapes and fabrication techniques.[1]

The surface of the example here was not gilded. Instead its two-stage umbrella lid is encrusted with a rich blue-green patination

that offsets the dappled gray tonalities of the cylinder's bronze skin. The lower stage of the high-domed lid still retains faint traces of incised lines describing lotus petal shapes. No longer extant are the wires and beaded ornaments that once dangled from holes placed around the edge of the lid precisely at the tips of the incised petal shapes. The body is composed of four interlocking sections, a fabrication technique to create cylinders of varying height that could accommodate sutra scrolls of practically any height (the scrolls were placed on end in sutra containers) so long as the section joins remained stable. The

sections were cast and then turned on a lathe for finishing and to hone the join flanges. The two-stage base is thicker and splays in six foliate arcs, and a separate, thin base plate was fitted underneath to seal the case.

The most notable aspect of the case is the incised figural composition spanning three sections that depicts fifteen Buddhist deities appearing in the *Lotus Sutra*.[2] This remarkable group includes Fugen Bosatsu [35], two other bosatsu, the guardian figures Jikokuten and Bishamonten, and the ten female deities known as the Rasetsunyo [36]. This ensemble represents a compilation of deities, female demons, and attendants who gained popularity in the Heian period as efficacious protectors of the faith. Fugen appears in chapter twenty-eight; Jikokuten, Bishamonten, and the Rasetsunyo in chapter twenty-six, the "Dhāranī" chapter, where the ten female demons are singled out as fervent believers of the *Lotus Sutra* and fierce protectors of its message and of those who also believe in its teachings.

The combination of these deities in one assemblage reflects another Japanese reinterpretation and realignment of classical Buddhist texts to comply with Japanese customs and doctrinal interests during the ninth to twelfth centuries. The imagery and ritual of Japanese Buddhism underwent significant transformation during this time, particularly within the Tendai and Shingon sects, largely because of a growing impetus to expand the reach of the faith beyond the aristocratic class. For example, interest in the *Lotus Sutra* was spurred by aristocratic women who noted the chapters specifically offering women the opportunity for Buddhahood.

Thus, while this figural assembly features the ten female demons outfitted in elegant Chinese-style robes accompanying Fugen, it should come as no surprise that also incised into the bronze surface of the cylinder is a dated inscription noting the name of the donor, a priest from the Enryaku-ji atop Mt. Hiei on the northern outskirts of Kyoto, the headquarters of the Tendai sect, founded by Saichō (767–822) [15]. The temple had strong ties with the Kyoto court and imperial family lineage.

While the original sutra scroll once placed inside the case has been lost, the stone outer container has survived intact. The elegantly incised Sanskrit and regular Japanese script on both body and lid are probably taken from the Hokke, the *Lotus Sutra* mandala that describes heavenly assemblies, the text of which had reached the Enryaku-ji by the mid-ninth century. Rather than the flat symmetrical order of a typical Esoteric (Mikkyō) school mandala composition [41], here the oversized lid and container provide a dynamic textured setting for the finely chiseled text. As in the seated Miroku, the Buddha of the Future [10], the relatively soft steatite allows the surface to be prepared and worked without undue concern for fracturing. It also retains the colorations of surface matter in the burial chamber with which it has come into contact, absorbing the warm reddish-brown tints of iron in the soil.

The lid was made oversize to help protect the body from the elements above the burial site. It is slightly peaked to shed moisture, and the central aperture permits the spire of the sutra case to pass through and above the lid. This opening explains why the lid of the bronze case enjoys its rich patination; it also enhances the appearance and compositional symbolism of the Hokke mandala inscribed on the lid's surface and, indeed, the entire form of the outer container. The spire, with its flaming jewel protruding above the stone lid, signals yet another hidden layer of religious meaning and ritual practice embedded in the burial mound that awaited the arrival of Miroku.

Finally, it should be noted that the incised depiction of Fugen and the ten female demons predates all paintings and other visual imagery of the subject presently known. As such, its historic and cultural importance in Japanese Buddhist art is momentous, pointing to the pivotal role in Japan of what in the West are called the "decorative arts," a term conveying lesser import to the art. Such is decidedly not the case in Japan and East Asia generally.

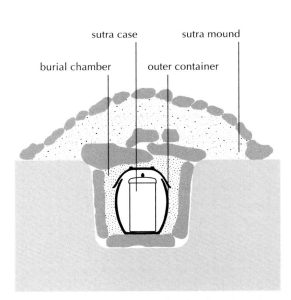

Fig. 7a. Typical kyōzuka, cavity lined with rocks and filled with charcoal and ash

sutra case sutra mound

burial chamber outer container

1. Seki Hideo, *Kyōzuka to sono ibutsu* (Sutra mounds and their remains), vol. 292 of *Nihon no bijutsu* (Arts of Japan) (Tokyo: Shibundō, 1990), figs. 71–72, 74–75.

2. Leon Hurvitz, trans., *Scripture of the Lotus Blossom of the Fine Dharma* (New York: Columbia University Press, 1976). See also George J. Tanake Jr. and Willa Jane Tanake, eds., *The Lotus Sutra in Japanese Culture* (Honolulu: University of Hawaii Press, 1989).

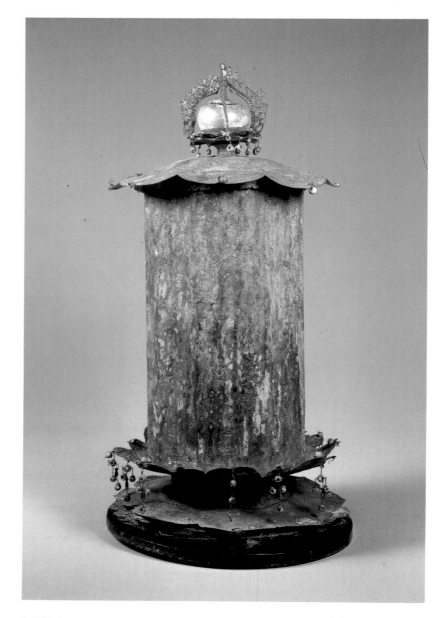

12TH CENTURY; GILT BRONZE WITH INCISED CALLIGRAPHY, GLASS BEADWORK, AND LIDDED GLASS JAR; H. 41.5 CM

Like the sutra case with two statues [6], this octagonally shaped case has a northern Kyūshū provenance, based on its ample size, lid shape, decor, and finely detailed beadwork, openwork, and cut-metal designs. It is an object combining remarkable sculptural power with delicate ornamental flourishes.

The case is made of two sheets of bronze forming four-sided panels, joined with five flat pins along the seams. This faceted cylinder is secured to the lotus base at the four directional sides using L-shaped flanges with attachment points at each end. The lotus leaf base is cut in an alternating pattern of large and then small leaf shapes from whose tips hang strands of blue and white beads.

An octagonal bronze foot separates the base from the base plate, again cut into lotus petal shape. The shaping of the lotus outlines, the manipulation of their surfaces to produce undulations resembling actual leaf patterns, and the careful articulation of the sundry edge lines bespeak the high level of craftsmanship available in late Heian period Kyūshū. The sutra case is delicate, even airy, yet imposing in its girth. This effect is even more impressive because it is not made of cast elements but rather single sheets of thin gilt bronze that have been cut, hammered, molded, and then joined with pins.

The decayed wood under the base plate indicates how the bronze lotus stand was kept

from the elements of the sutra burial chamber; for further protection, it was placed in a large covered ceramic or stone container (now lost). Other surviving examples recovered from northern Kyūshū sites indicate that Sueki ware jars, produced initially in the Osaka and the Nagoya regions, were the preferred ceramic ware for this purpose, rather than Tokoname or Sanage types. While elsewhere in Japan Sue wares had been displaced by more durable glazed ceramic wares by the end of the ninth century, Kyūshū apparently maintained local production.[1]

Because these Sue vessels were neither glazed nor as highly fired as the wares then in use on the main island of Honshū, the natural migration of burial moisture and earthen gases occurred more rapidly. As a result of the conditions in this underground environment over the centuries, an extraordinarily beautiful blue-green layer of mossy patination has replaced the original brilliant gold surface of the sutra case. The moisture in the burial chamber also affected the glass of the reliquary atop the lid, transforming its original translucent greenish-blue into an opaque dappled grayish-blue tone.

The presence of this glass reliquary (which may well be of Chinese manufacture) as a fully integrated element of the container's appearance and structure is thus far unique in the archaeological record of Buddhist artifacts in Japan. It rests on a raised two-course lotus pedestal from whose waving petal edges dangle pairs of white glass beads. The receptacle in which the reliquary rests consists of a gilt-bronze band fashioned into a shallow cup whose sides have a raised dot design created by a small metal punch. The bottom edge was cut so that tangs can slip into the upper lotus leaf plate for attachment.

The visual delicacy and allure of this finial structure derive in large measure from the four openwork flames issuing from the lotus base that join together around the reliquary. With a thin band of punched designs along their inner borders, the flames become patterned aureoles, embracing the bulbous glass form. The conception of and craftsmanship involved in realizing this finial ensemble evade satisfactory comparison with other known Japanese examples, seeming more compatible with the long tradition of such fine metalworking skills and interest in gilt openwork

that occurs in Korea during the Unified Silla and later in the early Koryŏ period.[2]

Finally, two points deserve mention about the lid and the inscribed surfaces of the body. The umbrella shape of the lid, achieved through gentle molding and hammering, occurs in other examples from northern Kyūshū. Seen in profile, the rounded contours and the proportions of the lid both cap the case with functional elan and highlight the finial, which is a direct reference to the flaming jewel symbol in East Asian Buddhist art [26, 49, 76, 78].

Inscribed in handsome block characters on the upper portion of the faceted panels of the body are the titles of eight chapters from the *Lotus Sutra*. Below is a pious inscription naming the donor and stating that by commissioning a copy of the *Lotus Sutra* to be placed in this container he sought the assistance of Miroku.[3] This popular bodhisattva resides in the Tushita Heaven, part of the vast Realm of Desire, from which he awaits the time when he will descend to earth to become the Future Buddha. Although the donor's name is known, no historical records have been uncovered to identify him. Also lost are the *Lotus Sutra* scrolls once placed in this case, as might be expected, and any shred of information as to the identity of the metalworker(s) who conceived and fashioned this extraordinary object, whose beauty is virtually unmatched among the hundreds of Buddhist reliquary objects known today.

1. *Kyōzuka ihōten* (Exhibition of relics excavated from sutra mounds), exh. cat., Nara National Museum (1973), nos. 29–38.

2. See *Pul Sari changŏm* (Art of Sarira reliquary), exh. cat., National Museum of Korea (Seoul, 1991).

3. See *Nara Kokuritsu Hakubutsukan zōhin zuhan mokuroku, kōgōhin: Kyōzuka imotsu* (Illustrated catalogue of the collection of the Nara National Museum: Objects excavated from sutra mounds) (Nara: Tenri Jihōsha, 1991), 88 and 118, no. 41.

Detail of the glass reliquary and its lid

9. Sutra Container with Bird Design

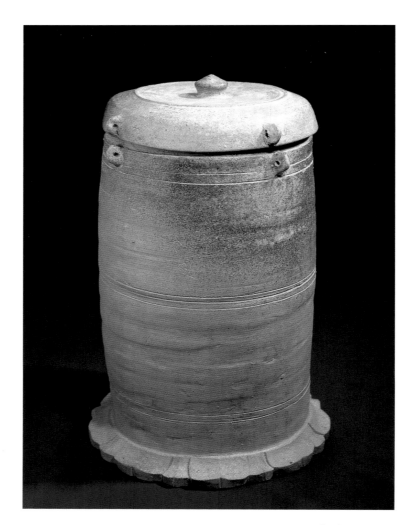

12TH CENTURY; STONEWARE WITH NATURAL ASH GLAZE AND INCISED AND CARVED DESIGNS; H. 36.3 CM

The Nara National Museum's extensive collection of Buddhist art includes an important group of materials related to the late Heian period practice of constructing kyōzuka. The floor, top, and sides of these pits were lined with specially selected stone slabs to buttress the earthen walls against collapse (fig. 9a). These cavities were dug to contain and preserve sutras that could be used upon the arrival of Miroku, the Future Buddha, following mappō in the mid-eleventh century.[1] Devotees believed that commissioning religious texts as well as mirrors, small Buddhist icons, even swords and ritual implements for burial in these mounds would improve their prospects for rebirth.

Although it is not clear just when the practice began, the earliest recorded Buddhist relics to be excavated thus far date to the beginning of the eleventh century. This set of relics was commissioned by none other than Fujiwara Michinaga (966–1027), the preeminent statesman of the era, and bears an inscription dated 1007.[2] Michinaga chose the environs of Mt. Kimpu (Kimpusen) located in the mountainous Yoshino region south of Nara for his offering. Long recognized as a site of natural beauty and spiritual power in the Shinto system of beliefs, Kimpusen quickly became a center for such burials following Michinaga's example. Other important concentrations of kyōzuka were located at the Nachi waterfall, a Shinto sanctuary, and at other Shinto sites in northern Kyūshū.

Michinaga provided fifteen scrolls of the *Lotus Sutra* and other religious texts with his own annotations (only fragments of which survive) as well as gilt-bronze cylindrical cases for burying them. In turn, these gilt-bronze containers were protected from the earth by large outer jars made expressly for that purpose from clay, stone, or metal. Ceramic vessels predominate in the late Heian and the Kamakura periods, and the

Tokoname, Atsumi, and Sanage ceramic centers located outside present-day Nagoya were particularly active. They also possessed reliable distribution routes.

The twelfth-century example here, likely a product of the Sanage kilns, is one of the most aesthetically satisfying outer cases known today, as well as one of the earliest in date. The orange-brown color of the body and darker olive-glaze spatterings visible at the top of the vessel are a natural result of the relatively high temperature wood firing of Sanage area clay. Otherwise the object's adornments simply comprise incised or raised course lines, a pyramid-shaped knob, and a masterfully carved lotus base. Pinched wads of clay are attached to the body and lid, each pierced with a hole so that the two parts could be aligned and then tied together.

The top rim of the body has been trimmed with a bamboo knife in order to accept the capped lid more securely, but the lid has warped and the join now reveals the workmanship. These outer cases were probably produced in considerable numbers, with the firing of body and lid done separately because the body glaze patterns do not continue up and onto the lid surface. Thus although we could expect the medieval potters of Sanage to have or share common utensils and measuring devices, production and then firing was not exacting. Moreover, these clay vessels were not necessarily made as single units, but rather as multiples, allowing for lower costs and an increased "success" rate in the firing since lids and bodies were conceived as separate units at the very beginning of the manufacturing process. The extraordinary modeling and incised detailing of this sutra container, however, suggest it received individual attention, unlike most other production pieces.

Compared to the clay bodies of nearby Tokoname ware from the twelfth to fifteenth centuries, Sanage grog is lighter in color because it was processed more thoroughly. This cylinder was composed in four sections of clay coils, luted together, and then scraped with a bamboo knife on a wheel. The base plate was then added and lotus leaf design carved. Comparable twelfth-century Sanage vessels, one of which bears large incised lotus petal designs cut into its lower body, have been excavated from sutra mounds on the

grounds of the Tendai sect temple Enryaku-ji, atop Mt. Hiei overlooking Kyoto [7].[3]

This outer container was excavated even farther afield: in Shikoku's Ehime Prefecture in a coastal setting. Kyōzuka have also been found in large numbers on both coasts of the Inland Sea and on some of the small islands that dot that bustling maritime thoroughfare. Other concentrations of sutra mounds occur in the secluded mountaintops of Nara and its neighboring Wakayama Prefecture, in northern Kyūshū [6–8], and in the area around Mt. Haguro, well to the north. It should be recognized, however, that the practice of burying relics occurred throughout the country and continued into the Edo period.

Finally, attention must be paid to a detail nearly lost when contemplating the sturdy, natural form of this vessel: a bird in flight deftly incised into the upper panel of the body. A few other ceramic cases with incised floral decor have been recovered, but this is the only known example with a bird motif. Also two small "+" signs were incised by the potter into the upper body margin and lower lid to help align these two parts, another clear indication of the special nature of this twelfth-century commission. The bird may represent a single sea plover, often seen in late Heian paper, lacquer, and painting designs flitting about sandbars, ocean beaches, or imaginary seascapes, alluding to Buddhist scenes of paradise such as mythical Mt. Horai.

1. Delmer M. Brown and Ichirō Ishida, *The Future and the Past* (Berkeley: University of California Press, 1979), 420–50.

2. *Nihon Bukkyō bijutsu meihōten* (Masterpieces of Japanese Buddhist art), exh. cat., Nara National Museum (1995), no. 174. See also Seki Hideo, *Kyōzuka to sono ibutsu* (Sutra mounds and their remains), vol. 292 of *Nihon no bijutsu* (Arts of Japan) (Tokyo: Shibundō, 1990), 18–24, pl. 1, and the kyōzuka distribution maps, p. 80.

3. *Kyōzuka shutsudō tōjiten* (Ceramics recovered from sutra mounds), exh. cat., Nara National Museum (1995), 5, no. 2–1; see also 9, no. 6–3; 30, no. 25–1; and 33, no. 28.

Fig. 9a. Later Heian period (12th century) votive objects from a sutra mound at Yamayatate, Iwate Prefecture

10. Miroku Nyorai

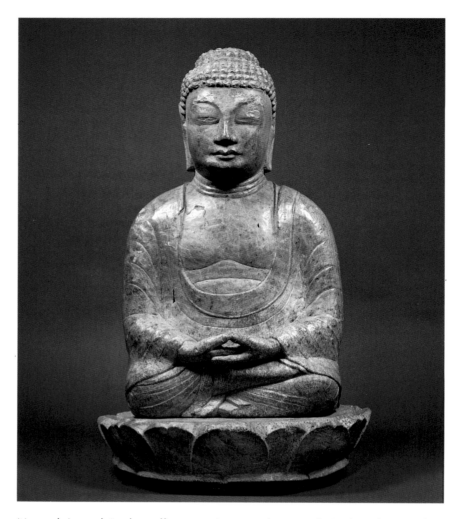

DATED 1071; CARVED AND INCISED
STEATITE; STATUE: H. 54.3 CM, BASE: H. 10.7
CM, DIAM. 40 CM. IMPORTANT CULTURAL
PROPERTY

While stone was seldom used in classical Japanese Buddhist sculpture, a small number of Heian period images remain. They tend to be effigies clustered together, as at Usuki on the southeastern coast of Kyūshū where an extensive rock outcropping provided the opportunity to create a cave-like devotional grotto similar to those created in China and Korea since the fifth century.[1] Single images were also carved into rock face during the Heian and, especially, the Kamakura eras along pilgrimage routes in the Kansai and Wakayama areas. Later, making images in stone to be enshrined along roads or as public icons in towns and rural villages became a common practice. These images were conceived and executed in the round as fully three-dimensional sculptures, unlike the earlier engraved images at Usuki. The southern

Nara plain and Asuka valley contain a good number of early stone relief images. In Korea, in contrast, fully three-dimensional, line-engraved, and multi-figural tableau were being venerated by the sixth century, and the tradition continued unabated into the nineteenth century.[2] Indeed, the rich stone deposits of Korea provided craftsmen with material suitable for projects varying in scale, usage, and context. Small hand-held Buddhist images for example were carved continuously from the sixth century, and no doubt they reached Japan from Paekche in the sixth and seventh centuries along with gilt-bronze and dried-clay figures. But at the time, and for the foreseeable future, stone did not hold the attraction as a working material that clay, dry lacquer, bronze—and then, of course, wood—did for the Japanese.

All of which makes this seated Miroku even more important in Japanese cultural history. It has two separate components: the round base with lotus leaf decor, and the icon. Each was carved from a separate block of steatite, a

relatively soft stone found on Kyūshū, the Korean peninsula, and the islands between the two countries. The base has a pinkish-brown fabric, indicating the presence of iron. The icon is made from a gray stone with blue-green mottling.

The craftsmanship of the chiseled surfaces of each piece is different, indicating more than one artisan produced the ensemble and suggesting the presence of a stone-carving workshop in Kyūshū in Heian period Japan. From the flat platform of the lotus base two attending courses of lotus leaves are described with broad, subtly modeled surfaces framed by diagonal edges and furrowed channels. The icon's carved surface includes a variety of modeling approaches. Straight-forward line incisions, somewhat hesitant in their paths, alternate with flat repetitive folds of the robe describing shallow edges or distinctive pointed troughs. The incisions scooped out of the upper arms add movement and volume to the upper torso, which is broad and stout and swells gently. The legs,

crossed right over left and extremely fore-shortened, are succinctly detailed so as not to draw attention from the upper body and no doubt conform to the size restrictions of the steatite block. Similarly the hands are fat and stubby with little detail; they are joined in the *hokkai jō-in* mudra, signifying earnest meditation on the vastness of the dharma (cosmic law). Mudras are specific hand and finger configurations conveying religious information. This Sanskrit term naming the origins of this iconographical symbolism and the hand gestures is not precisely known, in large part because no definitive early religious text exists. Nevertheless, in Japan mudras became standard nomenclature for identifying Buddhist deities, and through the centuries a distinctive but flexible repertoire of mudra conventions developed.

The bald and oversized head of this Miroku has carefully chiseled, polished facial features. The sensitive articulation of the chin and mouth and the narrow oblong slits defining the eyes, which are set under high arching eyebrows, deserve particular mention. Together with the delineation of the ears and the patterning of the hair and *uṣṇīṣa* (raised protuberance at the top of the head) these features create a distinctive face that is poised

Inscription on the back of the Miroku Nyorai

yet without the general refinements or idiosyncracies of comparably dated wooden images in the metropolitan Kansai region of Nara and Kyoto.[3]

A square aperture in the bottom of the image reveals that the body is a hollow cavity, and a lengthy inscription cut into the back surface and shoulders of the figure states that a scroll of the *Lotus Sutra* was placed inside by one priest Kyōin in 1070. It expresses his wish, along with other named donors, to be reborn upon the arrival of Miroku. Consequently, this figure served as a reliquary, interred by Kyōin's wishes as well as those of the other donors in a burial mound. In addition, a mandala of the nine realms and the names of the donors are inscribed into the upper surface of the lotus seat, thereby joining the worship of Amida (and his Western Paradise) with the advent of Miroku.

The burial mound for this Miroku was not located on one of the well-recognized sacred mountains in the Nara environs but rather on the island of Iki, off the west coast of Kyūshū, between the Korean peninsula and Japan.[4] This location and that of the better known nearby island of Tsushima played an important role in the trade routes between Japan and Korea before the fourteenth century. Tsushima in particular is noted for its successful commercial history and for counting a number of early Korean gilt bronzes among its temple treasures.[5] Future research will provide clearer insights regarding the relationship of this sculptural style to Unified Silla and Koryŏ period sculpture, the frequency of kyōzuka sites on the islands between Japan and Korea, and perhaps even the identity of Kyōin. His name, appearing in both inscriptions, provides an interesting link between faith in Miroku in the eleventh century and seeking rebirth in Amida's Western Paradise.

Thus, on this now-obscure island in far western Japan a group of donors well versed in current Buddhist teachings commissioned this stone image of Miroku as an act of piety, and with the hope that they would linger in the Western Paradise until Miroku arrived, some 5,670 million years hence. Since ancient times, Kyūshū's northern and eastern coasts had been the favored landing spots for immigrants and travelers from China and especially Korea. The advent of Buddhism in the sixth century and many of its later mani-

festations progressed through Kyūshū, including the building of sutra mounds, as a way of ensuring the continuation of the faith. Many relics have been unearthed from these mounds but none as extraordinary as this stone image whose aesthetic and documentary features point to relationships with free-standing temple devotional icons that occasionally bear relics in their body cavities [29, 31, 47].

Compared with contemporary wood sculpture styles and techniques in the Nara-Kyoto area, this Miroku appears provincial and unrealized in formal sculptural terms. However, comparison with the *kakebotoke* (hanging votive plaques) [65–67] or with the other Miroku in the exhibition [25], a work of the ninth century, indicates a commensurate level of unfettered spiritual sincerity, achieved in a more demanding and certainly rarer material. Moreover, this Miroku functioned as a reliquary containing the votive desires of its patrons and representing their wishes for reincarnation. It is the finest example of this type of sculptural kyōzuka presently known in Japan and a religious document of significant import.

1. Nara National Museum, *Kyūshū*, vol. 2 of *Kokuhō jūyō bunkazai Bukkyō bijutsu* (National treasures and important cultural properties of Buddhist art from Japan) (Tokyo: Shogakkan, 1975), pls. 31–32.

2. Hwang Su-yŏng, *Sekibutsu* (Stone Buddha), vol. 4 of *Kokuhō jūyō bunkazai Bukkyō bijutsu* (Tokyo: Take Shobō, 1985).

3. Compare for example similarly dated images cited in *Heian jidai no chōkoku* (Heian period sculpture), exh. cat., Tokyo National Museum (1971). For a related "provincial" piece, see the seated Sogyō figure of 1047, pl. 47.

4. Miwa Karoku, "Iki Hachigatamine kyōzuka ko" (A report on the sutra mound at Iki Hachigatamine), *Gekkan bunkazi* (Monthly journal of cultural properties), no. 190 (1979), 4–17.

5. *Kudara shiragi no kondōbutsu* (Gilt-bronze Buddhist images from Paekche and Silla in Korea), exh. cat., Yamato Bunkakan (Nara, 1982), especially nos. 14, 44, 50, 54, 60.

DATED 742; HANDSCROLL (ONE OF A PAIR): INK ON PAPER; 26.7 X 1573.1 CM

Buddhist concepts arrived in the Asuka valley in the sixth century. These ideas came not independently but as part of immigration patterns and diplomatic missions from Korea and then China. Two Korean priests are recorded as having brought sutras and a Buddhist image to Japan in the first half of the sixth century (538). The fledgling Yamato state was keen to learn from its continental neighbors about such matters as governmental and social organization as well as advanced material technologies. In the process extraordinary cultural exchanges also took place, the most significant of which centered around this new, foreign Buddhist creed.

Korean and Chinese high culture fascinated the early Yamato rulers and some powerful immigrant clans who supported their transmission, in particular Buddhism. By the mid-seventh century many temple compounds had been erected in the Asuka area, to the southwest of Nara, as well as near present-day Osaka.[1] Monks and nuns trained by visiting or immigrant Korean priests lived there, studied, and preached about the spiritual benefits of the faith. Their work was supported locally and flourished to a degree that eventually surpassed that of its continental neighbors, as can be appreciated by anyone visiting Japan today.

The support and growing enthusiasm for Buddhism was premised in part on the continuous flow of scripture and commentary into temple sutra repositories where these documents could be read, actively discussed, copied, and then dispersed for others to contemplate. These "libraries" were important components of early temple architecture and their contents represented the core of early Buddhist institutions. Japanese monks traveled regularly to China in search of sacred texts that could be copied and brought back for study. Then with the establishment of a strong centralized bureaucratic state in the Fujiwara capital and subsequently in Nara, together with the virtual establishment of Buddhism as a "state" religion by the mid-eighth century, conditions were right for a cultural renaissance of theretofore extraordinary dimensions.

Buddhism served the imperial system as its trusted spiritual advisor and protector. The state, in turn, actively promoted the spread of Buddhism by ordering the outlying provinces to build temples and then supplying them with imagery, ritual implements, and religious texts. Nara priests were sent to the provinces to deliver sermons, some of them based on sutras calling for the divine protection of the state [12]. In order to provide the texts for these activities, an official scriptorium was established at the palace, and surely this *Ajaseō-kyō (Sutra of King Ajaseō)* was produced there.

The text comes from the vast Chinese *Tripitaka* (a compendium of all Buddhist scriptures), known in Japan as the *Issai-kyō,* comprising more than seven thousand volumes.

應時二万二千菩薩同共發督我等欲與
文殊師利俱行即時如其數菩薩與文殊師利
俱悅忽以在彼阿剎土其慶而坐其慶者謂
室中所以能容者是菩薩威神數憲其坐已
文殊師利詵其姓名申呬隣尼者文殊師
利謂諸菩薩乃知何所法名随隣尼者而言
一切諸法故其意无所望故所作无有異
所念應時忿所知如智慧其法无知其本
所語如諦自謢不隨用轉上故忿入諸法行
隨鄰尼者則道之无不斷佛无持法之无擾
持僧之无於諸法无有殆在人之所問即能
解及龍閻又阿須輪迦留羅真陀羅摩休勒
人非人及釋梵下至一切諸罜至将鳥狩各
知其意随其所欲而忿教化令得其所忿曉
了有切德者盡知一切人之行任其
德不離於道教照於人随其所樂令一切皆
蒙其恩所任式令一切忿在中其慧无所不
心譬如地於世不以八事中有順何所作切
遍入為一切之所重而不以為勤若其心无
有異其法者知而本一切教化衆其教常以法
而施與不以為猷所詵法不堂當得其復不
斷菩薩若根本所以者何以精進而養成其
根故所施與不為廠忍用菩薩故以弌不

The scroll illustrated here contains volume two and is important as a historical document as well as for the elegant calligraphy. It tells a story of redemption. Apparently a young nobleman, Ajaseō, became the ruler of his kingdom by killing his father (the former king) and imprisoning his mother. But like the admonitory narratives linked to Taima mandala imagery [52], he realized his wordly errors through the intervention of the Historic Buddha's teachings and was saved. At the end of the scroll Empress Kōmyō (701–760) inscribed a prayer in memory of her father and dated it 1 May 740. Thus this volume represents part of an imperially commissioned project by one of Japanese Buddhism's greatest patrons, known from other sources to have begun four years earlier in 736. Some seven thousand volumes, it took about twenty years to complete. While such numbers may boggle the modern Western mind and do certainly overshadow similar achievements in the early Western world of manuscript production, they represent but a small part of the eighth-century reality in Nara. The scriptoria at the Tōdai-ji as well as the official sutra copying studio within the palace were well staffed and productive.[2] The handscroll illustrated here is recorded in a document kept in the Shōsō-in as having been copied from the 740 scroll in April 742 by a member of the imperial scriptorium.

The form and style of calligraphy seen here is called *kaishō,* an official script using Chinese characters that has, at its best, a refined structural shape and rhythm. Each stroke of the brush is deliberate, relating to both the other strokes within its symbol and the characters on either side of it. Scribes were trained to follow rigorously the calligraphic form of the model text in front of them, and their work was checked by more experienced copyists. This text shows a small number of corrections inscribed in red ink, as does the *Kako Genzai E-inga-kyō* [14].

The deep, rich black ink set against the tea-brown paper is characteristic of many sutras of the time, as are the marks from water damage and the worm holes. An expression of the country's highest patronage and professional calligraphic talent in the mid-eighth century, this volume finds few peers among contemporary texts.

1. *Ancient Japan,* ed. Delmer M. Brown, vol. 1 of *The Cambridge History of Japan* (Cambridge: Cambridge University Press, 1993), especially chap. 3.

2. See Oyama Jinkai, *Shakkyō* (Buddhist sutras), vol. 156 of *Nihon no bijutsu* (Arts of Japan) (Tokyo: Shibundō, 1979). See also Yoshiaki Shimizu and John M. Rosenfield, *Masters of Japanese Calligraphy, 8th–19th Century,* exh. cat., Asia Society Galleries and Japan House Gallery (New York, 1984).

12. Konkōmyō Saishōō-kyō (Volume 10)

8TH CENTURY; HANDSCROLL (PART OF A
SET OF TEN): GOLD POWDER ON PURPLE-
DYED PAPER; 26.4 X 841.1 CM. NATIONAL
TREASURE

The Nara National Museum's *Konkōmyō saishōō-kyō (Sutra of the Sovereign Kings of the Golden Light)* is part of a set of ten handscrolls thought to have belonged originally to an eighth-century kokubun-ji located in western Japan near modern Hiroshima. These monastic institutions, including nunneries, were founded in all the provinces outside Nara by order of Emperor Shōmu in 741.[1] During his twenty-five year reign, Shōmu, an avid and pious Buddhist, used his considerable political skills to marshal enthusiasm and support for unprecedented state-sponsored projects furthering the dissemination of Buddhist doctrine and ceremony throughout the country. The erection of Tōdai-ji represents his most ambitious effort.

Rallying his political factions in the aristocracy to align any regional territorial interests they might possess to an official state temple system whose authority would emanate from the capital, he created a new bureaucracy within Nara. In the edict of 741, which followed a devastating smallpox epidemic, the emperor pledged to "protect the country against all calamity, prevent sorrow and pestilence, and cause the heart of believers to be filled with joy."[2] Although unstated, this proclamation was also meant to address recent disruptions at court. Thus, monks and nuns were to be trained at these provincial temples, and eminent monks from Nara's great temples at Tōdai-ji and Kōfuku-ji were instructed to make visits to give sermons and offer religious training. Clearly the welfare of the state was inextricably meshed with the Buddhist institutions within and outside Nara.

The text of this sutra, based on a fifth-century Chinese scripture in use in Japan until Shōmu began to favor an early eighth-century translation, was avidly studied and copies in ink on paper were made and dispersed among Nara area temples, some of which still exist. But with the 741 edict, Shōmu also established a special scriptorium exclusively devoted to producing this sutra using fine gold-dust particles, exactly what is preserved in this handscroll.

Specially prepared purple-dyed sheets of fibrous paper, each with faintly ruled lines to frame the columns, were joined together. Then gold dust suspended in a binder was brushed onto the lustrous surface, creating the "golden" visual effect conveyed in the very name of the scripture. The extraordinary visual brilliance apparent here provides the basis for understanding Nara period and, later, Heian and Kamakura era approaches to "awesome beauty" (*shōgon*) as a valid path to spiritual awakening.

金光明最勝王経捨身品第廿六　三藏法師義淨奉　制譯

尒時世尊已為大衆説此十千天子往昔因
緣復告菩提樹神及諸大衆我於過去行菩
薩道非但施水及食濟彼魚命乃至亦捨所
愛之身如是因緣可共觀察尒時如來應正
等覺天上天下最尊最勝家百千光明照十方
界其一切智功德圓満將諸菩薩及於大衆
至殿嚴窣堵波詣一林中其地平正無諸荊
棘名華爰布其處佛告具壽阿難陀汝
可於此樹下為我敷座時阿難陀受教敷已
白言世尊其座敷説唯聖知時尒時世尊即
於座上跏趺而坐端身正念告諸菩薩汝等
樂欲見彼往昔菩薩本舍利不諸菩薩
言我等樂見世尊即以百福莊嚴相好之手
而按其地于時大地六種震動即便開裂七
寶制底忽然涌出衆寶網莊嚴其上大衆
見已尒時世尊即從座起作礼右
繞還就本座告阿難陀汝可開此制底之戶
時阿難陀即開其戶見七寶函奇環餙白
言世尊有七寶函衆寶莊挍佛言汝可開函
時阿難陀奉教開已見有舍利白如珂雪拘
物頭華即白佛言函有舍利色妙異常佛言
阿難陀汝可持此大士骨来時阿難陀即取
其骨奉授世尊受已告諸菩薩汝等應
觀苦行菩薩遺身舍利而説頌曰
菩薩勝德相應慧　勇猛精勤六度圓
常修不息為菩提　大捨堅固心無倦
汝等苾芻咸應礼敬菩薩本身此心合掌
是無量戒定慧香之所重馥衆咸上福田極難

The Shōsō-in treasury contains documents stating that seventy-one sets of this sutra, commissioned by the emperor, were completed in 746. The Nara National Museum volumes are one of only two complete sets now in existence.[3] They are unparalleled in conveying the imperial aesthetic associated with Buddhist scripture in the mid-eighth century in Nara and consequently are designated National Treasures. Just over five hundred years later, in 1294, another devout Buddhist emperor, Gouda (1267–1324), began copying and distributing the *Sutra of the Sovereign Kings of the Golden Light* to temples throughout the country. Only twenty-eight at the time, he was concerned for the well-being of the country. The Nara National Museum possesses one of these handscrolls whose calligraphic style refers to the strong, lithe brushstrokes evident in this eighth-century script.

1. To see a corpus of the surviving objects associated with these temples, see *Kokubun-ji* (The state temples in the provinces), exh. cat., Nara National Museum (1980).

2. See *Ancient Japan,* ed. Delmer M. Brown, vol. 1 of *The Cambridge History of Japan* (Cambridge: Cambridge University Press, 1993), especially chap. 7. See also M. W. de Visser, *Ancient Buddhism in Japan: Sutras and Ceremonies in Use in the Seventh and Eighth Centuries A.D. and Their History in Later Times* (Leiden: Brill, 1935), 1:14–16, 2:431–88.

3. Ōyama Jinkai, *Shakkyō* (Buddhist sutras), vol. 156 of *Nihon no bijutsu* (Arts of Japan) (Tokyo: Shibundō, 1979), pl. 2. See also *Nihon no shakkyō* (Japanese Buddhist sutras) (Kyoto: Kyoto Shōin, 1987) by the same author.

安樂令一切衆生所聞不虛解聲如響普見佛
出生令一切衆生善示別知諸佛正教悲能
守護持佛法者令一切衆生心常樂回聞持
佛法能照顯現如來法教令一切衆生深心
信解如來正教一切功德令佛歡喜善解
真諦志捨內外究竟大施是為菩薩摩訶薩
施聲聞緣覺種種來時善根迴向令一切衆
生得无上智淨諸神通精勤備習无有慚怠窮
克佛智力无所畏菩薩摩訶薩言諸方來一
切福田或求菩薩名聞故來或興菩薩回緣
故來或聞菩薩本願故來或復菩薩心願請
来菩薩於彼樂惠施而无猒倦尔時菩薩
於未求者發悔過心作如是言諸人當知我
應詣彼礼拜供養種種惠施而今為我故從
遠未菩薩即時敬礼悔過愛語慰喻屈辱遠
来得无疲惓憂令安隱供給所須或施摩尼
寶車載以閻浮提內第一女實或施金車載
以已國邑勝寶女或施清淨瑠璃寶車載以
內伎或施樂車載以童女容貌如天或施无

8TH CENTURY; HANDSCROLL (ONE OF A PAIR): SILVER POWDER ON BLUE PAPER; 25.5 X 538.6 CM

The *Kegon-kyō (Flower Garland Sutra)* was transmitted from India to China in the fifth century by Indian monks traveling across the silk routes of Central Asia. It is said to record a sermon by Śākyamuni (Historic Buddha) following his enlightenment. In China it is also known by subsequent translations and numerous commentaries, the most popular of which in Japan focuses on the odyssey of a young boy, Zenzai Dōji (Sanskrit: Sudhana), who in his search for enlightenment travels great distances to seek the wisdom of fifty-four eminent teachers. A number of Kamakura period mandala paintings with Dainichi (Great Sun Buddha) as the central icon provide visual depictions of parts of the text. More well-known is a superb narrative handscroll at the Tōdai-ji describing Zenzai Dōji's spiritual pilgrimage across the landscapes of Asia (fig. 13a).[1]

The teachings of the Chinese school of Buddhism known as Hua-yen (Japanese: Kegon) were in place in Nara by the mid-eighth century. They were studied assiduously through the use of sutra texts, more as academic exercises than as useful guides to attaining

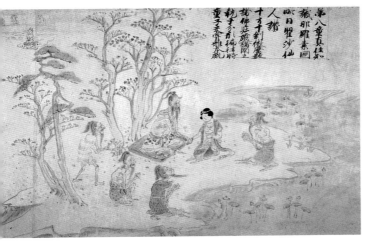

Fig. 13a. Detail from *Kegon Gojūgo-sho* (Journeys of Sudhana), 13th century; handscroll: ink and color on paper; 30 x 1287 cm; Tōdai-ji, Nara. National Treasure

spiritual awakening. The Tōdai-ji became the center of such learning and indeed the headquarters of the Kegon sect, thereby linking the precepts of this Buddhist doctrine with the imperial family, the temple's patrons.

The *Flower Garden Sutra* thus became, along with the *Lotus Sutra* and the *Sutra of the Perfection of Wisdom,* one of the most influential eighth-century scriptures. Its merits were extolled by the Tōdai-ji monks, and copies were commissioned for dispersal and study. It even provided the emperor Shōmu with the rationale for proclaiming in 743 the need to build a monumental gilt-bronze image of Birushana using all the available resources of the state.[2] This is the Great Buddha (Daibutsu) at the Tōdai-ji, now a late seventeenth-century image (see fig. 1, facing p. 1).

A number of multi-volume sets of the *Flower Garland Sutra* exist, identified according to their "editions." This scroll comes from the sixty-scroll codex. According to historical records it contains the text read either at the ceremony in 744 officially initiating the construction of the Great Buddha at Tōdai-ji or at the Eye-opener ceremony that formally consecrated this colossal icon in 752. This section may indeed have been a volume used at one of those state occasions or assembled as part of the offerings to the new deity. According to another view, it may have been produced for a ceremony known as Shūnie (also called Omizutori), the fire purification ceremony held at the Nigatsudō hall in the Tōdai-ji complex annually on the fifth day of the second month. Whichever the case, the Nara National Museum owns seventeen sheets from four separate volumes that are now mounted as two handscrolls. The Tōdai-ji still possesses twenty scrolls designated Important Cultural Properties, and other fragments are scattered in private and institutional collections throughout the country, where they are highly revered.[3]

The separation and eventual dispersal of these volumes was precipitated by a fire that broke out at the Nigatsudō in 1667 during the annual Omizutori. The copy of the *Flower*

Garland Sutra kept inside the devotional hall was damaged by the fire, its edges scorched brown, the paper made brittle to the touch. These sheets are now known affectionately in Japan as the Nigatsudō copy.[4] This designation does not allude just to historic circumstances; more important, it refers to the simple survival of the scrolls, that is, their rebirth and heightened aesthetic appearance—in form, color, and patination—after that event. One can see this fact clearly in their modern remounted condition. They endure as the only eighth-century religious text written entirely in silver powder on this ravishing blue paper. While the silver applied to other, later, sutras or Buddhist paintings has darkened through time because of oxidation, the brilliant silver forms here are as radiant as if they had just been inscribed. The chemical reaction that occurred in the fiery atmosphere of 1667 explains their luster, in part. Yet to the devout the apparent catastrophe resulted in a rebirth of the objects, attesting to the wisdom of the ideas given form in the materials of silver powder and plant fiber paper back in the eighth century.

1. For the history of imagery linked to this text, see Ishida Hisatoyo, *Kegon-kyō-e* (Painted imagery of the Kegon Sutra), vol. 270 of *Nihon no bijutsu* (Arts of Japan) (Tokyo: Shibundō, 1977). For a translation of the sutra, see Thomas Cleary, trans., *The Flower Ornament Scripture,* vol. 1 (Boston: Shambhala, 1985).

2. See Daigan Matsunaga and Alicia Matsunaga, *Foundations of Japanese Buddhism* (Los Angeles: Buddhist Books International, 1974). See also *Ancient Japan,* ed. Delmer M. Brown, vol. 1 of *The Cambridge History of Japan* (Cambridge: Cambridge University Press, 1993), 397ff.

3. See for example *Tōdai-jiten* (Exhibition from the Tōdai-ji collection), exh. cat., Tokyo National Museum (1980), no. 73.

4. See *Nihon no shō* (Japanese calligraphy), exh. cat., Tokyo National Museum (1980), pls. 16–17.

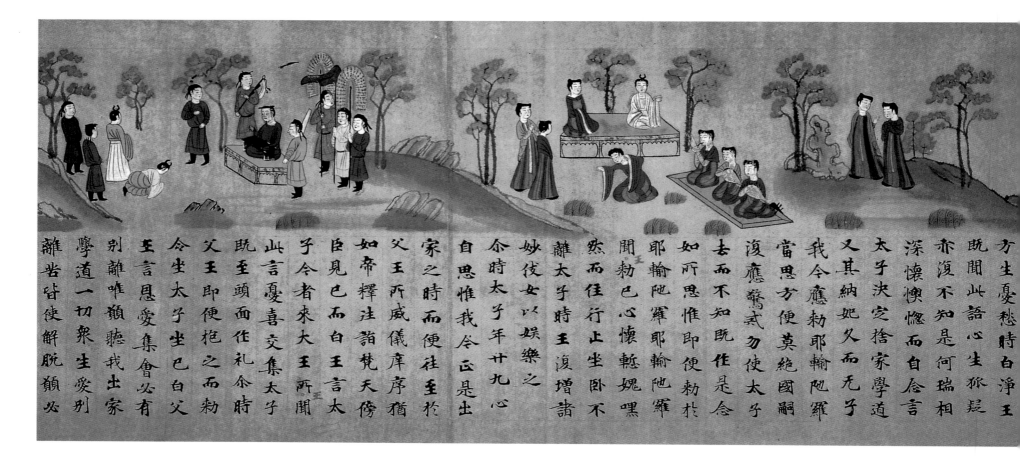

14. Kako Genzai E-inga-kyō

8TH CENTURY; HANDSCROLL: INK AND
COLOR ON PAPER; 26.4 X 115.9 CM.
IMPORTANT CULTURAL PROPERTY

This scroll, *Illustrated Sutra of Cause and Effect,* describes events in the life of Shaka, the Historic Buddha. The sutra was known in the Nara period in a Chinese transcription consisting of four volumes, which expanded to twice that size when the Japanese artisans working in the imperial studios were asked to amplify the text with narrative scenes corresponding to the text written below in neat eight-character columns. The project was probably a collaborative effort involving the sutra-copy office and a painter's studio. Documents preserved in the Shōsō-in treasury alone record sets of both illustrated and unillustrated text by AD 756. An even larger number likely appeared in the eighth century.

Of these, however, only four handscrolls have survived, and they have been separated over the years, some into small ten- or even five-line fragments suitable for use in the

tea ceremony. Copies of the *Kako Genzai E-inga-kyō* were produced in the Heian and Kamakura periods also, but no complete versions of these later copies survive to provide an accurate, comprehensive view of the entire eighth-century project.

This Nara National Museum handscroll is also a fragment; it belongs at the end of an extended segment, registered as a National Treasure, at the Jōbon Rendai-ji in Kyoto.[1] Together they form the longest extant version of this illustrated sutra and portray events corresponding to the first half of the second scroll in the set. The calligraphic style is crisp, leading some scholars to associate it with an illustrated set of scrolls datable to 753 mentioned in the Shōsō-in records. Characters written in red ink have been inserted occasionally in the text, which more than fills the lower half of the sheet. They are corrections of the copyist's work by a higher ranking member of the official scriptorium—a kind of proofreader responsible for the ac-

curacy of the transcription, a task demanding considerable concentration.

At the painting studio the narrative scenes and their elements—trees, rocks, grasses, mountains, and water—were sketched in first. The pale gray brushstrokes of the underdrawing that placed the figures are still visible. These single figures and groups constitute the important narrative components of the handscroll and so preceded the insertion of the landscape elements. The five passages in this Nara National Museum scroll fragment portray events in the life of Shaka following his decision to seek greater meaning in life than the secular world could provide, a place where as a prince he enjoyed special privileges and status.

In the opening passage Shaka kneels before a monk holding a *shakujō* (monk's staff) [81] engaged in a discussion of Buddhism's teachings. Then we see him traveling in a spring landscape with his white horse and two attendants when he comes upon a Brahman sent by his father, the king, to watch

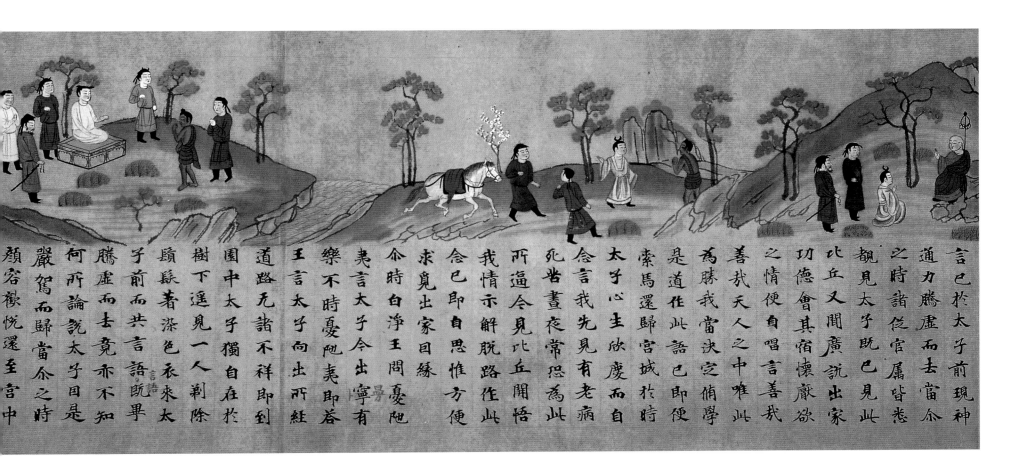

over him. The king reappears in the next scene, seated on a raised wood dais listening to the messenger's report of the meeting between prince and monk. The next narrative passage shows the prince seated on a large dais with an orange mat accompanied by his wife, Yaśodharā, who has arranged a dance performance with three musicians as a way to deflect the prince's attention away from spiritual pursuits toward the pleasures of the secular world. But her attempts fail, for in the last (far left) scene the prince is shown bowing before his father asking for permission to leave his royal life.

The story is as captivating to modern viewers as its presentation: small colorful figures in a landscape setting whose pictorial economy matches and supports the rhythm of the unfolding narrative. Trees, rocks, tufts of grasses, and figures are part of a visual repertoire that is adjusted ever so slightly by position, coloring, or gesture to impart the necessary information for any one scene. This standardization gives a consistency and familiarity to

the narrative and is no doubt based on earlier Chinese conventions that appeared in the handscrolls and decorative arts imported into Nara in the eighth century. The painted scenes on musical instruments and chests in the Shōsō-in provide pertinent sources of this figural type and "modular" landscape setting.[2] Even earlier precedents can be identified in the wall and banner painting traditions of China as exemplified at the Dunhuang caves in the far northwest.

But what one sees here in the Nara National Museum handscroll, rendered in a fresh, naive manner in contrast to the Chinese models, is the native expression of a religious theme incorporating a distinct sense of an ordered and continuous pictorial space.[3] The landscape is inhabited by small youthful figures as enchanting as the extraordinarily vivacious colors whose preservation is nothing short of miraculous. Here the beginnings of *yamato-e* (Japanese-style painting) can be discerned, a style that truly surfaces in the paintings [38–39, 42, 49] and lacquerwares

[74] of the Heian period. The *E-inga-kyō* well precedes those developments and, moreover, establishes important precedents for a significant category of pictorial art in Japanese culture: the portrayal of word and image in a single coherent format. Japanese Buddhist art is the birthplace of this pictorial form of expression, and the *E-inga-kyō* handscrolls are its earliest known examples.

1. *Nara Kokuritsu Hakubutsukan no meihō* (Masterpieces from the collection of the Nara National Museum), exh. cat., Nara National Museum (1997), pls. 159–60.

2. See *Minamikura 2* (South storage room 2), vol. 8 of *Shōsō-in hōmotsu* (Treasures of the Shōsō-in) (Tokyo: Mainichi Shinbunsha, 1996), 50–51.

3. Compare for example the scenes in the Tamamushi Shrine at the Hōryū-ji, dated to the seventh century; see *Bukkyō setsuwa no bijutsu* (Depictions of Buddhist scriptures), exh. cat., Nara National Museum (1990). For the extended Jōbo Rendai-ji handscroll, see Kameda Tsutomu, *E-inga-kyō*, vol. 16 of *Nihon emakimono zenshū* (Compendium of Japanese illustrated handscrolls) (Tokyo: Kadokawa Shōten, 1958).

15. Letter by Priest Saichō

DATED 813; HANGING SCROLL: INK ON
PAPER; 29.4 X 55.2 CM. NATIONAL TREASURE

The priest Saichō (fig. 15a) is best known in Japanese religious history as the founder of the Tendai sect of Esoteric Buddhism in the Heian era. Its headquarters, the Enryaku-ji temple atop Mt. Hiei in northeast Kyoto, was a center of serious religious study from the ninth to late sixteenth centuries (and continues today). It enjoyed particularly close ties with the imperial family and Kyoto's aristocracy, attaining the impressive scale of some three thousand buildings within its precincts. But they were destroyed in one fell swoop in 1571 by military authorities infuriated by the militancy of the temple's monks.

Saichō's beginnings were humble, as was the small temple he established in 788 above the empty marshland that in 794 became the new capital, Kyoto (then known as Heian-kyō). Saichō had left Nara earlier to distance himself from the machinations of the large Buddhist institutions there. With the patronage of Emperor Kammu (737–806), the Enryaku-ji became a center of quiet learning focusing on the *Lotus Sutra* texts and commentaries. In 804 Saichō journeyed to China with the emperor's support in order to gain official approval for the Enryaku-ji from religious leaders, thereby raising its status substantially. It was then that he learned the precepts of the Tendai sect, brought them back to Kyoto, and began preaching them while

occasionally criticizing the doctrines of the Nara temples. The arrival of a new emperor who was so distrustful of clerics that he determined no Buddhist temples would be situated within the capital's gates changed Saichō's simple world.

Kūkai (774–835), the other great prelate of the ninth century, introduced Shingon sect Buddhism to Japan upon his return from China in 805. He was granted permission to establish a temple (Tō-ji) at the southern entrance to Kyoto and set about forging strong alliances with the Kyoto aristocracy. His avowed interest in using painting and sculpture as visual adjuncts to religious training and teaching, not Saichō's more studious approach, won their support and propelled Shingon into the attention of Heian society.

Saichō also admired aspects of Shingon precepts and Kūkai, studying seriously with him and even sending some of his own monks at Enryaku-ji to Kūkai for training. In this regard Saichō was open-minded in his search for paths to spiritual awakening, but he was ultimately naive in disregarding Kūkai's ambitions for Shingon. Thus when Saichō sought formally to establish the Enryaku-ji as a temple that could officially ordain monks, Kūkai and the Nara establishment thwarted his efforts right up until his death in 822.

This unpretentious hanging scroll preserves a letter written in 813 before relations between these two founders of Esoteric Buddhism in Japan became strained. In it Saichō refers to the preface of a poem Kūkai used in a previous letter exchanged between the two prelates. Being ignorant of a text referred to in that preface, Saichō asked for help in identifying it so that he could search it out, read it, and then reply properly and knowledgeably. The letter is sent not to Kūkai directly but to Saichō's pupil, Taihan, who was then studying with Kūkai. Saichō makes a point in his writing and in the way he structured the lines of the letter to show deference to Kūkai, despite being the elder of the two distinguished priests. Saichō's humility and interest

in learning are evident here, some twelve hundred years later. Unfortunately, matters took a turn for the worse between the two spiritual leaders. Taihan, Saichō's student, was prevented from returning to Enryaku-ji, and Saichō himself was later told by Kūkai in harsh words that he could not borrow a sutra for study.

A few documents at the Enryaku-ji from Saichō's hand still exist concerning matters of temple administration, correspondence with various government officials asking for permission to perform specific ceremonies, and inventories of personal objects Saichō donated to the temple, some of which he brought back with him from China.[1] Indeed, many thousands of religious texts and historical documents survive in Japan from the Nara and Heian periods. Precious few letters, however, remain that allow insights into the personal lives and thoughts of the people themselves. In Japan this letter is revered as a direct, earnest expression of shared interests between two eminent high priests, one of whom—Saichō—signals his modesty by beginning his note with the words "we haven't seen one another for a long time." This phrase in Japanese has been the letter's informal name for many centuries. The most renowned piece of calligraphy from the hand of one of the country's greatest Buddhist leaders, it is written in clear, elegant brushstrokes that reveal the man's character for all to appraise.

Fig. 15a. Sculptural portrait of Priest Saichō, dated 1228; wood with traces of lacquer; h. 66.1 cm; Kannon-ji, Shiga Prefecture

1. For a compilation of Saichō's remaining documents, see Nagai Michiko and Horie Tomohiko, *Saichō, Saga Tennō, Tachibana Hayanari* (Saichō, Emperor Saga, and Tachibana Hayanari), vol. 13 of *Shosō geijutsu* (The art of calligraphy) (Tokyo: Chūō Kōron-sha, 1974). See also Nakata Yujiro, *The Art of Japanese Calligraphy* (New York: Weatherhill, 1973).York: Weatherhill, 1973).

16. Buddha Preaching
(Chapter 18 of the Kongōchō-kyō)

金剛頂瑜伽揩歸一卷

外道名為瑜伽金剛一乗教主王法

利樂一切有情諸菩薩嚴聞覺及諸

謂自性身受用身變化身是能依顧

上所説各各分別劑各不雜乱圓證四身所

曇荼羅三昧法門韋槃量同屢空證者如

此瑜伽中大意如遍照俄一一身分二毛孔

一一桐一一隨恢好一一福德資糧二智惠

資糧任於果位演説瑜伽之二乗不共佛法説

三十七尊四曇荼羅四印平相隣入如帝

四印具卅七乃至一尊成

或七千頌都成十石頌具五部四種曇荼羅

多種相應瑜伽教十八會或四千頌或五千頌

經中廣説説不成訖少種相及説薩近志地

限但證理門心不散乱任本尊瑜伽為限此

就世間出世間意地不假持殊應敷以為膺

一心於一一字實相理相應固而復始列上右旋

説四種曇荼羅具四印下至外金剛部為弟

説五部瑜伽曇荼羅別入第子儀具卅七六

金剛部瑜伽曇荼羅請佛為大梵天娑訶世界主

第十八會名金剛寶冠瑜伽於第四靜屢天

摩地相應法

光明量同屢空法身相應剎一切万物成空三

曇荼羅具四種曇荼羅此來无去此經中説屢空

盧遮那佛普賢菩薩及金剛部一一説四種

應背量同屢空法身相應利一切行者与二一尊相

第十七會名如屢空瑜伽住實際宮殿説呪

思應任他乱心背无二同真如法東皆成一切

間自他平等月嚴香味觸澤深

佛身

EARLY 12TH CENTURY; HANDSCROLL WITH FRONTISPIECE: SILVER AND GOLD PIGMENTS ON INDIGO-DYED PAPER; 26 X 486.6 CM

The decorative appearance of this *Kongōchō-kyō (Diamond Crown Sutra)* clearly communicates the period in which it was made. As the late Heian Buddhist paintings in the exhibition also demonstrate, using gold and silver to adorn religious imagery was not just a technical way to augment the appearance of a deity, it was viewed sui generis as a tangible, visible avenue toward attaining spiritual enlightenment. The radiance of the Buddha's wisdom and compassion expressed in the Taima mandala [52], for example, can be gleaned from its overt didactic and decorative features.

This strategy is evident in several other paintings, although not perhaps as apparent to a Westerner. But what is not evident to that same viewer is expressed in the Buddhist term *shōgon,* which conveys the important idea that creating and displaying objects of

transcendent beauty constitutes a form of spiritual awakening. Those who cause such extraordinary visual manifestations to come into existence (patron and craftsman), as well as those who protect and venerate these objects, provide themselves with yet another opportunity toward becoming enlightened beings [see 21, 29, 78].

In the late Heian period illustrated sutras were among the formats that nobility avidly sponsored, partly because of their own keen interest in the rigors of the task. It was, and had long been, considered spiritual work. Thus one could commission the copying of religious texts and by so doing accrue religious merit. But historical records also note the devotion of high-ranking noblemen who dedicated themselves in retirement from their official capacities to the daily transcription of holy texts.

This scroll, part of a much larger set, illustrates the standard format. Pieces of paper were dyed a rich indigo blue tone and then joined to form a handscroll. Ruled lines in

gold ink frame the frontispiece composition and the shorter vertical registers for the text. Following the line (or sometimes two lines) identifying the sutra and the particular volume and text section being presented, the Chinese characters appear, top to bottom, in a regular rhythm. Because the text is codified, the only opportunity for personal embellishment by the scribe lies in discreet stylistic flourishes of the brushstrokes or, as in this example, the use of gold and silver in alternating lines. Although the silver has faded considerably here, it once produced an effect nearly as striking as the bold gold characters.

Illustrated sutras with such alternating registers of gold and silver are traditionally linked to the thousands of sutras commissioned by a member of the Fujiwara family, Fujiwara no Kiyohira (d. 1128), and his descendants for the Chūson-ji in northern Japan. This extensive group of the fundamental Buddhist scriptures includes the *Daihannya-kyō (Sutra of the Perfection of Wisdom)* [75].[1] The volume from the *Diamond Crown Sutra,*

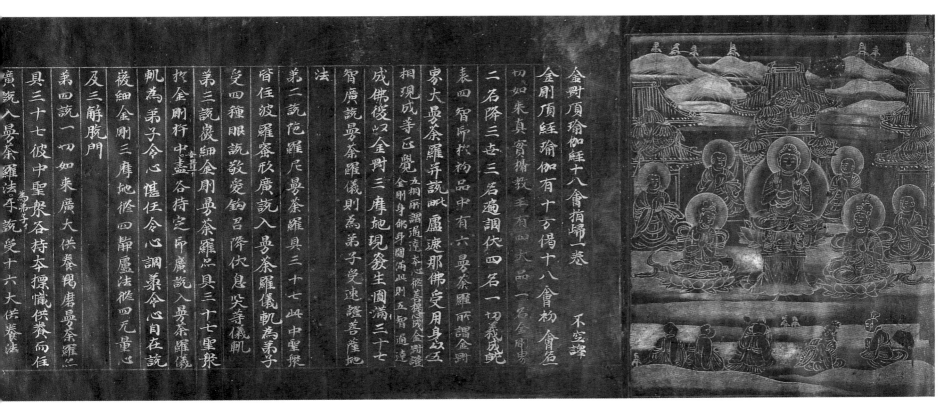

the textual source for the Diamond World mandala [41], is thought to date to the late seventh or early eighth century, when it became known in China. With the decline of the Chūson-ji beginning in the late twelfth century, the scrolls were gradually removed from the sutra repository at Chūson-ji and now can be found in other temple, public, and private collections throughout Japan and in a few Western collections.[2]

This scroll is typical in that the pictorial composition fills the frontispiece surface. Shaka is shown seated on a cloth-draped dais preaching in a temple courtyard to two bosatsu (in front of him), four monks (to his left and right), and five followers. The positioning of these adoring figures is lively, especially the figure in Chinese-style garb with his back completely to the viewer, hands raised above his head in prayer.

Bands of gold and silver washes summarily describe the landscape here and in the distance. They also create a simple pattern of alternating tones that produces a simulacrum of spatial recession. Indeed, one of the delights of viewing these Chūson-ji illustrated frontispieces is the scrutiny of the many quickly brushed lines and washes that in sum create a felicitous narrative with an economy of means. Since the copying project comprised 5,400 scrolls (and took some eight years to complete), such deft, abbreviated brushwork no doubt evolved out of necessity and provides the measure of visual pleasure absent in the dedicated but routine brushstroke of the calligraphy.

1. See for example Egami Yasushi, *Sōshokukyō* (Decorated Buddhist scriptures), vol. 278 of *Nihon no bijutsu* (Arts of Japan) (Tokyo: Shibundō, 1989).

2. See John M. Rosenfield and Elizabeth ten Grotenhuis, *Journey of the Three Jewels,* exh. cat., Asia Society (New York, 1979), 61–67, nos. 9–11.

17. Shaka Nyorai

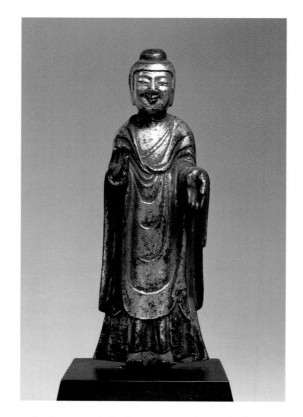

7TH CENTURY; CAST BRONZE, GILDED;
H. 15 CM

This small gilt-bronze image represents the person identified with the core of ideas and good deeds leading to the formation of Buddhism. Born Siddhrtha Gautama into a royal family in present-day Nepal, his search for spiritual enlightenment, its attainment, and his subsequent proselytizing constitute the lore upon which later Buddhist thought and practice was built. The life story of Shaka held great importance in early texts and commentaries. An illustrated biography, the earliest narrative painting in Japanese art, records events in the life of this prince of the Śākya clan [14]. Through time, oral traditions concerning the Historic Buddha were augmented by written texts and then visual imagery, all in the service of propagating the faith. Cast-bronze images of the deity appeared in China by the late fourth century, in Korea by the fifth, and in Japan, the last stage of Buddhism's journey into East Asia, by the sixth century. Although not the first of three-dimensional icons attempting to give form to the Historic Buddha (clay images preceded them), these small metal figures were the most durable and the most attractive because of their gilded surfaces.[1]

Early records in Japan note the arrival in the Asuka valley of bronze images brought by Korean priests traveling from Paekche to the island country as emissaries of their king (AD 538). Among the first cast images to come to Japan from Korea or to be produced in Japan with immigrant assistance are those of Miroku Nyorai, Kannon, and Bosatsu. The Hōryū-ji with its patron, Prince Shotoku Taishi (574–622), was a center for these small portable images as well as the more famous large-scale pieces installed as the principal icons of worship in the temple's golden hall in the early seventh century. The repository of small images at the Hōryū-ji must have been sizable in the Nara period since in the late nineteenth century almost one hundred pieces (including beautiful openwork halos) were transferred to the Tokyo National Museum. While many still exist in temples in the Nara and Osaka areas, major centers of Buddhism during the sixth through eighth centuries, still others were dispersed throughout the rest of the country in temples and private and public collections. A small number have even reached the West.

This figure depicts Shaka standing frontally, robed, with enlarged hands exposed and positioned in the symbolic *semui-in* and *yogan-in* gestures indicating mercy (without fear) and wish-fulfilling capacities, respectively. As one of the Nyorai, "one who has followed the path" of (absolute) truth, this Shaka Nyorai has several of the traits said traditionally to identify an enlightened being: the uṣṇiṣa as well as snail-like hair curls; a round, button-shaped jewel in the hair and a similar crystal in the forehead; large, extended, and perforated earlobes; a three-ringed neck; and plain clothing.

Here Shaka wears both inner and outer robes, the latter of which passes over both shoulders and indicates a traveling rather than a preaching Buddha. The configuration of the outer robe has two prominent stylistic features: a thick U-shaped loop of cloth on the chest exposing the inner robe; and regularly pleated robe patterns on both the left arm and the skirt of the inner robe. These features may also be seen in gilt bronzes of the Three Kingdoms period in Korea dating to the seventh century, images that had a direct and profound impact on Japan's earliest image-making techniques and style.[2]

Archaeological excavations confirm that Japan, poor in mineral resources, was receiving metal ingots with which to fabricate armor, weapons, agricultural tools, and Buddhist images by the mid-sixth century. Subsequently the knowledge of where and how to locate

native sources of various ores and the technology for bronze casting arrived with the immigrant craftsmen from the kingdom of Paekche. The most famous remaining monuments from this period are the Shaka triad (see fig. 3, p. 22) and Yakushi (dated 603) in the Kondō of the Hōryū-ji. Each bears an inscription relating the history of its creation and refers to the sculptor "Tori Busshi" (Master Sculptor Tori) as responsible for its manufacture at his workshop.[3]

This Tori style of the early to mid-seventh century featured a formalized arrangement of drapery, almond-shaped eyes, and a benign, restrained, smiling facial expression set into a tall, smooth-planed head. It is to be seen in several early seventh-century small gilt bronzes, the best known of which belong to the Hōryū-ji group at the Tokyo National Museum. But this group of forty-eight images displays an impressive range of sculptural styles considering their early date. Some half a dozen pieces exhibit stylistic and technical affinities with this Nara National Museum Shaka, which eschews the pronounced garment patterns and sculptural volume of the Tori style.

These images may all be dated to the Asuka–early Nara period in the first half of the seventh century, although modern scholarship in Japan and Korea increasingly indicates the likely Korean origins for some of these Shaka and other Nyorai gilt-bronze images. The lack of an elaborate pedestal accompanying this figure of Shaka actually helps diminish the Korean connection, as does the prominent triangular-shaped tang that inserts into a recess in a lotus base (now lost). Most sixth- and seventh-century Korean gilt bronzes are either cast as one piece with their base or have metal tangs protruding from each foot extending into recesses in a lotus base. But there is a cast-bronze tradition in both Chinese and Korean sculpture of the sixth and seventh centuries in which one large tang support is used, leaving the matters of provenance and influence open to future inquiry.

When compared with the other early gilt bronzes in the exhibition [18–19], the distinctive archaism and severe formal appearance of this modest image become apparent. Even viewed in profile or from the rear, its intensity and directness of expression convey the spirit of sincerity adopted by Nara's small core of Buddhist faithful in the early seventh century. Surely this small figure depicting the founder of this new faith would have been a prized icon of a private aristocratic clan member or his family. The staunch support of Buddhism by the Soga clan and by Shotoku Taishi is recorded as having led to the founding of more than forty temples in the Nara, Asuka, and Osaka areas. Private noble residences also contained areas reserved for worship. Gilt-bronze icons of this scale and appearance were no doubt venerated in these spaces by the growing community of monks, nuns, and laity. This diminutive image reveals the outward appearance given to Japan's earliest Buddhist imagery by its artisans and patrons, providing a base from which evolved a native expression in form and meaning.

1. For the tradition of early clay sculpture see Nishikawa Kyōtarō, *Sozō* (Clay images of Buddha), vol. 255 of *Nihon no bijutsu* (Arts of Japan) (Tokyo: Shibundō, 1987).

2. For an overview of this material as well as early Chinese and Korean icons and a map indicating the location of gilt bronzes in Japanese temples and shrines, see *Kondōbutsu* (Gilt-bronze Buddhist images), exh. cat., Tokyo National Museum (1987), especially pl. 21, from the Hōryū-ji trove.

3. For a clear presentation of this material, see *Hōryū-ji: Temple of the Exalted Law,* exh. cat., Japan House Gallery (New York, 1981).

18. Kannon Bosatsu

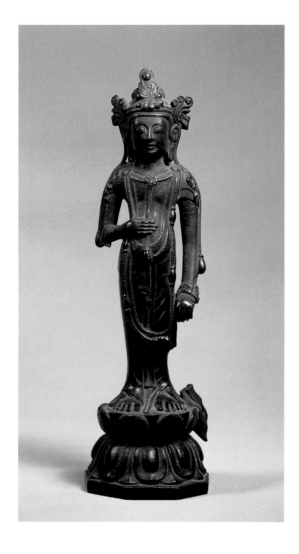

7TH CENTURY; CAST BRONZE; H. 31.1 CM

In the seventh and eighth centuries small portable gilt-bronze images served as the principal icons of worship for the new religion's supporters. These objects did not live then in the impressive monastic compounds or private residences with which we are familiar today. The shifting political landscape in early Japan meant their dwellings were modest in scale and materials, built with portability in mind.

The adoption of Buddhism and its proliferation among ruling class entities resulted in the establishment of small rural temples built for and patronized by these clan leaders and their followers. No doubt this emerging elite class also had spaces in their homes reserved for worshiping the new deities. Shotoku Taishi's residence for example was part of a family "palace" structure that evolved over the centuries into one section of the large temple complex known today as the Hōryū-ji. This most venerated of all Buddhist establishments in Japan at one time possessed hundreds of small gilt-bronze images, most of which survive as a group in the collection of the Tokyo National Museum. They constitute a treasure trove of sculptural styles, casting techniques, and iconography in early East Asian sculpture and include seventh-century Korean gilt bronzes of the Three Kingdoms period as well as images that could have been made on either the Korean peninsula or the Japanese islands.

Among the gilt bronzes from the Hōryū-ji group now in the Tokyo National Museum is one that provides a firm basis for comprehending the beautiful Nara National Museum figure illustrated here.[1] The principal shared features include a high double-stage lotus platform atop a low octagonal base; a tall slim body with long arms; a relatively small head with large tripartite crown and prominent ears and coiffure; long drooping jewelry strands with large round stone or glass beads, and oversized feet with subtly modeled toes protruding from the edge of the robe. Several of these features no doubt derive from seventh-century Tang and Three Kingdoms' examples known in the Hakuhō period in Nara.[2]

The Nara National Museum's small collection of early gilt-bronze statuary makes clear the rapid assimilation of foreign sculptural norms and their distillation into a distinctly Japanese set of appearances and preferred subjects. The identity of this Kannon derives from the seated Amida figure in the crown. The significance of the right hand crossed over and onto the torso holding the pendant necklace chain between the thumb and first finger, while not readily apparent, refers in all likelihood to the more common gesture in gilt bronzes of two hands crossing in front of the body grasping (and sheltering) a precious jewel.

The loss of surface gilding on this figure together with the dark pitted surface it has acquired over the centuries has altered its original appearance dramatically, while lending it a gentleness of surface and subtlety of facial expression appealing to the modern Japanese sensibility. Despite the loss of such "color" and even of the scarves that once trailed down over the right arm and through the left hand to rest on the lotus base, this figure stands out as the most refined of its iconographical type and one of the most finely modeled bronze images of the period.

1. See *Nihon Bukkyō bijutsu meihōten* (Masterpieces of Japanese Buddhist art), exh. cat., Nara National Museum (1995), no. 16.

2. *Kondōbutsu* (Gilt-bronze Buddhist images), exh. cat., Tokyo National Museum (1987), nos. 57–66, 90–91, 112–14.

19. Yakushi Nyorai

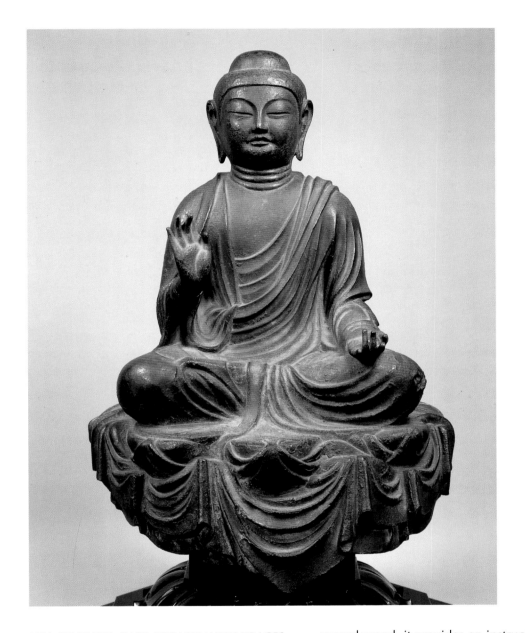

8TH CENTURY; CAST BRONZE WITH TRACES OF GILDING; H. 37.3 CM. IMPORTANT CULTURAL PROPERTY

Right hand lifted in the *semui-in* (fear not) mudra and left hand resting on left leg, palm facing upward to cradle the medicine jar once ensconced there, Yakushi Nyorai, the Buddha of Healing, sits perched on a high cloth-covered pedestal.

Although the lower section of the pedestal is a modern restoration made from black lac-quered wood, it provides an instructive model of one important kind of platform traditionally provided for this type of image in the Nara period. Indeed, a small number of original early pedestals in this configuration remain in Japan, pointing to its origins in Yakushi and Amida imagery issuing from Chinese Tang and Korean Unified Silla models.[1] Typically, a single rank of lotus leaves, most often in a double-petal configuration, surmounts the lower octagonal plate (or set of stepped plates). In these continental proto-

types another thin octagonal plate follows, on top of and from the center of which issue lotus buds curling from the tips of lotus leaves (especially in Silla period examples) and an octagonally shaped pillar, in that order. This middle section provides the focus for such seated figures and, especially, the elevation for displaying the drapery that cascades down from the upper platform, hiding much of its support structure from view.

The irregular pointed surface of the drapery patterns indicates that another lotus base with at least a three-ranked leaf course arranged in a classical alternating configuration underlies this rhythmical cloth design. Each raised point indicates where the Yakushi's robe has caught on the tip of an individual lotus petal, gathered in furls, and dropped again. The Shōsō-in retains an exquisitely preserved example of this lotus pod type, complete with vivid surface colors. Chinese stone sculptures from the mid-seventh and early eighth centuries, some of which are dated, illustrate the general composition of this formal pedestal presentation.[2] In Silla Korea, the ornate stele of 673 from Paekche featuring an Amida triad accompanied by apasaras, musicians, and other attendants illustrates a similar pedestal presentation.[3]

Such Korean and Chinese examples are most often monumental pieces sited in cave settings or placed outdoors for general viewing. In contrast, this seated Yakushi was surely installed in an interior space, either a temple or an aristocrat's home as a private image of worship. In either scenario (the last seems more likely) it possesses the scale and sculptural style reflecting the continent's new wave of sculptural influence in Nara in the Buddhist visual arts. Indeed, among eighth-century kondōbutsu (gilt-bronze Buddhist images) seated in this manner atop this type of stand, it is the largest known and one of the most appealing to the modern design sensibility, which gives particular importance to scale and balance.[4]

The scale and composite organization of religious image, attributes, and furniture augment the aesthetic and expressive qualities of this Yakushi. In particular the robe patterns suggest the fleshy body areas and architectural pedestal underneath, while retaining their own intrinsic decorative vocabulary. These patterns also provide a frame for the deity's

hand and facial gestures. Three thick neck rings connect the chest to the head, which is round and oversized. The plain hair cap and large ears enclose the broad facial mask subtly modeled onto the frontal plane. Especially noteworthy are the mouth and chin areas where ample soft flesh and indented dimples provide focus for the Yakushi's cherubic half-smile. Comparison with an oshidashibutsu mold in the Shōsō-in or a small gilt bronze in the Hōryū-ji, both of similar date and style, helps show the merits of this Nara National Museum Yakushi.[5] The solid gold Buddha of 706, excavated from the pagoda at Hwangbok-sa, offers particularly close parallels in facial modeling and expression.

Early pre-Nara gilt-bronze images, epitomized in the famous Shaka triad of 623 at the Kondō of the Hōryū-ji temple in Nara, frequently adopted a sculptural style based upon Korean models and were no doubt crafted with Korean expertise and materials. Such images done in the Tori studio manner were naturally transformed and adapted over time in Nara, so that by the late seventh to early eighth century indigenous sculptural expressions and preferred iconographical approaches emerged, particularly in Nyorai and Kannon imagery. Yet it is also worth remembering that the iconography of these "newly" introduced images was also evolving, so that categorically identifying certain Buddhist figures is as difficult today as categorically stating an image faithfully preserved in Japan was not Korean or, occasionally, Chinese. Such was the international climate of Nara.

By the late eighth century, when this figure was probably fabricated, Chinese Tang influence had superseded Japan's earlier close connections with Korea, and Nara's metropolitan culture responded in myriad ways, including refashioning previous sculptural idioms. The Buddhist sculpture of this era, in dry lacquer as well as gilt bronze, became for later generations the classical well to which sculptors and patrons went when they wished to measure Buddhism's past aesthetic and formal standards as they prepared to embark on their own efforts. Despite the loss of its former brilliant surface patination (the effects of fire) and the lack of the halo that once framed it, this Yakushi represents one of the most impressive technical and aesthetic accomplishments issuing from Nara's metalworking studios.

The worship of Yakushi began early in Japan, surely no later than the late seventh century. Gilt bronzes or dry lacquer images of the deity, however, are either few or conflated with Miroku Nyorai or even Amida images, because oftentimes the mudras signifying their respective identities are replacements for the originals that were damaged or lost over the centuries. (The right hand of this image has been restored.) But in the seventh and eighth centuries (and even later), as the interpretation and popularity of Buddhist texts evolved, so no doubt did the representation, attributes, and poses assumed by these exciting new Buddhist deities. Thus adaptations more in keeping with contemporary attitudes as well as outright misinterpretations occurred, leading to the modern uncertainty about the identification of some images or even in some instances to the expansion of appearances and mudras that had come to be traditionally associated with a particular deity. Thus the large seated figure "in European style" of the seventh century at the Jindai-ji in Tokyo has precisely the same hand gesture as this Nara National Museum Yakushi yet is called a Nyorai.[6] And later, in the Heian period, close resemblances to Shaka Nyorai images develop, further enriching the fertile iconographical landscape in Nara and Kyoto.

1. See for example the Amida dated 706 from Hwangbok-sa temple outside Kyŏngju in *5000 Years of Korean Art*, exh. cat., Asian Art Museum of San Francisco (1979), no. 83. In China examples exist at Dunhuang and in marble from the central provinces; see Matsubara Saburō, *Chūgoku Bukkyō chōkoku shiron* (Essays on Chinese Buddhist sculpture) (Tokyo: Yoshikawa Kobunkan, 1995), pls. 674 and 714–17.

2. For the Shōsō-in pedestal, see *Shōsō-inten* (Exhibition of objects from the Shōsō-in), exh. cat., Nara National Museum (1993), no. 66.

3. See Kim Won-yong, *Korean Art Treasures* (Seoul: Yekyong Publications), 1986, pl. 81.

4. For an overview of such material, see *Kondōbutsu* (Gilt-bronze Buddhist images), exh. cat., Tokyo National Museum (1987).

5. See ibid., no. 191. For the mold, see *Shōsō-inten*, exh. cat., Nara National Museum (1994), no. 11.

6. See *Kondōbutsu*, no. 127. For an expanded view of Yakushi imagery, see Itoh Shiro, *Yakushi Nyoraizō* (Images and paintings of Yakushi Nyorai), vol. 242 of *Nihon no bijutsu* (Arts of Japan) (Tokyo: Shibundō, 1986).

20. Rikishi

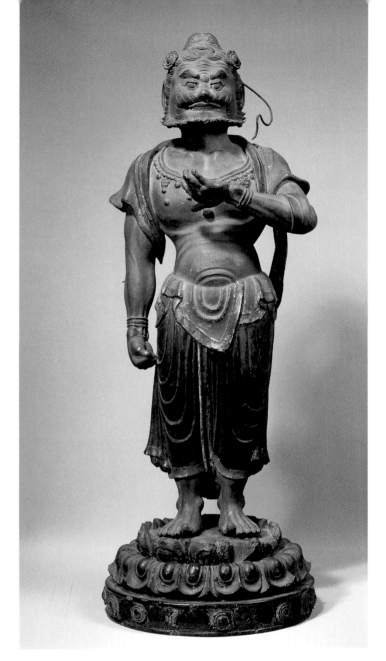

8TH CENTURY; DRY LACQUER WITH POLY-
CHROMY AND GOLD LEAF, H. 59 CM.
IMPORTANT CULTURAL PROPERTY

Although the earliest religious icons brought to Japan from Buddhist Korea were formed from molded clay or cast bronze, it was not long before dry lacquer and then wood images also began to appear from the continent. Soon after, image-making studios were established in the capital of Nara that began producing religious sculptures in lacquer and wood using the technology and expertise gleaned from immigrant craftsmen. Temple building programs—both planned and on-going—were so ambitious that mobilizing the entire country's resources became necessary.

Government buildings and monastic institutions of unparalleled scale and sophisticated architectural design and decor presented extraordinary challenges for temple studios as well as the capital's workforce, which was organized for the most part into an official studio system. Further, the introduction of special materials such as sandalwood or other fragrant woods from China and images fashioned from lacquer meant these studios needed to improve their knowledge of indigenous materials, hone their technical skills, and share information and experience with the other craft studios.

Lacquer had been known and used in an advanced way since at least the Jōmon era, c. 5000 BC.[1] But following the introduction of

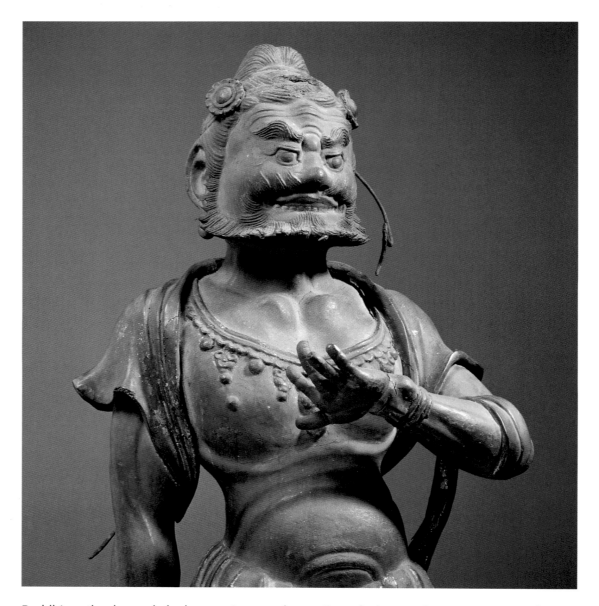

Buddhism, the demands for lacquer increased dramatically, necessitating an exponential expansion of the indigenous production system that had supplied principally decorative coatings for household utensils, furniture, cosmetic containers, and the like. During the Nara period the introduction of three-dimensional Buddhist images from the continent fashioned from lacquer offered a welcome addition to devotional sculpture. In contrast to bronze casting, the fabrication process and the materials permitted greater control and revision—even improvement—of the final image. More intricate decorative schemes could be applied to a sculpture's surface. Another distinct advantage was that lacquer is virtually impervious to water damage and insect infestation.

To make lacquer images, successive layers of hemp cloth soaked in lacquer were arranged over a wood armature or clay core and allowed to dry—in this case, two wood supports and five hemp cloth layers. Detailing and smoothing the surface was accomplished using a paste of lacquer mixed with a fine clay powder or sawdust. Once the core was removed, the resulting durable and highly portable object could be further adorned with polychromy, gold leaf, and even metal attachments. Of the many dry lacquer sculptures from the late seventh through the eighth centuries made for Nara's temple halls, the most famous are the monumental Fukūkenjaku Kannon at the Sangatsudō of the Tōdai-ji (see fig. 6, p. 25) and the set of Ten Great Disciples of Buddha belonging to the Kōfuku-ji (fig. 20a).[2]

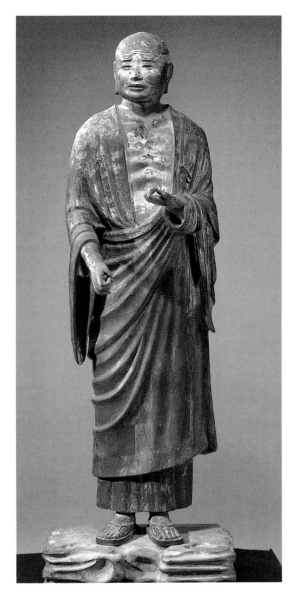

Fig. 20a. One of the Ten Great Disciples of Buddha, dated 734; dry lacquer with polychromy; h. 148 cm; Kōfuku-ji, Nara. National Treasure

This modest-sized image of the protective Buddhist deity known in Japan as Kongō Rikishi is one of the most remarkable and compelling dry lacquer figures to have survived from eighth-century Nara. It is in excellent condition, despite the insect damage to the wood base, also original and related to that of the Eleven-headed Kannon [23]. Dressed simply with a small scarf and waist skirt, and adorned with arm bands, crown, and necklace, the lean muscular figure poses in a stiff authoritative stance, big toes jutting upward, hands and arms taut. Dramatic flaring spikes of facial hair frame its mouth and head (metal wires supporting the lacquer paste are visible protruding from the beard). In appearance and gesture this male figure resembles the familiar ceramic and painted horse groom figures of Tang vintage. Indeed, its "foreignness" is enhanced by exaggerated facial characteristics and abundant tensed facial muscles. These features, as well as the entire body, are rendered with an exceptional clarity and nearly devoid of spiritual (or emotional) content. Because of these features the figure has been identified as a Kongō Rikishi since its sudden emergence from a private Japanese collection less than ten years ago. Traditionally presented as terrifying guardians of the Buddha, these figures are usually portrayed in pairs or sets. They assume vigorous postures on either side of the principal image on the raised dais of a worship hall: one glaring with tightly sealed lips (precisely this figure's expression) and the other grimacing with mouth agape, teeth flashing, beard and sometimes hair curls splaying outward in an overstated display of emotion. The earliest and most famous examples in Japan are a pair of large dry lacquer figures at the Sangatsudō of the Tōdai-ji dated to the mid-eighth century.

The Nara National Museum figure is smaller, much less vigorous in its pose, and simply attired, closer to the Kōfuku-ji disciples in mien and frontal carriage.[3] No other figure closely related in scale, sculptural modeling, and materials has appeared in Japan as the mate to this one. Other surviving lacquer sculpture does not compare particularly well in form or style. However, the seventh- and eighth-century dry clay sculptures still located in Nara temples are important for comparative study, as are some portable sandalwood votive shrines (zushi) that have been jealously guarded and preserved over the centuries in the Esoteric temples of Kyoto and Wakayama province, just south of present-day Nara.[4]

Another pertinent source for comprehending the eighth-century interest in Kongō Rikishi portrayal can be found among the hundreds of gigaku masks stored in the Shōsō-in repository in Nara. Typically carved from one piece of wood and then painted with polychromy and lacquer, these expressive mask-sculptures derived from Central Asian and Korean prototypes were also made of dry lacquer. Used for the annual schedule of dance and music performances at court, Shinto shrines, and Buddhist temples in Nara, these masks with Central Asian features are directly related to the figure illustrated here, whose state of preservation rivals that of the imperially sponsored and protected examples in the Shōsō-in treasury.[5]

1. See N. S. Brommelle and Perry Smith, eds., *Urushi* (Los Angeles: J. Paul Getty Trust, 1985).

2. See Kuno Takeshi, *Kanshitsubotoke* (Dry lacquer Buddhist images), vol. 254 of *Nihon no bijutsu* (Arts of Japan) (Tokyo: Shibundō, 1987).

3. See *Nihon Bukkyō bijutsu meihōten* (Masterpieces of Japanese Buddhist art), exh. cat., Nara National Museum (1995), pls. 45–47.

4. See *Danzō* (Danzō: The tradition of sandalwood imagery in Japanese sculpture), exh. cat., Nara National Museum (1991), pls. 6–18.

5. See *Minamikura 1* (South storage room 1), vol. 7 of *Shōsō-in hōmotsu* (Treasures of the Shōsō-in) (Tokyo: Mainichi Shinbusha, 1994), figs. 13, 27 (dry lacquer); 24, 45, 50, 52, 56, 70–71, 100 (wood).

21. Kokūzō Bosatsu

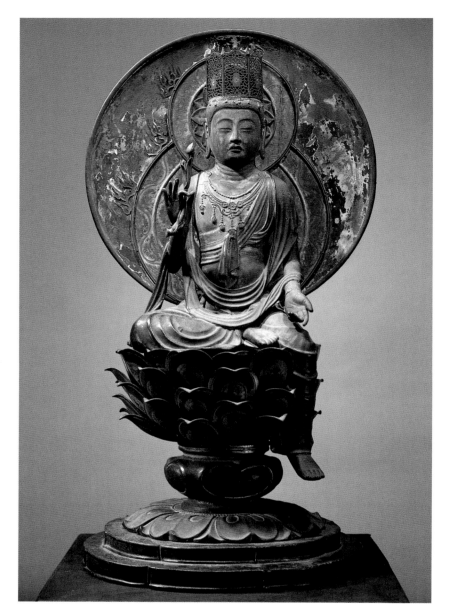

LATE 8TH CENTURY; DRY LACQUER WITH POLYCHROMY AND METALWORK; H. 51.5 CM; KAKUAN-JI, NARA. IMPORTANT CULTURAL PROPERTY

Kokūzō Bosatsu figures prominently in the layout schema of the Taizōkai mandala (Womb World realm) as the central figure of the Kokūzōin realm of that Esoteric composition [41]. There this Bodhisattva of Infinite Space resides as an emblem of the vastness of the dharma's wisdom.

Dry lacquer images from the later seventh century to the ninth century were made using two techniques: building an image in lacquer around a clay shape or wood skeleton [20] or applying lacquer over a solid wood core. In the standard wood-core method, successive

layers of hemp cloth soaked in lacquer are applied over a single block of carved wood. Detailing is achieved using a paste of lacquer mixed with sawdust, wheat chaff, wood ash, and plant fibers to form a putty-like compound that can be shaped before it hardens. Successive applications of an increasingly refined paste allows more finished surfaces. The Tōshōdai-ji and Kōfuku-ji sculpture studios produced such pieces from the late eighth century to the early ninth century, several of which survive, although in poor condition.[1]

Variations on this wood-core technique evolved in the eighth century as it became apparent that using more than one woodblock could result in economies of weight and production. Thus, separate blocks could

be fashioned for the torso, legs, head, and arms and then joined before covering with the lacquer-soaked hemp cloth layers. This approach was used by the artisans who made this Kokūzō Bosatsu image, which employs two principal carved wood plates to frame the image.

The thinner, back plate extends from the neck to the base and its outer face is carved with the shoulder hump and ensuing concave surface visible when viewing the figure in profile (fig. 21a). The front section of wood begins as a narrow core and extends downward into the swelling chest, arm struts, and large lap form. The wheat lacquer paste applied to these sections is particularly thick in the head and hands, where it is the primary material for building up, shaping, and identi-

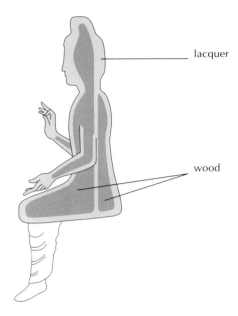

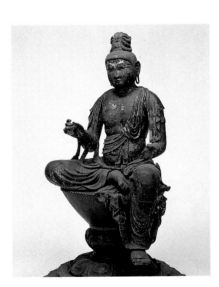

Fig. 21a. Cross-section, showing wood core and lacquer coating

Fig. 21b. Gakkō Bosatsu, 8th century; dry lacquer; h. 56.1 cm; Tokyo National Museum. Important Cultural Property

fying these forms. Smaller, separate pieces of wood were attached to the core to create the pendant leg, and iron wires wrapped around the ends of the arm were used to make the hands and fingers. This method of construction using a joined, multi-woodblock core occurs elsewhere in dry lacquer statuary of the late ninth century modeled in a variety of sculptural styles. The ninth-century seated Nikkō Bosatsu with a pendant leg at the Kōzan-ji in Kyoto and its mate, Gakkō Bosatsu now at the Tokyo National Museum (fig. 21b), are similar in posture and construction method.[2] Stylistically, however, this Kokūzō precedes the Kōzan-ji images by some fifty years and is perhaps better associated with such figures as those at Akishino-dera in Nara, the Kongō Rikishi in this exhibition [20], a seated Kannon Bosatsu from Gankō-ji in Shikoku, as well as the marvelous seated portrait of Yuima in the Hokke-ji nunnery in Nara.[3]

The Kokūzō figure illustrated here has benefited from repairs over the centuries, especially the halo and stand. In fact, a Kamakura period restoration project was crucial to the survival of this rare ensemble of palette and form. An inscription on the pedestal records that none other than the eminent priest Eison (1201–1290) [30, 32, 78] sponsored the refurbishing and repainting in 1282 in honor of the priest Dōji who venerated Kokūzō Bosatsu.[4] This is yet another instance of Eison's influence in thirteenth-century Nara and of the revival of Saidai-ji (Great Western Temple) and its affiliated Shingon Ritsu sect temples throughout the country.

Since the worship of Kokūzō flourished during the eighth and ninth centuries, Eison's gesture takes on special significance. The particular configuration of this image with pendant leg, moon-shaped halo, left hand extended in the *varada* (accepting prayers) mudra, and right hand grasping a lotus bud indicates that it was (and is) a single image rather than part of a set of five Kōkuzō, a more familiar iconography in the later Heian period. As such it served as the principal image of worship at an Esoteric rite known as the Gumonji-hō, which promised improved memory to the faithful. More pertinent, as an independent deity Kōkuzō was considered a visual emblem of the vastness of Buddhist wisdom and thus capable of bestowing seem-

ingly limitless benefits. Never a truly popular Esoteric deity with established iconographical features, Kokūzō Bosatsu images hardly appear in the Kamakura era.[5]

In his capacity as one of early medieval Japan's greatest Buddhist visionaries, however, Eison recognized this particular Kokūzō's religious and cultural significance in the Nara area and sought to honor the deity and the priest Dōji by protecting it from further deterioration. Although the fortunes of the Kakuan-ji have declined over the centuries, this Kokūzō survives as a gem-like reminder of classic dry lacquer sculptural style in eighth-century Nara. Indeed, it is the oldest extant image of this deity in any medium left in Japan.

1. See Kuno Takeshi, *Kanshitsubotoke* (Dry lacquer Buddhist images), vol. 254 of *Nihon no bijutsu* (Arts of Japan) (Tokyo: Shibundō, 1987), figs. 16, 87, 89, 101–10.

2. Ibid., figs. 13, 14, 84–86. The Nikkō and Gakkō images flanked a seated Yakushi Nyorai figure; see figs. 10–12 for other examples of large-scale dry lacquer images with wood cores from the Nara temple lacquer studios.

3. Ibid., figs. 17–18, 71, 89–90. The fabrication technique of the Yuima relates well to the Kokūzō Bosatsu.

4. *Masterpieces of Japanese Buddhist Art,* exh. cat., Nara National Museum (1995), no. 53.

5. For other painted and sculpted images, see Sawa Ryūken, *Mikkyō bijutsu taikan* (Survey of Esoteric Buddhist art) (Tokyo: Asahi Shinbunsha, 1984), 3: pls. 30–37.

Detail of inscription on base

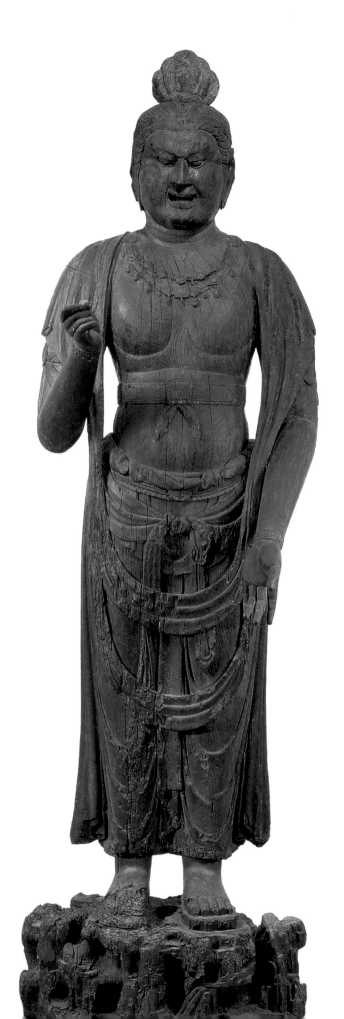

8TH CENTURY; WOOD WITH LACQUER AND TRACES OF POLYCHROMY; H. 168.5 CM; DAIAN-JI, NARA. IMPORTANT CULTURAL PROPERTY

One particularly fascinating aspect of early Japanese history is the relative alacrity with which the people changed residences, villages, and even palaces. As the nation moved toward firmer consolidation in the sixth and seventh centuries, the intense political maneuvering among aristocratic clans accelerated. One primary focus of clan activity was alignments to other clans and to the imperial family. The adoption and support of Buddhism became more common among the members of elite society, and clan-sponsored temples were erected among the villages of the southern Nara plain, the home of the Yamato state beginning in the late sixth century. The Japanese history *Nihon Shōki* (datable to ca. 720) notes that successive rulers moved from one palace-residence to another, a statement that modern archaeological excavations have confirmed.

These temporary palaces were surely no more than newly built residential units, no doubt designed following Korean prototypes of temple architecture. Thus secular and religious construction coalesced around established settlements. Excavations of historic sites provide information about their development, linked by a system of government roads extending to Osaka Bay to the northwest and directly north toward the future capital at Nara, then called Heijō-kyō.

The incorporation of Buddhist temples into state planning represents one important reference point for assessing the new religion's impact on civil affairs in the young nation. At the Fujiwara capital site, a city built on a grid laid out in 694 just before the move to Nara (in 710), numerous government buildings co-existed with nearby temples. In addition, three prominent mountains long known as the residences of powerful Shinto deities, the most potent of which was located within Mt. Miwa, overlooked the entire city.

In that context and setting the majestic solid wood sculpture of the eighth century shown here can be contemplated. The Daian-ji was one of the largest pre-Nara monastic institutions located in the Yamato plain. Founded in 617 by Prince Shotoku Taishi, it

enjoyed continuous imperial sponsorship together with the Yakushi-ji right up to its third move into the city of Fujiwara. By then it had received the name Daikandai-ji (Great Official Temple) and was the site of Buddhist ceremonies held to seek protection for the Yamato state. Its nine-story pagoda was the tallest structure in the land, a symbol of the close ties between secular and spiritual authority. Each of these two great temples in Fujiwara also contained worship halls, statuary, sutra repositories, and a large monastic population. They were the models for the kokubun-ji subsequently erected by imperial edict throughout the country [12].

The present-day Daian-ji—layout, scale, location, and holdings reduced dramatically from its eighth-century circumstances—was transferred by imperial order to Nara in 717 and received its current name. It occupied an entire city block in the new city. Once the administrative center of the emerging kokubun-ji system, it relinquished that position in Nara to the sole imperial temple, Tōdai-ji. In fact, four impressive guardian figures datable to the end of the eighth century at Tōdai-ji were originally part of a large sculptural ensemble at Daian-ji.

An impressive group of eighth-century wood images survives at the temple, however, including this Yoryū Kannon. No longer in a worship hall, it now resides in a concrete treasure house to protect it from fire.[1] Carved from a single piece of Japanese cypress wood (*hinoki*), including the base, which has suffered insect infestation, the figure stands well over life-size on its craggy pedestal, with left hand extended downward, palm facing the viewer. The right arm is raised from the elbow, with an open fist as if it held an attribute such as a *kundika* (water vessel) or a lotus stem, as in other Kannon imagery. Because the arms are restored and the facial expression—a scowl—does not conform to other Kannon representations, modern scholarship regards the traditional designation of the figure as a Yoryū Kannon with some skepticism. While it has lost its original polychromy, this imposing image is complete other than a new topknot and arms. The exposure of raw wood grain over centuries is a feature it shares with a group of well-known eighth- and ninth-century standing figures in Nara and Kyoto temples, the most important

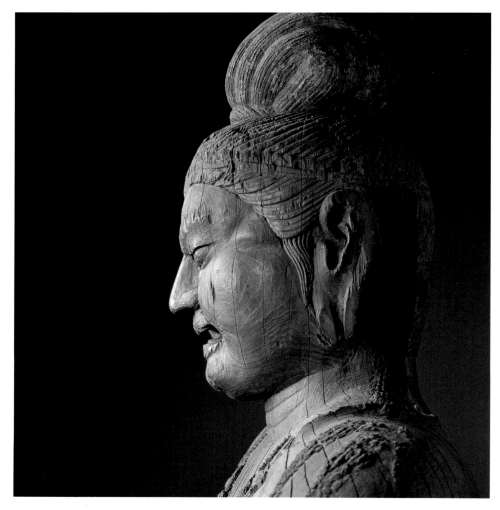

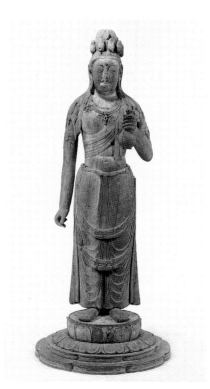

Fig. 22a. Jūichimen Kannon, 8th century; wood with traces of polychromy; h. 191.5 cm; Yakushi-ji, Nara

of which are those at the Tōshōdai-ji in south-western Nara. These pieces are especially significant because they represent a turning point in Japanese sculptural history that would come to illuminate the character, stylistic attitude, and materials of ensuing sculptural production in Japan.

Before these works were carved in the mid-eighth century, the official image-producing studio at the Tōdai-ji turned out Buddhist statuary that set standards of style, iconography, and materials. Gilt bronze [19], clay, and dry lacquer [20–21] predominated. Consequently, the appearance of the massive, vigorously carved wooden Buddhist images from the independent workshop at the Tōshōdai-ji proved something of a sensation in the capital, gaining a following of admirers—patrons and craftsmen alike. The founder of Tōshōdai-ji was the eminent Chinese priest Jianzhen (688–763), known in Japan as Ganjin, who brought with him to Nara in 754 artisans skilled in dry lacquer and wood image making. Like the Korean immigrant craftsmen

working in the Tōdai-ji workshops, these Chinese immigrants guided and trained native artisans, many of whom subsequently assumed control of sculpture workshops at other independent temples in the area that enjoyed the patronage of Nara's aristocratic families. Thus the impact of Tōshōdai-ji–style wood sculpture in the second half of the eighth century flowed both to other metropolitan monastic institutions and to smaller, more modest temples in the outlying countryside.

This Daian-ji Kannon represents a special interpretation of a style emphasizing scale, rigid frontality, and basic symmetry. But in its relative slenderness and lack of emphasis on schematized surface drapery, it departs from the emerging Tōshōdai-ji vogue. In addition, its scowling face, rock-like pedestal, and elaborate surface decor of jewelry, scarves, and garment bands represents a distinctive approach to sculptural form prior to the introduction of formal Esoteric imagery in the ninth century.[2] In fact, the entire group of remaining Daian-ji wood figures—nine in all plus

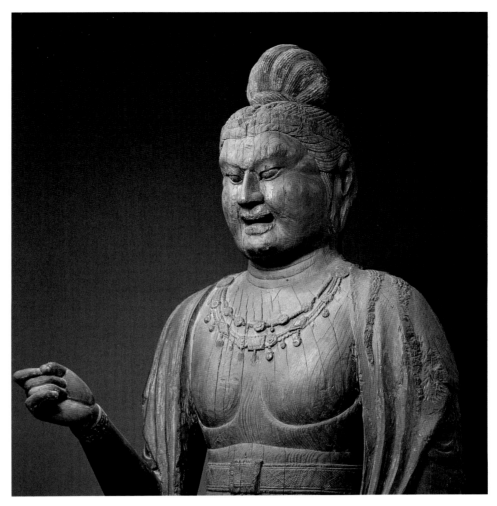

the four, dry-clay guardian figures that were transferred to the Tōdai-ji—suggest the likely existence of an independent sculptural workshop at the temple, one that favored maintaining close ties to Chinese-style sculpture.

Despite the inevitable evolution and development of an indigenous tradition, maintaining those ties was still a strong impulse in Nara. Even at the Tōshōdai-ji more than a single sculptural aesthetic can be discerned in the later eighth century, as figures of a Jūichimen Kannon there and at the nearby Yakushi-ji make clear (fig. 22a). In size, formal appearance, and surface treatment they share close kinship with this Daian-ji Kannon. The formulation for these pieces lies in Chinese Tang dynasty sculpture carved from aromatic woods, examples of which were highly revered in early Buddhist Japan.

The tradition of Jūichimen worship in particular provides pertinent examples [23, 31, 45, 66] supporting this view. Without knowing the original setting or iconography of this figure, gaining a fuller comprehension of its

particular meaning for worship at the Daian-ji with the other statuary is difficult. In this century the temple's principal image of worship is an eighth-century Senju Kannon. Still, it is possible to catch in this remarkable image a glimpse of that temple's special place among Nara's grand monastic institutions and the flavor of Esoteric Buddhist imagery that would so influence Buddhist art during the next five hundred years.

Also of note is the pedestal carved in the form of a craggy rock plateau. This is a rare example for Japanese Buddhist images of this date, although such pedestals do appear in China and later in Kamakura period sculpture in Japan. The flat boards under each foot also appear in the Thousand-armed Kannon and Shōkannon at Daian-ji and can be seen as well in late Tang sculpture. Finally, remnants of a lacquer paste used for hair curls, a white ground, and pigmentation indicate that it, like the Tōshōdai-ji group, was in all likelihood originally adorned with surface polychromy. This Yoryū Kannon must have been espe-

cially vivid, even startling, to worshipers who entered the Daian-ji's dimly lit devotional hall. While other solid wood icons at the temple share its bulging eyes and scowling face, they seem not to have endured as a sculptural idiom into the Heian period.

1. For a group of related eighth-century wooden statuary, see *Nihon Bukkyō bijutsu meihōten* (Masterpieces of Japanese Buddhist art), exh. cat., Nara National Museum (1995), pls. 62–67. See also Sawa Takaaki, *Art in Japanese Esoteric Buddhism* (New York: Weatherhill/Heibonsha, 1972).

2. For the range of expression in the Tōshōdai-ji studio style and related images in other temple collections, see *Kannon Bosatsu* (Imagery of Kannon Bosatsu), exh. cat., Nara National Museum (1998), pls. 15–20. See also *Tempyō* (The magnificent heritage from the days of the Great Buddha), exh. cat., Nara National Museum (1978), pls. 43–50.

23. Jūichimen Kannon

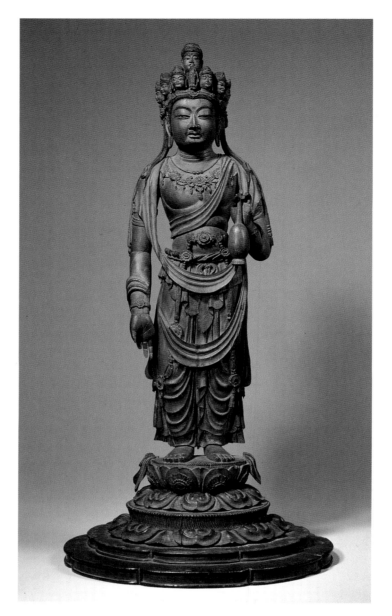

LATE 8TH CENTURY; WOOD WITH POLY-
CHROMY AND GOLD PAINT; H. 42.8 CM.
IMPORTANT CULTURAL PROPERTY

Jūichimen Kannon, the Eleven-headed
Kannon, is one of the traditional thirty-three
manifestations of the deity Kannon tradition-
ally acknowledged in Japan since at least the
seventh century [31, 45, 66]. Kannon is
closely linked to Amida, the Buddha who
normally appears as part of Kannon's crown
design. The various aspects all reflect in some
manner this bodhisattva's fundamental iden-
tity as a catalyst of mercy and compassion.
This trait is illuminated in the earliest Bud-
dhist sutras introduced into Japan in the sixth
and seventh centuries, which were then inter-
preted, promulgated, and used to help formu-
late painted and sculptural images of this
deity, as well as portable oshidashibutsu of
the seventh century.[1]

Interestingly, two of the earliest images of
this deity come from a major religious site of
the native Shinto and imported Buddhist
faiths. An impressive mural painting on the
east wall of the Kondō (constructed ca. 607)
at the Hōryū-ji, the family temple of the new
religion's most vigorous supporters, reflects
the refined majestic style of Tang painting. Its
presence there, like the oshidashibutsu, indi-
cates the acceptance of Jūichimen belief and
imagery at that time. Also datable to the latter
part of the seventh century is a small (31.4
cm) gilt-bronze image retrieved from one of
Shinto's most sacred sites: the Nachi water-

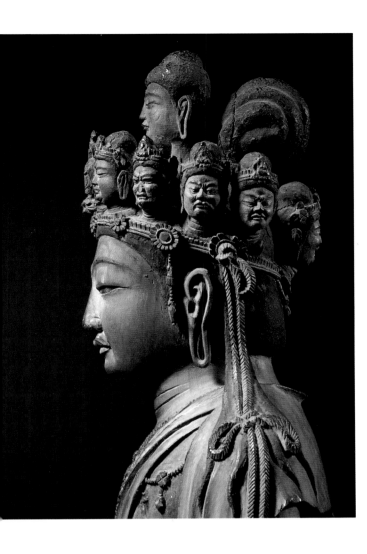

fall, part of the Kumano Shrine complex in Wakayama Prefecture well south of Nara.[2]

Judging from the number of Jūichimen images that survive today in Japan, however, this deity's real popularity began in the eighth century and endured into the Kamakura period. This is also just the time when fragrant sandalwood sculptures (known in Japan as *danzō*) from Tang China (of the seventh century), some of which had found homes in Nara temples, began to become prevalent among the devout in Japan [22, 25, 32]. This image from the Nara National Museum is among the finest and earliest Japanese portrayals of the deity known.

Traditionally dated to the ninth century in the early Heian period, it may very well be considered as a product of the eighth century.[3] It shares close affinities (stylistic and iconographical) with the eighth-century figures at Dōmyō-ji in Osaka, Jimpuku-ji in Yamaguchi (probably Chinese), and in this exhibition with the late Nara period aesthetics of the Kakuan-ji Kokūzū Bosatsu [21].[4]

The attributes, adornment, and construction of the figure are noteworthy. Although the figure is carved from one piece of wood (as yet unidentified), the lower stage of the base is carved from a separate, different type of wood. A hole in its center accepts a single wooden tang from the lotus base above, securing it. Also distinctive is the unusual manner in which the left hand, palm facing outward, frames the neck of the water bottle (*suibyō*), an established attribute of this deity since the seventh century. The thumb and the two fingers (broken at their tips) encircle the spout, allowing the rest of the form to hang dramatically before the viewer.

Jūichimen's most compelling attribute is a remarkable array of exquisitely carved miniature heads. Here the deity's topknot appears not in the center of the cranium as is usual for Eleven-headed Kannon images, but at the back. This placement and the two holes (now filled) in the head suggest that the headdress had additional ornamentation, enhancing the presentation of the multi-headed assemblage. The small heads are arranged in groups of three: three bosatsu in the front; three looking angry at the proper left; and three with tusks coming out of their mouths. A single laughing face is at the rear, and the larger head representing Amida caps the whole composition.

Each head provides visualization for one aspect of the deity's doctrinal attributes, although variations do occur in painted, sculpted, and engraved images. Here the bosatsu look compassionate; the angry heads attract those with evil intentions; the three with tusks alert those with good karma; the laugher at the back (normally hidden from the view of the laity) prompts wrongdoers to correct their ways; and the large Amida head signals the dharma path to those already intent on pursuing Buddha's teachings. All these heads were formed from the single block of wood (as was the water jar). The fundamental recognition of Jūichimen and its spiritual efficacy among the devout was based in large part upon the visual correlation between Esoteric religious texts' espousal of eleven vows to guide sentient beings and the palpable realization of these aspects in three-dimensional form. While new interpretations—both textual and visual—evolved among the Buddhist clergy, the fundamental appearance of Jūichimen was carried into the Kamakura period, after which it languished.

1. For an unusual and important Jūichimen oshidashibutsu image in the Hōryū-ji, attached to the back side of an Amida Triad of the late seventh century, see *Hōryū-ji kennō hōmotsu* (Treasures donated by the Hōryū-ji), exh. cat., Tokyo National Museum (1996), no. 190.

2. See Fukushima Hiromichi, *Jūichimen Senju Kannon-zō* (Eleven-headed and Thousand-arm Kannon imagery), vol. 311 of *Nihon no bijutsu* (Arts of Japan) (Tokyo: Shibundō, 1992), pls. 3–4 (Hōryū-ji painting).

3. The curator of sculpture at Nara National Museum, Inoue Kazutoshi, will soon publish an article presenting this view.

4. For the Dōmyō-ji image, see Fukushima Hiromichi, *Jūichimen Senju Kannon-zō*, fig. 50. For the Jimpuku-ji figure and related images, see *Higashi Asia no butsutachi* (Buddhist images of East Asia), exh. cat., Nara National Museum (1996), pl. 50.

24. Yakushi Nyorai

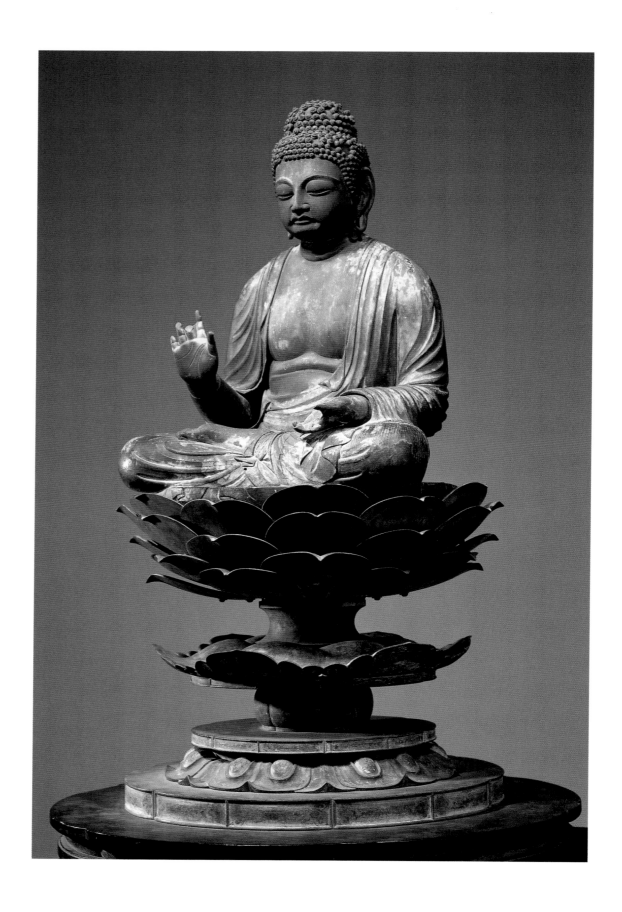

9TH CENTURY; WOOD WITH TRACES OF
POLYCHROMY AND LACQUER; H. 49.7 CM.
NATIONAL TREASURE

The Healing Buddha, Yakushi Nyorai, was especially popular during the early Heian period, and many images were executed for worship halls and private residences in the ninth and tenth centuries. But the presence of this deity was known well before then, in at least the seventh century, when the Hōryū-ji was established and became one of the great centers of Buddhist learning in pre-Nara period Japan.[1] Among the mural paintings in the golden hall is a depiction of Yakushi seated European-style surrounded by his followers and heavenly beings in paradise (unfortunately lost to fire in 1949 and replaced by a copy). Seated on the raised central platform are a number of important early Buddhist sculptural images in wood and cast bronze, among which is a late seventh century bronze image, framed by a halo, of Yakushi that bears the date of AD 603.[2] Judging from these impressive examples and a number of smaller gilt bronzes, the Healing Buddha must have been an accepted image in the Nara and Asuka areas. By the eighth century the magnificent large cast-bronze devotional image at the nearby Yakushi-ji had been placed in the temple's Kondō (see fig. 4, p. 24).

Thus, both large and small, standing and seated images appear before the late Heian period, all fundamentally identifiable by the extended proper left hand resting on or against the left leg, palm open and facing upward to accept the defining emblem of the deity: a small, lidded medicine jar (missing here). This left-hand gesture, considered in concert with the raised right hand, palm facing outward toward the viewer, helps identify the deity as Nyorai. The Hōryū-ji images (and others) provide a reliable iconographical context in Japan for the subsequent transformations of this deity that take place. But popular recognition of the deity as Nyorai, who vows to guide the faithful toward enlightenment by removing the obstacles of illness and disease,

won great favor in early Japan where these afflictions were normal and associated with uncleanliness, according to earlier Shinto beliefs. Although this stunning image has lost several fingers, it appears to have been in a normal pose, signifying a variation of "fear not" (proper right) and "wish granting" (proper left) mudras.

The image was carved entirely from a single piece of *kaya* (Japanese nutmeg) wood, including the base in the form of a lotus bud. (One small replacement piece carved for the restoration of drapery folds at the very front of the base has been added.) The lower parts of the dais are modern.

The clarity, strength, and sheer beauty of the carved wooden form and surface are apparent. This mode of depicting drapery folds as an alternating pattern of wide scooped areas bounded by rounded furls or shapely pointed ridge lines is well known in Japanese sculpture of this era, but rarely has it achieved such an extraordinarily pleasing aesthetic effect. Enveloping the compact fleshy body of the Yakushi, the robe helps define this meditative deity, whose modest scale assists also. The robe shows clear evidence of the polychromy that once adorned its surface, most of which has been lost, revealing the warm texture and grain patterns of the wood. This same patination—*gofun* (white powdered shell with a binder) over which a light yellow pigment is applied—appears also in the special category of Buddhist sculpture in Heian and Kamakura Japan known as danzō [23].[3] Specifically commissioned to be carved from fragrant woods, such images were thought to impart special efficacy to an image, based in part on the rarity (and expense) of the material imported from the continent. The Shaka of 985 brought to Japan from China two years later provides the actual sculptural basis and historical documentation for examining this tradition of sculpting in East Asia and for its related manifestations in Japanese art [see 32].

Thus by the early ninth century in Japan, it is apparent that the specific nature of various woods was carefully considered and the level

of sculptural sophistication extraordinary. This point is historically noteworthy because the previous tradition of image making had been done almost exclusively in dry lacquer and metal, crafts with vastly different technical requirements. Still, a small number of single wood-block images from Nara studios in the seventh and eighth centuries [22–23] provide historical and iconographical background for this remarkable piece. The most important are the large figures issuing from the Tōshōdai-ji's sculptural studio, the related images at the Daian-ji, and the Miroku Nyorai from Tōdai-ji in this exhibition [25].[4]

Currently within the spectrum of Japanese sculptural history there exist two images closely related to this seated Yakushi, the most important of which is a seated Amida Nyorai with flanking figures of similar dimensions and date in the Shitennō-ji in Osaka (fig. 24a). The Shitennō-ji is a very old temple, preceding in fact the Hōryū-ji. The sculptural conception of the Amida figure there, as well as details of surface carving, drapery configurations, and dais shape, strongly suggest that the Nara National Museum and this Shitennō-ji figure issued from the same sculptural studio in Nara. The other, smaller figure that properly belongs to this group is the Cleveland Nikkō Bosatsu (fig. 24b). Comparison of these three figures with other related, but distinct ninth-century sculptures reveals their special aesthetic niche in early Heian sculpture.

The provenance of the Nara National Museum Yakushi Nyorai includes the important and intriguing information that at least in the late nineteenth century it was the principal devotional image at the Nyakuō-ji Shinto shrine in the Higashiyama hills of eastern Kyoto. Thus it demonstrates, as do other pieces in the exhibition [28, 54, 56, 64–65, 67, 76], the palpable expression of *honji suijaku,* whereby native Shinto spirits found visual expression in corresponding Buddhist forms and vice versa. Whether this Yakushi

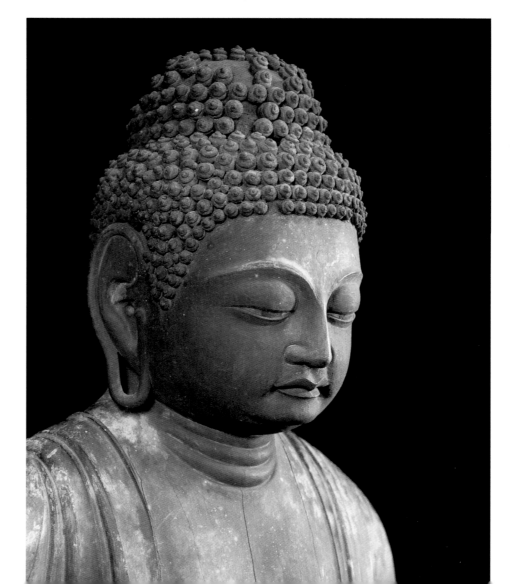

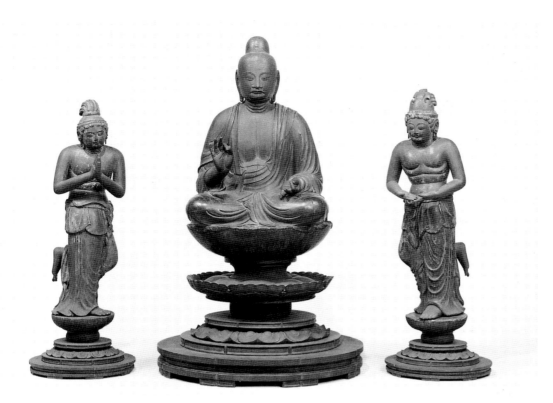

Fig. 24a. Amida Nyorai and two attendants, 10th century; wood with traces of polychromy; h. 50 cm; Shitennō-ji, Osaka. Important Cultural Property

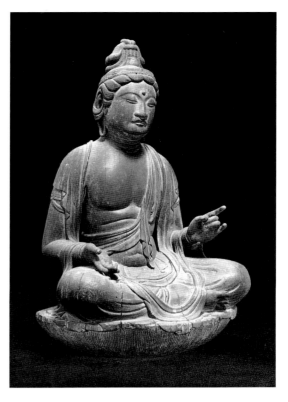

Fig. 24b. Nikkō Bosatsu, ca. 9th century; wood with lacquer and gold paint; h. 46.7 cm; The Cleveland Museum of Art, John L. Severance Fund 1961.48

image was made in the ninth century for the Nyakuō-ji Shrine or—more likely—was moved to the site at a later, unknown date has resisted investigations in this century. It is common for Buddhist icons to have been transported from one location to another, often on numerous occasions, since their original commissioning.

Whatever the history of its placement, its modest size and superlative sculptural expression suggest the work of a master craftsman and sophisticated patron in the ninth century. It is clear, however, that at the end of the nineteenth century, when the support of Buddhist temples and Shinto shrines was undermined by the Meiji government's reforms seeking the separation of church and state, this image, like many others, was destined to leave its sacred place at the shrine.

1. For the history of this important temple, see *Hōryū-ji: Temple of the Exalted Law,* exh. cat., Japan Society Gallery (New York, 1981), 20–31.

2. See Itō Shirō, *Yakushi Nyoraizō* (Images and paintings of Yakushi Nyorai), vol. 242 of *Nihon no bijutsu* (Arts of Japan) (Tokyo: Shibundō, 1986), pls. 1–2, 30–32. The halo originally belonged to another Yakushi figure, now lost.

3. See *Danzō* (Danzō: The tradition of sandalwood imagery in Japanese sculpture), exh. cat., Nara National Museum (1991).

4. Ibid., pls. 33, 36, 44, 47–54, 57–58.

25. Miroku Nyorai

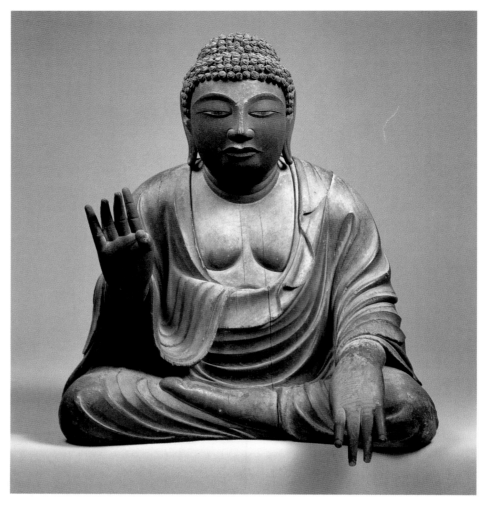

9TH CENTURY; WOOD WITH TRACES OF
POLYCHROMY AND LACQUER; H. 39 CM;
TŌDAI-JI, NARA. IMPORTANT CULTURAL
PROPERTY

Like the Yakushi Nyorai [24], this seated image of Miroku Nyorai combines remarkable aesthetic and spiritual sophistication with an anonymous sculptor's ability to channel his considerable technical skills toward elucidating quiet religious fervor. Barely fifteen inches tall, this unadorned image of the Future Buddha was made from a single block of hinoki, except for the right hand and "snail" curls of the hair. The loss of a thin dark layer of lacquer over the body (but not the neck and face) through the centuries has revealed the natural wood grain and the network of fine chisel marks.[1] It has also allowed closer viewing of the restrained yet complex organization of the sculpted surface. The figure's broad upper torso and enlarged head provide ideal surfaces for rendering thick fleshy body swellings framed by razor-sharp edges and contouring lines. The sculptural mode is actually lively, even aggressive, in extending the limits of naturalistic proportion without unduly exaggerating the placement or the shape of the head or the hands. Like the Yakushi, too, the image extends beyond its platform, making clear the sculptor's intent to portray the latent religious power of the deity as well as offer a tangible gesture of human accessibility, accentuated by the extended left hand.

Indeed, Miroku promises to the devout the prospect of rebirth. The deity is identified here both through temple tradition and by the mudras that may be particular to a small number of Nyorai images done in the Nara area.[2] Of iconographical note is the fact that within the repertoire of Buddhist sculptural imagery during the mid-Heian period, Miroku appears relatively infrequently. Amida Bosatsu and Yakushi figures make up by far the majority of iconographical types. Miroku images are well represented in the Hakuho and early Nara periods however, when belief in the deity was especially fervent.

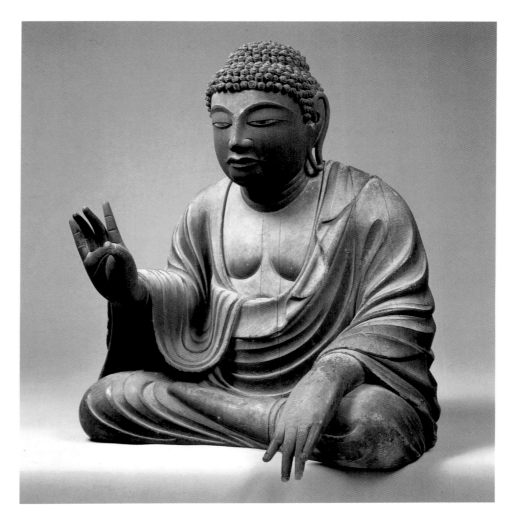

Future inquiry will no doubt be directed also into discerning the meaning of the humble scale of this figure and other ninth-century plain wood images. On the one hand, it issues out of the unpainted fragrant wood carving tradition known in Japan as danzō, which includes a number of modest-size and even miniature images and portable shrines.[3] The Jūichimen Kannon [23] is also an excellent, earlier example of this type. It may be that despite coming from Nara's largest Buddhist institution, where scale in the visual representation of religious imagery and furniture remained an issue of continuous relevance, sculptures such as this one were commissioned for special, private needs. Such a tradition exists regarding this Miroku at the Tōdai-ji, but there is no documentation to substantiate it. In addition we know that for years it was treated as a kind of secret image, hidden from view in a zushi at the Hokke-dō within that monastic compound.

Be that as it may, this Miroku remains a figure of singular spiritual and aesthetic force, and one of the most compelling and approachable Buddhist icons in all Japanese art. Moreover, it holds an important position in the history of the development of plain wood (and danzō) sculpture in Japan, for perhaps as much as any other sole figure, it demonstrates palpably the moment at which the internal forces at play in ninth-century Nara and Kyoto shaping the religious ideas, technical requirements, and aesthetic character of a truly native sculptural expression coalesced in an object of unremitting human sincerity and spiritual passion.

1. Kurata Bunsaku, *Jōgan chokoku* (Jōgan style sculpture) (Tokyo: Shōgakkan, 1971), pls. 48–49.

2. See one explanation in *Tōdai-ji,* vol. 2 of *Rōkudai-ji taikan* (Survey of Nara's six great temples) (Tokyo: Iwanami Shōten, 1968), 64–65.

3. See *Danzō* (Danzō: The tradition of sandalwood imagery in Japanese sculpture), exh. cat., Nara National Museum (1991).

26. Nyoirin Kannon

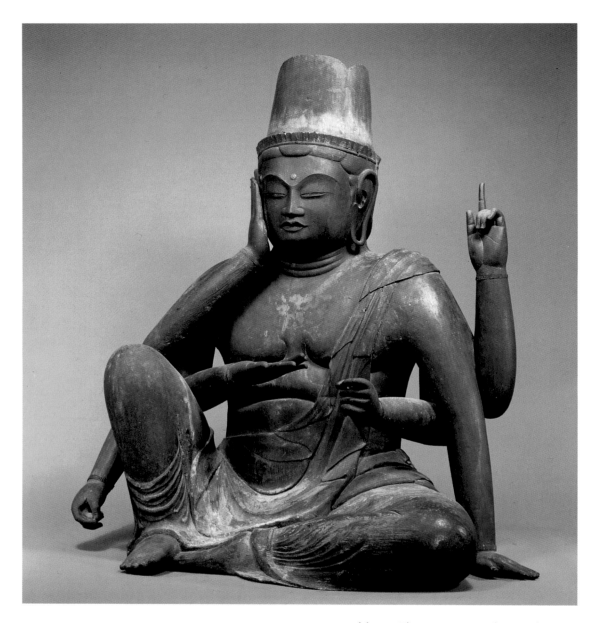

LATE 9TH–EARLY 10TH CENTURY; WOOD
WITH TRACES OF LACQUER AND POLY-
CHROMY; H. 94.9 CM. IMPORTANT CULTURAL
PROPERTY

This impressive figure of the Nyoirin Kannon,
one of the six principal forms of Kannon wor-
ship in Esoteric Buddhism, is carved princi-
pally from one massive block of hinoki. Two
separately carved wood segments joined to
the torso create the legs. The rich brown,
grained surface still shows vestiges of the lac-
quer coating and polychromy it once bore,
which age and exposure have effaced, espe-
cially in the lap area.[1]

The figure is a quiet but powerfully orches-
trated sculptural essay on space and broad
volumes, stasis and precisely stationed move-

ments of form. The open, seated pose derives
from the so-called royal-ease position (*rinōza*)
known in early Indian art and adopted in
later Chinese stone statuary. Some of those
statues were perhaps seen and collected by
Japanese monks traveling on the continent in
the Nara period, but no early examples sur-
vive in Japan. Examples from the Tang period,
while rare, no doubt existed but were lost
in the ninth-century pogrom in China against
the Buddhist faith and its institutions. Icono-
graphical drawings from the early Heian pe-
riod in Japan, however, show Nyoirin's power
and transformation into a Japanese Esoteric
deity of impressive aesthetic and religious di-
mensions. By the tenth century, it had secured
special status among Esoteric imagery, often
becoming a temple's principal icon of wor-

ship, even as a "secret" or hidden icon.

Nyoirin's pose must have been appealing and welcome to devotees of the Tendai sect of Esoteric Buddhism because images of many other deities in its vast pantheon look dour or even scowl. The relaxed posture is inviting, and the hand raised against the cheek as if the figure were in thought adds a decidedly human touch. The flaming (wish-granting) jewel (*nyoi hōju*) and spoked wheel (*rinbō*), which symbolizes the "wheel" of Buddhist law, refer to the deity's mandate to use its substantial powers to assist mankind. The deity's name, Nyoirin, derives from these two ritual emblems (nyoi and rin), which are modern replacements for the original attributes. Thus Nyoirin is the Bodhisattva of Mercy of the Wish-Granting Jewel. The other arm on the left once held a lotus blossom on a long stem, the one on the right a set of rosary beads (see detail of Nyoirin Kannon hanging scroll [49].

The wonderful tubular arms—their length and girth, plainness, and especially their positions in relation to each other and to the torso—enliven the entire sculptural form. The expansive lap and gently swelling legs are shaped and positioned so as to anchor the broad upright torso in a series of rhythmic swellings of flesh and thinly modeled patterns of the robe. These themes of grounding and release, dense form and openness, help frame the head, which is supported by the traditional three-banded neck and tapers into a massive vertical cap once encircled by an open metalwork crown with beadwork decor. The facial features are chiseled sharply and shallowly into the broad plane of the subtly modeled head. Indeed, the entire surface of the face has been finished to a degree not evident elsewhere on the figure, suggesting the focus of the sculptor on Nyoirin's thoughtfully pensive gaze.

Nyoirin, one of the six principal compassionate deities responsible for supervising the six stages of rebirth, held an important position in Esoteric Buddhist practice, particularly among Tendai sect adherents. Those who sought assistance searched and went to the fifth stage, where devas with supernatural powers resided. But such supplications in worship halls were normally conducted without Nyoirin in view, for traditionally the deity was hidden away behind the closed doors of

a lacquer zushi. Its allure and power seem only to have been enhanced by such treatment as a secret icon.

Just when this image was carved and where it was then installed is not known. Conjecture based on temple records in Kyoto and on its northern Japanese seacoast border (Tango) suggest the figure originally came from that vicinity and was moved on at least two occasions. Such relocations are not unusual events in the history of an image, a temple, or the lineage of priests responsible for the well-being of the temple, which might also change its religious affiliations over time from one Buddhist sect to another.

Lacking other forms of documentary evidence, this Nyoirin has been dated according to an assessment of its sculptural style. Its expansive robust form highlighted with shallowly carved garment detailing, together with the distinctive *hompa shiki* (wave pattern) surface designs in the leg garb, point to a time frame of late ninth to the first half of the tenth century. As such, it represents the second oldest sculpture of Nyoirin Kannon extant in Japan. The oldest and most venerable is the dry lacquer secret image at the Kanshin-ji in Osaka Prefecture.[2]

1. See Miyake Hisao, "Nyoirin Kannonzō" (An image of Nyoirin Kannon), *Kokka,* no. 1008 (1978), 38–43. See also Inoue Kazutoshi, *Nyoirin Kannonzō, Batō Kannonzō* (Images of Nyoirin Kannon and Batō Kannon), vol. 312 of *Nihon no bijutsu* (Arts of Japan) (Tokyo: Shibundō, 1992), pls. 2–4, 6.

2. For other related Nyoirin images, see *Kannon Bosatsu* (Images of Kannon Bosatsu), exh. cat., Nara National Museum (1977), nos. 38–41. The tenth-century Daigo-ji image retains its original openwork crown.

Detail of Nyoirin Kannon [49]

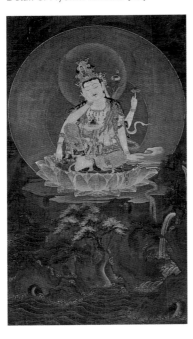

27. Jizō Bosatsu

10TH CENTURY; WOOD WITH BLACK LAC-
QUER AND CRYSTAL EYES; H. 103.8 CM;
DAIFUKU-JI, NARA. IMPORTANT CULTURAL
PROPERTY

Although no longer the vibrant temple it once was, the Daifuku-ji still serves its neighbor-hood parishioners in southwest Nara, not far from the Hōryū-ji in Ikaruga. Indeed, these temples have enjoyed a long relationship. This standing figure represents Jizō, a deity introduced into Japan in the eighth century as part of the Esoteric pantheon but whose popularity truly blossomed in the later Heian and Kamakura eras. In part this phenomenon was the result of the common belief that after the expected death of the Historic Buddha [17] mayhem and lawlessness would prevail on earth, followed by the arrival of Miroku, the Future Buddha [25]. It was into this inter-regnum that Jizō Bosatsu, a deity of compas-sion and benevolence, fell. Coinciding with the late Heian period rise of Amidism, inter-est in Jizō's powers expanded dramatically because he was viewed as an important at-tendant to Amida. Sculptural images of Jizō began to be produced in the mid-ninth cen-tury and production was sustained well into the fifteenth century and into the realm of folklore through the widespread expansion of his traits and powers.

Two basic image types are known in either seated or standing positions: in the earlier sculptural tradition Jizō is elaborately dressed as a monk holding a shakujō [81] in the proper right hand and the sacred jewel in the left; in later works the figure has a solemn introspective facial expression, wears only a robe, holds a sacred flaming jewel in the extended left hand, and makes the wish-fulfilling mudra with the lowered right hand. The first sculptural tradition, found primarily in ninth- and tenth-century images such as this example, portrays the deity prior to the accretions of Kamakura popular lore and the post-mappō optimism of the twelfth century. In these later versions Jizō acquired not only the guise of an itinerant monk but seemingly

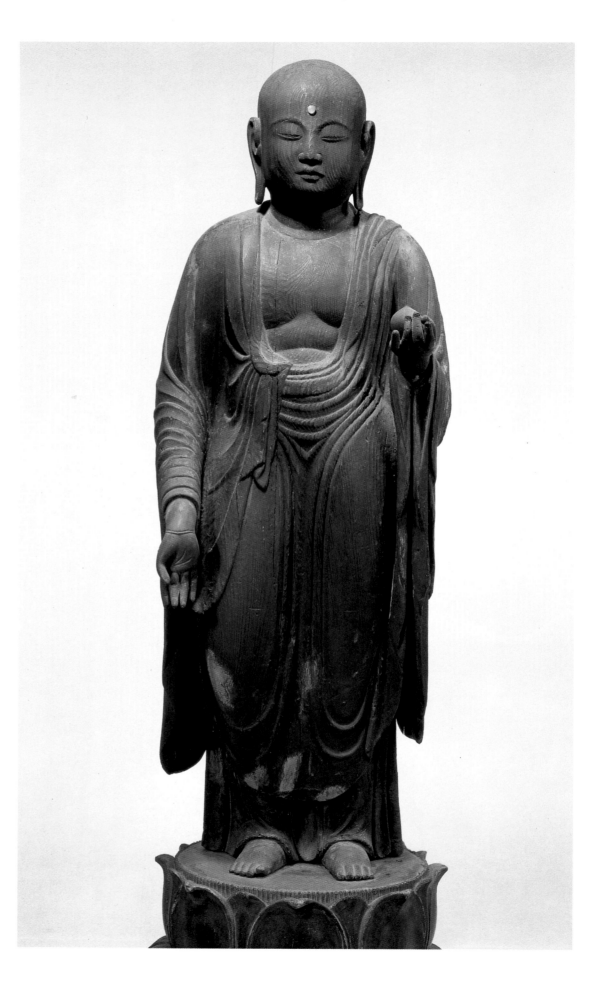

limitless power in soothing the complaints and curing the ills of children, mothers, samurai, and travelers.

The stocky proportions of this figure help place it in the earlier, plain wood style of the ninth and tenth centuries. The broad torso and thighs are linked together by a common surface language of swelling body areas and curvilinear surface patterns in the robe. This robust sculptural mode derives from the life-size or over life-size images of the eighth century produced from single wood blocks (ichiboku zukuri) for the Nara area's six great temples, such as Tōshōdai-ji and Daian-ji [22]. But here, as in many other later Heian Jizō examples, the image is smaller, the torso seemingly more compact and stocky, and the head proportionally larger than its eighth-century precedents.[1]

The fabrication of this image is noteworthy. It was formed principally from one piece of wood, but the head was detached and split into two pieces and joined bilaterally behind the ears. The two pieces were hollowed out to help prevent the cracking and checking of the wood (fig. 27a). At some subsequent point the torso itself was also split in half, hollowed out, and then reassembled. Later in its history the hands, lower legs, feet, and base were damaged. These features were carefully restored in the Taishō era (1912–26) by the Bijutsu-in sculpture conservation studio at Kyoto National Museum. The pedestal was also made then. The entire image was coated with a layer of thin black lacquer, unifying the surface except where isolated brown patches identify even more recent minor repairs. The gilded wood halo featuring twelve radiating spokes of light (the photograph was taken without the halo, but it will be incorporated into the sculpture for the exhibition) is a later, Edo period, addition, reminiscent of that seen in the Raigō shūbutsu [72].

Overall, those efforts helped maintain this modest but impressive figure. The unpretentious but dynamic surface modeling and rhythmic interlocking drapery patterns create an appropriate framing structure for Jizō's chest and head. While the carving of the facial features is sensitive, it is shallow compared to other ninth-century images [24–25], suggesting a date closer to the tenth century.

A number of Jizō images from Nara, the Nara area, and particularly southwest Nara exhibit comparable stylistic features, including two from the Heian period at the Hōryū-ji nearby (fig. 27b). They are a good deal larger, however, carved more deeply, and possess a more severe mien. Perhaps the closest affinities lie with Jizō figures at Yakushi-ji and Fuki-ji, also in Nara, where the greatest concentration of this imagery exists.[2]

1. For an overview of Jizō imagery, see Matsushima Ken, Jizō Bosatsuzō (Images of Jizō Bosatsu), vol. 239 of Nihon no bijutsu (Arts of Japan) (Tokyo: Shibundō, 1986). For a description of the sculptural technique, see Nishikawa Kyōtarō and Emily J. Sano, The Great Age of Japanese Buddhist Sculpture, AD 600–1300, exh. cat., Kimbell Art Museum and Japan House Gallery (Fort Worth and New York, 1982), 47–54.

2. For a survey of Jizō sculpture, see Chōkoku (Sculpture), vol. 3 of Jūyō bunkazai (Catalogue of national treasures and important cultural properties) (Tokyo: Mainichi Shinbunsha, 1973), 77–91.

Fig. 27a. Cross-section showing construction

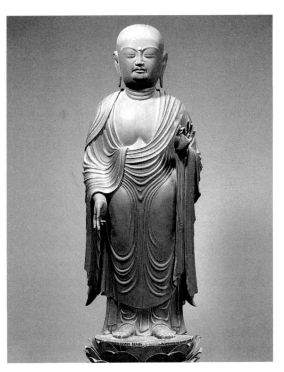

Fig. 27b. Jizō Bosatsu, 10th century; carved wood with traces of polychromy; h. 76.7 cm; Hōryū-ji, Nara. Important Cultural Property

28. Zaō Gongen

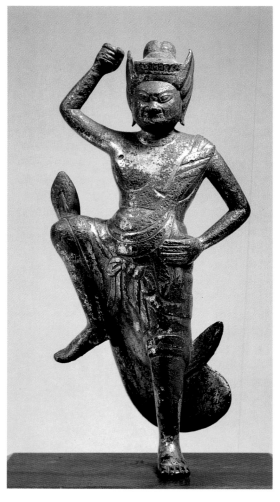

12TH CENTURY; CAST BRONZE, ENGRAVED, WITH GILDING; H. 30.5 CM. IMPORTANT CULTURAL PROPERTY

About 150 years after Buddhism's introduction into Japan, as assimilation of its novel ideas began, a series of practical accommodations with the various indigenous Shinto belief systems ensued. One focused on the established belief in the sanctity of mountains in and of themselves or as the abodes of numinous spirits called kami. Early advocates and practitioners of Buddhism in the eighth century were well aware of the country's rich fabric of sacred native sites; the Esoteric sects in particular were receptive in accommodating Shinto. As the Tendai and Shingon sects gained in popularity among the nobility and populace, by the early Heian era Buddhism's accommodating relationship with various Shinto elements and regional customs strengthened, especially the worship of mountain deities. Shinto, in turn, responded to such foreign notions as image making and the construction of devotional halls. In this way the syncretic schema of Buddhist deities manifesting themselves as Shinto kami (and vice-versa) came to be [54–57, 64, 65, 67, 76]. Instead of a separate exclusive relationship, the two powerful religious faiths formed an inclusive alliance that strengthened over the centuries and into the present.[1]

Among the anthropomorphic visualizations given to native kami, none has had more impact or is more striking than those representing Zaō Gongen. Recognized as the principal kami resident on Mt. Kimpu (Kimpusen) in the Yoshino mountain range south of Nara and the primary icon of the Shūgendō sect, Zaō Gongen's power seems perfectly encapsulated in this gilt-bronze image of the later Heian period. This was precisely the time when apprehension about the prediction of the end of the world in the mid-eleventh century (mappō) prompted the country's nobility to commission the production of these dynamic images. Copies of sutras, gilt-bronze images, engraved votive mirrors (kyōzō), and other offerings were commissioned for burial, with the hope that some measure of religious merit would accrue to the donor in his or her afterlife [6–10, 63].

Kimpusen's proximity to the early Asuka valley settlements and palaces, and to the subsequent capital at Nara, helped establish its authenticity and popularity as a potent Shinto site. Folklore, legends, and the activities of Shūgendō sect ascetics fueled the primacy of this mountain's resident spirit such that in the Nara and Heian periods Kimpusen became a most revered Shinto locale and the principal repository for kyōzuka in the eleventh and twelfth centuries.[2]

Just how the actual image of Zaō Gongen came into being and then developed into its earliest known form in the later Heian period is not clear. Most likely the fierce images of the myōō bodhisattva (widsom king) figures [30, 43–44, 50–51, 77], a type known in Esoteric Buddhism, served as prototypes. This small powerful image provides the standard characteristics: typically Zaō stands on its left

leg, with the right leg up to the side, knee bent and foot pointing laterally; the left arm is crooked at the elbow with the hand resting on the hip; the right hand is raised angularly, high toward the crowned head, the fist tightly clenched. It might originally have held a *sankōshō* (thunderbolt; Sanskrit: vajra) that was separately cast, judging from the earliest known surviving image incised on the exquisite bronze mirror (dated 1001) owned by the Sōjō-ji.[3] While it is a votive mirror and has several unusual (and intriguing) iconographical features, this piece is the earliest known appearance of Zaō Gongen as a religious icon (see fig. 64a).

The head of this Nara National Museum Zaō figure looks straight ahead, mouth closed like the Sōjō-ji icon. The nose flares broadly, above which the knitted eyebrows help frame the broad, glaring eye panels. Despite the pitted condition of the bronze surface, the scowling face is apparent, concisely framed by flaring upright hair panels, the crown band, topknot, and earlobes (somewhat reminiscent of the appearance of Batō Kannon [29]). This wrathful mien is meant to ward off evil.

The stance, energetic yet elegantly poised, complements the facial expression. Swooping robe furls and a spatula-shaped drapery panel behind the left leg help balance the figure and add a vivid sculptural gesture. For a modest-sized image this figure has extraordinary sculptural presence and is regarded in Japan as one of the finest gilt-bronze images of the deity in existence.

The figure was cast in one piece, with a venting hole on the back of the robe skirting still visible. The other small round holes visible on the torso and robes indicate where jewelry was once attached as separate elements to the body, a rare feature now visible only on a gilt bronze at Kimpusen-ji in the Yoshino district and as engraved designs in the large Sōjo-ji kyōzo. There the incised image of Zaō Gongen has an elaborate necklace with several pendant elements and a rinbō set flat against its stomach held in place by a long chain strand. Such may well have been the case with this figure's decor because an attachment hole is prominently visible in the stomach area. Originally, too, the gold surface patination must have enhanced the figure and highlighted the attached three-dimensional adornments.

Whether this Zaō served as a private devotional icon or was part of a set of Zaō images donated to a temple is impossible now to tell. Sets in bronze from Ōminesan-ji south of Yoshino, and in freestanding wood sculpture of the twelfth century at Sanbutsu-ji in Shimane Prefecture to the west provide examples of this type.[4] Comparison with these stout wooden sculptures points to another important characteristic of this Nara National Museum figure, namely its kinship to a Heian sculptural aesthetic most often seen in wood, where robust forms inhabit the highly refined confines of line and spatial contours. Thus this Zaō figure shares a strong formal affinity with the large Nyoirin Kannon of the early tenth century [26] or the Tōdai-ji Miroku [25]. In the thirteenth and fourteenth centuries a more finished, corporeal, three-dimensional, and worldly reality in sculpture became the norm, as can be seen in the wood Zaō figure in the collection of the Cleveland Museum of Art (fig. 28a).

1. For an excellent introduction to this subject, see Kageyama Haruki and Christine Guth Kanda, *Shinto Arts: Nature, Gods, and Man in Japan,* exh. cat., Japan House Gallery (New York, 1976).

2. *Sangaku shinkō no ihō* (Art treasures of the mountain religion), exh. cat., Nara National Museum (1985).

3. *Nihon Bukkyō bijutsu meihōten* (Masterpieces of Japanese Buddhist art), exh. cat., Nara National Museum (1995), no. 182.

4. *Sangaku shinkō no ihō,* pls. 1, 6.

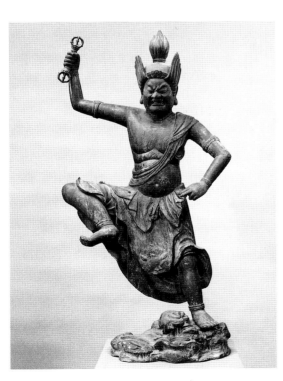

Fig. 28a. Zaō Gongen, 14th century; wood with black lacquer; h. 106.7 cm; The Cleveland Museum of Art, Purchase from the J. H. Wade Fund 1973.105

29. Batō Kannon

DATED 1241, BY RYŌKEN, ZŌZEN, AND
KANKEI (DATES UNKNOWN); WOOD WITH
LACQUER, POLYCHROMY, AND CUT GOLD
DECORATION; FIGURE: H. 106.5 CM,
BASE: 33.5 CM, HALO: 134.5 CM; JŌRŪRI-JI,
KYOTO PREFECTURE. IMPORTANT CULTURAL
PROPERTY

Batō Kannon is one of the six compassionate
bodhisattvas who help identify the doctrinal
six worlds (*rokudō*) or "levels of migration" in
Esoteric Buddhism. Each of the six deities pre-
sides over one domain, and devotees petition
that deity to cross through its realm or inter-
vene on behalf of a soul mired in such a pur-
gatory. The handscroll with scenes of hell [38]
provides a vivid depiction of the lowest realm.

Batō is recognizable from the attributes in
his hands and the mudras, the hand gestures
that refer to making blessings, warding off
evil, and clearing obstacles from the path to
enlightenment. The presence of a horse head
in the crown, framed by upright hair strands,
also identifies Batō Kannon. This motif sym-
bolizes and identifies the concept of the third
realm of the rokudō in which animals are con-
sidered the repositories for human souls seek-
ing redemption. Representations of Batō are
rare, much more so than Jizō, Jūichimen, or
even Aizen Myōō, another six-armed forbid-
ding deity in the Esoteric Buddhist pantheon.

Iconographical drawings of the Kamakura
period owned by the Shōmyō-ji in Kanagawa
record eighth- and ninth-century representa-
tions of Batō based upon sutra texts being
introduced into Japan.[1] The earliest version,
thought to date from the late seventh to early
eighth century, shows Batō with a lotus blos-
som in one hand and a sword in another. A
slightly later drawing—about mid-eighth cen-
tury—shows him holding a lotus flower on a
long stem in one hand and a long-handled
axe in another. The cast design of a rare Tang
vajra in the Nara National Museum collection
portrays the deity as one of the four great
myōō with four arms.[2] Thus it appears that the
cult of Batō in Tang China was strong, coming
to Japan by the mid-eighth century but not
truly flourishing there until the late Heian and
Kamakura periods, when Esoteric Buddhism's
influence was actually waning. The earliest

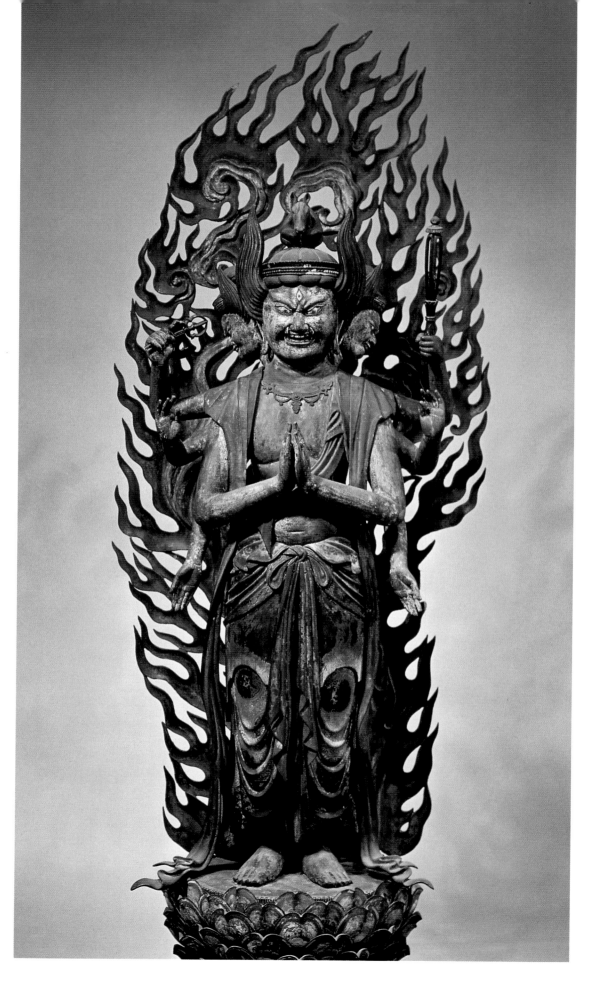

Batō Kannon of this type with three heads and six arms is recorded as having been part of an assemblage of six Kannon in the Yakushidō of Hōjō-ji, tutelary temple of Fujiwara Michinaga, which is no longer extant.

This startling image comes from the Jōruri-ji, a Shingon sect temple in the Saidai-ji lineage situated along an ancient pilgrimage route connecting the regions north of Lake Biwa to Nara. It is thought traditionally that it might have been carved to replace an earlier Batō image lost to fire, but that cannot be verified.

The animation of this figure results from an extraordinary synthesis of riveting facial expression, surface ornamentation, color preservation, and the deft sculptural modeling of figure, halo, and lotus base. Essentially all these elements retain their original character despite minor restorations. Paint has flaked off over the entire image but with particular effect on the face, where the fine white clay underpainting has emerged in a network of craquelure to mingle with the red outer surface, heightening the intensity of the figure's fanged scowl and setting off the clothing, the principal elements of which are a long shoulder scarf and a pair of skirts.

The outer waist robe is secured with a bow and extends to just above knee level in two arching hems. The hem borders are delicately painted with animal hair designs on a white shell ground. The rest of this animal hide skirt surface is prepared in multiple layers of rich green and blue mineral pigments over which two cut gold leaf (kirikane) designs have been applied. The underskirt features a resplendent orange surface on which deep blue roundels with gold kirikane decoration have been placed. In fact all the assembled clothing elements display an array of kirikane designs,

including vine, star, and manji (a reversed swastika design, emblematic of a buddha).

The base, which is original, has retained much of its vibrant form and tonal palette. It is designed in pre-Kamakura style: each petal is carved thickly with attention to modeling and then set into a separate niche in the stem rather than as a continuous set of petals. The halo (kohai) is perhaps the most remarkable element in this ensemble as it has survived virtually intact for more than seven hundred years. It is carved almost entirely from one piece of wood whose surfaces have been scooped, chiseled, and smoothed to add a pulsating, three-dimensional background frame for the standing Batō. It is difficult to cite another complete Esoteric sculptural ensemble as exciting as this one, particularly because it brings together so compellingly the elements of surface beauty and expressive wrath.

Fortunately, considerable historical data is known about this sculpture. Because of its joined wood construction technique, many items from its hollowed interior were removed during restoration in the Meiji era.[3] Chief among them is an extensive group of small, simply carved images of Batō Kannon (fifty-seven in all) and an inscription dated 1241 naming the three Nara sculptors responsible for the work (fig. 29a). Each is known by other collaborative work, too, much of which is at or associated with the Saidai-ji, the priest Eison, and the so-called "Zen" school of Nara sculptors active in the middle Kamakura era (see fig. 30a). Thus it is possible, for example, to consider Zen'en's diminutive Jūichimen Kannon [31] in this lineage also. In fact, these images and the records concerning them help identify the

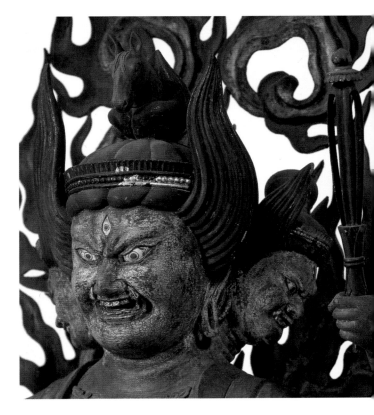

characteristics of the Zen studio of sculptors in Nara in the mid-fourteenth century. This Batō for instance is markedly different from the Batō Kannon dated 1224 at the Daihōon-ji in Kyoto by the acknowledged Kei school master Jōkei.

Also listed among the documents is the notation that the image was made for the "Nishi Odawara," the site of the current temple location. The Jōruri-ji in its present state dates from the early twelfth century and houses a unique group of nine large Amida images as well as other important Heian period sculpture. Just where this Batō Kannon figure was installed remains uncertain.

1. See Batō Kannon shinkō no hirogari (The spread of faith in Batō Kannon), exh. cat., Uma no Hakubutsukan (Yokohama, 1992).

2. See Higashi Asia no butsutachi (Buddhist images of East Asia), exh. cat., Nara National Museum (1996), pl. 86.

3. See Butsuzō to zōnai nōnyūhinten (Exhibition of Buddhist scriptures and the objects preserved inside Buddhist sculptures), exh. cat., Nara National Museum (1974), no. 21 and cover.

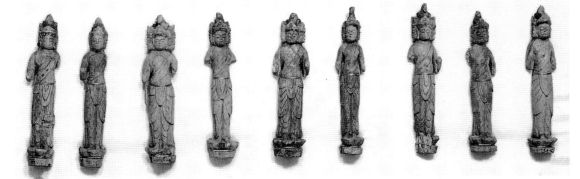

Some of the small wood images of Batō Kannon found inside the body cavity

30. Aizen Myōō

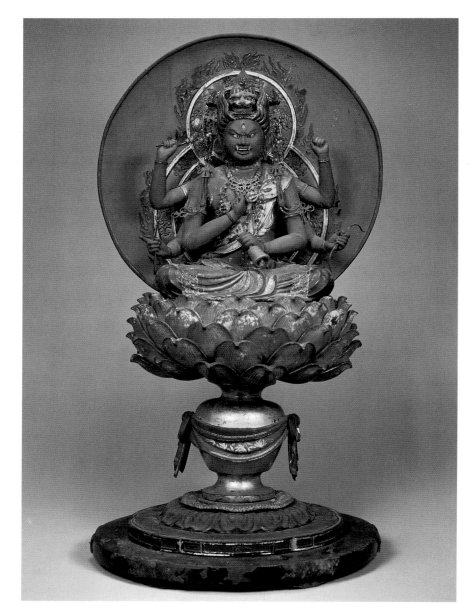

DATED 1256, BY KAISEI (DATES UNKNOWN); WOOD WITH POLYCHROMY, GOLD FOIL, AND GILT-BRONZE METALWORK; FIGURE: H. 26.2 CM, BASE: H. 29.3 CM, HALO: H. 30.3 CM. IMPORTANT CULTURAL PROPERTY

Perhaps the most renowned image of the Esoteric deity Aizen Myōō in Japan is that commissioned by the distinguished Kamakura period monk Eison [21, 78, 84] for his personal devotion at the Saidai-ji in Nara (fig. 30a). Made by Zen'en (1197–1258) in 1247, his last known work, it still resides at that temple. Modest in scale and vivid in color, it provided the aesthetic and iconographical basis for later interpretations of a deity whose Esoteric background did not prevent Nara temple priests from professing its virtues to populace and acolytes alike. Thus a ninth- to tenth-century icon in Kyoto's Esoteric sect world gained new interest during the dynamic years of Nara's revival in the thirteenth century, a phenomenon noted elsewhere and a recurring theme in Japanese cultural history generally.

Eison's evangelism was legendary, infusing the Nara Buddhist community with confidence as it faced the challenges of rebuilding during the thirteenth and fourteenth centuries. This small, exquisitely preserved image of Aizen Myōō of the mid-thirteenth century no doubt reflects the contemporary popularity of Aizen worship in Nara (rather than in Kyoto), as exemplified by Eison and his own private icon, done some nine years earlier. The sculptor of this Nara National Museum

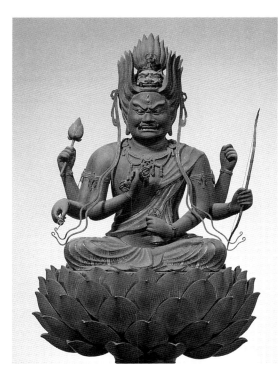

Fig. 30a. Aizen Myōō, dated 1247, by Zen'en; wood with lacquer, polychromy, and gilding; h. 31.8 cm; Saidai-ji, Nara. Important Cultural Property

image, Kaisei, remains obscure although he is said to have assisted in the Kei school of sculpture's restoration of the Tōdai-ji in the thirteenth century following its destruction in the civil wars of the late twelfth century.[1] A black ink inscription on the base of the spare, elegant pedestal also states the name of the patron of the image, the priest Jakuchō, a pupil of Eison and member of the Saidai-ji community. Surely then this small image served as Jakuchō's private devotional icon, following the example of his mentor. Saidai-ji became the center of Aizen worship in Nara by the early thirteenth century; it also produced the finest reliquaries of the era.

Almost miraculously, this small image has been preserved intact, in excellent condition despite its scale, surface refinement, and attached ornamentation.[2] The figure was produced in the joined-wood (*yosegi*) construction method practiced by Nara sculpture studios at that time, using wood retrieved from the Tōdai-ji reconstruction (ca. 1195–1220). The round halo, lotus base with pedestal in the form of a *kebyō* (gilt-bronze flower container) [87] draped in cloth, and lower three-stage lotus stand are all original and together support and frame the fierce image here and in the twelfth-century painting of Aizen in the exhibition [50].

The deity's vivid orange-red skin and scowling face derive from its theological underpinnings: Aizen, one of the wisdom kings, represents the ability to recognize and then to sublimate passion in an effort to quell the worldly vices of greed, lust, and egotism. Boldly stated, ultimately there is no distinction between spiritual enlightenment and human passions. Each of Aizen's six arms holds an attribute: bell, thunderbolt, lotus, lariat, bow, arrow. The third eye, flaring hair strands, and crown incorporating a lion mask are reminiscent of Batō Kannon [29], another multi-faceted Esoteric deity that attained wide popularity in early medieval Japan.

Scrutiny of the sculptural style of these two figures in comparison to Zen'en's Jūichimen Kannon [31] reveals their orthodoxy amid Kamakura sculptural studios and the particular individualism of Zen'en. While the surface of the Jūichimen has unfortunately been entirely relacquered, obscuring much of the artist's original intent, this Aizen presents precisely the opposite. Here the quality of

materials and sophisticated craftsmanship in wood, cut gold, and polychromy of mid-Kamakura sculptural studios appear unobstructed. Moreover, the balance and visual intensity of this small sculptural gem remind us that despite the inherent grand scale of Nara's Buddhist institutions and their massive rebuilding projects of the late twelfth and early thirteenth centuries, human scaled as well as institutionally driven endeavors flourished in the former capital.

1. See for example *Unkei to Kaikei to sono deshitachi* (Unkei, Kaikei and their disciples: Masters of Kamakura sculpture), exh. cat., Nara National Museum (1994). Note also the special 1000th edition issue of *Kokka* (1977) devoted to Kamakura period sculpture, where this Aizen is discussed (pp. 51–55) and two other works by Kaisei are noted.

2. This figure was preserved in the twentieth century in the collection of Muto Kinta, one of Japan's most famous collectors of Buddhist art.

31. Jūichimen Kannon

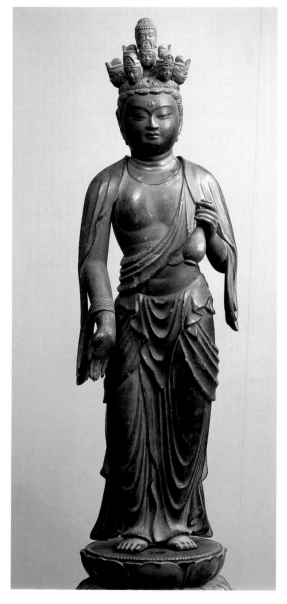

DATED 1222, BY ZEN'EN (1197–1258);
LACQUERED WOOD WITH POLYCHROMY,
GOLD LEAF, AND CRYSTAL EYES; H. 46.6 CM

The sculptor Zen'en is known through a small group of images, most of which are modest in scale, like this figure. Although not nearly as well known as the work of master sculptors Unkei (1151–1223) and Kaikei (ca. 1185–1223), both of whom directed large sculptural studios in Nara (and Kyoto) during the early thirteenth century, Zen'en's oeuvre allows a more considered view of the range of sculptural expression in thirteenth-century Nara and Kyoto. It illustrates the active, sustained patronage that was provided to this unheralded sculptor who until quite recently remained relatively unknown.[1] What is fascinating and

compelling about twentieth-century revelations concerning Zen'en is that the relevant documents are contained within the images themselves.

The text concerning this diminutive wood sculpture was revealed when a modern restoration was undertaken in the 1950s.[2] When the various pieced sections of wood that make up the figure were separated, an interior chamber was discovered that contained a handscroll with a handwritten *Kongō Hannyaharamitsu-kyō* on one side and printed images (*inbutsu*) of Jūichimen, the Eleven-headed Kannon, on the other (fig. 31a).[3] Despite its poor condition, the scroll revealed the names of the donors of this sculptural commission as well as the sculptor. Among the supporters listed is Han'en, abbot of the

Kōfuku-ji (beginning in 1219), whose name also appears in documents retrieved from the Amida figure in the Kondō of the Hōryū-ji and the Jizō Bosatsu in the Rockefeller Collection at the Asia Society Galleries in New York.[4] Zen'en also provided images at the request of eminent monks at the Tōdai-ji (1225) and Saidai-ji (1247).[5] Additional information appears in the extended inscriptions written in black ink directly on the carved wooden surfaces of the image cavities of these figures. Here, *shūji,* the Sanskrit character for Jūichimen, repeat in orderly rows over the entire surface of both front and back of the head and neck section.

The text gives the image an added dimension as an icon specifically created by a known group of members of the Buddhist

102

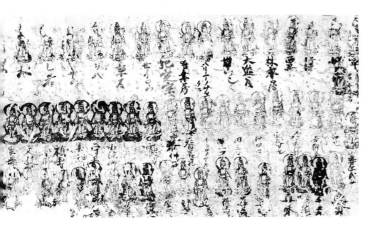

Fig. 31a. Printed images of Jūichimen Kannon found inside the sculpture

Fig. 31b. Monju Bosatsu, 13th century; carved wood with gilding, polychromy, and cut gold foil decoration; h. 43.3 cm; Tokyo National Museum

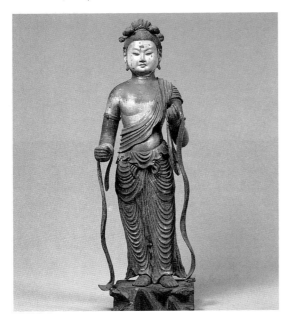

faith, petitioning for religious merit through this deed. And the sculptor also joins the petition by performing and completing the commission, conscious of its inspiration from the onset, and by willingly participating in the recording of the same. For the donors as well as the craftsman the image became a living act of piety during their lifetimes, a testament to their faith, and an offering that might endure past their time to embrace others.

Also of interest among the notices and invocations written on the interior body cavity is a wish for protection by one of the principal tutelary Shinto deities of the Kasuga Shrine in Nara, Gongen Daimyōjin. Thus once again the intimate web of relationships between the Shinto and Buddhist faiths surfaces, here in the context of Kasuga Shrine, the titular Shinto institution in Nara of the powerful Fujiwara family, linked for centuries to the Kōfuku-ji, the family's titular Buddhist temple. Among the five Buddhist deities recognized at Kasuga as the original manifestations of the shrine's kami are Jūichimen (4th), Jīzō (3rd), and Monju (5th), all images now extant, that Zen'en created in similar sizes and styles and date.[6] Perhaps he will be linked in future research to the sculpture studio at the Kofukū-ji in the thirteenth century, one of the most important centers of sculptural activity in the nation at a time when Nara's religious institutions were rebuilding themselves assiduously.

While sharply different in scale from the large "realistic" or Chinese Song-style modes of representation then popular in Nara sculpting ateliers, this small figure nonetheless illustrates Zen'en's distinctive style. Carved in the yosegi technique from hinoki, this Jūichimen has a decidedly youthful mien, distinguished by long narrow eye slits, narrow fleshy mouth, and flat soft nose set into a gently swelling face mask. The slight sway of the body and rhythmic pattern of liquid drapery fold lines in front, side, and back provide distinctive stylistic hallmarks for recognizing the work of Zen'en. He appears keenly aware of his predecessors' efforts among later Heian statuary: images such as the Eleven-headed Kannon at the Kōgen-ji in Shiga (ninth century) rather than his more famous contemporaries' endeavors in Nara. The Tokyo National Museum Monju (fig. 31b), Asia Society Jizō, and Nara National Museum Jūichimen

are particularly revealing and consistent stylistically, no doubt representing as much his patrons' wishes as his own aesthetic predilections. Clearly his talents were in demand during the rebuilding of Nara in the thirteenth century over a twenty-year period, but especially during the 1220s. His smaller images, intended for personal rather than institutional patrons, stand out clearly, as is evident by comparing this image with his Amida of 1225 at the Tōdai-ji.

1. Yamamoto Tsutomu, "Monju Bosatsuzō" (An image of Monju Bosatsu), *Kokka,* no. 1210 (September 1996), 16–22.

2. Virtually the entire surface of the sculpture had been lacquered again, probably in the Edo period.

3. Yamamoto, "Monju Bosatsuzō," 16–22.

4. *Butsuzō to zōnai nōnyūhinten* (Buddhist scriptures and objects preserved inside Buddhist sculptures), exh. cat., Nara National Museum (1974), no. 14.

5. For the Tōdai-ji sculpture, see *Tōdai-jiten* (Exhibition from the Tōdai-ji collection), exh. cat., Tokyo National Museum (1980), pl. 17; for the Saidai-ji image, see *Nara Saidai-jiten* (Treasures of Buddhist art from the Saidai-ji, Nara), exh. cat., Nara National Museum (1991), pl. 38 and cover.

6. *Nara Kokuritsu Hakubutsukan no meihō* (Masterpieces from the collection of the Nara National Museum), exh. cat., Nara National Museum (1997), pls. 89–91. For information about the important relationship between Buddhist and Shinto imagery and ceremony, see Kageyama Haruki and Christine Guth Kanda, *Shinto Arts: Nature, Gods, and Man in Japan,* exh. cat., Japan House Gallery (New York, 1976).

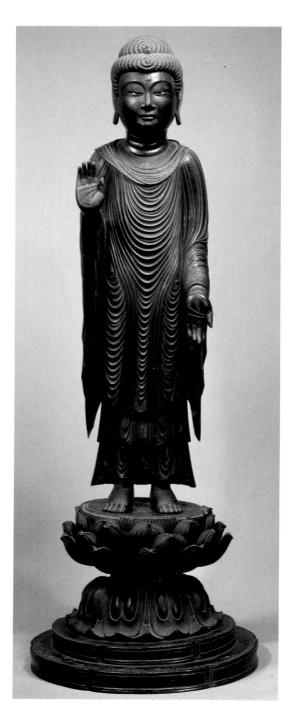

32. Shaka Nyorai

DATED 1273, BY GENKAI (DATES UN-
KNOWN); WOOD WITH LACQUER AND
CRYSTAL EYES; H. 78.8 CM. IMPORTANT
CULTURAL PROPERTY

One of the most revered and widely recog-
nized sculptural icons in Japan is that of
Shaka Nyorai. Commonly known as the
"Seiryō-ji Shaka" (fig. 32a), this figure with an
elaborate swirling robe pattern is always por-
trayed standing with the left arm down, palm
facing out, and right arm raised at the elbow,
palm facing out, with fingers extended. These
mudras convey to the beholder the messages
of "charity" (left) and "do not fear" (right).
This type of Shaka representation always has
a darkish brown or black surface patination
and is invariably carved out of sandalwood or
another aromatic dense wood species.

Although earlier images of Buddhism's
legendary founder exist, datable to the sixth
or seventh centuries, and other forms of rep-
resentation appear in accordance with the
development of Shaka worship through the
centuries, this Seiryō-ji type was preferred in
medieval Japan. That this popularity resulted
more from legend and apocrypha than from
historical data seems appropriate because the
identity of and facts surrounding the life of the
Historic Buddha are themselves shrouded in
mystery. What is apparent, however, are the
circumstances regarding the existence of the
tenth-century Seiryō-ji image in Kyoto, the
articles found inside it, and the extraordinary
ripple effect this image and the myths that
have accrued to it over the centuries have
had on Buddhist devotees in the country.

This Nara National Museum figure (and
many others in Japan) is based faithfully on
the Seiryō-ji image recorded as having been
brought to Japan by the Japanese Buddhist
monk Chōnen (d. 1016) in 987.[1] He had
commissioned it two years earlier as a copy
of a Shaka image then said to be at the Kai-
yuan-ssu, a temple in Kai-feng, Shensi prov-
ince, China. That image, in turn, had been
based upon much earlier Indian prototypes,
the most famous of which was made from
sandalwood and revered by itinerant pilgrims
from India as well as China. Legends about
Shaka emanated from Kausambi in northern

India, the area where the Historic Buddha
was said to have been brought up among the
Śākya clan.

Thus, more than a century after having
crossed through China with Chōnen, then
over the seas to Japan, worship of Shaka
gained special veneration, focusing on the im-
age at the Seiryō-ji temple in northwest Kyoto.
About two centuries passed before requests
for precise copies of the figure arrived in the
sculpture studios of Nara and Kyoto. This
immediately identifiable figural type then be-
came one of the most recognizable and effec-
tive icons in the dissemination and promotion
of Buddhism in medieval Japan.

Here Genkai, an otherwise unknown
sculptor, presents Shaka wearing a toga-like
garment that cascades down and across his
torso in a pattern of rigid folds bearing scant
relation to the body underneath. The style
is reminiscent of much earlier Indian and
Chinese sculptural traditions, and the patterns
are symmetrically arranged in keeping with
the severe frontal stance of the image. The
hands and head are disproportionally large,
and the hair is formed from rope-like braid
strands arranged in concentric raised patterns.
The image, framed by an elaborately carved
halo, stands on a two-stage lotus base.

Genkai's approach to this model does not
now include a halo, nor has he emphasized
the importance of the enlarged hands as sym-
bols of the important mudras. But the head is
large for the body, as in the Seiryō-ji proto-
type, and its alert youthful expression is
adroitly framed by hair and robe surface pat-
terns at top and below. The torso was carved
to create areas of crisp light and shadow
through a series of sharply chiseled robe fur-
rows that form into three distinct ranks as they
descend toward the drooping pleat levels at
the lower hem lines. The carved surface is a
technical tour de force, somewhat at odds
with the deity's quiet, forthright gaze. Never-
theless, the overall effect is startling and no
doubt dates to the late thirteenth century. Con-
temporary viewers surely recognized its blend
of contemporary panache and traditionalism.

Genkai carved the image from a single
piece of kaya wood and coated it with a red
and then brownish lacquer; the red tint can be
seen where the surface has worn thin. (The
Seiryō-ji Shaka also has red lacquer.) During
fabrication the back section of the head was

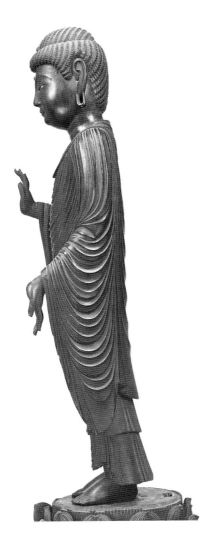

opened to allow crystal to be inserted for eyes, but there is no body cavity containing relics as in the Seiryō-ji figure and many other Kamakura period copies of the tenth-century prototype.

In this technical feature too then, Genkai's Shaka interprets an earlier revered icon and sculptural tradition rather than just reproducing it, as many sculptors in Kyoto and Nara studios did.[2] Considered in this way it offers an aesthetic parallel for the vigor and activism of the patronage and veneration of the Shaka cult in Japan. Genkai's name is inscribed in ink under the base of the figure, along with the important information that the priest Eison commissioned this Shaka and attended, with two of his disciples, the Eye-opener ceremony that formally consecrated it in the spring of 1273 (fig. 32b). Once installed in Gangō-ji temple in Nara, this Shaka represented another instance of that great priest's role in the religious and cultural life of thirteenth-century Nara.

1. See *Shaka, shinkō to Seiryō-ji* (Belief in the Historical Buddha and Seiryō-ji), exh. cat., Kyoto National Museum (1982).

2. Washizuka Hiromitsu, *Enlightenment Embodied: The Art of the Japanese Buddhist Sculptor,* exh. cat., Japan Society Gallery (New York, 1997), no. 21.

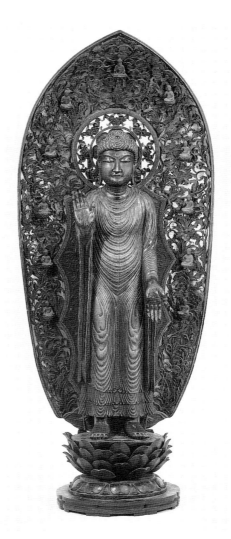

Fig. 32a. Shaka Nyorai, dated 985; China, Northern Song dynasty; sandalwood with lacquer; h. 160 cm; Seiryō-ji, Kyoto. National Treasure

Inscription on the bottom of the base, giving Genkai's name and information about the statue's commission and Eye-opener ceremony

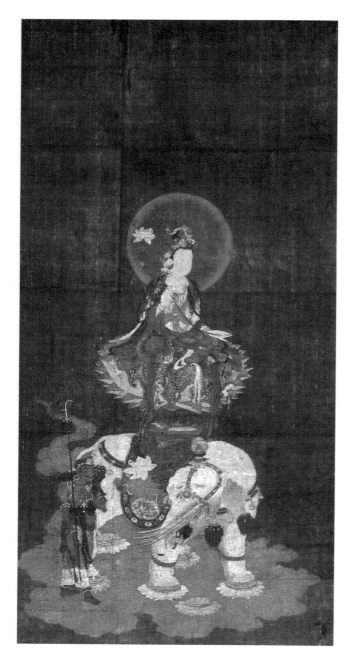
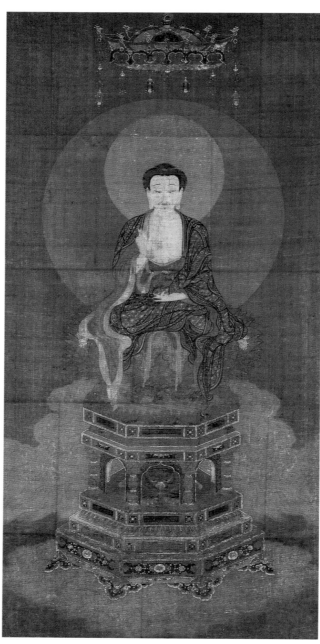
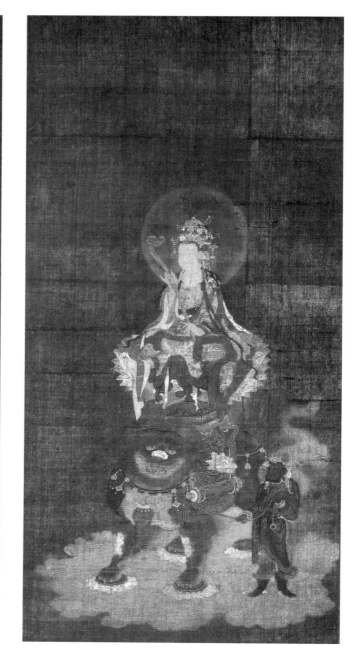

14TH CENTURY; THREE HANGING SCROLLS: INK, COLOR, AND GOLD PIGMENT ON SILK; 119.1 X 59.7 CM EACH. IMPORTANT CULTURAL PROPERTY

The *E-inga-kyō* illustrations [14] show Shaka as a young man, dressed in Chinese-style garb despite his origins in a northern Indian kingdom. In subsequent portrayals, including sculptural images, textiles, mirrors, sutra containers, and paintings of various sizes and formats, he appeared as an enlightened being. This imagery, conveyed to Japan by way of China and Korea, was meant to transmit the teachings of Shaka based on his sermons to his disciples and, following his death, the sermons memorized by his disciples, among whom Ānanda was prominent. Over time these ideas were recorded in sutras, translated and adapted by the Chinese from Sanskrit to conform to their culture and ideas, and then taken to Korea and Japan. Thus by the time these writings reached Japan they had been altered considerably or were largely of Chinese origin. No doubt this process also affected the *Lotus Sutra,* one of the principal texts expounding the words of Shaka, both as it first arrived in Japan and thereafter as it underwent revision and amplification in the temples of Asuka, Nara, Osaka, and Kyoto.

This dynamic living process of assimilation and acculturation of the dharma had a similar effect on the visual imagery intended to either illustrate these teachings or serve as devotional icons. From the eighth century on, various representations and compositions were formulated and developed that served these two fundamental purposes but that also strayed from textual veracity (at least as we understand it now) in order to achieve other, more worldly goals. Thus for example deities that do not appear in one chapter of a sutra are nevertheless inserted into imagery expounding the virtues of the text as a way to promote the superiority of an idea or perhaps to lend strength to a particular hierarchy of deities in that chapter.[1]

The many illustrated frontispieces, mandalas, and hanging scroll sets emanating from the *Lotus Sutra* are preceded by the Shaka's paradise mural at the Hōryū-ji and the large eighth-century textile in the collection of the Nara National Museum showing Shaka preaching, surrounded by bosatsu, disciples, and commoners.[2] More than a full century later, in frontispiece illustrations, Shaka appears again flanked by bosatsu attendants. Fugen, the figure to Shaka's proper right in this triptych, is either illustrated individually or as a part of a landscape setting in which Shaka preaches in twelfth-century frontispieces based upon the *Kannon-kyō (Kannon Sutra)* text. Monju, to the left, likewise is depicted riding his lion as is described in the "Anraku-kyō" chapter of the *Lotus Sutra.*[3]

Thus the stage was set for Kamakura-era depictions of Shaka flanked by Monju and Fugen, a subject that was popular at that time. On the one hand the importation of this iconography in Song and Yuan period paintings helps explain its new format and new status as an icon of worship.[4] The late twelfth century surge of popular interest in the *Lotus Sutra* and the *Kanfugen-kyō (Sutra of Meditation on the Bodhisattva Kanfugen)* in literature and painting also suggests indigenous reasons for this new imagery and iconography in painting, sculpture, and other Buddhist art mediums.[5]

In this Nara National Museum triad, Shaka is shown on an ornate multi-stage dais in the center of which crouches a karashishi facing the viewer—a feature that appears in the Kairyūō-ji censor for example [78] and in other triad images that usually include Monju and Fugen and many attendant figures assembled on a single hanging scroll.[6] Framed by a cloud bank and double-round halo, Shaka is described in reserved but highly professional brushwork and rich polychromy, as are Monju and Fugen although the side scrolls are not in as good condition as the central scroll. Each bosatsu has its attribute and vehicle—the nyoi [80] and lion for Monju, the white lotus flower and elephant for Fugen—and a groom who appears to be Central Asian [20]. The influence of Song and Yuan Buddhist paintings, avidly collected in Japan for centuries, appears in the style of painting as much as in a number of details. Comparing these scrolls with the Monju Bosatsu [34], Senju Kannon [46, 48], and Nyoirin Kannon [49] paintings illustrates the varied, contrasting stylistic approaches to subject matter practiced by the professional painters of the Kamakura period.[7]

This triptych was probably ordered from a studio for display as a devotional icon at a temple in the Kyoto-Nara area. The sight of Monju, emblematic of the Buddha's wisdom, and Fugen, the transmitter of those ideas into active teaching, on either side of an image symbolizing the entire history of the faith's precepts must have been very moving in the candlelit ambience of the medieval temple hall.

1. The practice is evident in the well-known bronze relief plaque of the seventh century in the Hase-dera temple collection. See Washizuka Hiromitsu, *Enlightenment Embodied: The Art of the Japanese Buddhist Sculptor,* exh. cat., Japan Society Gallery (New York, 1997), no. 3.

2. See *Bukkyō setsuwa no bijutsu* (Depictions of Buddhist scriptures), exh. cat., Nara National Museum (1990), nos. 53, 54–82. The Hōryū-ji mural is known through old photographs and modern copies.

3. Ibid., nos. 70–71, 78. A late twelfth century frontispiece illustration belonging to the Jingō-ji temple is a rare early example of this triad in Japanese art.

4. See for example *Nihon Bukkyō bijutsu no genryū* (Sources of Japanese Buddhist art), exh. cat., Nara National Museum (1978), pls. 14–17.

5. See the fine twelfth-century mirror in the Sumitomo collection in Naniwada Tōru, *Kyōzō to kakebotoke* (Votive mirrors and hanging plaques), vol. 284 of *Nihon no bijutsu* (Arts of Japan) (Tokyo: Shibundō, 1990), fig. 27. Of special note is the dais form, which is not characteristic of Chinese-inspired examples. For the important Shaka triad image in the twelfth-century frontispiece from Ikaruga-dera, Hyōgo Prefecture, see *Heian butsuga* (Buddhist painting of the Heian period), exh. cat., Nara National Museum (1986), pl. 70.

6. See Tanabe Saburosuke, *Shaka Nyoraizō* (Images and paintings of Shaka Nyorai), vol. 243 of *Nihon no bijutsu* (Tokyo: Shibundō, 1986), figs. 11–12, 105–7.

7. See also John M. Rosenfield and Elizabeth ten Grotenhuis, *Journey of the Three Jewels,* exh. cat., Asia Society (New York, 1979), no. 3. The painting techniques used in that triptych are related to this one although the palettes differ. The notes to nos. 5 and 6 are also helpful.

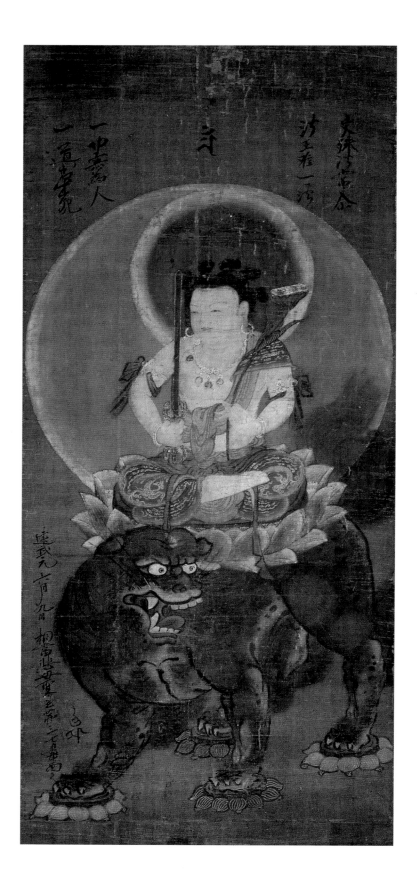

DATED 1334, BY MONKANBŌ KŌSHIN (1278–1357); HANGING SCROLL: INK AND COLOR ON SILK; 90.8 X 41.6 CM. IMPORTANT CULTURAL PROPERTY

One of the most dynamic Buddhist icons in this exhibition, this painting of Monju Bosatsu, the Bodhisattva of Wisdom, also provides unusual and important historical documentation on its darkened silk surface, telling us that the Shingon monk Monkanbō Kōshin painted this image for a memorial service in 1334 commemorating the death of someone, as yet unknown. Invocations in the four lines of script at the top of the painting confirm the power of Monju's wisdom. The single centrally placed symbol is *nām,* the Sanskrit character for Monju. The animated calligraphic style of the monk, no doubt an amateur rather than a professional painter, appears also in the energetic brush lines that outline the lion's form and enliven its ferocious face. The lion has a broad chest, short thick legs, and a mane embracing head and neck rather than flaring out as usually seen in fourteenth-century representations.

The seated Monju can be viewed in much the same manner: his features are broad, his stature short. The priest Monkanbō departed from the conventions of orthodox Monju figural portrayal to depict in the robe patterns two phoenixes among stylized cloud designs, an appropriate gesture for a memorial painting. His hair is banded to form five knots—emblematic of the five realms of knowledge, his fabled residence on Mt. Wu Tai (Five-terrace Mountain) in China, and the five-character mantra used to invoke his power. He holds in each hand an attribute associated with his identity symbolizing Buddha's wisdom: the sword represents the power and clarity of the dharma; the lotus stalk supports an album-type sutra of the *Hannya-kyō (Sutra of the Perfection of Wisdom),* which contains the wisdom of the dharma. Although these attributes are standard in Monju imagery, a number of variants appear in the many paintings owned by Tendai and Shingon sect temples, where Monju was particularly venerated from the twelfth century on.[1] Most painted representations—discounting some iconographical handscrolls, sculptural ensembles, and a rare votive shrine—date to the fourteenth century and later.[2]

Detail of a lion, among other animals of the world, mourning the death of the Historic Buddha [37]

As professionally executed versions of Monju proliferated because of popular demand, the imagery became standardized and the brush style increasingly rigid. In this environment the innovative composition seen in the Daigo-ji's thirteenth-century depiction of Monju crossing the sea stands out.[3] It is a large dramatic scene set in clouds drifting over waves, referring to China's distant Mt. Wu Tai from where he ventured into the world to appear to the faithful.

This Nara National Museum painting is also noteworthy in that it does not conform to the established canons of ink and brush style in fourteenth-century professional painting circles. This divergence signals the increasing influence of the bravura of pure ink painting that would in half a century become the accepted mode of painted Buddhist imagery—especially Zen sect related icons—by patrons and artists alike [61–62]. Perhaps more important, however, the Buddhist laity and clerics of the day could see in this painting a novel approach to a traditional subject holding the potential to awaken their own commitment to the pursuit of wisdom and enlightenment, as symbolized by Monju.[4]

1. See for example Sawa Ryuken, *Mikkyō bijutsu taikan* (Survey of Esoteric Buddhist art) (Tokyo: Asahi Shinbunsha, 1983), 3: pls. 21–27; on p. 227 is the twelfth-century iconographical sketch scroll owned by the Daigo-ji showing Monju with only a sword.

2. For the shrine at the Seiryō-in in Hyōgo Prefecture, see *Heian butsuga* (Buddhist painting of the Heian period), exh. cat., Nara National Museum (1986), pl. 87. This piece also relates to the figural painting style of other works in this catalogue: the keman [68] and the large shrine [75].

3. Sawa Ryuken, *Mikkyō bijutsu taikan,* pl. 26. For the printed Chinese images of these deities, dating from the late tenth century, see also *Higashi Asia no butsutachi* (Buddhist images of East Asia), exh. cat., Nara National Museum (1996), nos. 134–36.

4. For the famous Yuan Dynasty triptych venerated at the Kyoto Zen temple Tōfuku-ji, see *Higashi Asia no butsutachi,* no. 141. That catalogue also provides an instructive contrast to other Chinese Shaka triad portrayals in nos. 139–40.

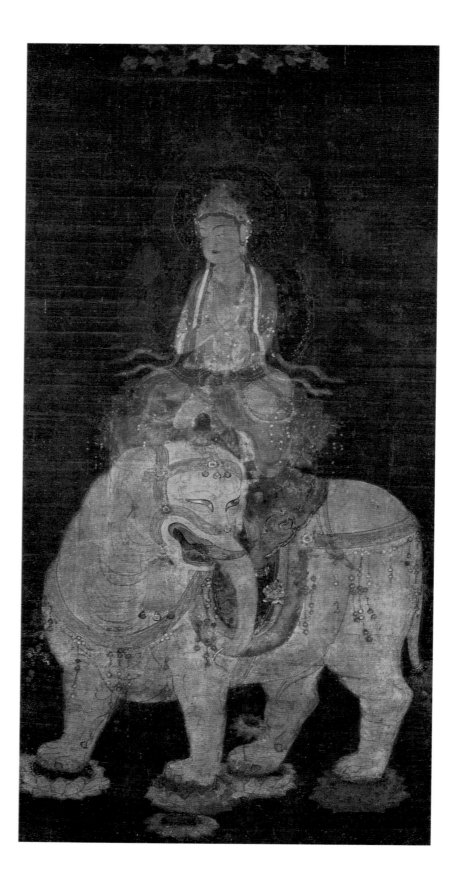

12TH CENTURY; HANGING SCROLL: INK, COLOR, AND CUT GOLD AND SILVER FOIL ON SILK; 61.6 X 30.7 CM. IMPORTANT CULTURAL PROPERTY

In comparison to the slightly later painting of Fugen and the ten rasetsunyo in this exhibition [36], this image of the Bodhisattva of Universal Virtue is smaller, darker, and more finely delineated. These aspects result from its origins as a late Heian rendition of the Buddhist deity first portrayed in Japan as a wall painting in the Kondō of the Hōryū-ji in Nara in the seventh century. Popular interest in the merits and efficacy of Fugen peaked much later, during the later Heian and early Kamakura periods (twelfth to fourteenth centuries).

Fugen sits cross-legged atop a large white elephant, an image derived from chapter 29 of the *Lotus Sutra,* which during the Nara period became one of the three most influential religious texts in use in Japan. In describing Fugen, the *Lotus Sutra* states that he emanates from "the eastern quarter" and his approach is accompanied by music and a "rain" of "jeweled lotuses."[1] His vehicle the elephant, a regal animal in ancient India, is white "with six tusks" that help protect the deity.

In this painting the elephant has lost much of its white tonality, revealing the artist's underdrawing and making the animal recede into the darkened palette of the silk. Giltbronze jewelry and bells hang suspended from the harness; it carries a golden lotus

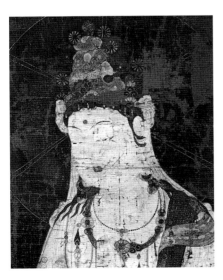

Fig. 35a. Detail of Fugen Bosatsu, 12th century; hanging scroll: ink and color on silk; 159 x 74.5 cm; Tokyo National Museum. National Treasure

blossom in its trunk; and its head is topped by a lotus pedestal supporting sacred jewels. The elephant's pose, in profile with its head turned backward in a three-quarter view, adds a dynamic note to the composition and the assertion in the text that Fugen will arrive after being beckoned by the faithful. Besides the four lotus pods supporting the elephant's feet, there are two additional blossoms (both near its feet) perhaps referring to the "rain" of jeweled lotuses in the text. Other lotuses do not appear in the well-known twelfth-century Fugen painting in the Tokyo National Museum collection designated a National Treasure (fig. 35a) but can be seen in the equally famous Bujō-ji painting and other examples from the twelfth to fourteenth centuries.[2]

The Fugen figures in both the Tokyo and Nara National Museum paintings share compositional elements such as the double halos and elaborate floral canopies overhead. In the Nara scroll fine cut gold and silver foil create the halo's decoration, as well as that dangling from the petal tips of the lotus base upon which Fugen sits. This treatment is also visible in the Heian period paintings of Jūichimen Kannon [45] and Senju Kannon [46]. The latter also provides a close comparison in figural style to this Fugen and a revealing contrast with the later Kamakura figural idiom evident in Fugen and the ten rasetsunyo [36].

Fugen's compassion is apparent in the gesture of clasped prayerful hands and slightly downcast head position. The rather tall head in three-quarter pose, the fleshy cheeks and jowls, small red mouth, and narrow forehead set upon a slender torso enveloped in robes, scarves, and red and gold jewelry make this portrayal decidedly feminine. Virtually the entire surface from the heavenly canopy to the elephant's trappings were meant to convey a glittering, lavish display of light consistent with the brilliant teachings and spiritual practices of the *Lotus Sutra,* whose principal patron among Heian period adherents of the Tendai sect was considered to be Fugen.

Only a few of these precious images from the Heian period, or even early Kamakura paintings based upon late Heian pictorial conventions, have survived. Interestingly, none has survived at the Enryaku-ji atop Mt. Hiei, the home of Tendai sect Buddhism whose core teachings emanate from the text

of the *Lotus Sutra.*[3] Adherents of the sect even expanded the number of chapters devoted to Fugen by adding the *Kanfugen-kyō (Sutra of Meditation on the Bodhisattva Kanfugen),* which describes the deity's powers in greater detail and the several merits of meditating before it. The appearance of Fugen accords with the description in the "Encouragements of the Bodhisattva Samantabhadra" chapter of the *Lotus Sutra,* in which the deity's protective powers are noted. As a result, devotional icons in sculpture and painting were no doubt commissioned in large numbers by monastic institutions affiliated with the Enryaku-ji for religious services and by private individuals linked to Kyoto's aristocracy for personal devotion, as Japanese scholars have suggested. This small painting may have been requested by a noblewoman. Extant Fugen pieces, unfortunately, are not numerous.

The most important sculptural rendition to survive is the twelfth-century image in Tokyo at the Okura Shokkokan.[4] Sculptural ensembles with Fugen and Monju flanking Shaka are also extant, especially in temples in the Kyoto–Lake Biwa area where the Enryaku-ji held considerable influence until 1571, when the military warlord Toyotomi Hideyoshi ordered its destruction [57].

Among painted icons, the Tokyo National Museum painting represents the finest example of this type of Fugen image, followed by the Bujō-ji, and then this Nara National Museum example.

1. Leon Hurvitz, trans., *Scripture of the Lotus Blossom of the Fine Dharma* (New York: Columbia University Press, 1976), 332.

2. See for example *Nihon Bukkyō bijutsu meihōten* (Masterpieces of Japanese Buddhist art), exh. cat., Nara National Museum (1995), pls. 123–24, 107–8.

3. See *Hieizan to Tendai no bijutsu* (Mt. Hiei and the art of Tendai sect Buddhism), exh. cat., Tokyo National Museum (1986).

4. See *Heian jidai no chōkoku* (Heian period sculpture), exh. cat., Tokyo National Museum (1971), no. 61. See also Yamamoto Tsutomu, *Fugen Bosatsuzō* (Images and paintings of Fugen Bosatsu), vol. 310 of *Nihon no bijutsu* (Arts of Japan) (Tokyo: Shibundō, 1992).

36. Fugen Bosatsu and the Ten Rasetsunyo

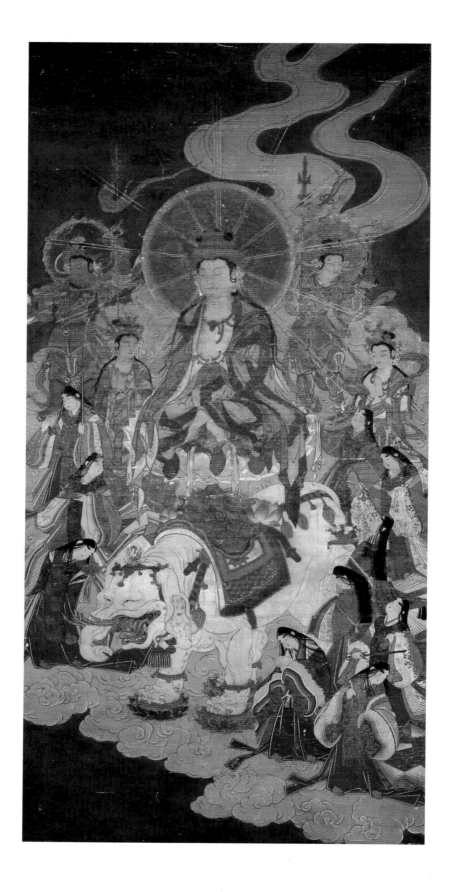

13TH CENTURY; HANGING SCROLL: INK AND COLOR ON SILK; 112 X 55 CM. IMPORTANT CULTURAL PROPERTY

The evolution of the texts, imagery, and subject matter imported from China and Korea into Japan over the centuries represents one of the most fascinating aspects of Buddhist cultural studies. Interpreting new ideas and then transmitting them into culturally familiar terms for a native audience presented great challenges to the Buddhist clergy and their secular patrons in early Japanese society. The various sutras collected and revered in the Nara and Heian periods, for example, provided the richest sources for visual imagery produced in those eras. Yet by the late Heian and Kamakura periods those same venerated sutras often held less importance than the many subsequent texts produced to interpret these texts for the laity. And, inevitably, imagery produced at home spawned the next generation of icons as the faith spread through the countryside.

As Buddhism moved from being closely allied to the state and its immediate constituents toward an accommodation—even embracement—of other social levels and their interests, imagery evolved that enhanced popular recognition. During the later ninth and tenth centuries, Shingon and especially Tendai sect teachings, which introduced concepts and practices offering the possibility of enlightenment in one's lifetime to those outside aristocratic circles, were instrumental in propelling this movement. Women, for example, had traditionally been excluded from contemplating Buddhahood until revisionist textual interpretations appeared in the Heian period, beginning with Saichō [15]. The *Lotus Sutra,* one of the oldest and most revered texts in the history of Japanese religion, includes a chapter in which the salvation of women is professed. In the "Devadetta" chapter the eight-year-old daughter of the dragon king demonstrates her attainment of Buddhahood.[1] Consequently, faith in this sutra by Heian era women, particularly women of aristocratic rank, became keen and may have been responsible in part for the rise in popularity of the deity featured in this painting: Fugen, the Bodhisattva of Universal Virtue. Normally seen on the proper right of the Historic Buddha [33], mounted on a tusked elephant as his vehicle, Fugen appears in the "Dhāranī" chapter of the *Lotus Sutra.* Here this great bodhisattva is accompanied by ten rasetsunyo (female guardians), who are noted in the same chapter.

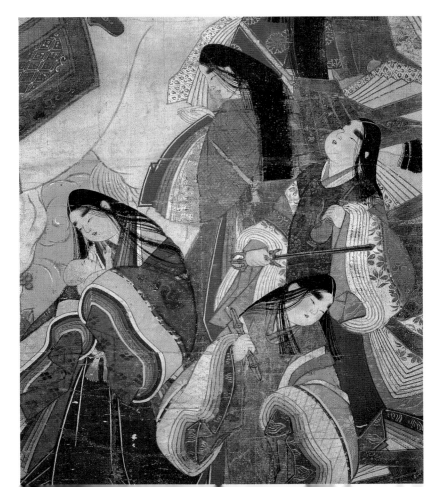

Fig. 36a. Frontispiece illustration, chapter 26 of the *Lotus Sutra*, 12th century; handscroll: ink, color, and silver and gold pigments on paper; 26.8 x 206 cm; Taisan-ji, Hyogo Prefecture. Important Cultural Property

Fig. 36b. Frontispiece illustration, chapter 14 of the *Lotus Sutra*, 13th century; handscroll: ink, color, and gold pigment on paper; 28.7 x 78.2 cm; Hase-dera, Nara Prefecture. National Treasure

The artist of this scroll adopted a nontraditional approach to this syncretic subject matter. Instead of typical Chinese dress, the female demons wear the lavish attire of the Heian court, offering a decidedly Japanese interpretation of a classic Buddhist subject and demonstrating the belief in the efficacy of the female demons. The traditional presentation of the subject, as seen in several twelfth- and thirteenth-century illustrated frontispieces to the *Lotus Sutra,* shows the bodhisattva accompanied by women in Chinese high court garb floating on clouds (figs. 36a–b). As more and more attention was given to explaining the Buddhist creed in native terms in the later Heian and Kamakura periods, the standard iconography was treated with increasing freedom in order to reflect changes in how the doctrine was interpreted. Thus, for didactic purposes, hierarchical mandala compositions were altered to make them more intelligible, illustrated frontispieces were added to sutra transcriptions, and deities not necessarily prominently featured in a written sutra text were given visual prominence in painting or sculpture, lacquerware or metalwork, even to the status of an icon for worship.

Independent images of Fugen appear first in the late Heian period as hanging scrolls and *mikaeshi-e* (illustrated frontispiece to a sutra) [16]. The visual amalgamation of Fugen with the ten female demons likely occurred first in the mid-twelfth century among Tendai adherents in Kyoto and then became accepted practice, as did its worship as a central icon with vast protective powers. A few compositional variants are known [7].

This impressive painting shows Fugen and entourage on a bank of clouds, sweeping in from the heavens. The three-quarter pose of the elephant and Fugen emphasizes the deity's presence to the viewer and the promise of relief. It is most interesting that together with the ten smartly dressed court ladies carrying their attributes are Fugen's four standard attendants (Bishamonten, Jikokuten, Yakushi Nyorai, and Yuse Bosatsu) outfitted in classic garb. This contrasting note in fashion was intentional and would not have been lost on contemporary Japanese viewers, especially women venerating this image as it clearly extols the potential redemptive powers of the female demons attending Fugen.

A few such representations exist in Japan, of which this is the earliest example belonging to a public collection. Its large scale indicates that rather than serving as a private icon (perhaps for an aristocratic lady) it may well have functioned in a temple setting as an instructive icon, helping spread understanding of the precepts of the *Lotus Sutra*.[2] Currently the earliest documents mentioning services where this image was venerated point to a time frame about one hundred years before the execution of this impressive icon.

1. Leon Hurvitz, trans., *Scripture of the Lotus Blossom of the Fine Dharma* (New York: Columbia University Press, 1976). George J. Tanabe and Willa Jane Tanabe, eds., *The Lotus Sutra in Japanese Culture* (Honolulu: University of Hawaii Press, 1989) also provides much useful information and interpretation of this most important religious text.

2. Compare for example the paintings in the Fukuzen-ji (Hyōgo) and Rozan-ji (Kyoto), and an example in a Tokyo private collection; see *Bukkyō setsuwa no bijutsu* (Depictions of Buddhist scriptures), exh. cat., Nara National Museum (1990), nos. 57–58, and *Courtly Splendor,* exh. cat., Museum of Fine Arts, Boston (1990), no. 14.

37. Nehan

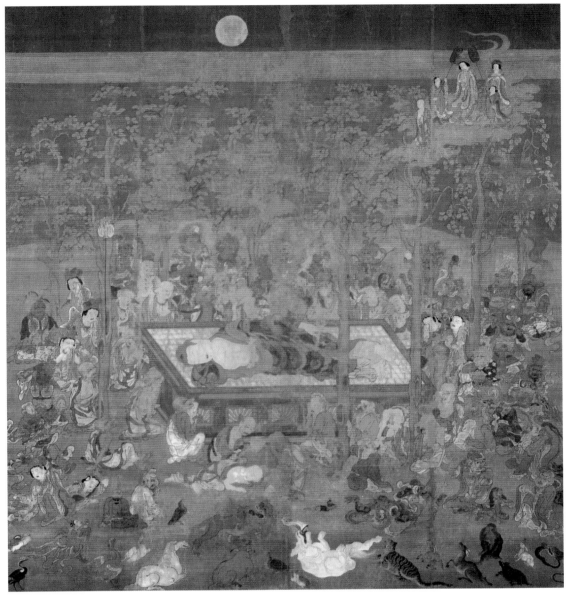

14TH CENTURY; HANGING SCROLL: INK AND
COLOR ON SILK; 180.3 X 164.8 CM; JŌDŌ-JI,
HYŌGO PREFECTURE. IMPORTANT CULTURAL
PROPERTY

Depictions of the death of the Historic Buddha
occupied a prominent place in the rituals
and visual imagery among all Buddhist sects
in Japan dating back to at least the seventh
century. In the pagoda of the Hōryū-ji a large
ceramic tableau was made showing the event
in a grotto-like setting.[1] Many dry clay figures
of Shaka's disciples and followers, as well as
bosatsu, stand around and in front of the re-
clining Buddha, some gesticulating with great
fervor in expressing their sadness. Actually
the events surrounding the passing of Shaka,
as described in the scripture devoted to it

(known in Japan as the *Dainehan-kyō*), tell of
a setting much more in keeping with that por-
trayed in this large colorful painting.

The sutra states that Shaka, aware of the
impending death of his mortal body, pro-
ceeded to a town in northern India where he
had given sermons on the dharma. There, in
a grove of *śāla* trees, he instructed his dis-
ciples to construct a bier upon which he laid
down. He asked his followers and disciples
to pose any last questions, after which he
entered a state of meditation and then died in
a reclining position on the bier.

Mourners of all classes of beings are de-
picted at this event, including his mother,
Maya, shown descending on a cloud with
attendants and a monk. The enlightened
bosatsu arranged in an arc around the back

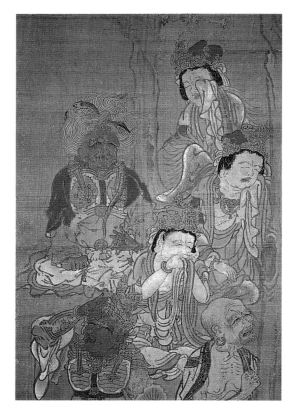

Detail of rakan and bosatsu weeping openly at the sight of the Buddha's nirvana

Fig. 37a. The death of the Buddha, dated AD 711, as depicted in the five-story pagoda at the Hōryū-ji, Nara Prefecture

edge of the bier look on with poised control, while hermit-like sages (known as *rakan*) with shaven heads and monk's robes wail. Guardian figures, multi-armed deities, nobles, and commoners—even the lowest level of beings, members of the animal world (real and imaginary)—are shown in attendance at the bottom of the composition, aware of the event's significance.

Although this complex image may be interpreted in a number of ways, it is perhaps best thought of as a powerful visual statement symbolizing the cosmic ahistoric truth of Buddhist principles, which endure regardless of earthly time. They existed before Shaka and would remain after his passing. Paintings describing the death of the Historic Buddha, which continues to be celebrated annually in Buddhist communities worldwide on 15 February, appeared in the late Heian period as frontispiece illustrations, wall paintings, and large hanging scrolls, the oldest of which is the large composition dated 1086 in the Kongōbu-ji on Mt. Koya, a center of Shingon learning established by Kūkai in the early ninth century [15]. In style and composition it reflects a transition from earlier Chinese prototypes, examples of which still exist in Japan, to an indigenous style and thematic presentation. The landscape setting is more fully described in this monumental painting, and a limited number of mourners are depicted, all with small identifying labels. The number of mourners is in keeping with earlier portrayals in the Dunhuang cave murals (cave no. 295), in Central Asian examples, at the Hōryū-ji (fig. 37a), and also on the wall murals (dated 1112, now known through photographs) at the Kakurin-ji in Hyōgo in which a Raigō scene appears on the reverse side of the wood wall panels.[2]

Such placement suggests among Pure Land (Jōdo sect) believers a direct conceptual and visual relationship between these two events by the late twelfth century. The annual ceremonies traditionally conducted on Shaka's memorial day also embraced the hope that Amida would some day come to welcome these followers on their death beds.

At the same time the more orthodox Buddhist establishments in Nara sought to assert the premise of the early textual descriptions. But despite their efforts and the existence of Song and Yuan images purported to illustrate the authentic continental origins of the Nehan scene, the wave of Jōdo sentiment in late Heian and especially Kamakura society carried the day. Thus the established canons of iconography and compositional placement for Nehan paintings relaxed in the Kamakura period, as did the ceremonies related to celebrating the memorial day. Nehan-zu paintings were often integral elements of these services, and many paintings were produced although little is known about the professional studio painters who executed them. Fortunately at least a few bear inscriptions with dates.

One early type of depiction showed Shaka lying flat on his back, arms outstretched along his body with a small group of mourners assembled, most of whom are restrained in their grief. With the rebuilding and subsequent revival of Nara beginning in the late twelfth century, coupled with the rise in popularity of Pure Land Buddhism, which sought a broader audience among the general population, more complex but inviting Nehan compositions developed. While they were often more orthodox in showing Shaka lying on the ornate bier on his side with his right hand tucked under his head, knees bent—precisely as described in the *Dainehan-kyō*—the surroundings as well as the painting style and choice of colors became freer and more descriptive in narrative content. Clearly the Japanese audience was reacting enthusiastically to a landscape setting they recognized, decorative designs and pigments they were familiar with, and such recognizable elements as facial appearance, clothes, and even animals.

The anonymous painter of this Jōdo-ji Nehan-zu chose to use a generous horizontal format rather than a vertical one, a type also in use in medieval painting studios.[3] He deviated from that norm, however, in creating a stark black band (the heavens) in which to place the sun disc and another band of gold pigment to indicate the clouds of earth and Queen Maya's entrance into one realm from the other. In this standard motif of showing Shaka's mother arriving to participate in the

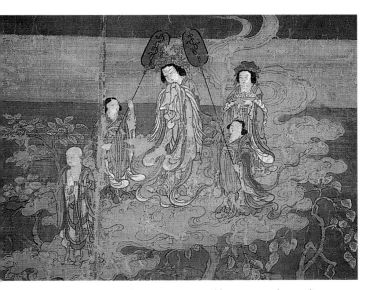

Detail of Queen Maya and her retinue descending to view her son

sad event, a special talent of the painter is obvious: he is a master colorist, revealed in the brilliant reds of the fans (and some robing details) on either side of Queen Maya's head, a tone then used in Shaka's robes and pointedly in the detailing of mourners' robing to create a complete tonal circle around the bier.

Likewise the extraordinary greenish-blue tone framing Shaka can be discerned encircling the bier in a sustained tonal rhythm. Moreover, the artist established anchoring points in the queen's retinue and the wings of a phoenix and *karyobinga* (half-bird, half-human creature) in the lower-left corner of the composition, forming a diagonal that passes through the midpoint of Shaka's recumbent form. These shared tones and colors bind the individual figures, groups of figures, and narrative vignettes into a cohesive unit. The sophisticated palette together with numerous alterations to the conventional presentation of this theme set this Nehan painting apart from the numerous more ordinary medieval renditions executed from the thirteenth to the fifteenth centuries, and their later imitators.

1. See Nakano Genzō, *Nehan-zu* (Depictions of the death of the Buddha), vol. 268 of *Nihon no bijutsu* (Arts of Japan) (Tokyo: Shibundō, 1988), especially the inside cover and pl. 1. The pagoda tableau probably dates to the beginning of the eighth century.

2. See *Nihon Bukkyō bijutsu meihōten* (Masterpieces of Japanese Buddhist art), exh. cat., Nara National Museum (1995), pl. 121. See also *Nehanzu no meisaku* (Masterpieces depicting the death of the Buddha), exh. cat., Kyoto National Museum (1978).

3. *Buddha Shakason* (Arts of the Buddha Śākyamuni), exh. cat., Nara National Museum (1984).

Detail of bosatsu dressed in elegant Chinese-style robes who collapse in grief in front of the funeral bier

Detail of Fugen's vehicle, the white elephant, rolling on its back in sadness at the Buddha's death

Detail of other mourning animals, real and imaginary

38. Jigoku Zoshi

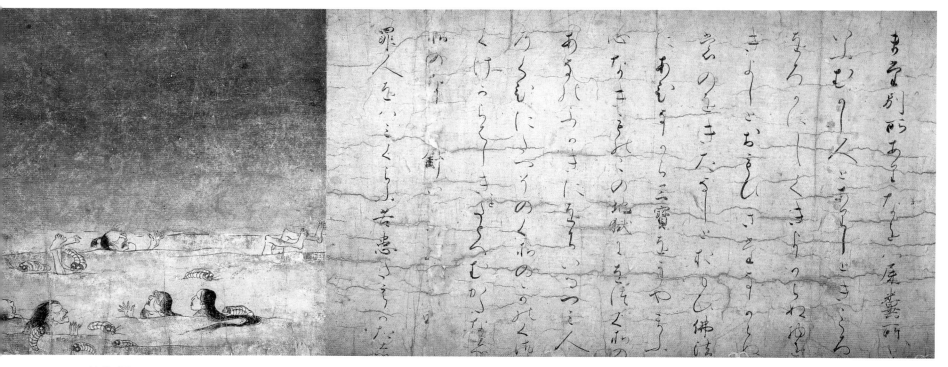

Hell of Excrement

LATE 12TH CENTURY; HANDSCROLL: INK
AND COLOR ON PAPER; 26.5 X 454.7 CM.
NATIONAL TREASURE

Certainly for Westerners there exist no more troubling, and fascinating, pictorial images in Japanese painting than the visions of hell described in this small handscroll—one part of a longer scroll that was cut up following World War II so it could be offered piecemeal to new collectors. The fragments have fortunately been preserved in Japan and in two American museum collections.

In classical Japanese handscroll (*emaki-mono*) fashion, the subject unfolds right to left in alternating passages of text written in cursive script followed by vivid illustration. The text announces the subject at hand—the name of a particular hell—and then describes its special characteristics. The illustrations are not a standard length but vary according to the visual impact and compositional requirements agreed upon by the painter(s) and their studio "editor." Several artists and calligra-

phers no doubt collaborated on this project, originally a set of handscrolls.[1] All the remaining fragments present gruesome scenes painted in vibrant red, orange, and brown tones whose intensity is only heightened by the ominously dark skies overhead that compositionally weigh down on the figural drama below. First-time viewers of this handscroll may think that black has never appeared before in such hues and such profound depths. Forms loom out of its foreboding embrace—clouds, bodies fleeing in disarray, wasps—only to merge back into nothingness. These hells appear illuminated by a dull glow oozing up from below the skyline or radiating from the reddish-brown earth or filthy cesspools.

Because the handscroll reads from right to left, the descriptions below conform to the sequence established by that orientation. So that Western readers can follow along, however, the illustrations appear from left to right on these four pages, presenting the scroll in reverse. First is a view of existence in the Hell of Excrement, where whiskered maggots

Hell of Measures

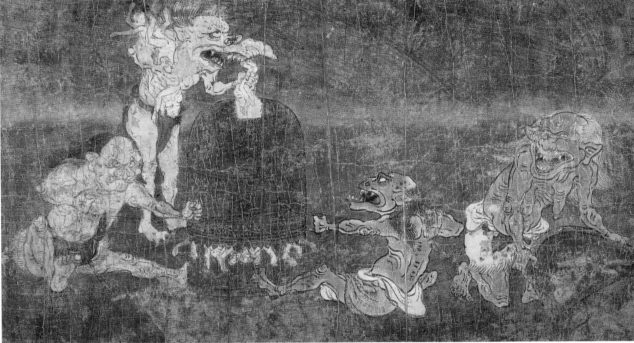

Hell of Mortars

cross the surface of a pool, feeding on the men and women (old and young) relegated to that misery. In the second illustration a large wrinkled hag with three eyes gleefully watches two women (young and old) and an elderly man pour flaming coals back and forth into rectangular containers. This excruciating exercise is their never-ending punishment for cheating customers during their previous lives as merchants when they falsified the weights of foodstuffs.

The following Hell of Mortars provides a grim view of the punishment meted out to thieves. Ecstatic demons stuff bodies into a large mortar that swivels back and forth, its teeth grinding up the dangling bodies. Then an orange-skinned hag scoops up the bones and joyously discards them in a stream of lava. The portrayal of these four figures is among the most dramatic and most accomplished of all the known painting fragments in existence. Each demon is carefully and individually characterized by physical attributes, apparel, size, posture, skin tone, and gesture.

A different approach is taken in the next segment, the Hell of the Cock, in which the regal bird tears mortals apart with its beak and sharp talons, expelling flames from its mouth. Barely visible amid the darkened pall of this hell, bodies (and parts of bodies) appear as if floating in space. In comparison, the cock is literally aflame, savagely intent upon its task of retribution against those who were cruel in their former lives. This segment and perhaps the Tenkeisei and Shinchū sections of the Hekija scroll [39] epitomize that rare and unusual melding of visual elegance and appalling subject in Japanese art. In Western paintings only Hieronymous Bosch (1450/60–1516) worked in an equally inspiring manner.

A quieter scene unfolds next. The slight figures doomed to crawl on a beach of hot sand with gases erupting in flames are those who hurt others by causing fires (always a potential disaster in a country of wooden architecture and dense urban living). The patterns of cloud bands, tripartite division of

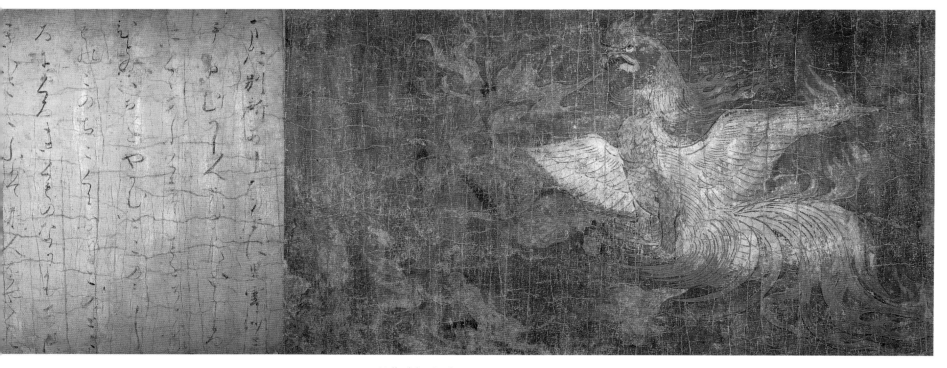

Hell of the Cock

the composition, and subtle mixing of mineral pigments to achieve the tones of each band of color are remarkable in this segment. This next scene, the Hell of Pus and Blood reserved for those who purvey unclean food, is close in theme, composition, and figural style to the first.

Although only a fragment of its original size, the final, seventh illustration depicts a nude young woman fleeing to escape the fire-breathing jaws of a furry animal of this hell. In fact, the subject and actual placement of this illustration remains a question among scholars. But the woman's condition is indeed precarious, as her stride, hand gestures, and turned head indicate. Two flying long-eared creatures assault her, drawing blood as she tries to swipe them away. Clearly this illustration is part of a larger scene whose preceding text section is also missing.

Thus this modest-sized scroll, and its related parts in other collections, describes one cycle in the pattern of retribution, rebirth, and judgment that was much on the minds

of Heian society familiar with the relevant Buddhist texts and teachings. Among those teachings was the notion that six realms of reincarnation existed into which a person would be reborn based on his or her karma (the cumulative record of one's good and evil deeds) in the present life. The lowest level is hell (*jigoku*), followed by hungry ghosts, animals, evil spirits, human beings, and then enlightened beings (*devas*).

In time *rokudō-e* (pictures of the six realms of reincarnation) came to embrace other related subjects and formats: sets of hanging scrolls visualizing the six realms; large didactic compositions of the so-called Ten Worlds (*jikkai-zu*); and even mandala compositions based upon the *Lotus Sutra* containing scenes of judgment and hell.[2] Of these, the narrative emakimono such as this Nara National Museum example are the earliest in date and, because of their small, personal format, the paintings most closely linked to aristocratic patronage during the Heian period.

Hell of Smoke

Hell of Pus and Blood

Unidentified Hell

The Kyoto and Nara area at this time was embroiled in a contentious, politically destabilizing fight between rival family clans. Battles spilled out of the capital, reaching into Nara where many temple buildings were laid waste; diseases of epidemic proportions swept through the population. In the face of these calamities, and the Buddhist prediction of the end of the world, an ingrained aversion to depictions of judgment and scenes of hell —which after all are described in the *Lotus Sutra* and were popularized in the tenth-century book *Ōjō Yōshū* (*Essentials of Rebirth in the Pure Land*) advocating belief in the Pure Land sect—waned. Historical records provide documentation for large-scale painting commissions executed in private residences that incorporated this disturbing imagery into everyday life, using motifs and scenes excerpted from the illustrated frontispieces of *Lotus Sutra* manuscripts.[3]

These beautiful and compellingly morbid visions of the fate of all unenlightened humans help us comprehend today the reality of a late Heian world at once so sophisticated and so vulnerable.

1. For a concise discussion of the history of the paintings, as well as background about the subject, see Miyeko Murase, *Emaki, Narrative Scrolls from Japan,* exh. cat., Asia Society (New York, 1983), 52–56. The Tokyo National Museum also has an extended section in its collection.

2. Shimbo Toru, *Rokudō-e* (Paintings of the six realms) (Tokyo: Mainichi Shinbunsha, 1977). See also Allen Andrews, *The Teachings Essential for Rebirth: A Study of Genshin's Ojōyōshū* (Tokyo: Sophia University, 1973).

3. Ienaga Saburō, *Jigoku zoshi, gaki zoshi, yamai zoshi* (Scenes of hell, ghosts, and diseases), vol. 6 of *Nihon emakimono zenshū* (A compendium of Japanese illustrated handscrolls) (Tokyo: Kadokawa Shōten, 1960), figs. 1–3.

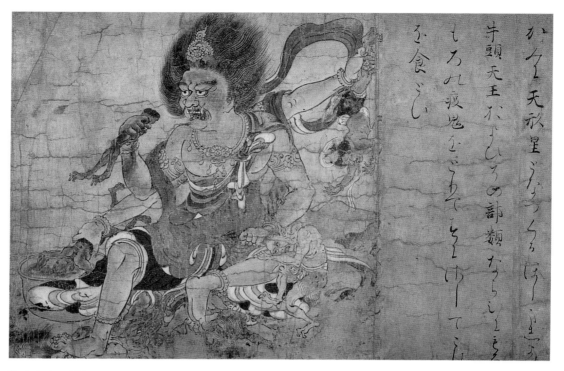

かくて天刑星とうつくほしてしる
半頭天王みつしうの部類ならえてをえ
もろれ疫鬼をとうえてをゆてこえ
ふ食ぶし

Tenkeisei and his prey

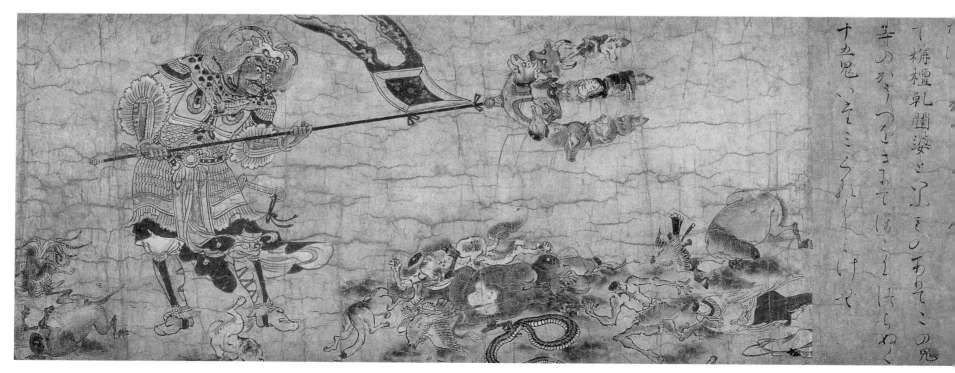

Sendan Kendatsuba

て栴檀乾闥婆をひきてこのまして
半のみうつをきてほこそはらねく
十五鬼いてこくれてこけや

LATE 12TH CENTURY; FIVE HANGING
SCROLLS: INK AND COLOR ON PAPER;
TENKEISEI, 26 X 39.2 CM; SENDAN
KENDATSUBA, 25.8 X 77.2 CM; SHINCHŪ,
25.8 X 70 CM; SHŌKI, 25.8 X 45.2 CM;
BISHAMONTEN, 25.9 X 76.4 CM. NATIONAL
TREASURE

Closely related in size, material, authorship and subject to the scenes of hell [38], these five fragments were originally part of a handscroll that was cut into individual hanging scrolls. The subject centers on the benevolent but awesome deities who protect ardent followers of Buddha's teachings by vanquishing the sundry and myriad malevolent spirits in the world who prey upon them.

A rich tradition of rendering depictions of hell based on literary descriptions in the *Lotus Sutra* exists in early Japanese art. Engraved scenes on the bronze halo of the principal icon in the Nigatsu-dō at Tōdai-ji provided an eighth-century reference for artists, as did the eleventh- and twelfth-century portrayals in sutra frontispieces from the so-called Chūsonji set [16] and mandala compositions such as that at the Kojima-dera [41].[1]

The situation is less clear with the Hekija paintings because clear visual prototypes have not been identified for their compositions. Consequently they are thought to represent essentially Japanese interpretations of Chinese texts, mixed with Japanese folklore and imagination. This commingling may be apparent in the first illustration identified in the preceding four-line text as the deity Tenkeisei, one who metes out punishment to evil spirits responsible for promoting pestilence and disease. This monumental multi-armed figure sits comfortably on a low rock plateau devouring demons. He holds one firmly in each arm as he prepares to dip them in a vinegary sauce before biting off their heads. Beneath him, squashed, lie the next round of victims, each portrayed in a distinct posture with detailed hair and skin tones like the demons above.

Tenkeisei resembles the Mikkyō deities known as myōō [30, 44, 50], the fearsome wisdom kings. Both Shingon and Tendai sects embraced these destroyers of those who controvert Buddhist law. Standing in dynamic poses, the multi-armed myōō are frequently depicted with raised hair and fluttering robes, infidels beneath their feet. The colors

of Tenkeisei's robe are particularly vibrant. He has orange skin, like that of Sendan Kendatsuba in the second section and Shōki (Chinese: Chung Kuei) in the fourth section, which helps identify them as foreigners.

Sendan hoists the severed heads of animals and demons in human guise, impaled on a trident, with their grisly remains at his feet. The coordination of body shapes and identities together with the puddles of red blood lead the viewer smoothly across the painting to the focus of the next illustration, a large winged and speckled insect with bloodshot golden eyes. Shinchū too grasps a multitude of evil spirits, each of which vainly attempts to avoid its gaping mouth lined with pointed teeth and awash in blood. This gruesome yet mesmerizing scene is set in a sketchily outlined landscape done in typical yamato-e brushwork and pigments of rich green and light brown [49, 56]. Shōki, the most famous demon queller in traditional Chinese art and literature, stands on a brown and gold ground in the following illustration. In keeping with his non-Japanese identity his skin color is highlighted and his facial features and gestures are exaggerated.

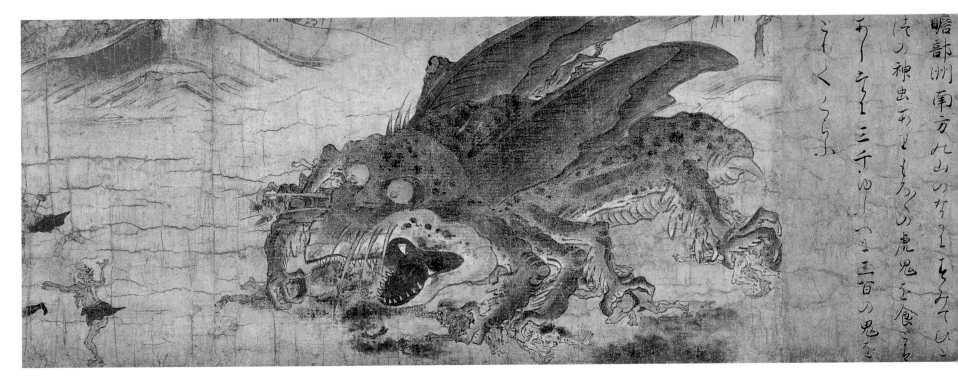

The monster Shinchū

But the skills of the landscape painter responsible for these paintings can be best appreciated in the last scene. In the left-hand margin of the composition he portrays a remote mountain setting in autumn using just a few brushstrokes. Tucked into this setting is a simple thatched hut, the abode for a monk who sits in front of it, lost in thought as he reads a religious sutra in handscroll format. Next to it is a black lacquer box, a container [74] for protecting the entire set of sacred scrolls.

The monk wears a simple gray robe, a color at variance with that of his much larger protector, Bishamonten. The leader of the four guardian kings, Bishamonten wears an elaborate suit of armor. Here he has descended from the heavens on a cloud, unknown to the studious monk, and fires off one arrow after another to drive away or kill several creatures with spiked wings and clawed feet. Using a quivering brush stroke, the artist uniformly exaggerated the features of these scabby demons.

The masterful use of space and density of forms, strident color and muted tonalities, repose and movement help lend a grandeur to the picture well beyond its physical size. Related compositions occur in *Lotus Sutra* frontispiece illustrations painted in gold on indigo-dyed paper (ninth to twelfth centuries) and in those of the *Heike Nōkyō* executed in exquisite yamato-e style on specially prepared papers containing pieces of gold and silver foil.[2] This sumptuous set of *Lotus Sutra* scrolls was donated to the Itsukushima Shrine by the Heike family in 1164.

The visual rhythm of this Hekija group moves apace from violent beauty to the muted silence of autumn, from monumental figurative scale to one comfortably placed in its natural surroundings, and from barren earth to verdant mountain terrain. The tales point once again to the rich fabric of the *Lotus Sutra,* the source for seemingly countless depictions of the life of Buddha and embellishments upon that story. In the later Heian period its popularity among the nobility took many forms, including wall paintings, folding screens, sets of hanging scrolls, and handscrolls, all produced to illustrate its teachings.

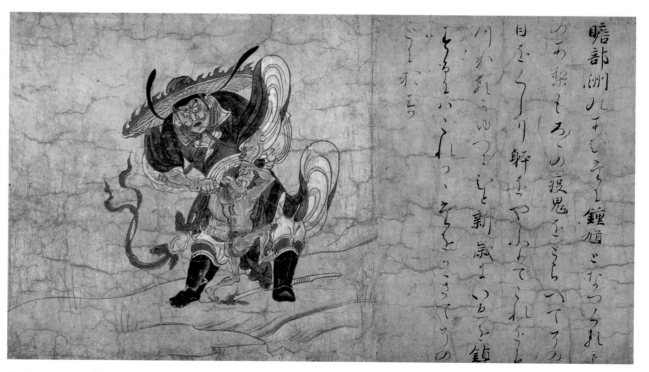

Shōki, destroyer of demons

Although slightly later in date than the hell scenes, these paintings surely issued from the same studios, thanks also to Kyoto's aristocratic patronage. Nobility had become increasingly sensitive to the precariousness of its status and well-being in light of recent plagues and fractious political events and so turned increasingly toward incorporating edifying religious imagery into its literature and into support of Buddhist-related imagery. The Hekija narratives are but one manifestation of that anxious world, but unique in their preservation to this time.

1. See Miya Tsugio, *Rokudō-e* (Paintings of the six realms), vol. 271 of *Nihon no bijutsu* (Arts of Japan) (Tokyo: Shibundō, 1988), figs. 20–27. At Tōdai-ji hell scenes also appear on the ablution basin (late eighth century) and in engraved imagery on the lotus petal base of the Daibutsu.

2. *Bukkyō setsuwa no bijutsu* (Depictions of Buddhist scriptures), exh. cat., Nara National Museum (1990), pls. 66, 70, 76.

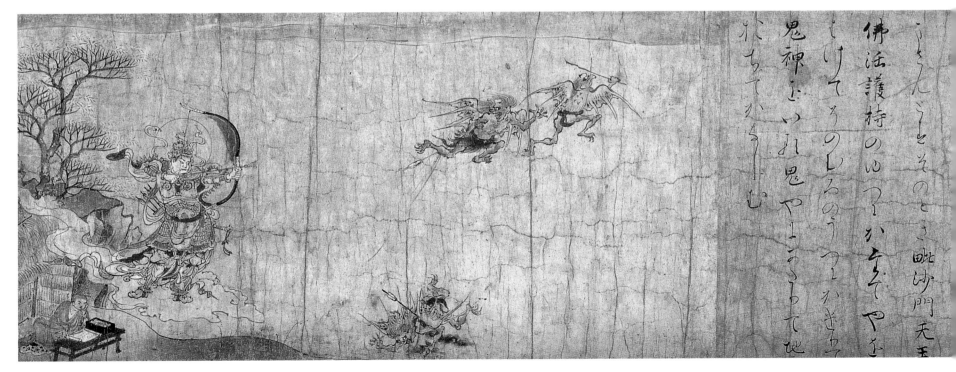

佛法護持のゆつてかたでやも
鬼神よいれ鬼やもうてて地
もけてろのしろのうつてわきつて
たちてかうし

うきんごとそのとさ毗沙門天王

Landscape with monk and Bishamonten, leader of the four guardian kings, vanquishing demons

40. Iconographical Sketches of the Deities of the Taizōkai Mandala

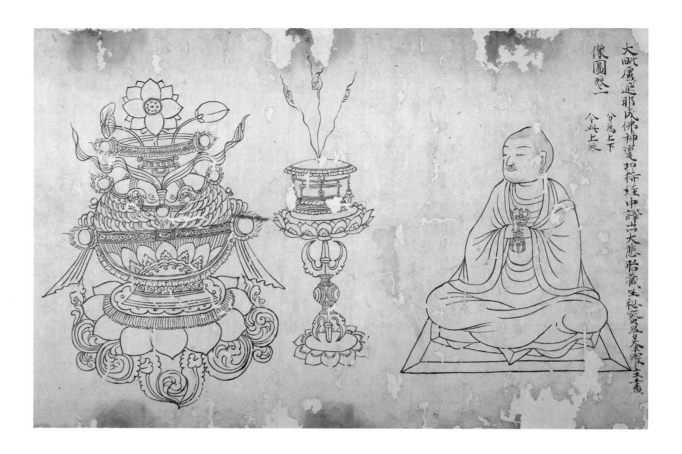

DATED 1194; HANDSCROLL (ONE OF A PAIR): INK ON PAPER; 30.3 X 1409.7 CM. IMPORTANT CULTURAL PROPERTY

This handscroll, one half of a paired set, depicts the many deities appearing in the Taizōkai (Womb World) mandala, which with its mate the Kongōkai (Diamond World) mandala, represents the fundamental innate "correctness" of all teachings and the active intelligence seeking to grasp and explicate that knowledge [41]. Thus the two mandalas form a coherent syncretic approach to attainment of the metaphysical "true word" (shingon) espoused by the Esoteric sects of Tendai and Shingon in Japan.

Esoteric thought and ritual practice originated in India well before the western Christian era and was actively transmitted to Tibet and China by the early eighth-century monks who brought with them texts (some of which had already appeared in China). By the time the Japanese monk Kūkai arrived in China and took up residence at an Esoteric monastery under the tutelage of the master Hui-kuo (746–805), intent on learning the teachings and ritual practices there, Esoteric Buddhism in China had evolved into an eclectic sect incorporating popular, even folk beliefs into its liturgy.

In 805, Kūkai brought Shingon, one stream of current Esoteric thought and ritual, back to Kyoto and was granted permission to establish two temples, one devoted to meditation (on Mt. Koya, southwest of Nara) and one to learning and ritual ceremony (Tō-ji in Kyoto). At Tō-ji Kūkai took a profound interest in commissioning the copying of religious texts and the production of sculpture, paintings, ritual metalwork, and lacquerwares, all of which could be used to promulgate the new faith.[1] These objects together with the exclusive and secretive rituals central to Shingon belief attracted a large influential following in the ninth and tenth centuries, when it indeed became the most important religion in the country.

Kūkai's receptivity to the visual arts as important transmitters of doctrine apparently began during his stay in China. Upon his return to Japan he became the most forceful proponent of this aid to teaching, ceremony, and the ornamentation of temple interiors, all meant to serve the higher purpose of glorifying Shingon's precepts.[2] Kūkai surely brought with him on his return any number of sutras, ritual objects, painted icons, and perhaps even some sculpture. He also surely carried handscrolls, like this one, containing ink drawings describing the identities, appearances, and contexts for the myriad deities found in the Shingon pantheon, according to the interpretations of various sutras. From these small simple sketches whole mandalas in vivid color on large silk hanging scrolls or in life-size wooden statuary could be composed for Tō-ji or any of its affiliated temples. These sketches (zuzō) can be found at several important Shingon temples in the Kyoto area, attesting to their portability and their

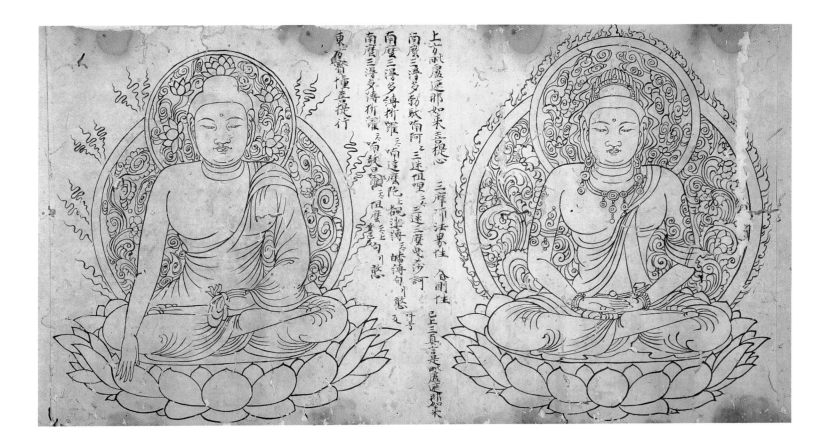

importance as the key visual reference tool to which priests and artisans alike turned regarding matters of religious iconography or identity, or the correct application of color to an icon. Most surviving zuzō date to the twelfth century or later, as does this scroll.

This volume is one of a pair and illustrates with names (and sometimes lengthy descriptive passages) the deities of the *Dainichi-kyō (Sutra of Dainichi),* a text known in China in the eighth century. It came to Japan as one scroll on the return of the monk Chishō Daishi or Enchin (814–891), a relative of Kūkai. In Japan the sketches were divided by Enchin and are then known to have been copied at least three times. This first scroll depicts eight realms or "courts" surrounding the central image of Dainichi Nyorai, the supreme cosmic icon of the Shingon faith who represents the nonduality of reason and knowledge. His name, Great Illuminator or Great Sun Buddha, conveys an idea of his essence.

The rendering of the figures is atypical of most similarly dated zuzō, as it retains the mannerisms of a taut Indian style as it might have been interpreted by Chinese artists. In some sections of the handscroll the deities are composed in two ranks, but this diminution in size does not detract from the visual assuredness of their appearance, nor an awareness by the viewer of the intensity of an endeavor of this scale, an act of religious piety in and of itself that is related to sutra copying. These sketches, however, served a more practical purpose in the life of a scholastic temple. Impressive collections can still be found in the Daigo-ji and Ninna-ji in Kyoto.[3]

Because the scroll is firmly dated to the twelfth century it provides an important document for assessing other figure painting styles of the late Heian period. Comparison with the Jūichimen Kannon [45], Senju Kannon [46], and Ichiji Kinrin [42] and Daibutchō [43] mandalas are especially revealing of the diverse stylistic modes available to Heian period painting studio artists.

1. For a good introduction to this subject, see William Theodore de Bary, ed., *Sources of Japanese Tradition* (New York: Columbia University Press, 1958), 137–55.

2. A good representation of this material appears in *Kōbō Daishi to Mikkyō bijutsu* (Kōbō Daishi and the art of Esoteric Buddhism), exh. cat., Kyoto National Museum (1984).

3. See Hameda Takashi, *Zuzō* (Iconographical drawings), vol. 55 of *Nihon no bijutsu* (Arts of Japan) (Tokyo: Shibundō, 1970).

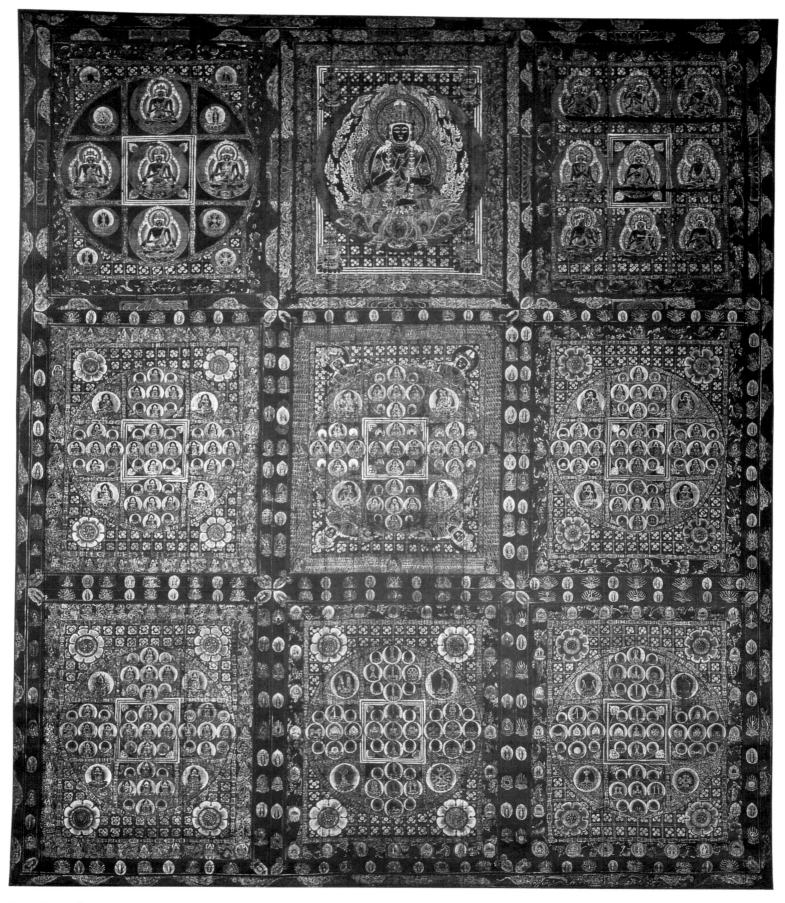

Kongōkai scroll

128

41. Ryōkai Mandalas

11TH CENTURY; TWO HANGING SCROLLS: GOLD AND SILVER PIGMENTS ON SILK; KONGŌKAI, 352.5 X 299 CM; TAIZŌKAI, 352 X 306.4 CM; KOJIMA-DERA, NARA. NATIONAL TREASURE

The complex web of ideas and rich visual imagery of Esoteric Buddhism occurred rather early in Japan. The magnificent dry lacquer Fukūkenjaku Kannon in the Hokke-dō at Tōdai-ji (eighth century) or the earlier wall painting at the Hōryū-ji of the Jūichimen Kannon (seventh century, destroyed by fire) attest to its acceptance, if not popularity, before and during the early years of the Nara period. Gilt-bronze icons recovered from sacred Shinto locations also indicate the beginnings of the process of accommodation between Shinto and Buddhism that later in the Heian period manifested itself as a new category of syncretic religious imagery [54–57, 65, 67, 76]. The impressive wood statuary at Daian-ji, represented in this exhibition by the Yoryū Kannon [22], offers a glimpse of the scale of that acceptance.

Thus even before the monk Kūkai returned from China late in 805 with Shingon sect experience and training and Saichō the year before with Tendai's teachings [15], scripture and imagery related to Esotericism was known. Yet it was not until these two strong-willed charismatic monks began teaching at their respective monastic centers, with official government approval, that its beliefs proliferated in the early Heian era. Shingon's popularity was propelled by Kūkai's influence at the large temples in Nara and then among members of the court at the new capitol in Kyoto.[1] His advocacy of using painted and sculpted imagery to explain arcane Shingon doctrine led to the production of schematized designs giving order to the cosmic philosophical structure of the Shingon belief system.

Known as mandalas, these compositions are diagrams or "blueprints" seeking to explain, pictorially, the path to enlightenment. By composing a concrete framework of deities and symbols together with the "courts" or realms they dwell in, artists illustrated the "directions" a believer might take toward realizing a particular goal. These paths were not random but followed the canons of Esoteric teachings as they had been introduced into Japan. Later in the Heian period new

interpretations became normal in response to a strictly Japanese audience and to changes proposed by Japanese Shingon and Tendai masters through the centuries. These two sects also favored minor alterations of their own, reflecting their distinct interpretations of scriptural text.

On his return from China Kūkai brought to Japan a pair of mandalas that have been lost. These were probably Kongōkai (Diamond World) and Taizōkai (Womb World) paintings and presumably had the same general appearance as the ninth-century pair still kept at Tō-ji in Kyoto, established by Kūkai.[2] The oldest pair of mandala paintings known in Japan, they are based on the *Sutra of Dainichi* and *Diamond Crown Sutra* respectively, both of which date to the late seventh or early eighth century. These Tō-ji Ryōkai mandala paintings are rendered in vivid color and gold paint in a figural style reminiscent of that seen in the Jūichimen Kannon [45] in this exhibition.

The smaller size and coloration of the Tō-ji paintings, however, hardly prepares one for these monumental Ryōkai mandalas, whose golden ranks of deities seem to emerge as low-intensity beacons glowing in the background of indigo-dyed silk. The third oldest pair of Ryōkai images extant, these paintings are in much the best condition. And while they depart from the Tō-ji pair in style, detailing, and iconographic variants of some of the deities, their organizational schema is close.

Concisely stated, the Taizōkai features a meditating Dainichi at its center surrounded by eight lotus petals with accompanying deities. Radiating from this central court above, below, and to either side are eleven ranks of deities occupying coherent iconographic spaces, each of which corresponds to the assemblies described in the *Sutra of Dainichi*. The Kongōkai presents a different schema, showing a more complex cosmic world divided into nine rectangular areas, each of which is itself a mandala. Dainichi, the large seated figure showing the mudra of knowledge (*chiken-in*), presides in the upper court.[3]

Because of their size, the paintings could only have been displayed in a large devotional hall, where they would have been suspended between columns in an open bay, facing one another. Raised platforms with ritual objects [84] as well as smaller tables, sutra stands, and offerings of fruit, rice, and

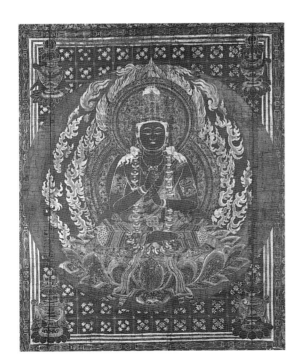

Detail of Dainichi Nyorai in the upper court, Kongōkai

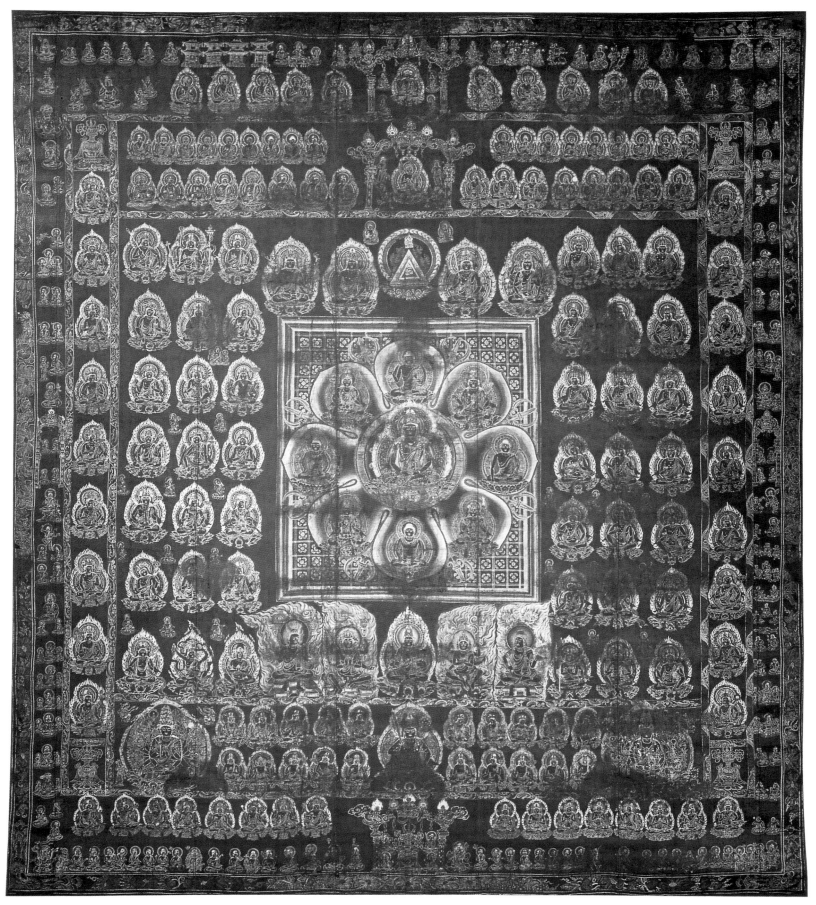

Taizōkai scroll

130

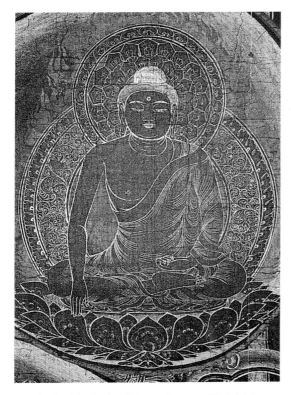

Detail of a deity in the eight-petal court of Dainichi, Taizōkai

flowers were placed before each of the mandalas. Precisely how ceremonies were conducted remains unclear since so much of Shingon teaching ritual was orally transmitted or held in secrecy. In an adaptation of the traditional ceremonies introduced by Kūkai, however, special rites using mandala paintings were conducted at both the palace and Esoteric temples. They are still held at Tō-ji and many Esoteric sanctuaries in Japan.

These paintings represent a period when Esoteric Buddhism of both Tendai and Shingon persuasions was enjoying its greatest patronage and popularity. The two scrolls are thought to have been given to the priest Shinkō (934–1004) by Emperor Ichijō (980–1011) in gratitude for prayers seeking his recovery from illness around the turn of the century.[4] While not the largest or oldest Ryōkai mandala paintings extant in Japan, they are the most resplendent, illuminating not only spiritual doctrine but also an emerging Japanese style of expression in color and form. The two schema may be said to map the world of spirit (Diamond World) and matter (Womb World). Or, to state it more fully: "Broadly speaking, the Diamond World mandala represents reality in the buddha realm, the world of the unconditioned, the real, the universal, and the absolute. The Womb World mandala represents reality as it is revealed in the world of the conditioned, the individual, the particular, and the relative."[5] A mesmerizing display of elegant brushwork modulates effortlessly in describing figural form, and the hands of several artists can be distinguished among the literally thousands of figures and decorative panels. Although work on these mandalas must have been a collaborative effort, the talent of the artists and quality of the materials are consistent. For anyone wanting to study Heian iconography or painting style these mandalas remain a primary resource. Those who wish to understand why the Heian period is considered a golden age in Japanese cultural history need to look no further than this pair of paintings extolling the search for spiritual enlightenment.

1. For a general background see Joseph Kitagawa, *Religion in Japanese History* (New York: Columbia University Press, 1966), chap. 2.

2. *Kōbō Daishi to Mikkyō bijutsu* (Kōbō Daishi and the art of Esoteric Buddhism), exh. cat., Kyoto National Museum (1984), cover and pl. 60.

3. For an interpretation of the courts, see Hisatoyo Ishida, *Esoteric Buddhist Painting,* trans. and adapted by E. Dale Saunders (Tokyo: Kōdansha International, 1987), 29–46.

4. *Nihon Bukkyō bijutsu meihōten* (Masterpieces of Japanese Buddhist art), exh. cat., Nara National Museum (1995), pl. 100.

5. Elizabeth ten Grotenhuis, *Japanese Mandalas: Representations of Sacred Geography* (Honolulu: University of Hawaii Press, in press).

Group of figures in an outer court, Taizōkai

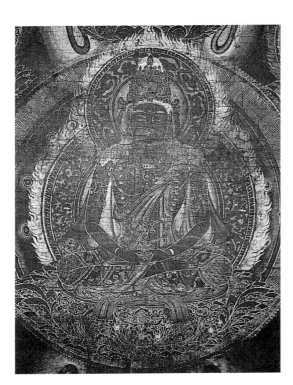

Detail of Dainichi holding a rinbō in the lotus court, Taizōkai

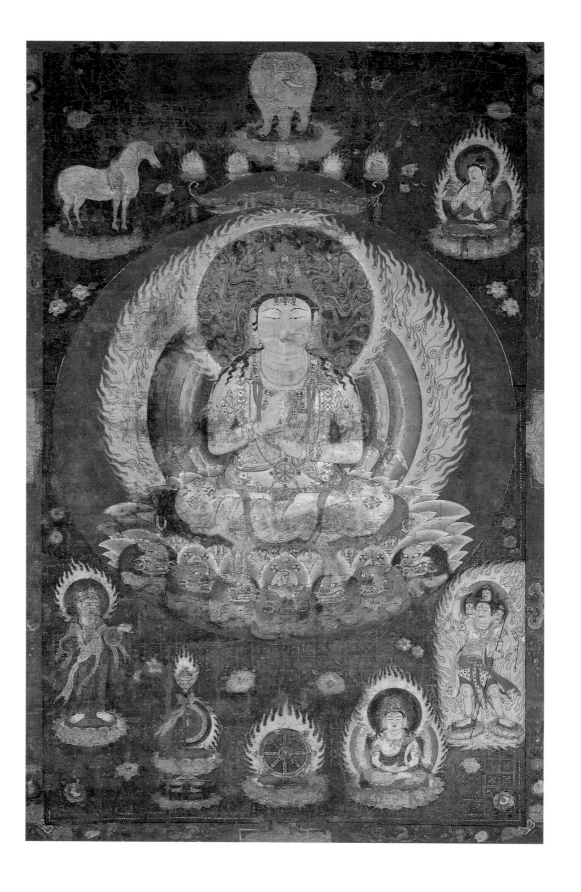

12TH CENTURY; HANGING SCROLL: INK, COLOR, SILVER AND GOLD PIGMENTS, AND CUT GOLD FOIL ON SILK; 79 X 49.2 CM. IMPORTANT CULTURAL PROPERTY

The Ryōkai mandalas, impressive in scale and among the oldest remaining Buddhist paintings in Japan, represent a special aspect of Esoteric Buddhism that survives in painted imagery today. In fact most extant mandala paintings present a single deity, focusing on its appearance, special attributes, and related attendants. Rather than contemplating a vast graphic description of religious hierarchy and canon, the viewer is given a discrete world to consider presided over by a centrally placed, recognizable image. Most of these mandalas were made for and are displayed at specific services, in the hopes of attaining some form of relief or benefaction.

Depicted here, seated on a magnificently appointed lotus base, is Dainichi Kinrin showing the *chiken-in* mudra, which signifies universal knowledge. This hand gesture as well as the hair, jeweled decor, and double halo with encircling flame are found in Dainichi's portrayal in the central court of the Kojima-dera Diamond World painting from about a century earlier [41]. Here, however, the deity's presence is based on a Sanskrit text first translated into Chinese by the monk Amoghavajra (705–774) and then transmitted to Japan by way of paintings, iconographical sketches, or both. The earliest zuzō showing an Ichiji Kinrin (One Syllable Golden Wheel) mandala, datable to the twelfth century, appears in the *Besson Zakki* compendium of iconographical drawings.[1] Ichiji Kinrin symbolizes the universal dimension of Buddha and his authority, something not dissimilar to Dainichi's purview, in which utterly no obstacles hindered the transmission of his word.

Interest in the visualization of this Esoteric concept as a mandala derived largely from the texts describing the deity's effectiveness in prolonging life and combating illness, among other benefits. The image also gained favor in a highly secret but important Esoteric service conducted at Tō-ji in the later eleventh century: the Rite of Respect and Affection.

Seven "treasures" or attendants and the deity Butsugen (seated in the lower right) traditionally surround Dainichi Kinrin, signifying the manifold aspects of its powers. Clockwise from the flaming rinbō at the lower border of the painting are the sacred jewels, goddess, horse, elephant, "storehouse" deity, warrior deity, and Butsugen.[2] These elements also appear in the Daibutchō mandala [43] but in a vastly different figural characterization. Interspersed among the figures in the Ichiji Kinrin are flowers with varied colorations, shapes, and leaves. In the lower register of the composition all these elements—figures and decoration—are set on a now-faded grid pattern with central foliate motifs, all applied in kirikane. At the top, banners, streamers, and flowers float down toward a red canopy topped with five flaming jewels.

The portrayal of all these elements is of the highest order and materials, in a style consistent with other late Heian icons such as the Fugen at the Bujō-ji in Shimane, the Fugen Reimei at Jikō-ji in Hiroshima, and the Senju Kannon in this exhibition [46].[3] Although the surface sustained damage from its display in rites and services over the centuries, the depth and subtly orchestrated beauty of its surface continue to radiate toward viewers.

The central figure is rendered in white pigments with light vermilion shading bordered with red outlining brushstrokes. Garment folds are highlighted in a tea-colored brown, robe forms outlined in silver pigment, and stylized floral patterns described in gold and silver paint. Unusual touches include the lines of silver dots in the torso garment designs and the lack of cut gold designs in the figures and decoration, a treatment reserved for the ritual objects and decorative accessories.

Perhaps the most remarkable features of the anonymous professional painters' technique and color sense, however, can be discerned in the painted red border with floral designs, the green hue of the lotus petals, and the manner in which the seven lions below the petals clench gold foil sankōshō in their powerful jaws. This scroll is the finest example known to exist, and one of the most compelling and enigmatic of all Heian period Buddhist mandalas.

1. For a survey of the iconographical drawing repertoire and history of its collection in Japan, see Hamada Takashi, *Zuzō* (Iconographical drawings), vol. 55 of *Nihon no bijutsu* (Arts of Japan) (Tokyo: Shibundō, 1970).

2. For other variations of this iconography, see Hisatoyo Ishida, *Esoteric Buddhist Painting,* trans. and adapted by E. Dale Saunders (Tokyo: Kōdansha International, 1987), 52–54.

3. *Heian butsuga* (Heian period Buddhist painting), exh. cat., Nara National Museum (1986), nos. 35, 37, 40, 50.

43. Daibutchō Mandala

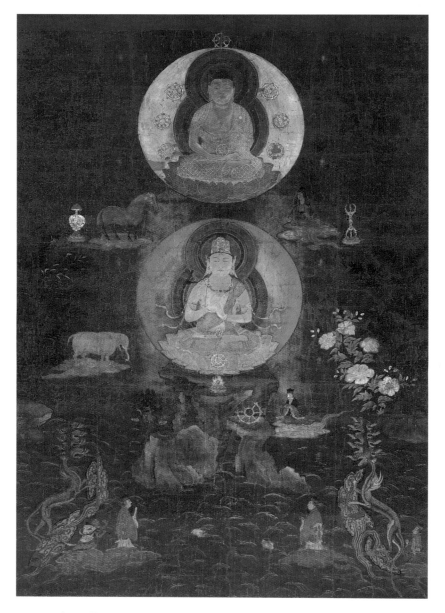

12TH CENTURY; HANGING SCROLL: INK, COLOR, AND CUT GOLD AND SILVER FOIL ON SILK; 125.5 X 88.5 CM. IMPORTANT CULTURAL PROPERTY

The subject of this rare Esoteric painting with landscape setting can be found among the *butchō* (deities) systematically aligned one next to the other in the two courts immediately above the central eight-petaled diagram with Dainichi in the Taizōkai (Womb World) cosmos [41]. In this court of Universal Knowledge these deities help provide guidance to those who seek to quiet the worldly distractions of emotion and attachment to self-delusion, so that awareness or knowledge of Buddha's nature may make itself apparent. The butchō aligned here give form to the notion that all sentient beings inherently seek enlightenment. Above the court of Universal Knowledge is the court of Shaka where deities symbolizing the manifold ways by which human beings actively strive to achieve enlightenment reside.

The title of this large mandala, Daibutchō, derives from the deities depicted in these courts, the *butchōson* (deities with uṣṇīṣas) who amplify, for didactic purposes, the circumstances of the Historic Buddha's enlightenment. In this way the legends attached to Shaka's worldly attainments of enlightenment come to encompass the more lofty dimensions surrounding the world of deepening consciousness itself. Thus butchō imagery moves from the descriptive text of the *Dainichi-kyō* to a graphic cosmological visual presentation in pigments on silk to, occasionally, single hanging scrolls extolling the virtues of a specific deity and its attendants such as this extraordinary example.

Iconographical drawings of this Daibutchō subject can be found in the twelfth-century compilation *Besson Zakki*. There Daibutchō sits on a pillar of rock jutting out of the sea, a reference once more to legendary Mt. Potalaka [48–49]. A pair of dragons, each with multiple heads, rise up from the waves together with a trail of clouds. Nearby, to one side of the craggy mountain are an elephant and a myōō figure; on the other side are a rinbō, a flaming jewel, and a storehouse deity (kneeling figure in classical Chinese attire atop a cloud).

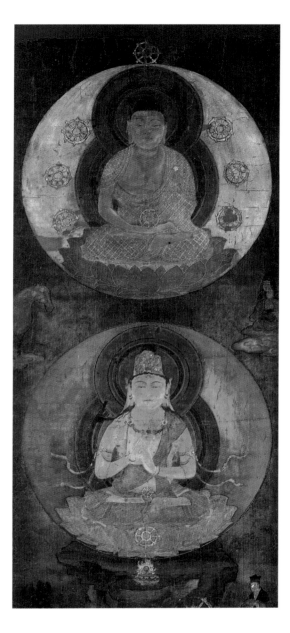

To either side of Daibutchō a small clump of bamboo and blossoming flowers frame the deity's roundel. Directly above is a seated Shaka Kinrin image flanked by a horse and elaborate lidded vessel on one side and a seated female figure and three-pronged sankōshō on the other. Seven rinbō surround Shaka Kinrin within its roundel. Then, in sequential order, appear the storehouse deity, rinbō, flaming jewels, fierce "warrior" deity, and the elephant. These seven treasures, seven rinbō, and Shaka all relate to Cakravartin, the legendary Indian king who rode in a chariot whose wheels (path) knew no obstacles.

Many of the elements in this Daibutchō also feature prominently in the Ichiji Kinrin painting [42]. In all likelihood their shared compositional and iconographic features came to Japan at about the same time, in the late eleventh century, if documents concerning rituals at Tō-ji temple are relied upon. Then other variants emerged and were used. For example the golden lidded vessel (upper left) and thunderbolt (upper right) also suggest other (perhaps continental) sources for the iconography.

More significant, however, this Daibutchō figural style differs markedly from that of the Ichiji Kinrin mandala, a distinction made all the more clear by the presence of iconographically identical central figures: Dainichi Kinrin. The dark yellow pigmentation of the torso, shading conventions, and the extensive use of cut gold and silver foil strips typify this painting's approach to illuminating the wisdom of Dainichi Kinrin. Cut gold (or silver) is not present in the Ichiji Kinrin Dainichi figure's garment designs.[1]

The landscape setting is especially intriguing. It surely depicts Mt. Potalaka, the "mountain in the sea," in decidedly archaic conventions and with Chinese symbols referring to the imaginary setting for that mountain, replete with seven- and nine-headed dragons and their attendant spirit kings outfitted in Tang-style garb. The highly stylized cloud formations, wave patterns, and even the two fish-like ocean creatures are intended to impart the aura of a magical legendary past.

But perhaps an even more noteworthy feature of this mythical landscape is the land banks with bamboo to either side of the composition, one portrayed with a gorgeous display of peony-like flowers. These motifs are unknown in the pertinent religious texts but appear iconographically in Japanese zuzō and elsewhere in Buddhist landscape imagery. A particularly relevant plant motif appears in the landscape of the famous stupa scene in the Fujita Art Museum's paintings of eight founders of the Shingon sect.[2]

The brushwork seen here is unusual for a Buddhist painting of this age; similar approaches do not appear until more than a century later in Kamakura painting. These familiar elements of nature remind the viewer in attendance at an Esoteric ceremony both of the deity's remote past and its enduring powers on the continent where Buddhism originated. They also help present a more appealing, natural-appearing iconic image than, say, the schema of the related Ichiji Kinrin mandala. Comparison with the Senju Kannon [46, 48] and Nyoirin Kannon [49] paintings clarifies further the important role landscape depiction played in the development of Syncretic, Esoteric, and Pure Land Buddhist religious imagery as the thirteenth and fourteenth centuries unfolded.

This painting represents an important reference point in that regard as well as in its iconography joining Shaka Kinrin with Ichiji Kinrin in this one painting of impressive dimensions. It regularly functioned as the principal votive icon at rites petitioning the butchōson for protection from calamity, and for prosperity. Among extant Heian period paintings it is both the finest example of its subject and one of the landmarks for the study of Heian period painting.[3]

1. For an insightful treatment of surface decoration in classical Japanese sculpture and painting, see Ariga Yoshitaka, *Kirikane to saishiki* (Cut gold leaf and painted decoration on Japanese paintings and sculpture), vol. 373 of *Nihon no bijutsu* (Arts of Japan) (Tokyo: Shibundō, 1997).

2. Fujita Bijutsukan, ed., *Fujita bijutsukan meihin zuroku* (Masterpieces in the Fujita Art Museum) (Tokyo: Nihon Keizai Shinbunsha, 1972), pl. 9.

3. See *Heian butsuga* (Heian period Buddhist painting), exh. cat., Nara National Museum (1986).

44. Sonshō Mandala

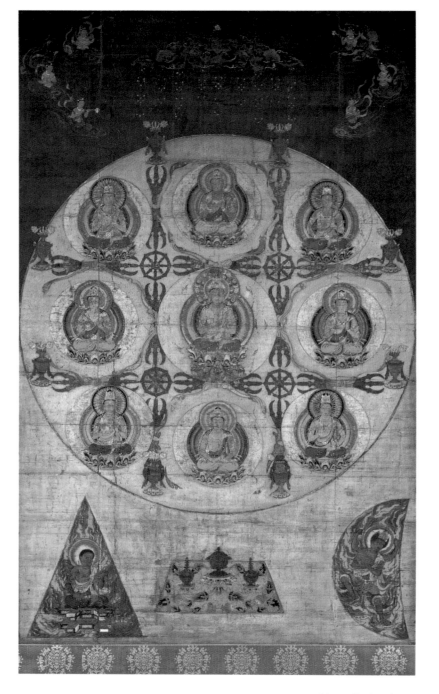

Detail of Fudō Myōō from Taizōkai [41]

13TH CENTURY; HANGING SCROLL: INK, COLOR, AND CUT GOLD FOIL ON SILK; 133.6 X 82.8 CM. IMPORTANT CULTURAL PROPERTY

Nearly as large in size as the Daibutchō mandala [43], this Sonshō mandala actually relates more closely visually to the smaller Ichiji Kinrin mandala [42] in its schematic setting, palette, and organization. All trace their textual and iconographic sources to the Dainichi Nyorai, the supreme embodiment of enlightened knowledge in Esoteric Buddhism.

Here Dainichi occupies the central position in the roundel, with the most colorful and structurally elaborate lotus base and halo. Seven lions portrayed in sharp ink lines with polychromy and cut gold eyes support a lavish three-stage throne for the deity. Red flame patterns flicker across the pale outer halo between the base and smaller upper halo, which is equally appointed in lustrous mineral pigments.

Eight deities of equal size, each displaying an identifying hand gesture, surround Dainichi. The presentation of these butchō (the uṣṇīṣas

Detail of Fudō Myōō

Detail of Gōzanze Myōō

signify their primordial genesis directly from the head of the Buddha) provides a vivid comparison with the figural representation in the Ryōkai mandalas [41] and Daibutchō mandala [43] and indicates the stylistic range of Buddhist painting studios in Nara and Kyoto. Still, it follows textual sources, some of which are ascribed to Zemmui (637–735), the Indian monk (known as Śubhākarasimha) who is well known in Buddhist history for having been invited by the Tang emperor Hsūan-tsung (685–762) to deliver lectures commenting on the *Dainichi-kyō,* a cornerstone sutra of the Shingon sect and the principal source of the Ryōkai mandalas and related images such as this one.

This Sonshō mandala is based on a text known in Japan as the *Sonshōki,* said to have been translated and commented on by Zemmui. It has become a discrete icon of Esotericism (principally Tendai) based upon the efficacy of a ceremony, known as the Sonshō ritual, for which it serves as the principal visual icon. This ritual of Tendai (which probably contains elements of Pure Land Sect Buddhism) includes invocations seeking general well-being, and good health as well as rain.[1]

Each of the powerful butchō is framed by three-pronged sankōshō, the tips of which touch four central rinbō. While rinbō appear frequently as visual symbols in Buddhist art generally, in actuality they are ritual implements (*dōgu*) of gilt bronze used in ritual practice; they signify that there are no obstacles to the Dainichi's teachings. At the peripheries of the halo, elaborate kebyō [87] are shown, both within and extending out of the halo. Each of them contains two pink lotus blossoms and a dōgu such as a three-pronged sankōshō, has a red cloth draped from the shoulder, and stands on a lotus pedestal. Kebyō appear most consistently as an integral component of the pedestal in Aizen Myōō sculpture and painting [30, 50] but are also used regularly as part of the Esoteric ritual object repertoire [84] and in the adornment of altars.[2]

The roundel is painted in several hues of a tea-brown pigmentation according to the individual halo placements. A band of cut gold foil encircles the roundel and sets it off from the pale green field below, which contains a fiery moon-shaped halo framing Gōzanze Myōō (right), a triangular halo framing Fudō

Myōō (left), and in the center a rectangular panel with a censor (*kasha*) [86] with two flanking, stupa-form reliquaries [79]. This central motif is particularly fascinating because it is as if the painter was attempting to incorporate Western notions of perspective into the schema. The leaf and blossom designs are augmented by gold and green tendrils that add a note of lavishness and exoticism to an otherwise somber icon. The textual source for this vignette is as yet not known.

Above, the three pieces of silk sewn together to form this hanging scroll have darkened so it is difficult to see clearly the detailing of a central canopy with floral designs. However, cut gold appears as tendril shoots and as part of a trellis of bead and metalwork suspended from the canopy down toward the roundel. On either side three heavenly attendants float down on colored clouds in a symmetrical pattern. Like the other figures in this painting, they are proportionally slender and the head shapes tall compared with the twelfth-century Senju Kannon, for example, which also displays a fine, delicate drawing technique [46].[3]

Nevertheless, the painting style, palette, and sensibility issue out of mainstream Buddhist painting conventions in the late Heian period. This Sonshō mandala possesses the gem-like qualities of invention, representation, and spiritual sincerity compatible with the arts of the Heian, a tradition that lingered into the Kamakura era where it eventually succumbed to the new waves of syncretic influences forming yet other modes of creative expression in Buddhist religious art. A small number of Sonshō mandala compositions attributable to the Kamakura period exist, of which this is among the earliest and most aesthetically charged.

1. For other compositions, see *Hieizan to Tendai no bijutsu* (Mt. Hiei and the art of Tendai sect Buddhism), exh. cat., Tokyo National Museum (1986), nos. 20, 21, 40.

2. See *Mikkyō dōgu* (The ritual objects of Esoteric Buddhism), exh. cat., Nara National Museum (1992).

3. See for example *Heian butsuga* (Heian period Buddhist painting), exh. cat., Nara National Museum (1986), nos. 33, 51–52, 77–79.

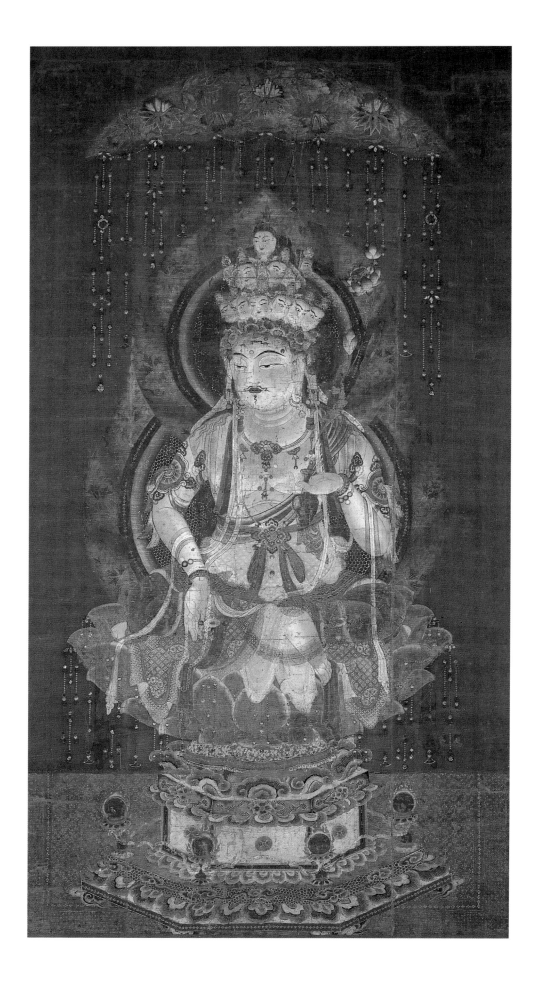

12TH CENTURY; HANGING SCROLL: INK AND COLOR WITH CUT SILVER AND GOLD FOIL ON SILK; 169 X 90 CM. NATIONAL TREASURE

This resplendent image of the Eleven-headed Kannon is seated cross-legged, gazing to its right, with a pensive facial expression, proper right arm lowered over lap, hand extended forward at a slight angle in a *yogan-in* (wish-fulfilling) mudra. The left arm is raised toward the chest, with the palm of the hand facing upward in an awkward position. The thumb and first finger hold a gilt-bronze water jar (with surface decoration) from which a long lotus stalk emerges. The lotus leaves and three flowers are shown in various stages of unfolding.

The Kannon's crown is surmounted by eleven small bosatsu heads arranged in three tiers with the large *butsumen* (front facing) head forming the pinnacle as in the Senju Kannon painting [48] or the eighth-century Jūichimen Kannon sculpture [23] in this exhibition. But here the bosatsu heads are adorned with seated Amida figures rendered in cut gold, outlined in black ink, and framed individually by double halos. This towering crown ensemble is an extraordinary display of regal structure and craftsmanship, the closest prototypes for which can only be found in eighth- and ninth-century painting and sculpture in Japan and, to a lesser extent, in China.[1]

Analysis of the painting style of this Kannon as well as its iconographical features leads one back once more to the Hōryū-ji mural paintings and to the Shōsō-in, with its assorted treasures capable of inventorying modes of figure painting in the eighth century in East Asia. The basic figural elements evident in this icon may be outlined as follows: the proportions of the figure are statuesque, firmly portrayed but with abundant, fleshy features; the articulation between torso and head is pronounced so as to both elevate the head and its symbolic stature and clarify the three neck bands that are a prominent iconographical feature signifying a Buddhist deity; the hands and feet are large and plump but carefully circumscribed with taut outlines; the torso is exposed to a large degree and/or swathed in loose-fitting diaphanous garments to emphasize the royal nature of the figure— a reference to the Buddha's princely histori-

cal origins; in contrast, the face is broad and fleshy with a full chin and lips, prominent nose augmented by demonstrative arcing eyebrows, and long eye slits framed by sweeping crescent-shaped lines of black or red pigment.

Whether an ink sketch on plain hemp cloth such as the famous bosatsu on a cloud in the Shōsō-in (fig. 45a), the polychromy of the (former) Hōryū-ji murals, or the richly textured surface of the Nara National Museum's embroidered panel of Shaka preaching (fig. 45b), these elements basically make up a figural vocabulary established during the Nara period that subsequent generations of artisans and their patrons extolled above and beyond the other figural modes then available in Japan.[2] Thus for example the figural type employed in the *E-inga-kyō* illustrations [14] does not reappear later in the Heian or Kamakura eras except as faithful copies of an ancient manner of representation. The small complex landscapes with figures painted on musical instruments in the Shōsō-in do not become part of the vital Japanese figurative tradition either, although their tonal palette of blended red and orange hues bordered with vermilion and chalky white pigments did find favor with Heian period patrons and was retained and enmeshed with Heian modes of figural representation.

Indeed that palette characterizes the skin tones of this Eleven-headed Kannon. The shading technique using alternating bands of reddish-orange and then white pigments emanates from Central Asian painting traditions now visible only in a fragmented condition. These in turn passed through western China and were assimilated in metropolitan centers of culture before arriving in Nara in the eighth and ninth centuries.[3] Fortunately remnants of these images survive in Japan (and in Western collections) to provide some background for a figural presentation as grandiose and as authoritative as this twelfth-century icon. While it stands apart from other large-scale iconic portrayals of the time, numerous techniques, materials, and parts of the surrounding elements combine to communicate its recognition by a Heian audience (as well as modern Japanese viewers in a museum setting). This information is primarily conveyed by the deity's setting: the elaborate lotus base and pedestal reminiscent of the Kairyū-ji reliquary [78]; and the background

Fig. 45a. Bosatsu on a cloud, 8th century; ink on hemp cloth; 138.5 x 133 cm; Shōsō-in, Nara

Fig. 45b. Detail of Shaka preaching, 8th century; Nara or China, Tang dynasty; embroidered silk; 207 x 157 cm; Nara National Museum. National Treasure

elements of a jeweled floor and double halo, and elaborate overhead canopy.

This floral canopy may well be the largest known in Heian painting and, again, refers to much earlier continental models. The clusters of blossoming flowers, however, are recognizable as a contemporary type, perhaps from the lily family. They are also the principal surface decor of the halo, thereby linking these structural (and decorative) features. In both instances kirikane outlines the petal shapes, a technical feature seen in only a few other paintings of the era [48]. Also unusual are the breadth and length of the trelliswork of colored beads, bells, and other metalwork that frame the icon's head and crown, in keeping with the shōgon of the entire visage. This concept of embellishing the outward appearance of a deity to glorify its sanctity, and in so doing afford the faithful viewer a vision toward attaining spiritual awakening, is expressed most clearly in the robe patterns and lotus pedestal decor present here. Combined, they constitute a virtual compendium of decorative techniques and surface designs developed by Japanese artisans since the eighth century and brought to a glorious crescendo in the later Heian period.[4]

The multi-tiered dais is a basic type identifiable in twelfth-century mandalas and single icon paintings, mostly Esoteric in subject, such as the Dainichi Nyorai in the Nezu Museum, the Senju Kannon in the Tokyo National Museum, and the Shaka Nyorai at the Jingō-ji in Kyoto. Individual decorative panels and sequences of tiers vary, of course, but the nature of the forms and the degree to which these daises are decorated is consistent. Fortunately the extant repertoire of Heian painting and imagery records these magnificently crafted structures, which no longer survive intact.

The robing and jewelry adorning the Eleven-headed Kannon are rendered in gold and silver pigments augmented with an extensive network of finely applied strips of cut gold and silver foil. Together they help to enliven the overall surface and establish visual coherence with the background elements above, below, and behind the Kannon. These decorative patterns also provide clarity for identifying the many elements that make up the clothing and understanding their placement relative to one another. The amount of layered robing, scarves, and metal and beaded jewelry in this painting far exceeds anything else in the exhibition and, for that matter, in virtually all Heian painting.[5]

It is this successful melding of earthly resplendence with the spiritual realm that characterizes this Eleven-headed Kannon for all to contemplate. While embracing a panoply of religious and cultural antecedents, calling upon the past to authenticate its spiritual lineage, this icon sits firmly and comfortably in its own time. But within that late Heian period cultural framework it has no peers in the scale of its presentation or in its embodiment of an ancient figural identity rooted in the distant origins of the Buddhist faith.

It is one of the finest, most dignified religious icons now extant to issue from the painting studios located in Nara. An inscription written on the scroll roller states it once belonged to the Hokki-ji in southwestern Nara not far from the Hōryū-ji.

1. For a broad survey of the imagery in Japan as well as in Asia, see Fukushima Hiromichi, *Jūichimen Kannonzō–Senju Kannonzō* (Images and paintings of the Eleven-headed and Thousand-armed Kannons), vol. 311 of *Nihon no bijutsu* (Arts of Japan) (Tokyo: Shibundō, 1992).

2. For a survey of this material, see Donohashi Akio, *Asuka Nara kaiga* (Paintings of the Asuka and Nara periods), vol. 204 of *Nihon no bijutsu* (Tokyo: Shibundō, 1983), particularly pls. 56–68, 80, 85, 97, and 105 in contrast to other figural types.

3. See *Higashi Asia no butsutachi* (Buddhist images of East Asia), exh. cat., Nara National Museum (1996), pls. 123–36.

4. See Ariga Yoshitaka, *Kirikane to saishiki* (Cut gold leaf and painted decoration in Japanese paintings and sculpture), vol. 373 of *Nihon no bijutsu* (Tokyo: Shibundō, 1997).

5. See *Heian butsuga* (Heian period Buddhist painting), exh. cat., Nara National Museum (1986).

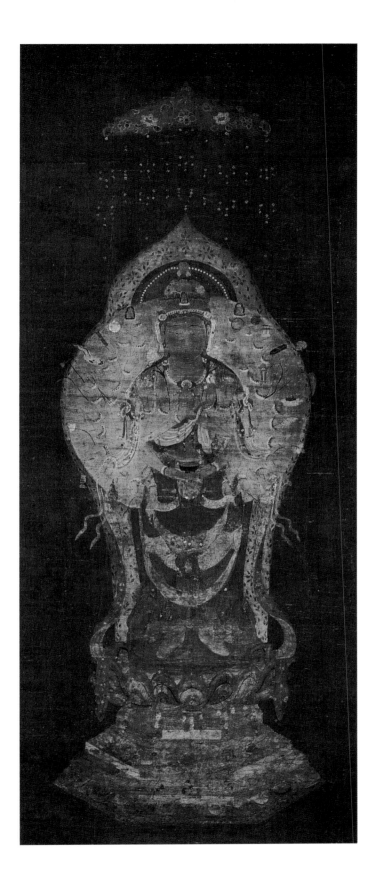

46. Senju Kannon

12TH CENTURY; HANGING SCROLL: INK,
COLOR, AND CUT GOLD AND SILVER FOIL ON
SILK; 93.8 X 39.5 CM. IMPORTANT CULTURAL
PROPERTY

This small, fastidiously detailed painting depicts one of the earliest and most potent bodhisattvas to gain acceptance in Japan: Senju Kannon, the Bodhisattva of Mercy with a Thousand Arms. This deity was portrayed in Northern Qi sculpture of the sixth century and later during the Tang dynasty in China. Belief in its power was based on models and texts transmitted from India, where Senju Kannon and Jūichimen Kannon imagery seem to be similar initially. Later, in seventh- and then eighth-century China, the separate attributes of these two deities became more clearly identified, whereupon another iconographical and visual conflation took place that reached Japan in the eighth century: Senju Kannon.[1]

The oldest extant representation of Senju Kannon in Nara can be found at the Nigatsudō hall of Tōdai-ji, carved into the halo of the principal image, an eighth-century sculpture hidden from public view. The *Senju Sengenkyō,* the sutra extolling the virtues of the deity, arrived during the eighth century, followed by other related religious texts and sermons given by eminent priests to the imperial family based on these texts. As a result, sculpted and painted imagery ensued during the Nara and Heian periods, the best known surviving examples of which are the famous dry lacquer icons of impressive dimensions at the Tōshōdai-ji (standing) and Fujii-dera (seated) in Osaka. Unlike later renditions of this deity, which by the ninth century had forty-two arms, these two images actually possess one thousand arms.[2] This extraordinary display of spiritual compassion—an array of one thousand extended arms of assistance—helps explain the acceptance and popularity of Senju Kannon in early Buddhist Japan.

The convention of showing forty-two arms is from the ninth century; two large arms are joined hand to hand in a gesture of adoration in front of Senju's chest. Below, two hands cradle an alms bowl. These iconographical features appear in this delicate portrayal of

the deity. Also depicted in vivid detail are the various attributes textually associated with Senju's powers, in a halo-like arrangement that consciously downplays the individual detailing of the arms and hands supporting them. This is a departure from the eleventh-century Kojima-dera portrayal [41] as well as the two other known twelfth-century paintings, in the Tokyo National Museum and Eihō-ji collections respectively.[3]

This painting is much smaller than these twelfth-century paintings, partly because it was not originally intended for public, institutional, or—it seems—private display and veneration. Instead it was commissioned to be rolled up and then placed inside the accompanying small Kannon sculpture in this exhibition [47]. As such it was to be hidden from view, a secret image not unlike the relics occasionally placed in Heian and Kamakura statuary to sanctify them [29, 31]. Normally, these relics would include written or printed texts, small carved figures, precious stones or crystal, and painted (or printed) paper sheets or scrolls with Buddhist images.[4] Like the custom of burying relics [6–10], this practice symbolized the presence of Buddha, past and present, but in very real terms for the laity, and in this instance for a patron of considerable means and sophistication. This exquisite image is the most renowned example yet known in Japanese Buddhist art of such a highly finished Buddhist painting being placed inside a sculpture, consciously and ritually secreted away from human sight.

The degree of complex staging, execution, and use of mineral pigments bespeaks the work of a major talent employed at a professional painting studio either in Kyoto or Nara. The glorification of the deity beginning with the elaborate four-stage pedestal and ending with the ornate canopy is extraordinary and can only be compared in this exhibition with the Eleven-headed Kannon of similar date although by a vastly different hand working in an archaic style [45]. The shimmering gold flecks apparent in the Senju's canopy decor, halo, and jewelry strands were made from cut gold foil pieces affixed to the silk. Likewise the dull black floral design visible in these areas is actually tarnished silver foil. This rare, and expensive, technique occurs only in Heian painting and calligraphy of the highest order, of which this image represents a

sublime example. Its placement within the dark body cavity of the wooden sculpture, while perhaps difficult for a Westerner to comprehend, does convey in a direct tangible manner the intrinsic nature of a truly pious act done without thought of immediate spiritual reward. Indeed this splendid icon remained hidden from human sight for nearly eight hundred years.

1. Fukushima Hiromichi, *Jūichimen Kannonzō–Senju Kannonzō* (Images and paintings of the Eleven-headed and Thousand-armed Kannons), vol. 311 of *Nihon no bijutsu* (Arts of Japan) (Tokyo: Shibundō, 1992), 50ff, fig. 111 (illustrating a portion of the eighth-century *Senju Sengen-kyō* in the Kyoto National Museum), and fig. 97 (a Tang iconographical drawing depicting the deity seated).

2. For a particularly fine photograph of the Fujii-dera image, see *Nihon Bukkyō bijutsu meihōten* (Masterpieces of Japanese Buddhist art), exh. cat., Nara National Museum (1995), pl. 49.

3. See *Nihon Bukkyō bijutsu no genryū* (Sources of Japanese Buddhist art), exh. cat., Nara National Museum (1978), nos. 52–53.

4. For the most comprehensive treatment of this subject, see Kurata Bunsaku, *Zōnai nonyūhin* (Objects placed inside Buddhist sculpture), vol. 86 of *Nihon no bijutsu* (Arts of Japan) (Tokyo: Shibundō, 1973).

Detail of Senju Kannon, Taizōkai [41]

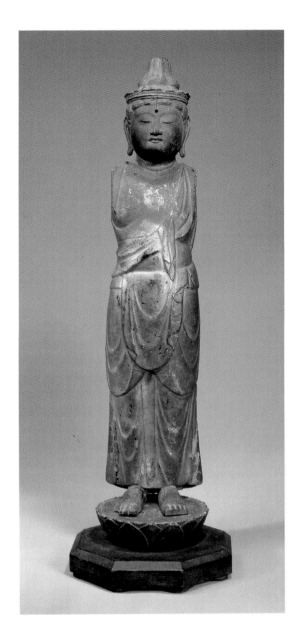

47. Kannon Bosatsu

12TH CENTURY; WOOD, LACQUERED AND
GILDED, WITH TRACES OF POLYCHROMY;
H. 61 CM. IMPORTANT CULTURAL PROPERTY

When this modest figure was discovered in 1936 it was not immediately apparent that anything was inside its body cavity. Then, as now, it had no arms, metalwork crown, or other attributes of its original identity. The figure was formed from several pieces of hinoki wood joined in the typical yosegi technique of the period. Its truncated condition barely alludes to what scholars propose as its original iconographical appearance: a thousand-armed Kannon.[1] If that were the case, then atop the head and raised hair band eleven small sculpted heads would have been attached. Indeed the drilled holes in the crown area permit such a supposition.

Forty-two arms, including a pair of clasped hands positioned directly in front of the chest, as in the Senju Kannon painted icon [46], would have been attached to the sides of the wood torso. Thus both sculpted and painted images would presumably have shared the same features as Eleven-headed Senju Kannon iconographical types. This represents the most popular version of the deity in Japanese Buddhist art, and in this exhibition [48], although it is not the only one known. Imagining ten small heads, each individually carved, with a red-robed Amida in the center would give an idea of the crown's original appearance.

Judging from its sculptural style, the image belongs to the Heian period, in the later twelfth century. The restoration of the figure did not reveal any documents about the patron(s) or sculptor. A closely related bronze image of an Eleven-headed Kannon at the Rinsai-ji in Ishikawa Prefecture provides an appropriate comparison (fig. 47a). A group of slighter figures thought to have been commissioned for a "thousand image hall" at Kōfuku-ji in Nara offers a slightly earlier parameter for considering this piece.[2]

Both painted and sculpted images nevertheless represent a special Heian period manifestation of Buddhist devotion. While they were conceived within a short time of each other, the painting antedates its sculptural receptacle.[3]

1. See *Heian butsuga* (Heian period Buddhist painting), exh. cat., Nara National Museum (1986), pl. 37. For other sculpture, see Nakano Genzō, *Mikkyō bijutsu taikan* (Survey of Esoteric Buddhist art) (Tokyo: Asahi Shinbunsha, 1984), 2: pls. 126–44.

2. Anne Nishimura Morse and Samuel Crowell Morse, *Objects as Insight in Japanese Buddhist Art and Ritual,* exh. cat., Katonah Museum of Art (1996), no. 38–43.

3. See *Butsuzō to zōnai nōnyūhinten* (Exhibition of Buddhist scriptures and the objects placed inside Buddhist sculptures), exh. cat., Nara National Museum (1974).

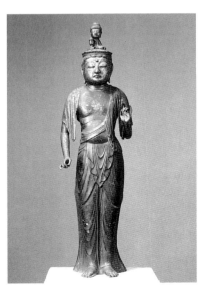

Fig. 47a. Jūichimen Kannon, 12th century; cast bronze; h. 71.5 cm. Rinsai-ji, Ishikawa Prefecture

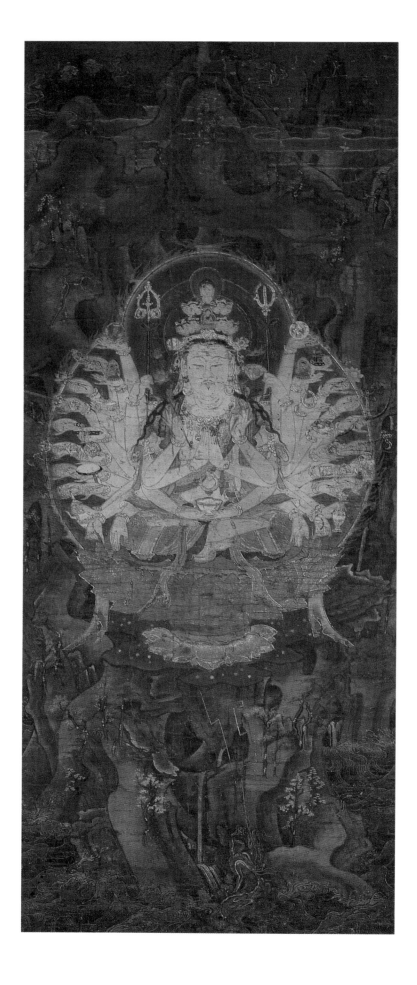

48. Senju Kannon

14TH CENTURY; HANGING SCROLL: INK, COLOR, GOLD, AND CUT GOLD FOIL ON SILK; 100.8 X 41 CM. IMPORTANT CULTURAL PROPERTY

Rising out of the frothy seas at the bottom of this modest-sized hanging scroll is a craggy promontory behind which a precipitous landscape looms. On the rock face sits a radiant golden image of the Thousand-armed Kannon facing directly out at the viewer.

Unlike the even smaller twelfth-century image of the same iconography [46], which is rendered on a clear silk background devoid of any embellishments (except for a canopy) that might provide a context for the deity, here Senju enjoys prominence in a scene embracing the natural elements of sky, earth, and water. The deity was placed high in the composition, partly because of the elaborate two-tiered dais supporting it, and partly to accommodate the tall flaming halo behind that literally reaches to the side edges of the picture.

The usual attributes of Senju include the standard forty-two arms; the twenty extended on each side signify twenty-five vows of salvation, and the small eye painted into the palm of each hand is there to assist Senju. Here that configuration has been altered slightly so that eighteen arms are arrayed on each side of the figure with their attributes in hand, including shakujō [81], rinbō [26, 49], crystal, sankōshō [44, 64], and kebyō [87]. In front of its torso Senju holds a gilt alms bowl, presses two palms together in the *kimyō-gasshō* (mudra of adoration), while the uppermost pair of hands holds a lotus pod and flowers.

Above, surmounting a gold crown, are eleven heads and a small red-robed Amida figure seated on a lotus pedestal facing forward. In Japan this presentation with eleven heads is the most popular type of Senju iconographic configuration (see the twelfth-century example in the exhibition [46]), but it is not the only one cited in early religious texts.

Senju's face is described in thin, taut red lines together with sharp tapering ink strokes that highlight the narrow eyes and mustache. The lips are painted red (much of which has flaked off) with ink outlining. The figure's facial expression—calm and reflective—is ren-

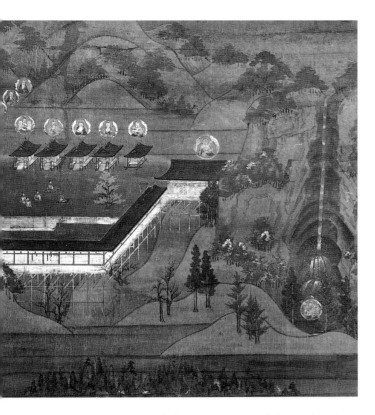

Fig. 48a. Detail of Kumano shrine with figure of Senju Kannon at the bottom of the Nachi waterfall. Kumano mandala, 14th century; hanging scroll: ink and color on silk; 143 x 62 cm. The Cleveland Museum of Art, John L. Severance Fund 1953.16

dered with a surprising economy of lines and, though resembling that of the Nyoirin Kannon of similar date [49], exhibits a reserved composure that is impressive. Comparison with the twelfth-century image is again instructive, illuminating within identical subjects the differences in late Heian and Kamakura figural characterization. The changes in materials, techniques, and palettes also provide insights into the evolution of Buddhist painting aesthetics at the time.

In contrast to Heian sensibilities, which favor precious, scintillating decorative motifs in silver and gold, here golden hues dominate the painting's core. Highlighting with strips of kirikane in garment designs and on the petals of the lotus base (much of which has been lost) give a special radiance unlike that of the gold pigments used in the torso, arms, and face. Set against the greens, browns, and deep blues of the mandala with its fiery ring and kirikane outline, the range of hues of this golden tone are clear.

This decorative metallic material was used also to link this spiritual vision with the landscape setting. Two zig-zagging kirikane lines heightened with red pigment signify thunderbolt patterns and link the jeweled rock plateau with the lower register of the composition. There, a red-winged dragon rises straight out of the waves, with one claw extended to offer a red jewel to Senju. Gray cloud bands encircle this imaginary beast, which helps identify the setting as a reference to Mt. Potalaka, said in Buddhist lore to be Kannon's residence. Comparing these motifs with those in the Daibutchō mandala [43] is instructive.

As one of the thirty-three manifestations of Kannon, Senju sits, glowing, in the embrace of this mythical mountain-island described and extolled frequently in early religious texts. Nara period mural compositions of the subject are recorded at the Saidai-ji and Kōfuku-ji.[1]

Here, rather than the vast horizontal composition one could expect issuing from the Chinese mural painting tradition, the vision of paradise is a lofty verdant landscape. The artist depicted towering peaks encircled by bluish clouds tinged in red. Flowering trees thrive in this high air, as they do below, all the way to the edge of the sea. Lichen and moss grow on the tree trunks, yet each tree or group of trees is differentiated from others by leaf shape or color. The passage from sea level to mountaintop includes the changing of the seasons from spring to fall. Waterfalls emerging from within dark grottos register the presence of clear mountain waters.

The origins of such an extraordinary combination of religious and worldly imagery harks back to eleventh-century Raigō paintings and the ensuing development of indigenous themes coupled with compatible compositional modes and expressive methods.[2] The Kubon Raigō (Nine Grades of Amida's Descent) paintings, featuring a one-cornered composition derived from Taima mandala narrative [52], emerged as prototypes for subsequent compositions with frontal or panoramic vistas in the late Heian period. And the enduring idea of linking a classical, continental text with a foreign-looking (read: Chinese) image finally gave way in the thirteenth and fourteenth centuries to imagery based largely on the landscape settings and cultural values visible in the immediate

areas of Kyoto and Nara. So as new religious thought and syncretic interpretations emerged, a newly invigorated imagery accompanied these ideas. The development of yamato-e is visible here in the colorful landscape surfaces, flowering trees, and gold highlights given to rock contours.

Also present is the intricate portrayal of Mt. Potalaka's imagined terrain. The many facets, dark caves, unseen valleys, and rugged cliff ledges cumulatively portray a place of power unlike, say, that seen in the Sannō mandala [57]. However, realizing the innovative syncretic nature not only of the Tendai and Pure Land sects' relationship at the time but also of the enduring honji suijaku system conjoining Buddhist and Shinto beliefs in recognizable devotional forms, this tall powerful landscape takes on another dimension. It may well be that while Senju Kannon presides over imaginary Mt. Potalaka in this striking painting it is meant also to signal the deity's presence in Japan south of Nara at the sacred Kumano shrine complex, which includes the Nachi waterfall. Indeed a number of Kamakura period Kumano mandala paintings include Senju Kannon as an integral part of the imagery but none perhaps as vividly as the panoramic Cleveland hanging scroll showing the deity seated at the base of the waterfall (fig. 48a).[3] No doubt the reference to deep mountain terrain as the repository of Shinto's animism would have been on the minds of the patron who commissioned this idyllic Buddhist vision and of the people who came to venerate it as an icon.

1. For the textual reference in the Avatamsaka Sutra of Potalaka and the literary references of Nara period paintings to this subject, see John M. Rosenfield and Elizabeth ten Grotenhuis, Journey of the Three Jewels, exh. cat., Asia Society (New York, 1979), no. 33.

2. Jōdo mandala (Pure Land mandalas), exh. cat., Nara National Museum (1983), pls. 45, 111–12, 115, 119, 149–51.

3. Suijaku bijutsu (The syncretic arts of Shinto and Buddhism), exh. cat., Nara National Museum (Tokyo: Kadokawa Shōten, 1964), nos. 54–55; see also Kageyama Haruki and Christine Guth Kanda, Shinto Arts: Nature, Gods, and Man in Japan, exh. cat., Japan House Gallery (New York, 1976), 105–13.

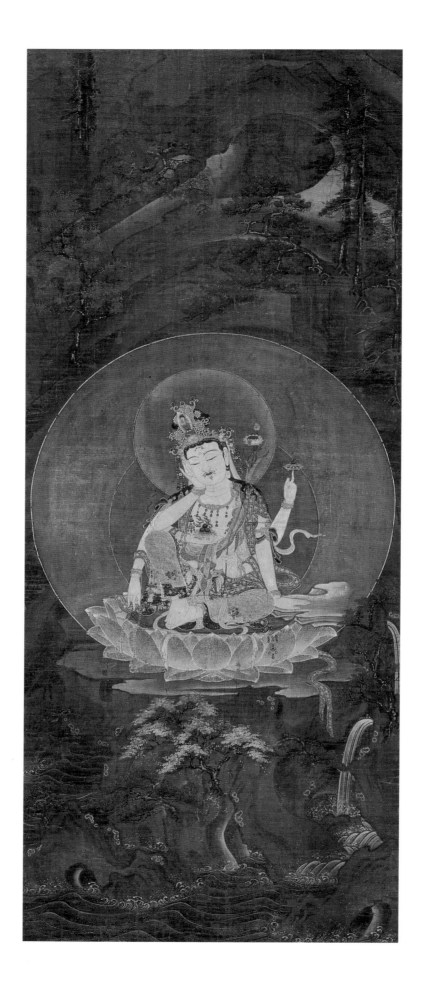

14TH CENTURY; HANGING SCROLL: INK, COLOR, GOLD PIGMENT, AND CUT GOLD FOIL ON SILK; 101.7 X 41.6 CM. IMPORTANT CULTURAL PROPERTY

Similar in size and date to the Senju Kannon [48], this beguiling image of Nyoirin Kannon, the Bodhisattva with a Wish-Granting Jewel [26], presents a distinct view of the development of Japanese-style painting in the Kyoto-Nara region. Above and below the golden roundels encompassing the pensive Nyoirin a vivid landscape enfolds. At the bottom, the ocean meets the waters of a thunderous waterfall amid boldly leaning rock ledges and cantilevered boulders. Their contours are rendered in firm modulating ink lines or, sometimes, in washes of kinde. A series of brown washes was then applied, over which layers of thick green mineral pigments were selectively added to create an attractively textured but rugged landscape.

Gold lines also enhance the wave patterns and the fissured plateau on which Nyoirin's lotus base rests. It is the large flowering cherry tree directly under the meditating deity, however, that eventually catches one's attention in the lower part of the composition. The tree must be old to have reached this size, a wonder considering its location. Four other trees also show signs of venerable age and the effects of coastal weather. Patches of lichen outlined in dots of white pigment confirm their endurance and the ambient moisture of the air. Minute trails of white cherry petals fall from the tree, identifying even more closely the season. In a related visual gesture by the artist, the uppermost branches of the tree on the right edge of this lower section splay over onto the deity's halo, much the way that Nyoirin's scarf end trails down into the landscape setting. The natural, increasingly Japanese-appearing world and the conceptual setting of Buddhist imagery in medieval painting are depicted in close contact with one another.

The ease, almost nonchalance, of these slight visual motifs bespeaks a new era of cohesion and compatibility between Buddhist communities (and their patrons) and their lay followers. In a new age in which the public looked increasingly toward developing their own institutions and the methods of strengthening their faith in more practical and familiar

ways, artisans responded by advancing new approaches to subject matter and technique.

Thus in the landscape above the halo the artist dispensed with the detailed categorizing of nature in favor of creating a pattern of sweeping arcs of green, brown, and gold. To the sides, tall cedars out of scale with the mountainscape or to Western notions of perspective rise upward, reaching almost to the top of the painting. Bold swaths of ink frame their structure, while thin gold lines highlight the arch of their clinging roots. Gold applied from behind the silk delineates a large and ominous opening in the mountain face. It also casts a gentle glow across the upper section of the painting and illuminates the shapes of the soaring trees. An unidentified species of tree is in bloom to the upper left beneath a section of damage where the outlines of another pair of tall cedars are just visible.

Thus the upper and lower portions of the composition create contrasting visions of the same natural prospect—a mountain rising into the air from the waters below—but in doing so provide an emboldened tableau and backdrop for Nyoirin. The painting's fine condition gives the viewer a rare opportunity to gain an idea of the extraordinary level of craftsmanship involved in the production of painted religious icons in the Kamakura period on such a fragile material as silk.

The halo and figure have been painted from behind with kinde. Kirikane was liberally applied to robe patterns and most notably to the reddish-pink pigment of the lotus petal surfaces. Few extant Buddhist paintings of the fourteenth century have the technical sophistication and excellent state of preservation visible here.[1]

Nyoirin's gold body is outlined with an evenly modulated red line. Each of the six arms possesses the attribute ascribed to it in the seventh-century text *Kanjizai Nyoirin Bosatsu Yugaho-kyō,* although the gesture of the leaning head probably derives from the deity's portrayal in the Taizōkai mandala (Womb World), where it appears in the Kannon court to the proper right of Dainichi [41].

This gesture, no doubt central to understanding the deity's general appeal in Japan since the ninth century, actually signifies a meditative state more evident, perhaps, in the imposing sculpture in the exhibition [26]. The three blue wish-granting jewels refer to

the powers of mercy; the rinbō signifies the Wheel of the Law, Nyoirin's teaching role aspect; and the hand placed flat on the golden brown rock ledge that impinges onto the lotus pedestal represents a gesture confirming his residence on Mt. Potalaka, the mythical island paradise where Kannon resided. But as this lush animated landscape enfolds, it becomes ever more apparent that the urgency and appeal of contemporary religious and secular issues in fourteenth-century Japan spilled over into visions such as this, putting new but more familiar imagery, forms, color—and ways of seeing the Japanese world—before the populace. As one might suspect, this imagery gradually became so familiar that actual mountain locations in Japan became associated with the idyllic Mt. Potalaka. Thus native geography accrued spiritual dimensions—especially where venerable Shinto antecedents could be identified.

1. For other early Nyoirin paintings, which are not numerous, see Nakano Genzō, *Mikkyō bijutsu taikan* (Survey of Esoteric Buddhist art) (Tokyo: Asahi Shinbunsha, 1984), 2: pls. 150–59.

Detail of Nyoirin Kannon, Taizōkai [41]

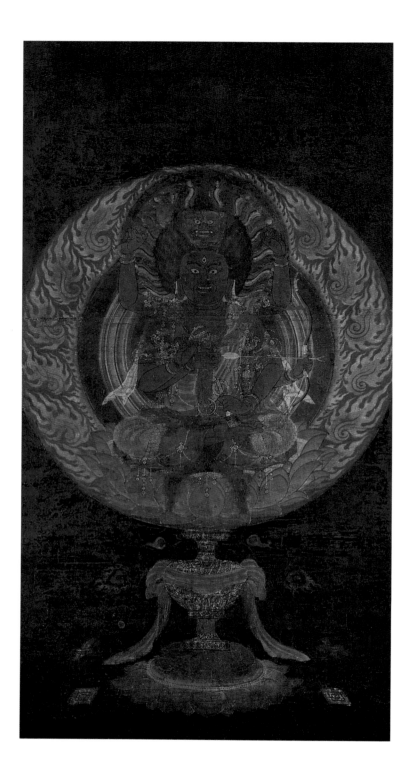

50. Aizen Myōō

12TH CENTURY; HANGING SCROLL: INK AND
COLOR ON SILK; 86.8 X 44.8 CM

Like the threatening Fudō Myōō [51] glaring
out from a fiery throne, Aizen Myōō is an im-
posing, even off-putting deity. But like most
religious icons whose appearance is both
unfamiliar and visually undeniable, Aizen's
image carries with it a formidable background
of Buddhist scripture, lore, and ceremony.

The textual basis for Aizen's appearance
and religious powers originates in a solitary
Chinese text of the eighth century, not an
even-earlier Indian scripture or commentary.
This text, known in Japan in its abbreviated
name as the *Yugi-kyō (Sutra of All Yogas and
Yogis)* became popular within Esoteric
(Mikkyō) circles and by the end of the ninth
century formed an important component of
the Mikkyō sutra repositories.[1]

This large painting follows Kaisei's sculp-
tural formulation of the mid-thirteenth century
in presenting Aizen, King of Passion, with
halo and lotus throne in a vivid hue of red, a
color emblematic of human desire [30].
Aizen's third eye, gaping mouth, and fangs
are prominently displayed, more than in
most Esoteric imagery, as if to reinforce the
appearance of the lion-crown overhead. This
feature, symbolizing commitment to the path
of spiritual awakening, served an important
function in sculpted images as the receptacle
for written invocations at the time of rituals
associated with the deity. The flaring bands of
hair signify the intense, even ecstatic quality
of Aizen's knowledge and power.

Each of the six arms holds an attribute: the
five-pronged sankōshō and the bell symbol-
ize the unity of wisdom achieved from
seemingly opposite principles; the bow and
arrow indicate Aizen's swiftness of action;
the clenched fist is an enigmatic reference to
the magical and unrecorded transmission
of Aizen ritual practices; and the ubiquitous
lotus bud. As might be expected, variants of
these attributes and their placement exist, but
fundamentally the appearance of the deity
follows developments within the Shingon
sect, particularly as the evolving imagery is
recorded in iconographical zuzō scrolls

beginning in the early twelfth century. Individual Aizen mandala paintings also occur, documented in zuzō as well.

Aizen's pedestal is more distinctive and iconographically determined than that of most other Mikkyō deities. The bulbous gilt vessel with a thin neck and flaring mouth represents the bounty issuing from Aizen's powers. Also an emblem of good luck in mainstream Buddhism, Shingon seems to have appropriated it by the late Heian period as another visual accretion to adorn the image. In this painting not only flaming jewels but also sutra scrolls are arranged symmetrically around the vessel as if they had spilled out of it, so abundant were the treasures of Aizen's efficacy.

The spread of interest in Aizen occurred dramatically in the twelfth century, a time also when nembutsu (repetitive chanting of Buddha's name) and popular Buddhism practices were beginning to spread dramatically. Whereas previously devotion to the deity had been largely practiced by the nobility and their cleric friends at Tō-ji, Tōdai-ji, Ninna-ji, and other Kansai area temples, in the thirteenth and fourteenth centuries it gained recognition among members of the military government and also, notably, from the priest Eison at Saidai-ji in Nara [21, 30, 78].[2] His successful invocation of Aizen at an imperially ordered ceremony to try to save the country from an imminent Mongol invasion in Kyūshū in 1281 dramatically raised the deity and the rituals linked to it to prominence in the public's eye. Ranging from the magical—which of course constitutes the still-enigmatic origins of the five wisdom kings (Godai Myōō)—to the sublime, numerous rites focusing on Aizen worship as the principal deity (honzon) are recorded. The variety of their intentions and their syncretic nature are perhaps what is most notable about them.

The size of this image (it has been trimmed on each side) suggests that it was commissioned for personal worship. The bright coloration of the halo with independent surface designs of flame curls is unorthodox.[3] However, this portrayal, more than those with a deep red coloration, does illumine one of the basic textual phrases describing the deity's attributes: "the color of his body is like the rays of the sun."

Through centuries of use at Aizen rites the surface of the painting has deteriorated. Yet the later strengthening of lines and remounting have preserved its character. Traditionally dated to the late Heian period, about the same time as the impressive Aizen painting in the Hosomi Foundation, it appears to share closer stylistic affinities with the Kamakura period images of Fugen and the ten female devas in this exhibition [36].[4]

1. For the best and most complete Western-language account of this deity in textual sources, iconography, and ritual, see Roger Goepper, Aizen-Myōō (Zurich: Artibus Asiae, 1993).

2. Nara Saidai-jiten (Treasures of Buddhist art from the Saidai-ji, Nara), exh. cat., Nara National Museum (1991), cover and no. 38.

3. For two other interesting variants of Aizen imagery, see Nezu bijutsukan meihin shūsei (Collection of masterworks in the Nezu Institute of Fine Arts) (Tokyo: Kōdansha International, 1986), nos. 49 and 57.

4. See Heian butsuga (Heian period Buddhist painting), exh. cat., Nara National Museum (1986), no. 44.

51. Fudō Myōō and Eight Attendants

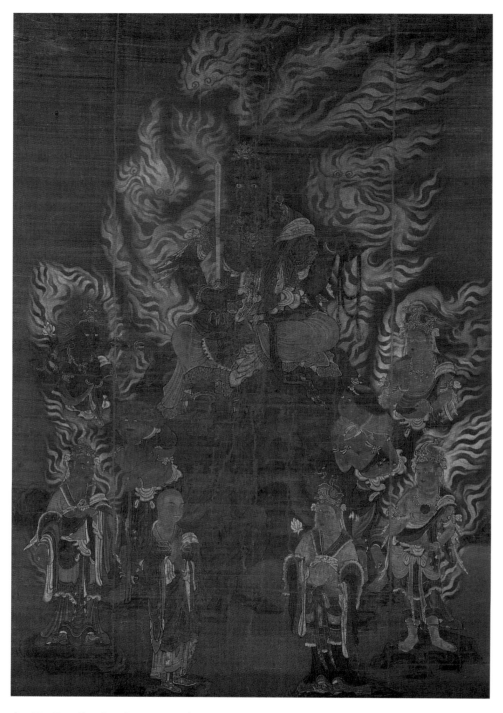

13TH–14TH CENTURY; HANGING SCROLL:
INK AND COLOR ON SILK; 129.6 X 89.3 CM.
IMPORTANT CULTURAL PROPERTY

Orthodox representations of Fudō (Immovable One) normally depict this formidable deity seated on a dais of stacked rock ledges, framed in a halo of fire, and surrounded by other, smaller myōō that together constitute the Esoteric world's Godai Myōō. Viewed either as a sculptural ensemble or as a set of large hanging scrolls (examples of both are in the Tō-ji collection in Kyoto), the experience is unforgettable.[1] This, of course, is precisely the basic human response the Esoteric clergy wished for among their followers some seven hundred years ago.

Myōō always display wrathful facial expressions consistent with their determination to persuade even the most wayward—or recalcitrant—beings to take up the path of Esoteric Buddhism's teachings. The myōō also carry swords to vanquish evil, all in the name of Dainichi, the supreme Esoteric deity embodying eternal (non- or ahistorical) reality. This Great Illuminator is graphically and centrally displayed in Ryōkai mandalas [41] where the myōō occupy the third court in the Womb World (Taizōkai) mandala painting, directly beneath Dainichi. Among the Godai Myōō, Fudō proved to be by far the most popular deity and, judging from the number of paintings and sculpture still extant, one of the most, if not the most, popular single icon of Esoteric Buddhism in Japan.[2]

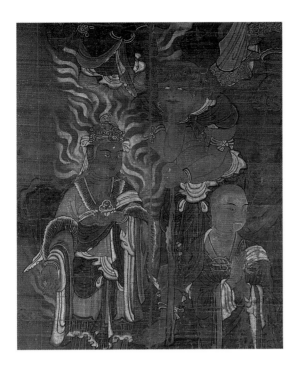

Detail of a Myōō deity, Taizōkai [41]

The Immovable One is shown here seated on a rock plateau with his right leg extended to a lower ledge in a relaxed version of the traditional cross-legged (immovable) portrayal. Each of the eight attendants also stands on a rock island or ledge contiguous with Fudō's boulder, a reference to the ocean waves in thirteenth-century iconographical sketches and paintings depicting this deity, a century and a half after the first images were painted for Kyoto's Shingon institutions. Fudō's skin is dark, allowing his chest, arm jewelry, and crown to stand out. His eyes also appear to bulge out of their bloodshot sockets because of the stark tonal contrasts. This fierce facial expression is not intended to frighten but rather to ward off evil. The palette of his robing is muted, save for the red under-robe with circular gold designs.

This same palette, enhanced by *urazaishiki* (pigments applied from the back side of the silk), subtly tempers the appearance of the attendants. They are arranged in the unusual but highly effective fashion of overlapping groups of four; and the two in front are framed by a continuous halo of red and white flames. Usually Kongara Dōji (the boyish figure gesturing in prayer to Fudō's left) and Seitaka Dōji (the red-skinned figure resting his head on his uplifted hand) occupy the most prominent positions in Fudō imagery. But these appealing characters with their human-like facial and body gestures convey the message of the wrathful Fudō's fundamental compassion toward humankind as he goes about his mission of roping in wayward souls.

The six other attendants are relatively staid in comparison, although the actual delineation of figural forms and attributes remains consistent. The brushwork describing the rock surfaces is particularly deft, with the ink washes carefully modulated to achieve the three-dimensional appearance of crevices and grottos in this aged rock.

Considerable attention has also been given to composing the glorious flaming halo that ignites the image. On top of a surface of white pigment, subtly adjusted ribbons of orange and then red pigment were applied to create an animated network of dancing flames. Not as intricately nuanced as the famous eleventh-century Fudō at Kyoto's Seiren-in, which provided the basic composition here, this Fudō (one of two thirteenth-century Fudō paintings owned by the Nara National Museum) is still a sensitive and magisterial thirteenth-century interpretation of a pivotal Esoteric deity.[3] Interestingly, the artist or studio responsible for this image referred pointedly to that most venerable of seated Fudō at the Seiren-in by incorporating three images of stylized *garuda* (part-bird, part-human creature) shapes into the flame patterns of this halo. Other such examples from the thirteenth century of this "hidden" pictorial gesture are rare.

The Nara National Museum painting surface comprises three pieces of silk sewn together, as the exposed vertical seams disclose. Its condition is good despite its age and long history of use in an Esoteric community.[4] One tradition, based on an inscription on the back of the painting's mounting, holds that it came out of the Shingon complex at Mt. Koya founded by Kūkai in the eighth century. Whatever the case may be, it remains a powerful religious icon and an important reminder that despite the surge of interest in Pure Land sect Buddhism in medieval Japan, the Tendai and to a lesser degree the Shingon sects still prospered thanks to loyal supporters who continued to recognize the fundamental legitimacy of their spiritual message within the broadening spectrum of Buddhist thought and ritual. Accommodation was, and continues to be, an abiding characteristic of Japanese culture. Esoteric imagery, too, was gradually adjusting to new compositional formats and stylistic motifs so that classic icons began increasingly to appear in settings more familiar to the laity such as a spring landscape with demonstrably Japanese features.

1. See for example *Tō-ji kokuhōten* (National treasures from Tō-ji, exh. cat., Kyoto National Museum (1995).

2. For a survey of Fudō imagery, see Sawa Ryuken, ed., *Sōran Fudō Myōō* (A complete catalogue of sculptures and paintings of Fudo Myōō in Japan) (Kyoto: Hōzōkan, 1984).

3. In *Heian butsuga* (Heian period Buddhist painting) exh. cat., Nara National Museum (1986), pls. 24, 26, 57, 59, 75.

4. See the range of paintings and their condition from the Enryaku-ji and its affiliated Tendai sect temples in *Hieizan to Tendai no bijutsu* (Mt. Hiei and the art of Tendai sect Buddhism), exh. cat., Tokyo National Museum (1986), particularly nos. 16–33.

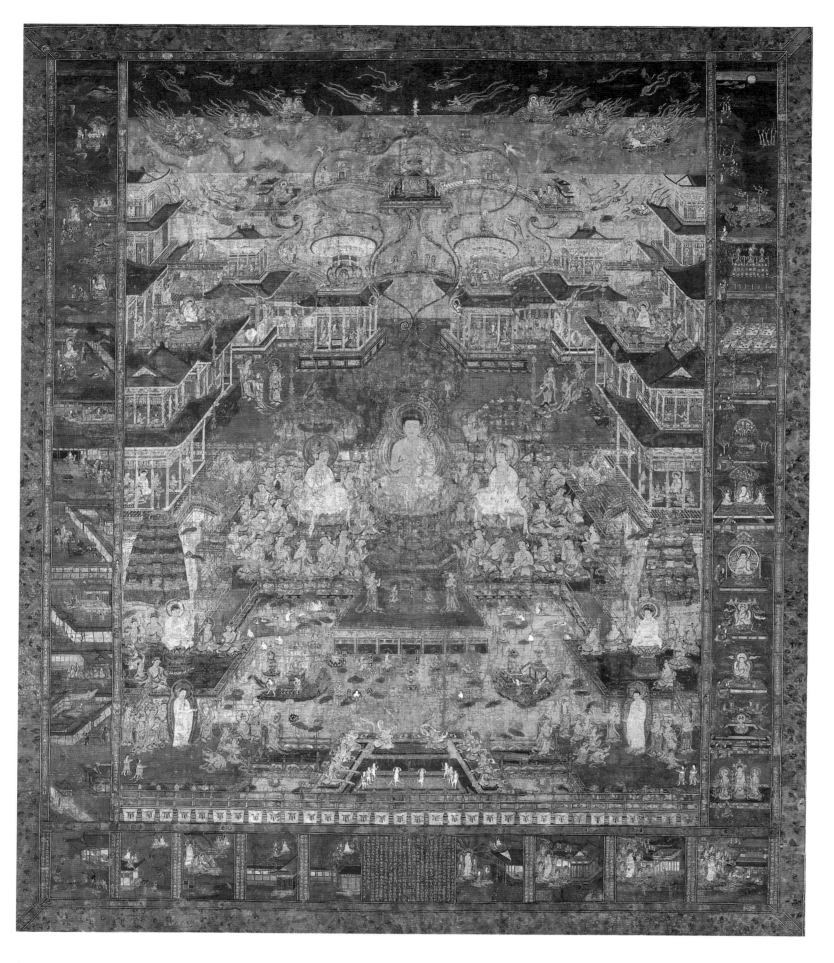

52. Taima Mandala

13TH CENTURY; HANGING SCROLL: INK, COLOR, CUT GOLD AND SILVER FOILS, AND GOLD PIGMENT ON SILK; 193.5 X 163.6 CM

During the later Heian era the Esoteric sects of Tendai and Shingon, and especially the former, were particularly influential because of their close relationships with court nobility. As the patrons who donated buildings and commissioned the paintings, sculpture, and ritual implements central to the secretive rituals of Esotericism, they hoped to gain spiritual merit in their quest for enlightenment and rebirth. For them the benefits of such acts in the present world coupled with their private spiritual commitment—including such acts as burying objects in kyōzuka [6–10] or copying religious texts—were perceived as immediate and, perhaps, attainable.

From an aristocratic point of view, the order of Esoteric Buddhism's pantheism and ritual practices harmonized with the rigidity of contemporary class structure in Kyoto and Nara. This concept can be understood visually by looking at the Ryōkai mandalas [41] and the set of ritual implements [84] and then contemplating the restricted (both clerical and aristocratic) audience in attendance when such religious diagrams were used (as well as the even smaller number of people who truly grasped their meaning and the content of the actual services performed).

Such an elite patronage and religious system was bound to sow its own seeds of transformation, both within its institutional framework as well as in the outside world. The Tendai sect atop Mt. Hiei at the Enryaku-ji, which Saichō [15] had founded, took the lead in responding to change, prompted certainly by the collapse of the Kyoto court in the twelfth century and by the sect's internal struggles within its own ranks. Just as Saichō had left Nara to remove himself from the jaded religious establishment in Nara, so too were Tendai's brightest monks leaving institutionalized Esoteric environs to go out into the cities and villages to carry the message of popular Amidism.

Monks such as Kūya (903–972), Genshin (942–1027), Ryōnin (1072–1132), and later Hōnen (1133–1212)—regarded as the founder of the Pure Land sect of Buddhism— began to preach an evangelical type of doctrine that offered the prospect of salvation to everyone regardless of social rank, gender, or education, provided they place their trust in the powers of Amida. One's faith could be expressed as a simple nembutsu, a repetitive chant invoking Amida's name. Other aristocratic supporters built devotional halls and gardens. But it was Genshin's *Essentials of Rebirth in the Pure Land* text that instilled in its many readers a palpable vision of Amida's Pure Land and the hope that he would come to receive one's soul for transport there, as seen in Raigō imagery [53, 72] and as implied in this composition displaying that Western Paradise.

Called a Taima mandala because the earliest (eighth-century) pictorialization of this paradise (and the one from which many copies were made over the centuries) is owned by the Taima-dera south of Nara, the central image shows Amida with his many attendants on an elaborate raised platform.[1] He is larger than any of the hundreds of other figures visible, and his hands form the teaching mudra. Before him beings undergoing rebirth in this paradise appear in various stages of realization atop lotus buds in the pond, while musicians and dancers perform. To the sides and especially above him a panorama with palatial buildings and towers enfolds right up into the skies. This ecstatic vision is heightened by rich mineral pigments and ample use of gold paint, both of which helped illuminate the painting's surface for its viewers inside a darkened temple hall.[2]

Around the periphery of this central court composition are three bands (left, right, and bottom), each containing several small illustrated scenes. These derive from the religious text, the *Kammuryōju-kyō (Sutra of Meditation on the Buddha of Infinite Life),* which forms the basis for the pictorialization of the Pure Land. These narrative scenes are read beginning at the left band (or "court") from bottom to top, then the right band from the top down, and finally the bottom horizontal narrative. The outer court on the left illustrates the redemptive story presented in the mid-eighth-century *Sutra of King Ajaseō* in the exhibition [11]. Here a small Raigō scene also appears along with an inscription about the origins of the first mandala depicting Amida's Western Paradise—a feature common to nearly all such paintings.[3]

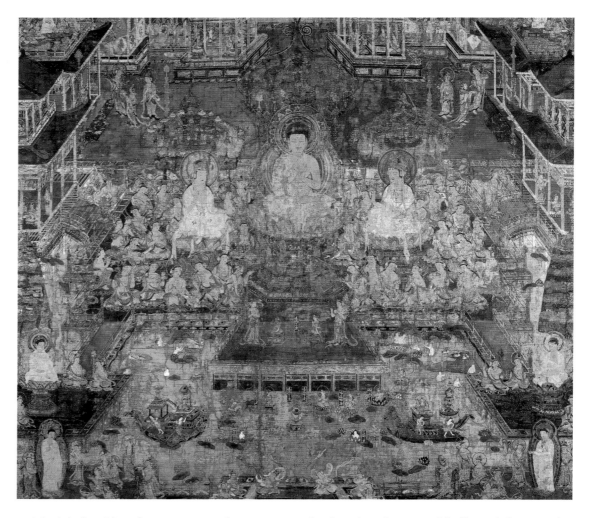

A lavish floral band now worn with age encircles the whole of the painting. Its palette is consistent with the rest of the composition, whose red, green, blue, and white pigments create a strongly orchestrated tonal aura against the areas of gold and silver, now darkened by oxidation. Part of the special beauty of these contrasting effects results from applying pigments (especially white) to the back of the silk as a way of adding depth and variation to the pigment on the front. This technique, known as urazaishiki, occurs in another painting in the exhibition [51].

Clearly the work of a trained professional painter or group of painters working in either Kyoto or Nara, this painting like most Buddhist paintings is unsigned. Painting studios in the thirteenth and fourteenth centuries were active producing mandala imagery of varying iconographies intended to teach the people of medieval Japan, in understandable visual narratives, about a path to spiritual salvation, open to all, leading to Amida's Pure Land. Paintings such as this one were displayed in devotional halls as didactic aids and as vivid reminders of the existence of such a heavenly abode. The splendid detailing of Taima paintings such as this fine example served to enmesh Pure Land followers in an almost palpable visual experience of what spiritually was to be.

1. For Taima and other related mandala paintings, see *Jōdo mandala* (Pure Land mandalas), exh. cat., Nara National Museum (1983), pls. 30–39, 41–88.

2. See thirteenth- to fifteenth-century representations of temple interiors with Taima paintings on display in the Nara National Museum (*Jōdo mandala,* pl. 43, 45). Another useful source based on the illustrated biography of Priest Hōnen is Nakano Genzō, *Raigōzu no bijutsu* (Art illustrating Amida's descent) (Tokyo: Dōhōsha Shuppan, 1985), pl. 40.

3. For a guide to Taima paintings and the iconography of the courts, see John M. Rosenfield and Elizabeth ten Grotenhuis, *Journey of the Three Jewels,* exh. cat., Asia Society (New York, 1979), no. 31. See also *Nihon Bukkyo bijutsu no genryū* (Sources of Japanese Buddhist art), exh. cat., Nara National Museum (1978), pls. 122–31.

53. Raigō

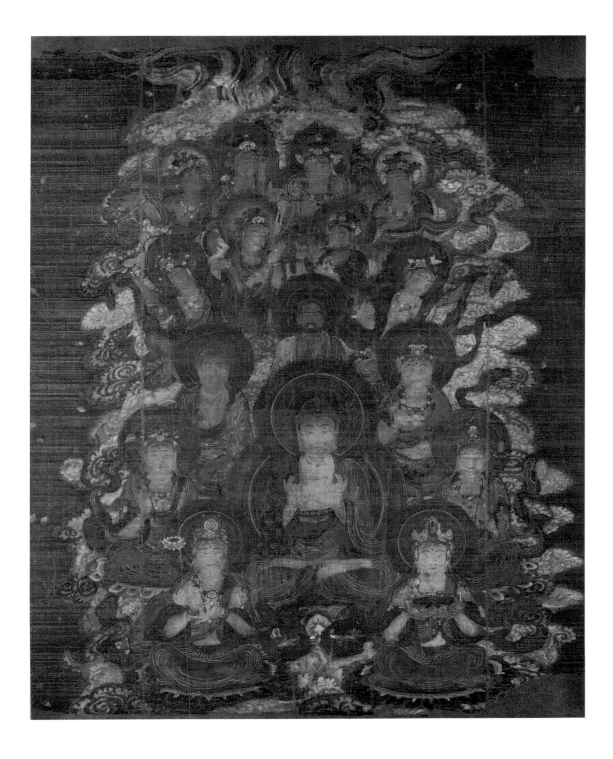

13TH CENTURY; HANGING SCROLL: INK AND
COLOR ON SILK; 103 X 82.4 CM; MATSUO-DERA,
NARA. IMPORTANT CULTURAL PROPERTY

The Tendai sect was ostensibly established
by Saichō [15] as a center of rigorous Esoteric
training, but he, unlike his contemporary
Kūkai, endeavored to embrace other teach-
ings he believed valid in the search for spiri-
tual enlightenment. This catholic rather than
orthodox approach permitted disciples and
monks to study other doctrines and texts and
to engage in rituals not strictly Esoteric in na-
ture, reflecting in part the supreme expansive
wisdom of Tendai's most important deity,
Vairocana, from whom all other aspects of
Buddhahood emanated, including Dainichi.

Thus following Saichō's death in 822 later
generations of his followers, including Ennin
(794–864), continued to evaluate other belief

Detail of the heavenly musicians in Amida's retinue

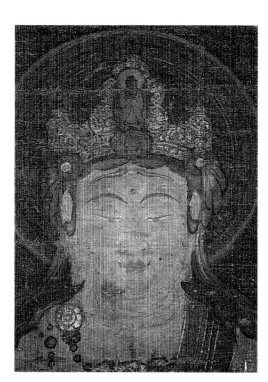

Detail of Kannon, who holds a lotus base for the soul of the deceased

systems. Ennin returned from traveling to Buddhist monasteries in China in 847 with experience in the repetitive chanting of Buddha's name. This ritual encouraged spiritual concentration and so was considered a useful adjunct to Tendai worship, one that honored Amida, the deity who presided over a paradise in the west known as Jōdo.[1]

Belief in Jōdo ideas emanated from early sutras such as the *Konkōmyō Saishōō-kyō* [12] describing the Buddhas of the Four Directions, a popular concept that led to representations such as the mural paintings at the Hōryū-ji in the eighth century. When a later Tendai monk named Genshin wrote *Ōjō Yōshū* (*Essentials of Rebirth in the Pure Land*), the time had arrived for a truly popular wave of interest in Amida, his Western Paradise, and the panoply of ceremonies and rituals—such as the nembutsu—central in Jōdo ritual to realizing human enlightenment.[2] Worship of Amida became increasingly the focus of meaning and worship, and Genshin's espousal of Amida's descent from the Western Paradise (Raigō) to greet the faithful as they were about to leave the human world struck a sympathetic note with the populace (fig. 53a).

The mid-eleventh-century wall paintings in the phoenix hall at the Byōdō-in in Uji, outside Kyoto, typify the existence in the Heian period of visual portrayals of Amida descending on clouds toward a Japanese landscape. Historical documents point to their existence in tenth-century Nara, based on the *Kammuryōju-kyō,* a sutra that describes the nine levels of rebirth in the Pure Land. This scripture and these images form the basis for the later developments in Raigō imagery; they also relate closely to the Taima mandala [52] and Nehan compositions [37].

Early painted compositions of Amida with heavenly attendants, such as the exquisite twelfth-century Amida triad at the Hokke-ji in Nara or the imposing twelfth-century sculptural ensemble from the Hoan-ji in Shikoku, present Amida seated, looking directly out at the viewer. This, the earliest compositional format in Japan for presenting these salvatory concepts associated with Heian Amidism, was likely formulated on the magnificent Byōdō-in wall murals. A variant of this format developed in the early twelfth century: Amida seated in three-quarter view on an elabo-

rately decorated lotus pedestal with a small retinue of attendants descending on clouds.[3]

By the thirteenth century artists began incorporating views of the Japanese landscape below these celestial ensembles—much as they would in more orthodox imagery [48–49] a century later—as a recognizable motif to establish for Pure Land followers an almost tangible vision of this promised descent to Japan. Using yamato-e pictorial conventions of form and color, the painters sometimes even inserted depictions of temples or noble residences where a monk or layperson about to die lay waiting for Amida.

Judging from the number of such Raigō paintings still extant, however, these innovative compositions were not nearly as popular as the one in this Matsuo-dera example. It portrays Amida seated, hands raised in the *tenpōr-in* (turning the wheel of the dharma), a preaching mudra. To the proper left, Kannon carries a lotus base for the soul of the deceased. To the proper right, Seishi holds a white lotus blossom on a long stem. Fifteen figures rise behind Amida, defined in groups of seven (framing Amida), and eight (the upper two registers of bodhisattvas). Stylized cloud patterns form a halo around the group in much the same way as the Fudō Myōō painting [51] or Batō Kannon sculpture [29]. These are not naturalistic billowing forms of mist and air but rather a convoluted series of interconnected curlicue patterns. Their derivation lies in the highly colorful cloud formations depicted in Song and Yuan dynasty Buddhist paintings that were avidly collected in Japan.

Indeed such eccentricities of form and the intentional heightening of tones evident here issue out of contact with continental (Korean and Chinese) religious imagery in thirteenth-century Japan. In this instance, however, it is possible to demonstrate that both the compositional format and figural style are based essentially on a series of Heian period models, close in date, and that this Matsuo-dera portrayal of Amida's descent provides a particular sinicized version of one known type. This is apparent when comparing this Matsuo-dera icon with one at the Anrakujū-in in Kyoto.[4] Both paintings are comparable in date and iconography (Amida is surrounded by Seishi, Kannon, Monju, Fugen, Jizō, Miroku, and Nāgārjuna in each version),

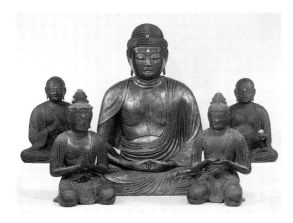

Fig. 53a. Raigō sculptural ensemble, 12th century; gilded wood; h. 52.2 cm. Hoan-ji, Ehime Prefecture and Nara National Museum

which probably issues not just out of Pure Land texts but rather Tendai sources, too. In the *Ōjō Yōshū* Genshin presents the idea that contemplation on heavenly visions (rather than the recitation of Amida's name) was most efficacious as a means to gaining salvation. His description helped give rise to this genre of Raigō imagery via Tendai sect sources and interest. Thus the seven bosatsu surrounding Amida represent Tendai attendant figures (as do the Bishamonten and Fudō guardian deities in the Anrakujū-in painting, which were cut off of this Matsuo-dera scroll).

Both paintings incorporate Esoteric (Tendai) and Amidist concepts as shared visual imagery. However, the figural portrayal in the Matsuo-dera image is achieved by a mixture of a white and dark red pigment that is subsequently outlined in vermilion. The interior drapery lines are gold pigment, and the application of pigments and gold foil from the back side of the painting that occurs in the Anrakujū-in Raigō is not evident here. Rather the reddish-orange pigment applied to highlight the attendants' faces is reminiscent of the Eleven-headed Kannon [45], and both works allude to earlier Chinese painting conventions. The effect here is to create a highly textured fabric of darkened figural forms with muted gold decoration, all imparting the genuine otherworldliness of Amida's paradise.

A late seventeenth-century inscription revealed in remounting the painting states that it once belonged to the subtemple Miroku-in at the Hōryū-ji. This Raigō is now considered to be a thirteenth-century painting done just after the Anrakujū-in image. Comparison with the subsequent developments in Raigō imagery, such as the embroidered scroll in this exhibition [72], reveals the visual grandeur of this composition.

1. For a comprehensive view of Pure Land imagery, see *Jōdo mandala* (Mandalas of the Pure Land paradise), exh. cat., Nara National Museum (1983).

2. See Allan Andrews, *The Teachings Essential for Rebirth: A Study of Genshin's Ojōyōshū* (Tokyo: Sophia University, 1973). See also Fukuyama Toshio, *Byōdō-in and Chūson-ji* (New York: Weatherhill; Tokyo: Heibonsha, 1976).

3. See *Heian butsuga* (Heian period Buddhist painting), exh. cat., Nara National Museum (1986), pls. 67–69, 74; see also *Nihon Bukkyō bijutsu no genryū* (Sources of Japanese Buddhist art), exh. cat., Nara National Museum (1978), pls. 36–38.

4. See Nakano Genzō, *Raigōzu no bijutsu* (Art illustrating Amida's descent) (Kyoto: Dōhōsha Shuppan, 1985), pls. 27–28; see also pls. 9–19, 25.

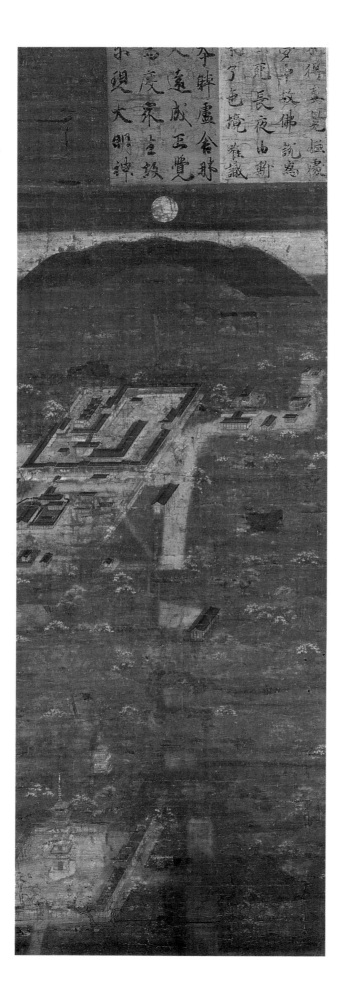

54. Kasuga Mandala

14TH CENTURY; HANGING SCROLL: INK AND COLOR ON SILK; 118.5 X 35.7 CM

The Nara plain extends south into the Asuka area bordered on the east by a number of mountain ranges that over the millennia have not changed greatly in appearance. These mountains stand guard over the fertile agricultural plain and their lower slopes contain the burial mounds of the local clan leaders who controlled the areas from the third through fifth centuries. The clear water that filled the village wells for drinking and irrigation ditches for rice cultivation as well as the timber used to build residences all come from these mountains. The people of the plain and the Asuka region revered the Shinto kami living in the mountains and took heed of their powers.

Area clans aligned themselves with specific local kami, held annual rites to honor and petition them, and situated their residences in accordance with those of the kami. The pre-Nara capital at Fujiwara was laid out according to a Chinese-style grid plan, but its location was chosen, more significantly, for its auspicious alignment to sacred Mt. Miwa, acknowledged since at least the third century as the residence of kami whom all clan leaders heeded.

Upon the move north from the Fujiwara capital toward Kawachi and then to Heijō-kyo (Nara) in 710, greater attention began to be given to local shrines and their resident deities. Clans that moved to the new capital at the request of the emperor transferred their traditional protective kami, summoned others from distant regions, and then enshrined them together with those local kami, thereby augmenting the realm of what had previously been a provincial Shinto domain [55].[1] The Fujiwara clan epitomized this phenomenon, and Kasuga Jinja, their family shrine in Nara, and the cult associated with it prospered for half a millennia as a result of their continuous support. Indeed, the well-being of the shrine was directly related to the political fortunes of the Fujiwara, who until their demise in the late twelfth century enjoyed close relations with the imperial family and its various branches.

The Fujiwara selected Mt. Mikasa in central Nara as the site for establishing their family kami in a suitable location and shrine structure, which was duly erected a little past mid-century (768). Kasuga Shrine, home of the Kasuga cult, evolved out of these humble beginnings into one of, if not the most influential Shinto cult organization in Japanese history. This hanging scroll is one of its manifestations in medieval times.[2] The shrine precincts, including outbuildings, are shown at the base of Mt. Mikasa (Mt. Kasuga is portrayed in darker pigments behind Mt. Mikasa), with a broad swath of light-colored pigment identifying the path leading out of the forested landscape down the mountain toward central Nara at the bottom of the painting. The red torii gate there marks the entrance into sacred ground and further up, toward the mid-point of the composition, another torii identifies the inner shrine grounds. Lush greenery highlighted with blossoming cherry trees establishes the season and creates a pleasing decorative surface effect in the composition. The bird's-eye view indicates that there is considerable distance involved in walking up and into the main shrine.

The shrine is meticulously described, including the subsidiary buildings located deep in the forest to the right (south) of the main compound. As in the Ikoma mandala [56], the patient recording of the components of landscape and architecture lends authenticity to the viewing experience, even though the clarity of depiction here is somewhat marred by the pigment losses on the silk surface.

Notable is the prominent inclusion of a five-story pagoda to the northern side of the path leading to the inner shrine. The tall red structure is enclosed within a gated and cloistered compound [3] that once also included a second pagoda of equal stature referred to in this painting only by a small three-story building to the east, which is obscured by a band of clouds. The foundation and pillar stones for these pagodas can still be seen today on the way to Nara National Museum. Like the Kōfuku-ji, its immediate neighbor to the west, Kasuga Jinja lost a number of buildings to fires in the mid-tenth and late twelfth centuries. Fujiwara Tadazane (1078–1162) provided the funds to build pagodas at Kasuga in 1113, the century when historical documents also relate the use of Kasuga

mandala paintings within the Kōfuku-ji at purification services and rites for honoring the family deity. This large temple enjoyed especially close relations with the shrine because it too was founded and supported by the Fujiwara family, and its Buddhist deities, like the Shinto kami of Kasuga, were considered benevolent protectors of the family's well-being. Indeed, some mandala paintings actually portray the corresponding five deities of each institution according to the honji suijaku relationship traditionally ascribed to them since Heian times [31].

Following the fall from grace of the Fujiwara clan and its several branches in the late twelfth century, Kasuga Jinja relied on support from the public and affiliated religious groups dedicated to worship of the five resident kami, who over the centuries had become well recognized in Japan. Thus whereas the early depictions probably served as private devotional icons, the many Kasuga mandala paintings that survive today likely served different purposes and a wider audience. Such is probably the case with the zushi too [76]. The proliferation of Kasuga imagery in varied media during the thirteenth and fifteenth centuries broadened the shrine's support and its influence well beyond the borders of Nara and Kyoto. Or to consider it from another perspective, it allowed the potential spiritual benefactions of this historic shrine and its resident kami to become more accessible to the public at large. This notion is consistent with the contemporary growth of popular Buddhism in medieval Japan [52–53, 72–73] and the mainstream Buddhist imagery that emerged from those developments.

This painting represents the most frequently copied subject in the honji suijaku repertoire and was probably executed by professional Buddhist painters in Nara, perhaps even those resident at the Kōfuku-ji, responding to continual requests from a far-ranging clientele.[3] The Shinto arts remained vibrant well into the fifteenth century, and representations of Kasuga Jinja were in great demand, partly because of the rise of yamato-e, which focused on indigenous imagery rendered in colorful tones. Kasuga Jinja presented a readily familiar subject; its historical and religious connections to Nara and a provincial network of affiliated shrines helped make it a perfect vehicle for yamato-e painters.[4]

1. See *Ancient Japan*, ed. Delmer M. Brown, vol. 1 of *The Cambridge History of Japan* (Cambridge: Cambridge University Press, 1993), chap. 2.

2. For background on this cult, see Susan C. Tyler, *The Cult of Kasuga Seen through Its Art* (Ann Arbor: Center for Japanese Studies, University of Michigan, 1992).

3. See *Kamigami no bijutsu* (The arts of Shinto deities), exh. cat., Kyoto National Museum (1974), no. 13.

4. See *Yamato-e* (Japanese-style painting), exh. cat., Tokyo National Museum (1993).

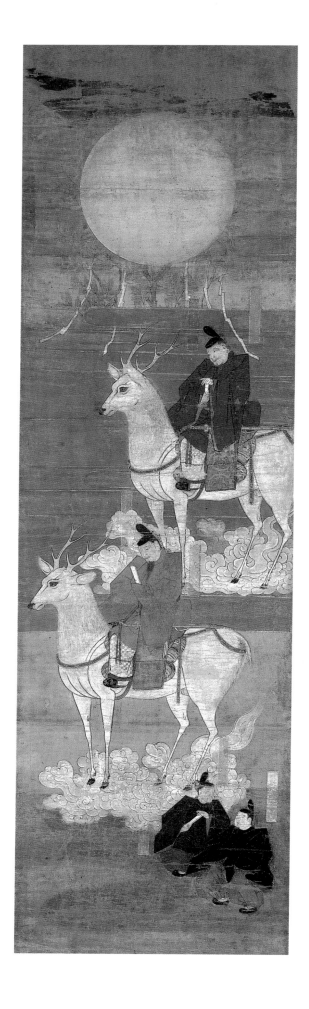

LATE 14TH CENTURY; HANGING SCROLL: INK
AND COLOR ON SILK; 140.6 X 40.2 CM

An important category of Buddhist art embraces and elucidates the lore and history of the Shinto faith. Well established in Japan prior to the arrival of Buddhism in the sixth century, Shinto might be characterized as an animistic belief system in which the forces of nature apparent in any given region were recognized. These forces were very important to the agriculture-based society living on islands surrounded by vast bodies of water, people whose lives depended on what Westerners might call "the elements" or "the forces of nature." Natural phenomena were considered tangible manifestations of powerful spirits with whom the people of the land we now call Japan made special efforts to synchronize their lives without conflict. These higher powers or kami were regionally and locally identifiable according to oral and then written tradition. They were believed to reside in the actual forms and processes of nature in these areas, meaning that, by and large, the natural landscape and such events as the changing seasons were regarded with more than normal attention.

Shinto ceremonies and rituals, as well as simple daily acts of acknowledgment, are known through much later literature (mythology and poetry) and the earliest recorded histories.[1] Initially, no man-made buildings or devotional images existed such as populate the Buddhist pantheon. On the contrary, places of veneration were recognized and came to be esteemed precisely for their natural power and beauty. And the maintenance of those conditions—the purity or cleanliness of that site—was a primary concern of the local populace and their clan leaders.

With the arrival of Buddhism, amid a social and political environment of steadily increasing competition and consolidation, it is not surprising that certain clans and their federations cautiously embraced outright a foreign set of beliefs that could further their political advantage. The process of identifying an imperial clan and its supporting nobility from other clans gradually shaped a stable federation in the Yamato basin during the fourth through seventh centuries. Noble as well as regional clans appropriated resident kami, which became the equivalent of tutelary clan deities and emblems of the increasingly intimate relationship between the secular and religious worlds.[2]

In this way the imperial clan and surrounding nobility accrued to themselves Shinto rites, myths, and locales that furthered their political ends. The imperial clan affirmed its origins with the mythical Sun Goddess (Amaterasu) and eventually selected regalia considered representative of such heavenly origins: mirrors, swords, spears, and jewels. This painting, Kashimadachi Shineizu (The Departure from Kashima Shrine), refers to that regalia in the large, mirror-like disc in the upper portion of the composition above the horizontal bands of blue clouds.[3]

The two white deer standing on cloud banks serve as the vehicles for two male courtiers, each of whom wears elegant official court attire: black-lacquered gauze cap, formal robe, sword, pants, and cloth shoes. Each also holds a white wooden paddle signifying official court authority. These noblemen represent the Shinto tutelary deities of Kashima Jinja (in modern Ibaraki Prefecture) and Katori Jinja (in Chiba Prefecture) en route to Nara. According to legend, the leader of the influential Fujiwara clan appropriated these two kami for installation in Nara at the new family shrine, Kasuga Jinja, close to the Tōdai-ji [54]. Its presence can be inferred from the dark band of deteriorated pigments at the top of the painting that once delineated the curvilinear outline of Mt. Mikasa, the location of the shrine. The kami arrived on white deer according to Shinto legend.

The branches and pale green leaves under the mirror disc are actually meant to support the mirror and represent the sakaki tree (a variety of evergreen). Both objects feature prominently in the creation myth about Amaterasu, and thus the imperial lineage, composed largely of Fujiwara or Fujiwara-related members. The narrow strips of white paper hanging from the sakaki branches are seen even today at Shinto shrines, attached to braided ropes wrapped around the trunks of aged trees or suspended at shrine entrances.

Although a relatively late icon whose condition has deteriorated over the centuries, it retains a dignified presence compatible with its subject.[4] Among the repertoire of honji suijaku painted icons related to the Kasuga Jinja, representations of the shrine precincts with its resident deities or depictions of the deer are well known, numerous, and generally slightly earlier in date than this painting. Here, though, we see the reenactment of a historic political event couched in the Shinto-Buddhist vocabulary of syncretic imagery: two kami from major Shinto shrines located in the territories of regional clans to the far northeast are summoned (and appropriated) by the head of the imperial clan's principal supporter, Fujiwara no Kamatari (614–669), upon his move into the new capital, Heijō-kyo (Nara). These kami then can be viewed both as venerable icons of Shinto religious art and as emblems of the Fujiwara clan's powerful ascendancy to authority in the Nara period.

1. See for example Donald L. Philippi, Kojiki (Princeton, N.J.: Princeton University Press, 1968).

2. For a detailed, thoughtful account of the founding of the Yamato state, see Ancient Japan, ed. Delmer M. Brown, vol. 1 of The Cambridge History of Japan (Cambridge: Cambridge University Press, 1993).

3. See Kasuga Mandala (Mandala paintings of the Kasuga Shrine), exh. cat., Nara National Museum (1978), no. 17.

4. See Suijaku bijutsu (The syncretic arts of Shinto and Buddhism), exh. cat., Nara National Museum (Tokyo: Kadokawa Shōten, 1964), and Kageyama Haruki and Christine Guth Kanda, Shinto Arts: Nature, Gods, and Man in Japan, exh. cat., Japan House Gallery (New York, 1976).

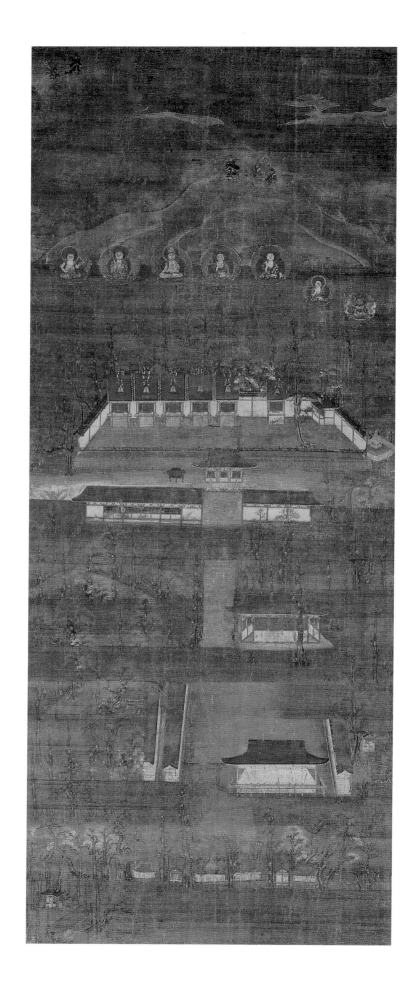

14TH CENTURY; HANGING SCROLL; INK, COLOR, AND CUT GOLD ON SILK; 105.3 X 41.9 CM. IMPORTANT CULTURAL PROPERTY

Mt. Ikoma is located northwest of Nara, past the Saidai-ji (Great Western Temple) on the way to the port of Osaka. The Ikoma mountain range marks a geographical boundary between the Nara and Osaka plains and because of its location was a natural abode for kami. The increasing numbers of families and clans living in the region in ancient times would certainly have recognized kami, sought their protection, and even claimed them for their own political advantage.

As the relationship between Shinto and Buddhism evolved in the early Nara period, Shinto kami were increasingly called upon both to defend the new religious creed and to lend clarity to its hierarchy of deities.[1] These kami also provided the native underpinnings for reminding people of the important ancestral lineages the imperial family and noble clans claimed. By the eighth century these interest groups were actively fostering an environment of mutual accommodation that gradually became accepted and codified within Nara, Heian, and then Kamakura period societies. Historical records of the eighth century, for example, document the visits of Buddhist monks to important Shinto jinja to chant sutras. Imperial edicts sent Buddhist religious texts such as the *Lotus Sutra* to jinja precincts, and actual structures known as "shrine temples" (*jingū-ji*) were built on their premises as well [24].

One of the country's most important imperially sponsored shrines at the time, Usa Hachimangu on the northern shore of Kyūshū, figures in this mandala. For appearing in the skies above and then alighting on the summit of Mt. Ikoma is the kami Hachiman with two attendants. The principal resident kami at Usa, Hachiman (whose name is normally incorporated into that of the shrine: Usa Hachimangu) became the center of cult worship at Nara and then Kyoto temples, beginning with the Tōdai-ji in the mid-eighth century. His powers were thus linked to the imperial family and their supporters and the court. This fact helps explain Hachiman's appearance (twice in this painting) in courtly black garb with colorful under-robes, accompanied by attendants.

Mt. Ikoma appears as two greenish-brown hills at the base of which are seven Buddhist deities, each seated before a blue halo set in a roundel circumscribed in kirikane. From left to right are: Monju, Jizō, Jūichimen Kannon, Shaka, Amida, Yakushi, and Bishamonten. These are the seven honji (Buddhist deities) corresponding to the seven suijaku (Shinto kami) of the syncretic belief system of that name, hidden behind the closed doors of the seven shrine buildings displayed on the back wall of the complex.

Because there are no small labels to help the viewer learn the names of the resident kami, as in the Sannō mandala [57], it must be assumed that during medieval times visitors to Ikoma Jinja or viewers of this hanging scroll would have already possessed that knowledge. The five principal deities are each identifiable, but—and more important for the Western observer—these kami represent five members of the imperial family of Emperor Ōjin (late fourth through early fifth century). It is they who are ensconced out of sight in the five shrine buildings lined up next to one another.[2]

Separated from these structures are two smaller shrine buildings, one of which is on a side wall. These are the residences of Ikomasan's original male and female kami who have been clearly assigned lesser roles in this composition. Like the Kashimadachi Shineizu [55] then, this ostensibly religious icon has a decidedly secular message to convey, well beyond the broad issue of state and religion.

The painting's bird's-eye perspective and central axis reveal the shrine precinct and the topography of the mountainside. While the viewer initially reads the image at one glance, the painter placed natural and man-made vignettes along the pilgrimage route, from bottom to top, creating a reflective visual rhythm. Thus the horizontal bands of brown ink washes that help organize the surface are broken up internally by the buildings; some are modest and must be studied attentively, others reveal their functions easily as a ceremonial dance platform or official gathering hall.

The placement of the buildings in relation to one another and their scale as they progress back toward the inner shrine are impressive, as are the fine brushwork, pale ink washes, and exacting application of cut gold foil in selected architectural details. The accomplished artistic talent and expensive materials requisite for such an elegant work suggest an aristocratic patron. While the painter's name remains unknown, his hand can be seen in such features as the tall solitary *katsura* (Japanese Judas tree) in the inner shrine grounds and another tree, with black depressions formed by its aged roots, standing alone in front of the audience hall in the middle ground. These touches, together with the small mural painting of an ox with attendant and the immense three-legged cauldron set enigmatically before the five honji, are revealing traits of the artist, and this mandala.[3]

Finally, mention should be made of the reference to spring—the cherry trees in blossom in the landscape—and the startlingly beautiful azurite blue tone used for the tile roofs of some of the shrine buildings. Normally only brown bark shingles, a natural product, are used for shrine roofs, and other Ikoma Jinja mandala of later date confirm the artistic license employed here to create a vibrant sacred space, laden with the poetry of color, form, and air.

1. For insights into eighth-century Buddhist narrative and its relation to earlier oral (and Shinto) traditions, see Kyoko Motomichi Nakamura, *Miraculous Stones from the Japanese Buddhist Tradition* (Cambridge: Harvard University Press, 1973).

2. *Suijaku bijutsu* (The syncretic arts of Shinto and Buddhism), exh. cat., Nara National Museum (Tokyo: Kadokawa Shōten, 1964), nos. 82–84.

3. See Sasaki Kōzō, *Kasuga, Hiei, Kumano: Shinto no bijutsu* (Shinto art: Imagery of the Kasuga, Mt. Hiei, and Kumano shrines) (Tokyo: Gakushū Kenkyūsha, 1982).

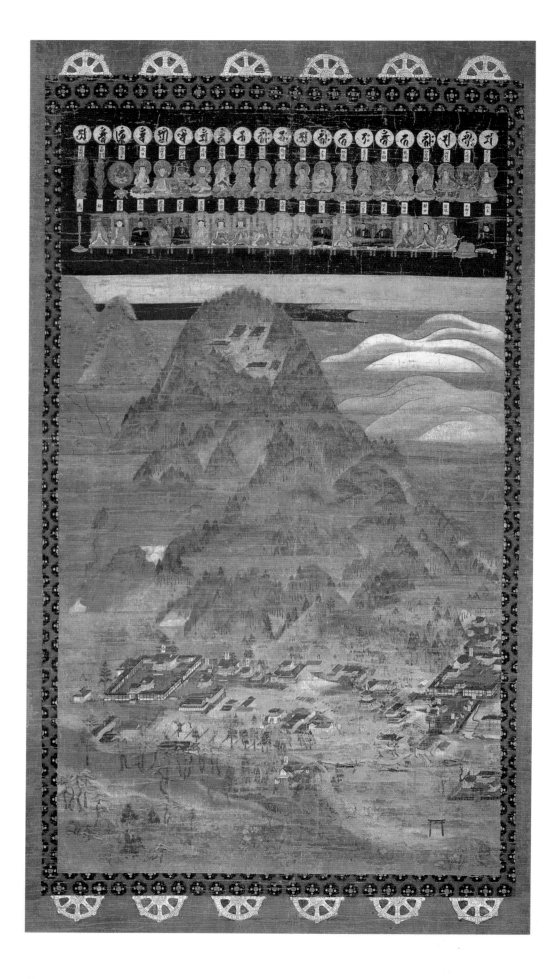

57. Sannō Mandala

15TH CENTURY; HANGING SCROLL: INK AND COLOR ON SILK; 121.1 X 66.8 CM

In contrast to the other mandala paintings depicting bird's-eye views of Shinto jinja, this hanging scroll incorporates a didactic, two-tiered register identifying the honji suijaku deities resident at the shrine complex illustrated below. The composition and the general condition of the surface indicate that this hanging scroll was in regular use as an instructional tool, as was the Taima mandala for example [52].[1] The upper white roundels show Sanskrit "seed" characters for each deity: the elemental signs and emblems of sound whose simple utterance has the potential to summon in the believer an awareness of the Buddhist deity [69, 73, 75]. Below the roundels are small white vertical rectangles inscribed with the names of the deities and then the Buddhist deities themselves, each sitting on a lotus base with a halo framing its head. The Sanskrit characters could be read from a distance in a temple hall, unlike both the inscriptions and the distinguishing features of the individual deities.

The lower register holds the twenty-one resident kami corresponding to each Buddhist figure above. They are dressed in classical Heian court attire and seated on raised footed platforms with high backs such as can be seen in the kakebotoke dated 1218 in the exhibition [65]. A dark blue pigment creates the field upon which this iconographical schema is laid out, highlighting the diminutive nature of this dictionary or blueprint of word and image, lending a visual coherence to the whole, and providing a tonal segue into the landscape portion of the painting where a thin band of blue sky peeks out behind mountaintops and bands of clouds.

The anonymous artist composed the picture essentially as a panoramic view, but with some subtle shifts of perspective in order to combine clarity of shrine organization with a believable, continuous landscape that proceeds from near distance to infinity. He used a bird's-eye view to disclose the man-made shrine buildings that make up the Sannō system complex. Sannō was closely allied to the Tendai sect headquarter temple

Enryaku-ji, founded in the early ninth century by Saichō [15].[2] While Saichō and his followers recognized a kami inhabiting Mt. Hiei, it was not until the later Heian period that the Hiei (Hiyoshi) Sannō system gained true religious prominence.

The scale of the shrine complex is impressive in its location on the eastern slopes of Mt. Hachiōji, to the east of Mt. Hiei and toward the nearby shore of Lake Biwa. The shrine complex is divided into three major areas along a horizontal axis at the base of Mt. Hachiōji. The most prominent are the Eastern Shrine (on the right, with nine individual shrine buildings labeled), the Western Shrine (to the left, featuring Omiya Jinja prominently and five other subsidiary shrines), and a less crowded middle area with a two-story, stupa-shaped pagoda. The Omiya River wends its way along the border of the setting, with shrine outbuildings depicted along its banks as well as bridges, shrubbery, and groves of spindly pine trees. Red torii gates signal the borders of and entrance into the sacred complex, as well as into individual shrine domains. While there are no pilgrims or visitors depicted in this expansive landscape, the carefully placed and proportioned forms and colors and the ease with which the buildings

of shifting from a horizontal to a vertical format in the yamato-e idiom, this painting of the Sannō mandala stands out as an especially successful reference point in that evolution.

The subtle shift from the bird's-eye view of the lower shrine to a profile of the hills, ridges, and valleys that make up Hachiōji-san is an accomplished one. The peak is then tipped forward to reveal clearly another three shrines. To the right, almost on the horizon, two clusters of low rounded mountains—Mt. Ibuki and Mt. Hira (with snow)—are balanced with the conical peaks of Mt. Hiei to the left. The towering mountains and seasonal references, gently reminding the viewer of the passage of time, and the diminutive scale of the shrine buildings, each painstakingly described, make this mandala composition one of the unheralded icons of medieval landscape painting in Japanese art.

A few mandalas of the Hiei Sannō deities survive from the later Kamakura period, usually composed in a circular iconographic arrangement featuring the kami Omiya in the guise of Shaka seated in the center.[4] The fascinating mandala painting owned by the Yamato Bunkakan in Nara identifies the kami residing in each shrine building with *mishōtai* (mirrors with incised or painted Buddhist imagery) suspended in front of the doors of each shrine. These discs are closely related to the mirrors placed in sutra mounds beginning in the eleventh century [63–64 and, with kaketoboke placement, 65–67]. But among landscape portrayals of the Sannō shrine complex, this is the finest. Indeed among landscape portrayals of "place" in Japanese art, this painting is a magisterial example.

Details of the middle area of the Sannō Jinja, with its two-story, stupa-shaped pagoda, and the nine labeled shrine buildings of the Eastern Shrine [79]

and mountain co-exist create a sense of graciousness and accessibility.

This sense of aged calm or repose that Shinto brings to the syncretic honji suijaku schema represents an important component of the medieval landscape painting tradition in Japan and the development of yamato-e [48–49, 54, 56]. The mountain scenery in this painting for example relates to a good number of thirteenth- and fourteenth-century illustrated handscrolls in the yamato-e tradition.[3] Yet considering the compositional challenges

1. *Hiyoshi Sannō gongen* (The cult of the Hiyoshi Sannō gongen: The fine arts of kami and Buddha), exh. cat., Shiga Kenritsu Biwako Bunkakan (Otsu, 1991), nos. 1, 3–5, 91.

2. For Hiyoshi-Sannō imagery at Enryaku-ji or at affiliated temples and shrines, see *Hieizan to Tendai no bijutsu* (Mt. Hiei and the art of Tendai sect Buddhism), exh. cat., Tokyo National Museum (1986), no. 85–90.

3. For related compositions, see *Yamato-e* (Japanese-style painting), exh. cat., Tokyo National Museum (1993), nos. 51, 54, 80–81, 89, 94.

4. See *Hieizan to Tendai no bijutsu,* 89–90. For a broader discussion of such imagery, see Sherman E. Lee and Michael R. Cunningham, *Reflections of Reality in Japanese Art,* exh. cat., Cleveland Museum of Art (1983).

13TH–14TH CENTURY; HANGING SCROLL: INK, COLOR, AND GOLD PIGMENT ON SILK; 120.2 X 81.1 CM. IMPORTANT CULTURAL PROPERTY

No doubt the most recognized portrait in the Nara National Museum collection and, indeed, one of the most renowned of all portraits among the Japanese public is this image of Shinran (1173–1262), the founder of the Jōdo Shinshū (True Pure Land) sect. Three venerable paintings survive in Japan recording this priest who is regarded as one of the country's most effective proselytizers of popular Buddhism, a legacy made tangible by the institutionalization of his life and teachings in the Shinshū sect organization. The two other portraits, both National Treasures, reside at the Nishi Hongan-ji, a vast monastic compound in central Kyoto that is the headquarters for the sect and many thousands of affiliate temples.[1]

The larger of these two paintings, extensively damaged and darkened with age, shows the prelate seated on a tatami mat holding rosary beads. His robe is a somber brown and the only original facial features discernible through the tattered silk surface are portions of broad eyebrows. Simple sandals, a staff, and a hibachi are set on the floor before the tatami, and dark boldly written inscriptions occupy panels above and below showing Shinran's distinct calligraphic style, done when he was eighty-three. That portrait, known as *Anjō no Miei,* is said to date to the

Fig. 58a. Detail of *Kagami no Miei*, 13th century; hanging scroll: ink on paper; 71.8 x 33 cm; Nishi Hongan-ji, Kyoto. National Treasure

mid-thirteenth century, as does a smaller sketch-portrait, *Kagami no Miei (Mirror-like Portrait)* (fig. 58a). It too possesses a bold inscription (not by Shinran) in ink on paper, the medium in which the portrait is also executed. The brusque, dynamic brushstrokes used to delineate the robing of this standing figure contrast vividly with the thin pale lines rendering the priest's face. It is the most celebrated of Shinran's likenesses precisely because of its directness, simple materials, and humble scale.

Among the many later versions, the portrait in this exhibition offers the most reliable, finished rendering of Shinran. It is called the *Kumakawa no Miei (Bear Fur Rug Portrait)* because of the black fur beneath the prelate, a source of warmth in Japan's winters, like the billowing white scarf wrapped high around the back of his shaved head. He wears an austere brown robe with a plain black *kesa* (monk's stole) tied over the left shoulder. His wrinkled, bony fingers grasp a rosary.

The portraitist's talents reveal themselves in Shinran's countenance. The shaping of the head, as well as the gradation of tones used to define hair stubble and at the same time impart modeling to the head, bespeak a professional artist's work. Although he has adopted a number of standard Japanese portrait painting conventions, his selective emphasis on the sitter's eye cast, flamboyant eyebrow shapes, and pug nose are all sensitively considered and then rendered in a variety of subtle ink washes and ink lines.

Likewise, while following the conventions of priest portraiture, the composition proffers a subdued range of tones, all modulated to create a setting compatible with the sitter's character and mien. Shinran's thought and faith had a firm basis in piety and consequently was especially attractive to the common people in medieval society who grasped his interpretations of traditional doctrine as it acknowledged their worldly circumstances. At a time when Japanese society was undergoing pervasive social and political tumult, Shinran proposed a faith attainable by all in their search for grace. He had after all left the Tendai headquarters at Enryaku-ji to advance the cause of Pure Land Buddhism, extending Honen's efforts to reform Buddhist orthodoxy so as to meet the needs of ordinary men and women in their everyday lives.

While Shinran rose to the status of an icon among his followers of all generations, this gritty depiction shows him as an old man with dark skin (a sign of the lower classes who perform servile work out-of-doors), craggy rather than refined physical features, and no discernible attachment to wealth, worldly possessions, or social status. The other portraits in this exhibition show or allude to these "advantages" with the possible exception of Daidō Ichii's image [61]. Shinran's only possessions noted in the portrait are his beads and his unusually shaped walking staff. His earnestness and his frailty are revealed equally.

The inscription in the cartouche in the upper right corner is written over a design of golden phoenixes and peony patterns. It is a poem recounting a dream in which Shinran purportedly met Shotoku Taishi, the sixth-century prince-regent whose energetic support of Buddhism greatly influenced its initial acceptance and then dispersion throughout Japan. Numerous portrayals of Shotoku were produced in the Kamakura era, the time when he came to be revered as an icon, and a cult developed devoted to his worship.[2]

Another inscription hidden from sight on the back of the mounting states Prince Son'en (1298–1356) wrote the poem and that the portraitist was one Jōga (1275–1356), a priest-painter said to have participated in painting the illustrated scroll of Shinran's biography who trained subsequent generations of Shinshū sect priest-painters, some of whose portraits and illustrated biographies of Pure Land priests survive. Jōga's identity is problematic, as is that of a school of Shinshū sect painters.

This image of Shinran, however, is certainly the finest fourteenth-century portrait painting of a man considered a saint by Pure Land adherents. Moreover, in comparison with many other fourteenth-century priest portraits, samurai, or courtier portraits, it invites contemplation by consciously eschewing convention.

1. See *Nihon no shōzō* (Japanese portraiture), exh. cat., Kyoto National Museum (1978), pls. 40–42.

2. See *Nihon no Bukkyō o kizuita hitobitō* (Imagery of the founders of Japanese Buddhism), exh. cat., Nara National Museum (1981), pls. 41–53, 113–22.

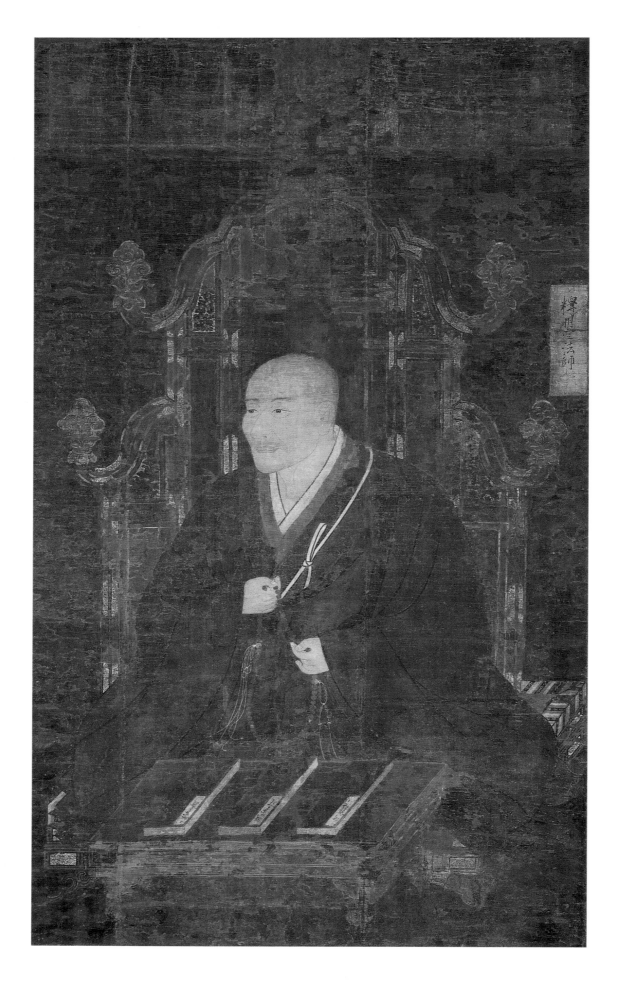

13TH–14TH CENTURY; HANGING SCROLL:
INK AND COLOR ON SILK; 168.5 X 100.2 CM.
IMPORTANT CULTURAL PROPERTY

This cleric's identity would have been forgotten save for the vertical white panel on the right border bearing the words "Shaka Myōkū Hōshi" in black ink. Priest Myōkū's background is obscure except perhaps for the agreement in otherwise conflicting historical documents that his family name was Miura and that he entered monastic life following the family's misfortunes in the thirteenth century.

When and with whom he began his studies and at what age are not known, although it is reported that he eventually was accepted by Shinran Shōnin [58] as a pupil and later settled in a region northwest of Tokyo where he founded a temple. Another record concerning Shinran's life places Myōkū in Shiga province, to the east of Kyoto. In this large painting he is depicted as a young cleric, perhaps in his forties or fifties, rather than as an elderly respected priest. And, like the portrait of Andō En'e [60], the trappings that describe the sitter declare an attachment to worldly materiality not seen in the portraits of more distinguished clerics [61].

The elaborate high-backed chair framing Myōkū is the painting's most fascinating and compositionally important element. Rising off a low-footed carved base adorned with lacquered and gold panels and fitted with a tatami mat with a colorful banded border, the tall back frames the priest's body in an elaborate schema of struts, panels, and floral knobs. Stout curvilinear moldings cap the screen and the narrow side panels. Narrow gilt-bronze fittings set against the abraded and darkened silk mark the carpentry joins in the structure and add brilliance to the setting. The unusual multicolored lacquer finials and tatami border function similarly, particularly as they also establish the boundaries of the sitter's pose. So far as is presently known, this remarkable furniture setting is unique to portraits of Jōdo sect monks, particularly to the multi-figural examples depicting the sect's five patriarchs.[1] This rendition however, is much more detailed, as if the sitter were being photographed as a close-up.

Before Myōkū on a low carved table with a red lacquered surface are three books folded accordion-style: a format commonly used for religious texts in medieval Japan. Each of the dark blue covers has a paper label identifying it as one of the three sutras focal to Pure Land Buddhism: (right to left) the *Daimuryōju-kyō* (*Larger Sutra of Immeasurable Life*), the *Kanmuryōju-kyō* (*Sutra of Contemplation on the Buddha of Immeasurable Life*), and the *Amida-kyō* (*Amida Sutra*). The presentation of religious texts on a lacquer table, often with such additional accouterments as a fan, censor, and incense container, occurs in Pure Land sect portraits and derives historically from other, more established religious portrait traditions in Japan. However, among portraiture emanating from the various Pure Land sects, this Myōkū composition presents an unusually vivid and elaborately detailed setting many decades before other known examples.

The young prelate grasps a rosary of wood beads similar to the one Shinran holds. His bulky garb includes white and brown underrobes and a dark blue-gray outer robe with blue kesa attached by a stark white band tied in a loop on his chest. The palette is muted, even severe, in keeping with Shinran's appearance, and the actual brushstrokes rendering the garment lines and forms are straightforward. Clearly the artist devoted much of his effort to the furniture apparatus and Myōkū's face. He gazes off to his right as if absorbed in thought while he silently prays, fingering the beads one by one. His high prominent cheek bones echo Shinran's, as does his beard stubble.

Unfortunately, the painting's condition has deteriorated markedly over the centuries because of its size and its exposure as an icon for extended periods of time, which places great stress on the silk surface (three pieces joined together) and paper backing. It no doubt was left hanging for relatively long periods as a didactic tool in Pure Land proselytizing. Priests frequently used large-scale Buddhist paintings such as Taima mandalas [52] as visual aids during lectures to parishioners, especially within Pure Land sect establishments. An inscription (now obliterated) that crosses the upper band of the painting from right to left would have assisted in this educational goal. If for example it contained

a passage from Shinran's writings, as has been suggested, then those words appearing above Myōkū's portrait would have served to convey the legitimacy of Myōkū in Shinran's lineage, and in turn to the next generation of his students. Perhaps future technical examination of the inscription will unveil the text and then its historical source. Meanwhile, tradition holds that the portrait formerly belonged to the Shinshū sect Bushin-ji in Shiga province, a temple Myōkū is said to have founded.

1. See for example *Nihon no Bukkyō o kizuita hitobito* (Imagery of the founders of Japanese Buddhism), exh. cat., Nara National Museum (1981), pls. 128–29.

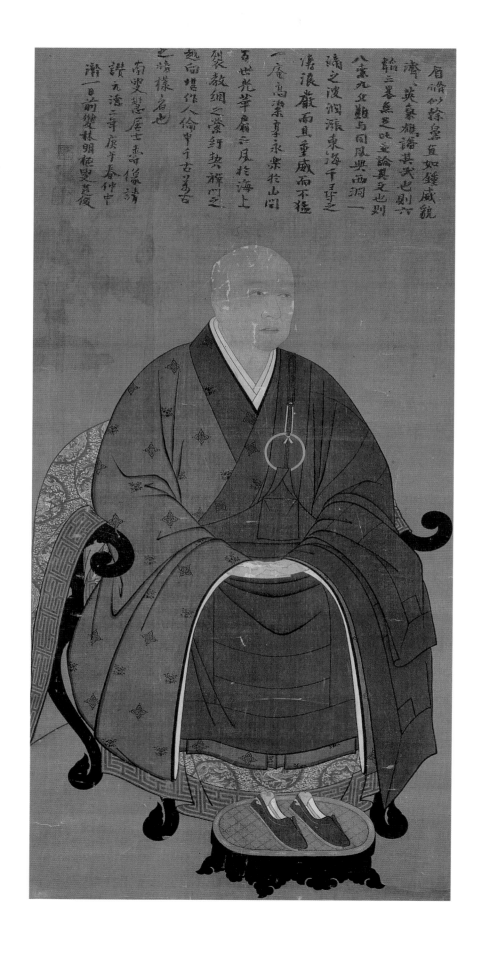

DATED 1330, INSCRIPTION BY MINKI SOSHUN (CHINESE, DATES UNKNOWN); HANGING SCROLL: INK AND COLOR ON SILK; 119.5 X 57.9 CM. IMPORTANT CULTURAL PROPERTY

Andō En'e (1285–1343), a prominent samurai and government official within the Hōjō clan administrative domain is depicted here in a portrait that could easily be mistaken for the formal portrait of an eminent Zen priest. The pose, composition, and pictorial style for such depictions evolved during the Kamakura and Muromachi periods, following the early thirteenth-century arrival of Song dynasty examples from China. Brought into Japan by Chinese priests invited to establish Zen temples and train acolytes or by Japanese monks returning from a period of study on the continent, these portraits of Zen (Chinese: Chan) masters became popular icons within Zen institutions. Such portraits were not only powerful visual reminders of established spiritual conduct, but also religious imagery reflecting the history and lineage of the temples that eventually came to own them. Alcoves were sometimes constructed to display them on special days of the year, in some instances in a founders hall within the monastic compound built specifically for that purpose. There sets of portraits or more than one portrait would be displayed, enabling lay supporters and devotees to appreciate the history and the validity of doctrinal transmission. The imprimatur of such visual (painted, calligraphic, and even sculptural) documents played a fundamental part in students'—and then their institutions'—well-being in medieval Japanese society, whose support was necessary for their sustenance.[1]

The Hōjō family domain on the eastern coast included Kamakura, the seat of the shogunate during the historical period of the same name, and the location of several impressive Zen temples founded and supported by the military leaders of the era. The Hōjō regents in particular embraced the sect enthusiastically and fostered its spread throughout the country. Not infrequently they and members of their affiliated clans governing outlying provinces sought the refuge of a Zen community upon retirement from governmental duties, taking the tonsure to become monks. Hōjō Takatori (1303–1333) and Tokiyori (1227–1263) pursued this avenue late in life and undoubtedly influenced officials such as Andō En'e to follow suit. While En'e served the Hōjō government in Kyoto, his later Zen studies took place in Kamakura under the tutelage of a Chinese priest at the Engaku-ji and Kenchō-ji. Although he retired to a countryside retreat, late in life he became the abbot of a Zen temple in modern Gumma Prefecture, northeast of Tokyo.

The lengthy inscription above the portrait bears the date 1330 and comes from the hand of the Chinese priest Minki Soshun, who had entered Japan the previous year and subsequently became the abbot of the Kenchō-ji. En'e is portrayed at age forty-five, and the precise linear delineation of his head and facial features illuminates his youthfulness. Despite silk losses, the viewer grasps immediately the sitter's individuality through such features as the single continuous brushstroke outlining the shape of the head and line of the jowls, or the slight droop of the left eyelid.

En'e is presented in a three-quarter pose, formally attired in priest's robes, in a meditative posture. The black lacquered chair is covered with a brilliant red and gold silk cloth displaying roundels featuring paired dragon designs. It has a blue-gray border and light tea-green lining. These patently Chinese decorative motifs are complemented by the tonalities and designs of the sitter's outer robes. In fact, the entire assemblage epitomizes the decorum prevalent in the samurai culture of thirteenth- and fourteenth-century Japan. Most if not all the materials and objects in the portrait came from Ming China, probably imported as part of an official government mission sponsored by the Hōjō administration.

The white silk inner robe is the only feature this portrait shares with the other depictions of priests in the exhibition. Soshun's inscription also establishes the portrait not as a *chinsō* (portrait of a Zen master) but simply a portrait of a samurai layman, for in 1330 En'e had not attained enlightenment through study with Soshun. Rather, like the half-portrait of his father, also bearing a 1330 inscription by Minki Soshun, it represents an entirely new secular portrait tradition based largely upon the chinsō model and introduced by the Hōjō regents some years earlier (fig. 60a).[2] This new format helps explain, in part, a certain lack of intensity in En'e's portrayal when compared to the others in this exhibition: the skillful, anonymous author of this image understood the worldly character of his sitter and his trappings. The spiritual dimension had yet to appear, although historical records tell us the impulses were in place.

1. See Helmut Brinker and Hiroshi Kanazawa, *Zen Masters of Meditation in Images and Writings,* exh. cat., Museum Rietberg (Zurich, Artibus Asiae, 1996; English translation of original German text, 1993), nos. 28–29.

2. These two paintings together with another portrait (now lost) once formed a triptych.

Fig. 60a. Andō Renshō, inscription by Minki Soshun, dated 1330; hanging scroll; 108.2 x 46.1 cm; Kumeta-dera, Osaka. Important Cultural Property

61. Priest Daidō Ichii

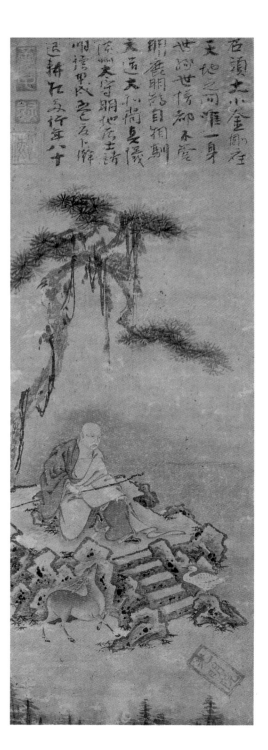

DATED 1394, ATTRIBUTED TO MINCHŌ KICHIZAN (1351–1431), COLOPHON BY SHŌKAI REIKEN (1315–1396); HANGING SCROLL: INK ON PAPER; 47 X 16.2 CM. IMPORTANT CULTURAL PROPERTY

A platform of large and small rocks with a "Diamond Throne"

Heaven and earth,
composed alike of only one body

The realms of causality and emotion transcended

The enlightened deer and goose,
unfaltering in their trust.

—Daidō, the Great Reverend Shingi, requested by the Governor of Tanshū, Myōji-koji, 1394

These words are dynamically inscribed in eight lines on the abraded paper above the pastoral scene with the lofty pine depicted in this small painting.[1] The tonalities of ink and the vigorous brushwork modulating from thick strokes to wispy linear gestures are all firmly placed within the narrow borders of the painting. The inscription, dated more than two decades after Daidō's death, comes from the hand of the monk Shōkai Reiken (1315–1396), himself once the abbot of the influential Zen monastery Tōfuku-ji in Kyoto's eastern hills.

Reiken's words, while vaguely descriptive of the scene portrayed below, conjure up far loftier thoughts and images for Zen adepts and the Buddhist faithful. For Reiken is pointing out that the seeming disparity between what is perceived as large versus small, above (heaven) and below (earth), rational versus intuitive—what pertains to the human rather than the animal world—is in fact all an illusion.

One special attribute of this small painting is the informal open-air portrayal of the eminent Zen prelate Daidō Ichii, one of Reiken's predecessors as abbot of the Tōfuku-ji. Daidō sits atop the rock platform surrounded by a pine tree, white heron, deer, and craggy rocks. The two animals are framed by rocks with combinations of ink washes that convey three-dimensional form (deer) or a highlighting background (heron). Like the smaller flanking figures of an orthodox Buddhist painting [33], these animals both frame the

central image and symbolically represent the spectrum of that figure's religious authority, and indeed of the Buddha nature itself. The deer, a familiar real animal in Nara and a well-recognized syncretic image linking Shinto and Buddhism since the Heian period, appears to almost genuflect in adoration before the aged monk. Zig-zagging rock contours provide an effective foil for the round deer form, and the combination of graduated ink-washes and large dot strokes enhance the presentation. The heron, standing on a rock, is set against a dark background to clarify its shape and position in relation to the larger deer. The message conveyed is that sentient beings inhabiting the earth, water, and air revere the Zen master.

Above, four boughs of the aged pine provide a symbolic canopy, much like the elaborate canopies positioned above the central icons of a devotional hall or classic Buddhist painting, and the vines even suggest the glittering trellises of linked beads and metalwork attached to those canopies [45–46].

The prelate Daidō Ichii enjoyed the tutelage of the Tōfuku-ji's founding abbot, Enni Ben'en (1202–1280), whose remaining portraits inform that relationship by either compositional format or brush style (fig. 61a). Daidō's talents as a religious leader and literary figure in fourteenth-century Japan represented a further consolidation of the Tōfuku-ji's stature within the Zen monastic community of Japan, then centered in Kyoto. Daidō appears with Enni as a young priest in a formal, multi-figured portrait on silk of the fifteenth century and as a Zen elder in this vivid depiction traditionally attributed to the Tōfuku-ji's most renowned monk-painter, Minchō Kichizan.[2]

Daidō holds a long crooked staff in one hand. His other hand peeks out from under the gray robe that falls over his left shoulder down onto his lap and left foot. His right foot is concealed, presumably crossed up under him in a kind of "half" meditative position. His chair, a rock with short bamboo grasses (sasa) sprouting from its edges, is not the formal wooden abbot's chair normally seen in Zen portraiture or in the Myōkū portrait from the Pure Land sect tradition [59]. This out-of-doors portrayal of a religious personage is reminiscent of the earlier tradition of rakan painting in which these saintly recluses ap-

pear in unbridled landscape settings, often seated on stone ledges or platforms. Here, however, stairs are depicted, an intriguing element that, like the well-known bifurcated pine in the Myōe Shōnin portrait at the Kōzan-ji in Kyoto, suggests the familiarity between nature's rusticity and man-made form, between the active search for spiritual enlightenment and its ubiquitous presence in everyday surroundings.

Daidō's identifying facial features are rendered in a series of detailed fine lines and slight ink washes. The contouring strokes that describe the shape of his head and ear establish the three-quarter view. Behind, a gray wash with dark highlights in ink flung onto the paper or blown through a bamboo tube to create a fine spattering frames the bent figure and rock platform. The red seal denotes its previous ownership by a subtemple of the Tōkufu-ji, the Kōmyō-in. The tops of what appear to be small fir trees are visible at the bottom edge of the painting, a motif not evident in the related sketch portrait of Enni Ben'en also at the Tōfuku-ji and also attributed to Minchō. This artist's oeuvre, displaying an impressive stylistic range within a circumscribed compositional framework, has been well recorded in art historical literature.

This modest sketch painting represents a departure from the norms of Zen portraiture in medieval Japan, much as the fourteenth-century Monju image in this exhibition [34] does from classic Esoteric painting. The synthesis of the format, style, subject, and innovative composition mark it as one of the most authentic, extraordinary expressions of Zen religious art and ideas that have been transmitted through the ages.

1. See Jan Fontein and Money L. Hickman, *Zen Painting and Calligraphy,* exh. cat., Museum of Fine Arts, Boston (1970), no. 42, from which this translation is adapted.

2. See Helmut Brinker and Hiroshi Kanazawa, *Zen Masters of Meditation in Images and Writings,* exh. cat., Museum Rietberg (Zurich: Artibus Asiae, 1996; English translation of original German text, 1993), nos. 28–29.

Fig. 61a. Zen Priest Enni Ben'en, attributed to Kichizan Minchō (1351–1431); hanging scroll: ink on paper; 35.5 x 41.8 cm; Tōfuku-ji, Kyoto. Important Cultural Property

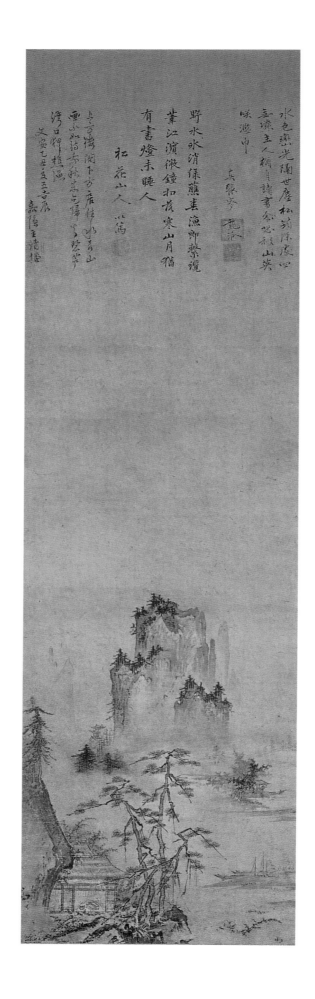

DATED 1445, ATTRIBUTED TO TENSHŌ SHŪBUN (ACTIVE 1423–1460), INSCRIPTIONS BY SHINDEN SEIHA (1375–1447), SHINCHU MINTOKU (D. 1451), AND KŌSEI RYŪHA (1375–1446); HANGING SCROLL: INK AND SLIGHT COLOR ON PAPER; 107.9 X 32.7 CM. NATIONAL TREASURE

Although colorful Buddhist paintings characterize the Kamakura period repertoire, the introduction of Zen doctrine in the late thirteenth century fostered an interest in Japan in monochrome ink painting. Like contemporary Chinese and Korean literature and philosophy, which also began to have a profound effect on Japanese culture, this new representational style found an increasingly impassioned audience among the new military rulers of the country who wished to distinguish themselves from the enfeebled aristocratic culture centered in Kyoto.[1]

Japan's emerging Zen community and later its tea ceremony aficionados embraced the aesthetics of calligraphy and painterly image: subtle ink tonalities applied to plain paper surfaces. The new symbols, themes, and graphic appearance of Zen pictorial art prompted the active collecting and study of Korean and Chinese paintings in medieval Japan. Inevitably Japanese admirers began to emulate and then interpret the subjects, compositions, surface appearance, and brush gestures they observed in the imported paintings.

Among the various formats embraced by the Zen communities in Kyoto and Kamakura, the seat of government of the military leadership located just west of modern Tokyo, none was more popular than a tall narrow hanging scroll that could be simply displayed in a special alcove of a room in a temple or residence. Whether pure calligraphy by an eminent monk or a pictorial subject—landscape, figural, bird and flower, or some subgrouping thereof—these amateur paintings gradually became the religious icons of Muromachi culture.

The small exquisite portrait of Daidō Ichii in this exhibition [61] provides an early glimpse of Zen painting composition, style, and materials. The modest-sized landscape attributed to the famous monk-painter Tenshō Shūbun illustrated here demonstrates the complexities of a fully developed landscape vision, one decidedly unlike anything in the Japanese topography.[2] Indeed, this scene derives entirely from the monk-painter's imagination and his familiarity with imported Korean and Chinese paintings. Thus the central massif towering over the composition in the distance is a form and compositional motif derived from a model painting. The same can be said of the jagged ledges, elongated pines, and rustic waterside dwellings visible in the composition from the near ground to the far distant bluish peaks. While the tables and ceramic jar in the thatched hut as well as the moored boats and temple roofs to the left of the mountain indicate human inhabitants, nary a person is to be seen.

Such tranquil views of humble existence in a rugged and unfamiliar landscape of water and earth were considered idyllic visions in Muromachi culture. They were visual paradigms of a life away from the distractions, even pollution, of ordinary human behavior in society and government. In fact, as the worldly relationships between the military leadership of the nation and the Zen monasteries they supported became increasingly interdependent, these small paintings became more and more prized. The lofty moral and philosophical values of traditional Chinese—and to a lesser extent Korean—society that the Japanese had reverently held for centuries re-emerged during the fourteenth and fifteenth centuries not only in literature but in a revival of Zen thought and perhaps most remarkably in such ink paintings as this hanging scroll.

Recognized in Japan as one of the foremost examples of the revered form *shigajiku* (poem painting) combining painted image with written commentaries, it has long been regarded as the work of Shūbun. A resident of the influential Shōkoku-ji, a Zen temple in Kyoto that enjoyed the patronage of the ruling Ashikaga family, the monk-painter held prominent positions within the temple bureaucracy. This status allowed him for example to accompany a diplomatic mission to Korea some twenty years before this painting was executed. There he sought out Korean painters, saw both Korean and Chinese paintings in that country, and invited a Korean ink painter to return to Kyoto with him to study. These events had a direct and profound effect upon Shūbun, the reverberations from which continued well into the sixteenth century. Although his authorship of this work is not secure (no extant painting by him has been documented and accepted categorically by modern Japanese scholars), this painting and the National Treasure landscape in the Tokyo National Museum are considered the finest examples of "Shūbun-esque" painting to have survived.

Both works share a distinctive range of brush styles and ink tonalities that cumulatively present and evoke the idyllic vision of purposeful rustic domesticity by a solitary scholar amid the grandeur of a natural (and powerful) landscape. Both paintings also bear inscriptions by eminent Zen clerics of the time commenting on the paintings' character and appearance. In fact, they share two: Shinden Seiha and Kōsei Ryūha, both of whom presided as the abbots of the Nanzen-ji Zen monastery in Kyoto during their lifetimes. This melding of word and image using the subdued "colors of ink" on a natural paper surface that has now acquired the patination of age appears clearly in this unassuming hanging scroll. Like the famous "minimalist" rock garden at Ryōan-ji, the understated Nō plays of Zeami (1363–1443), the rugged tea ceramics of the fifteenth century or indeed the tea ceremony itself, "Suishoku Rankō" is recognized as a Japanese cultural monument for all time.

1. Matsushita Takaaki, *Ink Painting* (New York: Weatherhill, 1974).

2. See Watanabe Akiyoshi, *Of Water and Ink*, exh. cat., Detroit Institute of Arts (1986), 59ff.

63. Mirror with Image of Amida Nyorai

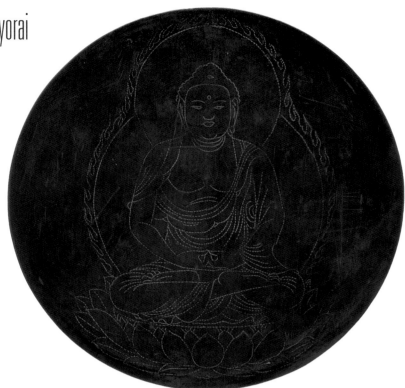

12TH CENTURY; CAST BRONZE WITH TIN PLATING AND INCISED DESIGN; DIAM. 20.5 CM. IMPORTANT CULTURAL PROPERTY

The Japanese first began casting metal disks known as mirrors in the Kofun period. Interred with human remains in large "coffin" jars, these objects signaled the early acceptance of continental, principally Chinese, belief systems in an afterlife. Earlier, in the Yayoi era, Chinese Han period mirrors appeared in the country, gifts no doubt to important clan leaders. One side of all these disks has an elaborately decorated surface, filled with concentric bands of designs radiating from the central raised (and perforated) knob to the edge. The other side, plain and slightly convex, provided the reflective surface. The social status and lore associated with Chinese mirrors was embraced and transmitted to subsequent generations such that the mythic powers of the mirror propelled it into becoming one of the three emblems of Shinto—and the imperial family.

While at first such Chinese mirror designs were copied using molds taken from an imported original, later Kofun period examples demonstrate the alacrity with which Japanese craftsmen began to interpret Chinese designs freely and create their own designs using a combination of straight lines and arcing curves producing what is known as *chokkomon,* or attached bells (usually five) to the perimeter of the mirror. Interestingly, although Kofun Japan enjoyed its closest contacts with Korea and depended upon imported ingots and immigrant craftsmen to fabricate much of its ceramic and metalwork wares, Korean mirror design did not gain a foothold in early Japan like other imported "foreign" materials, ideas, and even political systems. Cultural artifacts underwent a gradual but continuous process of transformation resulting in new distinct shapes and surface designs, usage, and meaning. Subsequent generations maintained the process of development. Thus, while Japanese mirrors were a significant element of Nara era Japan, in the late Heian period they appear in vast numbers, in a variety of shapes and sizes and with distinctly native-inspired designs.

At that time, Japanese political and economic isolation from the continent allowed extraordinary advances in the art of metalwork and the decorative arts. Mirrors for example changed dramatically in shape, size, weight, and surface decor.[1] Designs became more spacious, with pictorial compositions featuring cranes and birds amid trees or pine branches with needle clusters. The mirror itself became considerably thinner, with fewer beveled surfaces and a smaller knob.

This twelfth-century mirror bears designs on both surfaces, each in a dramatically different technique and thematic arena. The knobbed side portrays a pair of flying cranes, each with a pine branch in its bill. Other pine branches are arranged across the dark surface, which is partitioned by a single raised course line. This was a favorite Heian subject, allied to Japanese poetry and literature using the same imagery and to imagery associated with the native Japanese religion, Shinto.[2]

But since at least the late eighth century mirrors have been staples of Buddhist devotional halls or served as part of chindangū offerings [4–5]. Incorporated into the structure of ceiling canopies at the Sangatsu-dō at Tōdai-ji, suspended as a series of overlapping discs along the height of support columns, or placed on a special mirror stand in front of a hall's principal devotional image, the magical illuminating power associated with mirrors was an accepted feature of Buddhist life in Nara and then Heian and Kamakura Japan.[3]

These reflective surfaces were created by applying a thin layer of silvery tin to the bronze (much of it has flaked off on this piece). Occasionally the surfaces were painted, usually with Buddhist icons, or enhanced with en-

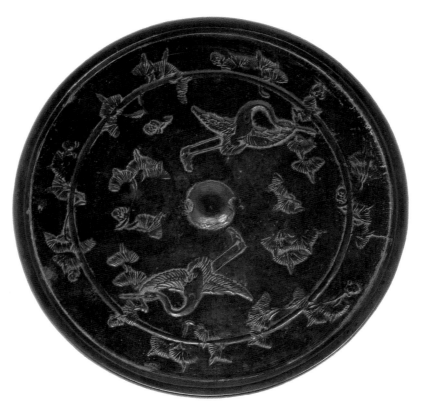

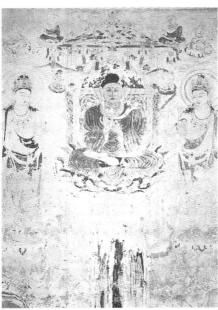

Fig. 63a. Amida triad, ca. 8th century; wall painting, Kondō, Hōryū-ji, Nara Prefecture

graved images such as the Amida of this particularly fine piece. Such kyōzō form an important category of ritual utensil closely allied to pre-Buddhist Shinto lore. The intermingling of these two belief systems is known as honji suijaku. This accommodation of foreign and native represents a vital and enduring characteristic of Japanese culture, right up to the present.

This mirror, and the following example, provide pertinent evidence of such adaptations in Heian Japan.[4] It is also a classic example of the religious efficacy of these mirrors: they were integral components of Buddhist and Shinto ritual, and were even worshiped. Unlike the Western view of painted or sculpted anthropomorphic images as the only visible icon of worship, in Japan other categories of visual form could stand for the existence of a holy being: mirrors, Sanskrit characters, tabernacles with "secret" images never seen by parishioners, even reliquaries [75–79]. Among Esoteric practitioners the round (meaning "complete"), polished ("clear" or "enlightened") mirror shape provided a simple but powerful vehicle upon which to contemplate in hopes of gaining access to Buddhahood.

The seated Amida depicted here was executed in a fine engraving technique known as *keribori* (kicking incisions) in which a metal stylus is guided across the mirror surface in a series of rhythmic staccato incisions that cumulatively impart an image at once evanescent and formidable. In this instance the artisan's control of the stylus was superb and the figural portrayal of the highest order known on this unforgiving surface. Other similarly dated kyōzō with single Amida Nyorai figures exist, but few examples match the condition and aesthetic quality of this piece. All such Amida imagery can best be considered with reference to the most venerable Amida figure in Japanese art, the triad at the Hōryū-ji in Nara (fig. 63a).

1. See for example Hōsaka Saburō, *Wakyō* (Japanese mirrors) (Kyoto: Jinbun Shoin, 1973).

2. For a useful and impressive collection of mirror imagery, see *Kinnen bijutsukan-zo kagami zuroku* (Anniversary catalogue of the museum's mirror collection) (Izumi: Izumi-shi Kubosō, 1986).

3. Noted in Sekine Shunichi, *Butsu, bosatsu to dōnai no shōgon* (The adornment of Buddhist images and temple interiors), vol. 281 of *Nihon no bijutsu* (Arts of Japan) (Tokyo: Shibundō, 1989).

4. *Kyōzō* (Votive mirrors), exh. cat., Tokyo National Museum (1975); see also Naniwada Tōru, *Kyōzō to Kakebotoke* (Votive mirrors and hanging plaques), vol. 284 of *Nihon no bijutsu* (Arts of Japan) (Tokyo: Shibundō, 1990).

64. Mirror with Image of Zaō Gongen

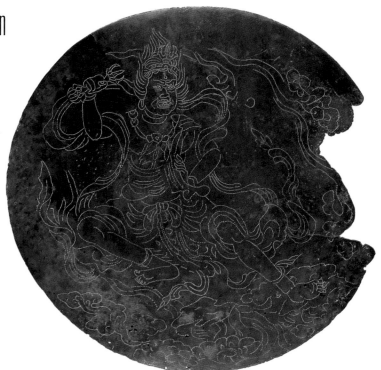

12TH CENTURY; CAST BRONZE WITH INCISED
DESIGN; DIAM. 21.5 CM

As several court scenes in illustrated hand-scrolls of the twelfth to fourteenth centuries show, mirrors served practical domestic functions in early Japan. Even in the eighth century great care was taken in casting mirrors with elaborate decorative designs, collecting similar mirrors from the continent for use by the imperial family and other nobility, and fabricating attractive stands for their display and lacquer cases for their storage. The Shōsō-in repository, preserving thousands of eighth-century documents and objects donated to the nation in 756 by Empress Kōmyō commemorating the death of the emperor, provides ample evidence.

The change in mirrors from Chinese shapes and designs to the more naturalistic scenes of birds, cranes, flowers, grasses, and insects such as those in the mirror with the image of Amida [63], reflects a determined evolution of Japanese taste and subject matter, an expansion of patronage, and greater complexity in the meaning and function of these metal discs. Mirrors were basic utensils used by aristocratic women to apply cosmetics. The mirror face was polished and then frequently tinned to increase its reflective capacity. Some

have a single hole or pair of holes drilled near their outer flange, indicating that cords were attached for suspension. Presumably these mirrors were offered to a Shinto shrine, where they were normally displayed outside the building as a way to petition the resident deity or to acknowledge a worshiper's previous request. This practice is consistent with the even earlier use and recognition of the mirror disc as the medium through which a Shinto deity manifested itself.[1]

Thus when delicately incised or painted Buddhist images were incorporated onto the disc face of a mirror, a correspondence was established between the local Shinto kami, its Buddhist counterpart, and the owner. Such mirrors might even have continued to be used as daily utensils, adding a distinctly otherworldly realm of meaning to the activity of maintaining beauty in a secular world. But what was the pattern of use and the fate of undecorated discs and undrilled mirrors and of mirrors such as the one illustrated here?

At least two related religious customs in Heian period Japan provide clues. The first involves a votive act of flinging mirrors into a sacred pond or stream. This practice developed in the Heian era when aristocrats came under the influence of a Buddhist sect known as Shugendō that advocated physical austeri-

ties associated with climbing rugged mountains. The cleansing power of mountain water and the still surfaces of the lakes in these sacred mountain areas led to an association with the clear polished surface and shape of mirrors. Thus began the practice of flinging mirrors into specifically recognized ponds or rivers as an act of spiritual transport whereby a person could offer himself in a pure light-reflective vehicle to the awesome power of the landscape's resident Shinto deity. Mt. Haguro in northern Japan and the Nachi waterfall region have yielded numbers of kyōzō and Esoteric ritual implements attesting to this late Heian custom.

Another sacred location for Shugendō practice incorporating Esoteric elements into its rituals were the mountains south of Nara in the Yoshino area, also home to numerous indigenous kami in the Shinto belief system. The figure engraved into the surface of this thin untinned disc face depicts Zaō Gongen, an indigenous wholly Japanese deity said to have appeared before Shugendō's founder, Enno Gyōja, as he meditated on Mt. Kimpu (Kimpusen) in the Yoshino district. Zaō Gongen's image is found on kyōzō such as this piece with some frequency, on kakebo-toke, and as freestanding statuary [28], including a rare wood image of the Kamakura

period in the collection of the Cleveland Museum of Art.[2] The vigorous body movement and gnarled facial mien reflect no doubt the influence of Esoteric Buddhist sculpture of the tenth and eleventh centuries, here melded in a syncretic manner typical of the Shinto arts at that time.

Numerous Zaō Gongen images and kyōzō have been unearthed on Kimpusen and at other sacred mountains, where they were buried in the late Heian era together with religious sutras, reliquaries, Esoteric ritual implements, and ceramics. Some were enclosed in specially prepared metal or ceramic containers [6–9]. Whereas a Buddhist deity (itself an emblem of a corresponding Shinto presence) is engraved on most kyōzō, here a non-Buddhist native deity appears. At the time Zaō Gongen had—and continues to have—special religious power for the Japanese.

The most important Zaō Gongen votive mirror is the large fragment of the deity with thirty-two accompanying figures, dated 1001, belonging to the Sōjō-ji in Tokyo (fig. 64a). This Nara National Museum mirror is also fragmentary as a result of a casting flaw or because insufficient bronze was added to the mold for the disk. However, the engraver not only decided to use the deformed mirror, but composed the cloud and fluttering robe designs to take advantage of the disc's irregular perimeter. This approach to the mirror form also appears in a plaque with an image of Zaō in the Cleveland collection (fig. 64b). Unlike the evenly spaced tooling marks seen in the Amida mirror [63], the staccato lines composing the figure of Zaō and the abbreviated landscape on which he stands oftentimes come so close together as to form a continuous line (for example in the raised arm), which appears to have been done deliberately to add definition, linear variety, and a simulacrum of visual depth to the composition. The metal craftsman also incorporated reference to what appears to be a lotus base with encircling petals in the landscape at the bottom center, an unusual motif for Zaō Gongen kyōzō.

This configuration may well derive from the iconography of Kongōsattva, a guardian holding a sankōshō in Esoteric Buddhism. Since Zaō was the principal deity of Kimpusen, regarded by Shugendō as a future Buddhist paradise, and related to the Diamond World

mandala [41] of the Esoteric pantheon, such visual iconographic borrowing is understandable. Thus Zaō was perceived as having great power as a native manifestation of Esoteric Buddhism's supreme deity, Dainichi, and the Future Buddha, Miroku [25]. In this way the act of commissioning a mirror engraved with Zaō Gongen's image and then burying it ritually at Mt. Kimpu or another sacred mountain site held special meaning in twelfth-century Japan directly related to the desire to be reborn in a future paradise.

1. See Naniwada Tōru, *Kyōzō to kakebotoke* (Votive mirrors and plaques), vol. 284 of *Nihon no bijutsu* (Arts of Japan) (Tokyo: Shibundō, 1990).

2. See *Sangaku shinkō no ihō* (Art treasures of the mountain religion), exh. cat., Nara National Museum (1985), 2:50–92.

Fig. 64a. Zaō Gongen with attendants; dated 1001; cast bronze plaque with incised designs; w. 76.3 cm; Sōjō-ji, Tokyo. National Treasure

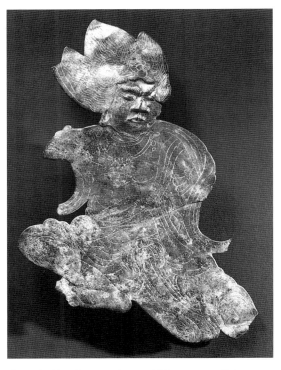

Fig. 64b. Zaō Gongen plaque, 12th century; gilt bronze with repoussé and incised designs; h. 25.8, w. 17.8 cm. The Cleveland Museum of Art, Severance and Greta Millikin Purchase Fund 1986.47

65. Kakebotoke with Images of Ten Shinto Deities

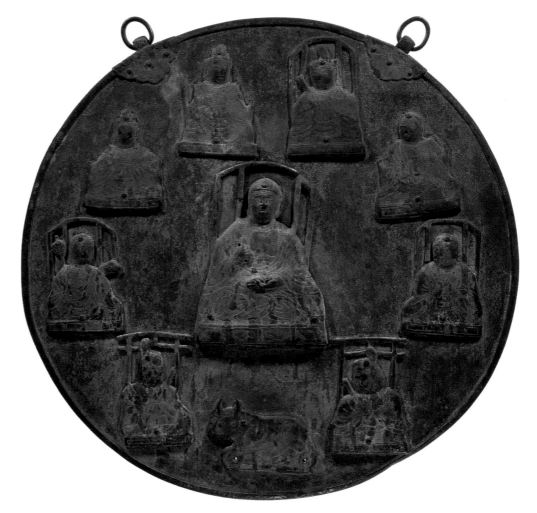

DATED 1218, MADE BY TAIRA-NO-KAGETOSHI; GILT BRONZE WITH INCISED AND APPLIED DESIGNS; DIAM. 30.4 CM. IMPORTANT CULTURAL PROPERTY

Kyōzō were popular in the Heian period. They combined elements of the secular (a cosmetic utensil), Buddhist [63], and Shinto [64] worlds and presented the faithful with an attractive, tangible medium for giving form to their fundamental religious beliefs. The fate of the majority of these kyōzō was to be given back to the earth, as initially proposed by Fujiwara Michinaga in his *Midōkanboku-ki* journal.[1] Because of clerics' prediction that the world would end in the eleventh century (mappō), many believers had sutras copied and then buried on Mt. Kimpu and other recognized sites, a practice that might assure their entrance into the future paradise of Amida.

The names of the metalworkers who fashioned these kyōzō are not known, nor have excavations revealed the locations of their workshops and the foundries that likely were their studios. Nara's great monastic centers, however, were responsible for image making and providing ritual objects, furniture, and interior furnishings. The quantity and the quality of the religious objects these studios produced for the country's expanding Buddhist population stimulated interest in maintaining this trade in the twelfth and thirteenth centuries and beyond, especially as the world's demise had yet not occurred as predicted. Nara was undergoing extensive rebuilding following the civil wars that had leveled most of the buildings at the city's major Buddhist temples such as Tōdai-ji, Kōfuku-ji, and Gangō-ji. Metal was necessary to reinforce new columns and beams and for the decorative architectural fittings, larger and more elaborate sets of Buddhist utensils, the jewelry and openwork decoration adorning Buddhist statuary, and secular items. The development and production of this metalwork meant a continuing commitment on the part of the skilled artisans working in Nara.

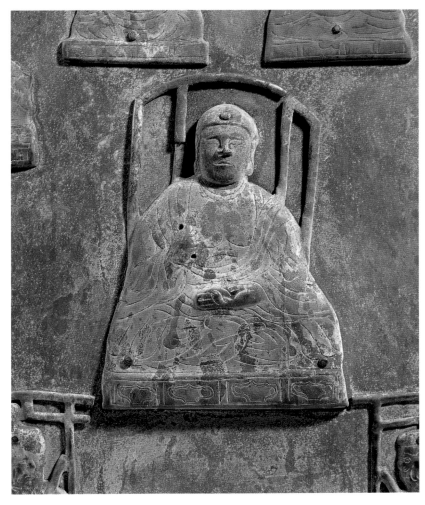

In the case of mirrors, new shapes, styles, and imagery appeared during the tenth through the twelfth centuries. Kyōzō gradually disappeared but only after they inspired the creation of a new class of suspended votive image: kakebotoke, three superb examples of which are in the Nara National Museum collection [65–67]. These three-dimensional hanging discs represent later stages in the evolution of religious images being applied to a cast metal surface or, as seen in the Zaō Gongen example [64], a cast metal plate. In fact, the fine line engraving of kyōzō images varies greatly in quality—much more so than the casting of the mirror bodies themselves. The evolution in engraving techniques from extremely fine lines to staccato keribori and then delicate *harigaki* (needle-point drawing) perhaps illustrates in part why the next logical step in image production would be applying sheet bronze cut to compose a picture or form a quasi–three-dimensional image.

To produce the desired form, identifying details of the image were incised with a metal stylus into the surface of the cutout form (it could also be gently hammered from behind to provide a primitive low relief). In the production of multiples of an especially popular single deity, a wood or metal matrix served as the positive mold over which the bronze sheet was placed for gentle hammering, then the incised detailing was done, and finally small pinholes were punched so the low-relief image could be attached to the back plate.[2] An identical process had been employed since the seventh century to produce oshidashibutsu images for pre- and early Nara temples as well as private patrons. Single and entire series of ban [71] and keman [68–70] had begun being used to adorn the interior spaces of Buddhist worship halls even earlier. These ban, made of metal and textile, were in use as early as the seventh to eighth century. In this way a unique Japanese form developed in the Heian period. Suspended from temple rafters and beams, kakebotoke came to decorate worship halls.

This example is one of the finest and historically important kakebotoke known. The base plate is large, relative to most earlier kyōzō, and its perimeter is encircled by a single narrow bronze decorative band that was tooled to conceal the irregular edge of the disc. Along the upper perimeter two bands cut in the shape of butterflies splay over each side of the band into the plate surface and are attached to one another by three pins. A notch at the midpoint of each butterfly band allows an independent clasp element to emerge that, in turn, serves as the receptacle for the suspension ring. These four separate pieces of cut bronze, fitted one into the other, provide the simple hanging structure for the kakebotoke and the field into which the figurative elements are arranged.

The mandala-like composition comprises nine seated figures and one reclining bull, elucidating the ten deities of the Hie Sannō Shrine, a large important Shinto complex in the western environs of Lake Biwa, just east over the mountains from Kyoto [57]. Among the figures, each of which is seated, are two women and three men in court attire, three monks, and the central deity in Buddhist monk's garb. At the bottom is an ox, also symbolic of a deity. Each is attached with multiple rivets to the base plate, on the back of which appear the identities of each kami where the attaching rivet is set. The ten figures are thought to be a compilation of seven deities from the upper seven shrines and three Shinto deities selected from the central group of seven shrines in the Hie Sannō complex, which embraces twenty-one shrines altogether. Also engraved into the rear surface by stylus is the date of manufacture (1218), the name of the artisan (Taira-no-Kagetoshi), whose identity is otherwise unknown, and the source of the donation in (modern) Kumamoto Prefecture in southernmost Kyūshū.[3]

The largest figure is identified as Omiya, the principal Shinto deity of the Hie Sannō complex whose correspondent Buddhist deity in the honji suijaku system is Sogyō Hachiman, a monk-warrior figure in Shinto art [56]. Omiya is rendered in shallow relief by the repoussé molding process, and his face, robes, and seat platform have been finely engraved into the surface. The chair backing is actually a reference to the panels or folding screens with painted designs used in Heian period court portraiture and seen occasionally in later Shinto imagery. The degree of relief visible in this Omiya figure surpasses that of the other smaller figures largely because its size allows the sheet bronze to be more malleable.

Yet despite the mechanical nature of their production, the encircling group possesses a variety of attributes, garb, poses, and line engraved detailing. While these are typological portrayals, the directness and sincerity of Shinto faith is made particularly clear. The artisan's metalworking skills too are not immediately apparent, yet the cutting of the figural sheets with contiguous screen backings, and the subtly nuanced three-quarter poses of most of the encircling kami required careful planning and then execution. Seen as an ensemble, they present a compelling vo-

tive mandala of the Sannō Shrine in three-dimensional form.

Painted representations of the mandala, while not numerous, exist in some number [57]. In fact, only paintings of Kasuga Jinja mandalas occur in greater numbers today in Japanese suijaku representations. Virtually all such paintings can be reliably dated to the later Kamakura period or after, with a very small number attributed to the second half of the thirteenth century at the earliest. Thus this Sannō kakebotoke, firmly dated early in the thirteenth century, constitutes an important historical document in the genre of kakebotoke, mandala representations, and honji suijaku art regarding the Hie Sannō cult in medieval Japan. While subsequent kakebotoke achieve more elaborate sculptural statements, with full-bodied deities and their accouterments emerging from the background disc frame, few provide the intriguing subject matter and visual narrative of this rare piece. It should be regarded as one of the most important honji suijaku kakebotoke currently known.

1. A useful source is Seki Hideo, *Kyōzuka to sono ibutsu* (Sutra mounds and their remains), vol. 292 of *Nihon no bijutsu* (Arts of Japan) (Tokyo: Shibundō, 1990).

2. See Naniwada Tōru, *Kyōzō to Kakebotoke* (Votive mirrors and hanging plaques), vol. 284 of *Nihon no bijutsu* (Arts of Japan) (Tokyo: Shibundō, 1990), fig. 8.

3. See Naniwada Torū, "Kakebotoke to sono meibun o megutte" (A reconsideration of votive images with inscriptions), *Museum*, no. 393 (December 1983), 17–18.

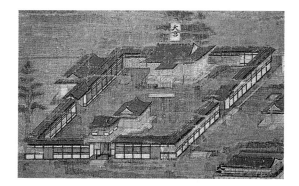

Detail of the Omiya Jinja from the Sannō mandala [57]

66. Kakebotoke with Image of Jūichimen Kannon

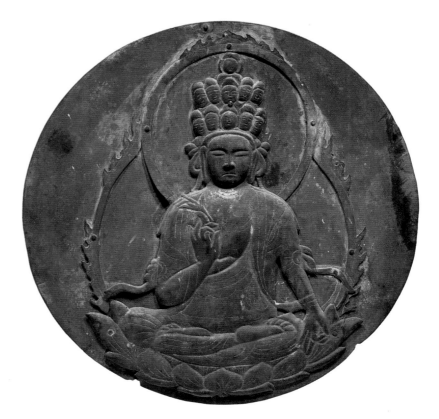

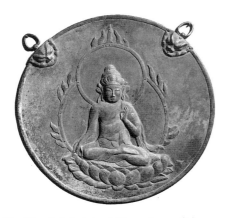

Fig. 66a. Kakebotoke, 12th century; gilt bronze with molded and incised designs; diam. 52.5 cm. The Cleveland Museum of Art, Leonard C. Hanna Jr. Fund 1985.16

12TH CENTURY; GILT BRONZE WITH INCISED AND APPLIED DESIGNS; DIAM. 23.6 CM

This kakebotoke with the large seated figure of an Eleven-headed Kannon is the oldest such kakebotoke in the Nara National Museum collection. The gentle hammering of bronze sheets created the raised and modeled surfaces of head, torso, arms, feet, and lotus base. This surface was given further definition by studio metalworkers through keribori and line engraving. These techniques have been orchestrated carefully to enhance the three-dimensionality of the low relief while adding surface interest to specific local areas.

The eleven-headed figure, one manifestation of Avalokiteśvara, as is Shōkannon [67], is shown seated, legs crossed in a meditating posture. The proper left hand is lowered, palm outward, the first finger touching the thumb in the *an-i-in* mudra. The right hand is raised, thumb and second finger touching, also in an-i-in mudra as the hand holds a flower, the blossom of which is now lost. Elaborate arm bands, hair curls, and robing are executed in openwork designs that add vivacity and visual depth to the figure. Atop its head two rows of five small heads and a single, partially blurred head complete the iconography of this deity, rendered rather plainly relative to the rest of the figure. Three pins secure the Kannon to the bronze back plate. The two-stage kohai with flame pattern edge design is fashioned from separate pieces of cut bronze and then pinned also.

Unlike the other two kakebotoke in this exhibition [65, 67], no rim band encircles the perimeter, nor are clamp attachments (or the holes for same) visible, suggesting that originally the plaque was set into a large disc probably of wood, or that instead of being suspended, it was set on a stand for viewing. This method of presentation, it will be recalled, was normal for mirrors—the predecessor of the kakebotoke form—beginning at least in the eighth century.

Stylistically, this kakebotoke is of the distinguished metalworking tradition associated with the Chūson-ji in northern Iwate Prefecture. There, in the mid-twelfth century a branch of the Fujiwara family commissioned artisans to apply splendid gilt metal, mother-of-pearl, and textile decoration to the principal devotional hall, much of which has been preserved. A kakebotoke of the same date and possibly workshop is in the Cleveland Museum of Art collection (fig. 66a).

67. Kakebotoke with Image of Shōkannon

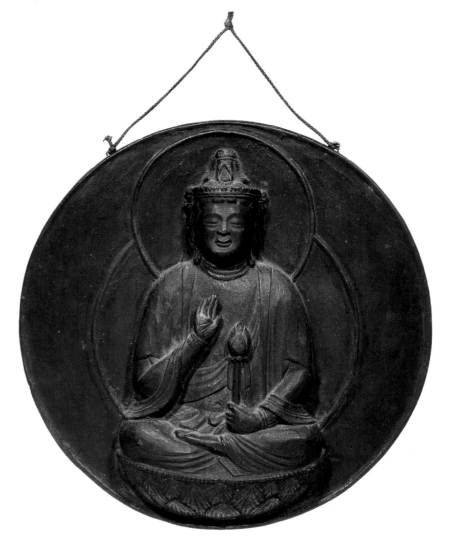

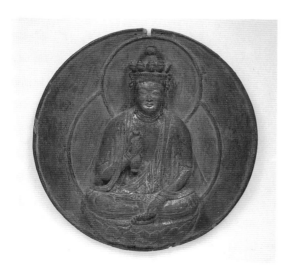

Fig. 67a. Kakebotoke, dated 1228; carved wood with traces of gilding; diam. 36.3 cm; Shōrin-ji, Yamagata Prefecture. Important Cultural Property

EARLY 13TH CENTURY, BY KYŌEN (DATES UNKNOWN); LACQUERED WOOD WITH TRACES OF GILDING; DIAM. 32.5 CM

This votive plaque is one of a small number of thirteenth-century wooden icons sculpted nearly in the round. The wood is *katsura* (a variety of evergreen) favored in the northern provinces by local sculptors and artisans since the Heian period. Elsewhere in Japan *sugi* (cedar) and hinoki were the preferred wood types. The figure is that of Shōkannon, an aspect of Kannon identified by the cluster of hair piled high on the top of the head that frames a small seated Amida figure. These identifying features appear on small gilt-bronze and wood Kannon images of the seventh century and then later in a few wooden images of the eleventh to thirteenth centuries.[1] Shōkannon here also prominently holds the long stalk of the lotus bud in its left hand, while the right hand is raised, palm outward in a gesture of greeting. Similar hand gestures appear in such historically disparate images

as the late seventh-century Yumetagai Kannon at the Hōryū-ji and the Daihōon-ji Shōkannon of 1224.

The latter is noteworthy since in date it relates closely to another well-known wood kakebotoke dated 1228 (fig. 67a). This Jūichimen Kannon image at the Shōrin-ji in northern Yamagata Prefecture also provides important information about the Nara National Museum Shōkannon because it has an informative inscription on the back stating its provenance and date of completion.[2] According to the inscription, the kakebotoke was donated to the Shōrin-ji by the priest Keigen in the fall of 1228 and it was made by Kyōen, a sculptor of Buddhist images.

Since the inscription in ink on the back of the Nara National Museum kakebotoke also credits these same two men with its creation and donation, and does so in a similar creditable style of writing, it is reasonable to view the two as having originally formed a pair or been part of a larger set of these images. Delving further into these texts reveals that

both pieces are called principal images (*gotai*) of a Jion-ji that was located within the recognized Shinto area of Mt. Hakusan. Rising out of a spectacular but rather desolate volcanic landscape in central Japan, Mt. Hakusan is normally covered with snow year round, one reason why it is deemed one of the most sacred mountains in the country and was long considered a center for Shinto and Shugendō worship, like Mt. Kimpu to the south of Nara.

Just how these two kakebotoke came to be identified with and linked to the Hakusan belief system is unclear, but they provide valuable data for comprehending the extent of that worship and its relationships with other sacred Shinto sites. Yamagata is also an area famous for its sacred mountains embracing the rigorous ritual austerities of Shugendō in particular.[3]

Whereas dated sets of bronze kakebotoke are known, this wood pair appears to be unique in Japanese Buddhist art. Comparison of datable gilt-bronze examples from the well-known Chūson-ji complex north of Sendai city in Iwate Prefecture reveals both similarities and differences. Most apparent among the former is the northern regional approach to format simplicity. Whether in late Heian or Kamakura eras, there is a preference in making kakebotoke using a disc with an unembellished surface and no elaborate hanging clamps. A raised band of wood or simple metal band frames the perimeter. A two-part halo, sometimes with double concentric bands, encircles the seated figure, almost reaching the upper limits of the kakebotoke plate. One distinct characteristic of kakebotoke from the Yamagata and Iwate area not seen in the Kansai area (Kyoto, Nara, and Osaka) or Japan Sea coastal areas near Ishikawa Prefecture is the relatively large scale of the central deity.

In this Nara National Museum example, the Shōkannon possesses a stout upright torso and fleshy neck bands and head. The lower body and lap appear to be stubby if one compares the length of the arms with the legs. The hands are small and the features sharply cut into the face's fleshy surface. Otherwise the detailing of the hair, headdress, and robes demonstrates a direct unmannered approach to surface modeling that is forceful and appealing. The Shōkannon is particularly

impressive both in scale and in the degree to which detailing has been restrained so as to allow a coherent sculptural form to rise from the back plate. The disc surface, it is worth pointing out, has not been finished smoothly to impart the sense of a metal surface. The artisan purposely left chisel marks over the entire composition to allow the natural wood "skin" to enliven the disc and form a visual contrast with the more finished surfaces of the Shōkannon.

While a faded inscription on the back acknowledges the names of the priest who commissioned this image and the artisan responsible for its manufacture, they have yet to be identified or placed within the context of their religious and social systems. Once again we are entrusted with an impressive work of religious art specifically sponsored and executed to adorn a worship hall, one sited on sacred Shinto ground and crafted by an artisan trained in producing Buddhist icons. This example and its mate in Yamagata at the Shōrin-ji are the finest and most historically significant wood kakebotoke known today and represent a sophisticated regional continuation of the metropolitan aesthetics of the eleventh and twelfth centuries in this important Buddhist format.

1. See for example *Kannon Bosatsu* (Imagery of Kannon Bosatsu), exh. cat., Nara National Museum (1977), pls. 4–13, 34, 54.

2. See Naniwada Toru, *Kyōzō to kakebotoke* (Votive mirrors and hanging plaques), vol. 284 of *Nihon no bijutsu* (Arts of Japan) (Tokyo: Shibundō, 1990), fig. 10; see also *Sangaku shinkō no ihō* (Art treasures of the mountain religion), exh. cat., Nara National Museum (1985), which places these objects in their proper Shinto-Shugendō setting, especially pl. 57.

3. See H. Byron Earhart, *A Religious Study of the Mount Haguro Sect of Shugendō* (Tokyo: Sophia University, 1970).

Fig. 67b. Interior view of in the Kondō, a Yakushi Nyorai kakebotoke (13th century) in situ, Reizan-ji, Nara

(TWO ELEMENTS), 11TH CENTURY; LAC-
QUERED COWHIDE WITH INK AND COLOR;
GILT-BRONZE FITTINGS WITH INCISED
DESIGNS; 47 X 54.2 AND 41 X 56.3 CM.
NATIONAL TREASURE

While dark and solemn overall, the interiors of Nara's and Kyoto's great worship halls enjoyed considerable colorful decor. After all, devotion to Buddha could be construed as a joyful exercise, with hopes of redemption and, possibly, an afterlife in a paradise. Flickering shadows and radiant light accompanied by heavenly music were part of this Buddhist architectural environment, particularly from the later Heian period onward.

Given the structure and layout of Japanese Buddhist temples, the ornamentation of devotional halls was divided primarily between the paraphernalia attached to the structure itself or its furnishings and that on painted walls, ceilings, and columns. Elaborately carved and adorned canopies were suspended from coffered ceilings above the principal statuary; metal and textile banners were hung along the columns flanking the central bay of the worship hall on either side of the principal image; and hanging openwork ornaments with bells and strips of colorful cloth were positioned along the horizontal tie beams between columns. Because the halls were open to the elements, drafts of air made the keman sway about, bells tinkling and surfaces and tails brightening the interior space. Keman, along with the other decorative appurtenances such as banners [71], were viewed as ornaments meant, ultimately, to extol the glory of the Buddha's teachings.

Keman are two-dimensional versions of sprays of flowers tied together with a braided cord and given to the Buddha as an offering. Being perishable, flowers were in due course replaced by votive hangings fabricated from textiles, cowhide, metal, and then wood. The keman illustrated here are from the best known and most important set surviving in Japan, designated a National Treasure. The set comes from the Tō-ji in Kyoto and comprises thirteen major pieces, all formed from cowhide. While it appears that keman, like ban [71], were always made as sets for a particular temple or shrine, some of the earliest keman or keman-related objects have unfortunately survived only as solitary pieces.

Three eighth-century examples clearly establish the form's origins, decorative formula, materials, and subject matter. The first example is looped and tied textile bands made of colorful resist-dyed swatches with seven borders from the Shōsō-in.[1] The second is a large openwork plaque in the shape of a Japanese fan (uchiwa) depicting paired phoenixes among hōsōge flowers, also from the Shōsō-in (fig. 68a). Comparing them with the two Nara National Museum keman shown here reveals similarities in structure and composition as well as an emphasis on openwork patterns and their interrelated spaces. Holes at the bottom edge indicate where additional elements—bells and banner "tails"—were once attached. The central axis features a design with two floral medallions that frequently appears in eighth-century textiles and metalwork and that by the Heian period had become integral components of hōsōge floral designs such as those in the nyoi (priest's ceremonial scepter) [80]. In the Shōsō-in example, the medallions serve as receptacles for glass beads, transforming them into jewel containers as well. The Shōsō-in metal plaque was suspended, clearly intended to hang in the worship hall because it was decorated on both sides. The openwork design, while primarily serving a decorative function, also eased the stress of forceful winds and weather on the keman, prolonging its service.

The third keman form was in use at the Tōshōdai-ji, the eighth-century temple in the western precincts of Nara not far from the Hōryū-ji. Formed from a skein of dried cowhide a meter long, this type of keman also has rich floral gatherings in an openwork design.[2] As in the two keman illustrated here, the hide surface was coated with lacquer, given a preparatory white ground, and then painted in vivid pigments. The openwork designs were not cut but punched so that the contour edges show scalloped rather than smooth continuous contours. The designs of blossoms, lotus flowers, and long-tailed Chinese birds facing the openwork pattern of looped cords extend from the top to the bottom of the fan shape. Although much deteriorated now, these keman were once brilliant and sturdy adornments to the halls of the Tōshōdai-ji, where ban also once fluttered. No doubt the temple's founder, Ganjin, a Chinese priest invited in the eighth century

Fig. 68a. Keman, 8th century; gilt bronze; 33 x 29.3 cm; Shōsō-in, Nara

Detail showing a karyōbinga among the mourners witnessing the death of the Historic Buddha [37]

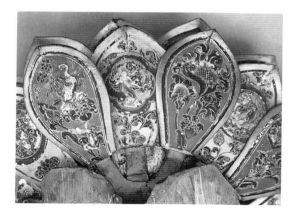

Fig. 68b. Detail of a censor stand in the Shōsō-in with elaborately painted lotus leaf surfaces, including the portrayal of a karyōbinga

by the Emperor Shōmu to come to Nara to help lead the Eye-opener ceremonies for the Daibutsu at the Tōdai-ji, was instrumental in formulating the temple's interior appearance, including these rare late Nara to early Heian period examples.

The Nara National Museum keman set surely still exists because of the durability of the cowhide. Prepared in the same way as the larger Tōshōdai-ji examples, they come from the Tō-ji in Kyoto, founded in the ninth century when the capital moved from Nara. Compared with the Tōshōdai-ji pieces, they are smaller, oriented toward a horizontal (rather than vertical) fan shape, and made from dried cowhide with metal borders to create a more rigid form. The set includes superb examples of the opposing karyōbinga, each standing on a lotus base and offering up a golden bowl filled with painted jewels. Identical imagery appears on a lotus petal attached to the base of an eighth-century censor stand in the Shōsō-in (fig. 68b), in the Nehan [37], and in the metalwork designs at the Chūson-ji in northern Iwate Prefecture, traditionally dated to the twelfth century.[3] Interestingly, the Nara National Museum set varies from one panel to another and was apparently made by different craftsmen. The examples exhibited here are the finest of the lot regarding condition, quality of painting, and technique. The figural style of the karyōbinga in particular is special in that it belongs neither to the Heian period's repertoire of highly finished colorful icon paintings nor to the ink sketch tradition. Rather it belongs to the lineage of such late Heian paintings as those attributed to Takuma Tametō (act. 1131–1174) in the sheets of iconographical sketches of Esoteric deities attributed to him, or to the earlier tenth- and eleventh-century traditions of wall paintings on prepared wood surfaces.[4] The drawing of the karyōbinga here is facile, imparting extraordinary strength to such details as the clawed feet.

Gold and silver have been used throughout the surfaces of the keman as well, adding to their attractive palette. Although the silver has oxidized and darkened with age, it lends added richness to the tone of the black-lacquered surfaces. The gilt clasps at the top (where they survive) are original and bear engraved and raised floral designs over the surfaces. Three pins join the two sides,

which originally also clamped the ends of a crimped metal band encircling the perimeter. Holes in the bottom border indicate where bells and clapper-shaped pendants were once attached, usually five or seven and alternating from one shape to another. Finally, the lines drawn on the central strings and bow indicate the original use of braided cords as the traditional binder for these bouquets of flowers and Buddhist deities, hung simply in a temple bay to help adorn the worship hall's interior.[5]

1. See the textile keman fragment preserved in the Shōsō-in used at the funeral ceremony for Emperor Shōmu in 756 (*Shōsō-inten* [Exhibition of objects from the Shōsō-in], exh. cat., Nara National Museum [1997], no. 28).

2. Ōoda Hirotarō, *Tōshōdai-ji,* vol. 12 of *Rokudai-ji taikan* (A survey of the six great temples of Nara) (Tokyo: Iwanami Shōten, 1972), pls. 118–19, 136–37.

3. Sekine Shunichi, *Butsu, bosatsu to dōnai no shōgon* (The adornment of Buddhist images and temple interiors), vol. 281 of *Nihon no bijutsu* (Arts of Japan) (Tokyo: Shibundō, 1989), pls. 9 and 15 (Chūson-ji), 107 (Shōsō-in), 108 (Tōshōdai-ji).

4. *Heian butsuga* (Heian period Buddhist painting), exh. cat., Nara National Museum (1986), pls. 7–9, 13–16, 20.

5. For one view of such an interior, see Sekine, *Butsu, bosatsu to dōnai no shōgon,* pl. 16.

69. Keman

14TH CENTURY; CAST BRONZE, GILDED, WITH INCISED AND PUNCHED DESIGNS; 43.3 X 42.2 CM. IMPORTANT CULTURAL PROPERTY

A number of technical and compositional features distinguish this keman from the two other examples in the exhibition [68, 70] and also from all other known gilt-bronze pieces.[1] Perhaps most revealing is that the entire structure is composed of individually cast elements that have been joined together. Instead of a plain hammered gilt-bronze band, the outer rim consists of forty-two five-petal lotus forms nested one into the other and then secured by pins at the top and bottom lotus petal junctions. Thus the size and aperture of each three-dimensional component was deliberately gauged to form the shape of the keman itself.

These elements are also the anchoring points for the central flaming halo panel with its lotus pedestal base and bold Sanskrit ban character. Through a series of clampings and pinnings, the halo rests as if it were floating

within the roundel, just touching the tips of six lotus petals. The attachments for the flame borders and cast Sanskrit components are crafted so as to be invisible. The mechanics of these articulations rival those of the Kairyūō-ji reliquary of slightly earlier date [78].

The third component is the formal double-looped braid with attached tassels, an elegant and dramatic departure from other keman designs. Here these braided ropes no longer serve as the symbolic binders of flowers placed as the central decorative feature linking the two sides. Instead, they act as independent framing devices, plain and solid in between the flaming halo edge and spiked lotus leaf points. Their spacing and the arcs they describe between the garland of clustered petals and the flat halo is critical to the overall design. This feature and the cascading lotus forms distinguish it from the related thirteenth-century wood keman at Ryōsen-ji in Nara, for example (see fig. 70a).[2]

This keman also retains two of its original five suspended elements: a damaged bell

with lotus petal surface design and pendant clapper. The original sequence was bell, clapper, bell, clapper, bell, as can be seen in illustrations from such handscrolls as *Hōnen Shōnin eden (Illustrated biography of Priest Hōnen),* Itsukushima Jinja's *Lotus Sutra* (fig. 69a), *Ishiyama-dera Engi (Illustrated history of the Ishiyama-dera),* and the wood keman [70] in the exhibition.

This keman comes from a larger set that once adorned the Hyōzu Taisha, a Shinto shrine located along the eastern side of Lake Biwa. The Nara National Museum currently holds in its collection the six pieces remaining from this set, which was originally between ten and twelve pieces. Hyōzu Taisha also owned one of the most lavish and important sets of ban [71], seventeen of which survive today (of an original thirty-two), of which the Nara National Museum now owns seven pieces.[3] From this set, which incorporates Sanskrit characters into each composition, it is clear that ensembles of ban as well as keman with emblematic Sanskrit panels were a recognized unit of Esoteric decorative symbolism within Buddhist devotional halls and in Shinto compounds. Moreover, the ban set is thought to have been commissioned for the shrine by Fujiwara Shigenaga between 1321 and 1325. The metalwork evident on the lotus-form hangers of these ban can be favorably compared to these Nara National Museum keman.

While medieval emakimono indicate the sequencing and placement of such decorative objects, the configuration and placement of this keman set remain uncertain. Because the Sanskrit symbol *ban* on this piece corresponds to Dainichi Nyorai in its Kongōkai realm [41], the set probably constituted major adornments to a shrine whose resident kami must have corresponded to Dainichi.

But the actual creation of the individual elements leaves little doubt about the importance of commissioning them or the skills of the metalworking studio responsible for their production. Each piece is cast, hammered, and tool-engraved before gilding. The technique and workmanship rival, if not surpass, that of the well-known keman dated 1243 with Sanskrit design from the Chōmei-ji, also in Shiga Prefecture.[4] The weight of the ensemble was engineered such that structural supports are not apparent but rather combine

to enhance the animation of the lotus petal garland and its contrasting central panel. The result—incised surfaces with the flat *shuji* (Sanskrit character) and contrasting (nickel-plated?) halo—adds a whole new vocabulary to the traditional keman repertoire, and a practical one in that it can be seen and understood easily from a distance.

1. *Kinkō* (Metalwork), ed. Suzuki Tomoya, vol. 24 of *Jūyō bunkazai* (Catalogue of National Treasures and Important Cultural Properties) (Tokyo: Mainichi Shinbunsha, 1976), 86–88.

2. See *Bukkyō kōgei no bi* (The beauty of Buddhist decorative arts), exh. cat., Nara National Museum (1982), pls. 173–83.

3. *Kōgeihin 2* (Decorative arts 2), vol. 5 of *Shinshitei jūyō bunkazai* (Catalogue of newly registered National Treasures and Important Cultural Properties) (Tokyo: Mainichi Shinbunsha, 1983), 200ff.

4. See *Mikkyō kōgei* (Decorative arts of Japanese Esoteric Buddhism), exh. cat., Nara National Museum (1992), pl. 184.

Fig. 69a. Frontispiece illustration from a handscroll of the *Lotus Sutra,* dated 1164; one of a set of thirty-three scrolls: ink, silver and gold pigment, and cut gold and silver foil on paper; 26.3 x 22 cm; Itsukushima Shrine, Hiroshima Prefecture. National Treasure

70. Keman

14TH CENTURY; CARVED WOOD WITH LAC-
QUER, POLYCHROMY, AND METAL FITTINGS;
29.3 X 34.3 CM

The evolution of the keman shape and deco-
rative design in Japanese Buddhist art can
be discerned from the three examples in this
exhibition. This wood keman falls at about
the midpoint in this historical evolution
and represents one of the finest examples of
its type. Each of the openwork designs—chry-
santhemums (fall) and peonies (summer)—
were cut from two pieces of hinoki wood and
joined back to back. Rich mineral pigments
were then applied over a preparatory layer
of black lacquer and then gofun visible where
surface flaking has occurred. The design and
dimensions correspond precisely to another
group of keman in western Japan.

Through an inscription on the storage box
for two keman from this set in the Kōbō-ji in
Okayama Prefecture, it is known that there
were initially twelve, that they were displayed
in the Kondō of the temple (no longer in ex-
istence), and that they were made about 1389
at the abbot's request. The Kōbō-ji pieces
are registered as Important Cultural Properties
by the government. Two other keman from
this same set belong to the collection of the
Okayama Prefectural Museum.

The sturdy metalwork attached to the lac-
quered and painted wood plates certainly
enhanced their durability. Furthermore, the
original two pendant elements and five bells
remain: a rare occurrence that provides pri-
mary evidence for understanding the configu-
rations of other, even earlier keman [68–69]
and for interpreting more clearly those
depicted in illustrated handscrolls of the
Kamakura era.

In addition to noting the evolution in the
materials and decor of keman surfaces, it is
worth mentioning the change in shape that
occurred during the twelfth to fourteenth
centuries. The expansive, even monumental
form of the eighth-century examples cited
previously gradually becomes more rounded
and compact by the twelfth century. This

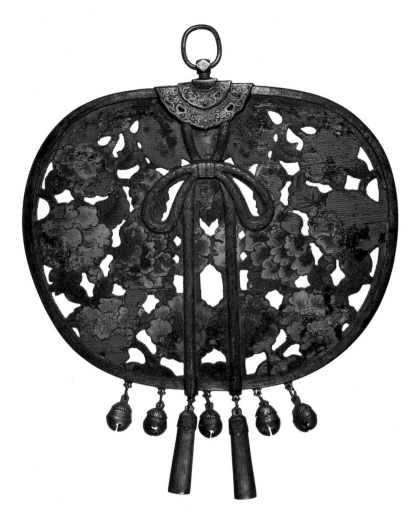

Fig. 70a. Keman, 13th century; wood with polychromy and metal fittings; w. 40 cm; Ryōsen-ji, Nara Prefecture. Important Cultural Property

evolution is shown clearly in the frontispiece to one of the exquisite handscrolls of the *Lotus Sutra* set at Itsukushima Shrine.[1] Donated in 1164 to the shrine by Taira no Kiyomori (1118–1181), the keman appears as a taut fan form with five bells and two spangles, with an attached bell on each. This wood example of the late fourteenth century departs from that norm, but the fourteenth-century keman in the exhibition [69] is close in its rounded, formal appearance.

A picture in a biographical account of the life of Priest Hōnen datable to the later thirteenth century, however, provides an example close in shape to the carved wood keman illustrated here.[2] It may well be that the broad horizontal form characteristic of early keman became a sharply circumscribed, vertically oriented form by the twelfth to thirteenth centuries, only to revert back to the earlier splayed shape in the fourteenth and fifteenth centuries (fig. 70a).

1. Sekine Shunichi, *Butsu, bosatsu to dōnai no shōgon* (The adornment of Buddhist images and temple interiors), vol. 281 of *Nihon no bijutsu* (Arts of Japan) (Tokyo: Shibundō, 1989), fig. 123.

2. Tōru Shimbo, *Hōnen Shonin eden* (Illustrated biography of priest Hōnen Shonin), vol. 95 of *Nihon no bijutsu* (Arts of Japan) (Tokyo: Shibundō, 1974), pl. 41.

71. Ban

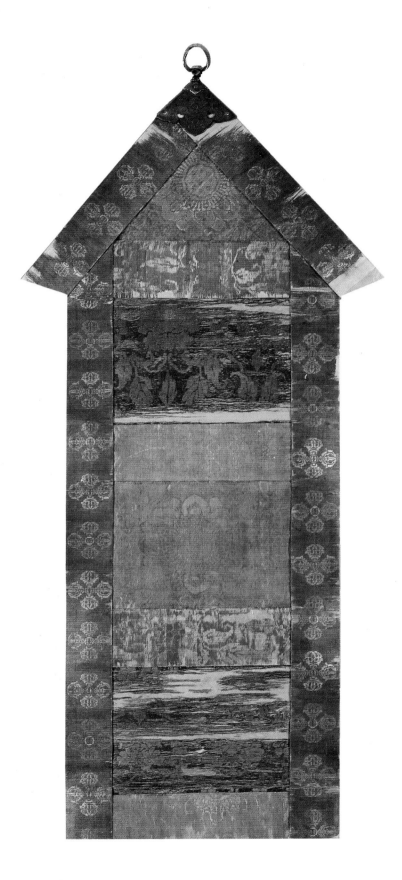

14TH CENTURY; JOINED BROCADE TEXTILE
SECTIONS WITH METAL FITTINGS; 89 X
31.4 CM

Textiles not only clothed the monks and disciples of the Historic Buddha, Shaka [17], they were also used to adorn the places where he stopped to deliver lectures. They were a simple but direct way to give added meaning to the event and its natural setting. Of course, while this theory can only be inferred from much later visual portrayals of Buddha or his followers in narrative and iconic imagery, an increasingly large body of reference material has emerged in recent years to advance its plausibility. This information appears on Chinese and Central Asian mural paintings, in iconographical and narrative handscrolls, printed sutras with illustrations, and banner paintings, among other sources.[1] The Shōsō-in and Hōryū-ji treasuries of Nara also provide precious examples of eighth-century textiles of varying technique, function, and design; taken together they convey the fundamental importance of the medium of textiles for religious as well as secular purposes in early Japanese culture.[2]

Unfortunately, woven cloth is fragile, more so than any other material traditionally used in the applied Buddhist arts. The beautiful textile mountings that frame the hanging scrolls in this exhibition for example have not been in place since the Heian or Kamakura eras. The original mountings deteriorated centuries ago and were carefully replaced when the paintings themselves were ready to be restored. While some portion of the original mounting fabric might have been salvageable and was reused, by the next remounting most was not and new fabric was set in place. In general, such fabric—of the highest quality as befits its role—lasts about one hundred to two hundred years, depending on how it is cared for and used. Thus most Heian and Kamakura period paintings have been remounted four or five times.

The *ban* (ritual banner) illustrated here, which is more than six hundred years old, is thus rare. Ban are composed of three main elements: a pyramidal "head," rectangular "body," and "tails" consisting of four long independent strips of gauze-like fabric that have been lost on this ban. The origin of these objects as outdoor adornments identify-

ing a special personage or place in large measure sealed their fate. As festive exterior symbols fluttering in the wind, marking a religious event or Buddhist monument for travelers, their condition of necessity deteriorated over time. Then they were either wholly replaced or reconditioned, as was the case with this ban.[3]

The original ring and metal clasp with engraved floral decor form the attachment point for the tip of the ban and the triangular form that carries the rest of the ban material. Folded paper (and in some instances thin slats of wood) provide internal support to create a rigid shape from which the rest of the textile can hang. The earliest ban are thought to have been made of openwork metal (fig. 71a) or from one piece of cloth upon which either a painted image was drawn or to which additional textile pieces were added. But in Heian period Japan the form changed: multiple textile pieces were joined to form a three- or four-panel body, with additional "arms" along each side. The arms of this Nara

Fig. 71a. Banner with canopy, 7th century; gilt bronze with openwork design; h. 510 cm; Tokyo National Museum (from the Hōryū-ji). National Treasure

National Museum piece have been lost but their attachment points are visible at the ends of the two pointed, triangular head borders.[4]

The multiple panel system allowed specific, related imagery to be coordinated in a sequence. Normally a lotus base, a Sanskrit character, a ritual implement, and then a figural design were linked one after another. These textile panels were either woven, embroidered, or both. Textile dividers of another design and color framed the panels. This example provides one central lotus panel (and fragments of two others) on either side of which are disparate sections of gold twill cloth that have been joined in a seemingly random manner. In actuality, their very existence is a marvel, and it is precisely that knowledge and the appreciation for their splendid age that prompted their inclusion in this religious context. The most prized kesa in Japan are also formed in precisely the same manner: from multiple pieces of old salvageable cloth (Central Asian, Chinese, Korean, Indian, or Japanese, or combinations thereof) sewn together in what appears to Westerner's eyes as a patchwork quilt devoid of any logical design. But in Japan in the eighth century and then in the later Heian period the appreciation of imported textiles from Central and East Asia, India, and Southeast Asia prompted the preservation, copying, and indeed the connoisseurship of textiles to levels and for audiences well beyond anything known in the West.

These textile ban were used in temple interiors in ancient and medieval Japan, suspended as iconographically coordinated sets, pairs, or alone (fig. 71b). The open bays and columns provided effective visual backgrounds. Still, these somewhat protected environments could not halt their deterioration. Note should also be taken of the fact that ban also adorned the precincts of Shinto shrines. But here, because of the secretive nature of Shinto ritual and imagery, the ban were not permitted to be displayed inside a building housing a kami but rather were hung outside, high up on exterior walls. As a result no Heian examples survive, and the few remaining Kamakura ban are often in pieces.[5] Nevertheless, ban such as this example are reminiscent of the more familiar revered old ceramics in Japan that despite having been

broken or damaged through use have been repaired with gold lacquer seams and returned to service by successive generations of appreciative, respectful owners.

1. See for example *Higashi Asia no butsutachi* (Buddhist images of East Asia), exh. cat., Nara National Museum (1996), pls. 121, 126–34, 196. This material dates generally from the ninth to thirteenth centuries. Note also the presence of textile banners on portable staffs in the *E-inga-kyō* [14].

2. See Sekine Shunichi, *Butsu, bosatsu to dōnai no shōgon* (The adornment of Buddhist images and temple interiors), vol. 281 of *Nihon no bijutsu* (Arts of Japan) (Tokyo: Shibundō, 1989), inside cover, pls. 20–23, 42, 122, 124–27, 130–35. In early Buddhist Korea these ban must have been enormous, judging from the size of the pole supports and bronze dragon heads used to suspend them at temple sites in Kyŏngju.

3. For two Shōsō-in examples, see the extraordinary ban illustrated in *Shōsō-inten* (Exhibition of objects from the Shōsō-in), exh. cat., Nara National Museum (1989), no. 38; for the Hōryū-ji, see *Hōryū-ji kennō hōmotsu* (Treasures donated from the Hōryū-ji), exh. cat., Tokyo National Museum (1996), no. 223–35; for the Heian type, see Sekine, *Butsu, bosatsu to dōnai no shōgon,* inside cover.

4. For examples of the various structural configurations and their origins in the metal banners (*kanjō-ban*) from the Hōryū-ji, see *Bukkyō kōgei no bi* (The beauty of Buddhist decorative arts), exh. cat., Nara National Museum (1982).

5. See *Kōgeihin 2* (Decorative arts 2), vol. 5 of *Sinshitei jūyō bunkazai* (Catalogue of newly registered National Treasures and Important Cultural Properties) (Tokyo: Mainichi Shinbunsha, 1983), 180–84.

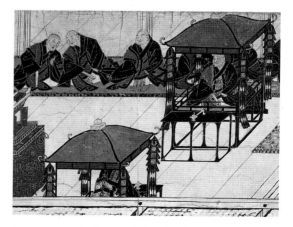

Fig. 71b. Detail of a temple interior showing ban hanging from lecture platforms for high priests. From the *Illustrated History of the Ishiyama-dera,* 14th century; handscroll, one of a set of seven: ink and color on paper; 33.3 x 1753.5 cm; Ishiyama-dera, Shiga Prefecture. Important Cultural Property

72. Raigō

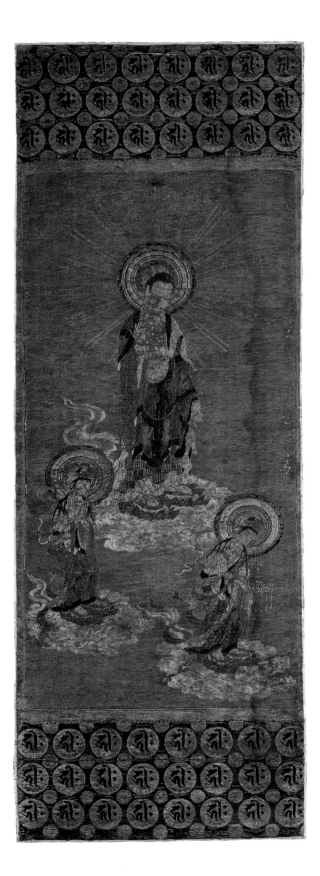

14TH CENTURY; EMBROIDERED HANGING SCROLL: SILK AND HUMAN HAIR DESIGNS; 71.7 X 25 CM

For Pure Land sect adherents in the fourteenth and fifteenth centuries, there could not have been a more potent image than that conjured up at the mention of the word "Raigō." Whether heard in a sermon or ordinary conversation, read in a text explaining the merits of this faith's belief system, or simply held in one's private thoughts, this word describing Amida descending from his heavenly Western Paradise was a commonly understood expression. Thanks chiefly to the proselytizing of the monk Hōnen and his followers, people from all stations in life were urged to express their belief in the salvatory powers of Amida, which could be accomplished just by the repetitive chanting of his name. Such a simple straightforward approach to faith had a dramatic impact on Japanese society in the thirteenth and fourteenth centuries and one that would continually expand in the ensuing centuries.

While belief in and devotion to Amida had a much earlier history in Japan, its followers were limited. During the Nara and then the Heian periods for example, nobility favored Amidism in tandem with Esotericism (especially Shingon). A number of impressive Heian period sculptural ensembles with Amida as the central icon still exist in Nara and Kyoto. Historical records tell of elaborate ceremonies honoring Amida being performed as well as mural paintings and even entire halls being made for dedication to this deity.[1] His image was also engraved into numerous kyōzō of superb craftsmanship that were buried in sutra mounds in the eleventh and twelfth centuries [63]. Among them are kyōzō depicting Raigō scenes in which Amida appears with attendants Seishi and Kannon on a cloud riding toward earth while lotus petals float down from the skies above.[2] Such profile or three-quarter view compositions were popular among Kyoto's aristocracy at the time, but other compositional and iconographical variants occurred that also gained varied degrees of success in the Kamakura and Muromachi periods [53].

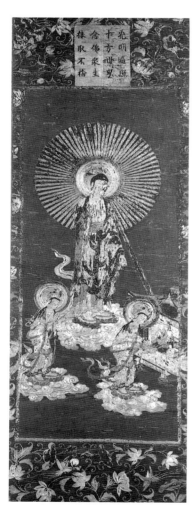

Fig. 72a. Raigō, 15th century; embroidered hanging scroll: silk and human hair designs; 109.1 x 37.2 cm; The Cleveland Museum of Art, American Foundation for the Maud E. and Warren H. Corning Botanical Collection 1966.513

One of the popular configurations in the fourteenth century depicted Amida standing in a three-quarter view with attendants Seishi and Kannon as a triad, rather than as part of a vast heavenly retinue. This composition became prevalent probably because its modest size made it more approachable and affordable to an expanding Pure Land sect laity composed increasingly of commoners. In addition, a new wave of Korean and Chinese Buddhist imagery had arrived from the continent in which single standing Amida figures or a triad were shown in three-quarter view.[3] Spurred perhaps by new foreign icons, by the more modest means and aesthetic values of Hōnen's disciples and followers, and also by the restrictions of space within ordinary residential architecture, these smaller Amida Raigō compositions proliferated. Such single hanging scroll icons could also be transported easily by monks traveling around the country preaching or, as the late thirteenth century illustrated biography of Hōnen tells us, be carried to temples or private residences to conduct a variety of rites, including rituals performed for those about to die.[4]

Thus far the appearance of embroidered Buddhist images (shūbutsu) have not been confirmed in medieval handscroll narrative paintings, but like the painted images this colorful embroidered Raigō shows each figure of the triad on its own lotus pedestal. The group moves from left to right in a motion enhanced by Kannon's leaning posture, offering the lotus base as the repository for the deceased's soul. The complexly modulated cloud and lotus pedestal forms reflect a keen painterly eye as well as superb needlework. Similarly, the dynamic rhythms and color coordination of the attendants' garments bespeak talents on a par with professional Buddhist painters of the day.

Set against the pale robin's-egg sky, Amida is shown clothed in a brown robe with striking blue border hems and inner robe patterns. Surrounding his head, which is bent in respect, thin rays of golden light issue out into space, forming a halo (which can now only barely be seen). The entire composition is framed above and below with roundels displaying three rows each of the Sanskrit character for Amida. This is a lavish display of color and dedicated craftsmanship using only colored threads sewn into the backing fabric.

The composition of the scroll, including the upper and lower borders, was first sketched out with brush and ink on a piece of silk backed with linen. These two plys provide the sturdy backing for the stitched threads that constitute the pictorial elements of the image. The ground is visible where threads have been lost over the centuries.

Above and below the central triad, two panels with twenty-four roundels displaying the Sanskrit character for Amida are arranged in three parallel rows. These correspond to the forty-eight vows identified in the *Muryōjū-kyō (Sutra of Immeasurable Life)* as being offered by Amida in his previous state as a bodhisattva. Indeed among these vows are two promising deliverance to the faithful by a Raigō ensemble into a heavenly, pure land. Each of these Sanskrit characters is rendered with threads incorporating human hair, a common feature of shūbutsu that signals the intensely palpable, human nature of these embroidered devotional icons (and in contrast to the painted versions). The pale roundels are set in a dark green field of threads, each encircled by red-colored strands. The roundels rest on individual lotus bases formed from bundles of green and purple threads.

This same technique (called *sashinui*) is employed to create the "rainbow" of halo patterns highlighting the heads of Amida, Kannon, and Seishi. A delicately orchestrated pattern of dark yellow, bluish-yellow, red, reddish-black, purple, and light yellow threads are interwoven and stitched in a truly painterly fashion so as to feature the deities' heads and facial expressions. Seventeen "spokes" of golden thread clusters can still be seen radiating from Amida's halo, despite deterioration over the years. And once again the artisan's underdrawing is revealed in the face along with the use of human hair for hair curls and part of the robe. These features also appear in the Cleveland Raigō shūbutsu in which three figures are portrayed in a temple building awaiting Amida's arrival (fig. 72a).

The robing of this Nara National Museum example is particularly distinguished for the complexity of surface patterns and their techniques, which involve layering and overlapping two or more embroidered pattern sequences to anticipate the imminent death of a Pure Land devotee. Remarkably, this scroll remains in good condition. The inherent fra-

gility of its component textile materials as well as restoration and remounting efforts have coalesced over the centuries to form its present state. Iconographically representative of the period, its fabrication bespeaks a highly sophisticated textile artisan.

Among known Raigō shūbutsu only one example has been registered by the nation as an Important Cultural Property.[5] It features an imaginary landscape with karyōbinga [68] but otherwise is not as distinguished as this example. The Nara National Museum also has in its collection a seventeenth-century Amida Nyorai Raigō shūbutsu indicating the continuation of this textile tradition in the arts of Japanese Buddhism. Its origins of course can be found much earlier, in the embroidered tapestries of the seventh and eighth centuries belonging to Nara temples and in the Shōsō-in treasury. Now visible as remnants of their original brilliant forms, they confirm the role of embroidered textiles in the Buddhist arts of Japan. Indeed the Nara National Museum's famous embroidered panel of Shaka preaching, a National Treasure of the eighth century (see fig. 45b), is the single most important relic of this category of religious object to survive in East Asian art.

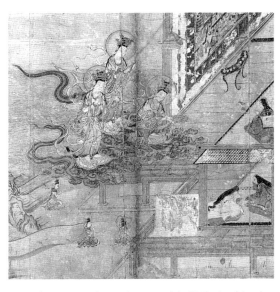

Fig. 72b. Raigō with a Taima mandala [52], ritual implements [84], and three-legged table [85] depicted in the temple room. From the *Illustrated Biography of Priest Hōnen,* 14th century; one of a set of forty-eight scrolls: ink and color on paper; each scroll approximately 33.1 cm high; Chiou-in, Kyoto. National Treasure

1. See Mitsumori Masashi, *Amida Nyoraizō* (Images and paintings of Amida Nyorai), vol. 241 of *Nihon no bijutsu* (Arts of Japan) (Tokyo: Shibundō, 1986).

2. See Naniwada Toru, *Kyōzō to kakebotoke* (Votive mirrors and hanging plaques), vol. 284 of *Nihon no bijutsu* (Tokyo: Shibundō, 1990), pls. 29, 32, 44, 57, 59.

3. Hamada Takashi, *Raigōzu* (Images of Amida's descent), vol. 273 of *Nihon no bijutsu* (Tokyo: Shibundō, 1989), 62ff. The mid-eleventh-century private residence turned into an Amida hall, the Byōdō-in outside Kyōtō, is a remarkable example of aristocratic support for Amidism.

4. See Tsukamoto Yoshitaka, *Hōnen Shōnin eden* (Illustrated biography of priest Hōnen Shōnin), vol. 8 of *Nihon emakimono zenshū* (A compendium of Japanese illustrated handscrolls). (Tokyo: Kadokawa Shōten, 1961).

5. See *Kogeihin 2* (Decorative arts 2), vol. 25 of *Jūyō bunkazai* (Catalogue of National Treasures and Important Cultural Properties) (Tokyo: Mainichi Shinbunsha, 1976), no. 425; see also Morita Kimio, *Shishū* (Embroidery), vol. 59 of *Nihon no bijutsu* (Tokyo: Shibundō, 1971), no. 53–57.

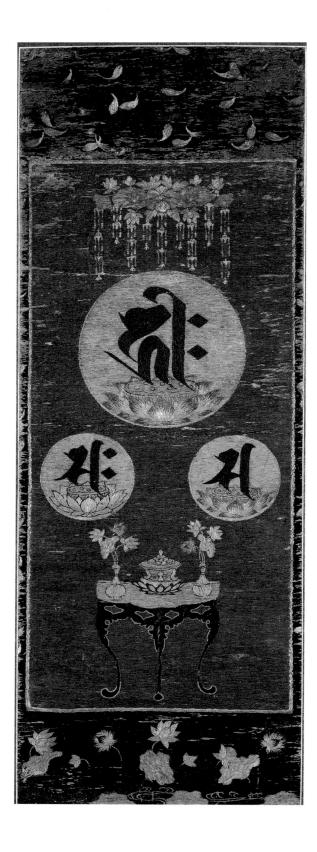

13TH CENTURY; EMBROIDERED HANGING SCROLL: SILK AND HUMAN HAIR DESIGNS; 69.3 X 25.2 CM

The term *shūbutsu* signifies a category of Buddhist image made using textiles. More specifically, it refers to Buddhist images that have been embroidered in silk, usually on the surface of a hanging scroll.[1] In this well-preserved example the background, including all details of the faux mounting surface, consists of thousands upon thousands of embroidered stitches.

The "mounting" design depicts white and pinkish lotus petals drifting down toward the framed image. This decorative motif derives from Pure Land Raigō painting imagery and is therefore closely associated with the subject of this work [52–53]. Below, stitched into the deep blue field of embroidery, is a pond with lotus leaves and buds in varying stages of bloom. The central icon is an Amida triad, identifiable only through knowledge of the Sanskrit characters representing Amida (above), and his principal attendants Seishi (proper right) and Kannon (proper left). Each character is positioned on a lotus pedestal and set within an embroidered roundel bounded by a thin coursing line of gold-colored threads. Above, a floral canopy incorporating lotus buds and suspended bead and metalwork designs nearly touches Amida. This lower canopy decor is similar to that seen in the twelfth-century Eleven-headed Kannon painting [45].

At the bottom of the composition a "heron-legged" type table is depicted with two kebyō and an elaborate kasha resting on its surface. This is precisely the form of the black lacquer table with *kozama* (window) detailing and gilt-bronze fittings included in the exhibition [85]. Among extant shūbutsu hanging scrolls this form of table appears so frequently as to suggest a special iconographic association with Amida triad imagery. The other type of table occasionally depicted is a low, square table showing—interestingly—three legs in frontal and side view. The shape of the two kebyō is unusual and important for the period, seen in only a few bronze examples

dated to the late fourteenth century [87] as well as examples from the early seventeenth century. The three-footed censor has a shape seen initially in the late Heian period, just the time when Raigō imagery was becoming popular. It stands on a lotus pedestal with thickly outlined petals arranged in two tiers. The silk thread tones are adjusted beautifully there to differentiate the separate forms and their detailing as well as create a gentle but distinct contrast with the surface of the table. Its creamy white tone would seem to indicate the black lacquered table was covered with a cloth, or in fact lacquered a light brown or yellow tone. No such tables are known. The colored threads used for the kebyō and censor set and to outline certain table features indicates their reference to the gilt bronze in actual examples [86–87].

Commissioning such an exquisite, labor-intensive object was an act of great faith and a commitment of considerable resources, comparable to some of the sculpture and metalwork in the exhibition. All the coloring was produced from natural dyes and traditional techniques. Individual threads are given a hue, which can be used as is or strengthened along its length in intervals so that as the sewing progresses tones gradually appear or disappear—just as in a painting where brush, ink, and mineral pigments provide those effects. The palette of this work is sensitive and includes red, indigo, and light yellow threads that even become sculptural in the design of the Sanskrit characters and table form, creating an effect that would not be possible with ordinary ink on silk or paper.

Early shūbutsu are rare Buddhist artifacts, both because of their initial expense and because of their inherent fragility. In the Auska and Nara periods embroidered scenes of Taima-like paradises [52] or Nyorai Buddhas with attendants were sometimes part of the furnishings of devotional halls. Several centuries later, as the affluence and deepening beliefs in the pious acts extolled by Pure Land popular Buddhism flourished, salvatory icons such as this Amida Nyorai appeared. Never numerous in number, they were rolled open and then rolled back up and put away for another occasion. As time passed the embroidered threads stiffened, broke, and fell off the back mounting until, inexorably, the religious image disappeared.

Today fewer then twenty Kamakura period shūbutsu are extant in good condition. One in the Rinnō-ji in Nikko has the same Amida Nyorai composition as this one.[2] Painted examples of this modest scale from the Kamakura period are not numerous, but there are quite a few instances of fourteenth- and fifteenth-century painted and embroidered icons of the single Amida Raigō type leading to the supposition that textile and painting studios used similar compositions from iconographical sketches as models.

1. *Kōgeihin 2* (Decorative arts 2), vol. 25 of *Jūyō bunkazai* (Catalogue of National Treasures and Important Cultural Properties) (Tokyo: Mainichi Shinbunsha, 1976), 104–5; see also the embroidered panels affixed to banners of the Kamakura and Muromachi periods. For the best discussion and compilation of shūbutsu, see *Shūbutsu* (Embroidered Buddhist images in Japan), text by Nishimura Hyobu (Tokyo: Kadodawa Shōten, 1964).

2. See *Kōgeihin 2* (Decorative arts 2), vol. 5 of *Shinshitei jūyō bunkazai* (Catalogue of newly registered National Treasures and Important Cultural Properties) (Tokyo: Mainichi Shinbunsha, 1983); see also Morita Kimio, *Shishū* (Embroidery), vol. 59 of *Nihon no bijutsu* (Arts of Japan) (Tokyo: Shibundō, 1971).

74. Sutra Box

12TH CENTURY; LACQUERED ANIMAL HIDE WITH SPRINKLED GOLD, SILVER AND GOLD ALLOY POWDER DECORATION, AND METAL FITTINGS; 12.1 X 31.8 X 17.6 CM. NATIONAL TREASURE

Emakimono of the Heian and Kamakura periods oftentimes provide revealing information about the way people—most frequently aristocrats or clerics—lived and the furnishings with which they surrounded themselves. Peering from a bird's-eye perspective down into their residences or devotional halls, the modern viewer surveys these living spaces and discovers as the handscroll unfolds myriad details about society and human behavior in medieval Japan.

Among the diverse accouterments of daily life at court and in court-supported religious institutions were the varied containers needed for protecting clothing, decorative or ritual objects, sacred texts, or sculpted icons. During the Nara and Heian periods the most precious secular as well as religious objects were customarily protected (and identified) by a container made from either wood or animal hide (oxen or cow or deer). Invariably these materials were enhanced for strength and visual appearance by applications of lac-

quer, tinted to take on a brown, red, or black hue. Designs were also created by inlaying metal or mother-of-pearl or adding finely granulated silver and gold powders to the wet lacquer. The result was a particularly rich vocabulary of decorative techniques and motifs that endure to the present day in Japan. The Shōsō-in treasury houses an extraordinary group of such wares, varying aesthetically from the plain to the sublime, that provide the basis for interpreting subsequent developments in the history of Japanese lacquerwares.

Broadly considered, it appears that while the demand for decorated lacquerware increased continuously from the eighth to the twelfth century, the taste for its surface decor evolved dramatically over the course of more than three hundred years. Thus, while in much of the eighth-century Shōsō-in material the technique of choice was carving into the lacquer and substrate surfaces to inlay other materials (a particularly demanding labor-intensive craft), by the eleventh century Japanese studio artisans had devised many ways to embed metal filings in increasingly precise decorative patterns on a succession of damp lacquer surfaces. The layering of these filings, whose size, shape, and tonality were routinely adjusted according to the desired end

result, was a lengthy process that also included polishing the individual layers of lacquer before proceeding to the next level.

This accumulative process allowed compositions of extraordinary brilliance and profound visual depth to evolve during the Heian period. At times this rigorous "painterly" technique was employed jointly with a gold and silver technique in which generous amounts of colored lacquer were added to parts of the surface to form three-dimensional elements in a composition. Members of the court and Kyoto's aristocratic families routinely ordered lacquerware incorporating either or both of these approaches for use at home or as donations to Buddhist temples. We can see these objects in the illustrated handscrolls of the time.

This sutra box surely resulted from such patronage. The shape is noteworthy for the deep cover, which alters the profile of the box to define a sturdy container enclosing an underlying frame and thereby suggesting greater volume than would otherwise be the case. The edges, contours, and profile are adjusted to produce a rhythmical shape of subdued elegant strength and create gentle highlights around the principal decorative motifs on the lid. This panel features a central lotus motif

with related designs at each of the four corners. Butterflies with varying wing patterns float in the gold-flecked field in between the two principal compositional areas as well as on the base and side panels with other lotus motifs. Although these motifs appear to have been applied with a brush to the lacquer surface, in fact they are gold filings or powder carefully sprinkled through a sieve onto the sticky lacquer to form the colors, lines, and shapes of the lotus motifs. The black veining and contour edges of the leaves or lotus pod are actually reserved areas where the black lacquer substrate is revealed. This *maki-e* (sprinkled picture) technique is one of the decorative styles developed over the three-century period discussed above that culminated in Buddhist utensils such as this box.[1]

The substrate of this sutra box is deer or ox hide that was shaped using a mold and then allowed to dry. A ground layer (or layers) of clear lacquer followed. Then tinted lacquer sprinkled with gold filings served as the field for a finer gold powder and a powder alloy of gold and silver known as *ao-kin* (blue gold). A palette of colors and tones emerged from these materials, used in an assortment of densities and placements, creating what appears to be a painted image.

Not merely appealing as decoration, the lotus design symbolizing the Buddha is appropriate because this container was made to hold a set of sacred Buddhist texts. Unfortunately, they were separated from the box, or perhaps lost, and the lack of a temple provenance deters future research into the origins of this exquisite twelfth-century object.

This sutra container is currently the only known surviving example of maki-e lacquer of this date with a hide substrate. Fortunately, this singular example of Heian lacquer craftsmanship and taste can be linked to a small number of sutra cases, cosmetic containers, and rosary boxes with wooden substrates. Of these, a sutra box with lotus and waterfowl designs in a private collection and another in the Kongō-ji collection in nearby Osaka with related imagery bear mention. The Tokyo National Museum's famous cosmetic box (*tebako*) with the design of water wheels discarded in a stream, however, most closely parallels the shape and scale of this Nara National Museum container, but the sensibilities diverge greatly.[2]

As an emblem of the Buddha and the accepted natural motif connoting the promise of rebirth in a western paradise, the lotus was recognized as a standard visual motif in paintings, metalwork, and lacquerwares in ancient and medieval Japan. Yet surviving Heian period examples are rare indeed. The fine condition of this box, with its original metal fittings, provides an all-too-rare opportunity to contemplate the taste for reserved opulence laden with spiritual references that informed so much of Heian culture.

1. See Arakawa Hirokazu, *Maki-e* (Japanese lacquer with sprinkled gold designs), vol. 35 of *Nihon no bijutsu* (Arts of Japan) (Tokyo: Shibundō, 1969).

2. See *Tōyō no shikkōgei* (Lacquerwares of East Asia), exh. cat., Tokyo National Museum (1977), pls. 63, 71–80; see also *Maki-e* (Japanese lacquer with sprinkled gold designs), exh. cat., Kyoto National Museum (1995), pls. 1–22.

75. Shrine for Daihannya-kyō and a Daihannya Handscroll

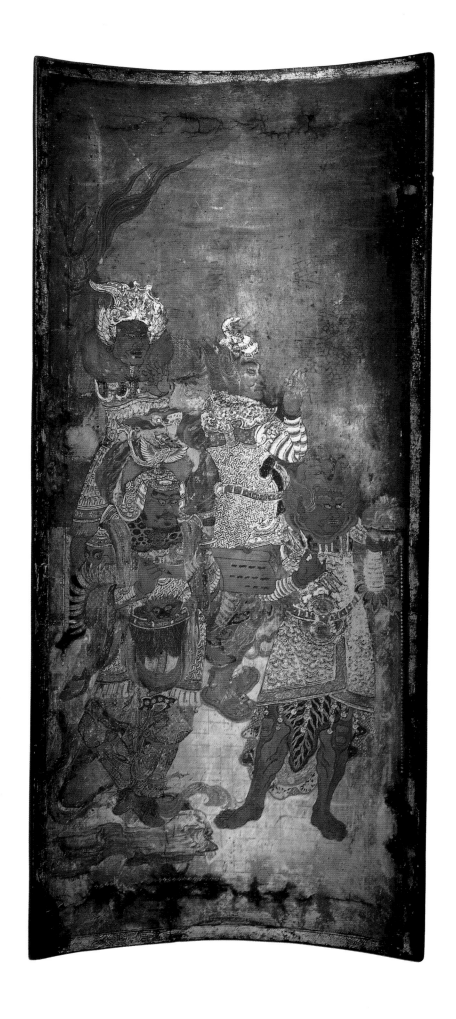

LATE 12TH CENTURY; SHRINE: LACQUERED
WOOD WITH POLYCHROMY, GOLD AND
SILVER PIGMENT, AND CUT GOLD AND
SILVER FOIL, H. 165 CM, DIAM. 62.5 CM;
HANDSCROLL: INK ON PAPER, 23.9 X 812
CM. IMPORTANT CULTURAL PROPERTY

The relics of the Historic Buddha were trea-
sured by generations of later proselytizers and
believers in the faith. Passed on to worthy
disciples for safekeeping and to identify suc-
cessive "approved" lineages, relics were also
interred in the ground at Buddhist temples
as a way of consecrating the site. Containers
were required for these purposes, as well as
for transportation, and later in the late Heian
and Kamakura periods for the veneration of
the relics themselves.

In Korea and Japan the simple stone con-
tainers of India or the elaborate gilt-bronze
examples from what is now Afghanistan and
Central Asia became complex objects of strik-
ing appearance. Crystal, bronze, iron, and
lacquered wood are among the materials

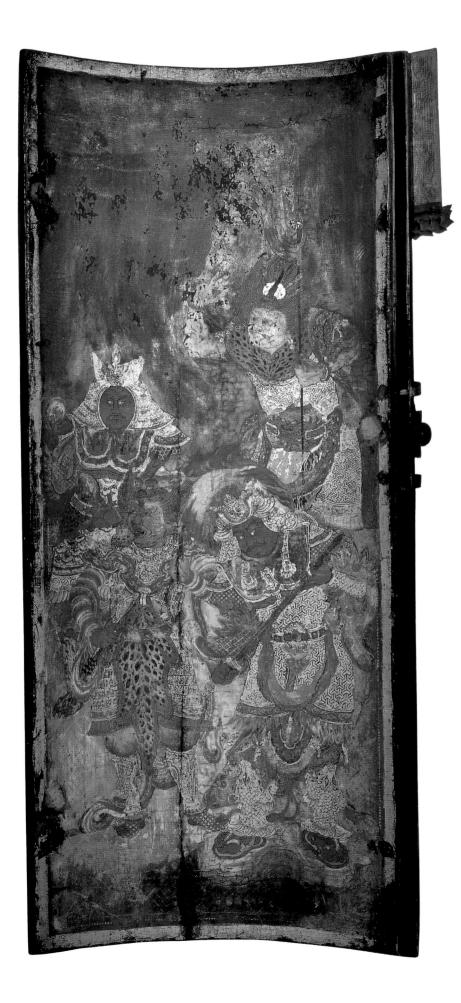

used to fashion the vessels intended to protect and then display the holy relics.[1] Of course, the historical veracity of these objects was open to question, as was for example the transmission of the many written texts of Buddhism. They were transcribed from Sanskrit into Chinese, along with numerous commentaries about them. Subsequent translations into Japanese or with Japanese guides to pronunciation enabled the faith to spread throughout the country, although the principal religious centers of Nara and then Kyoto were never eclipsed.

As has been noted, the official scriptorium at the Nara palace and the one at the Tōdai-ji provided texts for the kokubun-ji, for assorted ceremonial occasions, and for aristocratic commissions [11–13]. The last became more and more numerous during the ninth and tenth centuries, leading eventually to the transfer of more of this copying activity to other temples in Nara and Kyoto supported by aristocratic families. The capital had also shifted to Kyoto, and its links to the Tōdai-ji

establishment weakened. Members of the aristocracy, themselves educated in the Chinese classics as well as in the rigors of calligraphy, copied sutras as one means of accruing religious merit and practiced daily acts of piety as the Buddhist prediction of the end of the world in the mid-eleventh century loomed nearer, arrived, and then passed. Thousands of handwritten sutras were produced and distributed throughout the land. While the glorious visual imagery of temple architecture, sculptural programs, and large didactic or iconic paintings evolved through the centuries, the core beliefs endured for continuous referral in the written sutras. The words of the Historic Buddha and his disciples lived in them, capable of bridging institutional, sectarian, and personal needs. Understood in this way, these sacred texts were recognized as symbolic of the Buddha, and their veneration came to include, like reliquaries, specially adorned vessels for their display to the laity, a notable step beyond their protection in lavish storage boxes [74].

Contrary to initial impressions, this imposing lacquer zushi never housed a carved sculptural icon. It was instead conceived and produced for the sole purpose of enshrining a complete set of the *Daihannya-kyō* (*The Greater Sutra of the Perfection of Wisdom*). Known in a six hundred volume set, it was the text Emperor Shōmu ordered copied "in every province of the realm" in 737 in his efforts to attain civil order and relief from a smallpox epidemic. Among the early volumes still extant, the Nara National Museum possesses a late eighth-century scroll, vol. 96, from a set executed at the official government scriptorium and given to the Yakushi-ji in Nara. Considering this formidable lacquer structure, it would seem that the veneration and presentation of this fundamental religious text took on added meaning some four hundred years later. Further, it has a mate of identical dimensions in the Cleveland collection (fig. 75a).[2]

Each zushi held three hundred scrolls (less than a third are extant), which were divided into three groups, bound into a circle with a cord, and placed on end in the tabernacle. The four recessed holes in the lotus base indicate where the legs for a two-tiered shelf, used to organize the sutras, arose inside the shrine. The shelf was secured to the back

wall using the metal rings still in place. The two dark horizontal lines visible on the back wall indicate shelf levels. Above, hidden from view in the domed roof, is an eight-petal lotus canopy, lavishly painted with gold and silver foil as are some of the Heian paintings in this show [42, 44–46]. An openwork gilt band of much later date (probably Edo period) is just visible at the upper edge of the bay enclosure. This strap supported a trellis of wired beadwork and cut metal spangles (those in the Cleveland example are much later replacements). The metal door fittings are also much later in date.

In the two roundels on the rear curved wall are the Sanskrit characters for Shaka (left) and Amida (right), each positioned on a lotus base, as in the thirteenth-century shūbutsu [73]. Once again it is apparent that the written symbol for a deity is fully emblematic of that deity's authenticity and powers. Using Sanskrit clarified the connection to the deity's original immanence, which for some believers surely enhanced its spiritual efficacy. Any number of Kamakura period Buddhist paintings and reliquaries [77] use the elemental Sanskrit form of a deity or group of deities instead of depicting an image. This custom occurs less frequently in Heian imagery.[3]

The tabernacle rests on pair of two-tiered lotus bases, each unit of which centers on eight- or sixteen-leaf design elements. This numbering pattern is consistent with the roof designs and with the door imagery. Four guardian figures are depicted on each door, giving a total of sixteen for the original pair of zushi, which corresponds precisely to the sixteen deities of virtue mentioned in the *Daihannya-kyō* as protectors of the faith.

Once considered Kamakura era paintings, these dynamic compositions have been reconsidered recently and assigned a twelfth-century late Heian date, in part because of the lavish materials—cut gold and silver foil in particular—employed in the background and for the garb of the figures. The style of armor and the guardians' darkened, exaggerated, rough facial features make reference to the Central Asian figure type so often associated with the international Tang dynasty style in East Asian painting and ceramics. The animal skins, helmets, and leather armor patterns are varied and ostentatious, enhancing the individuality of each figure.

Fig. 75a. Shrine for the *Daihannya-kyō*, late 12th century; lacquered wood with polychromy, gold and silver pigment, and cut gold and silver foil, h. 165 cm, diam. 62.5 cm; The Cleveland Museum of Art, John L. Severance Fund 1969.130

The assemblies are arranged so that the guardians face the shrine sanctuary, but one helmeted deity is posed in a full frontal position. This vignette also can be seen in the Cleveland shrine. A later, perhaps fifteenth-century chest at the Tōdai-ji with seventy-five drawers for storing the *Daihannya-kyō* text also has painted doors, each of which depicts guardian figures, but in less-animated poses and wearing Japanese-style garb.

Although this unique pair of large Heian shrines has been convincingly placed in recent history as coming from the Jinkō-in in Kyoto, nothing is known about who commissioned it, where it was made and adorned, or indeed where it was placed in the devotional hall of its original twelfth-century temple setting. While modern conservation of both shrines has helped reassess their age and import, and demonstrated that the original outer surface of gold foil was covered with black lacquer in the fifteenth century, nothing has been recovered as yet to help access the impulses for their creation. To date no early records or depictions in illustrated manuscripts of the twelfth through fifteenth centuries provide specific insights into their use in the life of a temple. Their scale, expensive materials, and high-level craftsmanship clearly indicate their importance and unprecedented patronage. Differences in painting style and figural delineation point to the involvement of an experienced studio to accomplish the work. For now the sheer survival of this grand Nara National Museum example and its Cleveland mate must suffice. They rank among the most important Buddhist lacquer-wares from the Heian world, whose contents were worshiped just as if a sculptural icon were in place behind the doors.

1. See Kawada Sadamu, *Busshari to kyō no shōgon* (Solemnly decorated Buddhist reliquaries and sutras), vol. 280 of *Nihon no bijutsu* (Arts of Japan) (Tokyo: Shibundō, 1989).

2. Both zushi are thought to have belonged to the Jinkō-in in Kyoto; see *Nara Kokuritsu Hakubutsukan no meihō* (Masterpieces from the collection of the Nara National Museum), exh. cat., Nara National Museum (1997), pls. 36–37. The Cleveland tabernacle, which is now undergoing restoration at the Nara National Museum, could not be not included in this exhibition.

3. See for example *Heian butsuga* (Heian period Buddhist painting), exh. cat., Nara National Museum (1986).

Two sections of the *Daihannya-kyō*

76. Kasuga Cult Tabernacle and Reliquary

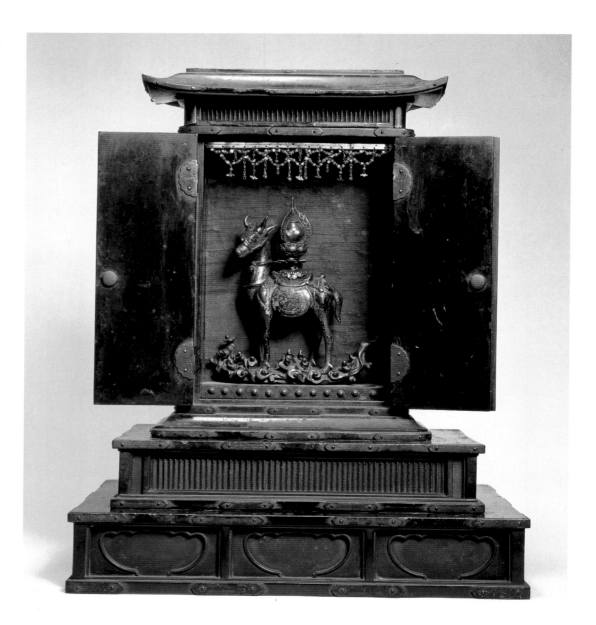

14TH CENTURY; TABERNACLE: LACQUERED WOOD AND POLYCHROMY WITH GILT-BRONZE FITTINGS AND BEADWORK, H. 37.2 CM; RELIQUARY: CAST GILT BRONZE WITH ENGRAVED AND PUNCHED DESIGNS, CRYSTAL VESSEL, H. 11.7 CM

This zushi is a particularly rare and beautiful example of the many small private tabernacles commissioned in the fourteenth and fifteenth centuries that illustrate the intimate relationship between native Shinto beliefs and Buddhism's imported precepts. Although the syncretic impulses of this honji suijaku belief system were forged in the Heian period, it is in the Kamakura, Nambokuchō, and early Muromachi periods that the rich inter-

woven fabric of this relationship in medieval Japan can best be measured.

At that time popular Buddhism, promoted with fervor throughout the land, entered into the households of Japan to an unprecedented extent. This phenomenon, coupled with the development of strong regional economic and distribution systems, allowed a proliferation of local temple and shrine building and the requisitioning of the furnishings, ritual utensils, icons, and related paraphernalia necessary to adorn these structures. These furnishings and devotional objects were ordered directly by individuals from the craftsmen at religious "outfitting" shops in Nara and Kyoto, stores frequently found in the neighborhood of the large metropolitan temples that regularly at-

tracted large numbers of visitors, especially during religious holidays. Or they might be clustered, as was the case with Nara, in a particular district specializing in the production of Buddhist-related articles such as the sculpture studios in the Tsubai-chō neighborhood in then-central Nara near the Kōfuku-ji. Lacquerwares and metalwork were also to be found at the local shops in Nara specializing in Buddhist furnishings and also the important ritual objects associated with nearby Kasuga Jinja [54]. Travelers to Nara did not miss the opportunity to pay homage to the kami there. This zushi features a gilt-bronze ensemble of the Kasuga Shrine *myōjin* (resident deity) deer astride an elaborate cloud, carrying a *shari* (reliquary) [78] on its back. The icon relates directly to the one in the painting of Kashimadachi Shineizu [55] in that both feature the familiar Nara deer as the vehicle (messenger) of an important religious concept, here the emblem of the Kasuga deity Takemikazuchi no Mikoto.

Instead of transporting that Shinto deity from his abode in Kashima to Kasuga, the deer carries on its back the dais for a shari in the form of a flaming jewel. The jewel is crystal with a rounded lid allowing access to the grayish-white stone relics inside. Three openwork gilt flanges (one is missing) are set into openings

Fig. 76a. Tabernacle with Taima mandala painting, 13th century; lacquered wood with metal fittings; h. 501 cm; Taima-dera, Nara Prefecture

in the lotus pod base and joined at the top, embracing and securing the crystal. The dais has three courses of petals, each finely etched in a pattern of veins. The entire structure rests on the saddle, held in place by a pin. The profile of the deer's lower body together with its neck and head turning out toward the viewer gives the shari a particularly dignified aura.

The deer is sensitively cast and tooled, including numerous trappings meant to identify the leather and metal regalia familiar to horse riders. The saddle side panel has a nanako [4] design for the background with raised and rounded perimeters and a darkened surface under the gilded surface. Tall spindly legs hoist the deer from its celestial base, enlivening this unusual composition in a firm, elegant concatenation of disparate shapes. The deer turns regally toward the viewer, its black lacquered eyes peering out and slightly down.

This perspective is important because the shrine surely occupied an elevated position relative to viewers and worshipers, as its two-tier platform indicates. Whether it was placed on a shelf suspended from the rafter system in a private residence, as is often seen today, or set on a raised platform or long counter in a subsidiary room of a temple hall is now impossible to know. This zushi has what is known as a Taima-dera shape, a tall narrow frame topped by a low roof with sweeping upturned corners, after the earliest mid-thirteenth-century example belonging to the famous temple of that name south of Nara (fig. 76a).[1] This style was popular in the Kamakura era because it allowed large numbers of devotees to walk around the zushi and view a magnificent painted vision of Amida's Pure Land within the confines of a modest-sized hall. That this form was used for small personal shrines as well reflects concerns about space while maintaining the desired architectural form in medieval residences. Indeed of all fourteenth-century zushi types, this one remains the most refined and structurally complex form.[2] The colored glass beads and metalwork curtain add to the tone of muted elegance characteristic of such shrines and their icons and suggest links to the Fujiwara family, the founders and patrons of Kasuga Jinja and the nearby Kōfuku-ji. In any event, the patron must have been devout as well as wealthy.

Other than the narrow metal band from which the beaded trellis is suspended and the butterfly door hinges, the metalwork attached to the zushi appears to be original. The lower platform kozama panels postdate the well-known Chūson-ji type, reflecting instead a developed Kamakura period vocabulary devoid of elaboration by either painting or applique. An instructive comparison can be found in the altar platform (*shumidan*) at the Jōmyō-ji in Wakayama as well as in the three-legged table in the exhibition [85].

The twelve bronze studs protruding from the face of the inner shrine base offer an especially distinctive elaboration in the metalwork adornment schema of this offertory. This is an unusual, if not unique feature of small Kamakura period zushi. Seen in conjunction with the curlicue knobs rising from the swirling bronze cloud form immediately above, however, it makes a coherent and individualized aesthetic statement in the rendering of this haunting votive object.

The cloud form, in a large and less complex configuration in wood, can be seen in the well-known Hosomi Foundation bronze *Deer with Sacred Mirror* of the fifteenth century. This imposing figure has unfortunately lost its original tabernacle setting. But it suggests the vivacity and importance of the Shinto-Buddhist syncretic relationship in the fourteenth and fifteenth centuries, already visible in painted imagery of the time [54–57].

The special nature of the Nara National Museum zushi manifests itself again when one considers it as an offertory for the worship of the Historic Buddha, Shaka. For the myōjin deity Takemikazuchi no Mikoto, who is purported to have ridden from Kashima Jinja on the back of a white deer, was (and still is) considered an incarnation of Shaka in the Kasuga cult. Considered in this way the reliquary can be viewed as a manifestation of Shaka, indeed Shaka himself, and daily devotion to this small shrine made it a living icon in the mind of the devotee.

1. Sekine Shunichi, *Butsu, bosatsu to dōnai no shōgon* (The adornment of Buddhist images and temple interiors), vol. 281 of *Nihon no bijutsu* (Arts of Japan) (Tokyo: Shibundō, 1989), pls. 12, 94, 102, and 104.

2. See *Mikkyō kōgei* (Decorative arts of Japanese Esoteric Buddhism), exh. cat., Nara National Museum (1992), pls. 170–71, 173.

77. Shrine with Reliquary

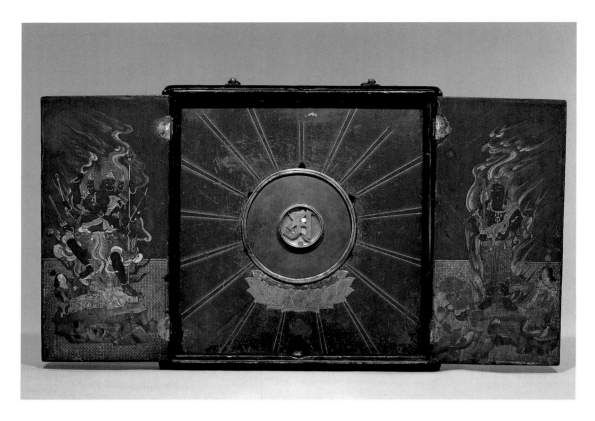

DATED 1387; SHRINE: LACQUERED WOOD WITH POLYCHROMY, CUT GOLD FOIL, AND METAL FITTINGS WITH INCISED DESIGNS, H. 30.3 CM; RELIQUARY: GILT BRONZE, NICKEL, INSCRIBED PAPER, AND GLASS. IMPORTANT CULTURAL PROPERTY

Like the Kasuga tabernacle [76], this thin box-shaped shrine combines a surprising number of materials, artisan techniques, and sophisticated religious ideas to convey its message. Structurally, it appears from the front to be a plain shallow box. Yet the gold paint, kirikane, specially tooled bronze and nickel rims fitted around two discs, and a glass panel within which is a cast gilt Sanskrit character, crystal bead, and round relic stones indicate its opulence.

These features are all assembled on a lacquered wood panel fitted into the shrine housing. On the surface a lotus pedestal and seventeen paired bands of radiating gold lines have been painted and kirikane applied. The pedestal and bands draw attention to the Sanskrit *aji* character signifying Dainichi Nyorai, the omnipotent Mikkyō deity about which the Ryōkai [41], Ichiji Kinrin [42], Daibutchō [43], and Sonshō [44] mandalas are organized. The central panel is framed by the fierce countenances of Fudō Myōō (right) and

Gōzanze Myōō (left) on the doors. Fitted into the back of the shrine facing one another are two colorful mandalas, painted on wood panels that are out of sight to the viewer. These Taizōkai and Kongōkai paintings are finely rendered in lavish polychromy using Sanskrit characters throughout, suggesting ownership by a Shingon practitioner or priest with an educated, even aristocratic background. Commoners would have been hard put to comprehend this matrix, much less read the Sanskrit, each character of which rests on a lotus dais, framed in a stark white roundel.[1]

This zushi must have served as a personal reliquary and shrine: its size and the scale of the interwoven visual imagery allow private contemplation alone. The two metalwork fittings at the top confirm this viewpoint. A cord attached to them would have allowed the shrine to be suspended around the neck. So, this shrine must have been worn openly on the devotee's body, publicly displayed as such on journeys outside the home.[2] Another noteworthy physical feature of this reliquary is the hole drilled in the lower margin of the central panel that extends into the hidden pair of mandalas. It appears to be an adaptation to the original structure, done to accommodate a wooden peg that supported a small shelf. Currently this arrangement is thought to

have supported a sculpted image, a notion that cannot be confirmed either through the preservation of the shelf or through study of other, related reliquaries.

But documentation does exist for the date (1387): an inscription written on a piece of folded paper found behind the central nickel-plated mirror. Each of the four quadrants surrounding this inscription has a Sanskrit character written in ink on a white paper disc. These characters correspond to four central deities of the Kongōkai realm (Diamond World): Dainichi Nyorai, the Great Illuminator of the Esoteric cosmology, is represented by the radiant metallic Sanskrit form on the front of the shrine; lesser deities are identified in ink on cut paper discs.

The panel paintings on the inside of the doors depict Fudō (right) with his two boy attendants and the three-headed Gōzanze (left). Each stands before a fiery halo on jagged rock islands in a sea of kirikane diadem patterns, gravely framing and protecting this trove of solemn, rich religious messages contained in a modest-appearing lacquered wood box intended to be carried on pilgrimage. One of the five myōō (wisdom kings), Gōzanze appears in the Kongōkai mandala [41] in one of the principal nine assemblies of deities. Additionally, he is considered

the vehicle for Ashuka, one of the four deities that join Dainichi in the Diamond World emblems of the five wisdoms. Fudō, a much more popular deity in medieval Japan, appears with his boy attendants Kongara Dōji and Seitaka Dōji [51]. Both of these wrathful-appearing myōō deities feature prominently in the lower section of the Sonchō mandala [44].

When the zushi is closed, the panels with the wisdom kings are folded in, protecting Dainichi, Shingon's principal deity. Wherever the devotee may go, the shrine bouncing against his chest is a palpable reminder of the wisdom of the faith that promises salvation through a determined exercise in the rituals illuminating the reality of the spiritual cosmos, wherein Dainichi reigns.

Inside, the dark steely blue pigments, rich mineral greens, and red and white highlights bespeak the work of an experienced yamato-e painter, akin to that involved in the larger *Daihannya-kyō* tabernacle some one hundred and fifty years earlier or to

the contemporary who rendered the Nyoirin Kannon painting [49]. The quality and the scale of painting lend an impressiveness to this tabernacle, placing it on a level consistent with the finest Buddhist paintings of the later fourteenth century. Indeed it possesses the heraldic dimensions and sophisticated spiritual elements that can be traced back to the twelfth century. Given the age of the zushi and how it was used, it is a wonder that it has survived in such fine condition. And given its date, it also represents an important art historical landmark in the Japanese Buddhist arts.

1. See *Nara Kokuritsu Hakubutsukan no meihō* (Masterpieces from the collection of the Nara National Museum), exh. cat., Nara National Museum (1997), pl. 32.

2. For another example of this type, see Sekine Shunichi, *Butsu, bosatsu to dōnai no shōgon* (The adornment of Buddhist images and temple interiors), vol. 281 of *Nihon no bijutsu* (Arts of Japan) (Tokyo: Shibundō, 1989), pl. 103.

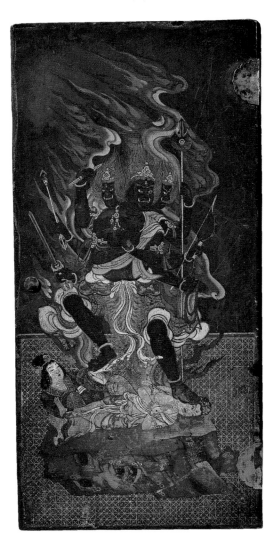

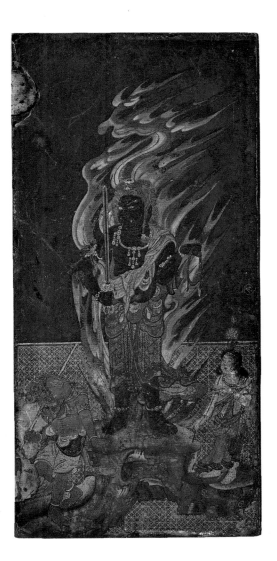

78. Shari

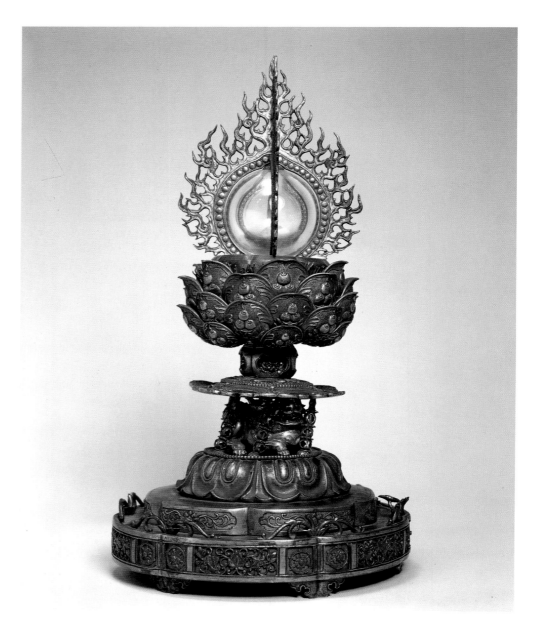

The Kairyūō-ji, known also as the Sumi-dera, is located northwest of Tōdai-ji in the vicinity of the more well-known imperial nunnery Hokke-ji. It has a small compound with a Saikondō (West Golden Hall) and sutra repository still standing from a pre-Kamakura complex including three separate golden halls for devotion. In the eighth century it appears to have enjoyed its greatest patronage, which dissipated until the eminent monk Eison of Saidai-ji in Nara's western precincts sought to revive its fortunes [21, 30, 78]. From that point on, the Kairyūō-ji was associated with the Saidai-ji system of Shingon Buddhism.

This extraordinary shari represents the clearest manifestation of that great prelate's relationship with the Kairyūō-ji in the thirteenth century because, by virtue of craftsmanship, design, and style, it surely belongs to the small group of exquisite thirteenth-century reliquaries still owned by Saidai-ji and its affiliate temple, Chōfuku-ji, also in Nara.[1] What is even more important from an art historical viewpoint is the presence of an inscription on the base plate providing a date of manufacture, the names of the patrons who commissioned the piece, and—remark-

ably—the name of the metalworker who fabricated it. None of the other Saidai-ji reliquaries offers such explicit documentation about its history or origins. It appears that by including his name along with those of other craftsmen, Shirakawa Morisada was acknowledging the creation of a religious object of such technical quality as to be construed as an act of religious piety, much the same way that patrons and sculptors in the thirteenth and fourteenth centuries wrote dedicating invocations placed inside their statuary [29, 31].

Certainly comparison with other thirteenth- or fourteenth-century reliquaries, and the Saidai-ji group in particular, makes the achievement clear. What is more, the technical sophistication of the metalworking evident in these reliquaries is rivaled only by their sublime aesthetic expression.[2] Each structural element and surface design in this Kairyūō-ji shari relates to and builds upon its neighboring components, producing the cumulative rhythms of outlines, voids, and forms that create the overall shape. From the massive pedestaled base to the openwork pattern of dancing flames, the reliquary pulsates with light and energy.

How is it that such an exquisite ritual implement emerges, virtually unannounced, in the early thirteenth century? What were the superb craftsmen making before this commission? And following this shari with the Saidai-ji group, what did they accomplish next? Generally we can say that their studios were helping rebuild the great Nara temple buildings destroyed in the civil wars of the late twelfth century. The restoration of Tōdai-ji and several related temples in the provinces by the monk Chōgen (1121–1206) marks the grandest such project of the era. But although we know a lot about the sculptors involved in these projects, precious little documentation has been recorded relating to the metalworking studio system of the time, a fact that makes this reliquary an even more important object in the history of Japanese "decorative arts" and highlights the significant gaps in our knowledge of the status of craftsmen in medieval Japan.

The appearance of elaborate finely crafted reliquaries in thirteenth-century Nara represents a special occasion in the considerably longer history of reliquaries in Japan. The notion of transmitting relics from or associated with the Historic Buddha or his immediate disciples occurs in both China and Korea at least from the fifth century. Early Buddhist practices and texts in Japan refer to relics as symbolizing the essence of the founder's teachings.[3] During the Asuka and Nara periods repositories for relics and other objects were normally deposited in special containers under the central foundation pole of temple pagodas as a kind of symbolic religious consecration of the architectural monument. The use of glass or crystal containers for these relics, and then later as part of the *zōnai nōnyūhin* (articles inside an image) placed inside Kamakura era statuary, reflects their symbolic potency. The jewel form, the nyoi hōju, evolved out of the stupa shape of the Heian period or earlier. This wish-granting jewel emblem also appears here in groups of three on a small lotus bud on the surface of each of the individually cast lotus leaves. This feature does not appear to occur on any of the other Saidai-ji reliquaries of this era. That it figures prominently in the decor of Heian icons, however, is evident in the pedestal base for the Eleven-headed Kannon [23].

One possible and intriguing idea could be that the two most prominent emblems of this piece, one apparent (flaming jewel) and the other hidden from casual viewing (crouching lion) might well be interpreted as referring to or even signaling to the initiated the presence of Monju (whose vehicle is a lion), a popular deity at the Saidai-ji where both painted and sculpted images are revered [34]. In fact, objects retrieved from a seated image of Monju dated 1302 include a scroll sketch portraying a flaming crystal shari and a lion's head, each set on lotus pedestals with iconographic notations of their specific identities. Thus the reliquary may signify the wisdom of Monju and his close relationship with the Historic Buddha, Shaka.

1. See *Nara Saidai-jiten* (Treasures of Buddhist art from the Saidai-ji, Nara), exh. cat., Nara National Museum (1991), nos. 19–26.

2. See other thirteenth-century reliquaries in *Bukkyō kōgei no bi* (The beauty of Buddhist decorative arts), exh. cat., Nara National Museum (1982), pls. 50, 52, 55, 58.

3. For the Japanese tradition of reliquary usage and its background, see Kawada Sadamu, *Busshari to kyō no shōgon* (Solemnly decorated Buddhist reliquaries and sutras), vol. 280 of *Nihon no bijutsu* (Arts of Japan) (Tokyo: Shibundō, 1989).

Detail of the inscription on the base, giving the date of manufacture, the patrons who commissioned the shari, and the metalworker who made it

79. Stupa-shaped Reliquary

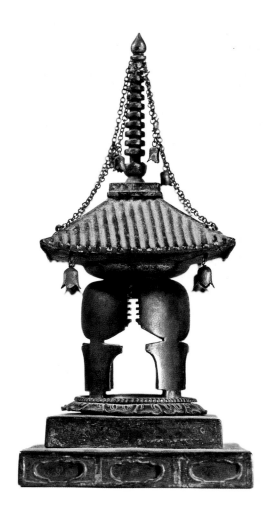

13TH CENTURY; CAST BRONZE WITH
GILDING AND ATTACHED METALWORK;
H. 17.6 CM

The stupa form, like the sacred flaming jewel, represents one of the basic early symbols adopted into early Japanese Buddhist art. Over time various types of stupa shapes came to be used, fabricated out of wood, stone, metal, or glass. The form arises in Japan in close association with narratives relating incidents in the life of Śākyamuni, including his death. Following his death and cremation his ashes were distributed to sites he had visited in his lifetime and placed in receptacles. As Buddhism spread in India these remains were divided, redistributed, and interred in grand monuments made out of stone around which the faithful walked as they prayed.

Such dome-shaped stupas eventually became freestanding architectural emblems of the Historic Buddha, his life, and indeed the Buddhist creed itself. As a multi-tiered architectural form with oval canopies suspended overhead, the stupa migrated across Central Asia to East Asia where different materials— mud, baked clay, cast bronze, wood—were used in construction. Only in East Asia did the dome-shape with rising finials evolve into the multi-storied pagoda and small reliquaries, both of which also symbolized the very existence of the Buddha/Buddhist law at that location [52, 54, 57].[1]

Large-scale as well as miniature temple pagodas in stupa form were made in Central Asia and in Korea during the Paekche and Unified Silla periods and were subsequently introduced into Japan. The textual source for Japanese interest in the pagoda form lies in the *Lotus Sutra,* one of the most revered scriptures in early Buddhist Japan, in which one chapter describes a jeweled pagoda rising out of the ground as Shaka preached to his disciples.

The *tahōtō* (jeweled tower) or stupa-shaped pagoda form did not immediately engage Japan's monastic communities and their patrons except as a reliquary or censor shape

in the eighth century. But beginning in the ninth century, according to historical records, and certainly by the eleventh century the hōtō came into existence as an important receptacle for relics.[2]

Numerous pieces have been excavated, including the one in this exhibition [3], but perhaps the best known are the tall (71.5 cm) sutra container from the twelfth century found on the grounds of Narahara Shrine atop Mt. Narayama in Ehime Prefecture on the Island of Shikoku and the even larger, dated example at the Saidai-ji (fig. 79a).[3] In these reliquaries we can see the architectural and decorative elements of the tahōtō form in the Kamakura and Muromachi periods. The tahōtō shape also began to appear at this time as an important architectural building within Shinto shrine temple compounds [57]. The basic components, whether used as a reliquary container in a burial or as a shrine inside a devotional hall, include the foundation platform, in this case two stages, the lower one of which features kozama designs. The circular body with two or four pairs of door openings follows, and then the roof, nine-stage finial, and the flaming jewel.

The Nara National Museum tabernacle illustrated here is unusual among this tahōtō-shape type in that the doors have been replaced by stupa-shaped cutout openings at the four directional points in the cast body. This novel approach to the classic tahōtō form is interesting because, by their very nature as enclosed repositories, such structures served as protective containers for relics or sacred texts. In this instance those objects (now lost) were visible without restraint through silhouetted windows repeating the symbolism of the stupa as an icon of the Buddha. In this way the contents were continuously in veneration.

1. See *Buddha Shakason* (Arts of the Buddha Shaka), exh. cat., Nara National Museum (1984), 92–131; see also Hiroshima Masahito, *Tō no kenchiku* (The architecture of pagodas), vol. 158 of *Nihon no bijutsu* (Arts of Japan) (Tokyo: Shibundō, 1979).

2. See Kawada Sadamu, *Busshari to kyō no shōgon* (Solemnly decorated Buddhist reliquaries and sutras), vol. 280 of *Nihon no bijutsu* (Tokyo: Shibundō, 1989).

3. See *Bukkyō kōgei no bi* (The beauty of Buddhist decorative arts) exh. cat., Nara National Museum (1982), 53–55, 60–63, and pl. 61.

Fig. 79a. Tahōtō-type reliquary, dated 1284; cast iron with bronze attachments; h. 172.2 cm; Saidai-ji, Nara. National Treasure

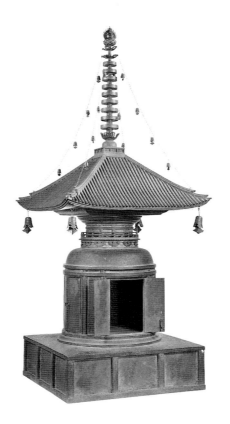

Detail of a tahōtō-type pagoda from the Sannō mandala [57]

80. Nyoi

12TH CENTURY; BRONZE WITH SILVER AND
GOLD GILDING, INCISED DESIGNS, AND
LACQUERED WOOD STAFF; 63.5 X 26.9 CM.
IMPORTANT CULTURAL PROPERTY

The sheet of bronze used to form the top of
this priest's ceremonial scepter was first cut
in the form of a cloud or fungus-like shape.
The edges were then crimped and punched,
creating a distinctive notched pattern reminis-
cent of earlier versions of this type of object
in which two sheets of material were fastened
together. Although difficult to distinguish to-
day, the metalworker next set out to engrave
into the sheet, from behind, a design begin-
ning from the lowest part of the central flange.
There a schematized mountain range appears
from which traditional hōsōge flowers issue
in sprays, rising upward into the curling
flanges. A central, linked hōsōge group in the
center of the composition forms a kind of
floral medallion, augmented by two opposing
phoenixes, viewed in profile. Elsewhere on
the surface, butterflies and birds are visible.
As the engraving technique is particularly
fluid and dynamic in creating accents of lin-
ear breadth and fineness, a lively and subtly
modeled surface results.

Fig. 80a. Nyoi, 10th century; tortoise shell with applied
bronze metalwork; l. 72 cm; Tōdai-ji, Nara. Important
Cultural Property

The bronze sheet was then carefully gilded
with gold and silver, the latter of which has
darkened over time through oxidation. Centu-
ries of use exposed the surface to incense
and oil lamp smoke as well as dust, further
increasing its darkened patination and lead-
ing to the loss of part of the left curl. The
thinness and malleability of the bronze sheet
allowed it to be bent on and around the verti-
cal stem and then pinned to the black lac-
quered handle, which is made of wood and
carved into a thin spatula shape with gently
rounded edges.

In addition to the Shōsō-in examples, five
early nyoi, all registered as Important Cultural
Properties, exist in Japan. The oldest in this
cloud shape is a tenth-century example in the
Tōdai-ji, made from taimai (tortoise shell) with
attached metal decor and a long extended
handle (fig. 80a). This feature is consistent
with earlier suigyū (water buffalo horn) claw-
shaped scepters in the Shōsō-in, formerly at
the Hōryū-ji, and known through variant
shapes in posthumous portraits of high priests
such as the tenth-century sculpture of Rōben
(689–773) at Tōdai-ji. Perhaps the closest
parallel is to a similarly cloud-shaped nyoi
formerly in the Hōryū-ji but donated early in
this century to the Tokyo National Museum.
The date on its back side corresponds to 957.[1]

The surface is gilded and decorated with engraved hōsōge patterns but without the bird, insect, and phoenix imagery of this Nara National Museum example.

The genesis and development of nyoi surface decor during the Nara to Heian periods remain largely unstudied. These objects have long been understood to have an origin in India as a back-scratching tool that gradually evolved within religious institutions into an emblem of spiritual authority used for formal rites and ceremonies. Several dry lacquer and wood portrait sculptures of the eighth and ninth centuries depict eminent priests whose poses indicate they once held a nyoi, now lost, or with a later replacement of indeterminate date (fig. 80b). Among many painted portraits, the fourteenth-century animated image of the priest Kōbō Daishi (643–712) or that of Gyoki (668–749) at Tōdai-ji provide a clear instance of the inclusion of this type of nyoi with a venerated monk's posthumous depiction.[2]

These representations are confirmed by examining two earlier iconographical sources: handscrolls in the Tokyo National Museum (1173) and Shitennō-ji (1163) depicting portraits of the patriarchs of Buddhism.[3] The Shitennō-ji handscroll features high priests of the Tendai sect. Although they are idealized representations of famous personages in Japanese Buddhist history, they also provide evidence for the continuation of a venerable portrait tradition going back at least to the eighth century, if the life-size dry lacquer sculptural portraits of the Nara period are to be believed. The simply drawn ink sketches on the scrolls then can be regarded as a kind of surviving "library" of visual references that priests and professional painters consulted when a portrait image was required.

One especially pertinent detail from the Shitennō-ji handscroll shows Shotoku Taishi flanked by two seated monks (Tendai sect on the left, and Zen on the right), each holding a nyoi related to the Nara National Museum example illustrated here. The one held by the Tendai high priest relates more closely as the handle is short and the cloud shape is compact, rather than flaring. Elaborately painted portraits of Shotoku Taishi also occasionally depict one of his boy servants holding a nyoi of either the suigyū or taimai-shape types. In the former case, one need only go to the

Shōsō-in repository to find several eighth-century examples still extant, made from a variety of materials, all exquisitely formed and decorated.

Finally, a number of objects in the Shōsō-in possess designs or compositions that are helpful in deciphering the engraved design of the nyoi's surface. One is an eight-lobed mirror whose central panel features two opposing phoenixes above a domed tripartite mountain range. Another is the metal openwork keman (see fig. 68a) with bells featuring two opposing phoenixes in a linked floral openwork design with a pair of bouquets closely related to that in this nyoi's design. And the small mirror cover with inlaid mother-of-pearl designs of mountains and flora encircling an elephant helps identify the origins for this type of circling, linked composition that plays such an important role in Nara and then Heian decorative arts.[4] A variant of it appears in the eleventh-century National Treasure keman with karyōbinga figures [68].

1. *Kōgeihin 2* (Decorative arts 2), vol. 5 of *Shinshitei jūyō bunkazai* (Catalogue of newly registered National Treasures and Important Cultural Properties) (Tokyo: Mainichi Shinbunsha, 1980), 305–7.

2. *Tōdai-jiten*, pl. 55, and *Nihon no Bukkyō o kizuita hitobito* (Imagery of the founders of Japanese Buddhism), exh. cat., Nara National Museum (1981), pls. 11, 16, 55, 75–76.

3. *Shitennō-ji no hōinotsu to Shotoku Taishi shinko* (Treasures of the Shitennō-ji and the worship of Prince Shotoku), exh. cat., Osaka Municipal Art Museum (1992), 96, pls. 113–15 and 125–26.

4. Ishida Mosaku, *Shōsō-in to Tōdai-ji* (The Shōsō-in and Tōdai-ji) (Nara: Shōsō-in Gyōbutsu Kankōkai, 1962), pls. 66 (mirror), 135 (keman with bells), 179–81 (nyoi), 309 (elephant).

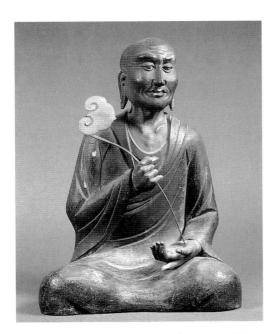

Fig. 80b. Gōyū Kokūzō Bosatsu, 9th century, China; wood with slight color and lacquer; h. 70.1 cm; Tō-ji, Kyoto. Important Cultural Property

81. Shakujō Finial

12TH CENTURY; CAST BRONZE WITH
INCISED DESIGNS; H. 27.9 CM

The monk's staff (*shakujō*) originated in India from the basic walking stick form. Durable yet light, it was a useful support for clerics as they carried their belongings from one religious site to another. At some point, a metal attachment was devised for the top that would create a noise, frightening away insects, snakes, and other worrisome creatures in the Indian landscape.

By the time the shakujō reached Japan via the Silk Road and then through Korea, it had taken numerous shapes, especially the finial. As it developed over the centuries in Japan the shakujō retained a symbolic rather than a functional role within the Buddhist establishment as an emblem of authority, an attribute of a particular deity such as Jizō [27], or a device used by mendicants to attract attention when begging for alms in the villages and cities of the country. Thus its function differed significantly from its use in India as, in part, a kind of warning device, allowing the material to shift from wood and bamboo to metal. The result was a tall slim rod form flaring slightly at the base.[1] The uneven and unpolished surfaces of these early hammered iron rods give them a distinctive character. In eighth-century Japan the staff head became an upside-down heart-shape made from two pieces of steel rod joined together. Metal rings, usually three on each side and each hammered to create two

Fig 81a. Shakujō, 8th century (one
of three such pieces); hammered iron;
l. 161.2 cm; Shōsō-in, Nara

or four sharp ridge lines along the periphery, dangled from the lower lobes (fig. 81a).

From the Nara to Heian periods, the shakujō form, decor, and constituent materials evolved. Cold hammered iron rods were replaced by "white" bronze and then cast-bronze poles bearing engraved designs. Poles came to be cast separately from the upper portion of the staff, which normally included a four- to eight-inch finial, that customarily flared slightly as it approached the point of connection with the staff rod. Eighth-century examples of shakujō with iron shafts and finials cast from bronze or white bronze survive by at least the twelfth century. Then the heavy iron and bronze rods were eventually dispensed with in favor of lacquered wood, and they were usually shorter—oftentimes much shorter, really becoming hand-held objects—than their metallic predecessors.

This Nara National Museum shakujō presents the basic later Heian form and incorporates a central Amida triad image. The three figures, each with double halos, sit on lotus pedestals supported by a base resembling two rising waves with tripartite curls. Actually this form, along with the rest of the finial features, represents highly stylized floral motifs (as is the entire "heart" form of the eighth-century examples). Consequently the imagery in these staff heads is directly related to the decorative floral patterns found in the textiles, lacquers, and related metal objects in the eighth and ninth centuries. There the stems, sheaths, branches, and leaves of plants are clearly delineated and dynamically linked to one another, much like the hōsōge patterns of other Heian ornaments [68, 71, 74]. Viewed in this way the staff head becomes a more coherent visual statement, complete with a structure signifying the unity of the organic world with the spiritual realm of abstract thoughts and emblems.

The Amida triad of this shakujō is unusual, perhaps even unique among shakujō of the period.[2] Other, standing, triads are known, but among Amida triads a seated ensemble linked to one another may exist solely in this finial, which is curiously reminiscent of seventh- and eighth-century oshidashibutsu in format and sculptural style.

1. Chinese paintings, particularly those from Dunhuang, contain scenes showing monks using walking staffs. See Ishida Mosaku, *Shōsō-in to Tōdai-ji* (The Shōsō-in and Tōdai-ji) (Nara: Shōsō-in Gyobutsu Kankōkai, 1962), pls. 183–86.

2. *Kinkō* (Metalwork), ed. Suzuki Tomoya, vol. 24 of *Jūyō bunkazai:* (Catalogue of National Treasures and Important Cultural Properties) (Tokyo: Mainichi Shinbunsha, 1976), 93–95.

82. Kei

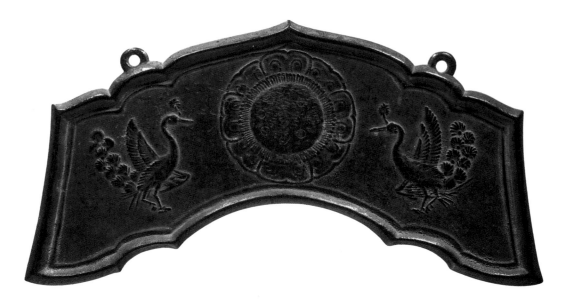

12TH CENTURY; CAST BRONZE WITH TRACES
OF GILDING; W. 22 CM

The Nara National Museum is fortunate to
have a small group of ritual chimes in its col-
lection from the twelfth and thirteenth centu-
ries, of which this example is the most finely
cast and elegantly proportioned. The design
consists of two peacocks seen in profile with
an eight-petaled lotus base between them.

This lotus design appears in nearly all kei,
from early Heian examples to those from the
end of the Kamakura era, an approximately
four hundred year period when the finest ex-
amples were produced. The lotus was by that
time the single most recognizable emblem of
the Buddha, a visual icon that stood by itself
in the earliest ritual chimes now in the col-
lections of the Shōsō-in and Hōryū-ji in Nara
(fig. 82a).¹ As time progressed, tendril and
then more elaborate and encompassing floral
decor in both raised and incised patterns
appeared on the surface to either side of or
surrounding the lotus pod. All embellishment
was confined by a border: a single rounded
band that subsequently evolved into a pair
of raised parallel bands of varying widths,
roundness, and height. Yet in all cases, as in
this example, the inner band never exceeds
the size of the perimeter band, emphasizing

thereby the recessed surface of the kei and
the centrality of the raised lotus pod.

This area of course was the target for the
priest's mallet during services, just as it had
been since the sixth to seventh centuries on
large temple bells in Korea and Japan. Kei
were suspended in their lacquered stands
[83] by colorful braided cords that passed
through the two cast loop holes spaced along
the upper border. The sound produced is
more dull than sonorous and unlike a West-
ern bell tone. Just how this tonal range came
to be accepted in Japan is not clear, nor are
the technical dynamics for producing the
tone. In fact, the size of a kei is more directly
related to the size of the worship hall in
which it was to be used and more specifically
to the space reserved for its stand amid the
related ensemble of ritual furniture placed
just within a hall's bay doors, often directly
facing the principal image of worship. The
kei stand is placed to the right or left of and
parallel with the priest's raised platform so
that the chime can be struck with ease as a
devotional service proceeds. Kei were also
integral to less formal ceremonies associated
with Pure Land sect Buddhism and so could
be placed according to the needs of that
sect's rituals or services (see fig. 83b).²

The origin of the kei shape and its gradual transformation lie in its musical function as a sound-producing object. One theory holds that it derives from the ancient jade plaques of angular shape used in China to produce tones. Sometimes plain, oftentimes inscribed with painted or incised designs, these plaques were suspended in sets from tall stands. They are found as parts of burial goods in ancient Chinese tombs and later as decorative accessories well into the sixteenth and seventeenth centuries.

Another more plausible source for exploring the origins of the Japanese kei lies in early Korean and then Japanese metalworking traditions linked to Buddhist architectural ornamentation, both interior and exterior.[3] We know from archeological material about the various metal ornaments attached to early pagodas and worship halls, including bells with internal clappers having large wind vanes attached to them (see fig. 79a). The shape of these vanes and, particularly, their upper border profile is close to a number of kei shapes and more prominent visually than the internal clapper to which they were joined as part of the bell. The production of a tone associated with an object of this shape provides one path of further inquiry, supported by Heian and Kamakura period reliquary decor.[4]

Another route of inquiry lies with the banners and canopy decorations traditionally displayed in Buddhist temple interiors, the most important of which is the metal *kanjō-ban* canopy of the Asuka period from the Hōryū-ji and other Kansai area temples (see fig. 71a).[5] Although it has lost a number of its smaller lower openwork elements, bead work, and glass beads, at least two (upside-down) V-shaped pendants of the seventh century remain intact. Additionally, some of the openwork patterns on components of the banner as well as line designs engraved into those patterns suggest a decorative vocabulary similar to that found in the later Heian period kei with simple floral decor at the Hōryū-ji, previously cited. The kanjō-ban has other, related, decorative pendant ornamentation, all of which deserve close examination in relation to the origins of the kei form and function.

Another topic of keen interest is the genesis, transmission, and sustained popularity of this kei's decor: opposing phoenixes.

Whether it issues out of religious textual sources, other Buddhist visual imagery [2, 37] or another medium is not clear. But by the twelfth century it had become one of the most commonly used motifs in Buddhist applied arts imagery.[6] While no two kei appear to be cast from the same mold, it is possible to date this Nara National Museum kei in relation to numerous Heian and Kamakura era examples, a few of which are dated. Furthermore the extended narrow shape, large lotus pod, and spacious surroundings for the phoenixes identify it as an early example.

1. For other registered pieces, see *Kōgeihin 1* (Decorative arts 1), vol. 4 of *Shinshitei jūyō bunkazai* (Catalogue of newly registered National Treasures and Important Cultural Properties) (Tokyo: Mainichi Shinbunsha, 1981), 144–55. For the earliest known kei, see *Shōsō-inten* (Exhibition of objects from the Shōsō-in), exh. cat., Nara National Museum (1982), pl.13.

2. See the variety of placement in Priest Hōnen's illustrated biography in Nakano Genzō, *Raigōzu no bijutsu* (Art illustrating Amida's descent) (Tokyo: Dōhōsha Shuppan, 1985), pl. 40.

3. For the reliquary from the pagoda at Songnim-sa temple dated to the eighth century, see *Pul Sari changŏm* (Art of Sarira reliquary), exh. cat., Seoul National Museum (1991), no. 7. See also the metal bell and drum illustrated in the *E-inga-kyō* (Illustrated sutra of cause and effect) handscroll in Kameda Tsutomu, *E-inga-kyō*, vol. 16 of *Nihon emakimono zenshū* (A compendium of Japanese illustrated handscrolls) (Tokyo: Kadokawa Shohan, 1969), 27.

4. See for example Kawada Sadamu, *Busshari to kyō no shōgon* (Solemnly decorated Buddhist reliquaries and sutras), vol. 280 of *Nihon no bijutsu* (Arts of Japan) (Tokyo: Shibundō, 1989), and *Bukkyō kōgei no bi* (The beauty of Buddhist decorative arts), exh. cat., Nara National Museum (1982), pls. 7–9, 53–56, 60–62.

5. See *Hōryū-ji kennō hōmotsu* (Treasures donated from the Hōryū-ji temple), exh. cat., Tokyo National Museum (1996), pls. 129–31.

6. See Sekine Shunichi, *Butsu, bosatsu to dōnai no shōgon* (The adornment of Buddhist images and temple interiors), vol. 251 of *Nihon no bijutsu* (Tokyo: Shibundō, 1989). See also the phoenix-related material in the Shōsō-in, especially among painted lacquerwares and textiles. In Korea the mid-seventh-century temple Hwangyong-sa in Kyŏngju has yielded round metal discs with paired phoenix decor. In *Pul Sari changŏm,* no. 4.

Fig. 82a. Kei, 10th–11th century; cast bronze; w. 25.2 cm, h. 10.2 cm; Hōryū-ji, Nara Prefecture. Important Cultural Property

83. Stand for a Kei

14TH–15TH CENTURY; LACQUERED WOOD
WITH METAL FITTINGS; 50.5 X 52.6 CM

The stands for kei have not endured as well as the ritual chimes they supported, largely because of their shape and material. Made from pieces of joined wood that have been lacquered and adorned with metal fittings, these thin structures are particularly susceptible to deterioration because of continuous exposure and use. This stand is typical of most construction.

The top framing element, or "roof," is carved from one piece of wood. Two rectangular cuts in its underside accept the beveled joints from the vertical members. These joints are not lacquered. Similarly, the long vertical posts are inserted by means of a notched,

hidden tang set into the stand base that, in turn, has been fitted into a large recessed notch cut into each of the feet. The roof is carved into an extended scroll shape, the base of which also arches. The kei was suspended with cords from the two small metal "eye" hooks set into the underside. The striking mallet would have hung from the hook set into the outside edge of one of the vertical supports. A small, butterfly-shaped metal flange, virtually invisible to the laity, adorns this simple hook where it joins the support. Normally the stand is placed in a position pointing toward the altar, close on the right side of the priest's dais to facilitate access to the mallet during services. But it can be placed wherever necessary to accommodate specific ceremonies (figs. 83a–b).

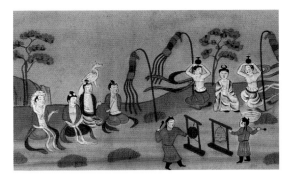

Fig. 83a. Detail of kei and drum stands. From *E-inga-kyō* handscroll: ink and color on paper; Jōbon Rendai-ji, Kyoto. National Treasure

This stand comprises six pieces of wood whose black lacquer surface has acquired a fine patination despite chipping, repair, and insect damage. Based on the relatively wide girth, short proportions of the frame, stoutness of the wood elements, and compact curling form of the roof ends, it is considered post-Kamakura in date.

The Nara National Museum possesses a thirteenth-century kei stand that clarifies this chronology.[1] As with the change in the kei form and the detailing of its perimeter band decor, the shape and size of the top element also provide an important source for gauging their relative chronology. The embellishments of form and surface design imparted to kei stands over the centuries affected their appearance and proportions. Although regarded more as "furniture" and devoid of ostensible Buddhist symbolism, they never achieved the status of a ritual implement, such as the chime itself. Other, related furniture such as tables, and lotus-shaped platforms for displaying Esoteric ritual objects have traditionally been accorded higher status either as singular objects or as part of a set, many of which are registered as Important Cultural Properties or National Treasures in Japan. Unfortunately, even in these historically preserved and treasured temple sets, the original kei stands rarely survive.

1. *Mikkyō kōgei* (Decorative arts of Japanese Esoteric Buddhism), exh. cat., Nara National Museum (1992), nos. 2–8, p. 43; for related furniture, see *Bukkyō kōgei no bi* (The beauty of Buddhist decorative arts), exh. cat., Nara National Museum (1982), nos. 31–47.

Fig. 83b. Detail of a kei and stand as depicted before a Raigō handscroll in a 14th-century temple interior. From the *Illustrated Biography of Priest Hōnen Shonin,* 14th century; one of a set of forty-eight scrolls: ink and color on paper; each scroll approximately 33.1 cm high; Chiou-in, Kyoto. National Treasure

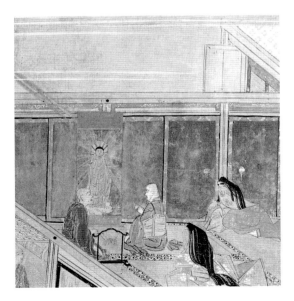

84. Set of Ritual Implements

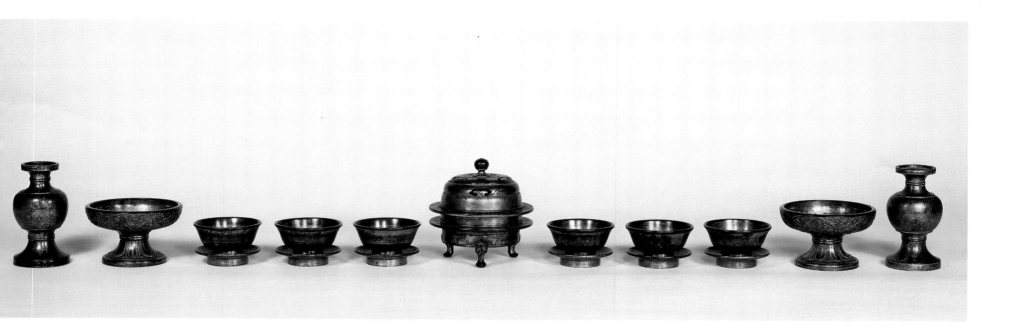

14TH CENTURY; CAST BRONZE WITH INCISED
DESIGNS AND GILDING; INCENSE BURNER:
H. 12.4 CM, DIAM. 12 CM; SIX DISHES: H. 3.7
CM, DIAM. AT MOUTH 7.8 CM; SIX PLATES:
DIAM. 7.8 CM; TWO FOOD DISHES: H. 6.8
CM, DIAM. AT MOUTH 11 CM; TWO FLOWER
VESSELS: H. 11.9 CM; SAIDAI-JI, NARA.
IMPORTANT CULTURAL PROPERTY

Although Esoteric Buddhism in Japan is most
closely identified with the great ninth-century
monks Saichō [15] and Kūkai, in fact a knowl-
edge of Esotericism was already in place in
the Nara period. The Tendai and Shingon sect
teachings actually issued from scripture, com-
mentary, and ritual that had existed in China
for centuries. Evidence of its arrival in Japan
prior to their successful leadership in popu-
larizing Mikkyō exists in a variety of sources,
including written documents, Buddhist imag-
ery, and some enigmatic ritual objects.[1]

Most familiar are the extraordinary dry lac-
quer sculptural images of Jūichimen Kannon
that remain in situ in mid-eighth-century

temples in Nara and the surrounding regions.
These are complemented by such pieces as
the monumental Fukūkenjaku Kannon in the
Sangatsudō at Tōdai-ji and the even earlier
wall painting of Jūichimen Kannon that once
graced the interior of Hōryū-ji's Kondō. In
the Shōsō-in treasury, records identify cere-
monies that took place—for example, seeking
the restoration of health to a member of the
imperial family—in which reference is made
to ritual objects and an altar or dais needed
for the occasion. Fragments of wrapping
cloths with identifying labels written in ink
on their exterior surface still survive at the
Shōsō-in; these cloths are believed to corre-
spond to those written records.

Among the objects stored in the treasury
that provide insight into a ritual object tradi-
tion in early Japan are three-pronged sankōshō
related to the later gilt-bronze versions that
appear in numerous paintings or as surface
designs in the metalwork and textiles in
this exhibition. These sankōshō have been
carefully cast from steel and bronze alloys

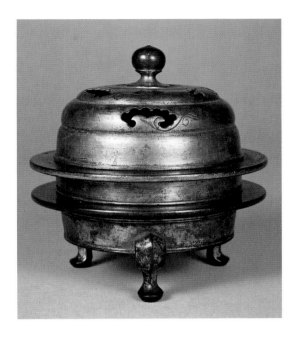

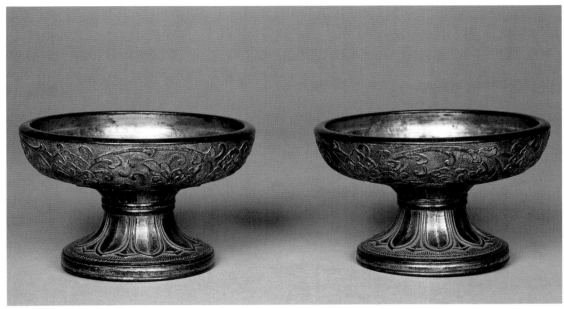

and, also important, have been found elsewhere in Japan in small numbers, often in remote locations suggesting their use in rites combining Shinto kami worship with nascent Buddhist ritual.

Fortunately Kūkai, Saichō, and their successors left documents, even inventories, of their belongings as well as donations of personal objects to their institutions. Among them the paraphernalia of daily life and temple ceremony emerge to record the importance of ritual implements that were held in the hand or, less frequently, set on a platform. In some instances it is believed that these pieces can be identified today.

Also of special note was the discovery early in this century of a complete altar ensemble retrieved from a pond located within the sacred precincts of Kumano shrine near Nachi waterfall. Itself long considered the residence of a kami whose counterpart in the honji suijaku system of representation is Senju Kannon [48], this Nachi ensemble comprises an Esoteric mandala of nearly seventy pieces

with the Dainichi Nyorai of the Kongōkai mandala (Womb World) at the center [41]. Datable to the first half of the twelfth century, it confirms the fundamental shapes, types, placements, and overall altar organization that continue to be used today at Esoteric temples throughout Japan.[2]

The dais from which this abridged set comes is square, as is typical, its sides carved with double lotus leaf designs that are broad and deeply carved. It could rest on a plain black lacquered base or on a base with kozama designs and incised gilt-bronze fittings [85] but in either style is only about 30–35 centimeters high, comfortable for access and viewing by those kneeling before it. Along each of the sides of the altar top and set 10–15 centimeters back from the lotus leaf edge, a sequence of gilt-bronze vessels is placed in line.

Fig. 84a. Altar platform and Esoteric ritual implements; altar: 13th century, lacquered wood, 183 x 183 x 45.1 cm; implements: 14th century, gilt bronze; Saidai-ji, Nara. Important Cultural Property

The sequence of pieces begins at the center of each side of the dais with a kasha and then proceeds in both directions with three small offering dishes (each with its own pedestal), a food bowl with a raised foot, and a flower holder. Other vessels and hand-held implements occupy the interior surface of the altar, forming a symbolic mandala such as the Taizōkai or Kongōkai. Thus this group represents one discrete unit of the ceremonial utensils necessary for performing Esoteric ritual on a specific altar at the Saidai-ji (fig. 84a).[3]

A number of impressive black lacquered daises can be found in the various halls at the temple, the best known of which is the hall dedicated to Aizen Myōō [30], one of the priest Eison's most favored deities. That altar is dated to the fourteenth century, somewhat later than the two superb early fourteenth-century examples in the Takuchōdo hall at the Murō-ji outside Nara and the dated (1289) altar at the Hōryū-ji.

This set of offering vessels dates to the fourteenth century, based on the individual shapes and the cast and engraved decor on the censor. The two food dishes, whose floral surface designs reflect earlier, Heian period metalwork decor, are especially noteworthy. They may therefore have been made after the other utensils. But there is also the view that all were made as part of a set that has fortunately remained intact together with the other three side sets, a rare occurrence given the extended use of the pieces and a traditional pattern of sharing and dispersal to individual priests as well as affiliated temples in the Esoteric system, and specifically within the Saidai-ji network of Shingon temples.

The placement of the dais also shifted according to the needs of a particular ceremony, the size of the hall needed, and related conditions (fig. 84b). In some instances it is clear that two daises were required when the Ryōkai mandalas [41] were displayed for a rite with a dais placed in front of each mandala. The platforms were thus placed inside the main hall to the right and left of the central bay entrance. Currently the two daises at the Murō-ji provide the most reliable arrangement for understanding their placement within a worship hall.

1. See Sakata Munehiko, *Mikkyō hōgu* (Liturgical objects of Japanese Esoteric Buddhism), vol. 282 of *Nihon no bijutsu* (Arts of Japan) (Tokyo: Shibundō, 1989).

2. See *Mikkyō kōgei* (Decorative arts of Esoteric Buddhism), exh. cat., Nara National Museum (1992); see also Ishida Mosaku, *Mikkyō hōgu* (Liturgical objects of Japanese Esoteric Buddhism) (Tokyo: Kōdansha, 1965), pls. 1, 592–96.

3. For the entire ensemble, see *Nara Saidai-jiten* (Treasures of Buddhist art from the Saidai-ji, Nara), exh. cat., Nara National Museum (1991), 42, 45; see also *Mikkyō kōgei*, 117.

Fig. 84b. Detail of temple interior showing ritual elements. From the *Illustrated History of the Ishiyama-dera*, early 14th century; handscroll, one of a set of seven: ink and color on paper; 33.3 x 1753.5 cm; Ishiyama-dera, Shiga Prefecture. Important Cultural Property

85. Three-legged Table

15TH CENTURY; LACQUERED WOOD WITH
METAL FITTINGS; 43.3 X 42.2 CM

Although this table is neither as old nor as ornately decorated as several of its predecessors among Buddhist furniture, it nevertheless is a classic. It is composed of half a dozen principal pieces of carved wood, and its proportions, lines, and weight make it a particularly fine example of an offering table.

The genesis of this shape among Buddhist furniture remains obscure. The earliest surviving versions in Japan can be dated confidently to the late Heian period, around the eleventh century, and are so accomplished in fabrication and inlaid mother-of-pearl decoration as to suggest a much longer tradition of use for this object in the history of Buddhist furni-

ture. Known as *sagiashi* (heron-legged) "butterfly shape" tables, they have tall, elegantly curved legs that gently splay away from the surface they support, creating a lithe, animated sculptural form out of a negligible amount of crafted wood.

Three primary examples survive, all of which are registered cultural properties. The most well-known is the sturdy Kamakura period example in the Kongō-ji, an important Esoteric temple between Osaka and Wakayama (fig. 85a). Slightly taller than this Nara National Museum example, virtually all its anterior surfaces are covered with inlaid mother-of-pearl insect, hōsōge, and other floral patterns. Narrow gilt-bronze panels with engraved floral designs on a nanakō ground are mounted along the horizontal borders and cap the table

feet, adding structural support and protection from wear. This decorative schema is related to the late Heian period four-legged table at the Daichōjūin subtemple of the Chūson-ji complex in northern Japan.[1]

Another contemporary three-legged table of this style in Heian decorative arts is the butterfly-shaped table of unknown provenance now belonging to the Hakutsuru Museum in Kobe.[2] It is taller than any other three- or four-legged tables of the twelfth to fourteenth centuries, which emphasizes the extraordinarily light, graceful form created by the "heron" legs and narrow moldings.

This Nara National Museum example follows the natural evolution of this butterfly table form from the Hakutsuru to Kongō-ji examples. Eschewing elaborate surface decorations, it relies entirely on shape for visual appeal. The three legs are thinly carved and attach to the table top by means of pegs that fit into holes drilled into the table top. Separately carved moldings are glued to the legs and create the four perforated kozama openings characteristic of Japanese Buddhist furniture design [76, 79]. The principal structural support is a sturdy 10-cm wide lacquered board spanning the underside of the top to prevent warpage.

These tables, like their four- and eight-legged relations, were actively used in devotional halls, usually placed directly in front of the central sculptural icon as part of a small assemblage of furniture that included rectangular side tables, the kei and its stand [82–83], and a raised dais for the officiating priest. Ritual implements of ceramic, lacquer, and metalwork were placed on top of the table surfaces, within easy access of the celebrant.[3]

Some emakimono of the thirteenth to fifteenth centuries depict temple interiors, showing how and in what configurations Buddhist furniture was used (fig. 85b). It is also possible to understand the particular status given the three-legged table within this context by considering their depiction on the elaborately embroidered textile hanging scrolls known as shūbutsu, one of which is in the exhibition [73]. It depicts the butterfly table as the platform for several gilt-bronze ritual implements, the central one being a censor [86]. Another shūbutsu, depicting Shaka and Amida, in the Fujita Museum of Art in Osaka contains an unusual table setting with a seated Monju

framed by two tall-necked flower vases [87]. And in this example, without any kozama decorative panels, we learn the existence of another type of butterfly table form that has not survived.[4]

The butterfly form appears throughout Buddhist decorative arts, and it became a staple of the secular art repertoire, particularly after the sixteenth century. In Heian and Kamakura metalwork it appears as the principal decorative feature for the support device on keman [68], ban [71], sutra wrappers [74], and kakebotoke [66]. It also appears on objects preserved in the Shōsō-in since the eighth century.

1. *Chūson-ji ōgon hihō-ten* (Exhibition of hidden treasures from the Chūson-ji), exh. cat., Sendai City Museum (1993), pls. 111–12.

2. *Kōgeihin 2* (Deocrative arts 2), vol. 5 of *Shinshitei jūyō bunkazai:* (Catalogue of newly registered National Treasures and Important Cultural Properties) (Tokyo: Mainichi Shinbunsha, 1983), 16–17.

3. See for example Tsukamoto Yoshitaka, *Hōnen Shōnin eden* (Illustrated biography of priest Hōnen Shōnin), vol. 13 of *Nihon emakimono zenshū* (A compendium of Japanese illustrated handscrolls) (Tokyo: Kadokawa Shōten, 1961), pl. 12.

4. Fujita Museum of Art, *Illustrated Catalogue: Arts and Crafts* (Kyoto: Benridō, 1954), pl. 69.

Fig. 85b. Detail showing a three-legged table. From the *Illustrated Biography of Priest Hōnen Shonin,* 14th century; one of a set of forty-eight scrolls: ink and color on paper; each scroll approximately 33.1 cm high; Chiou-in, Kyoto. National Treasure

Fig. 85a. Three-legged table, 13th century; carved wood with black lacquer, inlaid mother-of-pearl, and metal fittings; h. 45 cm; Kongō-ji, Osaka Prefecture. Important Cultural Property

86. Kasha

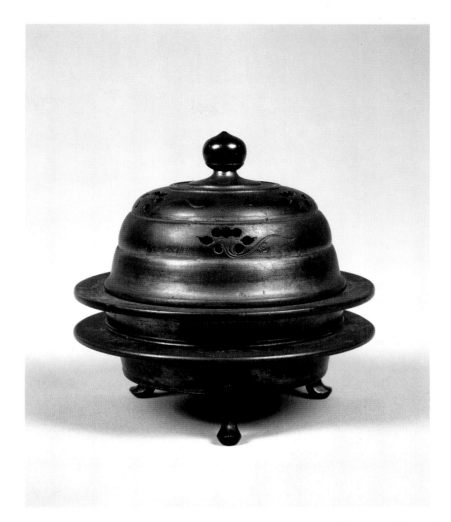

13TH CENTURY; CAST BRONZE WITH INCISED
DESIGNS AND GILDING; H. 10.3 CM, DIAM.
10.7 CM

One of the objects constituting the standard
set of Esoteric ritual objects, the kasha nor-
mally occupies the central position on an
altar table, flanked by a pair of kebyō [87],
two food stands, and a set of six small offering
dishes [84]. Other configurations, particularly
in Pure Land sect temples, place the kasha
along the back edge of an altar table, near
the surface of a Raigō image [72]. Normally
only one set of objects is used, and the con-
figuration adjusts according to the size and
shape of the lacquer altar table.[1]

In a typical Mikkyō setting with the Dia-
mond World and Womb World mandalas
displayed, incense burners occupy the central
position along each of the four altar dais
sides. This can be seen in the well-preserved
Murō-ji and Saidai-ji sets and in numerous
later groupings. Important variations of this
arrangement occur in smaller rural Esoteric
temples away from the metropolitan centers
of Buddhist learning in Nara and Kyoto. But
these censors can also date to the later Heian
period, the time at which identifying shapes
and configuring ritual object sets coalesced
in Japan, forming a truly indigenous presenta-
tion of ritual and form [44, 56].

Basically censors can be divided into three
categories: the stationary three-legged type;
the suspended globe with openwork designs;
and the hand-held variety. The last is known
in early Chinese, Korean, and Japanese ex-
amples and features prominently in portraits
of eminent monks. Examples of the hanging
globes occur in the Shōsō-in and Japanese
museum collections possessing Tang dynasty
gilt-silver bronzes. Other pieces have been
recently excavated in China. The stationary
or altar censor derives from a ceramic and a
stone prototype that features three legs sup-
porting a shallow basin. Oftentimes these legs
are fashioned with clawed feet and demon
or fantastic animal masks where they attach
to the body.[2]

In the Esoteric tradition of ritual objects, the censor has a domed lid that nests onto the body just where a flat rim or lip flares out from the body wall. The early kasha form emphasized the low platform from which the broad domed lid rose in a series of three gently rounded bands, culminating in a finial of lotus bud shape. Perforations in the lid at the upper two bands were aligned to offset one another, thereby allowing for a more pleasing visual effect when the perfumed incense clouds spewed forth from inside the body.

By the end of the Heian era or perhaps toward the beginning of the Kamakura period, two additional features were added to the kasha, one practical, the other aesthetic. The practical feature, an intermediate tray, had a perforated base to allow spent ashes to fall away from burning incense coals, thereby increasing efficiency and the longevity of the burn. The shallowness of the tray of the Saidai-ji incense burner [84] indicates a relatively early date in the fourteenth century for this piece.

The aesthetic component depends in large part on the wall height of the tray relative to the overall form and the dimensions of the flaring lip in relation to the tray lip below. Other, mid-Kamakura examples exhibit cast or cold-cut lotus petal designs applied to these surfaces. The most obvious alteration in decor of such kasha, however, is in the more elaborate attention given to the perforations in the lid. Together with the incised lines used to suggest drifting cloud shapes, these holes add an appealing decorative feature to the overall form, imparting a note of lightness to the composition with regard to shape, proportions, and jewel-shaped lid knob. Thus the example illustrated here precedes the Saidai-ji piece in date.

The use of burning incense to honor Buddha, dissipate foul worldly smells, and provide a perfumed offering to a deity has a long history in Asia, one recorded in ancient sutras as well as commentaries. In Japan this early association with Buddhist (and Shinto) notions of purification, cleansing, and gaining merit intensified the pursuit of fragrant woods throughout Asia. Pieces of such wood became so highly valued that they were carefully recorded and preserved in temple storerooms and in the Shōsō-in as well.[3] Likewise, Buddhist sculpture carved from such imported fragrant wood, or even carved from domestic stock in a similar style, took on enhanced meaning [23–25, 32]. The connoisseurship of fragrant woods and then the incense derived from them was a prized talent in Nara and Heian Japan and then in subsequent eras. Like the better-known tea ceremony, the identification, preparation, and presentation of incense is considered an art form in Japanese culture to this day.

1. See Nakano Genzō, *Raigōzu no bijutsu* (Art illustrating Amida's descent) (Kyoto: Dōhōsha Shuppan, 1985), pl. 40.

2. Sakata Munehiko, *Mikkyō hōgu* (Liturgical objects of Japanese Esoteric Buddhism), vol. 282 of *Nihon no bijutsu* (Arts of Japan) (Tokyo: Shibundō, 1989), pls. 18, 124–28.

3. See for example *Shōsō-inten* (Exhibition of objects from the Shōsō-in), exh. cat., Nara National Museum (1997), nos. 62–63.

87. Pair of Kebyō

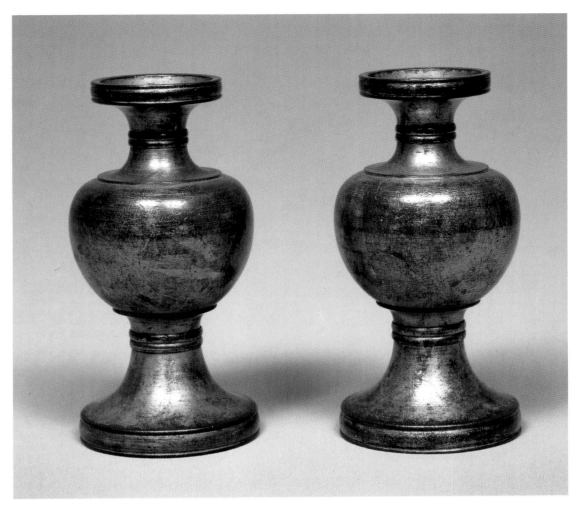

14TH CENTURY; GILT BRONZE; H. 20 CM

Heian period paintings dating from the eleventh century onward provide fascinating information concerning the materials, appearances, and functions of flower vessels in Japanese culture. Although such vessels are known and have been recorded even earlier in Tang China and Nara period Japan, during the Heian period the use of kebyō proliferated and they took many forms.

The eighth-century vessels found in the Shōsō-in repository or depicted on the murals in the grottos at Dunhuang portray a footed ceramic vessel of uniform shape that tapers as it rises toward a wide flaring mouth with a raised lip. Although the proportions and articulations of one body element to another vary, as might be expected, this form appears to have been standardized. It can be seen in Heian Japan as both imported glazed Chinese ceramics and bronze vessels. Dutifully copied by Japanese potters working at the Sanage kilns outside present-day Nagoya, the shape appears as a bronze vessel holding flowering peonies in a frontispiece illustration of a handscroll from the Heike Nokyō set dated 1164 at Itsukushima Jinja outside Hiroshima.[1]

By the end of the Heian period this vessel shape had been modified to emphasize a distinct pedestal base with raised foot that rose to meet a decidedly bulbous body. A tall slender neck issued from the body, flaring into a wide mouth with short lipped sidewalls. The form can be seen in some of the imagery in Buddhist sculpture and paintings (and their mountings) in this exhibition [31, 44, 50, 73] as well as in the two gilt-bronze late Kamakura period examples illustrated here. Heian period ceramic flower containers, sometimes covered with a rich iron-brown glaze, have been excavated from ancient grave sites and former temple grounds, confirming the fundamental shape in metalwork and the pattern of use in Buddhist Japan.

Detail showing a kebyō, from Aizen Myōō hanging scroll [50]

As ritual vessels used in temples daily, gilt-bronze kebyō of this size and type were typically placed on a black lacquer stand or table together with food offering dishes, a kasha [84, 86], and occasionally a ritual tray (*kongōban*) with its accompanying bell (*tōrei*) and, in Esoteric sect temples, sankōshō. For other occasions such as visits by dignitaries, memorial services, or private services at one's own chapel or family residence, they were frequently used in pairs and seem to have been produced as such at the foundries. Illustrated handscrolls of the Kamakura and Muromachi periods provide useful information concerning the various shapes, sizes, and settings for them in medieval Japan.

The elaborately embroidered Buddhist hanging scroll in the exhibition—presenting Amida, the deity presiding over the Western Paradise, in the form of its Sanskrit "seed" character [73]—provides another specific and unusual glimpse of the more private function of such flower containers. These two kebyō are traditionally said to form an original set with the previous censor [86]. Their shape does reflect an earlier Heian norm, as attested by the Shōfuku-ji (Hyōgo Prefecture) pair, registered as an Important Cultural Property.[2] And they surely can be placed close to the

time of the Hōryū-ji examples, dated 1302.[3] Yet the particular shape of the kebyō depicted on the three-legged table in the Amida embroidered scroll can be confirmed in the thirteenth century by the set in the Iwaya-dera in Aichi Prefecture (fig. 87a).

1. For a reproduction of this handscroll as well as a fine discussion of the origins and development of these vessels, see *Hana no utsuwa* (Flower containers), exh. cat., Izumi Kubōsō Kinen Bijutsukan (1994), 48–53.

2. *Mikkyō hōgu* (Liturgical objects of Japanese Esoteric Buddhism), exh. cat., Nara National Museum (1965), no. 457.

3. *Mikkyō kōgei* (Decorative arts of Japanese Esoteric Buddhism), exh. cat., Nara National Museum (1992), no. 124.

Fig. 87a. Pair of kebyō, 13th century; gilt bronze; h. 12.5 cm; Iwaya-dera, Aichi Prefecture. Important Cultural Property

Japanese Buddhist Art: Alive in the Modern Age

JOHN M. ROSENFIELD

The introduction of Buddhism into China [Korea, and Japan] from India . . . was one of those stupendous revolutions, like the carrying of Christianity to the Gentiles, which . . . bring humanity to pay common tribute to spiritual forces. How profoundly Chinese and Japanese civilization in general, and art in particular, were gradually transformed by this quiet, pungent, influence has never been written by any native scholar, and hardly even conceived by any European.

—Ernest Fenollosa (1912)[1]

The recognition of Buddhist sculptures, paintings, and ritual implements as "works of art"—objects of aesthetic enjoyment, subjects of historical inquiry—was one of the radical cultural changes generated by the modernization of Japan.[2] In the 1880s sacred images were being quietly taken from temple altars and placed in government museums or sold to private collectors in Japan and abroad. Only fifteen years earlier such objects were being destroyed or discarded as rubbish in a violent persecution of the Buddhist faith.

Rapid and contradictory changes of this kind occur often in societies undergoing the great stresses of industrialization and the loss of traditional values. Buddhist images had indeed become pawns in disputes raging among Japanese ideological camps at the beginning of the Meiji period. The Buddhist community was vilified by its ancient Confucian and Shinto rivals and by those who, under the slogan of "Civilization and Enlightenment" (bunmei kaika), sought to adopt Western values. In less than a decade, however, the attacks ceased, the Buddhist

community began to reconstitute itself as a modern and universal creed, and the government made Buddhist arts the symbols of a proud, outward-looking Japan. Ironically enough, the price paid by Japanese Buddhism for its own survival was the erosion of belief in its mystical precepts and ancient legends.

The rehabilitation of Japanese Buddhism took place in a postreligious intellectual climate. The oligarchy controlling the Meiji regime committed the nation to rapid modernization under slogans such as "Rich Country, Strong Military" (fūkoku kyōhei).[3] Industrial technology and the empirical sciences spread rapidly, and Japan experienced one of the chief cultural characteristics of the modern age, the collapse of the intellectual and political authority of organized religion. The divine forces once thought to be the matrix of all being came under challenge in Japan as elsewhere in the industrialized world—as reflected in the enigmatic, unforgettable phrase of Friedrich Nietzsche (1844–1900), "God is dead!"[4] For Nietzsche, religion had ceased to be the central force molding the outlook of humankind; instead, the arts became "the greatest stimulant to life," "the secret to the innermost being of the world." Of Christianity, the creed that fostered so many of Europe's greatest artistic achievements, Nietzsche said that it had been "gruesomely . . . wafted to us, as if out of the grave of a primeval past! Can one believe that things of this sort are still believed in?"[5]

Like altar paintings removed from churches to the galleries of the Louvre or Uffizi, Japanese Buddhist arts came to be prized for their aesthetic qualities, not for the holy mysteries or metaphysical goals that had originally in-

spired both artists and patrons. But even today, when Buddhist scrolls and statues are displayed in museum galleries (like creatures in a zoo, far from their original environments), the finest examples embody craftsmanship so skilled, proportions so consonant, and decor so eloquent that they convey the profound depths of Buddhist insight and the spiritual exaltation experienced by the original devotees.[6]

Among works in this exhibition, the magnificent twelfth-century painting of the savior bodhisattva Jūichimen Kannon [45] is an appropriate example of the transformation of cult objects into works of art and their migration from sanctuaries to private homes to museums. The earliest documentation about the painting indicates that it once belonged to a now-extinct temple, Denshō-ji in the Tatsuta District of southern Nara Prefecture.[7] As long ago as 1821, however, the painting had been transferred to the nearby ancient Hokki-ji, famous for its eighth-century pagoda.[8] In the early Meiji period the painting was acquired by none other than Inoue Kaoru (1836–1919), one of the leaders of the Civilization and Enlightenment movement, a powerful figure in Meiji political affairs and an energetic but somewhat erratic collector of works of art. The painting seems to have been much coveted by others, and in the 1890s Inoue sold it to his close friend, the businessman Masuda Takashi (1848–1937), a serious private collector of Buddhist art (Masuda's activities are further discussed below). After Masuda's death, the painting was acquired by the Hinohara family in Tokyo and registered as a National Treasure. Long considered one of the very finest of its era, it was recently purchased by the Japanese government and consigned to the Nara National Museum.

The head and body of the deity seem to glow with an inner light when seen against the darkened background, an effect produced by the application of white lead pigment on both the back and surface of the silk and by the brushing of delicate flesh tones on the surface. Harmonic rhythms are generated by the catenary curves of scarves and sashes draped over the body. Robes, painted in cinnabar red and malachite green, are adorned with skeins of flickering light that emanate from the patterns of finely cut gold-leaf. The lavish lotus throne and strings of jewels add

to the air of opulence. Emerging from the crown are the small heads that symbolize Jūichimen's vast power; the serenity and impassivity of the face befit the bodhisattva's ability to assume any form or transcend any obstacle in order to assist humankind. In this painting the aesthetic resources of Japanese Buddhist art reached an apogee of subtlety and refinement.

Traditional Purposes of Buddhist Art
From ancient times in India, Buddhist doctrine has indeed decreed that ritual and votive objects be imbued with high aesthetic values. Sculptors were advised to employ materials of the greatest rarity and value: sandalwood, silver and gold, ivory, and precious jewels. Painters should obtain the finest brushes and pigments, silks and papers. Even so, a clear distinction has always been drawn between objects made for religious purposes and those appreciated for their aesthetic qualities alone—craft goods, for example, or decorative paintings.[9] In Japan there is ample evidence from early times that educated persons were fully aware of the beauty of religious art and lavished great resources on it.[10] But there is no evidence that they removed such objects from ritual settings for purposes of private delectation.

In principle, art forms made for Buddhist religious purposes were sharply separated from those intended for secular contexts. Occasionally, however, the boundary line between them may appear to be blurred. This is especially true of works produced by monks of the Meditation School (called Chan in China, Zen in Japan), who deliberately mixed secular with ecclesiastical modes of expression. Even so, the distinction is a basic one, and it was clearly observed by an official survey of the Japanese national artistic patrimony completed in 1800, *Shūko jisshu* (*Ten Categories of Antiquities*).[11] To be sure, most of the nearly two thousand objects in the survey belonged to Buddhist temples: calligraphies, portraits of famous patrons and monks, bronze bells, and rubbings from engraved stone steles. They were selected, however, for their historical associations, not for their religious significance. A few paintings of Buddhist deities were also included, but these were prized because they were attributed to famous artists: the near-legendary Wu

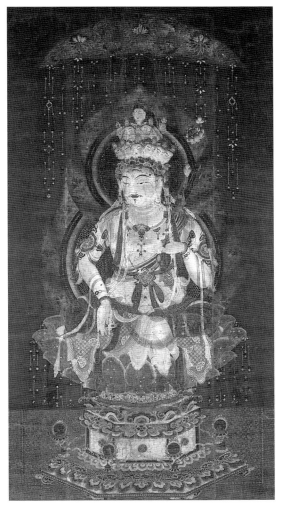

Detail of the savior bodhisattva Jūichimen Kannon, as depicted in the Nara National Museum's 12th-century hanging scroll, a National Treasure [45]

Fig. 1. *Kannon,* by Wu Tao-tzu; 154.5 x 57.5 cm; Daitoku-ji, Kyoto. Woodblock illustration from *Shūko jisshu (Ten Categories of Antiquities)*

Fig. 2. *White-Robed Kannon,* by Mu Ch'i; 169.1 x 99.9 cm; Daitoku-ji, Kyoto. Woodblock illustration from *Shūko jisshu*

Fig. 3. *Shōkannon,* c. 720; bronze, formerly gilded, h. 188 cm; Yakushi-ji, Nara. National Treasure

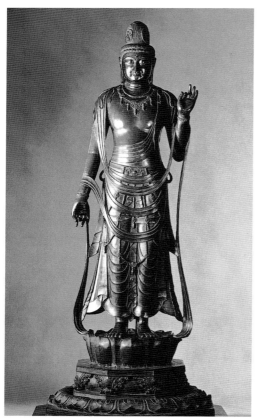

Tao-tzu (act. ca. 720–760) (fig. 1), the Tang court master, for example, or Mu Ch'i (d. after 1279) (fig. 2), the Ch'an monk whose secularized ink paintings were much prized in Japan. Deemed irrelevant to this project were the purely votive statues and paintings that now provide foundation stones for the history of early Japanese art: the exquisite bronze sculptures of the early eighth century at Yakushi-ji in Nara (fig. 3), for example, or the vast painting of Amida and the host of heavenly figures now preserved on Mt. Kōya (fig. 4). Not one such image was illustrated in *Ten Categories of Antiquities.*

Buddhist sculptures and paintings had been commissioned for metaphysical, idealistic goals: to spread the Buddhist dharma, to promote the well-being of emperor and empire, or to represent the powers and majestic splendors of the Buddhist pantheon. Others had been commissioned for more personal reasons: to aid the rebirth of a deceased parent in paradise, to cure an illness, or to bring good fortune to the donor. Underlying all such projects, however, was the intention to create a visual atmosphere in which the devotee would, in this life or another, realize the ultimate goal of all Buddhists: nirvana—the attainment of psychospiritual equilibrium and release from the cycle of rebirth. Such works were never intended as decoration in homes or palaces; their beauty was seen only as an adjunct to higher, metaphysical purposes.

Persecution
Buddhism is the oldest of the world's three major international religions (the other two being Christianity and Islam), and at the dawn of the modern era it was everywhere in a parlous, infirm condition. In India, its birthplace, it had died out more than a millennium earlier; in East Asia it had been more recently supplanted at the center of state values by resurgent Confucianism. In fifteenth-century Korea, for example, the Chosŏn dynasty ended its support of Buddhist temples, confiscated their lands, and severely restricted the number of clerics.[12] In China the Throne remained a loyal supporter of the faith, chiefly in its Tibetan Lamaist form, but Buddhism had absorbed so many folk beliefs that it was often accused of being merely a funerary cult engulfed in superstition.[13]

In Japan the Tokugawa regime had supported the Buddhist community with income from tax lands. In return it required Buddhist sanctuaries to maintain population registries and to provide elementary schooling for commoners. It was Confucianism, however, that the regime promoted as its official ethical creed. The core of Japanese higher education—promulgated by the official Confucian academy in Edo, by the regional domain schools, and by countless private academies—was the ancient Confucian precept of loyalty and service to family and state.[14] Furthermore, strict government supervision of the Buddhist community tended to stifle its growth and intellectual vitality, and as a consequence, new folk religions flourished in the nineteenth century in response to the needs of commoners.[15]

As early as the 1660s, severe attacks on the Buddhist community had been launched in widely scattered districts.[16] Ultranationalists and Japanese Confucian scholars made essentially the same accusations that were wielded against Buddhism when it first entered East Asia fifteen hundred years earlier: that it was an alien creed incompatible with national traditions; that it was focused on irrational goals; that it was contemplative and passive, devoted to the salvation of the individual at the expense of the social order; that temple lands and riches were a serious drain on the nation's economy; that the clergy were social parasites who ignored the strict rules of Confucian morality. Such arguments reached a crescendo in the decades preceding the collapse of the Tokugawa government.

When the Meiji regime took power in 1868, it immediately severed the long-standing connections between the Throne and the Buddhist faith (especially the Tendai sect). Declaring the native Shinto creed to be the basis of state ideology, it established a Shinto Office as one of the highest organs of government. On 10 April of that year the Council of State issued an edict forbidding the teaching of Christianity and ordering the removal of all Buddhist paraphernalia and personnel from Shinto sanctuaries. Buddhist temples were closed for miles around the Ise Grand Shrine. Dedicated primarily to the Sun Goddess, ancestor of the imperial line, Ise was a focal point of the cult of the divinity of the Japanese monarch. Kōfuku-ji in Nara, tutelary temple of the aris-

Fig. 4. *Descent of Amida and His Host,* 12th century; triptych: polychrome and gold on silk; 210 x 421.5 cm overall; Yushi Hachimankō Juhakko-in, Kongōbu-ji, Wakayama Prefecture. National Treasure

tocratic Fujiwara clan, was obliged to dissolve its alliance with the adjacent Kasuga Shrine, with which it had been closely linked for more than a millennium. (In the handsome Kasuga mandala [54], the shrine may be seen on the hillside with a Buddhist pagoda in the foreground.)

The harassment extended far beyond Buddhist-Shinto relations; in the next ten years or so, an estimated four-fifths of Japanese Buddhist sanctuaries were closed, most of them small rural temples. The clergy was reduced in number by perhaps two-thirds, and countless statues and paintings were destroyed, sold, or treated as rubbish (fig. 5). Most damaging of all was the confiscation of the agricultural estates once assigned to temples as sources of income. Kōfuku-ji, reduced to penury, sold off land now occupied by the Nara National Museum, the Nara Hotel, and prefectural government buildings. It offered its Five-Story Pagoda for sale for fifteen yen; a potential buyer sought to burn it in order to salvage the metal fittings, but the town refused permission, fearing that the fire might spread. The pagoda was spared for this reason alone.

In the most intense period of persecution, which lasted barely five years, destruction was widespread, but it received remarkably little documentation. A vivid account, however, describes the pillaging of the Hiei (or Hiyoshi) Shrine near Kyoto, one of the richest and most important sanctuaries of combined Shinto and Buddhist beliefs.[17] (The shrine is depicted in cat. no. 57 along with the Shinto and Buddhist deities whose worship had been coordinated.) In the fourth month of

1868, under the supervision of a high government official, soldiers burned priests' robes and confiscated bells and metal objects to be melted down for cannons or coins. They threw stone statues in a river. They used the bodies of wooden statues for target practice, played with the heads in a kickball game, and then burned the remnants.[18] Similar episodes took place throughout the nation—in Kamakura, Tsūwano, Matsumoto, and Kagoshima.

The Meiji anti-Buddhist campaign has many historical analogies. After the French revolution of 1789, for example, the Jacobins declared a policy of dechristianization targeted primarily at the Roman Catholic Church. In the name of liberty and reason, venerable monasteries and sanctuaries were looted, images desecrated and destroyed, church lands confiscated, and clergy humiliated and returned to lay life. In more recent times Marxist-Leninist regimes declared atheism a state doctrine and stamped out traditional religious organizations ("opiates of the people") or reduced them to shadows of their former status. Josef Stalin ordered the destruction of one of the most prominent public symbols of the Orthodox Church, the Cathedral of Christ the Redeemer in central Moscow. He intended to replace it with a lavish Hall of the People, which was never built; now the cathedral is being reconstructed. In the People's Republic of China in the 1970s, rampaging Red Guards destroyed countless Buddhist temples and images, even those that were archaeological sites and no longer in worship. Persecutions like these were inspired chiefly by contempt for mysticism

Fig. 5. Discarded Buddhist statues in Tōshōdai-ji, Nara, 1880

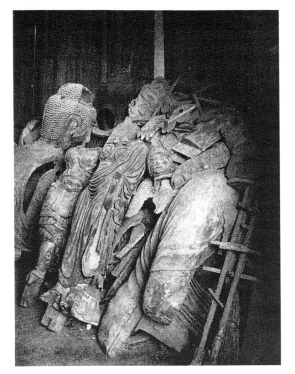

Fig. 6. The Buddhist priest Shimaji Mokurai, ca. 1910, perhaps the first Japanese traveler to India

Fig. 7. The art critic and historian Okakura Kakuzō, ca. 1901, an influential supporter of traditional East Asian art forms

(or superstition) and for the frequent alliance of religious establishments with reactionary regimes. In practice, however, where the faiths are deeply rooted in the lives of the common people, such attacks often mobilize and strengthen their victims—which was the case in Meiji Japan.

Reform

Even though Meiji government policies aimed not to eradicate the Buddhist community but only to separate it from Shinto, many Japanese Buddhists feared for its survival. Then in the early 1870s the government came under the control of more pragmatic and modern-minded leaders. Anti-Buddhist pressures were gradually eased, and in the 1880s, energized by the crisis, the Buddhist community began to adapt itself to the new political and social realities. Its thinkers acknowledged the accuracy of some of the Confucian criticisms, using them to justify the creation of a reformed creed and to seek new financial support from the faithful.[19] Clergymen studied foreign languages and traveled abroad to observe how their Western counterparts contended with the challenges of science, technocracy, and doctrines of the separation of church and state.[20] Becoming more concerned with social welfare, Buddhist organizations built hospitals and retirement homes, engaged in disaster relief, and opened universities. They propagated the faith by publishing newspapers and magazines. They demonstrated their patriotism by supporting the Japanese national cause in the Sino-Japanese (1894–95) and Russo-Japanese (1904–5) wars. They assisted Buddhist establishments elsewhere in Asia and began a missionary effort to implant Buddhism in the West.

For the first time in all of recorded history, persons from Japan began to set foot in India. The earliest may well have been the energetic Buddhist priest Shimaji Mokurai (1838–1911) (fig. 6), who, with a small group of clerics of the Jōdo Shin (True Pure Land) sect, had gone on a study trip to England, France, Germany, and Italy. Then, to explore the earlier history of Western religions, he and a companion traveled to Turkey and Palestine. On the return voyage in 1873, Shimaji alone made a pilgrimage to the Buddhist holy sites of India,

managing to get as far as Allahabad, at the junction of the Ganges and Jumna Rivers.[21]

Soon the Japanese Buddhist community began sponsoring elaborate studies of the history of the faith in India, China, and Korea, and the publication of Buddhist texts in modern languages. A corps of well-trained scholars, born mostly around the beginning of the Meiji era, ranged over all of Asia, following in the footsteps of European scholar-explorers such as Petr Koslov, Sergei Oldenburg, Edouard Chavannes, Paul Pelliot, Alexander Cunningham, and Marc Aurel Stein.[22] With seemingly limitless zeal they searched for manuscripts, surveyed temples and archaeological sites, copied inscriptions, photographed works of art. Korea, a Japanese colony from 1910 until 1945, became a major focus of their activities. The flowering of Japanese Buddhist studies in the Meiji and Taishō periods was a truly remarkable episode in the history of scholarship.

Buddhist Art Rehabilitated

Meiji government officials sought to create for the nation a new cultural identity in which the visual arts were given a vital role.[23] Inspired by Western examples, these officials built palatial art museums, devised new systems of art education, and created their own histories of Asian art. The new cadre of art administrators and historians discovered in the hundreds of images still preserved in temples and shrines a huge ready-made corpus of "art" dating from the long periods of time whose secular imagery had largely vanished. Even though Buddhist doctrines no longer occupied a central place in state ideology, Buddhist painting and sculpture were thus given great prominence in the new order of artistic values.

Japan's art establishment included the brilliant art critic and historian Okakura Kakuzō (1862–1913) (fig. 7), famous for his fiery endorsement of traditional East Asian art forms.[24] Okakura worked closely with Ernest Fenollosa (1853–1908) (fig. 8), the Harvard-trained philosopher and art historian then teaching in Japan, who provided an eloquent foreign voice for Japanese cultural aspirations.[25] Another influential voice was that of Ōmura Seigai (1868–1927), professor of art history at the Tokyo Art School and a respected scholar of Chinese sculpture and painting.[26]

Perhaps the central figure in this group was the government administrator Kuki Ryūichi (1852–1931) (fig. 9). Kuki, descended from a once high-ranking samurai family, had studied at Keiō Academy, the leading center of Western learning in pre-Meiji Edo; he is listed among the prominent disciples of the school's founder, the celebrated Enlightenment philosopher Fukuzawa Yukichi (1835–1901). At age twenty Kuki entered the Meiji government's Ministry of Education, working on the reform of elementary and secondary instruction. Immediately recognized for his high abilities, he was sent to Europe for a year's study. From 1884 to 1888, still in his thirties, Kuki served in Washington as minister plenipotentiary to the United States. Upon returning to Japan he joined the Imperial Household Ministry and was appointed head of a commission to investigate the national cultural patrimony—a project remarkably similar to the *Ten Categories of Antiquities* survey of a century earlier, discussed above.

In 1897 he drafted a law for the protection of old shrines and temples, providing government funds for conservation and repairs and setting strict limits on the sale of artistic properties; he was also given the rank of *danshaku* (or baron; an example of the new Western-style orders of nobility). Kuki and his colleagues were also responsible for a flood of lavishly illustrated publications intended for both Japanese and foreign audiences. One of the earliest and most influential was a twenty-volume collection of handsome plates and bilingual explanations entitled *Selected Relics of Japanese Art* in English and *Shinbi taikan* (literally, Compendium of True Beauty) in Japanese.[27] Other luxurious folios soon followed.[28] Among the most remarkable was a lavish publication in French made to accompany the Japanese exhibit at the Paris Universal Exposition of 1900.[29] The impact of these efforts was soon reflected in the first detailed German-language history of Japanese art, whose ideas and illustrations were taken largely from *Selected Relics*.[30]

Kuki and his associates established a canon of historical masterpieces and an official doctrine of Japanese and East Asian art history. They declared that Japan's gentle climate and splendid scenery had enhanced its people's sense of beauty and made it a natural home of the arts. They maintained that the highest

of the nation's artistic achievements arose from the Buddhist faith, which had brought advanced civilization from the mainland ("a history of Japanese art . . . is at the same time a history of Japanese Buddhism"[31]). They proclaimed that Japan was the repository and guardian of the great traditions of the Asian past. In India Buddhism had died out; in China "only low and ignorant people were believers."[32] "It is in Japan alone that the historic wealth of Asiatic culture can be consecutively studied."[33] "Japan . . . alone . . . is endowed by temperament to become the interpreter of East to West and of West to East . . . , a flash of human genius at highest tension."[34]

These authors were antiquarian in spirit; their histories of Japanese art through the Kamakura period were highly detailed. But when they dutifully outlined the work of all major schools of painting and decorative arts up to their own day, their attention markedly flagged. Indeed, in his preface to *Selected Relics,* Baron Kuki openly stated that "modern works of art, though of elaborate and skillful workmanship, are spiritless, while the ancient are meaningful and inspiring."

Two-thirds of their histories of early and medieval Japanese art consisted of Buddhist materials. The exceptional secular objects were the personal possessions of Emperor Shōmu (701–756) and his consort Kōmyōshi (701–760) preserved in the Shōsō-in storehouse in Nara, some later court calligraphies, and the rare narrative handscrolls of the twelfth century, such as *Genji monogatari emaki* (*Illustrated Tale of Genji*) and *Ban dainagon ekotoba* (*Illustrated Story of Ban, Chief Councillor of State*).

The early publications emphasized the pan-Asian character of Buddhism. The faith was now characterized as both time-honored and modern; it was the unfailing vehicle of cultural advancement, the unifying element in Asian civilization, and the counterpart to Christianity in the West. These were benign and idealistic sentiments, but they were easily linked with more aggressive ones when Japan developed imperial ambitions after defeating China in the war of 1894–95. Under the old slogan of "Japanese Spirit, Western Learning" (*wakon yōsai*), Japan boasted that, as the first Eastern country to master Western technology, it would assist the backward peoples of

Fig. 8. Ernest Fenollosa, ca. 1890, the Harvard-trained art historian teaching in Japan who wrote the first authoritative English-language survey of Chinese and Japanese art

Fig. 9. The bureaucrat Kuki Ryūichi, after 1897, who maintained that the country's highest artistic achievements arose from the Buddhist faith and headed a commission that investigated Japanese cultural patrimony

237

Asia to reassert their ancient high culture and repel the political and cultural encroachments of the Euro-American powers. The final paragraphs of Okakura's *Ideals of the East* (1903) state: "Today the great mass of Western thought perplexes us. The mirror of Yamato is clouded, as we say. Japan returns upon her past. . . . We know instinctively that in our history lies the secret of our future, and we grope with blind intensity to find the clue. . . . The scorching drought of modern vulgarity is parching the throat of life and art. . . . But it must be from Asia herself, along the ancient roadways of the race, that the great voice shall be heard. Victory from within, or a mighty death without!"[35] Anticipating its imperialist propaganda of the 1930s, Japan declared itself the leader of the new Asia. Buddhist art became a talisman of the Asian common heritage.

Buddhist Art Interpreted

Prominent in the group of scholars around Kuki Ryūichi was Ernest Fenollosa, author of the first authoritative English-language survey of Chinese and Japanese art.[36] Fenollosa had arrived in Japan in 1878 with a Hegelian view of history as an evolutionary process, progressive and teleologically determined. He believed that a grand historical mechanism was destined to create a new world culture, a synthesis of the sacred values of the East with the materialism and technological prowess of the West—and that such a culmination of human history was destined to take place in the very near future. He believed that the role of the historian was to define and interpret the workings of this evolutionary system, "as Dr. Schliemann traces the nine superimposed ages of Ilium" (a reference to the archaeological discoveries at the Homeric site of Troy).[37]

Fenollosa built each of his two volumes of *Epochs of Chinese and Japanese Art* around a separate, independent system of values. The first volume was devoted mainly to the Buddhist material that had only recently come into the purview of scholars: the rise of Buddhist art in India and its transformation as it spread through China, Korea, and Japan. The second volume featured the history of Chinese and Japanese painting traditions as taught by artists of the venerable Japanese professional painting schools, Kanō and

Sumiyoshi, under whom Fenollosa had trained for more than a decade.

In his analysis of Buddhist art Fenollosa stressed the Greek element that had entered the tradition in the so-called Gandharan school about the beginning of the Common Era.[38] Scholars of the late nineteenth century had been greatly excited by the discovery in present-day Afghanistan and northwestern Pakistan of thousands of Buddhist votive statues and narrative relief carvings based in large measure on Mediterranean models. Art historians had also accepted the theory that the stylistic development of Greek sculpture itself—from static, geometric, and abstract shapes to realistic and dynamically active ones—revealed the underlying principle that supposedly guided the evolution of all other advanced systems of the figural arts.

Fenollosa sought to demonstrate that East Asian Buddhist statuary had evolved in roughly the same fashion; and he and his colleagues became greatly preoccupied with chronology, with putting works of art in correct sequence according to their assumptions about the evolution of style. He also sought to identify the major artists and patrons within the Buddhist tradition, the Chinese and Japanese equivalents of the giants of Western traditions—a Phidias and Pericles, a Michelangelo and Pope Julius II. In doing so he disregarded the fundamental Buddhist principle that the goal of the devotee is not to manifest individual genius but to eliminate all traces of egoism and individuality. Fenollosa died long before the flowering of Buddhist studies of the 1920s and 1930s; concerned with large theories of human culture, he did not contribute to the factual history of Buddhist art, but he played a major role in validating that material as a fundamental element in the Western vision of the history of Asian art.

Private Collecting

Further insight into the process by which Buddhist icons were transmuted into works of art may be seen in the activities of Masuda Takashi, a high official of the Mitsui family's banking, mining, and manufacturing interests. Fluent in English and widely traveled abroad, Masuda was a passionate collector of Chinese and Japanese antiquities, and he encouraged his friends and business associates to acquire Buddhist materials. As Christine Guth has

shown, Masuda in 1896 began honoring the renowned Buddhist monk Kūkai (or Kōbō Daishi; 744–835) by holding an annual tea ceremony at his estate in Odawara on the anniversary of the monk's death.[39] At first Masuda displayed Kūkai's calligraphies at these ceremonies; then he showed Buddhist sculptures and paintings to his guests as works of art.

By the beginning of the twentieth century, Japan's new industrial millionaires had begun collecting on a large scale: Dan Takuma (1858–1932; mining engineer and administrator), Kawasaki Shōzo (1837–1912; shipbuilding), Nezu Kaiichirō (1860–1940; railroads and manufacturing), and Okura Kihachirō (1837–1928; mercantile interests). Even though the 1897 laws for registering and protecting cultural properties aimed to shut down the sale of Buddhist materials by temples and shrines, substantial numbers of paintings and sculptures had already entered the hands of private collectors and art dealers.

From France came Émile Guimet (1836–1918), son of a rich engineer-industrialist from Lyon.[40] Guimet had been fascinated by Egyptian art and began collecting it after a visit there in 1865. His interests in exotic religious art thus kindled, he came to Japan in 1876 and acquired many Buddhist sculptures. Guimet created a museum in Lyon and then, in 1889, moved his collection to a townhouse in Paris. This became the nucleus of the French national museum of Asian art, which today bears his name. Guimet's collection was academic, even encyclopedic, in character. He tried to assemble statues of all the deities of the Buddhist pantheon, with little regard to art historical or aesthetic considerations.

American collecting was sparked by Ernest Fenollosa and his colleague Okakura Kakuzō. Enlisting the help of such rich Boston brahmins and japanophiles as William Sturgis Bigelow (1850–1926) and Charles Weld (1857–1911), they enabled Boston's Museum of Fine Arts to acquire most of its huge Japanese Buddhist collection: some two hundred and fifty paintings, more than seventy sculptures, and dozens of ritual implements, robes, and liturgical masks.[41] Fenollosa also advised the Detroit collector Charles Lang Freer (1854–1919), a man of high aesthetic discernment who sought to acquire Asian art of all kinds and who founded the Smithsonian Institution's Freer Gallery in Washington, America's national museum of Asian art.[42] Important Chinese and Japanese Buddhist materials were included in the vast collection he bequeathed to the nation.

Public Museums in Japan
As early as 1872 the Japanese Ministry of Education had begun providing exhibition and museum facilities in Tokyo.[43] Initially modest in scale, these institutions soon began to acquire notable objects: archaeological materials from ancient tombs, craft goods attributed to such celebrated artisans as Nonomura Ninsei (active second half of the seventeenth century) and Hon'ami Kōetsu (1558–1637), and a now-famous twelfth-century Heian painting of Fugen Bosatsu, said to have come from "a certain temple in Yamato" (present-day Nara Prefecture) (fig. 10). In 1878 the museum was given the responsibility for more than three hundred Buddhist sculptures, paintings, textiles, seals, calligraphies, and ritual objects that had been transferred from the ancient monastery of Hōryū-ji in Nara to the Imperial Household. Although said to have been "presented" to the Throne, the collection was actually purchased by the government for ten thousand yen (a vast sum in its day), both to assist the financially distressed monastery and to provide the Throne with fine works of art comparable to those of European monarchs.[44] In the same year plans were made to build a more suitable museum in Ueno Park on land that had originally belonged to Kan'ei-ji, once the largest temple in Edo.

The impressive new Ueno Museum was inaugurated in 1882 with a ceremonial visit by the Meiji emperor. Two stories tall and clad in brick, it was designed in an Indo-Moorish style by the Victorian English architect Josiah Conder (1852–1920), an instructor at the Tokyo Industrial College.[45] Its first director was Machida Hisanari (1838–1897), who had studied at the South Kensington Museum (present-day Victoria and Albert Museum) in London. The building and its collections were thus created under the strong influence of the British Arts and Industries movement, which encouraged the industrial production of traditional craft goods.

In 1889, however, the Ueno Museum's policies were given a more art historical ori-

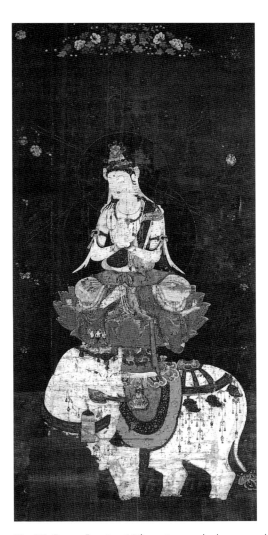

Fig. 10. *Fugen Bosatsu,* 12th century; polychrome and gold leaf on silk; 159.0 x 74.5 cm; Tokyo National Museum. National Treasure

239

entation. Its name was changed to Tokyo Imperial Museum; Kuki Ryūichi was appointed director, and Okakura Kakuzō became head of the art section. Together the two formulated a plan to construct similar grand structures in Nara (capital during the eighth-century flowering of Buddhist arts) and Kyoto (seat of the imperial court for the next millennium). Appointed architect of the Nara and Kyoto museums was Katayama Tōkuma (1854–1917), a promising student of Conder.[46] Katayama, after graduating from the Tokyo Industrial College, had traveled for two years in Russia, England, and France, and in 1886 he spent eleven months studying in Germany. In later years, when he became the government's chief architect, he designed the Akasaka Detached Palace (completed in 1909), the French Renaissance-style structure intended as a residence of Crown Prince Yoshihito, the future Taishō emperor; it is now a state guest house. Katayama also supervised the design of the Hyōkei-kan (also completed in 1909), the elaborate domed building in Ueno Park and now a museum of Japanese archaeological relics. It too was built in honor of Yoshihito. In this surge of museum building no effort was made to create a special environment for Buddhist materials by replicating the lighting and atmosphere of traditional sanctuaries. Those objects were displayed in essentially the same way as all other types of art.

The Nara Imperial Museum was allotted a spacious, tree-shaded plot of land that had once been part of Kōfuku-ji; deer from the forests of the nearby Kasuga Shrine still wander through its grounds (fig. 11).[47] In design-

Fig. 11. The Nara Imperial Museum, 1895, built on land once owned by the Kōfuku-ji

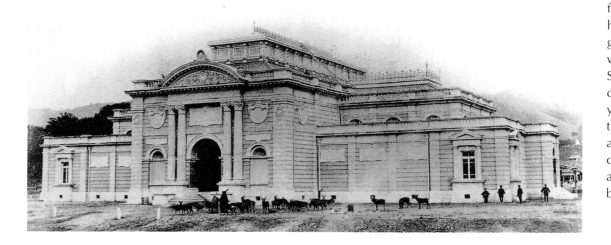

ing the building, Katayama is said to have been influenced by the Ny Carlsberg Glyptothek in Copenhagen, which was being constructed at the same time to house a great collection of Greek, Etruscan, and Roman sculpture. The Nara museum was fashioned in much the same Beaux Arts-Second Empire style, but on a more modest scale and without Glyptothek's grand dome. Katayama, obliged to use old-fashioned Japanese building technology, raised the structure around a wooden framework; the exterior walls were covered with yellow stucco that imitated courses of masonry; stone was used only to frame the windows and doors.

The Nara Imperial Museum was completed in 1895, and its inaugural exhibition comprised a miscellany of materials listed as "objects from the imperial collection," "imperial calligraphies," "historical materials," "works of art," and "artistic handicrafts." Some objects had been loaned by the Tokyo museum; others came from nearby Buddhist temples. An Osaka newspaper reported that more than six thousand persons visited each day, making it difficult to see the exhibits— intimations of the still-insatiable appetite of the Japanese public for museum exhibitions.

The Nara museum, unlike the Louvre or the British Museum, originally possessed few objects of its own. The great majority of its holdings were works deposited for safekeeping by nearby Buddhist temples and Shinto shrines. The museum organized special exhibitions each spring around different themes: works by local calligraphers, for example, portrait paintings, Kamakura period sculptures, or Nara-region temple treasures. The museum was given the responsibility for overseeing the Shōsō-in warehouse and for exhibiting samples drawn from its vast holdings. Over the years, the Nara museum gradually acquired its own collections, from which the present exhibition has been drawn. Some of the works were donated by private citizens, others by shrines and temples, and yet others, like the painting of Kannon mentioned above, were purchased by the nation and assigned to the museum. Withal, its collections are still relatively modest in size, and this exhibition includes works loaned by temples and other museums.

A Torrent of Scholarship

Located in the cradle of Japanese civilization, the Nara Imperial Museum and the government-funded Cultural Properties Research Institute became focal points of efforts to preserve and study early Japanese art and architecture, both Buddhist and pre-Buddhist. Expert scholars appointed to their staffs produced innumerable monographs. Local temples published scholarly magazines devoted to Buddhist arts. A number of private photography studios were established, producing beautifully composed large-plate images that today are treasured as works of art in their own right.[48]

Suited to the technological penchant of modern Japan, scholarship on Buddhist art took on a markedly science-like character, preoccupied not by devotional or mythological concerns but by concrete, historical ones. Scholars fiercely debated the differences in their estimates of the dates of certain works. They combed through diaries, letters, and dusty temple inventories looking for historical evidence about the images, their makers, and their patrons. Research teams scoured the countryside for objects that might have been shut away, and every few years they would announce, to great public excitement, the discovery of a long-forgotten work. They made x-ray photographs of statues to determine fabrication techniques; they studied paintings under infrared light to determine which parts had been restored. They traveled in China, Korea, and Central Asia, searching for prototypes and analogues of Japanese Buddhist images.

Scholars devoted much energy to linking the history of Buddhist art to Buddhist religious doctrine, which, like that of Christianity, had undergone a long and complex evolution. As Christian doctrines and beliefs had changed, so also had the visual arts in service to the creed. Buddhist scholars sought to establish the ways Buddhist art changed from monastic Buddhism (the so-called Lesser Vehicle now prevalent in Sri Lanka and Southeast Asia); to the lay Buddhism of the Greater Vehicle (prevalent in northern and eastern Asia); to Esoterism, which emphasized magic rituals and a vast pantheon of deities; to the Meditation Buddhism of East Asia, which absorbed much Chinese natural philosophy; and to the popular sects preaching salvation in the Pure Land. Scholars sought to clarify iconographic meanings and identify the theologians who had influenced the history of art.

Buddhist sculptures and paintings were registered as national treasures in far greater numbers than other types of material. In 1925, for example, the government completed yet another gigantic publication project, *National Treasures of Japan*.[49] About thirteen hundred works of art were reproduced, each with a large plate illustration and long explanation. Only some two hundred objects in that corpus were secular in character; all the rest—eleven hundred—were Buddhist paintings, sculptures, ritual implements, calligraphies, and religious texts. The system of registering cultural properties was revised in 1950, but Buddhist materials (along with swords) still constitute the largest single group.[50]

The flood of scholarship on Buddhist art continues unabated, and, as exemplified by objects in this exhibition, important discoveries are still being made. Take, for example, the miraculously well-preserved eighth-century statue of a Buddhist attendant figure [20] or the stone statue of the Buddha of the Future, Miroku [10]. The former, of great antiquity and rare beauty, appeared very recently without its existence ever having been previously recorded. The Miroku statue was discovered in the 1970s on a tiny island between Japan and Korea, where it had served as the container of holy texts buried to preserve them until the Buddhist messiah's coming.

Throughout the nearly fifteen hundred years of its presence in Japan, the Buddhist faith has never been a static monolithic creed. Despite the recurring efforts of both monks and government administrators to create centralized nationwide systems of official temples, it has remained a "community," a loose confederation of schools and sects without a formal hierarchical head. Since its introduction from Korea and China, the faith has often been embroiled in Japan's internal political struggles; it has also been much altered by developments in Buddhist doctrine originating on the mainland and, more recently, by Western thought. As it has evolved from the religion of a tiny ruling elite to that of all social classes to that of an industrial

nation, it has continually produced its own outstanding personalities: saintly ascetics, innovative theologians, fiery preachers, eloquent poets—and supremely gifted artists.

The scholars and administrators who gave Buddhist arts so prominent a position in Meiji Japan's new cultural identity perceived a fundamental dilemma in their position. If religion is the root of great art, how can great new art be produced by a society that gives priority to science and industry and disregards religion's transcendental and mystical beliefs? Baron Kuki, in his introduction to *Selected Relics,* observed that "troubles in the secular world are becoming more and more serious, while the spiritual world is more desolate than ever. . . . It is a great question, whether or not Buddhism will revive strongly enough to lift up fine art and open for it a bright way towards progress."

In Japan's "state-run citadels of culture"[51]—government-sponsored museums, exhibitions, and official histories—Buddhist art was given a uniquely high position. But twentieth-century Japan was far too diverse in its cultural life for a single definition of great art to prevail. In fact, from the eighteenth century onward, Japanese literary and artistic life had been fragmented into numerous factions and movements competing for patrons and prestige. Take, for example, the various schools of painting of the late Edo period. The best known included the Kanō and Tosa schools, which worked for the military and imperial governments respectively; the Rinpa school, which appealed to devotees of the Tea Ceremony; scholar-amateurs steeped in Chinese arts and letters; advocates of Western learning; or artists of the big-city pleasure districts (the so-called Floating World [*Ukiyo*]).[52] The cultural life of the Meiji and Taishō eras was equally diverse.

Baron Kuki's identification of Buddhism with the finest in Japanese art was contradicted even by his own son, Kuki Shūzō (1888–1941), an equally influential art critic and philosopher for the next generation.[53] Taking the hedonistic, irreverent art forms of the Edo-period Floating World movement as his model, Shūzō believed that the essence of Japanese art lay in spontaneity, accident, and play, not in the timeless canons of Buddhist imagery. Like his father, Shūzō studied in Europe, but with advanced thinkers like Henri Bergson and Martin Heidegger; he and his colleagues were attuned to a continual flow of ideas from Western philosophy and from European Modernist pictorial idioms such as Impressionism and Post-Impressionism, Cubism, Fauvism, Surrealism, and Constructivism. In so pluralistic an atmosphere, the canonization of Buddhist imagery by Japan's official museums and art history books was absorbed into a much more inclusive and diverse structure of national cultural life.

Even so, as this exhibition clearly shows, the Buddhist component remains a powerful factor. In Japan, as throughout the industrialized world, a desiccated spiritual atmosphere ("the scorching drought of modern vulgarity," in Okakura's words) has stimulated a great outpouring of interest in sacred values. Among the masses of people worldwide there appears to be an ever more powerful hunger for communion with credible inspiring truths, for access to spiritual authority, for an escape from materialism and cynicism, and for the personal attainment of spiritual equipoise. At the same time, young people in both Asia and the West seem impatient with the archaic language and time-worn legends of their ancestral creeds, and often they turn for sustenance to exotic beliefs—or, like Nietzsche, to the arts.

With so much ferment and instability in the spiritual consciousness of both Japan and the West, it is difficult to predict religion's future. A yearning for a state of grace and for communion with the divine is deep-seated in the human character. And those precisely are the values that Buddhist sculptors and painters sought to embody in their works. Traditional Japanese Buddhist art remains a vital force in the present-day world because it evokes the profound philosophic and spiritual insights of the religion that inspired it. Indeed, the artistic attainments of Japanese Buddhist art rank among the most subtle and elevating in all human experience; in no other tradition of religious art have aesthetic principles been more closely attuned to spiritual goals.

Notes

1. Ernest Fenollosa, *Epochs of Chinese and Japanese Art: An Outline History of East Asiatic Design* (London: Heinemann, 1912), 1:28.

2. In art history and the social sciences the terms "modern" and "modernization" refer to phenomena that are closely linked, though not obviously so. In the social sciences they denote capitalist industrialism of the past century; the growth of large cities; the ascendancy of the middle class; the development of mass political movements, bureaucracies, and the empirical sciences; and the rise of individualism and secularism. In the visual arts "Modern" and "Modernism" denote a rebellion against the canons of nineteenth-century Beaux-arts Neo-classicism. In painting and sculpture this mutiny took the form of extreme individualism, expressionism, or nonfigural abstraction; in architecture and design it took the form of functionalism and the use of industrial materials.

3. For an exploration of this and the many other slogans of the late Edo and early Meiji eras, see Charles Inouye, "Picturing the State: A Semiotic Analysis of the Meiji Slogan," in *New Directions in the Study of Meiji Japan,* ed. Helen Hardacre and Adam Kern (Leiden: Brill, 1997), 275–77.

4. *The Cambridge Companion to Nietzsche,* ed. Bernd Magnus and Kathleen Higgins (Cambridge: Cambridge University Press, 1996), 35–36, 313–14. *A Nietzsche Reader,* selected and translated with an introduction by R. J. Hollingdale (London: Penguin Books, 1977), 167–98.

5. *Nietzsche Reader,* 168.

6. In present-day Japan the loss of the transcendental power of religious art is by no means complete. Museum visitors—usually elderly—may occasionally be seen praying and even offering flowers and incense to Buddhist statues. The custom is far more prevalent in India.

7. *Nihon no Butsuga* (Arts of Japan) (Tokyo: Gakushu kenkyūsha [or Gakken], ca. 1975), fascicule 19; *Geijutsu shinchō* 281 (1973), 127.

8. Such transfers were not unusual. When small temples became impoverished or inactive, their ritual objects were often relocated to larger sanctuaries. The best-known example is the group of forty-eight gilt-bronze Buddhist statues that had been sent (perhaps as early as 1078) to Hōryū-ji by its branch temple of Tachibana-dera nearby. Eight hundred years later the forty-eight were included in a group of more than three hundred Buddhist objects transferred by Hōryū-ji to the Imperial Household in Tokyo and then deposited in the Tokyo Imperial Museum. Today they are preserved in a special Hōryū-ji Museum in Ueno Park. See Kobayashi Takeshi, *Gyobutsu kondō butsuzō* (Gilt-bronze Buddhist statues in the imperial collection) (Tokyo: Tokyo National Museum, 1947).

9. In modern Japanese usage this distinction is expressed by the terms *sonzō* (literally, exalted image) and *kanshōhin* (appreciation object). Sonzō ordinarily retain traces of the Indian origins of Buddhist imagery: the idealized appearances of fully enlightened Buddhas; the depiction of lavish jewels and ornaments for bodhisattvas and lesser-ranked deities; and, in painting, the use of brilliant colors and tightly drawn red outlines (iron-wire lines) around hands and faces.

10. Chapter 40 of the eleventh-century novel *Tale of Genji,* for example, describes the stirring atmosphere of a crowded Buddhist ritual. The magnificent robes of the priests and dancers, the incense, the images, the solemn chanting and music, the emotions of those pondering death and rebirth—"One would have thought that the possibilities of beauty were exhausted"—all combined to create a profoundly moving experience of aestheticized piety (Muraskai Shikibu, *The Tale of Genji* [Genji monogatari], trans. Edward Seidensticker [New York: Knopf, 1976], 2:714).

11. *Ten Categories of Antiquities* (Shūko jisshu), ed. Matsudaira Sadanobu (1800, 85 fascicles; repr., 4 vols, Tokyo: Kokusho kankōkai, 1908). It was produced by a team of artists and officials that included the prominent scholar-amateur painter Tani Bunchō (1763–1840), who toured the nation for four years, recording the holdings of shrines, temples, and private collections. The project has remarkable similarities to the surveys and registration of National Treasures made by the Meiji regime.

12. Yi Ki-baek, *A New History of Korea,* trans. Edward Wagner and Edward Shultz (Cambridge: Harvard University Press, 1984), 199–200; Martine Deuchler, *The Confucian Transformation of Korea: A Study of Society and Ideology* (Cambridge: Council on East Asian Studies, Harvard University, 1992), 103–7.

13. An account of twentieth-century Buddhism nonetheless indicates the survival of a core of disciplined, intellectually rigorous clergy. See Holmes Welch, *Practice of Chinese Buddhism, 1900–1950* (Cambridge: Harvard University Press, 1967), 346–48.

14. Ronald Dore, *Education in Tokugawa Japan* (London: Athlone, 1984); Peter Nosco, ed., *Confucianism and Tokugawa Culture* (Princeton, N.J.: Princeton University Press, 1984).

15. Robert Bellah, *Tokugawa Religion: The Values of Pre-Industrial Japan* (Glencoe, Ill.: Free Press, 1957).

16. See Tamamuro Fumio, *Shinbutsu bunri* (Edict separating Shinto and Buddhism). *Kyōikusha rekishi shinsho: Nihon shi* (New publications of the Kyōikusha: Japanese history), vol. 113 (Tokyo: Kyōikusha, 1977); Martin Collcutt, "Buddhism: The Threat of Eradication," in *Japan in Transition: from Tokugawa to Meiji,* ed. Marius Jansen and Gilbert Rozman (Princeton, N.J.: Princeton University Press, 1986), 143–67; James Ketelaar, *Of Heretics and Martyrs in Meiji Japan: Buddhism and its Persecution* (Princeton, N.J.: Princeton University Press, 1990); Tamamuro Fumio, "On the Suppression of Buddhism," in *New Directions in the Study of Meiji Japan,* 499–505.

17. For the cult and its art forms, see Kageyama Haruki, *The Arts of Shinto*, vol. 4 of *Arts of Japan*, trans. and adaptation by Christine Guth (New York: Weatherhill; Tokyo: Shibundō, 1973), 104–50.

18. Tamamuro Fumio, *Shinbutsu bunri,* 154–67.

19. Joseph Kitagawa, *Religion in Japanese History* (New York: Columbia University Press, 1966), chap. 5.

20. Kitagawa, *Religion in Japanese History,* 227–29.

21. *Uda kokiju ishū* (Congratulations on the seventieth birthday of Uda [i.e., Shimaji Mokurai]) (Tokyo: Shimaji Mokurai Shonin koki shukuga kai, 1910), 3.

22. Peter Hopkirk, *Foreign Devils on the Silk Road* (Amherst: University of Massachusetts Press, 1980).

23. This emphasis on the visual arts reflected both Eastern and Western values. Over the centuries Japanese potentates adhered to the Confucian principle that the practice and support of arts—including music, poetry, painting, and calligraphy—were manifestations of the virtues on which the ruler's mandate was based. At the same time, Meiji Japanese bureaucrats were impressed by the manner in which European monarchies used museums and academies of art and music to enhance their prestige and authority.

24. See *Okakura Kakuzō: Collected English Writings,* ed. Nakamura Sunao, 3 vols. (Tokyo: Heibonsha, 1984); *Okakura Tenshin shū* (Collected writings of Okakura Tenshin), ed. Kamei Katsuichirō et al. (Tokyo: Chikuma shobō, 1968).

25. Van Wyck Brooks, *Fenollosa and His Circle: With Other Essays in Biography* (New York: Dutton, 1962); Lawrence Chisolm, *Fenollosa: The Far East and American Culture,* Yale Publications in American Studies, 8 (New Haven: Yale University Press, 1963).

26. See especially Ōmura Seigai, *Shina bijutsu-shi: chōsohen* (History of Chinese art: Sculpture) (Tokyo: Butsuga kankōkai tozobu, 1915), which provided primary data for Alexander Soper, *Literary Evidence for Early Buddhist Art in China* (Ascona, Switz.: Artibus Asiae, 1959). Ōmura also published widely on Chinese and Japanese painting, the Shōsō-in collection, and woodblock illustrations.

27. Tajima Shiichi, ed., *Shinbi taikan* (Selected relics of Japanese art), 20 vols. (Tokyo: Nippon shinbi kyōkai [Japanese Authentic Beauty Society], 1899–1908).

28. Ōmura Seigai, *History of Japanese Pictorial Art, with Explanatory Notes on and Critical Descriptions of Masterpieces Selected from the Fine Arts of the Far East* (Tokyo: Shinbi shoin, 1909); Tajima Shiichi, ed., *Bijutsu shūei* (Selected masterpieces of old paintings and sculptures of the Far East), 3 vols. (Tokyo: Shinbi shoin, 1911); *Tōyō bijutsu taikan* (Selected masterpieces of Far Eastern art), 15 vols. (Tokyo: Shinbi shoin, 1911–18).

29. *Histoire de l'art du Japon, ouvrage publié par la Commission Impériale du Japan a l'Exposition Universelle de Paris, 1900* (Paris: Brunoff, 1900). This was the first time Japan sent abroad large numbers of works deemed to be historical masterpieces. Before—to expositions such as Vienna in 1873, Philadelphia in 1876, or Chicago in 1898—they sent mainly contemporary arts and craft goods: metal sculptures, lacquer work, cloisonné vessels.

30. Oskar Munsterberg, *Japanische Kunstgeschichte,* 3 vols. (Braunschweig: Westermann, 1904–7).

31. Kuki Ryūichi, in English-language preface to *Shinbi taikan,* unpaginated.

32. Ibid.

33. Okakura Kakuzō, *Ideals of the East* (1903; repr., *Okakura Kakuzō,* 1:15).

34. Fenollosa, *Epochs,* 1:52.

35. Repr. *Okakura Kakuzō,* 1:132.

36. Fenollosa, *Epochs.*

37. Ibid., 1:53.

38. John Marshall, *The Buddhist Art of Gandhāra. The Story of the Early School: Its Birth, Growth and Decline* (Cambridge: Cambridge University Press, 1960); Harald Ingholt, *Gandhāran Art in Pakistan* (New York: Pantheon Books, 1957).

39. Christine Guth, *Art, Tea, and, Industry: Masuda Takashi and the Mitsui Circle* (Princeton, N.J.: Princeton University Press, 1993), 100.

40. Bernard Frank, *Le Panthéon bouddhique au Japan: Collections d'Émile Guimet* (Paris: Réunion des musées nationaux, 1991); Ellen Conant, "The French Connection: Émile Guimet's Mission to Japan. A Cultural Context for Japonisme," ed. Hillary Conroy et al., *Japan in Transition: Thought and Action in the Meiji Era, 1869–1912* (Rutherford, N.J.: Fairleigh Dickinson University Press, 1984), 114–17.

41. See the account by Jan Fontein in *Asiatic Art in the Museum of Fine Arts Boston* (Boston: Museum of Fine Arts, 1982), 6–15; *Bosuton bijutsukan: Nihon bijutsu chōsa zuroku* (Pictorial catalogue of research on Japanese art in the Museum of Fine Arts, Boston, first-stage research: Buddhist paintings, sculptures, ritual implements, and ceremonial robes; Nō masks; ink painting; early Kanō school, Rinpa), ed. Anne Morse and Tsuji Nobuo (Tokyo: Kōdansha, 1997). The collection of Chinese Buddhist materials, many of them acquired by Okakura in China, is also of paramount importance.

42. Thomas Lawton and Linda Merrill, *Freer: A Legacy of Art* (Washington, D.C.: Freer Gallery of Art, Smithsonian Institution, 1993), chap. 5.

43. *Me di miru 120 nen: Tokyo kokuritsu hakubutsukan* (Looking at 120 years: The Tokyo National Museum) (Tokyo: Tokyo National Museum, 1992); Tomio Kentarō, "Visions of Modern Space," in *New Directions in the Study of Meiji Japan,* 719–24.

44. The complex negotiations between Japanese government ministries and the temple are recorded by Okudaira Hideo, *Museum* 389, 390 (August, September 1983). Christine Guth kindly provided this reference.

45. Badly damaged in the 1923 earthquake, that building was demolished and replaced by the current structure. See Kawahigashi Yoshiyuki, ed., *Josaia Kondoru kenchiku zumenshū* (Collected architectural drawings of Josiah Conder) (Tokyo: Chūōkōron bijutsu shuppan, 1980–81), 37–41, pls. 3–61.

46. Dallas Finn, *Meiji Revisited: The Sites of Victorian Japan* (New York: Weatherhill, 1995), 111–17; David Stewart, *The Making of Modern Japanese Architecture* (New York and Tokyo: Kōdansha International, 1987), 55–62.

47. *Nara kokuritsu hakubutsukan hyakunen no ayumi* (Nara National Museum: One hundred years of progress) (Nara: Nara National Museum, 1996).

48. The Asuka-en and Rokumai-sō companies, for example, located near the Nara National Museum, have remained in business since the Meiji period and still provide prints from their original negatives.

49. Monbushō (Ministry of Education), ed., *Nippon kokuhō zenshū,* 84 fascicles in 4 vols. (Tokyo: Nihon kokuhō zenshū kankōkai, 1923–38).

50. *Bunkazai hōgo no ayumi* (Progress in the protection of cultural properties) (Tokyo: Bunkazai hōgo iinkai, 1960).

51. This apposite phrase comes from Tomio Kentarō, "Visions of Modern Space: Expositions and Museums in Meiji Japan," in *New Directions in the Study of Meiji Japan,* 719.

52. Christine Guth, *Art of Edo Japan: The Artist and the City 1615–1868* (New York: Harry N. Abrams, 1996).

53. Leslie Pincus, *Authenticating Culture in Imperial Japan: Kuki Shūzō and the Rise of National Aesthetics,* vol. 5 of *Twentieth Century Japan: The Emergence of a World Power* (Berkeley: University of California Press, 1996).

Timeline

Japan

Kofun period	AD 250–552
Asuka period	552–646
Early Nara period	646–710
Late Nara period	710–794
Heian period	794–1185
Kamakura period	1185–1336
Nambokuchō period	1336–1392
Muromachi period	1392–1568
Momoyama period	1568–1603
Edo period	1603–1868
Meiji period	1868–1912
Taishō period	1912–1926

Korea

Three Kingdoms period	
Silla dynasty	57 BC–AD 668
Paekche dynasty	18 BC–AD 660
Koguryŏ period	37 BC–AD 668
Unified Silla period	668–935
Koryŏ period	935–1392
Chosŏn period	1392–1910

Glossary

All terms from Japanese except where indicated.

apasaras
Sanskrit. Class of heavenly beings who venerate major deities through gifts of dance, music, and flowers. Japanese: hiten.

arhat
Sanskrit. See *rakan*.

ban
Temple decoration. An ornate hanging banner, usually of metal or cloth.

bodhisattva
Sanskrit. See *bosatsu*.

bosatsu
Divine being capable of attaining enlightenment who postpones Buddhahood to assist mortal beings; one of the most prominent class of deities in Mahāyāna Buddhism, for example, Fugen, Jizō, Kannon, Miroku, Monju.

butchō
Protuberance from the top of the head; one of the thirty-two physical characteristics of a fully enlightened Buddha. Sanskrit: uṣṇiṣa.

chindangū
Ritual objects buried under the central altar of a Buddhist worship hall.

chinsō
Portrait of a Zen master.

Chan
Chinese. See *Zen*.

danzō
Sculpture made of aromatic hardwood, usually sandal but also cypress and cherry; usually left unpainted.

deva
Sanskrit. Class of deities subordinate in rank to supreme beings, for example, Bishamonten, Jikokuten. Japanese: ten.

dharma
Sanskrit. The body of Buddhist doctrine and law; the principles that govern all human and natural affairs. Japanese: hō, or minori.

dōji
Young male attendant of a major deity; symbol of rejuvenation of the faith.

emakimono
Illustrated narrative handscroll.

Ennin (794–864)
Monk of the *Tendai* sect. Pilgrim to Tang China and author of informative diary. Also called Jikaku Daishi.

Enno Gyōja (act. 7th c.)
Semi-legendary mountain-dwelling ascetic in Yamato region; reputed founder of *Shugendō*.

Esoteric Buddhism
So-called because its inner doctrines are revealed only to the highly trained. Developed in India in 6th and 7th c. and rapidly transmitted to China and Japan; stresses the attainment of enlightenment in this life through quasi-magical rituals conducted by clergy; rituals employ *mudras,* mantras (mystic syllables), and *mandalas.* Also called, in Sanskrit, vajrayāna, or Thunderbolt Vehicle, and mantrayana, or Vehicle of Mystic Syllables. Japanese: Mikkyō (Secret Doctrine), and Tantric Buddhism. See also *Kūkai, Shingon, Tendai.*

garuda
Sanskrit. Indian mythical bird, prominent in both Hinduism and Buddhism as protector and servant of great deities; occasionally shown as part-human. Japanese: karura.

gongen
Incarnation of a Buddhist deity; Shinto god declared as such. Sanskrit: avatāra.

harigaki
"Needle-point" drawing; using a metal stylus to incise an image on a metal surface.

hinoki
Cypress tree; wood commonly used in Japan for sculpture.

hompa shiki
Sculptor's method of depicting garments in which a sharp ridge is placed between each fold, resulting in a pronounced light-and-dark pattern on surface; derived from Western-influenced sculpture of northwest India (Gandhāra district); often seen in 9th c. Japanese Buddhist sculptures.

honji suijaku
Fusion of Shinto and Buddhism whereby Shinto gods are seen as avatars (suijaku) of Buddhist deities (honji). See *gongen*.

honzon
Principal deity in worship in a Buddhist temple.

hōsōge
Floral arabesque design common in Buddhist art in East Asia.

Hossō
Early Mahāyāna sect asserting that all existence is reducible to human consciousness; one of six sects or schools of Nara Buddhism (8th c.); headquarters at Kōfuku-ji.

hōtō
"Treasure pagoda." Single-story pagoda with cylindrical body.

inbutsu
Buddhist images printed on paper, often placed within a sculpture.

jingū-ji
"Shrine temple." Modest Buddhist sanctuary placed within a Shinto shrine.

jinja
Shinto shrine.

Jōdo
"Pure Land." Denotes paradises of fully enlightened Buddhas, the most preferred of which is the Western Paradise of Amida; popular Mahāyāna Buddhism in East Asia emphasizes rebirth in a Pure Land. Also the name of a Japanese sect founded by Hōnen (1133–1212).

Jōdo shinshū
"True Pure Land Sect." Founded by Shinran (1173–1262).

Jōjitsu
Early school of Mahāyāna Buddhism asserting that sensory experience is uncertain and that ultimate reality is unknowable; one of six sects or schools of Nara Buddhism; no headquarters temple.

kakebotoke
Hanging votive plaque, ordinarily made of wood or bronze, that adorns a temple.

kami
Shinto deity. Anything believed to have supernatural power or awe-inspiring character; includes heroes and ancestors as well as outstanding natural objects such as mountains, ancient trees, and waterfalls.

karashishi
"Chinese lion." In Buddhist temples a symbol of the Historic Buddha's royal lineage; a shrine guardian in Shinto contexts.

karyōbinga
Half-human half-avian creature of Indian mythology; its song is one of the delights of paradise. Sanskrit: kalavinka.

kasha
Medieval-period term for incense burner.

kaya
Hardwood tree akin to nutmeg; wood occasionally used for sculpture.

kebyō
Flower vase, usually bronze or ceramic, used on temple altars.

Kegon
Name of Mahāyāna sect asserting that all sentient beings are endowed with the Buddha-nature; one of the six Nara sects (8th c.), headquarters at Tōdai-ji. Sanskrit: avatamsaka; Chinese: huayan.

kei
Ritual chime.

keman
Hanging openwork plaque, usually fan-shaped, for adornment of temple interior.

keribori
"Kicking incisions." Metal engraving technique whereby a wedge-shaped stylus makes a series of staccato linear indentations.

kesa
Monk's outer garment, oblong in shape and often made of smaller pieces of textile sewn together. Sanskrit: kāśāya.

kirikane
"Cut metal." Gold or silver leaf cut into geometric or floral patterns and attached with lacquer to the surface of sculptures or paintings.

kōhai
Halo or nimbus behind a Buddhist image.

kokubun-ji
State-sponsored monasteries; established by imperial edict in the 8th c. in each province.

Kondō
"Golden" or main votive hall in a Buddhist compound; enshrines the *honzon*.

kongōshō
"Thunderbolt." Emblem seen frequently in *Esoteric Buddhism;* symbol of the irresistible potency of the Buddhist *dharma.* Sanskrit: vajra.

Kūkai (774–835)
Prelate who introduced *Shingon* sect into Japan upon his return from China in 805. Also called Kōbō Daishi.

kundika
Sanskrit. Vessel-type of Indian origin, usually made of metal or ceramic, to contain "pure" or "holy" water. Japanese: suibyō.

Kusha
Early Mahāyāna Buddhist school based on scriptures which teach that the self is non-existent while the *dharma* is real; one of the six schools or sects of Nara Buddhism (8th c.), but without headquarters temple. Sanskrit: abhidharmakośa.

kyōzō
Mirror engraved with Buddhist or Shinto images and placed in a sutra mound (*kyōzuka*).

kyōzuka
Mounds containing Buddhist texts and images buried to preserve them during the era of the end of the law (*mappō*).

maki-e
"Sprinkled picture." Lacquer technique by which powdered silver and gold are sprinkled over wet lacquer to form a design.

mandala
Geometric pictorial diagram showing relationship of deities to one another. Prominent in symbolism of *Esoteric Buddhism*.

mappō
"Last period of the law." Concept that the Buddhist *dharma* will pass through three lengthy periods from birth to complete decline, after which the cycle will begin again. In Japan the mappō era was thought to have begun in the 11th c.

Mikkyō
See *Esoteric Buddhism*.

mishōtai
Mirrors displayed before Shinto shrines; at one time embellished with painted or incised Buddhist imagery.

mudra
Sanskrit. Symbolic hand gestures displayed in depictions of Buddhist deities; employed also by priests in *Esoteric Buddhist* rituals.

nanako
"Fish roe." Circular decorative motif on surface of gilt-bronze ritual objects.

nembutsu
Repetitive chanting of a prayer or Buddha's name; common practice in popular Buddhism.

Nihongi
"Chronicle of Japan." Oldest national history; compiled in 720.

nyoi
Priest's ceremonial scepter.

nyoi hōju
"Wish-fulfilling gem." A round jewel, sometimes flaming, shown in hands of Buddhist deities.

oshidashibutsu
Thin bronze plaque usually hammered from behind into a mold to form a repoussé image.

Pure Land Buddhism
See *Jōdo*.

rakan
Reclusive Buddhist ascetic; concentrates on his own enlightenment and not on the salvation of others; the antonym of a *bosatsu*. Sanskrit: arhat; Chinese: luohan.

rinbō
"Wheel treasure." A spoked wheel; emblem of the power of the Buddhist *dharma*.

Ritsu
Early Mahāyāna sect emphasizing monastic discipline; one of the six Nara sects or schools (8th c.); main headquarters at Tōshōdai-ji. Sanskrit: vinaya.

rokudō
"Six paths." Six conditions in which persons are reincarnated, ranging from hell (the lowest), the realms of hungry ghosts, animals, semi-demons (ashura), humankind, and heavenly beings (ten).

Saichō (767–822)
Monk who founded the *Tendai* sect on Mt. Hiei near Kyoto; later traveled to Tang China. Also known as Dengyō Daishi.

sankōshō
A *kongōshō* with three pointed handles at the end.

Sanron
"Three treatises." Early Mahāyāna sect asserting that all fixed concepts must be negated in order to understand the real nature of existence; one of the six Nara schools or sects (8th c.); headquarters originally at Gangō-ji and Daian-ji.

senbutsu
Press-molded Buddhist images of baked clay.

shakujō
Monk's staff with metal rings attached at the top.

shari
Relic of a holy person, especially the Historic Buddha. Sanskrit: śarīra.

Shinto
The indigenous pre-Buddhist faith system in Japan.

Shingon
"True word." Name of the predominant sect of *Esoteric Buddhism* in Japan. See also *Kūkai, Tendai*.

shōgon
"Awesome beauty." Term denoting the lavish adornment of Buddhist sanctuaries and images as an act of piety. Sanskrit: alamkāra.

shūbutsu
Embroidered Buddhist image.

Shūgendō
Sects of mountain-climbing ascetics with *Tendai* and *Shingon* affiliations; traditionally founded by *Enno Gyōja*.

stupa
Sanskrit. Indian dome-shaped structure enshrining sacred relics or marking a holy site; origin of the East Asian pagoda. Japanese: sotōba, or tō.

suibyō
See *kundika.*

sutra
Sanskrit. Buddhist scriptures containing sermons attributed to the Historic Buddha. Japanese: kyō.

tahōtō
"Many-jeweled stupa." Ornate pagoda form.

Tendai
Chinese Buddhist school espousing the unity of sectarian doctrines. Contains elements of Esoteric, Pure Land, and Zen Buddhism; *Lotus Sutra* is its principal text; introduced to Japan by *Saichō;* headquarters at Enryaku-ji near Kyoto. Chinese: Tiantai zong.

urazaishiki
Pigments applied from the reverse side of the silk.

uṣṇiṣa
Sanskrit. See *butchō.*

vajra
Sanskrit. See *kongōshō.*

Yamato
A traditional name of Japan, derived from that of the area to the south of Nara.

yosegi
"Joined wood construction." Sculptural technique of gluing and pegging together small pieces of precarved wood to form larger, hollow statues; perfected in 11th c.

Zen
Japanese name for the Meditation school of Buddhism. Introduced to China in 6th c. and to Japan in the late 11th. Sanskrit: dhyāna; Chinese: chan.

zōnai nōnyūhin
Articles placed inside statuary.

zushi
Votive shrine containing Buddhist image, text, or reliquary.

zuzō
Iconographic drawings on paper used for training of Esoteric Buddhist monks and for guidance in preparing finished votive paintings in color on silk.

Concordance of Buddhist Deities

Acalanatha
See *Fudō Myōō*.

Aizen Myōō
Esoteric King of Passion. Sanskrit: Rāgarāja.

Ākāsagarbha
See *Kokūzō*.

Akṣobhya
See *Ashuku*.

Amaterasu
Sun goddess, central figure of the Shinto pantheon.

Amida
Buddha of Infinite Light and Infinite Life; resides in the Western Paradise; believed to approach the earth to receive the dying and to convey them to his realm; also one of the Five Wisdom Buddhas in Esoteric Buddhism. Sanskrit: Amitābha.

Amitābha
See *Amida*.

Amoghapāśa Avalokiteśvara
See *Fukūkenjaku Kannon*.

Ashuku
A Buddha of the past; one of the Five Wisdom Buddhas. Sanskrit: Akṣobhya.

Avalokiteśvara
See *Kannon*.

Batō Kannon
Horse-headed Kannon; bodhisattva whose manifestation as a horse symbolizes the trampling of evil. Sanskrit: Hayagrīva Avalokiteśvara.

Bhaiṣajyaguru
See *Yakushi*.

Birushana
Cosmic Buddha; see also *Dainichi Nyorai*. Sanskrit: Vairocana.

Bishamonten
Foremost of the Four Divine Kings; protects Buddhist altars on the north. Sanskrit: Vaiśravana.

Bodhisattva of Mercy.
See *Kannon*.

Buddha
A fully enlightened being. Sanskrit: tathāgata; Japanese: nyorai.

Cintāmaṇicakra Avalokiteśvara
See *Nyoirin Kannon*.

Daibutchō
See *Ichijikinrin Butchō*. Sanskrit: Mahoṣnisacakra.

Dainichi
Great Illuminator, Great Sun Buddha; central figure of the Esoteric Buddhist pantheon; divine essence of all other Buddhist deities; amplified version of Birushana. Sanskrit: Mahavairocana.

Dhritārastra
See *Jikokuten*.

Ekadaśmukha Avalokiteśvara
See *Jūichimen Kannon*.

Ekāsarosnisacakra
See *Ichijikinrin Butchō*.

Five Great Wisdom Kings
See *Godai Myōō*.

Five Wisdom Buddhas
See *Gochi Nyorai*.

Four Divine Kings
See *Shitennō*.

Fudō Myōō
Immovable One; one of the forms of Dainichi Nyorai. Sanskrit: Acalanatha.

Fugen
Bodhisattva who embodies the Historic Buddha's universal virtues; often paired with Monju, and shown riding an elephant. Sanskrit: Samantabhadra.

Fukūjōju Nyorai
One of the Five Wisdom Buddhas. Sanskrit: Amoghasiddhi.

Fukūkenjaku Kannon
Form of Bodhisattva of Mercy who carries a rope to extend to mortal beings in peril. Sanskrit: Amoghapāśa Avalokiteśvara.

Gochi Nyorai
Five Wisdom Buddhas who embody the five types of spiritual insight of Esoteric Buddhism, namely Dainichi, Ashuku, Hōshō, Amida (as Muryōju), and Fukūjōju.

Godai Myōō
Five Great Wisdom Kings, fierce protectors of the dharma in Esoteric Buddhism, namely Fudō, Gozanze, Gundari, Daiitoku, and Kongōyasha.

Gokuraku
"Utmost Pleasure." The name of the Paradise of Amida. Sanskrit: Sukhāvatī.

Gozanze Myōō
One of the Five Great Wisdom Kings.

Hayagrīva Avalokiteśvara
See *Batō Kannon*.

Hōshō Nyorai
One of the Five Wisdom Buddhas. Sanskrit: Ratnasambhava.

Ichijikinrin Butchō
Esoteric Buddhist deity said to have emerged from the usṇiṣa of the Historic Buddha. Sanskrit: Ekāsarosnisacakra.

Jikokuten
One of the Four Divine Kings. Sanskrit: Dhritārastra.

Jizō Bosatsu
Bodhisattva, usually depicted in the guise of a monk, who has power over all hells and is devoted to the salvation of all sentient beings between the nirvana of Shaka and the arrival of Miroku. Sanskrit: Ksitigarbha.

Jūichimen Kannon
Eleven-headed Kannon; savior of demons; one of the forms of the bodhisattva Kannon. The ten small heads in the crown symbolize the ten stages on the way to enlightenment (the eleventh, central head, represents Amida). Sanskrit: Ekadaśmukha Avalokiteśvara.

Kannon
Bodhisattva of Mercy who takes many forms; one of Amida's two chief attendants; probably the most popular of all deities in East Asian Buddhism. Sanskrit: Avalokiteśvara.

Kokūzō
Bodhisattva of Infinite Space. Sanskrit: Ākāsagarbha.

Ksitigarbha
See *Jizō Bosatsu.*

Mahāsthāmaprāpta
See *Seishi.*

Mahavairocana
See *Dainichi.*

Mahoṣniṣacakra
See *Daibutchō.*

Maitreya
See *Miroku.*

Mañjuśrī
See *Monju.*

Miroku
Future Buddha, to come to earth when the Buddhist dharma again prevails among humankind. Sanskrit: Maitreya.

Monju
Bodhisattva who embodies the wisdom and insight of the Buddha; often paired with Fugen and shown riding a lion. Sanskrit: Mañjuśrī.

Nyorai
Fully enlightened Buddha. Sanskrit: Tathāgata.

Nyoirin Kannon
Bodhisattva of Mercy usually shown holding a magic wish-granting jewel (nyoirin) in right hand; one of the forms of the bodhisattva Kannon. Sanskrit: Cintāmaṇicakra Avalokiteśvara.

Pradānaṣūna
See *Yuse Bosatsu.*

Rāgarāja
See *Aizen Myōō.*

Rākṣasīs
See *Rasetsunyo.*

Rasetsunyo
Ten female guardians of those who revere the Lotus Sutra. Sanskrit: Rākṣasīs.

Rikishi
Protector of Buddha.

Sahasrabhuja Avalokiteśvara
See *Senju Kannon.*

Śākyamuni
See *Shaka.*

Samantabhadra
See *Fugen.*

Seishi
One of Amida's two chief attendants, recognizable by the water bottle in his crown. Sanskrit: Mahāsthāmaprāpta.

Senju Kannon
Thousand-armed Kannon; one of the forms of the bodhisattva Kannon. Each of its thousand arms represents a means of saving sentient beings. Sanskrit: Sahasrabhuja Avalokiteśvara.

Shaka
Historic Buddha (Siddhartha Gautama), who was born a prince but abandoned the material world, meditated under a sacred tree, and attained nirvana (enlightenment). He set forth the doctrine that existence is an evil from which escape is possible through right thought and conduct. Sanskrit: Śākyamuni.

Shitennō
Four Divine Kings. Ancient Indian deities, guardians of the four cardinal points of the compass, namely Bishamonten (north), Zōchōten (south), Jikokuten (east), Kōmokuten (west).

Shōkannon
"Holy Kannon." The simplest, most basic form of the Bodhisattva of Mercy.

Sukhāvatī
See *Gokuraku.*

Tahō
Name of a Buddha of the remote past described in the Lotus Sutra as appearing with the Historic Buddha to demonstrate the timelessness of the Buddha-principle. Sanskrit: Tathāgata Prabhūtaratna.

Select Bibliography

Tathāgata Prabhūtaratna
See *Tahō*.

Vairocana
See *Birushana*.

Vaiśravana
See *Bishamonten*.

Yakushi
The Buddha who heals spiritual and physical ailments. Sanskrit: Bhaiṣajyaguru.

Yōryū Kannon
"Willow Branch Kannon." An incarnation of the Bodhisattva of Mercy in which its flexibility to the needs of the faithful is likened to that of a willow. Becoming popular in Middle Ages, the name was applied to much older images.

Yuse Bosatsu
One of Fugen's attendants. Sanskrit: Pradānaṣūna.

Zaō Gongen
Fierce Shinto god-protector of Mt. Kimpu near Nara, believed to be the place where Miroku will descend to earth; said to incarnate three Buddhist deities and to protect Shugendō mountain ascetics.

Akiyama Terukazu. *Japanese Painting*. Translated by James Emmons. Vol. 3 of *Treasures of Asia*. Basel: Skira, 1961.

Andrews, Allan A. *The Teachings Essential for Rebirth: A Study of Genshin's Ōjōyōshū*. Tokyo: Sophia University, 1973.

Bercholz, Samuel, and Sherab Chodzin Kohn. *Entering the Stream: An Introduction to the Buddha and His Teachings*. Boston: Shambhala, 1993.

Brown, Delmer M., ed. *Ancient Japan*. Vol. 1 of *The Cambridge History of Japan*. Cambridge: Cambridge University Press, 1993.

Cleary, Thomas F. *The Flower Ornament Scripture: A Translation of the Avatamsaka Sutra*. Boston: Shambhala, 1985.

Eliot, Charles, Sir. *Japanese Buddhism*. London: E. Arnold & Co., 1935.

Fontein, Jan, and Money L. Hickman. *Zen Painting and Calligraphy*. Exh. cat. Museum of Fine Arts. Boston, 1970.

Fukuyama Toshio. *Heian Temples: Byōdō-in to Chūson-ji*. Translated by Ronald K. Jones. Vol. 9 of *The Heibonsha Survey of Japanese Art*. New York: Weatherhill; Tokyo: Heibonsha, 1976.

Goepper, Roger. *Shingon—Die Kunst Des Geheimen Buddhismus in Japan*. Exh. cat. Museum für Ostasiatische Kunst der Stadt Köln. Cologne, 1988.

The Great Eastern Temple. Exh. cat. Art Institute of Chicago. 1986.

Hayashi Ryōichi. *The Silk Road and the Shōsō-in*. Translated by Robert Ricketts. Vol. 6 of *The Heibonsha Survey of Japanese Art*. New York: Weatherhill; Tokyo: Heibonsha, 1975.

The Heibonsha Survey of Japanese Art. 31 volumes. New York: Weatherhill; Tokyo: Heibonsha, 1972–79.

Hōryū-ji: Temple of the Exalted Law. Translated by W. Chie Ishibashi. Exh. cat., Japan House Gallery. New York: Japan Society, 1981.

Ienaga Saburō. *Painting in the Yamato Style*. Translated by John M. Shields. Vol. 10 of *The Heibonsha Survey of Japanese Art*. New York: Weatherhill; Tokyo: Heibonsha, 1973.

Ishida Hisatoyo. *Esoteric Buddhist Painting*. Translated and adapted by E. Dale Saunders. Vol. 15 of *Japanese Art Library*. Tokyo and New York: Kōdansha, 1987.

Kageyama Haruki. *The Arts of Shinto*. Translated and adapted by Christine Guth. Vol. 4 of *Arts of Japan*. New York: Weatherhill; Tokyo: Shinbundō, 1973.

Kageyama Haruki and Christine Guth Kanda. *Shinto Arts: Nature, Gods and Man in Japan*. New York: Japan Society, 1976.

Kidder, J. Edward. *Masterpieces of Japanese Sculpture*. Tokyo: Bijutsu Shuppansha; Rutland, Vt.: Charles E. Tuttle, 1961.

Kitagawa, Joseph M. *Religion in Japanese History*. New York: Columbia University Press, 1966, 1990.

———. *On Understanding Japanese Religion*. Princeton, N.J.: Princeton University Press, 1986.

Mason, Penelope. *History of Japanese Art*. New York: Harry N. Abrams, 1993.

Matsushita Takaaki. *Ink Painting*. Translated and adapted by Martin Collcutt. Vol. 7 of *Arts of Japan*. New York: Weatherhill; Tokyo: Shibundō, 1974.

Miyajima Shin'ichi and Yasuhiro Sato. *Japanese Ink Painting.* Exh. cat. Los Angeles County Museum of Art. 1985.

Mizuno Seiichi. *Asuka Buddhist Art: Hōryū-ji.* Translated by Richard L. Gage. Vol. 4 of *The Heibonsha Survey of Japanese Art.* New York: Weatherhill; Tokyo: Heibonsha, 1974.

Mōri Hisashi. *Japanese Portrait Sculpture.* Translated and adapted by W. Chie Ishibashi. Vol. 2 of *Japanese Arts Library.* Tokyo and New York: Kōdansha, 1977.

——. *Sculpture of the Kamakura Period.* Translated by Katherine Eickmann. Vol. 11 of *The Heibonsha Survey of Japanese Art.* New York: Weatherhill; Tokyo: Heibonsha, 1974.

Morse, Anne Nishimura, and Samuel Crowell Morse. *Object as Insight: Japanese Buddhist Art and Ritual.* Exh. cat. Katonah Museum of Art. 1995.

Murase Miyeko. *Emaki: Narrative Scrolls from Japan.* Exh. cat. New York: Asia Society, 1983.

——. *Japanese Art: Selections from the Mary and Jackson Burke Collection.* Exh. cat. Metropolitan Museum of Art. New York, 1975.

Nishikawa Kyōtarō and Emily Sano. *The Great Age of Japanese Buddhist Sculpture, A.D. 600–1300.* Exh. cat. Kimbell Art Museum and Japan Society. Fort Worth and New York, 1982.

Noma Seiroku. *The Arts of Japan, Ancient and Medieval.* Translated by John M. Rosenfield. Tokyo: Kōdansha, 1966.

Okazaki Jōji. *Pure Land Buddhist Painting.* Translated and adapted by Elizabeth ten Grotenhuis. Vol. 4 of *Japanese Arts Library.* Tokyo and New York: Kōdansha, 1973.

Philippi, Donald L., trans. *Kojiki.* Princeton, N.J.: Princeton University Press, 1968.

Rosenfield, John M., and Elizabeth ten Grotenhuis. *Journey of the Three Jewels.* New York: Asia Society, 1979.

Rosenfield, John M., and Shūjirō Shimada. *Traditions of Japanese Art: Selections from the Kimiko and John Powers Collection.* Cambridge: Fogg Art Museum, 1970.

Sansom, G. B. *Japan: A Short Cultural History.* Rev. ed. New York: Appleton-Century-Crofts, 1962.

Saunders, E. Dale. *Mudrā—A Study of Symbolic Gestures in Japanese Buddhist Sculpture.* Princeton, N.J.: Princeton University Press, 1960.

Sawa Takaaki. *Art in Japanese Esoteric Buddhism.* Translated by Richarld L. Gage. New York: Weatherhill; Tokyo: Heibonsha, 1972.

Seckel, Dietrich. *The Art of Buddhism.* New York: Crown Publishers, 1964.

Sugiyama Jirō. *Classic Buddhist Sculpture: The Tempyō Period.* Translated and adapted by Samuel C. Morse. Vol. 11 of *Japanese Arts Library.* New York: Kōdansha; Tokyo: Shibundō, 1982.

Tanabe, Willa J. *Paintings of the Lotus Sutra.* New York: Weatherhill, 1988.

Tanaka Ichimatsu. *Japanese Ink Painting: Shūbun to Sesshū.* Translated by Bruce Darling. Vol. 12 of *The Heibonsha Survey of Japanese Art.* New York: Weatherhill; Tokyo: Heibonsha, 1972.

Tsunoda Ryusaku et al., eds. *Sources of Japanese Tradition*, vol. 1. New York: Columbia University Press, 1964.

Varley, H. Paul. *Japanese Culture: A Short History.* New York: Praeger, 1973.

Visser, Marinus Willem de. *Ancient Buddhism in Japan.* 2 vols. Leiden: E. J. Brill, 1935.

Warner, Langdon. *The Craft of the Japanese Sculptor.* New York: McFarlane, Warde, McFarlane, and Japan Society of New York, 1936.

——. *The Enduring Art of Japan.* Cambridge: Harvard University Press, 1952.

Watanabe Akiyoshi. *Of Water and Ink: Muromachi-period Paintings from Japan, 1392–1568.* Exh. cat. Detroit Institute of Arts. 1986.

Yamasaki Taikō. *Shingon—Japanese Esoteric Buddhism.* Boston: Shambhala, 1988.

Checklist of the Exhibition

1. *Temple Roof Tiles;* molded earthenware
a. *Eaves-end Tile from a Temple Site at Yokoi, Nara,* 7th century; diam. 15.5 cm
b. *Eaves-end Tile from a Temple Site at Yamamura, Nara,* 7th century; diam. 19 cm
c. *Eaves-end Tile from a Temple Site at Yamamura, Nara,* 7th century; l. 31 cm
d. *Eaves-end Tile from Tōdai-ji, Nara,* datable to 752; diam. 19.3 cm
e. *Eaves-end Tile from Tōdai-ji, Nara,* datable to 752; l. 28.5 cm
f. *Eaves-end Tile from a Temple Site at Izumo Kokubun-ji, Shimane Prefecture,* 8th century; diam. 14.4 cm
g. *Eaves-end Tile from a Temple Site at Izumo Kokubun-ji, Shimane Prefecture,* 8th century; l. 24.4 cm
h. *Eaves-end Tile from Byōdō-in, Uji, Kyoto Prefecture,* 11th century; diam. 14 cm

2. *Tile with Phoenix Design,* 7th century; molded earthenware; 39 x 39 cm; Minami Hokke-ji, Nara Prefecture. Important Cultural Property

3. *Five-story Pagoda,* 8th century; molded, cut, and incised earthenware; h. 202.7 cm

4. *Jar with Hunting Scene,* 8th century; cast silver with gilding and incised and tool punched designs; h. 4.4 cm; Tōdai-ji, Nara. National Treasure

5. *Cicada-shaped Lock,* 8th century; cast silver with gilding; l. 3.5 cm; Tōdai-ji, Nara. National Treasure

6. *Sutra Case with Two Figures,* dated 1116; cast bronze with gilding; case: 45.6 x 15.1 cm; figures, h. 11.2 cm each. Important Cultural Property

7. *Sutra Case and Container,* dated 1141; container: carved steatite with incised inscriptions, h. 40.2 cm; case: cast bronze with incised design, h. 41.3 cm. Important Cultural Property

8. *Sutra Case,* 12th century; gilt bronze with incised calligraphy, glass beadwork, and lidded glass jar; h. 41.5 cm

9. *Sutra Container with Bird Design,* 12th century; stoneware with natural ash glaze and incised and carved designs; h. 36.3 cm

10. *Miroku Nyorai (Future Buddha),* dated 1071; carved and incised steatite; statue: h. 54.3 cm, base: h. 10.7 cm, diam. 40 cm. Important Cultural Property

11. *Ajaseō-kyō (Sutra of King Ajaseō) (Volume 2),* dated 742; handscroll (one of a pair): ink on paper; 26.7 x 1573.1 cm

12. *Konkōmyō Saishoō-kyō (Sutra of the Sovereign Kings of the Golden Light) (Volume 10),* 8th century; handscroll (part of a set of ten): gold powder on purple-dyed paper; 26.4 x 841.1 cm. National Treasure

13. *Kegon-kyō (Flower Garland Sutra),* 8th century; handscroll (one of a pair): silver powder on blue paper; 25.5 x 538.6 cm

14. *Kako Genzai E-inga-kyō (Illustrated Sutra of Cause and Effect),* 8th century; handscroll: ink and color on paper; 26.4 x 115.9 cm. Important Cultural Property

15. *Letter by Priest Saichō,* dated 813; hanging scroll: ink on paper; 29.4 x 55.2 cm. National Treasure

16. *Buddha Preaching (Chapter 18 of the Kongōchō-kyō [Diamond Crown Sutra]),* early 12th century; handscroll with frontispiece: silver and gold pigments on indigo-dyed paper; 26 x 486.6 cm

17. *Shaka Nyorai (Historic Buddha),* 7th century; cast bronze, gilded; h. 15 cm

18. *Kannon Bosatsu,* 7th century; cast bronze; h. 31.1 cm

19. *Yakushi Nyorai (Healing Buddha),* 8th century; cast bronze with traces of gilding; h. 37.3 cm. Important Cultural Property

20. *Rikishi (Guardian of the Buddha),* 8th century; dry lacquer with polychromy and gold leaf; h. 59 cm. Important Cultural Property

21. *Kokūzō Bosatsu (Bodhisattva of Infinite Space),* late 8th century; dry lacquer with polychromy and metalwork; h. 51.5 cm; Kakuan-ji, Nara. Important Cultural Property

22. *Yoryū Kannon,* 8th century; wood with lacquer and traces of polychromy; h. 168.5 cm; Daian-ji, Nara. Important Cultural Property

23. *Jūichimen Kannon (Eleven-headed Bodhisattva),* late 8th century; wood with polychromy and gold paint; h. 42.8 cm. Important Cultural Property

24. *Yakushi Nyorai (Healing Buddha),* 9th century; wood with traces of polychromy and lacquer; h. 49.7 cm. National Treasure

25. *Miroku Nyorai (Future Buddha),* 9th century; wood with traces of polychromy and lacquer; h. 39 cm; Tōdai-ji, Nara. Important Cultural Property

26. *Nyoirin Kannon (Bodhisattva of Mercy with the Wish-Granting Jewel),* late 9th–early 10th century; wood with traces of lacquer and polychromy; h. 94.9 cm. Important Cultural Property

27. *Jizō Bosatsu,* 10th century; wood with black lacquer and crystal eyes; h. 103.8 cm; Daifuku-ji, Nara. Important Cultural Property

28. *Zaō Gongen,* 12th century; cast bronze, engraved, with gilding; h. 30.5 cm. Important Cultural Property

29. *Batō Kannon (Horse-headed Bodhisattva),* dated 1241, by Ryōken, Zōzen, and Kankei (dates unknown); wood with lacquer, polychromy, and cut gold decoration; figure: h. 106.5 cm, base: h. 33.5 cm, halo: h. 134.5 cm; Jōrūri-ji, Kyoto Prefecture. Important Cultural Property

30. *Aizen Myōō (Esoteric King of Passion),* dated 1256, by Kaisei (dates unknown); wood with polychromy, gold foil, and gilt-bronze metalwork; figure: h. 26.2 cm, base: h. 29.3 cm, halo: h. 30.3 cm. Important Cultural Property

31. *Jūichimen Kannon (Eleven-headed Bodhisattva),* dated 1222, by Zen'en (1197– 1258); lacquered wood with polychromy, gold leaf, and crystal eyes; h. 46.6 cm

32. *Shaka Nyorai (Historic Buddha),* dated 1273, by Genkai (dates unknown); wood with lacquer and crystal eyes; h. 78.8 cm. Important Cultural Property

33. *Shaka Nyorai (Historic Buddha) Triad,* 14th century; three hanging scrolls: ink, color, and gold pigment on silk; 119.1 x 59.7 cm each. Important Cultural Property

34. *Monju Bosatsu (Bodhisattva of Wisdom),* dated 1334, by Monkanbō Kōshin (1278– 1357); hanging scroll: ink and color on silk; 90.8 x 41.6 cm. Important Cultural Property

35. *Fugen Bosatsu (Bodhisattva of Universal Virtue),* 12th century; hanging scroll: ink, color, and cut gold and silver foil on silk; 61.6 x 30.7 cm. Important Cultural Property

36. *Fugen Bosatsu (Bodhisattva of Universal Virtue) and the Ten Rasetsunyo (Female Guardians),* 13th century; hanging scroll: ink and color on silk; 112 x 55 cm. Important Cultural Property

37. *Nehan (Death of the Historic Buddha),* 14th century; hanging scroll: ink and color on silk; 180.3 x 164.8 cm; Jōdō-ji, Hyōgo Prefecture. Important Cultural Property

38. *Jigoku Zoshi (Hell Scenes),* late 12th century; handscroll: ink and color on paper; 26.5 x 454.7 cm. National Treasure

39. *Hekija (The Extermination of Evil by Buddhist Deities),* late 12th century; five hanging scrolls: ink and color on paper; *Tenkeisei,* 26 x 39.2 cm; *Sendan Kendatsuba,* 25.8 x 77.2 cm; *Shinchū,* 25.8 x 70 cm; *Shōki,* 25.8 x 45.2 cm; *Bishamonten,* 25.9 x 76.4 cm. National Treasure

40. *Iconographical Sketches of the Deities of the Taizōkai (Womb World) Mandala,* dated 1194; handscroll (one of a pair): ink on paper; 30.3 x 1409.7 cm. Important Cultural Property

41. *Ryōkai (Two Worlds) Mandalas,* 11th century; two hanging scrolls: gold and silver pigments on silk; *Kongōkai (Diamond World),* 352.5 x 299 cm; *Taizōkai (Womb World),* 352 x 306.4 cm; Kojima-dera, Nara. National Treasure

42. *Ichiji Kinrin Mandala,* 12th century; hanging scroll: ink, color, silver and gold pigments, and cut gold foil on silk; 79 x 49.2 cm. Important Cultural Property

43. *Daibutchō Mandala,* 12th century; hanging scroll: ink, color, and cut gold and silver foil on silk; 125.5 x 88.5 cm. Important Cultural Property

44. *Sonshō Mandala,* 13th century; hanging scroll: ink, color, and cut gold foil on silk; 133.6 x 82.8 cm. Important Cultural Property

45. *Jūichimen Kannon (Eleven-headed Bodhisattva),* 12th century; hanging scroll: ink and color with cut silver and gold foil on silk; 169 x 90 cm. National Treasure

46. *Senju Kannon (Bodhisattva of Mercy with a Thousand Arms),* 12th century; hanging scroll: ink, color, and cut gold and silver foil on silk; 93.8 x 39.5 cm. Important Cultural Property

47. *Kannon Bosatsu,* 12th century; wood, lacquered and gilded, with traces of polychromy; h. 61 cm. Important Cultural Property

48. *Senju Kannon (Bodhisattva of Mercy with a Thousand Arms),* 14th century; hanging scroll: ink, color, gold, and cut gold foil on silk; 100.8 x 41 cm. Important Cultural Property

49. *Nyoirin Kannon (Bodhisattva of Mercy with the Wish-Granting Jewel),* 14th century; hanging scroll: ink, color, gold pigment, and cut gold foil on silk; 101.7 x 41.6 cm. Important Cultural Property

50. *Aizen Myōō (Esoteric King of Passion),* 12th century; hanging scroll: ink and color on silk; 86.8 x 44.8 cm

51. *Fudō Myōō (Immovable One) and Eight Attendants,* 13th–14th century; hanging scroll: ink and color on silk; 129.6 x 89.3 cm. Important Cultural Property

52. *Taima Mandala,* 13th century; hanging scroll: ink, color, cut gold and silver foils, and gold pigment on silk; 193.5 x 163.6 cm

53. *Raigō (Welcoming Descent of Amida, Buddha of Infinite Light),* 13th century; hanging scroll: ink and color on silk; 103 x 82.4 cm; Matsuo-dera, Nara. Important Cultural Property

54. *Kasuga Mandala,* 14th century; hanging scroll: ink and color on silk; 118.5 x 35.7 cm

55. *Kashimadachi Shineizu (Shinto Deities Departing from Kashima Shrine),* late 14th century; hanging scroll: ink and color on silk; 140.6 x 40.2 cm

56. *Ikoma Mandala,* 14th century; hanging scroll: ink, color, and cut gold on silk; 105.3 x 41.9 cm. Important Cultural Property

57. *Sannō Mandala,* 15th century; hanging scroll: ink and color on silk; 121.1 x 66.8 cm

58. *Priest Shinran,* 13th–14th century; hanging scroll: ink, color, and gold pigment on silk; 120.2 x 81.1 cm. Important Cultural Property

59. *Priest Myōkū,* 13th–14th century; hanging scroll: ink and color on silk; 168.5 x 100.2 cm. Important Cultural Property

60. *Andō En'e,* dated 1330, inscription by Minki Soshun (Chinese, dates unknown); hanging scroll: ink and color on silk; 119.5 x 57.9 cm. Important Cultural Property

61. *Priest Daidō Ichii,* dated 1394, attributed to Minchō Kichizan (1351–1431), colophon by Shōkai Reiken (1315–1396); hanging scroll: ink on paper; 47 x 16.2 cm. Important Cultural Property

62. *Landscape Known as "Suishoku Rankō,"* dated 1445, attributed to Tenshō Shūbun (active 1423–1460), inscriptions by Shinden Seiha (1375–1447), Shinchu Mintoku (d. 1451), and Kōsei Ryūha (1375–1446); hanging scroll: ink and slight color on paper; 107.9 x 32.7 cm. National Treasure

63. *Mirror with Image of Amida Nyorai (Buddha of Infinite Light),* 12th century; cast bronze with tin plating and incised design; diam. 20.5 cm. Important Cultural Property

64. *Mirror with Image of Zaō Gongen,* 12th century; cast bronze with incised design; diam. 21.5 cm

65. *Kakebotoke (Hanging Votive Plaque) with Images of Ten Shinto Deities,* dated 1218, made by Taira-no-Kagetoshi; gilt bronze with incised and applied designs; diam. 30.4 cm. Important Cultural Property

66. *Kakebotoke (Hanging Votive Plaque) with Image of Jūichimen Kannon (Eleven-headed Bodhisattva),* 12th century; gilt bronze with incised and applied designs; diam. 23.6 cm

67. *Kakebotoke (Hanging Votive Plaque) with Image of Shōkannon,* early 13th century, by Kyōen (dates unknown); lacquered wood with traces of gilding; diam. 32.5 cm

68. *Keman (Hanging Fan-shaped Ornament)* (two elements), 11th century; lacquered cowhide with ink and color; gilt-bronze fittings with incised designs; 47 x 54.2 and 41 x 56.3 cm. National Treasure

69. *Keman (Hanging Fan-shaped Ornament),* 14th century; cast bronze, gilded, with incised and punched designs; 43.3 x 42.2 cm. Important Cultural Property

70. *Keman (Hanging Fan-shaped Ornament),* 14th century; carved wood with lacquer, polychromy, and metal fittings; 29.3 x 34.3 cm

71. *Ban (Ritual Banner),* 14th century; joined brocade textile sections with metal fittings; 89 x 31.4 cm

72. *Raigō (Welcoming Descent of Amida, Buddha of Infinite Light),* 14th century; embroidered hanging scroll: silk and human hair designs; 71.7 x 25 cm

73. *Amida Nyorai (Buddha of Infinite Light),* 13th century; embroidered hanging scroll: silk and human hair designs; 69.3 x 25.2 cm

74. *Sutra Box,* 12th century; lacquered animal hide with sprinkled gold, silver and gold alloy powder decoration, and metal fittings; 12.1 x 31.8 x 17.6 cm. National Treasure

75. *Shrine for Daihannya-kyō (The Greater Sutra of the Perfection of Wisdom) and a Daihannya Handscroll,* late 12th century; shrine: lacquered wood with polychromy, gold and silver pigment, and cut gold and silver foil, h. 165 cm, diam. 62.5 cm; hand-scroll: ink on paper, 23.9 x 812 cm. Important Cultural Property

76. *Kasuga Cult Tabernacle and Reliquary,* 14th century; tabernacle: lacquered wood and polychromy with gilt-bronze fittings and beadwork, h. 37.2 cm; reliquary: cast gilt bronze with engraved and punched designs, crystal vessel, h. 11.7 cm

77. *Shrine with Reliquary,* dated 1387; shrine: lacquered wood with polychromy, cut gold foil, and metal fittings with incised designs, h. 30.3 cm; reliquary: gilt bronze, nickel, inscribed paper, and glass. Important Cultural Property

78. *Shari (Reliquary),* dated 1290, by Shirakawa Morisada (dates unknown) and others; cast gilt bronze with openwork, punched and incised designs, and crystal; h. 34 cm; Kairyūō-ji, Nara. Important Cultural Property

79. *Stupa-shaped Reliquary,* 13th century; cast bronze with gilding and attached metal-work; h. 17.6 cm

80. *Nyoi (Priest's Ceremonial Scepter),* 12th century; bronze with silver and gold gilding, incised designs, and lacquered wood staff; 63.5 x 26.9 cm. Important Cultural Property

81. *Shakujō (Monk's Staff) Finial,* 12th century; cast bronze with incised designs; h. 27.9 cm

82. *Kei (Ritual Chime),* 12th century; cast bronze with traces of gilding; w. 22 cm

83. *Stand for a Kei (Ritual Chime),* 14th–15th century; lacquered wood with metal fittings; 50.5 x 52.6 cm

84. *Set of Ritual Implements,* 14th century; cast bronze with incised designs and gilding; incense burner: h. 12.4 cm, diam. 12 cm; six dishes: h. 3.7 cm, diam. at mouth 7.8 cm; six plates: diam. 7.8 cm; two food dishes: h. 6.8 cm, diam. at mouth 11 cm; two flower vessels: h. 11.9 cm; Saidai-ji, Nara. Important Cultural Property

85. *Three-legged Table,* 15th century; lacquered wood with metal fittings; 43.3 x 42.2 cm

86. *Kasha (Incense Burner),* 13th century; cast bronze with incised designs and gilding; h. 10.3 cm, diam. 10.7 cm

87. *Pair of Kebyō (Flower Containers),* 14th century; gilt bronze; h. 20 cm